Prisms and Rainbows

Prisms and Rainbows

Michel Butor's Collaborations with Jacques Monory, Jiří Kolář, and Pierre Alechinsky

Elinor S. Miller

Madison • Teaneck
Fairleigh Dickinson University Press
London: Associated University Presses

Associated University Presses
2010 Eastpark Boulevard
Cranbury, NJ 08512

Associated University Presses
16 Barter Street
London WC1A 2AH, England

Associated University Presses
P.O. Box 338, Port Credit
Mississauga, Ontario
Canada L5G 4L8

The paper used in this publication meets the requirements of the American National Standard for Permanence of Paper for Printed Library Materials Z39.48-1984.

Library of Congress Cataloging-in-Publication Data

Miller, Elinor S.
 Prisms and rainbows : Michel Butor's collaborations with Jacques Monory, Jiří Kolář, and Pierre Alechinsky / Elinor S. Miller.
 p. cm.
 Includes bibliographical references and index.
 ISBN 0-8386-3919-4 (alk. paper)
 1. Butor, Michel—Criticism and interpretation. I. Butor, Michel. II. Monory, Jacques, 1934– III. Kolář, Jiří, 1914– IV. Alechinsky, Pierre, 1927– V. Title.
PQ2603.U73 Z73 2003
848′.91409—dc21

 2002024289

In memoriam
Warren C. Miller

Contents

List of Illustrations 9
Acknowledgments 11

1. Introduction 15
2. Michel Butor and Jacques Monory: Bicentennial Blues 21
 Bicentenaire kit 21
 Monory and Butor 21
 The Serigraphs and the Poems 23
 Conclusions 35
3. Michel Butor and Jíří Kolář: Princes of Juxtaposition 38
 Introduction 38
 Guirlande liminaire: Vagues des villes éclosion 41
 L'Oeil de Prague 45
 Cartes postales pour un ami de Liechtenstein 84
4. Michel Butor and Pierre Alechinsky: The Double Gaze 92
 Introduction 92
 Le Test du titre 95
 Hoirie-voirie: Stances des mensualités 103
 Guirlande liminaire: La Méduse des chocolats 115
 Le Rêve de l'ammonite 119
 Le Chien roi 133
 Frontières et bordures: Comptine en blanc et noir 143
 ABC de correspondance: Dessins sur factures 152
5. Conclusions 172

Appendix A. Monory: Variants, *Bicentenaire kit* to *Boomerang* 177
Appendix B. Monory: Serigraphs 179
Appendix C. Kolář: Variants 180
Appendix D. Kolář: *Le Rêve de Jiří Kolář* Matrix 184
Appendix E. Alechinsky: Variants 187
Appendix F. Alechinsky: Text of Special Three-Copy Edition of
 Le Rêve de l'ammonite 189

Notes 199
Works Cited 224
Index 228

List of Illustrations

Monory and Kolář did not entitle the artworks reproduced here; the titles used for identification are taken from Butor's texts. The Alechinsky stanza from the *Guirlande liminaire* also takes its title from Butor's text. The other Alechinsky artworks he entitled himself, or they are identified here by their numbers, as in *Le Test du titre* and *Le Rêve de l'ammonite,* or the month, as in *Stances des mensualités,* or the support, as in *Dessins sur factures,* with one exception taken from the drawing.

Monory

Tombée de la nuit, blues [Nightfall, Blues] 24

Balistique, blues [Ballistics, Blues] 27

Les Figurantes de Washington, blues [Walk-ons of Washington, Blues] 29

Sous le couvert, blues [Under Cover, Blues] 31

Appel urgent, blues [Emergency Call, Blues] 33

Le Diamant du large, blues [The Diamond of the Open Sea, Blues] 34

Kolář

Vagues des villes éclosion [Waves of Cities Blossoming] 42

Baudelaire 49

Le Cygne [The Swan] 49

Le Page [The Pageboy] 53

Three Kolář *froissages* 59

Sous une pluie de presse [Under a Rain of Printed Matter] 65

Dame d'antan [Lady of Yesteryear] 67

Menu meuble [Little Test-tube Rack] 68

Mugissement d'eaux [Roaring of Waters] 68

Dame de ce temps-ci [Lady of Today] 69

Venise [Venice] 70

Pomme vêtue [Dressed Apple] 71

Reine de cinéma [Movie Queen] 72

Pipe 72

Plein opéra [Complete Opera] 73

Violon [Violin] 74

Ville moyenne [Average City] 75

Cathédrale ivre [Drunken Cathedral] 75

Orgue de pieds et de bras [Organ of Feet and Arms] 76

Planchette à découper [Chopping Board] 78

Stratification 78

Pompadour 79

Pomme de jouvence [Apple of Youth] 80

Le Beau burg [The Beautiful Town] 85

Le Chateau noir [The Black Castle] 87

L' Opéra d'automne [The Autumn Opera] 88

Triomphe de la vallée [Triumph of the Valley] 90

Alechinsky

Ça y est! [There you are!] 97

Hé hé hé [Hey, hey, hey] 98

Ça pousse [It is growing] 99

Stupeur! [What a surprise!] 100

Elle en pleure de rire [She laughs until she cries] 102

Elle triomphe [She is triumphant] 104

Janvier [January] 105

Février [February] 105

Mars [March] 106

Avril [April] 107

Mai [May] 107

Juin [June] 108

Juillet [July] 108

Août [August] 108

Septembre [September] 109

Octobre [October] 110

Novembre [November] 110

Décembre [December] 111

La Méduse des chocolats [The Medusa of the Chocolates] 116

Séquestration [Confinement] 122

Précipitation [Haste] 125

Respiration [Breath] 128

Les Oranges de Binche [The Oranges of Binche] 134

Sphinx en chapeau [Sphinx in a Hat] 136

De toutes parts [From All Sides] 138

Le Chien roi [The Dog King] 140

Page I, Espagne et Portugal [Spain and Portugal] 144

Page II, Sud-ouest de la France [Southwestern France] 146

Page III, Nord-ouest de la France [Northwestern France] 147

Page IV, Turquie d'Asie [Turkey of Asia] 149

Page V, Mer Mediterranée [The Mediterranean] 149

Page VI, Europe actuelle [Europe Today] 150

Page VIII, Empire d'Alexandre [The Empire of Alexander] 152

The Ladder 156

Grande fabrique de cuisinières [Big Stove Factory] 157

Bon Marché II 158

Piano 161

Millet-Armand Bureau de tabac [Tobacconist] 163

Caves girondines [Girondine Cellars] 164

Charronage [Cartwright] 165

Articles d'éclairage [Lighting goods] 167

Acknowledgements

My sincere gratitude is offered to the following, without whom this work would not have been completed: Michel Butor; D. Elizabeth Salak, my daughter, reader, and indispensable editor; Warren C. Miller, my late husband, reader for many, many years; Lois Oppenheim, colleague, experienced and patient guide in the obstacle course of publication; Pat Lancaster, colleague, reader and never-failing source of encouragement; Frédéric-Yves Jeannet, writer, collaborator with Butor, faithful counselor, *ami-frère;* Kevin Norris, photographer at Embry-Riddle Aeronautical University, maker of slides; Roland Giraud, curator of the Fonds Butor in the library at Nice; Lynn S. Cline of Southwest Missouri State University Library, home of the William J. Jones Rimbaud and Butor Collections, established by F.C. St. Aubyn; Antoine Coron, Curator of Rare Works at the Bibliothèque nationale; Kate Reich, Lynne Phillips, and Chuck Potter, interlibrary loan directors at Rollins College and Embry-Riddle Aeronautical University; Richard Sanzenbacher, Paul Edson, Steve Jones, Alan Pratt, lenders of art books, and Paul Braim, historian, all colleagues at Embry-Riddle; Jesus Camarero-Arribas, Seda Chavdarian, Lynne Diamond-Nigh, Jack Kolbert, Jacques La Mothe, Dean McWilliams, the late Anna Otten, and F. C. St. Aubyn, fellow Butor scholars; the Camargo Foundaton, for two fellowships: in 1977, when Dean McWilliams introduced me to Michel Butor, and in 1991, when I began work on this book; Rollins College and Embry-Riddle Aeronautical University, for sabbaticals in 1977 and 1991.

Then, in the end-game of acquiring permissions to reproduce texts and illustrations: Michel Butor, Pierre Alechinsky, Jiří Kolář, and Jacques Monory all graciously donated their rights; for the others, Jean-Louis Moreau located and successfully contacted the photographer of the *Rêve de Jiri Kolar,* and Dr. Roy Rosenstein of the American University in Paris, through personal contacts and inexhaustible persistence, managed to extract the most difficult of those remaining, including the sine qua non, those among Butor's texts that now belong to the publisher.

Finally, Holly Knowles, indexer extraordinaire, and Associated University Presses editor Christine Retz, whose knowledge of the *Chicago Manual of Style,* patience with the eccentric, and sense of humor have been sorely tested but never failed.

* * *

Unless otherwise noted, photographic reproductions are by Kevin Norris, processed by Lou Fiore, Speedway Custom Photo Lab, Daytona Beach, Florida.

Monory

Text courtesy of Editions Gallimard. Illustrations (*Tombeé de la nuit, blues; Balistique, blues; Les Figurantes de Washington, blues; Sous le couvert, blues; Appel urgent, blues;* and *Le Diamant du large, blues*) courtesy of Jacques Monory.

Kolář

Guirlande liminaire: text courtesy of Michel Butor. Illustration (*Vagues des villes éclosion*) courtesy of Musée Malraux, Le Havre, and Jiří Kolář; *Baudelaire* and *Le Cygne,* courtesy of Jiří Kolář, G. Kühner and J. Ságl, photographers.

L'Oeil de Prague: text of *Le Rêve de Jiří Kolář* courtesy Editions Gallimard; text of remainder of *Dialogue avec Charles Baudelaire* courtesy of Michel Butor. Illustration *Le Page* courtesy of Galerie Wimmer, Montpellier and Jiří Kolář; "Three froissages" courtesy of Collegium Helveticum, Zurich, Thomas Cugini, photographer; *Sous une pluie de presse, Dame d'antan, Menu meuble, Mugissement d'eaux, Dame de ce temps-ci, Venise, Pomme vêtue, Reine de cinéma, Pipe, Plein opéra, Violon, Ville moyenne, Cathédrale ivre, Orgue de pieds et de bras, Planchette à découper, Stratification, Pompadour,* and *Pomme de jouvence* courtesy of Mme Michelle Strauch-Barelli, photographer.

Cartes postales pour un ami de Liechtenstein: text and illustrations (*Le Beau burg, Le Chateau noir, Opéra d'automne,* and *Triomphe de la vallée*) courtesy of Robert Altmann, Viroflay.

Alechinsky

Le Test du titre: text and illustrations (*Ça y est!, Hé hé hé, Ça pousse, Stupeur!, Elle en pleure de rire,* and *Elle*

triomphe) courtesy of Pierre Alechinsky, Michel Nguyen, photographer.

Stances des mensualités: text courtesy of Editions Gallimard; illustrations (*Janvier, Février, Mars, Avril, Mai, Juin, Juillet, Août, Septembre, Octobre, Novembre,* and *Décembre*) courtesy of Pierre Alechinsky.

Guirlande liminaire: text courtesy of Michel Butor; illustration *La Méduse des chocolats* courtesy of Pierre Alechinsky.

Le Rêve de l'ammonite: text courtesy Editions Gallimard; illustrations (*Séquestration, Précipitation,* and *Respiration*) courtesy of Pierre Alechinsky and Bruno Roy, photographs by Bibliothèque nationale, Paris.

Le Chien roi: text courtesy of Editions Gallimard; illustrations (*Les Oranges de Binche, Sphinx en chapeau, De toutes parts,* and *Le Chien roi*) courtesy of Pierre Alechinsky, Michel Nguyen, photographer.

Comptine en blanc et noir: text courtesy of Michel Butor; illustrations (*Espagne et Portugal, Sud-ouest de la France, Nord-ouest de la France, Turquie d'Asie, Mer Mediterranée, Europe actuelle,* and *Empire d'Alexandre*) courtesy of Pierre Alechinsky, Michel Nguyen, photographer.

Dessins sur factures: text courtesy of Michel Butor; illustrations (The Ladder, *Grande fabrique de cuisinières, Bon Marche II, Piano, Bureau de tabac, Caves Girondines, Charronage,* and *Articles d'éclairage*) courtesy Pierre Alechinsky.

* * *

Jacket photograph of Michel Butor courtesy of Maxime Godard, photographer.

Prisms and Rainbows

1

Introduction

The prisms of my title represent the works created by the artists, and the rainbows the text written by Michel Butor. The prisms are an acceptable part of the analogy, since prisms can be in all different shapes and sizes and even materials; a diamond, for example, serves as an outstanding prism and produces excellent rainbows. However, the little spots with the colors of the spectrum, which the sun shining through the prism sends dancing over the floor, walls, and ceiling do not have the form of rainbows, and further, since each one contains all the colors of the spectrum, they do not properly represent the diversity of Butor's texts, some of which would be all blue, some more blue and green, some rather red, or red, yellow, and purple, as we shall see.

An alternative analogy would be alchemy, a subject Butor has often considered, as his readers know very well.[1] He has himself written about alchemy and can be imagined practicing it, not using lead or "base" metal, but artworks, and drawing from them not gold, but poetry.[2] He knows how to tumble the lines, colors, and forms of the artworks into the retort, melt, stir, and bubble them, and then pour forth meaningful printed words. But immediately this analogy fails, first because the artworks are not at all "base," and second, because we would have to qualify them as catalysts rather than reactants since they remain intact after the spell is over. Observers who have not read the text—because they arrived late or were not paying attention—will see the artwork just as it was before the experiment. And yet, those who have read the text will never again see the artwork as the same. Thus the nature of the catalyst depends on the observer, scarcely a scientific situation. Further, each individual in the observing crowd will have a different opinion on exactly what has occurred. No matter how determinedly we watch, elbowing around the sorceror, we will not catch his every move, since the process is at least in part magical. Finally, a third flaw in this analogy is the same as found with the prism: gold is the constant desired result of alchemy, whereas each collaborative text is different from all the others. Thus, the idea of Butor as alchemist turns out to be an even less satisfactory analogy than the prism. Neither analogy succeeds entirely, but the inherent beauty of the rainbows is surely far more apt than the imposed value of gold.

The process of light's producing what scientists call "chromatic aberrations" or "dispersions" has been understood since Newton, and we will indeed learn something of Butor's transmutation of art into poetry, but there will always remain the unexplained, reminiscent of the alchemist's magic. As only one of the crowd, my opinion is by no means definitive. Other readers will have other ideas, and none of us can know exactly and completely what Butor saw. I offer here my understanding of what Butor found in the artworks of three visual artists. My intention has been, through the study of these collaborations, to encourage others to seek them out, to look and look again. I fervently hope others in the crowd will be moved to present their own perceptions.

THE COLLABORATIONS

Butor's definition of a collaboration differs from the standard. His meaning includes at least four modes: (1) the simultaneous co-labor found most often in the performing arts, for example between orchestra conductor and choreographer, or between librettist and vocalist; (2) collaborations composed successively as Butor and the artist pass the latest version back and forth, adjusting, adapting, adding, and subtracting; (3) publications in which the text was written before the artist became involved and created accompanying "illustrations"; a number of Butor's texts have been illustrated first by one artist and then by another; (4) works in which the artwork preceded the text and thus served as source. It is works in this last mode that are the subject of this study.

One may wonder why these collaborations demand attention when Butor's accumulated oeuvre *not* drawn from artworks is immense and encompasses early poems, novels, expository essays dealing with artists, writers, and their works, from Rabelais and Montaigne through the recent Balzac study to the contemporary, including himself, and any number of other subjects, plus reflections on his travels, interviews and "conversations," and unclassifiable genres. He continues to

publish in all these areas (except the novel, which he has apparently given up permanently), but he sees a clear point of demarcation in his work, the moment at which he began writing poetry inspired by a visual artwork. In conversations with Madeleine Santschi, he specified, "I absolutely needed painters or musicians to reach that," and further, "It made me write what I would not have been able to write otherwise. . . . Painters caused me to invent, to discover other rooms."[3] The moment was in his first collaborative work, with the artist Zañartu, published in fifty copies[4] and has been followed by hundreds of other texts inspired by internationally known artists, such as Calder, Masson, Picasso, as well as by those as yet known only locally or regionally—or because of their collaboration with Butor.

Scholars find many challenges keeping track of the collaborative works, especially given Butor's commitment to small, provincial, and foreign presses. When text and artwork are published together, it is usually in an exhibition catalogue or in a limited, rare, or deluxe edition, an "artist's book." Further, handwritten copies of very small editions are not identical; "when it is written by hand, in order not to be bored I vary the text."[5] In the spring of 2000, Butor's own computerized list of artists includes more than two hundred, and with some he has published more than thirty different works. For an exhibit in 1991, Bernard Teulon-Nouailles wrote of Butor's works that "An inventory is essential, which risks proving not to have been exhaustive at all."[6] A very useful stage in such an inventory is Jesus Camarero-Arribas's enormous and comprehensive bibliography of 1996 listing approximately 950 "artist's books," single and limited editions.[7] However, whatever one collects is condemned to be immediately out of date, as Camarero's bibliography illustrates. Understandably having omitted a number of critical articles about Butor's work that were published in the United States, it appeared just as Butor brought out five new books in the fall of that year. Rendering the challenges still more daunting, every text relates to others.[8] The parts are understandable individually, but the reader cannot appreciate Butor's work as an integral whole until all parts are seen and, ideally, understood together. Nonetheless, the temptation to abandon hope must be fiercely resisted, and scholars must rejoice over the vast expanse of Butor's works, some still barely studied.

Even as the cascade of "artist's books" overwhelms the reader, Butor has published these texts—without the artworks—in collections of poems, or in his other works, such as the four (to date) *Illustrations,* five *Matière de rêves* [*Stuff of Dreams*], and also in the last four of the five *Génie du lieu* [*Spirit of the Place*]. The texts become integral parts of the new publication, and are no longer obviously related to the artwork that gen-

erated the initial collaboration. In his infinitely varied fashion, Butor intercalates lines or parts of lines from the original into other texts and contexts, even though he recognizes that the original collaboration was one integrated whole, in which "the ideal is to succeed in creating an object in which the components react so much with each other that separation would be almost impossible."[9] The texts are indeed transformed as they are incorporated into a new environment, but the fortunate reader who has seen Jean-Claude Prêtre's Suzannes and Arianes will see those paintings again in his mind, in a bright new light, when an intermingling of Butor's texts derived from them appears in *Gyroscope*—that outstanding example of intertextuality—among texts derived from Picasso's minotaurs.[10]

Only one of the works studied here, the collaboration with Jiří Kolář, *L'Oeil de Prague* [*The Eye of Prague*], demonstrates this transformation, as it contains not only the texts of two distinct earlier collaborations, both originally in the fourth mode, where the artwork precedes the text (see p. 15), but also texts from a collaboration with a musician and allusions to others, plus a collaboration with a photographer. In all the other works treated here, the focus is on the original collaboration (in the fourth mode), and subsequent publications of the text are identified here mainly because of their greater accessibility. In some cases these later uses are mentioned for confirmation of variants; the fanatic scholarly impulse to trace a given text through its various divisions, rearrangements, rejoinings has been quashed in so far as possible and the versions relegated to the Appendices.

ARTISTS IN THIS STUDY

The three artists treated in this study were selected for practical rather than aesthetic reasons. First, availability played an essential role. Butor generously had given Dean McWilliams and me a *Bicentenaire kit,* with the Jacques Monory prints,[11] and he also gave me the four Lichtenstein postcards and a copy of the exposition catalogue, *Michel Butor et ses peintres* [*Michel Butor and His Painters*], which contains the Kolář and Pierre Alechinsky collaborations of the *Guirlande liminaire* [*Prefatory Garland*]. The Kolář collaborations of *L'Oeil de Prague* and the Butor/Sicard studies of Alechinsky were available in bookstores. Rare works were then located with the assistance of kind colleagues and patient librarians.

Second, all three artists use figuration in varying degrees. Few literary critics feel at ease writing about visual art, as was noted at the Colloque de Cerisy of

1973 devoted to Butor,[12] and this literary scholar is especially uncomfortable if the art is not figurative. But Butor feels that "however abstract they may say that it is, it is always figurative. A square is a form, of course, it does not only represent; it represents all sorts of things. A square is very figurative, it is as figurative as a nude. It represents something else" (*Thèmes,* 15). My endeavor has been to see that square as Butor saw it. Through his understanding of visual art, his erudition, and above all, his poetic vision, the artist's square may become almost anything in Butor's text.

All three artists have collaborated with Butor in the fourth mode, in which artwork precedes text. None of the three has, to my knowledge, worked with Butor in the first mode, the simultaneous. Monory has collaborated with Butor only once as of this date and, although the two did correspond over a period of time, the discussion concerned the selection of objects to be included in the *Bicentenaire kit,* not the artworks or texts. Up to a point, the Alechinsky collaboration, *Le Rêve de l'ammonite* [*The Dream of the Ammonite*], could be considered an example of the second mode, successive development, in that Alechinsky printed different stages of the engravings of the work in different colors, and, after the text was written, added marginalia and drawings for each of the section title pages. However, Butor did not then alter the text of the dream. Alechinsky added no drawings to Butor's textual comments in the special third edition (in three copies) created for the Bibliothèque nationale, found here in Appendix F.

Both Kolář and Alechinsky have worked with Butor's texts in the third mode, in which the text preceded the artworks. Camarero's bibliography lists thirteen such items with Kolář and sixteen with Alechinsky. Some of these are collections containing collaborations with a number of artists, such as the text *Guirlande liminaire,* and two are three-part collaborations among in one case, Hugo, Butor, and Kolář, and in the other, Balzac, Butor, and Alechinsky. These text-first collaborations with Kolář and Alechinsky are *not* treated here, although it is fascinating to study in them the artworks Butor's texts inspired. For example, Kolář's choice of figures for his collages in *Fenêtres sur le passage intérieur* [*Windows on the Inner Passage*] reveal his close reading of the texts of that work. Similarly, Alechinsky's drawings for the May 1968 text, *Tourmente* [*Torment*], vividly demonstrate his own sympathies. Seeing just what the artists found in Butor's works can only increase one's own understanding of the texts.[13] However, these collaborations have been, with regret, omitted from the present study since they show us what the artists found in Butor's texts rather than what Butor saw in their "squares."

THE APPROACH

With the goal of discovering what elements in the artwork can be determined to have inspired what aspects of the text, we will also find what in the text is not recognizably derived from the artwork. The catalytic artwork produces the poetry only in the essential combination with magic, which would be the writer's art. Unprovided with an established method for dissecting magic, I have fallen back on conventional literary analysis of the texts, of their structure, poetic devices, and content.

The complex matrices, typical of Butor's habit of setting for himself challenges, limits, are examined. The widely different effects produced by the frequent use of repetition, rhythm, and harmonious sounds are identified. The humor, from farcical to ironic, which almost all the texts contain, is pointed out. Both the harmony and the humor are found to serve as rhetorical devices supporting political subtexts, which are present in varying degrees in all the works.

POLITICS

The political requires explanation, for Butor's definition of politics in poetry is broad, inclusive, and idiosyncratic. He has said that the poet who believes poetry has nothing to to do with politics is grievously mistaken, especially as politicians "profoundly mistrust poetry and do everything they can to draw poets into their service."[14] The poet's responsibility is on a much grander scale than support of a candidate for an election: the poet needs to try to lead us "to feel that it is the totality of the political system we are in today which is bad, and which it would be appropriate to change" (111). The poet is not to succumb to nostalgia for any good old days: "We are a beginning of something. What we call democracy is evidently not satisfactory. What there was before was even less so" (121–22). What, then, can a poet do to effect change? "They can make proposals, ask, point out" (123). As examples, Butor proposes changes in the publication and distribution of poetry, establishing and opening up libraries, encouraging the study of languages and letters: "We need a new state of letters and languages to reach a veritable amelioration of our economic and political problems, which will certainly imply moreover a change of personnel in that area" (126). Given politicians' mistrust of poetry, the obstacles seem insurmountable, but Butor believes there are "little poets hidden, lost, repressed within contemporary politicians" (125) who will respond to the poets' call and, eventually, approve the enactment of the needed legislation. The desired "change of per-

sonnel" then takes place as "such a president, after having taken this sort of step, will know how to retire finally to cultivate his garden" (126). In these texts we will find this poet's calls for change over a wide range of concerns, from notorious established social injustices to particular individual behavior that is hurtful to others. According to his definition, Butor's collaborative texts are political. Some address particular problems more directly than others, but all contribute to our understanding that "the totality of the political system we are in today . . . is bad."

Each of our three artists treats political issues; indeed, Butor said of Jiri Kolář in *L'Oeil de Prague,* "All his art is political. It is an art of resistance. Mine is, too."[15] The political statements of Monory are readily recognized, and many of Kolář's works require no explanation. But other Kolář artworks, and many of Alechinsky's, would not appear in themselves to represent any particular political position. Nevertheless, we know Butor sees all Kolář's work as political, according to his definition, and he has almost always seen a political message in Alechinsky's, as we will see in our examination of these collaborations. The influence of the artist varies from one artist to the next, and from one collaboration with a given artist to the next, but, with different degrees of intensity, Butor's texts express his belief that, through "perpetually denouncing the inanity of electoral speeches"—and in these works familiar well-worn and betrayed campaign promises flicker by—poetry can give "snapshots of paradise" (*Utilité* 120).

HUMOR

To the deliberative end of encouraging others to use poetry to improve our world, Butor naturally calls on the devices of rhetoric. Two in particular are seen in these collaborations: humor and harmony. Among our artists, Kolář and Alechinsky regularly use humor.

In these texts, the humor is primarily incongruous, farcical, exaggerated, ironic, and "black." Butor's version of black humor diverges from the contemporary American form in that it is never sexual and only rarely violent, but presents the nightmarish, grotesque, and frightening in ways that leave us laughing. Pertinent is Butor's response to a question on Rabelais: "What fascinates me also in his work is his strategy of protection, his means of defense in the face of the multiple interdictions, religious and political, which struck him daily: his ideas were so subversive that he had to disguise them, to parody them unceasingly."[16]

Happily, at least in the West, censorship is not quite so life-threatening as it was in the sixteenth century when, Butor explains, Rabelais was constrained to use many ruses to protect himself, especially "the carnival,

which was at the time the only space for transgression of the established power. That is why laughter takes on such importance in Rabelais. It is a mask, an art of camouflage, a rampart against censorship" (187–88). Probably Butor's modesty would prevent his seeing this description of Rabelais's works as applicable to his own, but our study of the collaborations confirms the resemblance. The political subtext is very often concealed under the comic.

HARMONY

Although some of the works of all three artists could be seen as visually harmonious, the specific rhetorical device of verbal harmony is the prerogative of the poet. The harmony of the texts is treated here regarding repetition, rhythm, rhyme, predominance of particular sounds, all the elements of the musical text. The expository texts, of course, do not exemplify these harmonies, but in the poetic texts harmony is a constant, the patterns of usage varying from one text to the next.

The examples of harmony cited here are of course given in the original French. A sound corresponding to a single letter is indicated by italics: *i*. When the phonetic symbol is necessary it is given in brackets; for technical reasons the nasal [ã] is also given in brackets, but the other vowels are simply qualified as nasal in the text.

THE METHOD

The selection of artworks to be reproduced here has been based on the content of the corresponding Butor text, its political message, and its use of humor or harmony or both in support of that message. Identification of individual elements in the artworks that Butor has used must be subject to caution. If a viewer inspects the artwork *before* reading Butor's text, this first understanding may very well be obscured or dispersed on reading the text. At that point, looking again at the artwork, the viewer will probably see what Butor saw, as suggested in the text. An example of this phenomenon is Alechinsky's *Le Test du titre* [*The Test of the Title*], where numerous artists and writers have recorded their first understanding of the drawings.[17] Some, no doubt, would cling to their own text even after reading Butor's, but this reader/viewer finds that the preliminary understanding completely vanishes after reading Butor's: those amorphous forms have become for me now unquestionably shoe heels and banana peels. It is from this post-text viewing that the identification of elements in the art is recorded here. It is hoped that the reader/viewer will examine the artworks reproduced here *before* reading Butor's corresponding

text, will look at the artist's square and see it perhaps only as a square, in order to experience to the fullest the play of Butor's imagination.

In regard to discussions of an artwork that is *not* reproduced here (because it is reproduced elsewhere or is inaccessible, or because it has not generated a text that is a clear example of harmony, humor, or politics), I describe the work only briefly and mention the main elements Butor has incorporated in the corresponding text. These elements are regularly described from my viewing (if the artwork is available at all) *after* reading the texts. Each reader/viewer would see these artworks and elements differently before reading the texts, but every effort has been made to report here only those recognizable enough to enable general agreement *after* the text is read.

TRANSLATION

It is of course impossible to translate poetry. Dr. Johnson said so in 1776; "But as the beauties of poetry cannot be preserved in any language except that in which it was originally written, we learn the language."[18] Recognizing Johnson's point of view, Ronald Strom, in his translation from the original *romanesco* of the sonnets of the Roman poet Giuseppe Belli, goes on to say, "True enough, we learn the language, we read the poetry, and inevitably we want to share the 'beauties' even with those who do not know the language. Hence the urge to . . . translate" (Strom 263). Strom's poetic translations may well, as he says, "suggest that *romanesco* is a language worth knowing." But no one needs to "suggest" that French is worth knowing, and I must state very firmly that I do not pretend to be a poet. In my translations of Butor's poetry, I have sought accuracy above all, and hope to have achieved comprehensibility. For the reader to appreciate fully Butor's texts as poetry, it is best to read them in French, and my English translations of sections or entire poems appear only in the notes. In the text are found English translations of titles (on their first occurrence), and of words or short phrases from Butor's poems not otherwise included, all in square brackets. Citations exemplifying harmony are not translated.

Unless otherwise noted, all translations, including the occasional occurrence of citations from languages other than French, are my own.

OTHER STUDIES

The greatest external source for the study of Butor's collaborative works with visual artists is his own, the published "conversations," the headnotes in republications, and in the case of Alechinsky, his studies written with Michel Sicard. Understanding these studies is rendered easier by Butor's own position on schools of literary scholarship: he does not use the vocabulary of current doctrines, feeling they will disappear within a decade.[19] Among scholars, Butor's collaborative works with visual artists have attracted critical interest primarily as they appear in the subsequent publications, without the artworks. The five volumes each of *Illustrations* and of *Matière de rêves* have been much considered from different literary perspectives, but the sources in visual art are not often treated. One outstanding exception must be mentioned, however. Already in 1978, Jean-François Lyotard studied the original artwork along with the text in his brilliant and clear discussion of "*Les Montagnes rocheuses*" [*The Rocky Mountains*] first published with photographs by Ansel Adams and Edward Weston in *Réalités* in 1962. Lyotard explains in detail Butor's use of typography and page format to create a poem that is meaningful and effective without the original photographs, as it was revised for *Illustrations* in 1964.[20]

Scholars capable of treating interart works certainly exist and have published illuminating works, considering *ut pictura poesis,* ekphrasis, the concept of the sister arts, the particular case of the performing arts.[21] The approaches do not usually, however, suit the study of Butor's collaborations. For example, Thomas Hines's principles for collaborations include that the subtraction of any part destroys the form—yet Butor does so regularly. Further, among Hines's rules is that all collaborations create an original work that cannot be broken down into the individual arts, which is what Butor freely does and what I have done in examining these. Tellingly, Hines states, "Nearly all criticism of combinations of the arts operates upon one variation or another of the theory of primary form. . . . A sign of the failure of the critic to transcend the critical categories of his specialty."[22] Mea culpa. Yet, I would argue that just as Butor does *not* republish transformed versions of the artist's handiwork, but only of his own texts, so it is proper to study the transformed texts without the artworks. I do not believe Butor thinks of his text as "primary" to a collaboration, but it is nevertheless the part he can rightfully use as he pleases. Neither primary nor secondary to the collaboration, the text is his part, and in its subsequent appearances could simply be termed "originally a collaboration."

Since Lyotard's, some studies deserving careful attention have been made of Butor''s collaborations, by scholars expert in both literature and art. In his 1988 essay, "*Approche du continent Butor*" [*Approach to the Butor Continent*], Raphaël Monticelli considers the many different forms that Butor has used in his com-

binations of writing and visual art, including *Boomerang* as "the book as polychrome sculpture."[23] His study extends well beyond the identification of specific sources of Butor's work in visual artworks, to the whole of his "exploration of the relationships between writing and space"(9). Calle-Gruber's "conversation" with Michel Sicard, himself an artist and frequent co-worker with Butor in art criticism, offers a particular close-up point of view of Butor's collaborations with artists, within the context of his whole oeuvre, with many hitherto unrevealed details (*Metamorphoses* 137–47).

Then, Butor's 1989 collaboration with Claude Lorrain, *L'Embarquement de la Reine de Saba* [*The Embarcation of the Queen of Sheba*], has generated quite a number of critical studies.[24] This collaboration differs from most, first, in that Butor has obviously not known the artist personally, and second, the artwork can easily be seen, in the original, as well as in reproduction—even on the book jacket. Several of these essays, two of which address directly the relationship between the art and the poetry, are collected in Mireille Calle-Gruber's *La Création selon Michel Butor* [*Creation According to Michel Butor*].[25] In one, Léon Roudiez treats Butor's collaboration with Lorrain in *L'Embarquement* in contrast with the study in *Illustrations* of "*La Conversation: sur des tableaux d'Alessandro Magnasco*" [*Conversation on Some Paintings of Alessandro Magnasco*], pointing out that Butor specifically identifies the Lorrain painting, whereas "it is not made precise either how much nor which paintings of Magnasco have served as pretext for '*Conversation.*'"[26] Taking not only the texts but also both artworks and their media into consideration, Roudiez relates these texts to other noncollaborative works and concludes, "the whole oeuvre of Michel Butor is a series of meditations starting with anterior texts—graphic, literary, musical, or topographical. It is a question in a nutshell of the universal and unrealizable desire for an apocalypse" (175–76). This essay is most valuable to anyone studying Butor's collaborations.

The second essay in this collection to focus exactly on the collaboration with artworks is Jacques La Mothe's "*Traces préliminaires pour une exploration de l'île de Vénus*" [*Preliminary Tracks for an Exploration of the Island of Venus*], which examines Butor's *Le Rêve de Paul Delvaux* [*The Dream of Paul Delvaux*] (republished in *Matière de rêves II*), with scrupulous examination of the paintings. This very clear and probing study details Butor's use of Jules Verne, Klossowski, Baudelaire, St. Augustine, minerology, and "a Proustian perfume," together with intriguing historical material Butor would have known and that La Mothe has unearthed. Both the original *Rêve de Paul Delvaux* and the version without the art are treated, within a much larger context of Butor's other works. La

Mothe explains the organization of his essay with a disclaimer that he does not pretend to have found the only possible reading, but rather suggests a reading that "derives from the Heisenberg principle" (87). This principle is one I believe Butor would approve: no one will ever know everything, at least not all at the same time.

Several essays in the Butor issue of the Spanish journal, *Anthropos* treat the collaborations.[27] For example, Jean Roudaut's *Pierre Butor and Michel Alechinsky* (155–59) develops the very close working relationship between the two; we will see later that Butor himself used this intermingling of names in his special three-copy version of *Le Rêve de l'ammonite.* We will be examining in detail La Mothe's *Ecografías* (143–52) as published in the original French in his *Architexture* (145–65).[28]

One additional article of La Mothe's demands mention, "*Prélude pour déchiffrer Matière de Rêves*" [Prelude for Decoding *Stuff of Dreams*].[29] In it Butor's understanding of the dream as artistic material is carefully, sympathetically, and imaginatively analysed, and an amazingly clear vision of the structure of the five volumes as a whole is presented. The Appendices provide an invaluable basis for scholarly study and at the same time highlight some of Butor's humor. For example, in the sequence of female beings giving birth, nursing a baby, and then turning into animals, the guillotine gives birth to an automobile, fills it with gas, and both turn into flies; the ventriloquist gives birth to an alarm clock and winds it up before turning into not an animal, but a sigh (191–92).

The "counter-texts" La Mothe has "decoded" in this article are fully developed in *Architexture*. Naturally a generous portion of this splendid book concerns Butor's collaborations with visual artists since so many of the dreams are derived from artworks. (Further, La Mothe has not hesitated to study Butor's collaborations with musicians.) We will refer here particularly to La Mothe's studies of the dreams provoked by Kolář and Alechinsky.

Perhaps some future metatheory will successfully include all Butor's collaborations, but it seems unlikely, given his determination not to fall into any traditional category. Once there were an accepted collaborative genre that included visual artists, more than one artist per collaboration perhaps, and musicians, one or many, Butor would manage to find a way not to fit it. He has frequently revealed his interest in modern science, and we should not be surprised to find him inventing a new kind of collaborative genre with mathematicians, one or many, living or dead, Euclidean or non-Euclidean. Alchemists can in theory transmute any matter they please, after all, and light passes through a prism made of any transluscent matter whatsoever.

2

Michel Butor and Jacques Monory: Bicentennial Blues

BICENTENAIRE KIT

One of Butor's most unusual collaborations is a box, the *Bicentenaire kit. [Bicentennial Kit]* Published on the occasion of the bicentennial of the signing of the U.S. Declaration of Independence, in a limited edition of three hundred, it includes eighteen serigraphs by Jacques Monory, one a triptych. The *Kit* as a whole is a collaboration: Butor and Monory together selected for inclusion the "objects or authentic documents, modified, reproduced, sometimes imagined, gleaned in the fifty states of the Union";[1] Monory designed the box and some of the objects; Butor wrote the "Catalogue," which contains fifty numbered texts, plus seven unnumbered.[2]

As with most kits, "some assembly" is required. The box itself is finished: blue, not the sober blue of the flag but a garish, almost flourescent blue. It is soundly constructed of hard plastic; the drawers slide smoothly, and the objects fit perfectly in the sections designed for them. However, for the creation of a celebration from all the materials in the box, we need instructions. Many of the objects in the box—the sheriff's badge, the dollar bill—are familiar, but some are not: Butor is delighted at how few Americans recognize the Shaker peg. Anyone who has tried to put together a Swiss chalet or even a simple barn from a kit knows the instructions are, as if by some internationally accepted regulation, rarely very clear. A number of Monory's serigraphs recall instructions in a kit: his use of "call-outs," lines from one image to a superimposed label, which suggest a diagram, and his frequent horizontal division of a given serigraph into two or more parts, which suggest successive steps in a process. But the primary source of instructions for assembling our celebration is Butor's "Catalogue." The fifty texts regularly refer to each of the objects, including the serigraphs, the box and the "Catalogue" itself. The seven unnumbered texts provide overall guidance as we prepare for the final Bicentennial Party and its aftermath.

Many kits have a didactic purpose: when we have put together the plastic dinosaur bones in order, we find we have learned something about the dinosaur itself. Evenly distributed among the "Catalogue" texts are eighteen "blues" poems, each corresponding to a specific Monory serigraph. As we pursue our assembly of the *Bicentenaire kit* we will inevitably uncover its didactic content, why in the midst of the Bicentennial celebration it is appropriate to sing the blues.

Butor republished the "Catalogue" in *Boomerang,* which is printed in blue, red, and black sections; it is within the blue sections that the revised text of the "Catalogue" appears. The complete contents is listed in *Le Retour du Boomerang* [*The Return of the Boomerang*], including identification of the pages in *Boomerang* where each segment appears.[3] With the aid of the lists and page numbers from *Retour,* the poems are easily located in *Boomerang.* All but one of the eighteen serigraphs included in the *Kit* are printed entirely in the monochrome blue Monory was using exclusively at that time. Six of the poems and serigraphs are reproduced here. (References to reproductions of most of the other serigraphs are given in Appendix B.)[4] The serigraphs are not numbered and are loose leaves in their folder in the box, but by determining the order of the poems, Butor also ordered the serigraphs. To aid in their identification, here we give the number of the corresponding poem, and for the poem we give its number in the "Catalogue" and the page numbers in the "Catalogue" as "C: 00" and in *Boomerang* as "B: 00." It is the relationship of poem to serigraph that is the primary focus of this study.

MONORY AND BUTOR

French artist Jacques Monory[5] has visited the United States and recorded his impressions in a style he insists is neither hyper nor neorealist and goes on to explain: "When one represents in two dimensions something that exists in three, it's already a breach of realism. . . . Today, however, all words are loosely applied. . . . I'm a realist in the sense that I like all that is included in reality, in everyday daily life. It's my primary matter."[6] His work is thus figural, which facilitates describing those serigraphs not reproduced here.

Agreement on technique, shared interests, and a common message explain Butor's selection of Monory

as collaborator for the *Kit*. In an interview, responding to a question about his technique of projecting a photo negative on the canvas and then painting on that image, Monory replied, "I take most of the photos myself but sometimes I use press photos, which I rephotograph" (32). Further, Monory reuses earlier works, rearranged, clipped, modified, in collage fashion, reorganizing them to create new juxtapositions. In the same way Butor uses intertextual methods: he selects texts, sets them in different contexts, cuts, arranges, and rearranges them. Monory uses one segment in pink in a reproduction of Hopper's *House by the Railroad* (#9 *Hopper's Land, blues* C: 28, B: 45). The color, as well as the label "*Hommage à Edward Hopper*" [*Homage to Edward Hopper*] make very clear that Monory does not claim the pink work as his own, but appropriates it as Butor does the texts of others, for their resonance. In the *Kit,* Butor insets citations in italics, and in the revision in *Boomerang,* he prints somewhere in the cited text, in all capitals, the name of its author, with the same effect as Monory's pink.

Such techniques would have drawn Monory and Butor together, and their interests overlap as well. Monory has explained his use of monochrome blue, that "blue is the image of the dream" (Stephano 29), and Butor has given us no fewer than five volumes of *Matière de rêves* [*Stuff of Dreams*]. Butor very much liked Monory's venture into all colors, as in his "Technicolor" pieces, which inspired Butor's *Ballade du tremblement du ciel* [*Ballad of the Skyquake*] published in *Exprès: Envois 2*.[7] Butor made a collage of two Monory reproductions in color, which he gave to Monory;[8] the collage is described in the headnote to the *Ballade*. Art critics mention other interests Monory shared with Butor: Baudelaire, Poe, and Rimbaud. J. C. Bailly calls Monory a "Baudelarian painter"[9] and Gilbert Lascault also finds rapport between Monory and Baudelaire, citing three additional critics who agree. He notes further that both Monory and Baudelaire appreciate Edgar Allan Poe.[10] Butor has more than once used texts from Baudelaire and has created his own revised version of Baudelaire's and Mallarmé's translations of *The Raven*. P. Gaudibert cites Rimbaud in relation to Monory's *A False Start, Continued,*[11] and Rimbaud is the subject of one of Butor's *Improvisations* and also of his collaborations with Henri Pousseur and René Bastian in the *Hallucinations simples* [*Simple Hallucinations*], the text of which appears in *Gyroscope*.[12]

Regarding the fundamental message of the *Kit,* J.-F. Lyotard examines several of Monory's concerns about the state of United States society, with which Butor would agree. In his poetic analysis of Monory's work, Lyotard views the monochrome blue in a Freudian and Hegelian frame of reference, as "the color of the steel

separating Tristan and Isolde," where the lovers are obliged to become capitalists, and the blue is that of "adjustment among banks" or of "discounted interest."[13] Of Monory's paintings in series, Lyotard states that his "catalogue" technique reflects industrial reproduction of identical articles presented as in a spare parts store, "whose model is provided by capitalist working conditions" (178). Lyotard sees the realism of Monory as hyper or neo-realism, and believes it derives not from any representational issue, but from "libidinal and political economics*"* (201). Monory's works "do not allude to a copy of a hypothetical object, but consist in the cutting up and plastic display of the object, in conformity with the rules according to which capital cuts up and displays 'objects': all things. Far from sending one to some exteriority, this realism excludes all exteriority, presents only interchangeable items of equal value" (ibid). Examples of the quantification of the subject, with labels and numbers, appear in several of these serigraphs, with the effect Lyotard has identified.[14]

Interestingly, Lyotard finds that Butor and Monory drew opposite conclusions, that where "*Mobile* was one of the greatest books on capitalism," it was "a warm book, affirmative and warm, while the painting of Monory is affirmative and cold" (178). Other critics have treated Monory's coldness. Lascault finds it paradoxical: in the cold, "we love more, we suffer more."[15] A. Jouffroy sees it as "for the painter as for the poet . . . a mirror—an ice to see better."[16] Elsewhere Jouffroy sees in Monory hope for the future: "It is in vain that [he] makes fun of everything"; through his work art may find again its "innocence [today] compromised by the ideology of financial powers." He exhorts Monory to continue "toward the destruction of false values."[17]

The immobility in time that is identified by Lyotard (*Figurations* 171), that "with Monory there is no story" (174) is perhaps especially important to Butor. He is free to draw what he will from the serigraphs with his characteristic open-endedness.

The fact that Butor and Monory were thinking along the same lines is evident from the letters and proposed lists included in the *Kit*. Butor spent the whole academic year and summer of 1973–74 in the United States and did not receive Monory's list of objects or the serigraphs until his return to Nice in the fall. Monory and Butor both selected WANTED posters, but not the same ones. Monory selected ten objects; all but one, a flyer from "6-Gun Territory," appear in the box. Butor listed a restaurant placemat of the Declaration of Independence; Monory proposed one of pictures of all the presidents: the latter prevailed and became one of the most expanded of the sections, using not only texts from *Mobile* but also stains appropriately selected for each presidential portrait, such as Nixon's, spotted with axle

grease. We also learn in the correspondence included in the *Kit* that Butor's original list included "8 (?)" serigraphs, and the letters ask more than once how many he can expect. Once Butor had the serigraphs he could incorporate specifics into the rest of the *Kit* beyond the poems themselves, for example, the choice of the bloody hand in de Lille d'Adam's play, #25 *Envie, fabrication* [*Desire, imitation*] (C: 60–1, B:161), readily relates to the handprint in the serigraph corresponding to #36 *Balistique, blues* [*Ballistics, Blues*] (C: 76, B: 172). The text refers to Monory's turquoise blue as "*un peu fermenté*" [a little fermented] (#44E *Six masques de carton léger, fabrication* [*Six masks of light cardboard, imitation*] (C: 89, B: 429); Monory's surprising use of pink in #9 *Hopper's land, blues* (C: 28, B:45) can easily be seen as a "fermented" red.[18] Clearly Butor had no difficulty accommodating all eighteen serigraphs; indeed, they form a primary structure of the box and its "Catalogue."

THE SERIGRAPHS AND THE POEMS

Turning now to the eighteen serigraphs and accompanying poems, we find the subject matter falling roughly into four areas, each a recognized problem in U.S. society: racism, consumerism, violence, and alienation or isolation. We will examine six collaborations in detail, those in which the serigraphs, or parts of them, are not readily accessible. Léon Roudiez, in his article on Butor's work written in response to Claude Lorrain's painting, *The Embarcation of the Queen of Sheba*, makes a distinction that is useful to this study. Roudiez explains that Lorrain does not represent the real but assembles "elements of conventional reality," which he then "submits to rigorous composition."[19] As we examine Monory's works, we can see that he does represent "conventional reality," as Roudiez uses that term regarding Lorrain, in the individual segments of each work. The superpositions, juxtapositions, and combinations Monory then effects, together with his labels and texts written on the work, create a commentary on the "conventional realities" utilized, and produce a different reality, Monory's reality. Every viewer will perceive different realities, dependent on his or her own points of view, "according to his experience, predispositions, education, and the way of reading which are his own" (174). Since our primary interest is the collaboration, the essential, regardless of the positions of all the different viewers, is to understand Butor's reading of the serigraph.

In our in-depth analysis of one collaboration from each of the four subject-matter categories (plus two additional examples of particular interest) we will treat the structure of contrast or sameness, the syntax, poetic devices, vocabulary, figurative language, and Butor's additions to the elements visible in the serigraph. Following each detailed analysis we will briefly treat others in that category.

The form of the poems is the same throughout: six lines, with no period, almost all a single complete sentence. As half of the serigraphs are composed of two equal horizontal segments, so most of the poems are structured around a duality: two elements are considered and determined to be either contrasting or else actually the same. The subject matter, or theme, is taken directly from the serigraphs: seven of the poems treat alienation or isolation, four consumerism, four racism, and three violence. Butor's treatment of details in the serigraphs varies, as does his syntax and his use of poetic techniques. The vocabulary throughout is basic, even in one poem including popular expressions: the nouns are primarily, indeed almost exclusively concrete, there are very few descriptive adjectives, and a limited number of verbs. In almost all poems a specific time and place is given; in all but two, the speaker is an impersonal, distanced observer. Poetic devices are restrained: half of the poems have none of the repetition we expect from Butor, and half have no figures of speech.

Butor entitles all his poems "blues," and all but one end with a reminder of that title, in an expression using "blue"; the one without such an expression speaks of "blue" as the color of a military uniform. The relation to Monory's monochrome blue is obvious, but Butor uses in the titles the plural, "blues," which leads us into the domain of music. Without engaging in musical analysis here, we must just cite from Jacques La Mothe's splendid study of the *Bicentenaire kit* as a whole; he here speaks of the blues:

> the popular song of Afro-americans emancipated from slavery, certainly, but socially oppressed and humiliated by racial segregation: the blues, whose scale oscillates between the major and minor modes, will give the tone, born of the contamination of the diatonic scale by the African system. It is thus that Butor contaminates the expression of murderous violence by that of lucid despair . . . and takes up in recurrent fashion all the expressions in language which have been deployed around the word "blue" from "to see blue devils" (to have black ideas) to the "Blue Peter" (signal flag of departure) passing through "to feel blue" (to feel rotten) or "to go blue" (to flush crimson).[20]

This description of Butor's "blues" as a "contamination" of Monory's frosty cold is most perceptive. Butor's poems are here themselves prevailingly cold, and we will see him describe an intolerable situation in

sometimes quasi-scientific language. However, the "blue" expressions, derived from emotion, create a tension maintained throughout. "Blues" music is always emotional, most often a lament: one need only think of "Gloomy Sunday" as an example. Through the "blue" and the "blues," Butor "contaminates," as La Mothe says, Monory's iciness with his own cold exposition, constraining the reader to sense all the warmth of feeling that he has specifically not expressed.

Racism

The serigraph *Tombée de la nuit, blues* presents contrasts between the full-page scene and the inset, which is in the mind of the figure designated as "No. 1," an American Indian. The expensive yacht and posing girls could come from a tourist advertisement: the Indian himself has been affected by the consumer society, as one would expect him to dream of wide-open and free spaces, as represented in the later triptych, #30, *Souvenirs de l'ouest, blues* [*Memories of the West, Blues*].

#1 TOMBÉE DE LA NUIT, BLUES

> A la tombée de la nuit dans les rues de Flagstaff
> Arizona
> L'Indien venu des réserves Navajo ou Hualapaï
> Appuyé sur un mur de briques parmi les poubelles et les
> journaux
> Dans la lumière des enseignes et des feux de circulation
> Rêve de Floridiennes à cheveux clairs paresseuses dans
> leurs lagunes
> Bleues parce que "to see blue devils" veut dire avoir
> des idées noires
>
> (C: 12, B: 33)[21]

The structure is built on contrasts; there is no figurative language, and there are only a few additions by Butor to the elements seen in the serigraph.

Butor's title echoes the immediately preceding unnumbered text in the *Kit,* "Prelude," where the reader is invited to imagine himself celebrating the Bicentennial in front of Independence Hall in Philadelphia, "at nightfall." The poem takes the reader to a very different site, and the first contrast is posed: Philadelphia and the Founding Fathers versus Flagstaff and an Indian, a Native American. Concern for the plight of the Native American is central to the *Kit* as a whole. Butor, noted for his deep and abiding concern for indigenous populations worldwide, wrote these texts before the invention in the United States of "politically correct" terms, and he says simply, "Indians." It is very clear from his texts that he knows the peoples called "Indians" by the explorers who thought they were in India are in reality the

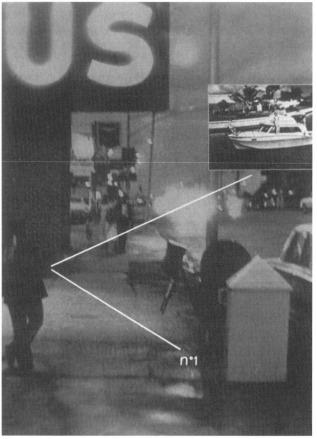

Jacques Monory, *Tombée de la nuit, blues* [**Nightfall, Blues**] (**#1**).

original inhabitants of the Americas. In this instance the use of "Indian" contrasts vigorously with the other figures identified by a place name, the Floridians. The latter acquire identity simply by living in a particular state, and if they were Californians it would make little difference, as they would still be U.S. citizens. The Indian, however, does not now and never did live in India and yet has not been assimilated into the U.S.; he is a man not at all without a country, but without a country recognized by anyone else. He could move back to Oklahoma or farther back to the deep South, and he would still be an "Indian," still subject to racist discrimination. With this understanding, I respect throughout this study Butor's use of the traditional term.

Beyond the contrast with the preceding text, this poem is internally structured on a further contrast. The tawdriness of the city street, itself an alternative to the restrictive reservation, is opposed to the luxury and openness of a Florida waterway. As the specific tribal and place names give way to the figures of the dream, the "Florida women" are qualified as "lazy," which

contrasts retrospectively with the Indian. A man "lean-ing" in a bus station could be condemned as "lazy," but could as easily be involuntarily idle, unemployed, un-able to find work. Butor follows Monory's label of the man in the dark, "No. 1," in making him an Indian, since he and his people were the first in the United States. However, he changes the brunette women of the seri-graph into blonds with "fair hair," and in so doing he heightens still further the contrast between reality and dream, nightfall and daylight. Then, by naming the site Arizona, Butor summons up the dryness of the desert for further contrast with the boat scene.

The syntax is uncomplicated; the participles qualify-ing the Indian are themselves devoid of connotation, "come" and "leaning." However, the collection of sim-ple, concrete nouns Butor has assembled creates a definite atmosphere. The Indian names, the familiar Navajo and unfamiliar Hualapaï encourage the recogni-tion that many more tribes eke out desperate existences on reservations most of us have never heard of. Butor does not reiterate in the poem Monory's identification of the bus station, certainly among the most depressing of United States sites,[22] but his addition of the name, Flagstaff, evokes the devotion of Americans (who are not Indian) to the piece of cloth that is a flag, or in this case, just to an empty pole that holds it. Nothing in the serigraph identifies the yacht scene as Florida, rather than California or some other locale with both palm trees and water, but Butor selects Florida as about as far away from Flagstaff as one can go in the United States. The "blue" functions in two ways, qualifying the lazy Floridian women's lagoons as blue, and also introduc-ing the expression "to see blue devils." The effect is that the very blueness of these lagoons creates the devils for the Indian. This collaboration sets the tone of all eigh-teen stanzas.

A second poem treating racism directed at American Indians is #30, *Souvenirs de l'ouest, blues* [*Memories of the West, Blues*] (C: 68, B: 166), the triptych Butor placed at the halfway point of the "Catalogue." The background of all three panels is an expanse of mesa-studded western desert, all three barred with a single diagonal line.[23] Toward the back of the center panel is a man on horseback, wearing an ordinary hat.[24] A super-imposed block shows the window of a souvenir store where a typical Indian chief's head in feathered war bonnet is identified as "A"; the living horseman is also marked "A"—he must see himself as reduced to a tacky tourist item, and beheaded besides. Here contrast is heightened by opposing sameness: Monory's identi-fication of souvenir and human being is ironic, but both appear against the harsh, timeless rocks.

The poem includes one of the few instances of poetic devices, anaphora and repetition:

Au-dessus des bombes à laque pour les chevelures des secrétaires
Au-dessus des bombes à vernis pour la patine des antiquailles
.
Au-dessus du creux des rocs au milieu des tours de roc le Navajo
.

(C: 68, B: 166)[25]

The repetitions reflect the subject matter of the three panels of the triptych. One of Butor's additions is the "*bombe,*" an aerosol can, whose primary meaning is indeed "bomb." By selecting this word and repeating it, Butor suggests bombs that would *not* be spray cans of cosmetics or varnish. The busts are "*fixant l'espace de la vitrine*" [gazing at the space of the shopwindow] and the horseman of the serigraph seems to be staring into the space of the rocks, but the contrast (or parallel) is deliberately not finished. This is the only poem not in complete sentence form, ending simply with "*le Navajo,*" immediately followed by the "blue" expres-sion, "a bolt from the blue," that is particularly appro-priate since, as Butor has recorded elsewhere, Indian legends recount the white man's just going away, as unexpectedly as he came.

Obviously, racism in the United States, is not directed exclusively against American Indians, and two poems treat racism directed at African-Americans. The composition of the serigraph in #33, "*L'Instruction publique, blues*" [*Public Education, Blues*] (C: 73, B: 172) is the same as that of Monory's sixth *Incurable Image,* which shows a movie screen of marching Nazis and the backs of the heads of an audience. Here, the Nazis have been converted to whites beating and kick-ing a black man.[26] The characters in the film on the screen are "A" and a white student in the audience, who is not paying attention, also is labeled "A'" (A prime): they are all members of the same set of human beings; the student, however, is distinguished as a member of a different subset. The contrast set up by Monory in the two segments is very clear: the student labeled "A'" is learning nothing from the scene "A." If we know the *Incurable Image* recalled by the composition, we must recognize the parallel between the Nazis and these white men, as well as that between the audiences, who know nothing and refuse to learn.

Butor's choice of qualifiers and discreet additions to what is visible in the serigraph reinforce the point. He explains that the montage was made by a professor of "black studies" (in English), suggesting that it was com-posed, artificially prepared, in an artificially created field of study; as surely it is unnatural to divide the study of human beings according to skin color. Further, the foreign expression, "black studies" precedes the foreign

custom "*lynchages*" [lynchings], which does appear in French dictionaries, but usually defined as summary execution "as practiced in the United States." Identification of the site of the scene as Alabama adds yet another term that might sound strange and foreign to the French, further contrasting with the ordinary-looking student. The student's note-taking is done "*distraitemenet*" [distractedly], her comfortable seat is "*rabattable*" [folding], and she is "*lorgnant un de ses camarades*" [leering at one of her classmates], who does not actually appear in the serigraph. Inattentive, she has no concept of what it means to be black in the United States, let alone black and blue, as in the "blues" expression.

In the second collaboration alluding to racism against black people, #21, "*Dans l'antre de la panthère noire, blues*" [*In the Black Panther's Lair, Blues*] (C: 53, B: 110), the upper segment of the serigraph is of a building with puffs of smoke seeping from its arched windows; the lower segment is of an interior in which a white child is showing us his model airplane. On the wall behind him two posters are displayed: "The Black Panther," showing only shoes and lower legs, and *Art Today,* the latter with slightly tattered edges. A neat flowered tote bag stands behind the child, near a bookcase with books and other items piled on open shelves. The serigraph is thus composed of two contrasting parts: the threatening appearance of smoke issuing from a building's windows and the calm of the child. In the latter segment additional contrast is added by the two posters, the one political and the other aesthetic. The feet of the Black Panther in the poster are not wearing boots and do not suggest violence; the *Art Today* illustration depicts three indistinguishable paintings hung as in an exposition, a fuzzy dark smear obscuring part of one side, over which two clear white chevrons stand out. Below the poster is a shelf holding an object that could be half of a hollow gourd—or anything.

Butor's title immediately implies threat with the word "*antre*" [lair] and refers to the Black Panthers as "*des fauves en chasse de porcs*" [wild beasts hunting pigs], using the derogatory term for the police popularized during the riots of the 1960s, when the police were so often accused of brutality. The poem presents the fire in violent language, rare in this work:

> *A l'extérieur les nuages de fumée qui montent à l'assaut*
> *des moulures*
> *Jaillissant de la fournaise obscure entre les colonnes*
> *métalliques*
>
> (C: 53, B:110)[27]

In the poem the books are "*en désordre*" [in disorder]" and "*furieux,*" [furious], and the posters, implying both of them, "*se déchirent*" [are tearing]. In each case Butor converts the neutral elements seen in the serigraph to a violent level. Further, the child is seen "*à travers la vitre*" [through the window], and thus, as the upper segment of the serigraph is clearly "*l'extérieur*" [the outside] and the lower "*l'intérieur*" [the inside], Butor has placed the child of the serigraph inside what appears to be a burning building. The child is described with another familiar term, "*sapé*" [done up], and although his clothes in the serigraph are quite ordinary, Butor sees the child as "*sapé comme un petit prince de ville universitaire*" [done up as a little prince of a university town].[28] These complications then, emphasized with two repetitions, become personal: "*Mon ami Eric en réalité un ami de Jacques Monory Eric*" [My friend Eric in reality a friend of Jacques Monory Eric], in conversational style and then the narrator acts: "*Quand je l'ai reconnu quand il l'a reconnu*" [When I recognized him when he realized it]. The verb tenses clarify that the child "*jouait tranquillement*" [was playing peacefully] as he waited, in the imperfect, for the return of the Black Panthers, and then after "*je l'ai reconnu*" in the perfect, it is "*à travers la vitre bleue*" [through the blue window] that "to look blue" is introduced and explained as "*avoir l'air déconcerté*" [to appear disconcerted], whereas its meaning in English is rather "to look sad," which Butor would know very well.

The force of this collaboration lies in the outside/inside contrast. From the point of view of those on the outside, "I" as well as the readers/viewers, Black Panthers are violent militants, given to attacking the police and burning buildings, and the white child is thus in danger. However, the situation appears quite different seen from the inside. The *Art Today* poster must have been put up by the Black Panthers. The story of *The Little Prince* is pacifist, and the image, whether true to life or not, of a "university town" is of the calm groves of academe. The child was perfectly content playing as he awaited his friends' return, until "I" turned up, observed him from the outside through the window, and interrupted his game.[29] It is the view from the outside that turns the Black Panthers into "wild beasts." On the inside, the child, specified as "in reality" someone Jacques Monory knows, is "disconcerted" or even "saddened" by the attitude of those who do not recognize that the people called Black Panthers are human beings.

Violence

There is inevitable overlap of themes in the collaborations, since they reflect the social problems in the U.S., which are clearly interrelated, and racial violence is only one of many kinds of violence prevalent here. I follow here the order in which Butor introduced the themes as they occur in sequence among the other items

Jacques Monory, *Balistique, blues* [Ballistics, Blues] (#36).

in the "Catalogue": racism (#1), violence (#3), consumerism (#6) and alienation (#9).

In *Balistique, blues* [*Ballistics, Blues*] (#36) Monory hangs the gun as if for a recoil test. In the same segment appear what must be a splotch of blood and bloody fingerprints: those who handle guns usually end up stained with blood, their own or that of others. His superimposed blocks are bitterly ironic: he has selected Oklahoma's war heroes rather than United States heroes in general probably because Oklahoma is the state where so many Indians are forced to live on reservations and then offered the opportunity to fight in U.S. wars. The war that ended in 1973 was never formally declared, and was furiously resisted by a great part of the population, but soldiers died there, and Monory's figures are surrounded by poppies, that emblem originally of casualties of World War I, the "war to end all wars." Monory's heroes might be dressed in hospital gowns, evoking the wounded. The irregularly shaped segment of the "Modern Volunteer Army" is only of women, in every kind of service uniform. In the war that ended in 1973, men were drafted and women only volunteered. In that war women were not sent into combat, and an irony supplied by the passage of time is that now

they are. Monory suggests that in this whole picture, that of the United States approach to war, everything is wrong.

#36 *BALISTIQUE, BLUES* [*BALLISTICS, BLUES*]

> *Les techniciens de la maison Winchester en s'aidant de*
> *la photographie instantanée*
> *Ont découvert que les fusils à canon long de 25 pouces*
> *Faisaient moins de recul que ceux de 30 pouces de*
> *même poids*
> *Avec même balle de telles études permettront de*
> *faciliter la tâche*
> *De nos vaillants guerriers à l'intérieur et à l'extérieur*
> *de nos frontières*
> *Bleus parce que l'uniforme des fédéraux était bleu*
> (C:76, B: 172)[30]

The full-page serigraph has generated a poem focusing on a single subject, and Monory's superimposed segments are referred to only in the last two lines. This poem is one of the few that can be read as two sentences: the first, in the past, is the cause of the second, in the future. The deliberately uncomplicated syntax is in accord with the serigraph, and this collaboration is structured on the absence of contrast, on sameness, continued throughout the poem.

This is the only poem without an English "blue" expression. In this collaboration, the roles of Butor and Monory are reversed: Monory's images concern the ugliness of war, while Butor remains dispassionate. Always sensitive to words in painting, as explained in his book with that title,[31] Butor has left Monory's superimposed segments to speak for themselves relative to the Vietnam War and the two World Wars. Then, his own knowledge of U.S. history sends him further back in time to the war "inside . . . our frontiers" and with the "our" identifies with U.S. citizens. Of course, the uniform of the Union Army, the Federals in the Civil War, was blue, as opposed to the Confederate gray of the Rebels, but in the wars "inside and outside our frontiers" the enemy has sometimes become "us," just as the Confederate states were gradually and painfully incorporated back into the Union. Then, Butor would know that it was wearing khaki, not blue, that "our valiant warriors" were sent by MacArthur to Washington to attack the veterans of World War I. He knows, too, that until very recently, khaki was the uniform color for U.S. soldiers who protected the populace in time of natural disaster or were sent overseas. Finally, all soldiers of all armies have reason to sing the blues, regardless of the color of their uniforms. Poetic devices are extremely limited. The only repetitions are of numbers of inches, the numbers written in figures and of "same," qualifying weights and bullets. "High-speed" (*instantanée*),

qualifying photography, is promptly associated in this context with "instant death," which is the goal of those "valiant warriors." Those two descriptive adjectives, the only ones in the poem other than "blue," underline the cold-blooded tone of serigraph and poem. Limiting himself primarily to the vocabulary of a military technical manual, Butor has in this poem created a resonating commentary on all wars.

#45 *Les jeux du hasard, blues* [*Games of Chance, Blues*] (C: 90, B: 430) is divided in half horizontally. The upper segment of the serigraph shows a gambling casino empty except for a few cleaning workers in the background. The lower segment is of a woman collapsed at the desk of some official who resembles Stravinski, who is looking at us. Two of his filing cabinets lack labels: the rest of his life is to be spent filling them with folders of sad cases, as a superimposed tiny label with an enormous number hints. Among unidentifiable objects on the counter is a gun, very clear and seeming to float slightly above the counter. The viewer is free to imagine meaning.

Like #36, *Balistique, blues,* this poem can be read as two sentences, each deriving from a segment of the serigraph. The first sentence of the poem is two lines long, describing the casino. Reflecting the second segment, Butor confirms in the text our recognition of Stravinsky. We can hypothesize on the use of Stravinsky, perhaps by association with that infamous game of chance, Russian roulette. Or perhaps he serves as the revolutionary, breaking free of tradition, thus providing contrast with the mechanical, regulated life of the state employee who, doing his boring job, may be as blue as the woman. The second sentence of the poem is compound: the first part Butor's additions to the serigraph, the second part matching the scene in the lower segment. Butor does not explain why the woman drove from Las Vegas to Los Angeles in five hours to try to prevent a misfortune, but does explain she arrived too late. The essentials of the narrative are omitted, just as they are in the serigraph. Whatever the "*malheur*" [misfortune] was, since it involved a gun, it implies a violent act. One normally thinks of "the blue book" as the Social Register rather than of state functionaries, "*registre des employés de l'Etat,*" as Butor translates it. There may be the suggestion that today state employees have taken the place of the former elite. Unlike such elite, always envisioned as blissfully happy, this state employee has known too many pathetic situations to be moved, and is surely not happy over having to deal with one more gun.

In #3, *La Famille du meurtrier, blues* [*The Family of the Murderer, Blues*] (C: 14, B: 33), the serigraph is again divided into segments, the top an endless, straight road through empty fields; in its lower right is a posed photograph of a family of six. The bottom segment is of perforated wallboard against which are displayed four vertical rows of handguns, no two exactly alike.

This poem includes more complicated syntax and more poetic devices than "*Jeux du hasard, blues.*" The rhythmic repetition of the ugliness of the guns is captured by Butor in three relative clauses dependent on prepositions, which are awkward, while the repetitions of "*avec lequel*" [with which] provide harsh [k] sounds. "*Tuer*" [to kill] repeated in three different tenses, "*a tué, aurait pu tuer, va tuer*" [killed, could have killed, is going to kill], mercilessly spreads the slaughter over all time. Butor adds place-names, underlining the harsh image of Stove Pipe Wells by translating it: "*Les puits des tuyaux de poêle.*" The nearby town he calls "Emigrant," not "Immigrant" Junction, as anyone would emigrate if possible from what seems in more than one sense "*La Vallée de la Mort*" [Death Valley]. The complexity of the syntax is echoed in the names assigned to the family: sorting them out is difficult. The only one definitely identifiable is "*Jimmy le père*" [Jimmy the father] in his Ku Klux Klan costume of sheets and hood, holding a gun, the one who was *not* murdered. Butor emphasizes the ironies in his explanation, adding that "true blue" means a patriot, which results in a double irony: if either the murderer, or else the KKK member whom he did not kill, is considered to be "true blue," the concept of patriotism must embrace the most violent criminal acts.

Consumerism

The United States is often labeled "the consumer society," and neither Monory nor Butor hesitates to represent this disquieting aspect of our lives. The upper half of the next serigraph, #6 *Les Figurantes de Washington, blues* [*The Walk-ons of Washington, Blues*] seems calculated to produce feelings of national pride and approval of the beauty of it all, complete with flag-raising Iwo Jima war heroes. But the representation of that famous photograph as if it were a postage stamp, with perforated edges—although it carries no indication of monetary value—already leads us to see that something is wrong. Leggy girls in the lower half seem a curiously inappropriate addition, contrasting with the neoclassic Memorial and dramatic Iwo Jima statue.

#6 LES FIGURANTES DE WASHINGTON, BLUES [*THE WALK-ONS OF WASHINGTON, BLUES*]

Devant le monument à Jefferson au milieu des cerisiers
en fleurs les jeunes filles en robes des années folles
Couronnées de raisins en plastique compulsent les
dernières annonces de soldes dans les quotidiens

Jacques Monory, *Les Figurantes de Washington, blues* [The Walk-ons of Washington, Blues] (#6).

En attendant le tournage de leur couplet dansé pour
 une publicité de jus de fruits
Babillant de militaires tout en griffonnant à leurs vieux
 parents un hello
Timbré du monument à Iwo Jima bleu
Parce que "to tell blue stories" veut dire raconter des
 histoires grivoises

(C: 21, B: 37)[32]

Looking at the serigraph along with Butor's poem one can see contrasts in layers. Butor combines the two segments, placing the young women actually on the steps of the Jefferson Memorial. To the contrast between the flowering cherry trees[33] and the plastic grapes, Butor adds another with his juxtaposition: Proust's *"jeunes filles en fleurs"* [flowering girls] are opposed to these in their silly costumes. The whole world of Proust's young girls is evoked, not only the delicacy of the young narrator's visions, but also the later revelations, as we find these girls telling "smutty stories," which supply the "blue" in "to tell blue stories." Butor expands on the models' activities in three participial phrases, each an addition to Monory's image. The young women are not raising flags in battle, but waiting,

chattering about soldiers who are not in combat. One of the models in the serigraph might be writing; Butor adds the "hello" to the aged parents and does see the Iwo Jima segment with its serrated edges as a postage stamp, despite its not showing a value. It is Butor who identifies the ridiculous costumes as "roaring twenties," which implies the girls are involved in some sort of show, and it is Butor's text that brings it all home: a commercial, the sales, the plastic. Their raison d'être is to make an advertisement, to sell something to make a profit for someone else. Clearly they are not even aware they are being exploited, and, as they look for sales, they are very much participants in the consumerism. These activities set against the Jefferson memorial on the one hand—Jefferson, who with all his faults, many of which Butor brings out in the *Kit,* at least propounded noble principles[34]—and on the other hand the Iwo Jima soldiers in a terrible battle, infuse the scene with bitter irony.

In #24, *La Rue mur, blues* [*Wall Street, Blues*] (C: 59, B: 112), once more divided in half horizontally, Monory's upper segment is virtually blank; we see only fluorescent lights, with an indistinct pool of additional light, apparently from a streetlight outside, which enables us to see the corner of ceiling and wall: all is empty. In the lower segment streetlights stand out against skyscrapers.

Butor's text provides action: bank windows become silent, doors are bolted, clients go down to the subway, none of which is actually depicted. The actions Butor offers then, the streetlights coming on and reflecting on the buildings, may be clearly seen in the lower segment and are described by Butor in one of the rare similes, *"les réverbères/tels des yeux pédonculés de martiens allument leurs pupilles"* [streetlights/like the stemmed eyes of Martians light up their pupils]. The botanical term, "stemmed" is the only unusual word in all eighteen poems. This perception seems quite appropriate: the strange activities of Wall Street, totally alienated from work of any kind, are as alien to humanity as any "alien" creature from another planet.

#39 La foule en ruines, blues [*The Crowd in Ruins, Blues*] (C: 80, B: 363) also deals with that center of capitalism. The major part of the serigraph is a close-up of some building stones fallen in the street, with a superimposed block showing crowds milling in Wall Street. Monory's crowd, perhaps of a 1929 bank riot, could also be just a noon crowd of drunks. The smashed stones do not appear to have landed on anyone, but the dark interior underneath could contain anything.

With figurative language, Butor's text takes us beyond the 1929 crash and the cracking of that Wall Street wall, to the current world. People fear one of the *"prétentieuses corniches"* [pretentious cornices] will fall on

them—as, of course, has actually happened—ever since the earth quaked during the Watergate affair: *"les façades républicaines ont commencé à trembler/Autour de l'epicentre du grand hôtel de l'écluse"* [Republican façades began to tremble/ around the epicenter of the big Watergate building]. Butor overlays New York and Washington as centers of catastrophe: *"la ville des aigles et des vautours"* [the city of eagles and vultures] could refer to either city or to both. As the noonday crowds rush to bars to seek oblivion in drink, Butor's internal rhyme, *"La foule qui s'écoule"* [The crowd which flows], conjures up the image of their flowing like a river. He translates "blue ruins" as alcoholic drinks. When the façades start to collapse, we see what was really holding the building up, and crowds get drunk, to avoid seeing or knowing the real cause of the destruction.

The serigraph, #12, *Les Détails de Miss Liberty, blues* [*Details of Miss Liberty, Blues*] (C: 41, B: 101), is full-page: the Statue of Liberty surrounded by hand-printed, precise statistics on its size and weight, etc.,[35] the whole image represented as torn in two by a ragged diagonal line.

Butor immediately creates a vivid contrast by setting directly after the title the words, *"il est interdit"* [it is forbidden]. The contrast between liberty and the forbidden is continued through the past, when one could climb into the Statue's torch, the torch *"que brandit . . . l'ambassadrice"* [brandished by . . . the lady ambassador], and the present, when one can only *"grimper ses intérieurs par un escalier en colimaçon"* [clamber up its insides on a spiral staircase]. The deterioration of the statue is of course caused by air pollution, itself caused by the unrestrained production of capitalism. To Monory's statistics, Butor adds the information that the Statue, though received by both the American people and the American government, was paid for by the French people, not by the French government, a telling twist to the contrast. Then, in a simile, the Statue's holding the Declaration of Independence is compared to Moses' holding the Law. This is the only reference Butor makes in the poems to other documents included in the *Kit:* the Declaration of Independence (#32F *Authentic facsimile memorabilia, même* [*Authentic facsimile memorabilia, itself*] (C: 71, B: 171)) and Moses' receiving the Law as seen in the idiotic wax museum (#4 *"Prospectus, même"* [Prospectus, itself] (C: 18, B: 37)). Almost no one attends to the laws of Moses any more, and today in the United States the Declaration of Independence seems to have no more meaning than they. Butor adds that we can still go into the crown of the Statue of Liberty, but we must recognize that what we see from the windows in her crown is corrupt New York City or else *"le large"* [the open sea]—as in the

last collaboration, #50, *Le Diamant du large* [*The Diamond of the Open Sea*]. Butor's blues expression here, "Blue stocking," he translates as *"lourde muse,"* literally "heavy muse." Like #32a', the Liberty Bell, in Butor's rendering, *La Cloche fêlée* [*The Cracked Bell*][36] (C: 71, B: 170) the Statue is cracked and seems to represent a big, heavy, dangerous deception.

Alienation and Isolation

Along with the racism, the violence, the consumerism, American society today seems to feature alienation of all kinds, from work, from family, from others, resulting in isolation. Butor and Monory devote over a third of the collaborations to these issues.

Monory labeled #15, *Sous le couvert, blues* [*Under Cover, Blues*] as Oklahoma, with his characteristic endless numbers, as if there were thousands of such scenes to be identified.[37] With one of his arrows, he focuses our attention on the child, and the pattern of light running down the roof serves as a focusing vector as well. We cannot really tell what is in the dark area between the two segments of slanting roof, pipes, part of a window. It is a depressing scene of unremitting sameness, the only relieving contrast being between the harsh man-made shingles and the softness of a living tree brushed in by the artist. Everything is covered or partly covered.

#15 SOUS LE COUVERT, BLUES

> *Séparé de l'horizon nu par l'abri de quelques arbres*
> *Aux abords d'un village de l'Oklahoma sous le toit couvert de lattes*
> *Derrière le mur couvert de planches et la fenêtre à petits carreaux qui s'écarte*
> *Précautionneusement quand on tourne une manivelle à cause du vent de poussière*
> *A l'ombre du store mi-baissé dans les replis d'un rideau de chez Sears*
> *L'enfant surveille la route vide bleue parce que "to feel blue" veut dire éprouver du cafard*
>
> (C: 47, B: 107)[38]

Butor's syntax provides for the addition of one isolating element after another in a series of prepositional phrases and subordinate clauses building toward the subject and verb, which are held back until the last line, followed finally only by an empty road. The rhythm of the patterns in the serigraph is captured not only by Butor's repetition of the "cover" of the title in both roof and wall, but also by the series of prepositional phrases. That first word, "separated," is reinforced by virtually every noun and adjective, for a cumulative effect of utter lonesomeness.

Jacques Monory, *Sous le couvert, blues* [Under Cover, Blues] (#15).

Butor has added much to the details in the serigraph. He does not often use children in his work, but Monory does, and it is Butor who identifies the skull-like face behind the curtain as that of a child. It is Butor who specifies that the window can only be opened "cautiously," because of the dust storms. It is Butor who adds that the curtain comes from Sears (with the allusion to *Mobile*), which recalls the consumer society and mass production: more sameness, together with the sense of distance from other populated centers, which leaves mail order the only means of supply. Butor sets the scene not even within the Oklahoma town, but only nearby. We do not see the road in the serigraph, but since Butor knows Oklahoma, he begins and ends his text with emptiness.[39] The "blues" expression could not be more aptly selected: this child has every reason to "feel blue."

Another child appears in #18, *Les éventails de l'autoroute, blues* [Fans of the Highway, Blues] (C: 50, B: 109) Again there are two horizontal segments in the serigraph. The top is an endless divided superhighway (not the same view as in #3), with a superimposed block of a child and man, stiff and expressionless, facing the camera, in a drab interior behind what could be a pulpit, with shelves in the background. The lower segment is a close-up of three cardboard "funeral" fans, stuck in a rack of the kind provided for the purpose in old churches before air-conditioning. The pictures on the fans, lush vegetation and a moonlit lake behind an elegant lady, provide startling contrast with the dry desert, barren store, and the empty highway on which only part of one car is showing.

Butor tells us that the fans used to be distributed by an unidentified "*l'on*" [they], perhaps the owners of the now abandoned mines he mentions, caught up in wild generosity brought on by a festival mood. He adds adjectives describing the ladies as "*rêveuses*" [dreamy], the foliage as "*douces*" [soft], in contrast with the sites of the company parties, which were on plateaus covered not only with cacti but also with juniper, a bush that prickles with thorns. "Once in a blue moon" could allude to the rarity of gifts, however inappropriate, received from bosses, while continuing the contrast between dream and reality.

Of course the master of causing the viewer to feel American isolation is Hopper. Monory's tribute to Hopper in #9 *Hopper's land, blues* (in English in the text) (C: 28, B: 45) stands out from all the other serigraphs not only because of its pink segment but also because of wide framing (blue) borders. Evenly divided horizontally, as usual, this serigraph has a box in the upper right-hand corner with the text, *Homage à Edward Hopper* and below it is a reproduction in pink of the Hopper painting, *House by the Railroad*. The remainder of the upper segment is Monory's reworking and updating of the original from a different angle, with junked cars and distant cattle instead of the railroad—and of course few passenger trains remain functional in the United States today. Only a bare pole, probably once for a flag, a palmetto, and a tumbleweed break the desolation. Hopper's house was isolated to begin with; Monory's is all the more so: faded, deteriorating elegance in the midst of a boundless wasteland. Below it, the whole lower segment is a detail of gingerbread, those carefully handcrafted architectural jigsaw decorations created for their beauty. Totally impractical and extraordinarily expensive to maintain, they are left to decay.

Butor identifies the scene as Texas, perhaps because of the cattle, which he, interestingly, calls "*vaches,*" milk cows, rather than "*boeufs,*" beef cattle, and yet Monory's scene is surely Texas and not Wisconsin. That the scene represents a "glorified Texas" forces the recognition of what Texas is in its natural condition. Butor then adds a series reminiscent of his own earlier text, "between the center and the yet":[40]

Dans le décor d'un Texas glorifié bleu parce que "to be
between the devil and the deep blue sea"
Veut dire être entre Charybde et Scylla entre le marteau
et l'enclume entre tornade et torpeur entre vestige et
vertige entre centre et absence)

(B: 28, C: 13)[41]

The classical allusion in the "blues" expression is star-
tingly distinct from the preceding text. Butor's choice
of it to translate the common parlance of the English
shifts the tone to a different world. "The hammer and
the anvil" shift back again to the commonplace, while
increasing the force: we are no longer simply caught
between two dangerous elements, but two elements
now smash together to crush us. In the world subject to
weather, "torpor" usually precedes the "tornado" as
well as following it. The rhyming "vestige" and "ver-
tigo" differ in French by only one letter and, moving
away from the trapped feeling, reflect rather the storm:
a tornado leaves behind only "vestiges," and we lose
our balance as with "vertigo," in an overpowering sense
of desperation, which echoes through the repeated
sounds. The poem has stated that there are "*maint logis
abandonné entre Virginia et California*" [many aban-
doned houses between Virginia and California]. The
Hopper house and Monory's house are centers amidst
this enormous absence; abandonment is the absence in
the center.

Isolation does not occur only in the vast western
plains. Monory's serigraph #42, *Les Aveugles, blues*
[*The Blind, Blues*] (C: 85, B: 426) shows an aspect of
the life of people who are not quite like most. In this
full-page image, a man in a business suit and a nun, both
blindfolded, each holding a gadget, stand in a yard in
front of a classic façade among various objects, a baby
buggy, a stool, a trash can. They are typical Monory
people. Superimposed on the upper right-hand corner is
a shopwindow displaying an artificial eye surrounded
by false eyelashes that look like centipedes. Across the
top runs one of Monory's endless bands of numbers.

In his poem, Butor uses circuitous syntax, exactly
suited to the serigraph. He first sets the scene with a
structure used throughout, a prepositional phrase, "*De-
vant la portique du Massachusetts Institute of Technol-
ogy*" [In front of the entrance to the Massachusetts
Institute of Technology], and then establishes two
developments with the anaphora, "*Sous l'oeil*" [Under
the eye] and "*sous la surveillance*" [under the supervi-
sion], the first deriving from the superimposed segment
and continued through the middle of the third line.[42]
There the second series is begun, deriving from the full-
page image. The two "under" developments interlock
with three "*dans*" [in] phrases: "*dans une vitrine*" [in a
shopwindow], "*dans toutes les circonstances de leur*

vie fabuleuse" [in all the circumstances of their fabu-
lous life]," and "*dans l'espoir tremblant*" [in the trem-
bling hope]. The subjects are not given until the fourth
line, and the verb in the fifth line is separated from its
object by another long—and essential—prepositional
phrase before the final one, a list of obstacles:

Dans l'espoir tremblant d'une amélioration de leur sort
l'homme et la religieuse aux visages masqués de
loups opaques pour éliminer le peu de vision qui leur
restait
Cherchent à l'aide d'un petit radar portatif leur chemin
entre les poubelles portemanteaux volets et tabourets

(C: 85, B: 426)[43]

With the syntax Butor suggests to the reader the feeling
of finding one's way, as if blind, among obstructions.

Butor's additions are needed: given Monory's will-
ingness to black out eyes to disguise faces (seen also in
serigraph #48), viewers would not necessarily know the
man and the nun were blind without Butor's explana-
tion: in this test using radar for the blind, the blindfolds
are to assure the validity of the test. We can now under-
stand Monory's band of numbers as implying these tests
or all technological tests are astronomically numerous.
Butor also adds that the shopwindow is Californian
because of course it is the eyes (and eyelashes) of
California that suggest the "fabulous life" of the
"happy." There are numerous descriptive adjectives in
this poem, among them Butor's addition that he sees in
these people a "trembling hope," but to most viewers
not only are they not trembling, but they are not moving
and never have moved. Butor, however, sees what is
hidden within them.

The blues here as "blue funk" could well refer to the
blind under normal circumstances, conjured up for the
readers as we feel our way through the syntax and the
obstacles. It could also further include the blind relying
on radar as in the experiment treated here. Because they
are relying on technology, the blind have given up "the
little vision remaining to them," becoming bats, blind,
dependent on radar. This descent on the great chain of
being resembles the woman with the prize-winning cat
we will see in #48, who becomes herself a monkey.
Butor is always appreciative of the wonders that tech-
nology has brought us, but usually cautions against
accepting them without reflection. The man in his
proper business suit and the nun with her rosary beads
are part of constituted groups in society, and yet be-
cause they are blind they are marginalized.

The blind are not the only group in society who are
set apart. Monory has also thought of the imprisoned. In
#48, *Fauves d'intérieur, blues* [*Wild Beasts of the*

Home, Blues] (C: 94, B: 431) Monory has combined at least two earlier works. The background is a tiled hallway with barred windows, lit by fluorescent lights, almost totally blocked from our view by a hospital screen. Superimposed are two small images: on top, a monkey who appears to be howling and below, a woman clutching a tabby cat and show ribbons, with trophies behind. Her eyes are masked. We understand that the woman seeks fame through simply owning the prizewinning cat, but since she is portrayed in the serigraph with masked eyes to prevent, exactly, our recognizing her, her efforts are vain. Held uncomfortably, the cat looks at us, like the Indian's horse in #30 and the gull we will see in #50.

In this poem, Butor uses more figurative language than in any of the others. Both cat and woman are qualified by oxymorons: "*animal seigneur esclave*" [animal lord slave] and "*soubrette geôlière*" [waiting-maid jailer]. The suburb of cat-shows is metaphorically transformed into a jungle, the cage into a penitentiary. There is a repetition in "*nombreux rubans*" [numerous ribbons] and "*nombreuses coupes*" [numerous trophies], and the expansion of ideas in "*du sourire des félicitations*" [of the smile of congratulations] and "*malades ou mourants*" [sick or dying]. We need Butor's text to follow Monory's leap from the woman to the howling monkey and from the cage, which we don't see, to the penitentiary hospital, which we would have to recognize by the bars. Here Butor develops oppositions in ways of seeing: the cat is both lord and slave, pride of the household but locked in a cage, the woman both jailor and handmaid, recipient of congratulations but very like a giant howling monkey, lower, so to speak, in the great chain of being. The idea of ways of seeing goes farther. In the prison hospital the "sick or dying" are hidden from us despite the flourescent light, which would lead us to believe that Monory and Butor understand that the woman, disguised from us with her masked eyes, does not see herself, either as exploiter or as a howling monkey.

The hint of a different feeling appears in the next serigraph #27, *Appel urgent, blues* [*Emergency Call, Blues*], although it is a continuation of #24 *Wall Street, Blues* with the upper segment of the empty bank shifted slightly upward. It is evenly divided horizontally and, difficult to discern but visible in the lower segment of the subway layer below the bank are legs and shadows of waiting passengers on two platforms with rails between. In the superimposed image of a kneeling woman holding a little boy, some kind of splint is attached to his foot, and a sort of suction dart. This is Monory's only child with any expression, one of pain or sorrow, but he has not left the child to collapse alone. The kneeling woman is a rare example among Monory's figures,

Jacques Monory, *Appel urgent, blues* [Emergency Call, Blues] (#27).

portraying as she does, humanity in a less grim light than most. The nurse's lack of expression is typical, but her eyes are closed, she has knelt on the floor, and her hands hold the child gently, comfortingly.

#27, *APPEL URGENT, BLUES*

> *Sous le plafond d'une banque les téléphones restent*
> *silencieux dans la nuit*
> *Sous le plancher de cette banque les usagers du*
> *métropolitain*
> *Attendent le dernier train de la nuit et sous tout ce*
> *réseau de fils et d'affaires*
> *De voies et d'heures supplémentaires au plus profond*
> *d'un hôpital spécialisé*
> *Un enfant las d'attendre la dernière visite de la nuit*
> *s'est écroulé dans les bras de son infirmière*
> *Bleu parce que "to go blue" veut dire devenir cramoisi*
> (C: 63, B: 163)[44]

Butor uses the same introductory phrase as for #24, "*Sous le plafond d'une banque*" [Under the ceiling of a

bank], and we would not have known otherwise that it was a bank—any more than we would have in #24 other than through the association of its title, *"Wall Street, blues."* The *Emergency Call* is not made to or from the bank, where the phones are silent at night, waiting for the next working day, nor from the subway, where people wait for a train that will come, but rather is related to the tired child. Anaphora leads the reader deeper and deeper underground, from the bank, to the subway, to the child. Overlapping repetitions, "silent in the night," "the last train of the night," and "last visit of the night" emphasize our reaching the very last layer. The syntax of parallel verbs and multipled prepositional phrases reflect the "network" of mechanical activity, bringing us in the very depths to the simple statement that the child has collapsed. The reader assumes "the last visit" is by a doctor, but does not know what is wrong with the child. The unknown is, as always, threatening, which Butor reinforces in his "specialized hospital," withholding the nature of the specialization. Butor reflects Monory's apparently sympathetic feeling by placing in the emphatic last position the phrase, "in the arms of his nurse." Only one other collaboration allows for compassion, #50.

This next serigraph, #50, *Le Diamant du large, blues* [*The Diamond of the Open Sea, Blues*] offers another animal, unmoving, a gull looking at us, (as birds do, with one eye), like the Indian's horse in #30 and the cat and monkey in #48. All Monory's observing animals in these serigraphs contrast with the human activity around them: animals do not imprison or discriminate against one another, nor, as here, play competitive sports. The gull is just perched there, beak closed, not cheering either team. Monory would have selected baseball since it is considered the national game in the United States and thus elicits fanatic enthusiasms found elsewhere for soccer. The sign, "What's stopping you?," which may seem unrelated to either gull or base-ball, enables the realization that the choice is ours: whether as individuals we will devote our energies to watching sports entertainment or to helping those in need. The artificial lighting and crowd in the baseball stadium contrast forcefully with the tranquil open sky and sea behind the gull.

#50 *LE DIAMANT DU LARGE, BLUES*

> *Au milieu de son tintamarre le métro de New York City*
> * nous avertit que l'orgueil la peur et la confusion*
> *Empêchent cinq millions d'handicapés de recevoir*
> * l'aide dont ils ont besoin*
> *Et le cri silencieux qu'il nous instille dans les os qu'est-*
> * ce qui vous arrête vous est répercuté par toutes les*
> * mouettes sur toutes les plages de toutes les côtes*

Jacques Monory, *Le Diamant du large, blues* [The Diamond of the Open Sea, Blues] (#50)

> *Et l'on peut l'entendre aussi dans les remous de*
> * l'énorme foule à l'astrodome de Houston qui hue et*
> * siffle les idoles du base-ball*
> *Sur le terrain nommé "diamond" c'est-à-dire à la fois*
> * losange ou plutôt carré sur pointe et diamant*
> *Bleu parce que "blue Peter" veut dire chez les marins*
> * pavillon de partance*

(C: 96, B: 432)[45]

Previous mentions of the subway (#24 and #27) do not refer to the noise we find here; the "uproar" emphasizes that it is in this very subway that the sign appears that Monory has reproduced and Butor explained—and without his explanation we would not have known where the sign was. It is on the sign that a vocabulary of emotions appears, and it is the sign that addresses us directly and that Butor treats with poetic devices, such as, the oxymoron "silent cry." Further, the sign instills the cry in *our* bones, followed by "all" repeated three times: the "our" is all-inclusive. The adjective "enormous" then is reinforced by two actions, booing and

hissing, as one action would not be enough for the crowd bent on condemning its "idols," since even popular heroes are unworthy, disdained, even those baseball players who are paid diamond-studded salaries. The tone, emotional this once, is promptly chilled by the prosaic "that is to say," and the exactitude of the two meanings of "diamond," the one geometric and the other suggesting market value.

The structure of this poem differs from that of all the other poems, in pendulum swings from the New York subway to the seacoasts, back to the city and crowds of the Houston Astrodome, and finally out to sea. There are contrasts thus between the enclosed subway and Astrodome on the one hand and the open air of the coast and sea on the other, between handicapped people and free-flying gulls. Butor probably selected the Blue Peter, the sailors' flag signalling imminent departure, because this is the end of the "Catalogue," or because he would like to leave a land that has not lived up to the two-hundred-year-old promises so often cited in the *Kit*. This is the only poem with a true variant in *Boomerang,* where instead of the "flag of departure" we have a "flag of distress." Of course, the poem is not set at the end in *Boomerang* and thus departure was no longer suitable, but there is no justification in nautical usage for the Blue Peter as a distress signal. It would appear that Butor felt the anticipated audience of *Boomerang* could better tolerate the truth than the audience of the *Kit,* which would have included many in the United States. Alternatively, he may have felt that the situation in the United States had deteriorated in the two years between the *Kit* and *Boomerang.*

Regarding Monory's part of these collaborations, La Mothe said, "The works of Monory refer directly to our life, to our evasions . . . how can one not see oneself as overwhelmed on all sides by forces which we can neither measure nor control? The absence of the past which seems annihilated, if not evacuated, from the illusory present and from the future which is blind, even death-dealing, which emanates from this series of images, without leaving us crushed, for all that, can only leave us without much hope."[46] We will recall his saying also that "Butor contaminates the expression of murderous violence [Monory's] by that of lucid despair" (118). There is no denying the justice of these statements. And yet, in these two poems, #27 and #50, and only in these two, Butor and even Monory suggest there is a vestige of compassion, of humane behavior, left in the United States, to be found either in the subway or beneath its level. The nurse in #27 is unmistakably comforting the suffering child. In #50 someone or some organization negotiated with the subway company to post that sign: someone cares. No reason is given for believing anyone will act on the challenge of the sign, but Butor specifi-

cally states that the "silent cry" is "instilled in our bones" and that the gulls repeat it everywhere.

CONCLUSIONS

With only two dim glimmers of hope, these collaborations display a very sad picture of the United States. Butor's political stance is very clear. We remember his statement that "it is the totality of the political system we are in today which is bad." However, unrelieved gloom is not generally considered very persuasive. In these poems Butor's use of humor as a rhetorical device is not be found. The latent hilarity in the enormous pompousness of the Bicentennial celebration is an integral part of the *Kit* as a whole, but the collaborations with Monory are not humorous. We know that even the "blues" allow occasionally for a light-hearted touch. The basic form of "blues" lyrics expresses a lament in A, "My baby done left me," varies it in an A', "My baby left me for good," with a B, "I feel so blue," and then after minor variations in the repetitions, turns the lament around in the final B: "Gonna find me a new woman right in her neighborhood."[47] But Butor does not use such twists in these collaborations, maintaining the deep melancholy of the bluest of the "blues." Monory's work may produce shock or a shudder, but not laughter. As we have seen, even his animals, the Indian's horse, the cat, and the gull simply stare at us and the monkey howls. There is nothing to smile at in these images, and as sources for Butor they could only inspire sadness and the blues.[48]

Rather, it is through the rhetorical force of the poetry that Butor persuades readers to hear his political message in this work. It is clear that the consistent device is litotes. Never does Butor state, "the omnipresence and use of handguns in the United States is barbarous," or "mistreatment of human beings because of skin color is totally unjust and unjustified," or "a society dedicated to getting and spending is lost," or even "in the immensity of this land there are individuals and groups who are lonesome and who suffer through the lack of concern of others." On the contrary, he withholds any conclusion, but simply tells us the situation. On the single use of the first-person narrator, "When I recognized him when he realized it," the first person does no more than identify the figure in the serigraph, blandly stating that he and Monory are friends. "I" could have said, "I was dismayed and terrified to see my friend's friend, Eric, involved in the dangerous activities of the desperate Black Panthers," and Eric could have replied, "But you don't know them!" But the "I" is as dispassionate as the unidentified speaker of all but one of the other poems. The other is of course the last, when the "silent cry" of

the "What's stopping you?" sign is "instilled in *our* bones." The "our" and implied "we" appear only this once, but our bones still hear it: the reader finds himself included in this "our" and whenever we hear a gull cry, we will hear it again.

This understatement, firmly controlled emotion, we have seen throughout the poems. While respecting the constraints of this consistent tone and of the structure based on contrast or sameness, Butor creates a wide variety of developments. From the initial contrast of #1 with the preceding "Prelude" and its own internal contrasts simply presented, through the overwhelming sameness of #15, to the pendulum swings of the contrasts in #50, the structure of each poem is different from that of all the others. The syntax, too, varies widely from the one with an incomplete sentence, #30, through the relatively uncomplicated #1 and #36 to those with multiple participial phrases as in #6, relative clauses as in #3, or both in #15, to the parallel verbs and prepositional phrases of #27, and especially in the circuitous path through phrases and clauses to the subject held back as long as possible in #42. In every case the structure is in accord with the content, heightening the effect of the message.

Conforming to the limits Butor set himself, the vocabulary is almost exclusively simple and concrete, incisive, the mot juste to establish the grim atmosphere, from the English "black studies" and the "lynchings" of #33 through the familiar and conversational of #21, to the numbers and dry facts of #36 with its two piercing descriptive adjectives, the cynical "valiant" killers and the photographic term, "high-speed," applied to the killing. The only noticeable uses of harmony occur in the harsh sounds of #3 and then in the soothing "*la foule qui s'écoule*" on, of all ironic places, Wall Street (#39). Certainly figurative language and poetic devices are kept to a bare minimum; only two similes appear: the Statue of Liberty's resemblance to Moses (#12) and the streetlights' to those stemmed Martian eyes (#24). It is true that eleven of the eighteen poems do contain repetition—insistently in #15 and #36—and anaphora also in #3, and the two poems, #24 and #27, begin with the same phrase, while #27 includes anaphora and other internal repetition, but in only a few, in particular the last two poems, are the repetitions combined with other devices. In #39, with its harmony, there is the earthquake/Watergate metaphor, while oxymoron and metaphor appear together among the repetitions in #48, followed by the oxymoron and three uses of "all" in #50. Thus, the only poetic device used regularly throughout is repetition. The influence of the source, Monory's no-frills artworks, is evident, but already in *Mobile* Butor was remarking on the identical repetitions of place names, mail-order products, and the attitudes of speakers from one state to the next in the United States; the predominance of repetition as a poetic device in these poems is thoroughly appropriate to the subject itself.

Even in his addition to his poems of elements that do not exist in the serigraphs, Butor is discreet. In several poems, place names are added, both providing atmosphere and clarifying Monory's images, and in three, individuals' names are given: the murderer's family members (#3), the child Eric in the burning building (#21), and Stravinsky as a bureaucrat (#45), each with a different effect. Factual details are added to two: in #36 about the recoil tests and the blue uniforms and in #12 about the current condition of the Statue and its being a gift not of the French government but of the French people. Actions are attributed to Monory's unmoving figures in several: the Indian dreams in #1, the inattentive student leers at another (invisible) student in #33, and all the human actions in #24 are Butor's creations, added to Monory's empty scenes. Once, Butor's addition of "through the window" establishes the inside/outside contrast fundamental to the artwork, the perception of a threatening situation that may be nothing of the kind (#21). Once, he adds sound effects, the uproar of the subway and the yells of the baseball crowd, plus the echoing cries of gulls (#50). In at least three it is Butor's additions of strands of narrative that give meaning to the collaboration: explaining the recoil tests (#36) and the radar tests for the blind (#42), the point of the funeral fans given by mine bosses (#18), and in at least one it is Butor's additions, identifying the face in the window as a child, the dust storms, the Sears curtains, and an empty road, which expand the image far beyond its frame (#15). In only one is there a literary allusion, #6, where in addition to the actions attributed to the models, to his combining the two segments of the serigraph in his poem, the allusion to Proust's "*jeunes filles en fleurs*" resonates through the remainder of the work. In Proust's decadent, declining society, problems of violence and consumerism were not important, but alienation and certainly racism were very much at issue.

Thus all the poetic devices ordinarily used to support an argument are carefully limited. This barrenness contributes to the reader's willingness to accept the position, to be persuaded by what appears to be quite rational. The ideas are presented as factual data; we are to consider them calmly and make up our own minds—to agree.

We have of course not "assembled" the entire "kit" here, since the poem/serigraph collaborations are only one part of the whole. We could imagine them as the foundation pieces of the Swiss chalet (or barn) that, once snapped together, provide the basic structure of the rest. When the other triangular, hexagonal, multi-

colored or puce pieces are set in place we find the overall message of the *Kit* to be very clear: so long as that #13 (Butor would of course make it #13!) *Dollar, itself* (C: 42, B: 102) remains the focal point of United States society, so long will the Patty Hearsts (#7— (lucky 7 indeed!) of *Patricia Hearst, Reproductions* (C: 22–5, B: 38) walk scot-free while other unknown, certainly poor prisoners, hidden by screens, sicken and die. In the joyful merriment at our Bicentennial Party the guests representing the fifty states are to decide which state is "the most guilty" and that one is to be "destroyed or at least damaged by fire" (#47 *Signature material, imitation* (C: 92, B: 430). The Postlude states simply, "now you must move toward the writing of your own declaration of independence, the intensification of your war of which you are probably only slowly becoming aware" (C: 93, B: 431). Yes, Butor here recommends "war," and it is "your war," meaning the United States citizens celebrating the Bicentennial. Of course, he does not speak literally, not the Butor who has stated that his purpose in both teaching and writing is "to improve the world."[49] Rather, just as he has suggested in these poems, we must become aware, pay attention, not look away and pretend it is not happening. We must recognize the justice of his indictment, heed his warnings, and join his protest. No thinking, caring denizen of the United States could resist his persuasion.

3

Michel Butor and Jiří Kolář: Princes of Juxtaposition

INTRODUCTION

What's in a name, or at least its pronunciation? I am told that Kolář, pronounced correctly in Czech, sounds like "collage."[1] Another art critic states that Kolář is translated to "collage" in English,[2] but he must intend that the name has become synonymous with the technique, as dictionaries give the translation as "wheelwright." In any case, Kolář is accepted as a master of collage, and Butor used him as an example of a contemporary collagist in his *Les Mots dans la peinture* [*Words in Painting*].[3] I offer here first a brief background of this collagist and then consider the attitudes, methods, and kinds of sources he shares with Butor.

I have been examining Monory's serigraphs, primarily in collage form, and will now see how very differently Kolář develops the basic technique. Not satisfied with the accepted kinds of collage made by others, Kolář has gone on to invent many variations. I noted that in his collages Monory sometimes uses his own earlier works, cutting, rearranging, and transforming them; Kolář does not ordinarily use his own works again, other than developing series of the same outline form containing different interiors, but instead incorporates images from every imaginable source, from the old masters to road signs, from advertisements to fragments of printed text, and subjects these images to treatment that sometimes leaves them almost totally unrecognizable. Although already in 1962 he was experimenting also with knotted strings, arrangements of keys or razor blades, all of which he calls poems,[4] his primary material has remained printed matter of any and all kinds, but rendered illegible by his transformations. Butor stated in a conversation, "Once, Jiří Kolář said to me: 'If hell exists and if I go there, I know what my torment will be. It will be to put back together all the books which I have torn into little pieces!'"[5]

Some understanding of Kolář's determined destruction of the written word can be found in a sketch of his life. Born in 1914 to a working-class family, he grew up in Kladno, a small mining town in Czechoslovakia, "a proletarian among proletarians."[6]

He had hoped to be apprenticed to a printer, but the economic depression diverted him to whatever odd jobs he could find. He encountered poetry by chance, educating himself, and his first artistic works were poetry. Although the established young poets of Prague thought him a rustic (24) he was welcomed by the visual artists of Group 42, who found his poetry in accord with their own goals of "trying to join the fate of art to that of the contemporary world," in opposition to what they saw as "the academic aims to which modern art had succumbed" (26). The group dissolved in 1948, but some of Kolář's books of poetry were published. Indeed, it was his poetry—deemed subversive—that caused his imprisonment for a year in 1953 when some was found in the house of a politically involved literary critic (31). Because he was kept in prison while the trial dragged on for a year, and then was finally sentenced to just a year, he was released at once. He says simply, "It was a decisive experience for me."[7]

In 1938 he exhibited twelve collages at a Prague avant-garde theater, but it seems to have been the prison experience that left him feeling "words were betraying him,"[8] and he gradually developed "analphabetograms," poetry for the illiterate, "crazygrams," poetry for the insane, as well as "evident poetry," which he describes as "poetry that excludes the written word as a bearing structure of culture and mutual understanding."[9] His experiments with assemblages were provoked by a visit to the Auschwitz Museum, with its display of the remnants of destroyed lives, which he felt as "one of the greatest shocks of [his] life," where "reality caught the artist by surprise" (50).

Citing Claude Lévi-Strauss on the correspondence between the first writing and the formation of towns and eventually empires, he agrees that "the role of writing is first and foremost to facilitate slavery" (74). Within his account of the development of his art in the context of other art and literature, which is included in his "Responses" in *L'Oeil de Prague* [*The Eye of Prague*],[10] he expounds further on this view of writing as a political activity. There the rich are referred to with the familiar derogatory term, *"richards"* [money-bags] (197) and

they are identified along with the politicians as engaged in manipulating others. Kolář specifically questions the role of literature in these operations: "Don't nations still today work to subjugate their citizens by means of symbols translated into words?" (175), but he does except "certain great artists," Shakespeare and Dante, but adds that Dante shows "traces of the spiritual tyranny of religion, reflections of a submission inscribed falsely against the Aristotelian principle of liberty" concluding that "almost all literature has conspired to reduce man to slavery" (176). The "almost" is important: Kolář's collaborations with Butor demonstrate that Kolář does not class Butor among the conspirators.

Kolář's stance has been amply treated by critics: Aragon writes very movingly of his political artworks generated by the events of 1968.[11] Among other critics, Janus has found his political position made visible in his use in collage of reproductions of the old masters, explaining, "The rich artwork of frescoes, paintings, expensive pigments has been transferred to simpler material, paper, glue, the use of scissors, which is a more proletarian dimension of the work." Thus Kolář "makes use of an art which has always been aristocratic in a popular sense, divests it of its economic value which . . . tied it to the capitalist world and changed it into a social art, a proletarian art."[12] This collaboration with the artists of the past leads Janus to say, "What he particularly seeks to emphasize is the passage (which is a moment of crisis) from the individualistic period of art to a more collective model (Kolář works primarily through the works of an infinite number of other individuals), from an aristocratic model to a popular model" (15).[13] Kolář himself feels art is not a matter of public versus private interests, political versus poetical, beautiful versus ugly, but all of these and more, which cannot be separated.[14] Among the simplest and clearest statements is Butor's: "All Kolář's art is political. It is an art of resistance. Mine is, too" (L'Oeil 34).

In regard to humor, our other particular focus here, Kolář's interest and knowledge extend beyond the classic to the film and American examples: in his discussion of literature he states that Ionesco "in his first one-act plays equaled the greatest successes of Chaplin and of the golden age of the American grotesque in general" and indeed "understood the anatomy of laughter" (L'Oeil 197). He goes so far as to say of his own works, "I admit that the humorous aspect interests me often more than all the res⌐

Beyond the always pol⌐
morous content, Butor an⌐
teristics, the most evident ⌐
has invented genres, whic⌐
most part abandoned hop⌐
endeavoring to package ⌐

ther. In 1969 Raoul-Jean Moulin wrote that "his collages owe nothing—or very little—to Cubists, Dadaists, Surrealists, nor Russian constructivists"[15] while Miroslav Lamač sees in Kolář's series, "Homage to Kasimir Malewitch" elements of surrealism, Ernst, Schwitters, among others.[16] Other critical statements about Kolář could also apply to Butor: that he is at a "mid-position between verbal and plastic expression, between poetry and art . . . [is] daringly transcending established categories,"[17] and is simply "beyond classification."[18] Among his numerous unclassifiable variations on the collage technique, we list here, under the names Kolář gave them, only those identified in his collaborations with Butor; there are many others.

Chiasmage. Torn bits of printed pages, using material in different languages, different scripts, musical notes, Braille, petroglyphs, hieroglyphs, more or less the same size and shape, rearranged and glued to the support in patterns. He creates these also in relief, three-dimensional forms, both empty and filled. He has said chiasmages "taught me to observe myself and the world around me from a thousand and one angles, compelling me to come to terms with a thousand and one experiences, thousands of destinies, etc."[19]

Froissage. A photograph or artwork is crumpled up and then flattened and glued down in crumpled form. According to the anthropological interpretation of the froissage, "it tries to evoke not merely the outward marks of destruction (of a natural or social catastrophe) but also different deformations of man's inward vision, whether it be under the effect of different ordeals of life, or a refined demagogy, a bad education, mental imbalance, etc."[20]

Intercollage. The outline contour of the original is retained but filled with a second artwork or other material.

Prollage. Reproductions of two or more different artworks are used, giving the effect of three dimensions. There are at least two kinds: (1) the contour of the second image is applied to the first, or (2) strips of different artworks are placed alternately.

Rollage. One to three reproductions of the same artwork are cut into two to ten strips of equal width. After experimenting with many sizes, Kolář now uses a width of eight millimeters regularly.[21] Reassembled, the strips give the effect of movement. Sometimes Kolář cuts them also horizontally, forming squares. If more than three reproductions are used, the work becomes a ⌐ollage multiplié" [multiplied rollage]. Kolář has said ⌐is technique "has brought [him] closer to the multiplication of reality."[22]

Stratifié. These are constructed with layers of ⌐ifferent kinds of printed matter, into which incisions ⌐re made, hollows created, giving the appearance of

geological strata. Kolář is cited as saying they "made me realize just how many unknown layers make up life and just how many unknown deposits exist within each of us, whenever we succeed in unearthing one of them" (49)

Ventillage. Pieces of reproductions overlapping but fixed in only one spot to allow for actual movement, which creates new combinations.[23]

Butor has written about Kolář on many different occasions. Aubral, citing the pertinent passages in *Les Mots dans la peinture* (158), goes on to state that Kolář should not be considered just as an artist Butor appreciates but rather as someone whose art demanded more of Butor.[24] In succeeding years, Butor's own art has demanded more and more of the reader. Butor explains in *L'Oeil de Prague* how the structure of *Illustrations II*,[25] dedicated to Kolář, was inspired exactly by Kolář's work: "The texts mingle with each other in somewhat the same way as do the images in his collages in strips or thin sheets" *(L'Oeil* 32). We will see in our study of this work how Butor uses this method in the text, especially in the forms of *prollages* and *rollages.* Certainly, in the first *Illustrations,*[26] Butor had already rearranged a given text, utilizing different fonts, different locations on the page, and different shapes for the blocks of words—and appropriately dedicated that book to the typesetter. But in *Illustrations II* single lines of one text are indeed "mingled" with those others, running heads and type of different point sizes appear, with the resulting book a *multiplied rollage.*

Another characteristic Kolář and Butor share is intertextuality. The influence of poets on Kolář may be more immediately seen than that of other visual artists. Apollinaire's "calligrammes" appear related to Kolář's arrangements of the letters of an artist's name in the form of a recognizable artwork, such as Brancusi's *Bird in Space.* Then, Mallarmé's *Coup de dès . . . ,* "whose shattered typography reveals, page after page, the whites as the true space of the poem"[27] could easily be seen as related to Kolář's distrust of the written word. Butor, of course does use the written word, and it is in this description of Kolář's poetry—written in words—that startling resemblances are found: "The technical procedures that are Kolář's means of expression in the plastic arts are also traceable throughout his poetry. These are collage methods, the use of quotations from other poets as well as from banal reality fragments; incomplete phrases caught in chance conversations on the streets or in the cafés; rows of statistical data and sober, non-metaphoric observations; the inclusion of documents, the revelation of manners of speech, the repetition of part sentences and the play on words."[28] We know that Butor finds materials in these same kinds of sources; however, we should note that there is a

definite difference between Kolář's and Butor's reusing their own works. Kolář only rarely refers to his earlier works except in the outline contour of, for example, a butterfly, which when repeated is filled with a fragment of a different artwork.[29]

In the collaborations with Monory's serigraphs, Butor only referred to an earlier phrase of his own once, although of course in the *Kit* as a whole texts from *Mobile* were cut, rearranged, and transformed like Monory's serigraphs. Now we will see in one of the collaborations with Kolář one of Butor's brief texts reappear intact within another, and, in that primary text, two other previously published, longer texts, as well as generous segments of others. Regarding the re-use of his own texts, Butor feels that a text's appearance in book form is a point of demarcation. "For me, publication in a review and in a book are very different. In a review, it remains still temporary, it is a kind of trial balloon, while in a book, when it is there, in that brick of a volume, clearly marked with the stamp of a single author, there."[30] Despite this distinction, we can never be sure a given text has made its final appearance because, as he has said, his "attic" is filled with texts he thinks of as complete, which sleep there, but, he adds, they dream.[31] We will see here in *L'Oeil de Prague* examples of his use of both "trial balloons" and "bricks" that have been dreaming.[32]

In addition to the shared content of politics and humor, shared label of unclassifiable, shared techniques of intertextuality, Kolář and Butor both demonstrate a resistance to closure, a concern for the involvement of the reader/viewer, and, risking a step on the perilous ground of authorial/artistic intention, I must remark in both a will to change the world through art. Butor's openendedness is very well known. Kolář's open structure, deliberate ambiguity, has been described: "We have the impression Kolář's collages can continue indefinitely . . . a true and correct picture of infinite zero."[33] Kolář has said of himself that his sort of poetry—and we should remember that he thinks of his artworks as poetry—requires reader participation, attempts only "to arouse in man at least a thrill of tension and sheer joy or a peaceful smile. If it succeeds in doing this it has accomplished the essential. What other greater proof can art give in this world of desolation?"[34] Butor has often spoken of his own works' demands on the reader, and where he may not conceive of the world as exclusively desolate, he is certainly dedicated, both in teaching and in writing, to bettering it.

One aspect of our study of these collaborations is not shared by both: the matrices. Butor often uses a matrix to develop a series of stanzas or poems, a technique that is a natural extension of his interest in music and of his many collaborations with musicians.[35] In the collabora-

tion, *Fenêtres sur le passage intérieur* (in which the text preceded the artwork), Kolář's use of the same structure for all five of his illustrations could perhaps be seen as his own version of a matrix,[36] but in the three works studied here Kolář does not use one. Butor frequently does, the ultimate example (so far) being his "Don Juan," for which a computer program has been written so that anyone need only enter appropriate data to create new stanzas for Don Juan.[37] Here we will find examples of matrices in the *Guirlande liminaire* as well as in *L'Oeil de Prague*. For a student of Butor, fond of puzzles, deciphering the matrix can become obsessive. The end result—discovering where Butor has altered the fixed matrix to suit a particular poetic need—is invariably illuminating.

The third collaboration treated here, the set of Lichtenstein postcards, does not contain a matrix. In this series, the tendency toward unclassifiability that Butor and Kolář share may be seen. Kolář would call the postcard artworks *intercollages,* already his own term for the technique. Although the texts are prose poems, they could form a subcategory of "postcard-sized" poems, and Butor has collaborated with many different visual artists and photographers in this subcategory of a genre. In this series, as in the other two collaborations studied here, the shared positions and techniques of Butor and Kolář are very evident, as we shall see.

GUIRLANDE LIMINAIRE: VAGUES DES VILLES ÉCLOSION

One of Butor's most revelatory collaborative works is the *"Guirlande liminaire"* [Prefatory Garland], a poem in sixteen parts, each part a collaboration with a different artist, arranged alphabetically by artist. Composed as a catalogue for the art exposition, *Michel Butor et ses peintres* [Michel Butor and His Painters], the text is based on sixteen of the works destined for the exposition.[38] Though the works of art differ from each other in all imaginable respects, Butor uses in his textual responses the same structure for each and maintains a complex matrix of phrases throughout. The result is one closely unified poem, which provides an excellent overview of the diversity of artists with whom Butor has collaborated.[39] The individual components for each artist may be detached to stand alone, and, indeed, Butor has done so with the Kolář stanza examined here: it solos in *L'Oeil de Prague* [The Eye of Prague]. The various artists demonstrate a number of different concerns that fall within Butor's definition of the political; we will find the text with Kolář, *Vagues des villes éclosion* [Waves of Cities Blossoming], to be an excellent

example of Butor's use of the poetic to support the political.

In addition to the demonstration of Butor's ability to collaborate with such widely divergent artworks, the poem illustrates the imaginative use he makes of a fixed matrix: the same phrases reappear at intervals, but always in new contexts and always generating new images and ideas. In addition, certain words are altered and selected specifically for the particular artist. The Kolář text is the focus here; in the next chapter the Alechinsky text will be examined. In both cases references to the other texts are necessary in order to understand the workings of the matrix and to see the ways Butor has integrated each artist's text within the whole.

All the texts are set opposite the corresponding artwork, as rectangular dizains, framed by two triangles of text, each of six lines. The arrangement is reminiscent of the old-fashioned photograph album, where "mounting corners" (the triangles) were used to fix the photograph (the dizain) in place. Thus the dizain, with the artist's name set in large capitals above it, reflects the artwork opposite. For each artist "labeling lines" are used, which do not appear elsewhere in the *Guirlande*. Herewith the three stanzas of the Kolář text, with the phrases and words used uniquely for him set here in boldface:

VAGUES DES VILLES ÉCLOSION

l'interprète d'entre les lignes caresses gongs
 retournements
la toundra des après-midi la matraque des **employeurs**
yeux d'**échassiers dents de rouages** la charmeuse d'un air
 d'**ombrelles**
en compagnie des anciens sages racines
cherchant prophéties les électrodes
et les plectres

 KOLAR
 vagues des villes éclosion
 des compagnons d'interférence
 humus de nos bibliothèques
 pollen de la photographie
 ornithologie des échos
 messagerie des tremblements
 atlas des multiplications
 le jardinier des résistances
 le salut par l'inadvertance
 l'interprète d'entre les lignes

 de flux en reflux
 le sel tinte sur lequel une souche
 saigne alignant ses petits poissons
semences remuées **fêtes** descendant en se balançant
pour renverser la **pesanteur** avec armes d'**enfants trouvés**
et l'orgue des tempêtes douces **vagues des villes éclosion**[40]

The successful effect of the whole must be appreciated with the recognition of Butor's having accomplished it within the self-imposed restrictions of the matrix. The lines of each dizain composed in response to the particular artwork have been regularly distributed throughout the whole *Guirlande,* to create the triangles.[41] From the very beginning, we see the first and last lines of the dizain (the "labeling lines") repeated respectively as the last phrase of the lower triangle and the first phrase of the upper triangle. We will find the other lines of each dizain repeated at specific places in the triangles of succeeding artists' parts or, since the *Guirlande* is circular, of preceding artists' parts. Thus the second line of the Kolář dizain (II, 2) "companions of interference" reappears seven artists later in the lower triangle of Staritsky (III, 2/3), *"compagnons des interférences"* [companions of interferences]. Since the dizain supplies only eight octosyllabic lines and the triangles require a total of sixteen, some dizain lines must reappear more than once. And so they do. The third line of the Kolář dizain (II, 3) "humus of our librairies" is used again verbatim six artists later in the lower triangle of Saby (III, 3b) and then a third time three artists after Saby (and thus nine after Kolář), in Vieira da Silva (I, 4/5), still verbatim but this time in the upper triangle. The pattern continues as the repetition of an original line is placed according to regular movements backward through the artists and forward through the artists' triangles. The second reappearance of that line moves forward through the artists, and backward through the triangles. Thus, the fourth line of the Kolář dizain, "pollen of photography," is found five artists later, in Peverelli (III, 4a) as *"moisson de la photographie"* [harvest of photography]—and we will be examining such alterations—before its second reappearance in its original form, ten artists after Kolář, in Alechinsky (I, 4a). Since the second and ninth lines of the dizain recur only once, one additional repetition of two phrases is needed to fill up the triangles' spaces. Butor solved this problem creatively by placing these third repetitions on either side of the dizain at the end of the upper triangle and the beginning of the lower. Thus, both following the prescribed order, the first two reappearances of line 5 of the Kolář dizain are placed, first, four artists later in Parant III, 4b, and, second, eleven artists later in Bryen I, 3b. Line 6 of Kolář, then, reappears, first, three artists later in Matta III, 5a, and, second, twelve artists later in Dotremont I, 3a. Finally, the third reappearance of both lines 5 and 6 is in sequence, in the same artist's triangles, eight artists after Kolář: Kolář line 5 in Vasarely I, 5/6, and Kolář line 6 in Vasarely III, 1/2. Because the format separates the triangles, it is not immediately apparent that the two lines were already in sequence in the original dizain.

We need not entertain the thought, however, that the repetitions march along with no variation. We have seen alterations in particular words and will examine them more closely relative to Kolář and later to Alechinsky. In addition, I need to mention that there is one line in the whole poem that ignores the matrix altogether.[42] Unraveling the matrix is critical to recognizing and appreciating Butor's changes for each artist, which result in different harmonies and different images.

Let us turn now to the Kolář artwork that generated this blossom in the *Guirlande.* Kolář's *chiasmage* of many small pieces of texts, approximately the same size and shape, set upside down, sideways and at angles, forms a repeating pattern suggesting mosaic.[43] The band of six lines of text running across the center horizontally are interrupted at each bend. The diacritical marks identify Kolář's native language, Czech. The whole moves, and the longer one looks at it, the more the background seethes and changes, the more the eye is drawn for relief to the flowing serpent. Through the collaboration we are privileged to see what Butor sees: a river flowing in waves through a crowded city of tiny

Jiří Kolář, *Vagues des villes éclosion* **[Waves of Cities Blossoming].**

streets. Evident at once is the appropriateness of the "waves" relative to Kolář's collage, and of Kolář as the "interpreter" who reads between the broken and mosaic lines of the *chiasmage*.

Let us first consider this collaboration with Kolář as an independent poem in three stanzas. The dizain is in regular octosyllables, and octosyllables are combined or divided to create the triangular shapes.[44] The regular rhythm enables the reader to find a way among the irregular rhymes, alliterations, hard and soft sounds, the not-always-exact repetitions of phrases, and the startling juxtapositions of images.

The harmonic arrangement reflects the "ebb and flow" of the poem, its "waves," from the contrasting hard and soft sounds of the upper triangle, through the increased use of soft sounds in the dizain to the lower triangle's repetitions, rhymes, and virtually exclusively soft sounds, as it gently builds to the repetition of the labeling line with its alliteration and the hard consonants in the last eight syllables. Thus, in the upper triangle harsh consonants, as in "gongs," the [k]'s, and the repeated "-*ectre*" are balanced by the soft [ʃ]'s, *z*'s and the many *s*'s. The vowels, too, are in contrast: short front *a*'s are offset by the soft [u]'s. The harmony of the dizain initially recalls the harsh consonants in *"vagues," "éclosion,"* and *"compagnons,"* but only two additional [k]'s appear and the one [g] is softened by an *r*. The majority of the vowel sounds are soft, many nasal, emphasized by their occurrence in end rhymes. Soft *z*'s and soft [ʒ]'s continue. Sibilants predominate, particularly remarkable in the two sounded final *s*'s (*humus, atlas*). The lower triangle begins with the repeated soft sounds of the waves, *"flux et reflux."* Among the alliterations and rhymes, the [ã] recurs in internal rhymes, the soft [u] is heard again, and the only hard consonant is the [g] of *"orgues,"* which is tempered by the soft sounds of the "sweet storms" (*tempêtes douces*) until, after all the accumulation of soft vowels and consonants with so many sibilants, the wave breaks on the beach as the hard sounds at the end of the labeling line return.

The contrast between the calm "river" and the restless background of the collages is fundamental to the poem. The carefully controlled harmony of the whole is reflected in the words that suggest music: "gongs," "plectrums" (the tools for strumming a lyre or guitar), "echoes," "tinkle," "organs." Other senses are also invoked, as the kinetic is included in the strumming tools, in "caresses," "cudgels," "turning inside-out" (or upside-down), "tremblings," "bleeding," "balancing," "overturning," "weapons." Taste is summoned up by the salt, and the little fish as well.[45] Against this sensually evocative background, Kolář is presented as "interpreter," and the "lines" he reads "between" are surely

derived from the patterns of text in the collage. He frequents "aged men" who are wise, and is associated with prophecies. Other references to knowledge appear: "libraries," "the message-center," the atlas. Photography reminds us of Kolář's artistry—his collage is composed of texts reproduced by some photographic means. Images of life and growth are created: "humus," "pollen," "multiplications," "the gardener," "salvation," "the ebb and flow" of nature, and the "seeds." Among the happy images is the "charmer" who does not carry the umbrella of gray days (*parapluie*) but has "an air of parasols," evoking warm sunshine, and the "festivals"; even the "storms" are qualified as "sweet" or "soft." The "blossoming" of all the "companions of interference" continues the agreeable idea of an increased number of friends ready to address problems. As one of Butor's "companions of interference," Kolář is seen as engaged in "resistances," a concept very important to Butor.[46]

The contrast is strong between these soothing images and those suggesting elements requiring resistance, crying out for salvation, even if inadvertent. Afternoons seen as "tundra," endless and bare, will be recognized by any worker; the employers' "cudgels" will be familiar to many, at least figuratively The sharp eyes of "wading birds" are threatening, and the "cog-wheels" of machinery remind us of Chaplin's terrifying *Modern Times*. "Electrodes" evoke technical horrors, often medical. The study of birds is reduced to only the echoes of vanished species, a futuristic vision of desolation. The "tremblings" could be translated here as "earthquakes," and the combination of "atlas" and "multiplications" foresees still further dissolutions of nations. Whatever forces demand "resistance," however, "salvation" is to be achieved, and Kolář is to be a guide, as the last line of the dizain reminds us in the repeated labeling line.

The second triangle extends the contrasting strands of doom and hope, always in a tightly woven fabric. We saw "wise roots"[47] in the first triangle, and here is a bleeding stump. A stump is almost always man-made, not the natural end of the botanical cycle, and bleeding confirms the violence of deforestation. Here is a "heaviness" to be overcome, and "weapons"—and the effectiveness of any weapons "foundlings" might possess could only be limited. Still, there are "festivals," which may be "descending," with negative force, but are also "balancing," with positive force. Threatening "storms" are qualified by the vigorously contrasting "sweet." The proximity of the "seeds" to the "stump" and then to the "foundlings" produces an incompleted parallel: the parent trees of the seeds, now stumps, have been destroyed, and the foundlings have by definition been abandoned by their parents. However, with or without parental

trees, it is in the nature of seeds to contain new life, and the same is true of the foundlings. The word chosen by Butor to close the stanza is critical: "blossoming" (*éclosion*). It could also be translated as "hatching," as of an egg, "opening" as of a flower, "beginning" or "dawn."

Looking now at the whole *Guirlande,* our understanding of the Kolář stanza is increased. We will seek first the sources of the Kolář triangles in other artists' texts. Butor has made changes to provide elements especially appropriate to Kolář. Those "cudgels" (I, 2b) derive from Matta (II, 7), where they are those *"des officiers"* [of officers], and when they recur in Peverelli (III, 5b) they belong to *"insurgés"* [insurgents]. "Employers" are found only in Kolář. Where we could expect, although not be pleased about, insurgents and officers as linked with cudgels, we probably find employers wielding them at least somewhat surprising. The image summoned up is of strikers, riots, an oppressed work force beaten with truncheons. The reader will remember that the poem was written after the Prague Spring of 1968 and before the dissolution of the Soviet Union.

The next instance concerns eyes and teeth. The original dizain line in Parant (II, 6) is *"voix d'affamés dents d'exténués"* [voices of the starving teeth of the exhausted], already a vivid image of misery. In the repetition in Dotrement, the "voices" become *"yeux"* [eyes] (III, 5a). Now in Kolář (I, 3a) we find "eyes of wading birds teeth of cog-wheels." Birds are among Kolář's most preferred subjects; here Butor has selected wading birds, conjuring up the frightening swiftness of their long beaks as they snatch their prey. Reinforcing the contrasts of Kolář, these grim images are set next to the feminine "charmer with an air of parasols" (I, 3b). She appeared originally in Peverelli (II, 5) with *"un chant de flûte"* [a flute song], which is not altered in the other repetitions in Dufour (I, 5/6) and Vieira da Silva (III, 4b). Rather than reiterate the musical references found elsewhere in the Kolář stanzas, Butor prefers to underline even more vividly the fundamental contrasts by juxtaposing the "parasols" to the "cog-wheels," seen as biting and grinding teeth.

In the lower triangle of Kolář (III, 4a), "seeds stirred festivals" has undergone quite a metamorphosis from the original in Bryen (II, 4), *"écailles rumées dans la boue"* [scales stirred in the mud], which recurred without change in Peverelli (I, 4a). Those "seeds" appear elsewhere, as we will see in the Alechinsky stanza, and here in Kolář form a part of the image of the "stump" and the "foundlings" mentioned earlier. But the "festivals" occur only in Kolář, displacing the "mud": despite the oppression and the sinister surroundings, with Kolář there are still celebrations.

The original phrase in the Dufour dizain, *"pour renverser les dictature*s" [to overturn the dictatorships], is

repeated without change in Peverelli (III, 1/2) and only slightly amended in Vieira da Silva (I, 6a) to *"déjouer les dictatures"* [to thwart the dictatorships]. When the phrase appears in Kolář (III, 5a) it has become "to overturn the heaviness": prudence would have led Butor not to mention dictators here in the Kolář stanza. The "heaviness" then is to be "overturned" in Kolář with "weapons of foundlings" (III, 5b). The source of this phrase is in Francken (II, 7), where it is *"les armes des couturières"* [the weapons of the dressmakers] and in its other reappearance in Bryen (I, 2b), the weapons are gone, replaced by the relatively innocent *"ongles des couturières"* [fingernails of the dressmakers]).[48] Where armed dressmakers carry appropriate meaning in the Francken stanza, so the concept of helpless foundlings identified as having weapons, and weapons effective enough to overturn the heavy weight of oppression, offers a clear image of Kolář's "resistance" through art, as Butor sees it.

Looking at the stanzas from the other direction, for changes operated on the lines from the Kolář dizain as they flicker and shine forth through the other artists' triangles, I must admit it would hardly be reasonable to cite all of them here, and thus will give only three examples, to indicate the wide range of effects Butor has created with his matrix. The fifth line of the Kolář dizain "ornithology of echoes," repeated verbatim in both Parant (III, 4b) and Vasarely (I, 5/6), becomes in Bryen (I, 3b) *"ornithologie des humeurs"* [ornithology of humors]. Then, Kolář II, 7, illustrates the possibilities inherent in the matrix, with first one term and then the other affected, as the original "atlas of multiplications" becomes in Masurovsky (III, 5b) *"atlas des pérégrinations"* [atlas of peregrinations] and in Dufour (I, 2a) *"vivier des multiplications"* [fishpond of multiplications]. One of the most delightful of the alterations is from Kolář II, 6, "message-center of tremblings," with its possible suggestion of earthquakes. This line reappears in Vasarely (III, 1/2), where the only change is that the "message-center" is made plural, but in Matta (III, 5a) it has become *"messagerie d'inondations"* [message-center of floods], and then, the very opposite of such catastrophes, in Dotremont (I, 3a) *"messagerie des ronflements* [message-center of snores].

I will similarly cite only a few examples to illustrate the point that even when a dizain phrase recurs intact, the context varies according to the demands of the matrix, and the resulting effect is totally different for each artist. Thus, when Kolář II, 2, recurs in Staritsky (I, 5/6– III, 1–3a), it is as a part of this sequence: *"surimprimées de lèvres moîtes métamorphosées en dragons / compagnons des interférences fissure insectes migrations"* [imprinted with moist lips metamorphosed into dragons / companions of the interferences crack insects migrations]. Kolář's "companions" are grammatically depen-

dent on the "blossoming," and are part of a general, overall single "interference." In Staritsky the "companions" are of many "interferences," followed by a single crack, and are set in apposition to the dragons, which are themselves transformations of "moist lips." These dragon companions are well suited to Staritsky and could even perhaps be seen represented in his painting.

Another shift occurs when Kolář II, 3, reappears in the lower triangle of Saby (III, 2/3): *"nuages / d'où jaillissent les vifs humus de nos bibliothèques"* [clouds / from which leap forth the living humus of our libraries]. The "clouds from which leap forth the living" comes from Hérold II, 2, where it was followed by *"corsages de feuilles d'acanthe"* [corsages of acanthus leaves] (Hérold II, 3). Now in Saby the "living" of part *a* of the line qualifies "humus." This transfer of force of the adjective does not happen in the subsequent recurrence, in the upper triangle of Vieira da Sylva (III, 4/5): *"buissons d'aisselles évasives humus / de nos bibliothèques temples"* [bushes of evasive underarms humus / of our libraries temples]. Rather, the shape of the triangle emphasizes the "humus" as related to those "evasive underarms." When the "humus" is revealed as that "of our libraries" in the next line, the arrangement summons up an image of weary, unkempt graduate students.

The next line, Kolář II, 4, turns up intact in Alechinsky (I, 4a), where the context produces a virtually opposite image: *"pollen de la photographie insectes migrations fissures"* [pollen of photography insects migrations cracks]. The last three nouns have been rearranged to allow for those "cracks" to be *"développées dans le miroir"* [developed in the mirror] at the end of the first Alechinsky triangle. Thus in Kolář the photographic pollen is paired with the fruitful humus of the library, while in Alechinsky it leads to infestation, deterioration, separation.

Two other artists are qualified as "the gardener of resistances" (Kolář II, 8), Francken and Masson, and in both cases the context creates a different "gardener." Francken's gardener is surrounded by fire: *"et les incendies attendus / le jardinier des résistances / plumages ramages brasiers"* [and the expected fires / the gardener of resistances / feathers florals furnaces] (I, 2a). Masson's, on the other hand, *"dans les allées des confidences / le jardinier des résistances ailes et flammes becs langueurs"* [in the alleys of confidences / the gardener of resistances wings and flames beaks languors] (III, 6a), retains the "flames," but resolves into languorous walks, whispered secrets, accompanied by birds.[49]

Kolář II, 9, recurs only in Hérold (I, 1b): *"déploie sur l'étang ses festins le salut par l'inadvertance / flèches bourgeons déchirements"* [furls on the pond its banquets salvation through inadvertence / arrows buds rip-pings]. There the "arrows" phrase is one of the displaced Masson lines, which leads us into a different set of reasons for the alterations. But the inadvertent salvation of Hérold, preceded by water and banquets, is a far merrier one than Kolář's, with its resistance and interpretation.

Finally, I cite only one example of the effect on a Kolář triangle of two dizain lines, from two different artists, appearing contiguously, both intact. Vasarely II, 6, is *"de flux en reflux le sel tinte"* [from ebb to flow the salt tinkles], but the salt becomes *"ciel"* [sky] in Bryen (III, 5a), and *"miel"* [honey], which does not tinkle but *"bouge"* [budges] in Parant (I, 3a). The next phrase in the Kolář triangle is "on which a stump bleeds" (from Vieira da Silva (II, 2), where it is preceded by the labeling line, *"population des coquillages"* [population of shells]. In Kolář the conjunction of the salt and the bleeding stump arouses the sensation of putting salt on a wound, or, alternatively, suggests sowing the earth with salt to prevent future vegetation. These painful ideas are present in neither of the original dizains, but seriously expand the condition of Kolář's "foundlings." The reader is encouraged to seek out other effects of Butor's either changing or not changing phrases in the matrix.[50]

Thus Butor's collaboration with Kolář's collage, while remaining an integral part of the whole *Guirlande,* offers a keen view of Butor's understanding of Kolář's work. The poem is as musical and rhythmic as the collage, with its ribbon moving against the seething mosaic background. The frightening images of predatory birds and teethed machinery, of cudgel-wielding bosses, of repressed foundlings far too near the bleeding and the salt are all visions added to the matrix specifically for Kolář, seen as Butor's cohort in resistance. The tension is then created by the positive images, the festivals and parasols again added only for Kolář, the others carefully rearranged from the basic matrix. As one of only three among all the artists qualified as "gardener of resistances," Kolář together with his "companions," will interfere and bring salvation, however inadvertently realized. This collaboration illustrates well Butor's statement that "all Kolář's art is political," which we will be examining in the next section, *L'Oeil de Prague.* The force of the poem is found in that "blossoming," placed at the end of the repeated labeling line, where the tension of the whole is finally relaxed and Butor reveals Kolář's collage as the promise of a new beginning for a better world.

L'OEIL DE PRAGUE

L'Oeil de Prague[51] [The Eye of Prague] is a particularly rich work for this study. In it Butor's collaborations with Kolář provide clear examples of the "politi-

cal utility" of Butor's poetry, while the texts remain harmonious, image-filled—and often humorous. The work is composed of three distinct parts, already a kind of collage. The first part is Butor's text, *Dialogue avec Charles Baudelaire autour des travaux de Jiří Kolář* [*Dialogue with Charles Baudelaire Around Works of Jiří Kolář*]. The second section is Kolář's text, *"Réponses"* [Responses], from 1973, setting forth his position on art as it has developed from his beginnings as a writer. The final section is composed of thirty-one Kolář *froissages* entitled *"La Prague de Kafka, 1977–78,"* [*The Prague of Kafka*], each artwork accompanied by a citation from Kafka.

The blending together of all three parts in this book results in a haunting ambiance for the part that is our focus here: even without consideration of the Kafka/Kolář collaboration, which is fascinating and deserves critical study on its own, Kolář's *froissages* are omnipresent to the reader of Butor's text, constituting a disturbing visual background. All thirty-one *froissages* were created from photographs, crumpled, and then flattened. The effect is of the world as we perceive it taken apart and then put back together somehow, anyhow, often so that it makes no apparent sense. Parts of buildings we know stand straight lean here at wild angles, no longer connecting with themselves. Parts of people have disappeared, some appear to be walking backward, legless or headless. Aspects of a scene that would normally have been overlooked assume new importance. Everything is bathed in a golden light with clear, often brilliantly blue—but cracked—skies.[52] From the first page, the structure of Butor's text reflects Kolář's *froissage* technique: the original segments of text have been, so to speak, crumpled, flattened out, and glued in different places. We can read them as they stand, just as we can look at a collage without identifying its uncrumpled original, but with a little effort we can understand both collage and text more fully. Regularly, disassembling a Butor text in order to reconstruct its identified components has resulted in a clearer comprehension of the masses of clustered ideas that Butor juxtaposes in different combinations, adding, subtracting and altering as he goes. Our study here concentrates on the Butor text, but the reader of *L'Oeil de Prague* will always be aware of the presence of the other two sections.

Unlike most "artist's books" Butor has collaborated on, the text, *Dialogue avec CB,* is *not* derived from the *froissages* included in the book, nor do they illustrate his text. Instead, three different sets of collages that are not included and that cannot all now be seen, are the sources. One set of collaborations derives from a Kolář exposition, *"Hommage à Baudelaire"* [*Homage to Baudelaire*].[53] A second set of collaborations is based on Kolář collages now held in private collections. The third set of collaborations consists of a series of Kolář collages published in *Coloquio/Artes* with the accompanying text, there entitled *Le Rêve de Jiří Kolář* [*The Dream of Jiří Kolář*], and elsewhere *Le Rêve des pommes* [*The Dream of the Apples*].[54] The texts of each of the three sets of collaborations are interwoven throughout the *Dialogue avec CB,* forming thus within the overall collage of *L'Oeil de Prague* a collage in the form of Kolář's *rollage multiplié,* in which slices or sections of each appear, disappear, and reappear.

Identification of a given set of collages is facilitated by the form of the text as a whole: the speeches that correspond to each of the three sets of collages are allocated to specific speakers. One additional group of speeches is taken from one of Butor's collaborations with a musician; these also are recited always by the same speaker, though intertwined among those created in collaboration with Kolář. We will examine the speakers and with them the sets of collages each in turn, focusing on segments that are particularly political, often with harmony or humor.

On the first page we learn from a deceptively neat statement that there are eight characters participating in this discussion, each with his attribute, like a painted saint.[55]

> *L'ordonnateur: N'étaient nos attributs: le divan pour le rêveur, le bâton de craie professoral pour l'explicateur, la partition pour le chanteur, l'éventail pour le compositeur, le volume pour le lecteur, la calculatrice pour le combinateur, et pour moi-même l'inévitable magnétophone, nous aurions l'air, tous les huit, de reflets les uns des autres dans un complexe miroir. (9)[56]*

Six Characters

We will examine the speeches of these characters in this order:

The Organizer, who speaks in expository discourse, introduces and describes collages of set 1 and set 2.

The Explicator, Butor the professor, who speaks in expository discourse.

The Combiner, who cites explanatory passages from Butor's *Opusculum Baudelarianum.*[57]

The Reader, who recites Butor's variations on Baudelaire from the *Opusculum.*

The Composer, who recites lines from Butor's *Cent phrases pour l'éventail d'Arnold Schoenberg* [*One Hundred Sentences for the Music-stand of Arnold Schoenberg*].[58]

The Singer, who reads Butor's poems derived from set 2 collages

The Dreamer, who reads *Le Rêve de Jiří Kolář,* based on collages of set 3.

We will also discuss the Letter-Writer, who is not named in the initial list cited above.

Our first concern remains those texts derived from specific collages that display a political force, which are presented by the Organizer and read by the Singer (set 2) and the Dreamer (set 3), but all the speeches of all the characters contribute to the whole. Thus we examine here first the six characters whose speeches do not derive directly from a specific collage, then, the Singer, and finally, the Dreamer.

Organizer and Explicator

The Organizer and Explicator give the impression of real-life conversation, the Organizer clarifying and prompting the Explicator. He also describes some of the collages included in Kolář's *Hommage à Baudelaire* exhibit (referred to here as collage set 1). He introduces the variations on Baudelaire, and gives the signal *"Arrêtons-nous un instant devant"* [Let us stop a moment in front of . . .] before describing the Kolář works of set 2, a phrase altered for Kolář's mobile works to *"On soulève et on découvre"* [One lifts and one uncovers]. These described works of set 2 have all but one provoked Butor poems, which are read by the Singer. The Organizer does not describe the collages from set 3, *Le Rêve de Jiří Kolář,* the bases of the Dreamer's speeches.

Responding to the Organizer's questions, the Explicator speaks as Butor the Professor, telling us of Kolář's artistic evolution as well as of his present work, and crediting Kolář with confirming him (Butor) in his investigations of the *"possibilités plastiques de la lettre"* [plastic possibilities of the letter] (32) and in particular of the very matter letters are written on. This appreciation of paper leads the Explicator to speak of waste in our society, recalling the Hopi god of death who lives in garbage piles. *"Tout ce que nous rejetons va sécréter, décréter notre mort"* [All that we reject will secrete, will ordain our death] (51). However, whenever we manage to save or rescue something, such as scraps of old papers, *"l'avenir est un peu moins sombre pour nous"* [the future is a little less dismal for us] (52).[59] This agreement of Butor and Kolář on the importance of resisting wasteful tendencies in our society is only one of many points of agreement. Further, the Explicator develops a theory justifying Kolář's treatment of women as a liberation, which the Organizer interrupts with the pointed question, *"La femme support et suppôt?* [Woman as support and servant?] (64), and we will see in Butor's poems to what extent his position is in accord with Kolář's. Perhaps the most revealing of the Explicator's speeches, cited earlier regarding the *Guirlande liminaire,* is, *"Tout l'art de Kolář est politique. C'est un art de résistance. Le mien aussi"* [All Kolář's art is political. It is an art of resistance. Mine is too] (34).

Letter-Writer, Combiner, Reader

In the initial statement of the characters present at this conversation, the reader who has counted to eight will have noted that since the speaker with the tape recorder is the Organizer, there are only seven speakers listed. Butor has begun, as he so often does, with a puzzle. The subtitle hints that the missing eighth character is Baudelaire, but when an eighth speaker finally enters the conversation with *"Mon cher ami"* [My dear friend] (14), he is identified only as the Letter-Writer. And then on the next page it is the Combiner who begins reading a different letter, this one addressed to *"Mon cher J.K."* [My dear J.K.] (15); as this letter would reasonably be Butor's reply to the first, the reader concludes that the author of the first, the Letter-Writer, must be Kolář, and not Baudelaire.

The Combiner continues to read fragments of the second letter, *"Mon cher J.K.,"* which explains how, for a text to accompany a Kolář exhibition, Butor manipulated lines from Baudelaire poems and intercalated them with Baudelaire's letter from the first edition of *Spleen.* Is the first letter then Baudelaire's? The question remains unanswered for three more pages, until finally the Explicator names the *Opusculum baudelairianum,* the text Butor wrote for the Kolář exposition, and the Organizer specifies that it is this text that Letter-writer, Combiner and Reader *"distillent"* [distill] (19) here.[60] Thus, the puzzle is resolved: it is after all Baudelaire who is the author of the *"Mon cher ami"* letter. The second letter, *"Mon cher J.K.,"* is Butor's letter to Kolář, and when the Combiner repeats his speech at the end, we will have seen just how Butor's techniques have related to Kolář's (16, 79). All three, the Letter-Writer who is Baudelaire, the Reader of the variations, and the Combiner are closely linked, although their speeches may be widely separated in the text.

But our first impression, that the Letter-Writer was Kolář, remains with us as more fragments of Baudelaire's letter are read, because Kolář could very well have written these thoughts to Butor. In the cited letter Baudelaire refers to the flexibility of the order of the poems as wholes within the *Spleen* collection, a flexibility that Butor has chosen to reflect using individual lines from the poems. This use of Baudelaire's lines is a kind of collaboration, and it is evident the Kolář

works derive also from Baudelaire. Analysis of the Kolář/Baudelaire collaboration falls beyond the scope of this study, except in so far as it is on these collaborative works that Butor based the *Opusculum*.[61] The Butor/Baudelaire collaboration has been thoroughly analyzed in two splendid studies. Barbara Mason's, mentioned above, concludes that the transformed lines are "a haunting, echoing hall of textual mirrors," an image that could aptly be applied to Butor's use of citation elsewhere as well.[62] Although only a line or two of a few variations are found in *Le Rêve des pommes* in *Matière de rêves II* [*Stuff of Dreams II*], Jacques La Mothe includes the *Opusculum* in his comprehensive study of the five volumes of the *Matière de rêves*. He meticulously examines Butor's selection of particular poems and lines, as well as the effects of his arrangement and rearrangement of the citations, displaying samples of the minute changes made in the process (200–208).[63] I do not believe further analysis of this particular collaboration would be fruitful.

However, just how the Kolář collages in the *Hommage à Baudelaire* exposition influenced Butor's creation of the variations still requires attention. In that passage from the *Opusculum* mentioned above spoken twice by the Combiner, Butor explains that *"il s'agissait . . . pour jouer convenablement avec vos images, de soumettre le texte baudelairien à certaines techniques parentes des vôtres* [to play appropriately with your [Kolář's] images, it was a matter of submitting the Baudelairian text to certain techniques related to yours] (16, 79). At least one of these "certain techniques related to yours" is readily seen in Kolář's *rollages*. Just as the original artworks have been sliced up and set in alternating juxtaposition to each other, so Butor has sliced up Baudelaire's poems and juxtaposed the lines to one another in a new order. In both cases the product creates an effect different from that of the original, while still recalling the intensity and atmosphere of the poems or artworks used.

To see how closely Butor's rearrangements of Baudelaire's lines correspond to the strips of images in Kolář's *rollages,* one need only take a quatrain as example:

> *Mère des souvenirs, maîtresse des maîtresses,*
> *Dis-moi, ton coeur parfois s'envole-t-il, Agathe,*
> *O toi, tous mes plaisirs, ô toi, tous mes devoirs,*
> *Loin du noir océan de l'immonde cité?*
>
> (14)[64]

Here only two Baudelaire poems are utilized, *Le Balcon* [*The Balcony*] (in the first and third lines, *Moesta et errabunda* [*Sad and Vagabonding*] in the second and fourth. One can see the alternating arrangements in the Kolář work, *Baudelaire,* described by the Organizer as

one of several, *"des agrandissements en diverses couleurs du fameux portrait de Nadar, combinés soit entre eux, soit avec des portraits de femmes que Baudelaire a pu connaître, ainsi le merveilleux portrait d'une négresse au Louvre"* [for which Kolář had used enlargements in different colors of the famous portrait by Nadar, combined either among each other or else with portraits of women whom Baudelaire could have known, such as the marvelous portrait of a Negress in the Louvre] (26).[65]

The Organizer goes on to describe others among the collages in the exposition: *"Il y avait aussi de grands collages en relief. Celui-ci, intitulé 'le Cygne' montre cet oiseau qui se détache sur un composition en bandes dans lesquelles il y a des portraits de Baudelaire, des portraits de diverses femmes, des lettres du nom de Baudelaire,[66] de la musique, et la tête de la grande Odalisque d'Ingres"* [There were also big collages in relief. This one, entitled *Le Cygne* [*The Swan*] shows the bird standing out on a composition in bands in which there are portraits of Baudelaire, portraits of various women, letters from the name of Baudelaire, some music, and the head of the great Odalisque of Ingres] (26).

A relationship may be seen between this collage in relief, where Kolář's work moves into an additional dimension, and the Butor variations taken from three or four different Baudelaire poems, such as this quatrain that utilizes four poems:

> *Et le vert paradis des amours enfantines*
> *Du passé lumineux recueille tout vestige*
> *Avec l'art d'évoquer les minutes heureuses,*
> *O boucles, ô parfum chargé de nonchaloir!*
>
> (62)[67]

Rereading the originals (and admittedly simplifying them), we find that Butor's rearrangement of the lines results in a conclusion very different from Baudelaire's overwhelming and consistent melancholy. The first line is from *Moesta et errabunda,* in which the question is posed of whether one can ever find again the innocent pleasures of youth, now far away beyond the sea. The second is from *Harmonie du soir,* a poem that suggests that memories of the past do somehow live on. The third is from *Le Balcon,* where the possibility of reliving past happiness in memory is offered, in the midst of nostalgia. The fourth is from *La Chevelure,* [*The Head of Hair*] which tells us with exotic touches that lost happiness can be found in the real-life present. Thus Butor's recombining certainly reflects the past bliss Baudelaire paints so vividly, but brings it resoundingly to us in the present, still alive.

In the original *Opusculum*, each page carried the title of the name of another Baudelaire poem, one of those

Jiří Kolář, *Baudelaire.*

not used in the variations, and these titles are given in *Dialogue avec CB* by the Organizer, providing one more collection of images to blend with the variations of the quatrains. These, the Combiner says, can serve as a *"couronne illuminante que l'on pourrait faire tourner elle aussi"* [illuminating crown which also could be

Jiří Kolář, *Le Cygne* [The Swan].

made to turn]" (56). For example, the Organizer asks for *"votre version du 'Serpent qui danse'"* [your version of the *"Snake who Dances"*] (68); on the next page the Letter-Writer says, *"J'ose vous dédier le serpent tout entier"* [I dare to dedicate to you the whole serpent] (69), and the quatrains on those pages include *"un gouffre interdit"* [a forbidden abyss] (69) and *"paradis innocent plein de plaisirs furtifs"* [a paradise innocent full of furtive pleasures] (68). By reversing the order of Baudelaire's original *"Moesta et errabunda"* from the unusual (*innocent paradis*) back to the normal (*paradis innocent*), Butor gives more emphasis to the idea of "innocence"; we know what the serpent brings to paradise.[68]

Some of these titles serving as "illuminating crown" immediately suggest relationships with Kolář: the *Rêve parisien* [Parisian Dream] could become a *Rêve praguien* [Praguian Dream] (or nightmare!), *Ciel brouillé* [Blurred Sky], Voyage, *Reversibilité* [Reversibility] are the most obvious: indeed, *Reversibilité* even contains the lines:

Et les vagues terreurs de ces affreuses nuits
Qui compriment le coeur comme un papier qu'on froisse

[And the vague terrors of these frightful nights
Which squeeze the heart like a paper which is crumpled]
(46)

Butor has often said that literary criticism should send the reader back to the text under consideration. Reading Baudelaire in conjunction with *The Dialogue avec CB* is inevitable, and at each "turn," as the Combiner said, new vistas are opened.

When the Combiner speaks of the effect of moving rhymes around in the Baudelaire variations, he uses musical terminology: *"éloignant les rimes les unes des autres, transformant en réverbération évasive leur insistance, il modifie leur musique. C'est comme une nouvelle orchestration. C'est bien la même mélodie, mais le timbre sonne tout autrement: notre temps a passé par là"* [distancing the rhymes from each other, transforming their insistance into evasive reverberation, modifies their music. It is like a new orchestration. It is indeed the same melody, but the timbre sounds quite different. Our times have been through that] (48). Butor's knowledge of music allows him to select the precise terms to clarify his analogy. A transposed rhyme indeed has a different effect, not the immediate sound of, for instance, couplets with end rhyme, but is an echo, heard at a different moment, exactly like a reverberation. The timbre of the instrument is just what differentiates performances of the same melody played on a flute and on a violin: the notes are the same, but the sounds are very different, just as Butor says. Baudelaire's melancholy waltzes, organs, and violins are still playing in Butor's variations, but with new sounds. Thus Butor pays tribute to Baudelaire: not all melodies can withstand alteration of timbre. As to what has happened in "our times," great changes in musical composition have certainly occurred, but Butor would have more all-encompassing thoughts in mind as well. He is very aware of the major change that occurred for Paris, for France and for the whole world as a result of World War II. Paris is no longer the center of all culture; France and other imperialist nations are no longer ruling vast empires; the world is differently balanced or off-balanced.[69]

In *Dialogue avec CB*, the original text of the *Opusculum* was altered primarily to allow for all the speakers, but, in addition, the new context provides further illustration of the Combiner's statement about the quatrains, that *"on peut naturellement enchaîner la fin de notre opuscule à son début"* [one can naturally link the end of our 'opuscule' to the beginning] (50). In *Dialogue avec CB*, Butor adds three Baudelaire variations that did not appear in the original nor in the revision in *Répertoire IV*, and obviously not in *Matière de rêves II*, where only one or two lines are used in each

appearance; thus, these variations were created especially for this work.[70] Here they first frame the Letter-Writer's and Combiner's interjections of the salutations from their respective letters. Then the Combiner adds the third new variation after the repetition of the original description from Butor's preface (16) with its reference to submitting *"le texte baudelairien à certaines techniques parentes des vôtres"* [the Baudelairian text to certain techniques akin to yours] (79). Thus, those "certain techniques," common to Kolář and Butor, allow for a virtually infinite creation of new works, not so much in the self-contained circle Baudelaire suggested, but rather as in an endless spiral.[71] Throughout, the Organizer, Combiner, Letter-Writer, and Dreamer all have carefully apportioned turns introducing the Baudelaire variations, but the lines of poetry are always recited by the Reader. The quatrains appear throughout the text, usually in groups of three, about every five pages. Finally, even the Reader falls silent, as only the Composer and the Dreamer speak on the remaining page.

Composer

The Combiner's use of musical terms to explain the effects of shifting rhymes, mentioned above, is far from the only musical reference in *Dialogue avec CB*. The source of the Composer's speeches is the chorus from the opera, *Procès du jeune chien* [*Trial of the Young Dog*] or *Petrus Hebraicus*, written with Henri Pousseur.[72] Early in the *Dialogue avec CB*, the Explicator tells us about the *Cent phrases pour l'éventail d'Arnold Schoenberg* [*One Hundred Sentences for the Music-stand of Arnold Schoenberg*], but does not identify them as the Composer's lines (20).[73] In *Dialogue avec CB* the Composer does not reflect any specific set of Kolář collages, but rather the Kolář *rollage* technique. The *Phrases,* taken from the separate Butor text, are inserted line by line in among the explanations, variations, poems, and even stanzas of the same poem, in the order of the original, just as Kolář puts together his *rollages multipliés.*

These sentences or phrases of the Composer's are all in the form either of a plural future: "they will do" or succinctly modified nouns, as if in the form of memos for a desired utopian community. The community at one point resembles the Jews as they reach the Promised Land: *"Reviendront dans leur patrie quittée depuis toujours"* [They will come back to their homeland left since forever] (#16),[74] but with a definite difference: *"Leurs voies ne seront point les voies du Seigneur"* [Their ways will not at all be those of the Lord] (#40).[75] It is true some of the precepts given are those preached by current religions, but these people in their utopia will

actually follow them: *"Ne tueront pas leurs pères et ceux-ci ne les tueront point"* [They will not kill their fathers, who will not kill them] (#20), and *"Ne s'en voudront plus"* [They will not bear grudges against each other] (#61). If vestiges of the Judeo-Christian tradition remain, they are part of a different system, which would seem close to the Tao in that *"Leur agir et non-agir embellira la nature"* [Their action and non-action will beautify nature] (#45).

These people will appreciate the natural world, the *"Couleur des pierres dans le lit du torrent"* [Color of stones in the torrent's bed] ((#49), and they will be *"Elèves des oiseaux"* [Students of the birds] (#97). True environmentalists, *"Marqueront le monde sans laisser de traces"* [They will mark the world without leaving tracks] (#42). In Butor's marvelous community, *"Ils apprendront à leurs camarades à jouer du piano"* [They will teach their friends to play the piano] (#54)— the greatest gift! Their attitudes are revealing: *"Ils se trouveront toujours un peu bêtes"* [They will always find themselves a little stupid] (#61) and, as they do not know, *"Demanderont ce que c'était qu'une réaction petite-bourgeoise"* [They will ask what a petty bourgeois reaction was] (#59). We will not be surprised to find that *"Art enchaîné ni par savoir ni par devoir"* [Art will be limited neither by knowledge nor duty] (#6). Further, reflecting Butor's concern to break down barriers built by different languages, *"Creuseront la tour de Babel"* [They will hollow out the tower of Babel] (#29), and *"Savants ouvriers bergers parleront tous patois"* [Scholars, workmen and shepherds will all speak patois] (#62). Thus social classes will be leveled through a common language, and it is worthy of note that the libretto of the opera already takes a step in that direction, written in both German and French.

The interweaving of the Composer's ideal community or world with the other voices is as complex as that of any musical composition. This voice could be heard as a ground bass, continuing throughout, holding all the other voices together. It would be a highly developed ground bass with its own fundamental message.

Here I will, with regret, limit my discussion of the Composer to the first poem, *Le Page* [*The Pageboy*], and later to the poems *Résistance* and *"Ballade des froissements du monde"* [*Ballad of the Crumplings of the World*]. However, random choice of any one of the statements will show the force of this voice as it relates to the surrounding texts. More than once Butor attaches handwritten copies of the Composer's speeches, not initially written in collaboration with Kolář, to Kolář collages, as we will see. The paradise created in the *Phrases* certainly has political force, certainly is poetic, and even is, in its own way, humorous.

The Singer

The operatic statements of the Composer, the Baudelarian voices of Letter-Writer, Combiner, and Reader, and the explanatory conversation between Organizer and Explicator continue throughout *Dialogue avec CB*. The next speaker to be examined here is the Singer, whose texts derive from the Kolář collages of set 2. His function is to recite Butor's poems, collaborations that were written in conjunction with the Kolář works described here by the Organizer, in more or less detail.[76] Examination of the sources in the set 2 collages for this group of poems poses a particular challenge, as only one of the artworks can be reproduced here, plus a reproduction of the source of one line of the *Ballade des froissements du monde*. Fuzzy reproductions of two other artworks exist, but collapsed to two dimensions, unlike the mobiles of the original.[77]

Therefore, in this section we will examine first the poem for which we can see the corresponding collage. With all the poems we will consider structure and harmony, but with this one it is possible to enter more deeply into the details of the collaboration than with those whose collages we cannot actually see.[78] This poem speaks to Butor's and Kolář's political concerns, and, as it happens, portrays a woman unsympathetically. However, the political treatment of women does not stop here: six other poems present women in as many different lights, and we will examine three of them, bringing out the identified artworks as sources, with mention of the harmony as appropriate. We will next examine three other poems of a wider political nature, following the same approach. Finally, we will look at a poem exemplifying the humorous, the only one generated by this set of collages.

Le Page [The Pageboy]

The Organizer presents the first collaboration and the Singer recites Butor's texts, interrupted by the Composer:

L'ordonnateur: Arrêtons-nous un instant devant cette "Femme à sa toilette" de Giovanni Bellini au musée de Vienne, sur laquelle se balancent, suspendues par des ficelles, une carte représentant une montre sur le cadran de laquelle les heures sont remplacées par les emplois suivants:
Le chanteur.
 1. Le baladin,
 2. Le page,
 3. Le peintre,
 4. Le gondolier,
 5. L'horloger,
 6. Le marchand,

Le compositeur. Plus de maladie nécessaire.
Le chanteur.
> 7. *Le médecin,*
> 8. *Le juge,*
> 9. *Le condottiere,*
> 10. *Le banquier,*
> 11. *Le patriarche,*
> 12. *Le doge,*

L'ordonnateur. Et une carte postale américaine humor-
istique ancienne représentant deux énormes oranges sur
un wagon, avec un petit garçon en salopette, burette à la
main, pour donner l'échelle, au verso desquelles on peut
lire cette chanson intitulée "le Page":
> *Le chanteur.*

> *C'est moi qui apporte à Madame*
> *Le jus d'oranges du matin*
> *C'est moi qui nettoie pour Madame*
> *Les voitures de ses visites*

> *C'est moi qui avertis Madame*
> *Des rendez-vous de ses amants*
> *Et lui signale entre les heures*
> *Les appétits de ses enfants*

> *C'est moi qui retrouve Madame*
> *Après ses entreteins du jour*
> *Nous venons de même roulotte*
> *Je croyais que j'étais son fils*

> *Mais je ne sais plus qu'en penser*
> *Lorsqu'elle me serre en ses bras*
> *Et me donne un dernier baiser*
> *Avant d'aller à sa parure*

(12–24)[79]

The structure of the poem, in octosyllabic quatrains, is that of the majority of the poems derived from set 2. The pattern of repetition of *"C'est moi qui . . . Madame"* will be found with variations in six other poems, the other twelve being constructed on matrices varying from the very simple to the very complex. The harmonies of *Le Page* are less obvious than in other poems, many of which contain overwhelming contrast between hard and soft sounds. Here the little page sings his gentle song filled with *m*'s, in almost exclusively soft sounds, including rhymes (*amants/enfants, mais/sais, penser/baiser*), the final [y] of *parure* reechoing those of the first stanza (*jus, voitures*). *Le Page* is the only one of the poems with a suggestion of narrative: time passes in Madame's activities, *after* visits and *before* going to dress, and the child's former belief, in the past tense, is succeeded by his present confusion: he "no longer" understands.

Our reproduction of this collage is taken from the exposition, *Passage de Butor II* [Butor's Passing II] and the three-dimensional aspect is lost, as the cards originally suspended by strings are attached one on top of the other, obscuring the clock face and its list of occupa-

tions.[80] The Organizer does not mention the banderolles here, saying only later that the Composer's speeches, the *Phrases,* have been used "in many others of these objects in collaboration with Kolář" (*dans bien d'autres de ces objets en collaboration avec Kolář*) (20). The phrases inscribed on the banderolles in our reproduction certainly relate to this text, particularly to the occupations on the clockfaces. The intercollage in one of the oranges is also not mentioned by the Organizer, but it figures in the collaboration through association with the clockfaces, suggesting that the social situation in Bellini's Venice and in the little boy's world is timeless and continues to the present and beyond.

Butor has drawn from the collage the contrast between the plain little boy in his overalls and the elegant Bellini beauty. Even crumpled, she still has her mirrors and letter, presumably from a suitor; her luminous world is totally removed from that of the child on the railroad flatcar in his glaring artificial scene, created by trick photography. He stands, in his old-fashioned hat, so small, between the giant orange and the threatening futuristic horrors of the other orange, unable to bridge the gap between the silly commercialized postcard and the ageless Venetian beauty. The orange of the collage appears in Madame's orange juice in the poem, but the relationship between the pageboy and his mistress is Butor's invention, as is the reminder of the child's uncertain future, since he has already evolved and "no longer" knows: he will inevitably grow up, and then what? We are left feeling very sorry for the little boy on the postcard, the Pageboy of the poem, unable to understand the vain woman of the poem and painting, who is not his mother, in her self-indulgent world. Society, in both his world and hers, is made up of oppressors and oppressed.

Of the occupations Butor has written on the clockface, only *"-hand"* and *"-in,"* the last syllables of *"marchand"* and *"médecin"* [merchant and doctor] are visible behind the postcard in our reproduction. The two sets of six echo in all directions. The first set are ordinary people, the powerless, including the painter (of course), the gondolier of Kolář's and Bellini's Venice, the clockmaker appropriate not only to this clockface but also to Kolář's frequent use of them, and the pageboy himself. The second set are the powerful: including another Venetian reference, the Doge, the patriarch, always suggestive of the repression of women, and the banker, a preferred object of Butor's attacks, and probably linked to Kolář's use of currency, especially antique and devaluated, as we will see later.

The *Phrases* of the banderolles are closely related to the poem. Just before the passage cited here, the Composer has recited a *Phrase* the Pageboy would find

Jiří Kolář, *Le Page* **[The Pageboy].**

comforting: *"Enfants, la mère ne vous dérobera plus le sein"* [Children, the mother will no longer take her breast from you] (#9) (11). Then, the Composer's interruption, *"Plus de maladie nécessaire"* [No more illness necessary] (#10) (12) leads directly to the doctor. The visible *Phrases* on the banderolles are particularly peaceful, evoking a world preserved from destruction, without anger, without schisms caused by social, religious or other differences. The banderolles are also inscribed on the back, as we can see. A part can be seen, *"res du malade"* from *"Frères du malade and du criminel"* [Brothers of the sick and the criminal] (#34), and as they follow the sequence used throughout *Dialogue avec CB,* we can deduce that the next sentence would be a direct recall of one of the occupations listed on the clockface: *"Les juges se laisseront juger"* [Judges will allow themselves to be judged] (#35). Then, after *"Plus outre"* [Further] (#36), standing alone emphatically, appears *"Personne esclave de personne"* [No one the slave of anyone] (#37). Viewers able to manipulate the *ventillage* at the expositions would have seen those phrases on the back of the banderolles.[81]

Thus with the simple words of the poem, the occupations listed on the clockfaces, and the superimposed messages of the banderolles, Butor has collaborated with the spirit of Kolář's collage. The little boy waits on the lady hand and foot—this lady who even requires a reminder of the needs of her own children—but is unsure of his relationship with her. His harmonious song is unresentful, uncomplaining; it is the reader/viewer who

recognizes the need for societal change, as in the banderolle statement, "No one slave to anyone."

Views on Women

Within *Dialogue avec CB* a number of poems reveal Butor's views on women, three of which we will examine here. We must first note, however, the poem conspicuous by its absence. Only one of the Kolář collages described by the Explicator, *Hommage à Bela Kolářova* [*Homage to Bela Kolářova*], did not move Butor to create a poem in collaboration. Discussing Kolář as a *"sculpteur de nature morte"* [sculptor of still lives], the Explicator tells us of Kolář's use of objects to create *"natures mortes dans l'espace"* [still lives in space], in this case an *"ensemble de couvercles de casseroles"* [collection of saucepan covers]; *"les objets sont aimés d'une façon nouvelle par ce vêtement d'écrits et d'images qui les caresse, les protège, les célèbre, en particulier les objets ménagers, ceux qui étaient et sont encore dans une large mesure l'empire des femmes"* [the objects are loved in a new way by this clothing of writings and images which caresses, protects and celebrates them, in particular household objects, those which were and still are to a large extent the empire of women] (63). Of course, Kolář's offering any kind of homage to his wife already shows him to be advanced beyond ordinary husbands, which Butor appreciates: his recognition of the norm lies in the phrase, "were and still are to a large extent." However, the Organizer does pose the question, *"La femme support et suppôt?"* [Woman as support and servant?] (64), which the Explicator does not answer, continuing instead by drawing a parallel between liberation of women and liberation of the artist from the constraints of the page: *"Ce sont les chaînes et voiles de la femme que les objets se mettent à condenser, tels des filtres qui purifieraient l'atmosphère. Une nudité neuve attend notre baiser"* [It is the chains and veils of women which objects begin to condense, like filters purifying the atmosphere. A new nudity awaits our kiss] (64). But, even though Butor is entirely in sympathy with Kolář's efforts to liberate the artist, offering homage to his wife with saucepan lids would not be his way. In Butor's works the appearances of Marie-Jo's persona are as a whole person, not at all relegated to the partial and subordinate.[82] His hommages to her run throughout his work and are absolutely not limited to her kitchen skills. In answer to the Organizer's question, women may serve as supports, but not as servants.

The *Homage à Bela Kolářovna* saucepan cover collage is, then, the only collage described in *Dialogue avec CB* that did not generate a collaborative poem, and

we can see why. We will now look at three collaborations treating the political issue of the status of women.

WOMEN IN RELATIONSHIPS OF LOVING EQUALITY

One of Kolář's three-dimensional artworks, *Astre des Nuits* [*Star of the Nights*], inspired Butor to add two lines of text and an American Indian legend recounted (or invented) by Chateaubriand,[83] and this minimal contribution turns the unhappy lovers of the artwork into a loving couple (67–68). Here we look at an example which the Organizer describes as *"Le diptyque des portraits de Piero della Francesca, visages de profil remplacés par des oeuvres cubistes évidées ellesmêmes pour ce "Dialogue"* [The diptych of the portraits of Piero della Francesca, faces in profile replaced by cubist works themselves emptied out for this "Dialogue"] (65). This work would be Piero della Francesca's *Triumphal Diptych of Federico II de Montefeltro and Battista Sforza* in the Uffizi.[84] The subjects of the diptych are in profile, facing each other, but they do not appear to be engaging in dialogue, perhaps not really looking at each other. It is the stanzas of Butor's poem that create the dialogue; the stanzas here are set opposite to bring out the repetitions:

DIALOGUE

Je vois tes yeux	*Je vois tes yeux*
Ton horizon	*Tes cheveux*
Ton sommeil	*Tes boucles d'oreille*
Tes soucis	*Tes soupirs*
Ton sourire	*Ton horizon*
Ton fleuve	*Tes remparts*
Ta respiration	*Tes seins*
Je vois ton coeur	*Je vois ton coeur*
Où je me vois	*Où je me vois*

(65)[85]

The woman speaks in the first stanza, the man in the second, both using terms more appropriate to a landscape than a person, clearly reflecting the river and ramparts of the diptych. Beyond the repetition of the first and last lines, "Your horizon" appears in both stanzas, and both stanzas are filled with sibilants. Although Sforza's earrings do not appear in the original, the hair ornament fastening the elegant chignon coiled over her ear could have inspired that reference. While Butor looked at the collage, he still saw the original diptych in his mind; it may be that Kolář's cubist replacements prompted him to convert Federico and Sforza, despite their ceremonial appearance and expressionless eyes, into a loving couple, who could murmur his love poem to each other. Through its repetitions and echos the poem is a very clear statement of the equality of the two people who love each other.

WOMEN TRAPPED IN MEANINGLESSNESS

Two poems portray women's lives as empty and oppressed, the one sarcastically entitled, *Le Calendrier des réjouissantes* [*The Calendar of the Rejoicing Women*] (53–54), and the other, which we examine here, *Toilette nocturne* [*Nocturnal Toilette*] (20).

The Organizer describes the artwork as a *"très grand collage mobile"* [very large mobile collage], thus a *ventillage*. To one side of two photos of nudes Kolář hung a nineteenth-century fashion engraving made into a *rollage,* and to the other an old toy shop advertisement, pages of records from defunct businesses, and some tiny keys. It is on the backs of the business records that Butor wrote the stanzas of the poem. On the backs of the nudes, the Explicator tells us, are written bits of the text spoken in *Dialogue avec CB* by the Dreamer.[86] The Explicator says also that he, Butor, added to the collage two fans, with some of the *Cent phrases pour . . . Arnold Schoenberg* written on the backs.[87]

The fans themselves Butor made from the plates of *Musique de chambre noire* [*Music of the Dark Room*].[88] Butor's introductory paragraph explains:

> *Pour explorer les possibilités plastiques des nouvelles photocopieuses imprimantes, dont le traitement prévu devait profondément transformer la matière, des objets familiers produisant des figures vides parfaitement identifiables: brosse à dents, pelote de laine, mètre de charpentier, tube de colle, cuiller, pince, paire de ciseaux, gant de jardinier, etc., avec des transparences parfois, des niches à texte où j'ai fait sinuer mes phrases comme des fourmis dans leurs galeries, m'efforçant d'extraire des trésors de couleurs de ces amphores de blanc enfouies dans l'ombre."* (*Envois 2: Exprès* 37)[89]

In addition to cracked rough-textured concrete backgrounds, there are also backgrounds made up of rows of repeated letters of the alphabet or of numbers, against which the various domestic objects stand out in white silhouette. In these white spaces Butor printed participial phrases, e.g., *"La découpure des verres traversant l'accompagnement du souvenir"* [The cutting of glasses crossing the accompaniment of memory], *"L'instrument poursuivant le sillage des découpures et des échos"* [The instrument pursuing the furrow of the cuttings and the echoes].[90] The Organizer told us in his description of the collage of *Toilette nocturne* that Kolář had cut away in the photos of the two nudes *"une pleine lune et un croissant dont le blanc reste intact"* [a full moon and a crescent whose white remains intact] (19), and those celestial white forms contrastingly recall the everyday objects shown in the same technique in *Musique de chambre noire.* For these fans for *Toilette noc-*

turne Butor probably selected images from *Musique* in accord with this poem, those representing traditional activities of women: tableware, ribbons, clothespins, rather than the wristwatch, toothbrush, or revolver also found in *Musique.*

The Organizer told us the *rollage* of the nineteenth century fashion engraving was constructed by being *"découpée en petits carrés et recomposée"* [cut up in little squares and recomposed] (19), recalling the "cutting" cited above from the *Musique* texts. This technique frequently used by Kolář[91] can be seen as Butor cuts up and rearranges the elements of his poem from one stanza to the next, as if each word or phrase were a "little square," each stanza becoming a new "recomposition."

TOILETTE NOCTURNE

Les dames se déshabillent
Dans le miroir de la Lune
Et vont chercher la clef des nuages
Au magasin des jouets d'hiver

La Lune se déshabille
Dans le magasin des nuages
Va chercher la clef des miroirs
Parmi les jouets des dames de l'hiver

Les nuages se déshabillent
Dans le miroir des jouets d'hiver
Et vont chercher la clef des dames
Dans les magasins de la Lune

Les miroirs se déshabillent
Dans les nuages des jouets des dames
Vont chercher la clef de la Lune
Dans les magasins de l'hiver

(20)[92]

The women, the fashions, the moon, the key and the toy store all derive directly from the Kolář *ventillage.* In addition, the new arrangement of each stanza reflects its mobile nature; the elements of the text move around one another just as the figures would have done. Those variations are the essence of the poem: the repetition of "undresses" and "go(es) to seek" in the first and third lines is stable throughout, and the second and fourth lines maintain their basic structure while the elements around those phrases move constantly. The variance in meter is restrained, primarily seven-, eight-, and nine-syllable lines throughout. ("Of winter" becomes "of the winter" without regard for regularity in the meter.) The harmony is also restrained: all are soft sounds with the exception of the hard [k] and *g* in *"clef"* and *"magasins."* The final two lines concentrate the *l*'s, five of them. The whole is gentle and peaceful, effortlessly creating flickering images.

And yet, what are the ladies associated with? Undressing, mirrors, and toys, as well as the Moon ("th' inconstant moon that monthly changes in her circled orb"). Repetitive, meaningless, stupefying movement beautiful as the poem may be, and it is, the representation of the ladies is of trapped automata.

WOMEN EMPOWERED

A very different image of women appears in *Confessions d'hiver* [*Confessions of Winter*] (67), where a furious de Kooning *Woman* combined with Arcimboldo's *Winter* and a background of text from Rousseau's *Confessions* suggests that egotistical abusers of women will live to regret their actions. Then in *La Reine des neiges* [*The Queen of Snows*] (66), which we examine here, the female figure takes us beyond economic, environmental and emotional ruin to the end of the world:

LA REINE DES NEIGES

Sur un lit de destructions
L'olympienne se détend
A son cou une perle de foudre
A ses pieds des mules de laves
Son regard s'est noyé dans les incendies
Tout cette angoisse deviendra nacre pour ses ongles

Sur un nuage de fin du monde
La délicieuse prend ses aises
Née de l'écume de l'Histoire
Duvet de supplices bracelet de plaies
Pour son sourire que de cités
Nous distillerions dans la catastrophe
Reposer un instant la tête au creux qu'elle cache

Sur la fureur des anciens
La toute-neuve étend son ivoire
Les remparts deviennent marées les empires torrents
Dans le gouffre entre ses jambes s'effondrent les
* mensonges*
Alambic de l'apocalypse la Terre se change

(66)[93]

The Organizer describes the collage only as the Manet *Olympia* and *"une grande tempête romantique"* [a great romantic storm]. A reproduction of this collage was printed in *Métaphores,*[94] but its quality does not permit discernment of details. Olympia's head is obscured down to the nose, irregular spaces blanked out around her for Butor to write in the three stanzas. The background may well be a landscape: sharp edges, perhaps cliffs, are surrounded by swirls.

The stanzas are of unequal numbers of primarily octosyllabic lines; in *Dialogue avec CB* longer lines are set flush left, and thus the first two stanzas have the same shape. In the third stanza, the first three lines reflect that shape, including an eight plus five–syllable line, as in the last lines of the first two stanzas, but with two additional longer lines. The words at the lines' ends consequently stand out: "fingernails," "hides," and in the last stanza, "torrents," "the lies," and finally, "is changing," a brief summary of the whole.

The play of the harmonies is complex. The many soothing *l*s and neutral *d*s of the first two stanzas are replaced by forceful *f*'s in the third; [k]'s and hard [g]'s maintain throughout, but the [k]'s of stanza two are alliterative (*creux qu'elle cache*) and recalled in stanza three by the final [k] of the important word, *"alembic."* The repeated soft vowel sound of the first stanza [u] (*cou, foudre*) reappears in the others (*sourire, toute/gouffre*), and the [y] of the first stanza's *"mules"* is used three times in the second (*nuage, écume, duvet*) and even once in the third (*fureur*). The nasal [ã] is present throughout, no fewer than eight times in the third stanza without counting the prepositions, *"dans"* and *"entre."* The last line illustrates clearly the contrasts: *"alambic de l'apocalypse"* with its repeated front *a*'s, labials and sharp *i*'s, ending with *"la Terre se change,"* all of soft sounds and including one final nasal [ã]. The whole is unified by this use of sounds: *"noyé"* and *"angoisse"* in the first stanza are echoed by *"ivoire"* in the third. Nasal *o* sounds a knell from *"destructions"* through *"ongles"* and *"distillerions"* to, finally, *"s'effondrent"* and *"mensonges."*

Juxtaposed to the "great romantic storm" (which could have provoked the snow of the title), Olympia has become a female Jupiter, calmly observing the destruction of everything. Butor has transformed details from Manet's painting: her neck ribbon and slippers have become Jupiter's thunder and lava. Manet's cushions have become a "coverlet," and Butor in his choice of the word *duvet* specifies a luxurious goosedown comforter, set in unlikely juxtaposition with "tortures," while Manet's bracelet is just as inappropriately applied to "wounds." It is certain those suffering in the world can expect no relief from this queen. She is associated with Venus but born of the foam of History, rather than of the sea. For a moment's rest on that hollow hidden by the modestly posed hand of the painting, we, that is, we men—Menelaus, for example—would condemn cities to destruction. Like the Olympia of the painting, cold as ice, so in the poem she is totally unmoved. Her bed is of destruction, the blank space Kolář has created, but she also is seen as stretching her ivory self, the "brand-new" over "the fury of the ancients." If this "fury" is read as a reference to the uproar Manet's painting provoked, the "brand-new" becomes a new way of conceiving of art, an essential and positive way, since through it the lies

disappear. The Earth can only change for the better when there are no more lies.

Whether or not an allusion to Manet and new art is seen, the development of the poem is from natural disasters (observed but not necessarily caused by the figure) through the empires, specifically the selfish work of mankind, to the Apocalypse. How "the gulf between her legs" is to effectuate this is a mystery, since we do know that only in dreams do men clamber successfully back into the womb, but it is through the distillery of this figure that lying is to stop and the Earth change. Following the poem, the Composer says *"Hardis en lumière"* [Daring in the light] (#76), and it is outside the womb, born and alive, that, after the Apocalypse, survivors will find a better world.

This end-of-the-world vision found in the form of a woman might at first suggest that Butor sees women as the conventional evil of Eden, but nothing could be further from the truth. That the figure in this poem is cold and calm about the end of the world should be seen in conjunction with the state of the world. Changing it for the better cannot be done painlessly—and the acceptance of Manet's new direction in art was fraught with turmoil—but the quest for truth is the end that must be pursued regardless of the "anguish." Butor's using Kolář's (and Manet's) female figure to this end must not be seen as antifeminist. Quite the contrary. The poems included in this work show clearly Butor's concern for the status of women. We have seen in *Dialogue* a happy relationship based on mutually recognized equality, then in *Toilette Nocturne* women trapped by society in meaningless lives, and finally *La Reine des neiges* portrays a woman in control, the conduit to a better world, no matter how painful the path may be. Butor's works stand as evidence of his seeing women as living beings in the world along with all the others, the men and the animals, no better and no worse.

Views on Society

We will consider three poems, one of which is very brief, and the other two quite extensive, all illustrations of the political in this set of collaborations.

ARTICULATIONS

The political force is relatively subtle in *Articulations,* the first of five short poems whose corresponding artworks are described by the Organizer as *"pendules et montres, une véritable vitrine d'horloger, avec leurs cadrans diversement transformés, leurs cadrans qui parlent"* [clocks and watches, a veritable clockmaker's shopwindow, with their dials transformed in different ways, their dials which speak] (58). The poem is com-

posed of two twelve-line stanzas of primarily five-syllable lines. In *Dialogue avec CB,* the stanzas are set in sequence, but if they are set opposite one another, one sees clearly the relationships in harmony, rhyme, and meaning:

ARTICULATIONS

STANZA 1	STANZA 2
Le temps des insectes	*Le temps des rumeurs*
Sonne dans les prés	*Gèle dans l'hiver*
Rumeurs des élytres	*Valse des élites*
Bourdonnements ronds	*Grognements des freins*
Les métamorphoses	*Les métamorphoses*
Au gré des saisons	*Au fil des salons*
Les générations	*Les révolutions*
Du matin au soir	*Du soir au matin*
Les métaux polis	*Les métaux rouillés*
Des harnachements	*Des arrachements*
Qui se brisent	*Qui s'enflamment*
Dans la poussière	*Dans la misère*

(58)[95]

The soft "buzzings" of stanza 1 are in sharp contrast with the harsh "growlings" of stanza 2. The contrasts in sound and meaning continue as the clocks tick. The same line in each, "The metamorphoses" emphasizes the difference between "at the will of the seasons," the normal insect lifetimes,[96] and the "drifting through salons," the purposeless lives of the elite. The one leads, in accord with nature, to reproduction of the species, the other to revolution, with at least the two meanings of the physical revolving of the waltz and of course the political. The superrich rhyme in *"harnachments"* and *"arrachements"* continues the contrast between on the one hand uniting and on the other separating. The natural activity of the insects leads calmly to dust, to which we all return, while—and the contrast is emphasized by the rhyme (*poussière, misère*)— the elite dance on through rust and flames to misery.

Before examining the next poem, *Résistance,* (35–36), it is important to point out again that the contributions of the other speakers are carefully intercalated among the descriptions of Kolář works and the accompanying Butor poems. Thus, it is just before *Résistance* that the Explicator makes the statement cited earlier, "All Kolář's art is political. It is an art of resistance. Mine is, too" (34). The placement of the Explicator's speech is deliberate. Throughout, the speeches of other characters run, inevitably influencing our reading of the whole, but we are still unraveling the tapestry and must not be tempted to weave it back too soon.

RÉSISTANCE

In this example, each element mentioned by the Organizer is reflected in the poem. He describes the Kolář work as *"une basse pyramide d'images"* [a low pyramid of images] in six layers, a combination of the

stratified and *ventillage* techniques. Briefly, the elements are:

a Cranach Venus, set in a velvet coat;
a dead World War I French soldier, set in a devaluated 1000-mark bill;
a nude woman embracing a nude male corpse, set in a beer can;
rectangles in a mosaic of celestial maps and one terrestrial map, surrounding a band inscribed *"Résistance"*;
greeting cards, one from Henriot champagne, printed in Vienna during the Austro-Hungarian empire;
landscape from the *Très riches heures du duc de Berry* set against texts in German Gothic script.

<div align="center">

RÉSISTANCE

</div>

Un champagne qu'on ne nous servira pas
Mais dont nous connaîtrons toutes les bulles
Une ivresse que nous ne subirons pas
Mais dont nous étudierons toutes les vapeurs

Un manteau que nous n'enfilerons pas
Mais dont nous caresserons tous les velours
Une gaze que nous ne soulèverons pas
Mais dont nous baiserons tous les replis

Un billet de banque qu'on ne nous changera pas
Mais dont nous démêlerons toutes les lianes
Un pays où l'on ne nous invitera pas
Mais dont nous visiterons toutes les tombes

Un soldat qui ne se relèvera pas
Mais dont nous enregistrerons tous les gémissements
Un massacre que nous n'empêcherons pas
Mais dont nous ensevelirons tous les cadavres

Un ciel où nous n'irons pas
Mais dont nous imaginerons tous les sphères
Un âge où nous ne reviendrons pas
Mais dont nous distillerons tous les parfums

Un titre que nous n'expliquerons pas
Mais dont vous développerez tous les sens

(35–36)[97]

The regularity of the structure of the poem, the couplets made up of one line of a noun qualified by a relative clause in the negative, followed by the second line with "But of which/whose," is strongly emphasized by the repetition of "not" and "all." These repetitions of "all" (*tous/toutes*) together with the "we, us" (*nous*) provide a large number of soft [u]s, which occur also in "velvets" (*velours*) and "will lift" (*soulèverons*) and finally in "you" (*vous*) of the last line. This underpinning of the same soft sound is bolstered by the *r*'s, integral part of the future tense, and their repeated ending in nasal *o*'s, which creates the effect of a tolling bell. Other recurrent

sounds are almost exclusively soft, and thus the front *as* and [k]'s of "massacre" and "corpses" (*cadavres*) stand out all the more distinctly. In this same stanza, the third, the length of the lines (ten, eleven and twelve syllables) is expanded for the only time by a syllable, as we "record" the "groans" of the dying soldier. The first line of the following stanza is in contrast noticeably short, only seven syllables: "we" can have little to say about this "sky, where we will not go"—even though by 1983, the original publication date of this work, fourteen years have passed since the walk on the moon; though some have been there, "we" can only imagine.

The sources of the various elements that "we" addresses in the poem are, as indicated, seen in the collage. A very indistinct two-page reproduction in *Metaphores* shows some of these, arranged overlapping one another on a flat surface with some of the strings visible, but with no attempt to re-create the original. There are two cards, with *Résistance* hand-printed by Butor above an abstract pattern. The maps mentioned by the Organizer could be the unidentifiable background of the whole. The quality of the reproduction limits precise identification, but a card with the first two lines of the poem, "A champagne . . . we will know" and another with all four lines of the next stanza, "A coat . . . we will kiss," all in Butor's handwriting, can be made out. The thousand-mark note appears twice, with a fuzzy image on it that could be the World War I soldier mentioned by the Organizer. The beer can appears twice, once showing a bare arm, which could be that of one of the nudes. The greeting card which we are told *"avait de fortes chances d'être complètement cachée par les précédentes"* [ran a good chance of being completely hidden by the preceding ones] (34) is indeed hidden, because the fragment of a card (or drawing) that is visible shows a gentleman in dinner clothes against a background of drawing-room chair or set table with a cloth, and thus is more probably the champagne card. The Cranach Venus, inset in what looks more like a T-shirt than a "coat," is in an Odalisque pose, with a necklace. She could be one of the "Quellnymphes" (nymph of the fountain or spring).[98] Parts of a page of text appear, in German, *"schaft & Arbeit"* and a few other words can just be made out, but not in Gothic script, and thus probably post–World War II.

The "landscape from the *Très riches heures du Duc de Berry"* is positively identifiable. It is November, the background of tree trunks clearly recognizable, as is the body and head of the peasant, although Kolář has trimmed off his legs and his right hand, the one holding a stick to throw into the trees to knock down acorns. With the aid of the original we can identify curving lines on the right in the collage as pigs, eating the acorns. The Organizer told us we could see bits of this piece from

the beginning, and that it was set in *"une bouteille d'or sur fond d'or déchiré"* [a gold bottle against a torn gold background] (34), which reflects the gold of the *Très riches heures* and suggests the champagne of both collage and poem. The peasant is hard at work, with determined expression, preparing for the vigorous throw of the stick. He is not served champagne either.

Regularly, after each stanza appears a line from the Composer: *"Mithridatisés des discours"* [Innoculated against speeches] (#32), *"Forçant leurs forces"* [Straining their forces] (#33), *"Frères du malade et du criminel"* [Brothers of the sick and of the criminal] (#34), *"Les juges se laisseront juger"* [The judges will allow themselves to be judged] (#35), and preceding the final couplet, *"Plus outre"* [Further] (#36). We will remember seeing some of these *Phrases* earlier on the banderolles of the *Le Page* collage, where we needed to deduce them from fragments since we could not physically manipulate the banderolles to see their backs. Here the critical last statement is not hidden away, but stands out on the next page: *"Personne esclave de personne"* [No one the slave of anyone] (#37) (37).[99] The Composer's interruptions pointedly underline the message of the poem, that the promises of politicians have not achieved social justice, and thus the people will force themselves on to help those in need, further and further until equality is reached. In the futures of the poem "they" will continue to oppress "us," and the poem rehearses the luxuries that we will not enjoy contrasted with the images of "massacres" and "corpses," and if the dead soldier recalls all the wars of this century, the "massacre which we will not prevent" surely brings vividly to mind the slaughter now so frequent as to have generated the word "genocide." Butor has called our times *"cette horrible fin de siècle"* [this horrible turn of the century].[100] The call to "you" at the end is to all who suffer rather than profit from the wars and injustices of society: we are exhorted to understand and to support this unfurled banner of resistance.

BALLADE DES FROISSEMENTS DU MONDE

Our last example of the "political" in poems derived from the collages of set 2 is the longest of the Singer's poems, The history of its creation is particularly intriguing. The headnote to its previous publication (*Envois 2: Exprès* 11–13) is divided in the *Dialogue avec CB,* with miniscule variants, between the Explicator and Organizer. The Explicator introduces the poem by telling us that when Kolář began to make relief collages, *"J'ai adjoint à certaines de ces sculptures légères de longues bandes de papier calque les traversant, les enjambant, les escaladant ou ceinturant, phylactères sur lesquel j'ai inscrit les paroles qui me semblaient*

Jiří Kolář, Three Kolář *froissages.*

monter de ces métamorophoses" [I fastened to some of these light-weight sculptures long bands of tracing paper, crossing, stepping over, climbing up them or girdling them, phylacteries on which I inscribed words which seemed to me to rise from these metamorphoses] (71). A catalogue of a 1999 exposition includes a page with reproductions of three of these Kolář relief collages, with the attached bands of text.[101]

The second of these, on a contemporary abstract artwork, crumpled, carries the line *"J'entends l'envol des chevelures dans le temps qui passe"* [I hear the flight of locks of hair in time which passes], which appears in Stanza 1 of the *Ballade*. In a note to the author Butor states, *"Les textes ont été écrits spécialement pour ces froissages en relief. Il devait y en avoir une trentaine en tout. 15 pour lui, 15 pour moi. Il m'en reste 7. . . . C'est avec ces textes que j'ai fabriqué la Ballade des froissements du monde"* [the texts were written especially for these froissages in relief. There were to have been about thirty altogether, 15 for him, 15 for me. I still have 7. It is with these texts that I put together the *Ballad of the Crumplings of the World*].[102] In the *Dialogue avec CB* the Organizer continues, that

for the larger sculptures there were two bands, the Explicator then specifying, "One for the sound, one for the perfume" (*Une pour la sonorité, l'autre pour le parfum*) (72). In the same note to me, Butor cites one of these sets of two bands: *"J'entends la guitare des bistrots parisiens au tournant du siècle/ Je sens les absinthes et les thé la sciure et le tabac d'orient"* [I hear the guitar of the Parisian bistrots at the turn of the century/ I smell the absinths and the teas the sawdust and the oriental tobacco]. These two lines appear respectively in stanza 1 and tercet 1 of the *Ballade*.

Thus the Explicator's words take on new meaning, that *"on reconnaîtra au passage des strophes"* [one will recognize as the stanzas go by] (72) Ernst's *Napoleon in the Desert*, Veronese's *Venus and Mars*, Grünewald's *Temptation*, Breughel's *Mad Meg* as well as works of two other artists, Mucha and Canaletto, for we can see that each artwork would have generated a line or several lines of text. The poem as a unified whole, with its divisions into quatrains of "I hear" and tercets of "I smell," its movement and its message in many more lines than the "une trentaine" [about thirty], Butor mentioned, thus was developed and organized from this disparate collection. The abstract of wavy lines shown in the catalogue set above is one of the Explicator's *"d'autres spores de la forêt de reproductions"* [other spores from the forest of reproductions] (72), which he tells us also figure in the poem. The other two *froissages* reproduced in the exposition catalogue, the Dutch genre scene and the Wild West poster, with their lines of text, did not make the cut for the *Ballade*.[103]

BALLADE DES FROISSEMENTS DU MONDE

J'entends le roucoulement de la mer à l'oreille des
 rochers nus
J'entends l'envol des chevelures dans le temps qui
 passe
J'entends la guitare des bistrots parisiens au tournant
 du siècle
Et le galop d'un cheval emballé dans l'avenue
 d'automne

 Je sens les absinthes et les thés la sciure et le tabac
 d'Orient
 Avec le sillage d'une dame à voilette et châle de
 plumes
 Dans les sillons des vieux papiers qui lèvent

J'entends les ébranlements des grands fonds qui nous
 engloutiront dans leurs tourbillons
J'entends les rugissements des fauves qui ont décidé
 d'envahir nos bosquets classiques
J'entends Venise à Londres les appels des marmots et
 les calculs dans les banques
Le raclement des ancres au long des quais et les
 cloches des crieurs

Je sens les étalages des marchands de poissons les
 collections de parfums et d'épices
Le goudron la fumée le lard le cuir et la colle
Dans les rainures des vieux papiers qui fermentent

J'entends les craquements des serrures sous les poings
 des rebelles avides
J'entends les pas de l'incendiaire qui veut tirer l'or de
 nos faux-semblants
J'entends le serpent des folies impériales
Qui vocalise ses cantilènes sur la moire des déserts au
 matin

 Je sens l'aigreur des lichens le suint crayeux des
 béliers pétrifiés
 L'exaltation de la poudre et l'appel des sauges
 Dans les rides des vieux papiers qui tanguent

J'entends les baisers en cascades l'explosion des rires
Les lointains tonnerres qui grondent et les danses des
 vignerons
J'entends le hennissement des chevaux et le frottement
 des soies
Le cliquetis des armes et le tintement des bijoux

 Je sens le miel des antres le genièvre des pelages
 Le musc des replis le sel des larmes et la suie de la
 forge
 Dans les drapés des vieux papiers qui germent

J'entends les grognement des étamines les cris de
 plaisir des pistils
Les feulements des pétals qui s'ouvrent et les
 pépiements de la Lune
J'entends les craquements des ossements et le
 mûrissement des pustules
Le grouillement des vers et le vent sur les cimes

 Je sens l'haleine des sangliers la fiente des aigles la
 moisissure des charpentes
 La sueur surie dans les plis de la bure et l'encens de
 l'aube
 Dans les vallons des vieux papiers qui grouillent

J'entends le gémissement des larves que nos
 incantations arrachent
A la sottise où elles se complaisaient depuis des
 millénaires
J'entends le croassement des flammes le ricanement des
 proverbes et le marmonnement des ruines
Le clapotement des soldats et les râles de la cuisine

 Je sens les piqûres les morsures les coupures et les
 déchirures
 Les fractures les étouffements et les fièvres
 Dans les circonvolutions des vieux papiers qui
 tremblent

Prince des juxtapositions augmentations diminutions et
 contractions
Croisements greffes mutations prélèvements et
 multiplications

Tu découvres les premiers balbutiements d'un nouveau-
né sauveur
Dans les lèvres des vieux papiers qui saignent

(72–76)[104]

In the stanzas of this free-verse ballad, the initial verbs of both the quatrains and the tercets, which alternate throughout, suffer in translation. Both *"J'entends"* and *"Je sens"* can be read two ways: "I hear" or "I understand," and "I smell" or "I feel." For the most part the primary meaning is intended, but the secondary one is latent and gradually predominates. We have noted the Explicator's statement about the *froissages* with two bands: "One for the sound, the other for the scent" (72). Two pages have passed since the last Baudelaire citation, but this clear allusion to *Correspondances* recalls that synaesthesia vividly, and the meanings of the repeated "I hear" and "I smell" continuing throughout the poem make the *Ballade* the epitome of "correspondences," especially as we envisage the Kolář artworks as integral part of the whole. Butor relaxes the insistance of the repetition half way through: still within the traditional ballad structure, the "I hear" of line 2 of the quatrains is suppressed, beginning with stanza 4, a frequent device of Butor's, to establish a pattern initially and then gradually vary it. The "old papers" constitute the other consistant repetition, varied in the remainder of the lines as they perform actions showing them to be very much alive, first as yeast rising, then seeds germinating, and finally trembling and bleeding. Three other repetitions occur in the course of the poem, which are not evident in English since in each case the context requires a different translation,[105] and, of course, the loss of the repetition in the translation affects the sound of the whole.[106] The French words, with their multiple meanings known to the reader, constantly recall each other, reinforcing the "correspondences."

As one might expect in a poem focused on what "I hear," the harmonies are extraordinarily rich, even for Butor. The only end rhyme occurs just before the Envoi: *"ruines, cuisine,"* where it prolongs the series of *i*'s present from the beginning and the collection of rhyming words in *-ion* in the Envoi, which themselves culminate in the *"balbutiements,"* a simple *i* without [j]. A word in *-ion* has occurred in every stanza but the fifth, where the focus is on words in *-ment,* begun already noticeably with the hiatus of *"le hennissement"* in the stanza 4 quatrain. The words in *-ion* naturally echo the very frequent nasal *o*'s. Harsh sounds (for example, the repeated front *a* and [k] of *craquements*) are fairly evenly distributed throughout (as the *"calculs"* of the stanza 2 quatrain, *"cascades"* of the stanza 4 quatrain, and those in stanza 6, *ricanement, clapotement, fractures*). The soft sound of [u] immediately attracts atten-

tion in *"roucoulement"* in the first quatrain, but is limited to at most two occurrences per stanza thereafter. Among the many other repeated soft sounds, the sibilants occur most often in alliteration, as in the stanza 1 tercet and especially the *"sueur surie . . . encens"* of the stanza 5 tercet, where *"je sens . . . sangliers"* and internal *s*'s of *"moisissure"* bring it out still further, even as the [y] of *"bure"* echoes that of *"surie."* Alliteration also appears in *"vallons"* and *"vieux"* of the stanza 5 tercet, while the stanza 5 quatrain is filled with initial *p*'s.

These lines recounting what "I hear" are themselves worth hearing and then hearing again, as the placement and combination of sounds varies through the poem. The syntax is also varied: the lists of items are supplemented by relative clauses or prepositional phrases; the complexity resolves itself always in the identical structure of the last line of each stanza. The whole is overwhelmingly musical.

These evocative, provocative lines then derive from Kolář's *froissages* using the works named by the Explicator (72). The stanzas are evidently related to the four works, taken in the order given. However, throughout, the particular work serving as source of a particular stanza influences other stanzas as well.[107] In addition, Mucha and Canaletto and the unidentified "spores from the forest of reproductions" have clearly all generated other elements in the poem, as we have seen in the "locks of hair" derived from the wavy lines in the *froissage* shown in the Zurich catalogue.

Thus, stanza 1 with its "guitar of Parisian bistrots at the turn of the century," "absinths," "teas," "sawdust," "Oriental tobacco," and "lady in a little veil and feathered shawl" derives recognizably from Mucha's subjects. Stanza 2 is certainly from Canaletto, as the Venice and London indicate, with anchors, quays, banks, and street-criers. Stanza 3 reflects Ernst's "Napoleon in the desert" in a Napoleon clearly portrayed as caught up in "imperial follies," and the "serpent" of those "follies" appears in Ernst's water like the Loch Ness monster. The curious segmented multicolored obelisk of that painting could have provoked the "petrified battering-ram," and its "chalky ooze." In stanza 4, Veronese's "Venus and Mars" is the source by implication of the "kisses," and possibly "the explosion of laughter," and the dark sky of the painting is seen in this stanza in "distant thunders rumbling." The horse, silky garments, a sword and pearls all appear in the painting, but in the poem Butor has coupled them with nouns of his own: the whinnies, rubbing of silk, clanks, and tinkles are his audible additions. The "salt of tears" and "the sweat of the forge" are certainly those of the absent Vulcan, who has Butor's sympathy, as we will see later in the Dream. In stanza 5 the force of Grünewald's *Temptation* is

hidden in the "groans" and "cries" attributed to flowers, but in the third line appear "crunchings of bones," which we may observe in the painting, along with the "ripening of pustules" in the web-footed creature with a horrible rash. He seems to be tearing up a book, perhaps the "old papers" of the refrains. The attacking monsters and the wooden building in the background of the painting are evoked in the tercet, together with St. Anthony (who is viewed in the painting by a heavenly observer), represented in the poem with his "sour sweat in the folds of his robe," contrasted with the "dawn incense."

To find a painting more terrifying than the Grünewald, one would select probably Bosch or Breughel, and in stanza 6 we find one of Breughel's least understood and clearly frightening works. The whole is usually interpreted as an allegory of avarice, and *Mad Meg* could suggest any horrors, including the "moaning" "larvae" snatched from thousands of years of foolish complacency by "our incantations," and the heads with legs could be seen as larvae, or anything else nameless. Specifics in stanza 6 deriving from the painting include flames, ruins, and the "sneering of proverbs," in the explanation given of the creature shoveling coins from his own rear end: "he is stinking rich," a Dutch proverb, "Hy heeft Gold als dreck."[108] There is a crowd of uniformed soldiers in a giant bowl, more in the water, and among the apparently stolen items in Meg's bag is a long-handled frying pan: "splattering of soldiers" and "death-rattles of the kitchen." "Bites" and "chokings" are visible, and the "fevers," if taken figuratively as the sick lust for wealth.

Some "other spores of the forest of reproductions" probably generated the "wine-growers' dances" rather than the dancing devil silhouetted in the upper right of *Mad Meg*. Similarly, details, such as in stanza 2, the "street urchins" and the goods displayed aromatically on street stalls, are not readily seen in Canalettos, but from whatever source, Butor included them and they vividly add sounds that "I hear" and odors "I smell."

The music of the whole resonates and echoes with the shifting ideas. The perfumes of the poem seep between and among the stanzas and images. The deliberate ambiguity of the verbs, appropriate to reading the *froissage,* increases until in the next to last stanza we certainly "feel" rather than "smell" insect bites, and also "understand" as well as "hear" the "moaning of larvae," "croaking of flames the sneering of proverbs and the muttering of ruins." Played off against the very precise items listed, the dual meanings increase the force of the poem as the vividness of each individual line builds to an overwhelming cascade of images.

The movement of the poem is from the melodious calm of Muchas's sinous representations through the developing threats and active aggressions Butor found in the other *froissages*—the explosion, thunder, arms, and tears—until the anthropomorphic vision of snarling plants among bones and worms gives way to the violence of the sixth stanza. No simplistic picture of "us" and our adversaries, the poem allows for "our shams" and it is "we" who with our "classical arbors" will be overwhelmed by the collapse of capital. The arsonist—usually conceived of as a less than sympathetic actor—believes he can profit from those "shams" that are labeled as ours. He and the "voracious rebels" are associated through the structure, as is that "serpent of imperial follies," found in the desert of Ernst's Egypt, but who recalls also Algeria and the long agony there. It is *our* "incantations" that snatch those larvae away from their established errors, with the violent results. Nonetheless, the awakening of the "larvae" is necessary, desirable. Completing the rhetorical purpose, they are also possible, as the Envoi explains. The "newborn savior" Kolář discovers is of course, art, which Kolář's work exemplifies. As the readers hear the "crumplings of the world," smell its perfumes and fear the collapse of the stock market and the wars and rumors of wars, Butor tells us art remains. We need only look back at the one *froissage* we have from the collection that served as source for this poem to recognize Butor's accomplishment. From the most diverse elements imaginable, he has created poetry, indisputable proof that in the midst of chaos art remains.

Read within the *Dialogue avec CB,* this *Ballade* is interrupted only by the Composer, who speaks regularly (as in *Résistance*) between each stanza and between the quatrains and tercets within each. If Butor calls Kolář "Prince of juxtapositions," in the Envoi, this poem certainly demonstrates his own right to such a title. Just before the *Ballade,* the Composer has said, *"Aimeront les balbutiements"* [They will love babblings] (#81) (71), and there are the babblings at the end of the *Ballade.* Each of the lines of the Composer between the stanzas of the *Ballade* is intimately related to the poem, advances its progress, while still developing his own theme. Before the larvae are awakened by *our* incantations and the overwhelming last two stanzas, he says, as if it were a musical term, *"Allegro bruciando"* [Burning hot allegro](#92) (75). Thus his interruption leads the reader quickly (*allegro*) into the overwhelming heat of the conclusion. The Composer's "thread" could be seen as made of different fiber from the others, perhaps of gold, distinct but everywhere in the tapestry, unifying the whole.

We turn now from this most politically charged of the Singer's poems and its brilliant demonstration of Butor's poetic art to the *Anatomie illustrée [Illustrated*

Anatomy] (42–47), a poem that could be seen as political only in its mocking of the self-importance of human beings, but that certainly includes humor.

Humor

The collage, *Anatomie illustrée,* is described as one of Kolář's mobile, layered works, another stratified *ventillage,* with parts of the lowest levels visible through the others. Just before this poem the Explicator has spoken of the use in a thoroughly different way of known images, causing them *"dire ce qu'elles ne pouvaient encore dire, ce que l'on n'osait pas dire"* [to say what they could not say yet, what people dared not say] (42). Through these rearrangements, images *"éclairées de face, jadis seules visibles, font maintenant passer leurs ombres, envers ou radiographies"* [lit from the front, formerly only thus visible, now make their shadows, backs or X-rays pass by] (42). This poem very clearly illustrates these passing shadows.

The format of the poem is constant. Like the *Ballade des froissements du monde,* this poem is not interrupted by the Explicator, the Reader's Baudelaire quatrains, or even the Dreamer. The Composer interjects his lines regularly, but the absence of any other interference in the continuity of the presentation facilitates the reader's progress through the Organizer's descriptions of each layer of the collage, introduced by the same phrase used for the other stratified *ventillage, Résistances,* "one raises and one uncovers." Each description is followed by the Singer's groups of three or four lines, numbered from (1) through (58) that, we are told, are written on the backs of the layers. It is only at the end of the poem that the Organizer reveals: *"On soulève et on découvre enfin en totalité ce dont on pouvait voir des fragments depuis le début: incrustée dans un mosaïque de vieux romans anglais, l'illustration d'un dictionnaire encyclopédique au mot 'anatomie' avec ses 58 numéros"* [One raises and one discovers finally the totality whose fragments could be seen from the beginning: incrusted in a mosaic of old English novels, the illustration from an encyclopedic dictionary for the word "anatomy" with its 58 numbers] (47). Thus Butor has created fifty-eight lines, each composed of a body part, or in some cases clothing, a physical resemblance or a function, plus another noun. In most cases the conjunction of the two is surprising, ridiculous, sometimes surreal. The layers of the collage as described by the Organizer often offer recognizable sources for Butor's choice of these words.

I consider here only brief extracts. Of the second layer, the Organizer says: *"On soulève et on découvre le centre de ce dont on voyait déjà le pourtour—le ventre*

de la Bethsabée de Rembrandt incrusté dans le cylindre d'une boîte de bière avec une déchirure qui permet de voir à l'étage inférieur lorgner la Méduse du Caravage" [One raises and one discovers the center whose outline one could already see: the stomach of Rembrandt's Bathsheba incrusted in the cylinder of a beer can with a rip which allows one to see leering on the level below the *Medusa* of Caravaggio] (44). The subtitle for this section is *"Contenu du gant ou la main de la baigneuse"* [Content of the glove or the hand of the bather] (44): Rembrandt's *Bathsheba* is a "bather," as a servant is washing her feet. Her disproportionately large hands are bare, the left one appearing more spongey than flesh and bone. They were apparently more interesting to Butor than the beautifully rounded stomach, as the first three lines of the section following are:

> 32) *Les doigts ou les indiscrets.*
> 33) *Le déchireur ou l'ongle.*
> 34) *Le pouce ou le décapsuleur.*
>
> (44)

> [32) The fingers or the indiscreet.
> 33) The shredder or the fingernail.
> 34) The thumb or the bottle-opener.]

The incongruity of the Rembrandt in a beer can is reflected in the text. The combination of the body part with its possible use provides more incongruity, always with variety—picking at something and opening a bottle are very commonplace activities, but what "indiscretion" fingers might be involved in is left to the imagination.

The *Medusa* on the next level is set in a *"publicité pour plomberie"* [plumbing advertisement] and the subtitle is, *"le Portrait ou signalement d'un buveur de bière"* [Portrait or description of a beer-drinker] (45). The first of Butor's lines clearly derives from the *Medusa: "Les mèches ou les serpents"* [The locks of hair or the serpents] (45), and the facial features Butor treated may be seen emphasized in Caravaggio's severed head: her forehead, ferocious eyebrows, and bulging eyes. On the other hand, *"Le nez ou la pompe"* [The nose or the pump] is probably drawn from the plumbing ad, and *"L'essuie-mains ou les mustaches"* [The hand-towel or the moustaches] (44), whatever its source, is downright farcical. The text of the fourth layer of the collage, composed of geographical maps, carries a subtitle, *"Le Socle du colosse ou le rêve du marcheur"* [Pedestal of the colossus or dream of the walker]. This series of texts begins with *"Les avant-coureurs ou les orteils"* [The forerunners or the toes] (46), combining thus incongruously the image of

smashed statues with that of their still visible toes seen as heroic heralds.[109]

Under an additional subtitle on the back of these maps, *"l'Intérieur de la vue ou la coupe sagittale"* [The Interior of the view or the sagittal cut] (46), all the non–body part words suggest the outdoors, but the alternatives Butor has carefully chosen speak exactly to the insides:

> 55) *La prairie ou le crâne.*
> 56) *Le cerveau ou les nuages.*
> 57) *Les fougères ou la cervelle.*
>
> (47)
>
> [55) The prairie or the skull.
> 56) The mind or the clouds.
> 57) The ferns or the brains.]

Distinguishing the brain as either *cervelle* [matter], which could perhaps be seen as physically resembling ferns, or as *cerveau* [intelligence], Butor presents the grand and glorious brilliance of humankind as a prairie, vast, windswept, and empty, and what do we find in our minds but clouds? Is this satire or a simple truth?

Throughout, as the images from the collages change, the sounds within a given group of three or four lines are harmonious, but restrained. There is no rhyme and little repetition, but much alliteration, as in this group:

> 49) *La voie rouge ou l'aorte.*
> 50) *La veine cave ou la voie bleue.*
> 51) *La forêt ou les bronches.*
>
> (47)
>
> [49) The red road or the aorta.
> 50) The hollow vein or the blue road.
> 51) The forest or the bronchia.]

Here we find repetition of *voie*, the five *v*'s, four front *a*'s, two short *o*'s, one emphasized by its proximity to the *a* of *aorte*, and the hushing consonants [ʒ] of *rouge* at the beginning and [ʃ] of *bronches* at the end. In other cases the alliterative sound is continued from one group to the next. Thus, in the four groups from #19 through #31, a flock of eight *p*'s occurs, six of them initial, together with four *b*'s in the last group of four lines. Both *d*'s and the unvoiced plosive *p* appear then in the last line of the group #39–#41, *"La pente douce ou le dessus de pied"* [The easy slope or the top of the foot] (46). The [ə]'s, the inverted order of the alliterated *p*'s and *d*'s, the [u] becoming [y] combine here to produce as musical a line as imaginable. Here, as throughout the *Anatomie*, one must recognize Butor's humor through incongruity, since all that poetic harmony is lavished on the top of a foot.

The Dreamer

Finally, the last speaker, the Dreamer, whose texts derive from the collages of set 3. The Organizer told us in his introductory statement that the eight speakers were in a room filled with artworks and that *"Celles que le rêveur commente sont projetées au plafond au-dessus de lui. Il les contemple à travers ses yeux fermés"* [those the dreamer comments on are projected on the ceiling above him. He contemplates them through his closed eyes] (9). Thanks to the publication of twenty of the Kolář collages in the Portuguese journal, *Coloquio/Artes* (5–14), we are privileged to see almost all of what the Dreamer sees, the third set of collages that contributed to *Dialogue avec CB*.

The Dreamer's voice is the most frequent in the conversation: three times he is silent for several pages, not interrupting the Singer, Composer, and Organizer as they go through the fifty-eight parts of the *Anatomie illustrée* (42–46) nor the Singer and Composer in *Résistance* (35–36) and the *Ballade des froissements du monde* (72–76), but otherwise he is omnipresent. There are eight phases in this dream, plus opening and closing phases. The organization of the whole is very clear, thanks to the signals Butor gives the reader. Each phase ends with the Dreamer's statement, standing alone: something *"couve"* [smoulders]. Each phase includes a fixed matrix composed of seven elements (referred to here as "B"), plus two pairs of sentences, each repeated later with a different partner (referred to here as "A").[110] (See Appendix D for complete matrix.) Our primary interest in the artworks as sources of the text dictates reproducing here most of these collages, with brief summaries of the text each provoked, but first, to situate the reader in the matrix, I cite the whole of the opening text and the first scene of phase 1, through the Dreamer's receipt of a gift. Subsequently I cite at length only those especially political or humorous texts, pointing out remarkable harmony as appropriate.

Opening Phase

The opening eases us into the Dream, ending with the "smouldering" and beginning with the "A" repetitions, but not yet demonstrating the "B" matrix.[111] Intercalated speeches of the other characters in the room with the Dreamer are here indicated by the "/":

> *Je suis sous une pluie de presse. / Dans mon miroir-lit de supplices, je capte l'approche d'un désert, oasis de calme et soulagement. / Les journaux, les affiches, les pages des livres tombent en bourrasque. / Je me débats, incapable de lire pour l'instant. Une feuille plane plus lentement, s'approche; j'y reconnais des caractères allemands. / Elle me caresse le visage, m'aveugle, s'enroule*

autour de ma poitrine, glisse sur mes jambes, s'étend sur le sol entièrement recouvert par celles qui l'ont précédée. / Sur celle-ci sont des groupements de lettres britanniques, mais je n'arrive pas à saisir un mot dans son ensemble. Celui-ci presque, il m'attire dans le dédale des averses d'étiquettes; je le poursuis, il se retourne; j'ai failli attraper une phrase entière . . . / . . . Et puis voici des accents circonflexes renversés sur certaines lettres, qui m'avertissent que je suis passé dans une région de langue tchèque. / Les manuscrits s'en mêlent, de plus en plus anciens; descente dans un puits d'écriture. / Dégoulinades de morse et de braille, lambeaux de cartes de géographie, poussière de manuels scolaires; tous mes vêtements en sont traversés, j'en suis moi-même transpercé. / Mes mains sont moulées dans des gants de missel, mes jambes enrobées dans un pantalon de dictionnaire, et je porte un masque de catalogue de fonderie. / Je respire les bribes[112] et les jambages; l'intérieur de mes narines se tapisse d'échantillons. Je mâche des mots. J'étouffe . . . / Le feu couve. (9–12)[113]

Jiří Kolář, *Sous une pluie de presse* **[Under a Rain of Printed Matter].**

The reader will not realize the repetitive function of the sentence "I am under a rain of printed matter" (9) until it recurs in phase 1 (18). The second sentence, the "mirror-bed" with its desert and oasis will not reappear until the conclusion (71), and at that point the reader will know what the "mirror-bed of tortures" is and recognize in the last lines the "oasis of calm." The opening contains only one pair of these "A" repetitions. Sources of the text of the opening are easily found in Kolář's *chiasmage.*

We see the plethora of kinds of printed matter described, some German Gothic characters and what are called "British letters" (10) where we might think "CAGO suggested Chicago, and "ebec" perhaps Quebec. We can certainly see in the collage the overwhelming effect of a furious "downpour," a "maze," in which it is impossible "to grasp one word as a whole." We cannot make out the inverted circumflexes of Czech, but Butor's mention emphasizes Kolář's presence, as does the Braille, recalling Kolář's artworks for the blind. His choice of elements blends his own experience in with Kolář's: maps, textbooks, dictionary. We would not expect to find Butor with a missel, but he would not deny its presence among the world's writings, and as for the foundry catalogue, we will later see what use Alechinsky makes of old bills from a foundry. Kolář's portrayal of a morass of all kinds of writing, in which the individual words are rendered meaningless by the quantity and fragmentation of their presentation, is clearly reflected in Butor's introduction to the dream.

Although we might well find mild humor in the incongruities of this situation, the political is limited to the mentions of Czech and German, a quiet reminder of Butor's concern for the barriers raised by the different languages of the world. Similarly, the harmonies are soft-pedaled: frequent *i*'s and front *a*'s, several [k]'s, but most interestingly the alliterative *p*'s are reechoed in the Composer's interruptions: just after the *"pluie de presse"* the Composer says, *"Reposeront dans la question paisible de la paix"* [They will rest in the peaceful question of peace] (9). Again, when the Dreamer speaks in a bevy of *l*'s: *"incapable de lire . . . plane plus lentement"* the Composer interjects his own, *"Le ciel les sanglera d'amour invulnérable"* [Heaven will gird them with invulnerable love] before the Dreamer continues with *"m'aveugle, s'enroule . . . glisse . . . sol."* The Dreamer's *m*'s at the end, increased by the alliteration of the recurring "my" (*mon/ma/mes*), *"moi-même . . . mes mains . . . moulées . . . missel . . . masque . . . mâche des mots"* are continued in the Composer's significant word, *"mère"* [mother] (#9). Since Butor completed and published both texts before combining them here, these echos from one speaker to the other cannot appear regularly, but they provide a happy coincidence here at the beginning of the dream, one that Butor chose to maintain. The text is very rhythmic, primarily octosyllabic, with occasional decasyllables and hemi-

stiches, always achieving variety. As we pursue the phases of the dream we will note that certain segments are richer in both harmony and rhythm than others.

Phase 1

The first full phase of the dream begins following "Fire smoulders." We see that movement from one collage to the next takes place both during the "A" repetitions, and, as at the end of this citation, the Dreamer's receiving a gift.[114]

> *Tel un courant d'air frais passe une dame d'antan: / je l'ai déjà vue quelque part. Puis on transforme encore le dispositif en détaillant chacune des lamelles de verre en petits carreaux . . . / . . . Ce n'est qu'une ombre de profil, mais je reconnais son chignon, son collier, son nez; tout autour d'elle le temps s'apaise en paysage classique. Derrière de grand rochers s'éloigne un orage naturel entraînant en ses derniers remous faucons et mouettes. / Pardessous les branches des grands chênes, j'aperçois une baie avec un port, même un navire. Un laboureur encourage ses boeufs; conversations de bergers. Dans des buissons se cachent des satyres épieurs (14). / L'animateur de ces domaines, couronné de laurier, confortablement installé sur un canapé de pierre et de mousse, écoute le chant d'une flûte. Je sais qu'elle est jouée par le musicien monstre à l'oeil unique, l'argileux Polyphème à peine dégagé de sa montagne, mais, à l'endroit où il devrait se trouver, se creuse à l'intérieur de la dame passante une rue moderne, une rue qui devait sembler il y a quelque cinquante ans moderne à l'extrême, mais pavée de granit brillant de la dernière ondée. / Dans ses narines, de fines branches figurent l'excitation nerveuse produite par les odeurs siciliennes: thym, lavande et fromages. Dans le dos, le bord de deux voitures bleutées. Le rétroviseur de la première m'invite à m'aventurer dans cette douce solitude urbaine; et au moment où je pénètre en ce profil, la voix de la dame profère calmement, comme si elle avait déjà parlé depuis longtemps, mais que mes oreilles se fussent débouchées seulement à l'instant de mon passage: / . . . Tous les musées du monde s'écroulent par plaques, et tandis que mes semelles de papier frottent sur le granit humide, les coups de canon lui répondent . . . / . . . Et tandis que mes doigts diaprés chiffonnent les tulles qui gonflent dans la nef, la dame creuse se retourne et me fait don d'un de ces petits meubles que les chimistes disposent sur leurs étagères pour suivre commodément l'évolution de leurs préparations dans leurs tubes à essais. / (16).*[115]

In the reproduction of the collage *Dame d'antan* [*Lady of Yesteryear*] we see the storm diminishing, as well as birds and at least some of the characters mentioned. We see the street within the lady's silhouette, and agree the pavement appears glistening from a recent shower. We see branches Butor identifies as herbs at the level of the lady's nose, and can just make out the two cars and rearview mirror. When the lady appears, we might think she and the "classic landscape" were the source of the "oasis of calm" the Dreamer saw from the "rain of printed matter" and this impression will blend in with others as we continue reading. The transformation of an image by slicing slivers of glass into little squares describes Kolář's technique of *rollage,* especially the works in which he cuts both horizontally and vertically, creating, exactly, little squares, which he then displaces.[116]

The passage is soothing, rich in *i*'s, [u]'s, and [y]'s with many soft [ʒ]'s and *l*'s, but we do not find humor, and the political is limited to the the "spirit of these lands" (15), who seems to be enjoying more than his share of luxury.

With this phase begins the full matrix of the dream, composed of elements repeated either with no change, with minor changes, or with variables. Briefly, the elements are the following.

First pair of "A" repetitions introducing the first collage;
Matrix B
 a *"tandis que"* [while] statement;
 a lady reciting a Baudelaire variation;
 "tous/toutes les [] du monde s'écroulent par plaques" [All the [variable] of the world collapse by slabs];
 a second "while" statement;
 "les coups de canon lui répondent" [the cannon booms reply to her];
 the third "while" statement;
 the lady making the Dreamer a gift, introducing the second collage;
finally, another pair of "A" repetitions introducing the third collage.

Throughout, we will see the first "while" statement presenting the Dreamer's actions, as he interacts with the various ladies. Outside of this "B" matrix, the second through eighth items, the Dreamer's connection with other figures is very limited. He "knows" what they want, but communication is by sign language, a wave or a glance. As the Dream proceeds, a knight silently turns him over *"au nain liftier jaune"* [to the yellow dwarf elevator operator] (40). Next, the opera tenor actually takes a pipe from the Dreamer's mouth, but they do not speak (49). The Dreamer feels he "must" give his violin to the bust with the huge eye (55), but it is not until the closing phase that "they" actually act upon him. Thus it is through the "while" statements of the matrix that the Dreamer is seen to be relating to the dream figures.

A theme is consistently recalled in the second and third "while" statements, that of paper. These phrases

Jiří Kolář, *Dame d'antan* [Lady of Yesteryear].

are always repeated verbatim, with one exception, the fingers: they vary from simple fingers to paper ones to liquid paper ones. These "while" phrases will remind readers of of the "liquid paper" of precomputer days, when Butor was writing the *Dialogue avec CB*—and of one's own fingers spotted with White-out, as in the "mottled fingers" just seen in the preceding text. These carefully arranged repetitions concerning paper of course recall the opening phase with its artwork filled with paper scraps.

Throughout, these second and third "while" statements (with one exception) contain in alternation references to paper in either one "while" phrase or in both. Additional references occur outside the matrix, as in the opening, where the Dreamer wore gloves, pants, and a mask all made from paper books, and the Dreamer is almost always dressed in paper, including the soles of his shoes, and once even *"mes pas de papier"* [my footsteps] are paper (55). It is true that by phase 8 at one point in the cathedral he says, *"je ne suis plus vêtu que de rayons"* [I am no longer dressed in anything but rays] (69), presumably because he was swimming in the *"humeurs"* [humors] of the *"femme-battement"* [battement-woman] (69), and it is reasonable that this state of undress is what left him *"indécent dans cette assemblée"* [indecent in this assembly] (78) with Mme de Pompadour in the conclusion (78). The importance of paper reappears there in Mme de Pompadour's *"beaucoup de livres et de partitions"* [many books and music scores] (78) and in *"les pages de ses livres"* [the pages of her books] (79), which the Dreamer tears out.

Phase 1 of the dream continues, as the Dreamer carries the test-tube rack given him by the Lady of Yesteryear.[117]

Jiří Kolář, *Menu meuble* [Little Test-Tube Rack].

Menu meuble [*The Test-Tube Rack*] is an example of Kolář's collage sculptures, discussed later by the Explicator (63). It answers precisely Butor's description so far as we can tell, since he had a much closer view.[118] As the Dreamer walks he plays with the test tubes, and their contents is transformed. Some mild humor is present, as *"l'oreille de cette femme devient un oeil d'homme"* [the ear of that woman becomes a man's eye], and it is very harmonious. The precise description of the test-tube rack, is filled with alliterative *p*'s *"à petits pieds et profil de piano droit, reliés par deux planchettes"* [with little feet and the profile of an upright piano, linked by two little planks], and the transformation of the images within the test-tubes allows for multiple repetitions of *"oeil"* [eye], *"narine"* [nostril], *"oreille"* [ear] and *"collier"* [necklace]; the phase ends with additional repetitions of *"nouveaux, nouvelles"* [new]. The political is limited to the suggestive juxtaposition of the Statue of Liberty to a winegrower's cottage and some knives.

Following the description, the dream moves on. As we read, we will not know the "turn of the street" will prove to be an "A" repetition, but we recognize "I am under a rain of printed matter," and the text corresponding to the third collage, *Mugissement d'eaux* [*Roaring of Waters*], begins.

Thus, movement from the collage of the "rain of printed matter" to the "lady of yesteryear" occurred at the first "A" repetition line, the next with the gift of "the little rack," and this third was introduced with the second set of "A" repetitions.

This collage is readily recognized in the text, even the four tiny ships at the bottom. The Dreamer's realization

Jiří Kolář, *Mugissement d'eaux* [Roaring of Waters].

that he is in a different situation is rendered humorous through his attempt at logical thought: *"Ce doit être la manipulation de ces tubes. Croyant agir seulement sur des cultures de visages anciens, je me me suis déplacé dans ma propre époque avec une extrême rapidité"* [it must the manipulation of these tubes. Thinking I was acting only on the cultures of ancient faces, I have moved in my own period with an extreme rapidity] (18). Of course, shaking up images in test tubes always transports the shaker in space and time! Then, either humorous or political, the surprising combination of *"fleuve père ou mère"* [father or mother river], is reminiscent of the contemporary feminists' prayer to "Our father/mother God." The cannonfire throughout assures our never forgetting the political subtext. The harmony maintains especially in the frequency of *i*'s, and the play of hard [k]'s and [g]'s with [z]'s.

Phase 2

The next phase of the dream and the next scene provide another touch of humor in the simile of a *"grand chapeau de paille telle une auréole un peu penchée"* [big straw hat like a slightly fallen halo] (22).

There is no political force in the text of *Dame de ce temps-ci* [*Lady of Today*], but it is very harmonious: the *i*'s give way to [e]s, especially in the four repetitions of *"pommiers"* [apple trees] where the alliterative *p*'s are augmented by three repetitions of *"plutôt"* [rather]. The soft sounds of the *"fleurs"* [blossoms] occur no fewer than seven times, including one in the "B" repetition.

Recalling the waterfalls of the previous collage, water imagery is continued as the Lady of Today gives the Dreamer an artichoke basket, which, with absurd humor, can be used as a boat, in which he *"glisse sur le fleuve"* [floats along the river] (25). The corresponding collage is clearly a sculpture like the test-tube rack, as it has *"les bords, les coins, les poutrelles"* [edges, corners, little beams] (24), all constructed from the pages of an illustrated dictionary. The images listed are dazzling in their variety, as anyone given to browsing in a Larousse can imagine. They range from a *"mite"* [clothes moth] and *"la coupe d'une fleur de renoncule"* [buttercup] to well-known artworks, where the only remarkable harmony occurs: *"un amour de douze ans jouant avec un papillon"* [a twelve-year-old Cupid playing with a butterfly] (24).

A pair of "A" repetitions has again signalled a change of collage and a change of scene for the Dreamer: he tells us, *"N'était la couleur, ce serait Venise ici, une Venise vide sous un ciel de draps froissés"* [If it weren't for the color, this would be Venice here, an empty Venice under a sky of rumpled sheets] (25). His description in *Venise* [*Venice*] includes references to sites in

Jiří Kolář, *Dame de ce temps-ci* [Lady of Today].

that city, and despite the denial of the text and the crumplings of the collage, we can see for ourselves that it is.

This text is rich in harmony, the *v*'s of *"Venise . . . Venise vide"* [Venice . . . empty Venice] (where the "empty" is clearly added for its sounds, since in the *froissage* human figures are visible), the *"vieillotte"* [old-fashioned] speech and the *"vendeurs"* [sellers] who *"viennent"* [come] offering *"violettes"* [violets], many sibilants, [k]'s, including the *"Procuratie vecchie"* [old pimps], and [ʃ]'s, until the heaving sidewalk *"m'engouffre dans les plis de cette place semblable à un lit défait"* [engulfs me in the folds of this square similar to an unmade bed] (25). This phrase, with its

Jiří Kolář, *Venise* [Venice].

simile, recalls the metaphor earlier on the same page of *"un ciel de draps froissés"* [a sky of rumpled sheets]. Full of sibilants, *l*'s and *p*'s, this passage is followed by more *p*'s: *"Je passe de la Piazetta à la Piazza"* [I pass from the Piazetta to the Piazza]. There is a distant suggestion of the political in the contrast between the street sellers and the Doge's palace, and at the end of this phase, we recognize the culturally appropriate selection of the variable that "smoulders": *"bruit"* [noise]. With no motorcycles or cars and only an occasional delivery truck, the blessed silence of Venetian streets is broken even today only by the distant—smouldering—hum of the canal boats. In the time of the Doges evoked by Butor, there would have been only boats powered by hand, perhaps accompanied by a gondolier singing instead of speaking into his cell phone.

Phase 3

The first repetition "A" sentence that begins phase 3 tells us that we are indeed still in Venice: *"Du porche de la tour de l'Horloge à demi englouti sort une élégante"* [From the porch of the half-engulfed Clock Tower comes forth an elegant lady] (29).[119] Butor's detailed description of her macramé jewelry is heavy with *l*'s,

sibilants, and then not only *p*'s but also *b*'s: *"sur sa poitrine pend un superbe bijou qui ressemble à un balcon"* [On her chest hangs a superb jewel which resembles a balcony] (30). She whistles to him with alliterative *d*'s from *"devant le palais des Doges"* [in front of the Doge's palace] (30), and the apple she gives him is *"chaude, c'est comme si elle palpitait dans le changement de lumière en passant dans la colonnade sous le soleil rayé"* [warm, as if it throbbed in the changing light passing along the colonnade under the striped sun] (31), still in lush harmony: two [ʃ]'s, sibilants, three *p*'s, open [ɛ]'s and [j]'s.

A suggestion of the political occurs in *"tandis que, filant au vent lunaire qui s'est engouffré, dispersant les lambris, j'arrache les membres de tous les obséquieux"* [while spinning with the lunar wind which has swept down, pushing aside the panelling, I tear off the members of all the obsequious ones] (31). At this point the reader associates the "obsequious" with the courtiers of an omnipotent Doge, and the Dreamer's reaction demonstrates his feelings.

It is humor, however, that predominates in the apple:

C'est une pomme vêtue d'une chemise, pas seulement d'une chemise, c'est une pomme en déshabillé; il lui reste

un carré de velours rouge, une pointe de satin noir, diverses couches de coton à raies (31) roses et grises, à raies bleues, à pois roses, à petits carreaux. / C'est une pomme avec une braguette à fermeture éclair. Je n'y puis résister. J'ouvre doucement: un nuage de lettres dactylographiées sort de la fente. Je referme. Je ne suis plus à Venise. (32)[120]

Close examination of the collage, *Pomme vêtue* [*Dressed Apple*], might cause the reader to wonder why the Dreamer identified the zipper as a trouser fly, since it would be upside down, but the point is surely irrelevant in the context. The repetitions, of *"pomme"* and *"chemise"* and then of *"raies"* and *"rose,"* supply soft sounds among the hard [k]'s, and unify the passage tightly; the very short phrases move it along briskly around the "cloud of typed letters." Those letters, which are not seen in the collage, recall the original "rain of printed matter": to Kolář's surreal image, scrupulously described, Butor has added that allusion. As the waterfall imagery was maintained while the Dreamer floated in his artichoke hamper, so the dressed, or undressed apple, humorously absurd as it is, contributes to the unity of the whole dream.

The "lunar wind" in the preceding repetition "A" will now be explained, as the second set of repetitions "A" in phase 3 moves us on to the next collage: *"Le ciel est si noir qu'il paraît blanc"* [The sky is so black it appears

white] (32). We might note that the second sentence in this set of "A" repetitions, *"Degrés, rochers"* [stairs, rocks] (32), was previously seen just before the reprise of the waterfall, as we landed our artichoke basket-boat at the steps of the pier in Venice, but in this context those words now suggest moon rocks.

The corresponding collage is simply a photograph of the surface of the moon, to which Kolář has added on one side the highway signal for a slippery road and on the other, silhouetted in plain white against the black of some lunar "sea," a horse and rider. The lunar dust, rocks, cold, absence of gravity and lack of oxygen the Dreamer experiences, well known to us now through astronautical accounts, are all evoked by the photograph.

To these Butor's texts adds, in a bevy of *d*'s, a highway crossroads sign and an automobile with its driver, all composed of *"cartes lunaires"* [lunar maps] which are repeated five times, even more than the apple trees on the dress of the Lady of Today in phase 2. And here we find a clearly political addition: the driver, becoming Tycho Brahe, a frequent figure in Butor's work,[121] gives the Dreamer *"un sourire de tendre connivence comme lorsqu'on s'amuse des jeux de ses enfants qu'un étranger pourrait trouver bizarres"* [a smile of tender collusion as when one is amused by one's children's games which a stranger might find peculiar] (33). It was Tycho's astronomical studies that enabled Kepler to formulate his theories, and the Dreamer would naturally find him on the moon, but Tycho's independent thinking, especially in religion—which eventually cost him his royal support—is the reason he and the Dreamer would, as in the comparison, feel in "collusion."

The white horseman[122] of the collage leads them on, after *"le gel couve"* [the freeze smoulders] to phase 4.

Phase 4

In this scene, *Reine du cinéma* [Movie Queen], the reader of the text alone without the collage will not learn the identity of the "horseman."

Ce doit être Elisabeth Taylor. Cheveux noirs relevés en grand chignon avec bandeau d'or, voile de gaze brodé d'or, colliers de diamants, brocards. Mais son visage est masqué par un rectangle d'invisibilité. Le cavalier descend de son cheval. Dans la lumière de cette salle, il prend le teint des illustrations de magazines, cheveux brossés en arrière, calvitie naissante à deux pointes, cravate sombre sur col blanc. / C'est à la pomme que je n'ai cessé de palper dans mes mains, qu'il s'intéresse évidemment. Je descends de la voiture qui s'éloigne. C'est à cette pomme qu'il pense que va s'intéresser la reine. Il saisit alors une loupe d'éclaircissement, qui tout en permettant à celle-ci de détailler le fruit séducteur, me permet de reluquer ses lèvres gourmandes. / Je profite d'un moment d'inattention

Jiří Kolář, *Pomme vêtue* [Dressed apple].

du cavalier pour me glisser à l'intérieur de la braguette. La reine prend la pomme dans sa main, et tandis que je pénètre entre ses lèvres, sa voix, la même voix, profère calmement: . . . / . . . Toutes les législations du monde s'écroulent par plaques, et tandis que mon masque de papier essuie l'intérieur de ses lèvres, les coups de canon lui répondent. (37–38).[123]

Even without the collage, the described costume of Elizabeth Taylor is identifiable as Cleopatra's. The title, *The Movie Queen* thus assumes a satirical tone. Then, the idea of Elizabeth Taylor or any queen moved to gluttony over an apple is humorously absurd, as is the Dreamer's managing to climb into the dressed apple through the trouser fly. The harmony develops appropriately: the repetitions of "apple" and some soft [ʃ]'s are gradually overwhelmed by the sibilants and the unusually generous number of harsh [k]'s. The effort of the "horseman," apparently some celebrity, to tempt Taylor with the apple seems not so much satanic as bizarre.

However, when we can see the collage, the "horseman" is readily recognized as the young Nixon, sandwiched between Taylor and the close-up of her lips, and the political force becomes primary. It is "legislations"

Jiří Kolář, *Pipe.*

that collapse in the matrix line. Within two pages he is mentioned again as *"le ci-devant cavalier de loupe"* [the former magnifying-glass horseman]. Butor's use of "former," the term used scornfully by Revolutionaries for the nobility, cannot fail to evoke that historical queen, then called "former," and her fate. She is best known today by the circumstances of her becoming "former," and the suggestion is that Nixon's place in history will be determined similarly.[124] Here, when we know the identity of "the former magnifying-glass horseman," his use of an apple as enticement leads to his inevitable association with another even better-known Tempter.

The Movie Queen gives the Dreamer a pipe. We are told that the words issuing in a *"brouillard"* [fog] from the pipe, five of them in alliterative [k]'s, are taken from a *"vieux roman"* [old novel], and these words are to *"servir de tabac"* [serve as tobacco]. There is humor in the contrast between, on the one hand, Magritte's saying his realistic painting of a pipe was not a pipe and, on the other hand, the Dreamer's insisting *"ceci est bien une pipe"* [this really is a pipe] (40), even though its only realistic aspect is its shape. With this juxtaposition of illusion and reality, the smoke leads us to a new scene.

Here, in a collage we would very much like to see but do not have, *"Tout est aminci"* [everything is thinned] (40).[125] The Dreamer nears a shore, *"Fumant toujours ma pipe de vieilles paroles séchées, polissant les vieilles images réchauffées"* [Still smoking my pipe of old dried words, polishing the old warmed-over images] (41). This humorous self-denigration is combined promptly with the image of the Dreamer's walking on water, but avoiding sacrilege, as they are only *"les eaux de soufre apprivoisé"* [waters of tamed sulphur] (42), a phrase that adds one more *v* to the many others in this scene.

Phase 5

The text accompanying the *prollage, Plein opéra* [Complete opera], is linked to the previous scene

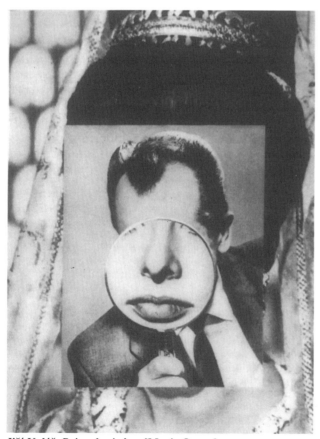

Jiří Kolář, *Reine de cinéma* [Movie Queen].

Jiří Kolář, *Plein opéra* [Complete Opera].

through continued alliterative and internal *v*'s, specific expressions repeated here, *"truites-virgules"* [trout-commas], and *"pavillon"* [pavillion], as well as through the action: *"Le ténor . . . m'aperçoit marchant sur les eaux du lac"* [The tenor . . . notices me walking on the waters of the lake] (49).

Details of the text can be seen in one or the other of the paintings composing the *prollage,* even the *"fron-daisons"* [foliage] of the repetition "A" line that introduced the scene (47). The action cannot be seen as anything but humorous. Opera-lovers will recognize a parody of the typical plot: the *"corpulent chevalier"* [portly knight] *"désignant du doigt"* [pointing] to his warlike costume has been trying *"de s'arracher aux embrassements de son opulente amante"* [to tear himself away from the embraces of his buxom lover] (48). The soprano is amazed when the tenor now *"désigne du doigt"* [points], in identical terms, at the Dreamer's pipe and sings about it *"dans un aria tout différent"* [in a totally different aria] (49). We may not know an aria about a pipe, but many a Manon has brought down the house singing to her table. In the "while" phrase, the Dreamer's *"doigts dégrafent son corsage pour lui permettre de respirer plus librement"* [fingers unfasten her blouse to allow her to breathe more easily], surely a

thoughtful effort on behalf of an opera soprano, but nevertheless comical.

Amid recollections of flowers and waterfalls, the soprano gives the Dreamer a violin. Elements of this next collage, *Violon* [*Violin*], are found in the text: *"le Scribe accroupi sur son socle d'immeuble de béton en construction sur un quai du Caire; et les trois Parques de Phidias"* [the Scribe crouched on his pedastal of a cement building under construction on a quay in Cairo; and Phidias' three Fates], and also *"la découpure d'une ville américaine au bord d'un lac, que je ne suis pas pour l'instant capable d'identifier, . . . / Cleveland? Milwaukee?"* [a skyline of an American city on a lakeshore which I cannot for the moment identify . . . / Cleveland? Milwaukee?] (50–51).

This gift has summoned up a different voice: it is not the Dreamer who recalls his childhood efforts at the violin, but the writer.[126] His voice blends with that of the Dreamer until the end of the passage, where again it is the writer who is unable to recognize the American city—the sameness of American cities is a point Butor underlined in the *Bicentenaire kit.* And it is the writer who speaks longingly of *"le Caire même, un Caire que je n'ai pas revu depuis des années, un Caire en paix, serait-il possible."* [Cairo itself, a Cairo I have not seen

Jiří Kolář, *Violon* [Violin].

Further, these phrases provided a close link with the next scene, in which the collage (which we do not have) permits the writer to continue his evocation of the Nile, including the nostalgic *"les naseaux des chevaux qui se baignent et même ceux des hippopatames comme autrefois"* [the nostrils of horses bathing and even those of hippopatomi as in former times] (52). This passage forcefully supports the political point, the writer's wistful longing for peace in Egypt. This phase ends with *"Le tremblement couve"* [Trembling smoulders] (52), reminding us that the Dreamer's hand trembled as he played pizzicati—since he had no bow—on the violin.

Phase 6

In this phase the first sentence of phase 1, "Like a breath of fresh air passes a lady of yesteryear: I have already seen her somewhere" (14, 29, 55) reappears for the third time. This time, as soon as we see the collage, *La Ville moyenne* [*The Average City*], we will know we, too, have "already seen her somewhere," because the superimposed contour of the "bust" in *La Ville moyenne* is identical to that of the *La Dame d'antan*. Back in phase 1, the succeeding text, (also an "A" repetition) described the figure with, *"Ce n'est qu'une ombre de profil, mais je reconnais son chignon, son collier, son nez"* [It is only a shadow in profile, but I recognize her chignon, her necklace, her nose], and then concluded with the background setting of the *La Dame d'antan: "tout autour d'elle le temps s'apaise en paysage classique"* [all around her the weather is calming in a classic landscape] (14). Now in phase 6 the ending is altered to: *"elle est tout entière faite d'une peau de neige"* [she is entirely made of a skin of snow], and here the contour does indeed enclose an interior of background white. Further, the introduction to the collage, *"C'est une ville moyenne: des garages, quelques voitures"* [It is an average city: garages, some cars] (54), clearly describes the street scene of the intercollage of *La Dame d'antan.* Thus, the recalls in the "A" repetitions of the text remind us not only of the earlier appearance of the words, but also of the earlier collage.

Now, in phase 6, Butor's description of the lady of this collage is precise: *"Ce n'est qu'une demi-figure. Son buste géant glisse doucement sur le sol. Des lèvres juteuses comme des quartiers d'orange emplissent sa poitrine"* [It is only a half-figure. Her giant bust slides softly on the ground. Lips juicy like orange sections fill her breast] (55). Just as in the two collages, the outlines of the texts are the same, but the two images are very different.

The Dreamer had been contentedly playing his violin, drawing forth *"notes perlées"* [pearly notes] in *"le torpeur de l'après-midi"* [the afternoon torper], but this

again for years, a Cairo at peace, could it be possible?] (51). The mild political cast of the juxtaposition of the ancient world to jarring skyscrapers is reflected in the harmony: the writer's first words are full of sibilants; then, as he and the Dreamer blend, more and more soothing alliterative *m*'s are introduced until the hard [k]s gradually take over, in "Cleveland," "Milwaukee" and the repetitions of "Cairo."

It is immediately following this speech of the Dreamer's that two lines were omitted in *Dialogue avec CB* through printer's error: *"Je joue dans une felouque, je glisse au long d'un Nil de notes"* [I play in a fellucca, I slide along a Nile of notes] (52, *Coloquio/Artes* 11, *MR II* 71). Not only are the imagery and metaphor of this beautiful line thus lost in this edition, but the repeated soft [u]'s and *l*'s as well as the alliterated *n*'s.

Jiří Kolář, *Ville moyenne* [Average City].

In the third scene of this phase, *La cathédrale ivre* [*Drunken Cathedral*], the *froissage* may be taken from the same cathedral as that in one of the *froissages* included in *The Eye of Prague,* the *Cathedral of Saint-Guy* (105).

The text reflects *"le ciel de toiles à matelas froissées"* [the sky of rumpled mattress ticking] (57), and we can see that the cathedral *"tord sa tour"* [twists its tower]. The brief passage offers several recalls and poetic devices. The second "A" statement, *"Le temps a passé plus lentement qu'en bien des points du monde, mais beaucoup plus vite qu'en Egypte"* [Time has passed more slowly than in many parts of the world, but much more quickly than in Egypt], followed by, *"Passe une longue barque à multiples rameurs"* [A long boat with many oarsmen passes] (57)[128] recalls the moment just before the Prague apple scene, when the Dreamer had settled down *"comme dans une barque"* [as in a boat] (56). An additional recall occurs in the "rumpled mattress ticking," which will bring back Venice and its two references to unmade beds (25), where the Dreamer

half-figure with an *"un oeil énorme"* [enormous eye] (55) is watching *"chacun de mes gestes"* [my every move] to the extent that *"Je ne peux plus jouer, je ne peux que lui offrir ce violon comme à une cruelle rapace divinité"* [I can no longer play, I can only offer her the violin, as to a cruel, rapacious divinity] (55). Once again the oppressor is seen, here spoiling the tranquil enjoyment of an innocent. The threatening nature of this passage corresponds to a decrease in harmony. The background description is heavy with consonant groups and *r*'s (*plâtrés, brèches,* etc.), there are a few alliterative *f*'s and a series of [ʒ]'s, but the "cruel, rapacious divinity" with its [k] and front *a*'s is harsh.

The bust with the huge eye does not, despite her evil nature, fail to produce a gift, the Apple of Old Prague, and the second repetition of the apple phrase, *"Je la palpe, la respire"* [I touch it, I breathe it] (56). The list of sites, religious and secular, which appear on the collage's apple[127] is unified by specific eighteenth-century dates, contrasts, past versus present. Three [u]'s (*carrefour, tour, poudrière*) soften the didactic effect of the list, while alliteration is limited to five *v*'s, the first of which, "V. Kotcich" (56), standing alone, draws attention to the four others.

Jiří Kolář, *Cathédrale ivre* [Drunken Cathedral].

was floating in his artichoke-basket boat. A parallel adds, *"Il s'élève de cette pomme des vapeurs de cidre; il s'élève de ces ruelles des vapeurs de bière"* [From the apple rise vapors of cider; from the alleys rise vapors of beer] (57). An antithesis and amplification, *"Ce n'est pas moi qui suis ivre, c'est la cathédrale elle-même, une ébriété de douleur"* [It is not I who am drunk, it is the cathedral itself, an inebriation of sorrow], contribute to the personification of the cathedral, which suffers from *"l'indifférence des passants"* [the indifference of the passersby] (57), and resists: it *"chante de toutes ses craquelures"* [sings with all its cracks] (57–58).

In this scene, delivered in rapid phrases but generously provided with the poetic devices and recalls, the only remarkable harmony links three *-ures* endings: the *craquelures* with its two harsh [k]'s to the *"serrures"* [locks] and finally to *"Le fissurement couve"* [The splitting smoulders] (58). The political is limited to the presentation of organized religion as disdained today. This "splitting" of established religion leads to that of the Dream itself.

Phase 7

Phase 7 becomes increasingly disorienting. It begins (in *Orgue de pieds et de bras* [Organ of Feet and Arms], with action: *"virevoltent"* [turn around swiftly] (61) and a series of *v*'s as the Dreamer finds himself in a whirling, indistinct state inside the cathedral, which is much in contrast with the mournful exterior. The traditionally white dresses of those making their first communion are *"teintes dans les fibres des vitraux"* [dyed in the fibers of the stained-glass windows] (61). To the motion and color Butor adds music: *"C'est un orgue de pieds et de bras qui tourne autour des colonnes en laissant de grands espaces vides sur le dallage gris"* [It is an organ of feet and arms which turns around the columns leaving large empty spaces on the grey paving] (62).

The Dreamer covers himself *"de battements pastel"* [with pastel battements] (62), the ballet step visible in the rollage, with neatly pointed toe. *"Un visage parfois se dessine entre les strophes et les échos"* [A face sometimes takes shape between the strophes and echoes] (62); we may have thought the bust with the huge eye in phase 6 was a strange Lady, but this dimly seen face, together with *"un essaim de doigts"* [a swarm of fingers] (62) and eventually qualified as the *"femme-battement"* [battement woman] functions as a very mysterious Lady in this scene. The brief passage is restrained in its concise sentences and harmony: *l*'s and *v*'s, many in the matrix "B" lines.

We do not have the collage of the Lady's gift of *"une boîte de papillons japonais"* [a box of Japanese butterflies] (62) and cannot see what in Butor's strikingly beautiful description might derive from the collage, but the text is extremely harmonious. The butterflies' dances are couched in long sentences, containing four repetitions of "butterflies" and continued alliteration of *l*'s and *v*'s, together with additional alliterative *p*'s and *d*'s, The text is filled with color, expressed in precise terms from heraldry and botany.

The third scene blends in almost seamlessly, as the butterflies continue their movements. The repetition

Jiří Kolář, *Orgue de pieds et de bras* [Organ of Feet and Arms].

"A" statement, *"La vitre de la boîte se délite en minces lamelles"* [The glass of the box splits into thin strips], suggests one of Kolář's *rollages* or *prollages*. Almost any collection of Kolář's works offers intercollages of a butterfly outline, fillled with Manet, Matisse, or Picasso. These butterflies become figures from neoclassical paintings, evoking music in a harmonious series: *"hélant, chantant, jouant guitare et castagnettes"* [calling, singing, playing guitar and castanettes] (64), echoed in the participial ending of *"le dormeur cuvant son vin"* [the sleeper fermenting his wine] (64). The phase ends as *"La transparence couve"* [Transparency smoulders] (65).

Phase 8

We do seem to see phase 7 still, as if through a transparent glass, as we move to the next, while the butterflies become *"une femme de notre temps, américaine semble-t-il, robe courte bleue, agenouillée au fond d'un parc au bord d'une eau tranquille où elle contemple son reflet vêtu de feuilles vertes, coiffé d'algues"* [a woman of our time, apparently American, in a short blue dress, kneeling at the back of a park on the shore of a tranquil water, where she contemplates her reflection dressed in green leaves, with a hat of algae] (69). Our suspicion that she is the figure from the advertisement is confirmed when a *"papillon-doigt"* [butterfly-finger] writes in the sand, "are you springmaid?" (in English). The butterfly-finger *"brouille"* [blurrs] the Springmaid citation *"ainsi que son image"* [as well as her image] (69), and the blurring continues as the Dreamer is ridiculously *"ne . . . plus vêtu que de rayons"* [no longer dressed in anything but rays], while he swims in the "humours" of that *"battement-woman"* last seen amorphously in the first scene of phase 7. We never see more of her, as she is now collapsed into the Springmaid girl, who *"emprunte"* [borrows] the mirror of the next scene from *"sa soeur verte"* [her green sister], the Springmaid girl's reflection in the water. The incongruity of the American commercialism of the Springmaid advertisement juxtaposed to a cathedral may be seen as humorous—or political—or both. The connection is insisted upon, because the Springmaid girl's pond *"coule de la boîte dans la cathédrale"* [flows from the box in the cathedral] (69).

The scene is rich in harmonies, [j]'s, many *l*'s, mingled with the [k]'s of *"Les vaguelettes de la margelle lèchent leurs genoux qui se caressent en un clapotis de peau"* (69), which continue through the regular "cannon booms." The next scene will bring a very different use of sounds.

The gift the "green sister" offers is

une sorte de miroir rectangulaire à manche de corne....Il s'agit en réalité d'une de ces planchettes dont se servent les ménagères pour découper en rondelles fromages, légumes, charcuterie, hacher menu persil ou ciboulette, taillée dans la matière des musées. Je m'y regarde, y vois en effet mon reflet; c'est donc bien aussi un miroir; mais je m'y reconnais sous les traits du dieu que je hais le plus, du beau dieu Mars, l'épée séductrice, alors que je suis le fils de Vulcain, son lointain neveu à vrai dire, à travers migrations et tours de la roue de Fortune, Mars, découpé en lamelles, qui se dandine dans sa mini-jupe sortant à peine de sa cuirasse. (70)[129]

Jiří Kolář, *Planchette à découper* [Chopping Board].

The chopping board, a *rollage,* is one of Kolář's "still-life sculptures," and the Dreamer goes on to review *"l'autre côté du miroir"* [the other side of the mirror] (70), which must indeed be built on a mirror since he continues to see himself in the various images there (not visible to us), including an adult tied to a stake.

The word *"miroir"* occurs three times in this passage, adding to the collection of alliterative and internal *m*'s of Mars and the possessive adjectives *"mon, ma, mes."* Sibilants run throughout the scene, but the list of the housewife's foods and the images on the back of the chopping board offer no harmonious effects, and the hiatus of *"je hais"* [I hate] and *"le hachoir"* [the chopper] (70) is harsh, in accord with the meanings.

The "A" repetitions serving to introduce the third scene of this phase are both particularly remarkable: the first at last explains the "mirror-bed of tortures" mentioned at the very beginning (10): now we have seen that mirror-chopping board. Then, in the second "A" sentence appears the only substantive change in these repetitions. The glass slices of the butterfly box turned *"avec un léger sifflement"* [with a light whistle] (68), echoing the sound of the tops the butterflies played with, whereas here they turn *"avec un léger ronflement"* [with a light rumble] (71). Mars elicits a deeper, darker sound than colorful dancing butterflies.

The voice here again becomes the writer's, and it is he who hates the God of War. The choice of the term "mini-skirt" effectively and humorously ridicules the "handsome" god of war with his "seductive sword." The writer is not through with Mars. In a series of grating [wa]'s, two emphasized by rhyme, he introduces the next collage together with a recall of an earlier adventure: *"Enfin l'on s'y croirait sur la surface d'une autre Lune! Plus besoin de scaphandre, j'ai pris la forme d'un grattoir ou d'un rasoir"* [Finally one would think one was on the surface of another Moon! No longer needing a spacesuit, I have taken the form of a scraper or a razor] (71). Become a razor, he warns those thinking of igniting any booming of cannons: *"Si jamais apparaît dans le fourré de verre quelque nouveau dieu Mars, fût-il une partie, un aspect de moi-même, je suis devenu microtome pour le transmuer en préparations infra-minces et le traverser des lumières polarisées de mes brèches"* [If ever some new god Mars appears in the thicket of glass, even if he were a part, an aspect of myself, I have become a microtome to transmute him into infra-thin preparations and pierce him with the polarized lights of my breaches] (71). The glass box in the repetition "A" statement simply "splits into thin slices," but for Mars the writer reserves the "infra-thin" slicing produced by the instrument used to prepare samples for examination under a microscope, the mi-

crotome. Thus any sign of war is effectively discovered and destroyed.

Next, with only the Composer's brief interruption, the Dreamer presents a different reason for his becoming "a scraper or razor": *"On prend ici l'imprimé par le travers. Stratification des emballages et avertissements. Charrue tellurique, je creuse des rainures au milieu de cette mesa"* [Here printed matter is taken in cross-section. Stratification of wrappings and notices. Telluric plow, I hollow out grooves in the middle of this mesa] (72). Now become a plow, it is the Dreamer who carves out the rock and discloses its secrets.

The mention of the "mesa" brings the writer's voice back again briefly, recalling Butor's real-life experiences: *"Près de la forêt pétrifiée, dans l'Arizona de mes patiences, le désert peint. Anfractuosités de nacre où la lettre d'antan devient perle"* [Near the petrified forest, in the Arizona of my patience, the painted desert. Craggy rocks of mother-of-pearl, where the letter of yesteryear becomes pearl] (72). As Kolář's cross-section (*stratified*) reveals a previously unknown view of the pile of papers, so cross-cuttings in the petrified

Jiří Kolář, *Stratification.*

forests provide information about the unimaginably distant past and send us a pearly letter.

Following the musical lines concerning patience, with their alliterative *p*'s and nasal *a*'s, this last phase before the closing ends on an unsettling note: *"Mais l'ennemi veille, d'autant plus dangereux qu'il s'est ici déguisé en femme"* [But the enemy keeps watch, all the more dangerous because he is here disguised as a woman] (72). We might now interpret "the enemy" as Mars in his mini-skirt, but would wonder why the end of this phase is signalled by, of all things, a kiss: *"Le baiser couve"* [The kiss smoulders] (72).

Closing phase

The two repetition "A" statements recall the first communicants in the cathedral (61), and the "faded rococo salon," introduced much earlier with the lady of the apple-trees, *La Dame de ce temps-ci* (21). Neither of these provides a threatening enemy, but the closing phase reveals all. In that "faded rococo salon" we find *"La marquise de Pompadour tient audience tout en prenant son petit déjeuner. Les courtisans s'empressent autour"* [The Marquise of Pompadour holding audience while having her breakfast. Courtiers flock around] (77).

The Dreamer is grievously distressed by this scene and addresses the chopping board: *"J'étais si tranquille il y a un instant; miroir, pourquoi m'as-tu capté cette magicienne horrible, pourquoi as-tu réveillé si violente ma passion de déchiqueter?"* [I was so tranquil a moment ago; mirror, why have you insidiously brought me this horrible sorceress, why have you awakened in me so violent a passion to slash to pieces?] (77) At first the "sorceress" seems more unsteady than dangerous, as the Dreamer describes the elements of the collage, adding details and presenting the incongruous as if perfectly normal: Mme de Pompadour's moustache and beard.

> *Beaucoup de livres et de partitions, une corbeille de fruits confits, la théière et le sucrier. Engoncée dans son amoncellement de satins, volants, falbalas, guirlandes, bracelets, noeuds, dentelles, roses de gaze, elle soutient son énorme tête molle sur des coussins./ Son regard vague cherche à distinguer ses favoris parmi la foule à travers son monocle tremblotant; sa longue moustache trempe dans sa tasse, et sa barbe poivre et sel ruisselle sur sa poitrine soutenue.* (78)[130]

Not visible in the artwork, vigorous action moves in short sentences with increasing speed: *"On m'a vu. Des gardes-françaises me saisissent./ Je suis indécent dans cette assemblée. Il faut que je m'agenouille, que je*

Jiří Kolář, *Pompadour.*

caresses [sic] *ses chiens, que je lui lèche les chaussures. Il faut surtout que je leur abandonne ce dangereux, ce décisif miroir-table d'opération qu'ils vont s'efforcer de souiller"* [They have seen me. Guardsmen seize me./ I am indecent in this gathering. I have to kneel, pat her dogs, lick her shoes. Especially I must give up to them this dangerous, this decisive mirror-operating table which they will try to besmirch] (78). Only now do we learn the identity of that "enormous limp head" when Pompadour *"prend alors le sourire d'Alphonse Daudet"* [then takes on the smile of Alphonse Daudet]. That gentle, humorous Provençal author of *Tartarin de Tarascon* and *Le Petit Chose* [*Little What's-His-Name*] could not be more in contrast with the scene of the collage. It would be Daudet's head with *"son énorme tignasse"* [its enormous shock of hair] that generated Pompadour's tenderly drying the Dreamer, but it is the image of Pompadour's body surrounded by sycophants that has provoked the Dreamer's attack.

Different threads of the dream are woven together here. The Dreamer was "tranquil" in the Arizona desert. The "mirror-bed of tortures" of the repetition "A" state-

ment has become a "mirror-operating table." He is "indecent" because he is presumably still dressed "only in rays" as earlier during his swim. He has survived many bizarre situations, but has not been arrested before or forced to perform humiliating acts. The Mars mirror was not only "dangerous," but "decisive." It was at that point that the Dreamer reacted violently, and now in the "B" repetitions he continues—while *"les impossibilités du monde s'écroulent"* [the impossibilities of the world collapse] (79), thus rendering anything possible. He *"arrache les membres de tous les obséquieux"* [snatches off the members of all the obsequious ones] (79), no longer courtiers of the Doge as in phase 3 (31), but now of Pompadour, and appropriately the "cannon booms reply" (79). Then, *"tandis que je pénètre à l'intérieur de ses paupières"* [while I penetrate to the inside of her eyelids] (79), the site where he previously lodged with the *"cruelle rapace divinité"* [cruel rapacious divinity] (56), he persists: *"j'arrache les parties de ses vêtements, les pages de ses livres, bracelets, monocle, les poils de sa barbe et de ses sourcils"* [I snatch off parts of her clothing, the pages of her books, bracelets, monocle, the hairs of her beard and eyebrows] (79). It is his hatred of the God of War that drives him to aggression. The humor is limited to the ridiculous combination of Daudet and Pompadour, and the political has come to the fore.

Even in the violence of this phase the harmony is remarkable. The scene contains a number of paired alliterations, many *f*'s among the *l*'s especially in the list of items of Pompadour's costume, all of which are repetitions from her description except the "eyebrows," and those eyebrows are prominent in the collage. Sibilants gradually become more frequent, and the [ʃ]'s of *"chiens," "lèche," "chaussures"* reappear with the emphasis of repetition in *"arrache,"* itself hardened by its front *a*'s, reflected in *"pages," "bracelets," "barbe"* (79) even as another pair of [ʃ]'s appears in *"cherche."* The gradual increase of soft sounds leads us gently to the last collage, from the "kiss" that "smouldered" at the end of phase 8, to the *"pomme de jouvence"* [apple of youth] (80).

Je la palpe, je la respire; c'est un fruit qui a rougeoyé sur l'arbre du verger d'ailleurs, du verger d'alors, du verger d'éveil, de celui dont parlaient confusément enluminures et tapisseries,et je puis revivre son drame en léchant, mordillant sa peau./ Pulpe de lèvres et de sourires, en te mâchant je connaîtrai la science du bien et du mal, je deviendrai semblable aux plus beaux mots de toutes les langues, lorsque les murmurent ou les chantent les plus sensibles de toutes les femmes./ Je deviendrai hanté, enté par tous les dieux mes pères, pépin de reconciliation, baiser de paix, l'or du grand large. (80)[131]

Jiří Kolář, *Pomme de jouvence* [Apple of Youth].

Butor concisely describes Kolář's collage as an apple covered *"de lèvres et de sourires"* [with lips and smiles] (80), which we can see. It has become the *"pomme de jourence"* given him by Pompadour.

The last speeches are filled with repetitions: *"verger"* [orchard] three times, recalling the apple orchard on the dress of *The Lady of Today* (22). "I touch it, I breathe it" recurs for the third time, but it is here for the first and only time that the Dreamer licks, bites, and chews the apple. Superlatives pile up: *"aux plus beaux mots"* [the most beautiful words], *"les plus sensibles"* [most sensitive], along with amplifications, *"léchant, mordillant"* [licking, biting] *"les murmurent ou les chantent"* [they murmur them or sing them], and *"hanté, enté"* [haunted, joined with] and three times the all-inclusive: *"toutes les langues"* [all languages], *"toutes les femmes"* [all women], and *"tous les dieux mes pères"* [all the gods my fathers]. Through these repetitions the harmony is filled with the soft hushing consonants [ʃ] and [ʒ]; the superlatives add [u]'s, *p*'s and the [y]'s, heard also in *murmurent.* The rhyme of *hanté, enté,* the nasals of *pépin* and *reconciliation,* and especially *grand* through its meaning here of "open," lead to the assonance of *baiser* and *paix* and finally to the open vowels of *or* and *large,* with its one last [ʒ]. Thus the Dreamer awakens to a vision of peace.

Throughout the Dream, the pattern of two sets of repetitions constitutes a collage technique in words, parelleling Kolář's use of the same figure with different treatment, as in, for example, his apples. Through this

device, the reader remains aware of the collage technique, of the modern possibilities of exact reproduction fundamental to Kolář's work as well as Butor's. As we have seen, each repetition is affected by the context and there is no possibility of monotony. The constant mentions of paper, from its emphasis in the rain of printed matter to the tearing out of Mme. de Pompadour's pages prevents our forgetting for a moment the writer, although we hear his voice only in the middle of the dream as he plays the violin, again briefly in Arizona, and then as he reveals his hatred of the god of war, finding peace at the last.

Within the constraints Butor set himself in the organization of the "A" and "B" repetitions, the settings and figures in the Dream shift, and the richness of the harmony varies. But steadily throughout, until the closing phase, the ability of the Dreamer to act, his level of interaction with the other figures, and his anxiety increase. In the opening phase he is helpless, and only "almost" catches a sentence. He then observes and acts merely to "manipulate" the test-tube rack and it is not until later that he realizes this act has caused him to move rapidly in his own time. He is unable to hold on to the artichoke hamper, and though in Venice he brings the hamper, now a boat, to shore, he slips about and is engulfed in the folds of the Piazza. He "knows," with no exchange of words, that the Venetians think he is a street-seller. Similarly, he "knows" the Lady with the macramé jewel wants his hamper. He dares to open the apple's zipper and to close it when the letters fall out. The absurdity of the *Pomme vêtue* gives a break for laughter before we go to the Moon, where, aware of potential problems, the Dreamer is well prepared in a spacesuit. He is able to get in the lunar map car, and communicates by sign language with the driver. Then he "knows" the white horseman wants the apple for the movie queen and he "profits by the horseman's inattention" to get inside the zipper. He catches the words issuing from the pipe (as he was unable to do in the *La Pluie de presse*), fills his pipe, whereupon the horseman acts directly upon him, turning him over to the elevator-operator, that yellow dwarf with a flashlight in the form of a jester's bauble. The Dreamer is unconcerned at sinking into the "viscous water" on "the other side of the Moon" and simply walks on it.

At that halfway point, the end of phase 4, Butor set the long break while *Anatomie illustrée* is presented. When the Dream takes up again with the *Plein Opéra*, the Dreamer knows the Tenor "desires" his pipe, and knows he is not threatening. It is the writer's voice that tells of his learning to play the violin and, as the Dreamer plays it (with no bow) in the Nile boat, it is the writer who longs to see Cairo in peace. Then the Dreamer knows he "must" give the violin to the bust

with the huge eye, and he "staggers" in old Prague (57). His surroundings become increasingly blurred, as the Lady, composed only of a face and "a swarm of fingers" (62) and then somehow also of the pointed toes of the ballet step, is transformed into the girl of the Springmaid advertisement. The Dreamer only observes the butterflies, but in the "B" matrix he swims in what must be the Springmaid girl's "humours," the water she kneels by. When he sees his reflection in the chopping-board mirror, it is the writer, in great distress, who refuses the identification with Mars and then remembers the painted deserts of Arizona, but the Dreamer is aware that the "enemy" is on guard. The *Ballade* here clearly marks the end of this second part of the Dream.

Finally in the closing phase, as the Dreamer regrets his earlier tranquility and present rage he is very rapidly acted upon: arrested, forced into various acts and then wiped dry by Mme de Pompadour. He next himself acts on others, tearing up people and things. The movement thus rises gradually to this violent climax, until the denouement of the last calm apple scene. In the closing phase violence and serenity are contrasted on several levels: the guards versus the Dreamer as victim; Pompadour, the King's favorite, versus the gentle bourgeois Daudet; the Dreamer now aggressor versus Mme de Pompadour/Daudet and the courtiers now victims; and the whole violent scene versus the final kiss of peace.

In the Dream as a whole, we have noted that the harmonies vary and are less forceful in passages such as the *La Ville moyenne* and the *Cathédrale ivre,* and more rich in passages such as the description of the Venice collage, the macramé necklace and the *Pomme de jouvence.* Until the middle of the Dream, soft alliterations of *p* are very frequent, but gradually, first in Venice, then in most of the scenes in phases 4 through 7, it is the more forceful *v*'s that predominate, until finally the *p*'s reappear in the Apple of Youth. The *i*'s of the opening scenes give way as the Dream proceeds; then regularly throughout either soft [u]'s and [y]'s or else harsh front *a*'s, often accompanied by hard [k]'s accord with the meanings. In many cases it is the repetition of a particular word that produces alliteration, usually reinforced by the surrounding text.

The harmonious effect of the whole is produced not only by the choice and arrangement of the sounds but also by the discretion in their use: the two instances of hiatus in the *Planchette à découper* are the more telling because none have occurred before. Similarly, rhyme is almost entirely absent and downplayed: the three *-ures* endings in the *Cathédrale ivre* are offset by the numerous [k]'s. In the Butterfly Dances, the rhyming participial terminations are harmonious, but it is the rhythm of the long sentences which are the more remarkable, as they flow along while the butterflies dance

and dance. It is rhythm, too, that comes to the fore in an entirely different beat, in the short choppy sentences of the *Cathédrale ivre* and the violent scene of Mme de Pompadour. Virtually any point in the text of the Dream demonstrates the beauty of this harmonious poetry. For example: *Un long poisson au milieu des vagues violettes. Le passage du Soleil au-dessus des falaises, les pieux, les pilotis d'un embarcadère. Les terrasses d'un village, ses portes, ses fumées. Nous approchons de la rive, du quai* (52). These three rhythmic sentences— one thirteen syllables, one fourteen, and the last a decasyllable—with harmonious alliterations of soft *p* and *v,* filled with sibilants, *l*'s and mute [ə]'s, develop in amplifications in descending number, painting musical images with words. It would be very satisfying to see the collage, but even in its absence we experience the poetry, sailing *"le long d'un Nil de notes"* [along a Nile of notes] (omitted from 52).

Touches of humor recur throughout the Dream, such as the "slightly fallen halo," of *La Dame de ce temps-ci,* the Tenor's efforts to escape the Soprano's embrace, and Mars wearing a "mini-skirt." It is the *Pomme vêtue,* already humorous in the collage, which is outright laughable with its letter-filled fly. Similarly, suggestions of the political appear everywhere, such as in the test tubes, in Venice, on the Moon, in the violin. The scene of *La Reine du cinéma* contains a more obvious political statement (at least for readers who can see the collage) in the "former" President, and the antiwar position in the chopping-board images could not be more clear, reiterated by the writer.

The Dream, we must remember, is only one part of the *Dialogue avec CB,* constantly interrupted by the other speakers. As at the beginning, at the end the Composer's interjections blend with the Dream. The Dreamer snatched away *"les membres des obséquieux"* [the members of the obsequious] (79) before Mme de Pompadour gave him the apple, and the Composer's interruption is, *"Inventeurs de membres"* [Inventors of members] (#98), and just as the Dreamer speaks of being *"semblable aux plus beaux mots de toutes les langues"* [resembling the most beautiful words of all languages], the Composer's last speech is, *"Brûleront les mots et dans les mots"* [They will burn words and in words] (#100). As pointed out earlier, the two texts were written separately, but Butor's selection and arrangement result in a combination of the two that goes beyond repetition. What can "inventors of members" be? Designers of new forms of artificial limbs, surely a valuable pursuit in these days of concealed land mines, or in another sense, discoverers of others belonging to some group? Those who burn "in words" could well be poets, but those who "burn words" could not be destroy-

ing language, not in Butor's utopia; they must be burning barriers built by the multiplicity of languages. These and many other possibilities introduced by the Composer echo and reecho as the Dreamer gazes at the "gold of the open sea."

Conclusions

Now we have examined each thread, we can see the tapestry of the whole *Dialogue avec CB* more clearly and completely. With a page selected quite at random, one that includes all but one of the speakers (it is the Explicator who is missing) let us now observe a piece of the completed weaving:

Le compositeur. Ne s'en voudront plus.
L'ordonnateur. "Monocle" dialoguant dans les cadrans
 avec un Munch.
Le chanteur. Le temps d'un parfum
 Le sein des souffrances
 L'horlogerie des chevelures
 La nuit
Le rêveur. . . .A l'intérieur les premières communicantes
 virevoltent, leurs robes teintes dans les fibres des
 vitraux. Et voici que les triangles deviennent
 frondaisons. . .
L'ordonnateur. A nous maintenant de nous lire votre version de "Parfum exotique"
L'épistolier. Dans l'espérance que quelques-uns de ces
 tronçons seront assez vivants pour vous plaire . . .
Le lecteur. Car à quoi bon chercher tes beautés
 langoureuses
 (Les violons vibrant derrière les collines)
 Ailleurs qu'en ton cher corps et qu'en ton coeur si
 doux,
 Avec les brocs de vin le soir dans les
 bosquets?(61)[132]

The harmonious nature of the page as a whole is very evident, in the alliterative *v*'s, not only in the Baudelaire lines but in almost every speech, in the *i*'s, which are primary, balanced by the many nasals, the harsh [k]'s and [g] of the Organizer's speech, scarcely heard again until the last Baudelaire lines, where they are softened by his [œ]'s. The reader will find it impossible not to recall earlier passages: Baudelaire's violins will certainly summon up the dreaming writer and *"les notes perlées que je tire de mon instrument"* [the trilling notes that I draw from my instrument] (55). The comic is absent from the lines we see on this page, and yet, as the reader recalls other parts of each speaker's contributions, it is inevitable that the statements of this text bring those elements back to mind. For example, the Singer's "heads of hair" could recall the opening line of the *Anatomie illustrée: "L'aigle et la chevelure"* [The eagle and the head of hair] (43), and through a natural connection the comical *"essuie-mains ou moustaches"* [hand-towel or mustaches] (45). The humor is only one

recall away. Similarly, the mention of a monocle reminds us of "the elite" as they dance their way to destruction in *Articulations.* "The langorous beauties" and "your dear body" in the Baudelaire variation will bring back Butor's images of women's idle lives, as in *Toilette nocturne.* The Letter-Writer's "broken pieces" will remind us of the Dreamer's ripping up Mme de Pompadour's possessions. Although the only immediate political statement on this page is the Composer's, the political force of the whole also remains only one recall away.

The text in itself, without the recalls from beyond it, presents ideas generated by the Composer's line: forgiveness, suffering, hope (concepts included in the Christian beliefs inherent in the girls' making their first communion).[133] Then, the particular words of each speaker resonate among one another, for example, the two "perfumes"; the glass of the monocle and the "stained-glass windows"; "time," "clockworks," "night" and "evening"; "breast," "body," "heart," even *Spleen*; "foliage," "groves"; "broken pieces," "divided into ten fragments"; "turning swiftly" and "vibrating" (*vibrant*) could be associated with dancing and the "violins." Even though each speaker has a distinct style and subject matter, the text is comprehensible as a whole through the reader's hearing in his mind Bernard Weinberg's "intellectual chord."

Weinberg developed this term in his analysis of *Un Coup de dès . . . ,* where he described exactly Mallarmé's presentation and its goal:

> Musical sounds may actually be produced simultaneously and the resulting complex sound may be completely intelligible. . . . But were two single words to be pronounced together, neither would be understood; and were two or more lines of thought to be read simultaneously, say in a choral reading, only complete confusion and unintelligibility would result. . . . Hence Mallarmé's system in *"Un Coup de dès . . ."* never involves simultaneity—except for that kind of simultaneity which only the individual reader can himself achieve by holding one or even several lines of thought in abeyance and suspense while he pursues, separately and now, the thought contained in the words immediately before him.[134]

I believe Weinberg's recommendation to the reader of Mallarmé merits attention by the reader of Butor: "The two thoughts could not have been printed as simultanous, nor could they be read silently or aloud as such; but the mind of the reader may grasp and apprehend them together. The intellectual 'chord' is possible, and its achievement is what Mallarmé's method of presentation has as its ultimate goal. As we read, we must use all those resources of our intellect that are susceptible of leading us to the 'intellectual chord'" (247).

This page alone illustrates Butor's creation of the materials required for an "intellectual chord" even without recalls of the rest of the work. The page would produce a different "intellectual chord" for each reader: mine is composed of the synaesthesia of perfumes, music—not only in the violin but also in the poetic harmonies of *Monocle,* the Dreamer's speech and of course the Baudelaire variation—all notes in a chord of exhortation, despite brokenness and suffering, to forgive and to love. Each page would produce a different chord, and each rereading new harmonies, since different elements assume greater or lesser importance, given Kolář's and Butor's resistance to closure. The work as a whole thus becomes a symphony performed each time by a different orchestra, and with audiences wearing different perfumes—we could even extend the analogy to audiences dressed in clothing of different colors, from the references to visual art reflected in the text, as, on this page, the allusions to Munch and the girls' "dresses dyed in the fibers of the stained-glass windows." With all the fascinating changes in interpretation of even the smallest elements, however, *Dialogue avec CB* remains a clearly identifiable work; we know the symphony is Beethoven's regardless of the conductor and orchestra.

Recognizing the overwhelming effect of the "intellectual chord," we can still review the parts played by harmony, humor, and the political. We have noted effects of the devices of recall and reprise throughout, and the harmony of the Dream has just been summarized. Baudelaire's harmonies are his own (treated extensively by scholars), and Butor selects the lines and places the quatrains to accord with the contexts, often producing contrast. Their rhythm is naturally alexandrine throughout, providing a stable base for the poems recited by the Singer, which are usually octosyllabic but with widely varying harmonies. The *Anatomie Illustrée* offers only some alliterations, a little superrich rhyme and onomatopeia. *Le Page* and *Toilette nocturne* are composed mainly of soft hushing sounds, the former including humming *m*'s and a few rhymes, the latter many *l*'s collected in its last line, but also a judicious number of hard [k]'s and [g]'s. *La Reine des neiges, Résistance,* and the *Ballade* are harmonic variations on the theme of contrast, in which hard and soft vowels and consonants are set against each other, *La Reine des neiges* with many [ã]'s and nasal *o*'s, *Résistance* and the *Ballade* with the deeper nasal *o*'s only. *Résistance* and the *Ballade* include repetitive structures, which *La Reine des neiges* does not. The rhythm of the *Ballade* with its thirteen- and fourteen-syllable lines and stanzas ending in a decasyllable differs from that of all the others. The force of the nasal *o* is amplified in the rhyming *-ion,* the soothing [u] is present but

relatively rare, and sibilants and [y]'s more often provide soft sounds. The alliteration of *v*'s and *p*'s now recalls that of the Dream. The *Ballade* serves as an ideal example of Butor's use of harmony.

We would not expect any conversation with Baudelaire to be comic, and there is indeed little humor in this work. We have noted that the Composer's phrases are occasionally amusing, that *Anatomie illustrée* contains some humor derived from incongruity, and that some scenes in the Dream are laughable in their absurdity, which is often surreal.

As for the political, the Composer, Singer, and Dreamer together make us aware of the existence of oppressors and oppressed, conceived of as an undesirable situation. Women are especially presented as oppressed, constrained to live uselessly as in the *Toilette nocturne.* The contrast of another possibility, of equality, appears in *Dialogue,* and we recognize that Butor's position on the status of women is more genuinely egalitarian than Kolář's. The identification of an "elite," both men and women, as oppressors is clear in *Articulations,* and reaffirmed in the Pompadour section of the Dream. We see that it is the lust for power that is the cause, suggested in the juxtaposition of Nixon and collapsing government in *La Reine du cinéma* of the Dream. Other allusions to injustice appear in the Dream's test tubes, the Venetians, Tycho Brahe on the Moon, and the violin; the poem *Résistance* summarizes it all. The chopping-board of the Dream clarifies Butor's position: war is absolutely not the solution. *La Reine des neiges* shows that there must be an end to the way things are, and that the ending will be very difficult to reach, a theory the *Ballade* reinforces, in that moving the "larvae" to action will virtually require magic, but the struggle is still absolutely necessary. In the *Ballade* we learn that the savior of the world will be art.

Dialogue avec CB stands as illustration of salvation through art. At the very beginning the Explicator identified the apple as *"le fruit de l'arbre du Paradis, celui de la connaissance du Bien et du Mal, la tentation, la séduction, la pomme du jugement de Paris"* [the fruit of the tree of Paradise, of the knowledge of Good and Evil, temptation, seduction, the apple of the judgment of Paris] (12). Now at the end, the Dreamer eats the apple, and the expulsion from Eden and everything that followed—including the Trojan War—is swept away. After all his tumultuous experiences, it is through art that the Dreamer finds "reconciliation" and peace at the last. As the Composer said in his very first speech, "They will rest in the peaceful question of peace."

In the three different sets of Kolář collages, Butor has found inspiration for a symphonic tapestry of text that strongly supports his claim regarding Kolář's works and his own: "All Kolář's art is political. It is an art of

resistance. Mine is, too" (34). It is this art that must save the world. The Explicator says of Kolář:

> *Il n'y a pas seulement la beauté de la conception, la vertu de l'ingénieur, il y aussi ce moment d'ajustement exquis. Les gens qui mettent au point des automobiles sont des artistes en leur domaine. En réglant bien le carburateur on fait chanter la machine. Un bon mécano doit avoir de l'oreille. Il y a un moment où cela sonne juste, qu'il faut savoir saisir. Si nous combinons deux images ou deux découpures de la même image, il faut les faire glisser doucement l'une par rapport à l'autre, et guetter le moment où cela se met à vibrer. C'est l'oreille de l'oeil.* (58)[135]

In *Dialogue avec CB* Butor demonstrates that he, too, has that ear, that he is "a good mechanic."

CARTES POSTALES POUR UN AMI DE LIECHTENSTEIN

Postcards would not seem a very attractive format to a poet, but Butor has created collaborations with many different artists in this form, with spaces left for address and postage stamp, as if someone might actually relinquish one to the care of the postal service.[136] His texts in this unclassifiable genre are usually poems, whose brevity is necessitated by the particular spatial constraints. Sometimes the poems are made up of only a few words; in this series with Kolář each prose poem is concise, but within the limits of length Butor still finds room for lush harmony and touches of bittersweet humor to support his political exhortation for the preservation of nature.

The complete series of eight postcards in *Cartes postales pour un ami de Liechtenstein* [*Postcards for a friend from Lichtenstein*], comprised of four collaborations with Kolář and four with the artist Gregory Masurovsky, was commissioned for the Lichtenstein Almanach of 1989, and on the original cards the texts are given in German as well as French. Butor republished the set of texts in 1992 in *Avant-goût IV* [*Foretaste IV*].[137] The Masurovsky collaborations tell of the medieval castle of Vaduz, capital city of Lichtenstein, of alpine villages and pastoral scenes, where *"les cinémas tentent de nous séduire avec leurs promesses de déserts rouges, guerres des étoiles, jungles d'asphalt, tours du monde en quatre-vingt jours"* [cinemas try to seduce us with their promises of red deserts, star wars, asphalt jungles or trips around the world in eighty days] *(Avant-goût IV* 177). We do not have access to the Masurovsky artworks, but even without them the differences between Butor's collaborations with him and those with Kolář are evident. The structure of each text derived

from Masurovsky is unified, scenes set in the tranquil beauty of the high mountains, whereas the structure of the texts derived from Kolář is of two contrasting sections, as Butor reflects Kolář's intercollage technique. This technique, in which the contour of one image is filled with a very different second image, produces a disparity between the primary photograph and that of the intercollage: one is an unmistakably Parisian scene, and the other a view of mountains, with wide-open uninhabited spaces, presumably Lichtenstein. The texts present a modern city, with escalator, fireworks display, metro, and opera house, seen in four different ways as the antithesis of the beauties of nature,

The first text establishes the situation and speaker, which are continued in all four, and I will first consider these constant factors. Then, for each collaboration in turn, I will follow the theme of the real and unreal, identify the elements in the artwork that have served as sources for the text, and point out particular harmony and humor. Finally I will treat the political message of the whole as it is developed through all four texts.

Le Beau burg

 L'oncle Jules nous a montré un des plus impressionnants édifices métalliques de la capitale. Ah, c'est lorsqu'on est enlevé par son escalier mécanique suspendu que l'on sent en quelque sorte rouler sous ses pieds le progrès industriel dont nous attendons tant d'avantages! Et figurez-vous que lorsqu'on atteint une certaine altitude, délivré des fumées des usines et locomotives, de la rumeur souvent hargneuse de la foule poussiéreuse et hagarde, on aperçoit un château parmi des montagnes, on respire les baumes des forêts, et ce qu'on entend alors c'est le cri des choucas, le cliquetis des armures et les mélodies des damoiselles avec harpes et luths. Mais il n'est pas encore possible de s'y rendre vraiment. Ce n'est qu'un mirage auquel s'amusent nos ingénieurs.[138]

Kolář's photographs are all of real sites and monuments that exist physically in this real world; it is his juxtapositions, differently arranged in each collage, which create unreality. In reality, the beauties of nature exist still today, but there are no expanses of mountain vistas in the middle of the monuments of Paris, no tiny Paris inside a remote castle. The texts encourage our realization of the effects of the gradual encroachment of the one upon the other: the combination of nature and city does not and cannot exist in reality.

The name, Uncle Jules, sets the stage for the play of the real and unreal, which is the basis of these texts. From De Maupassant's *Mon Oncle Jules* [*My Uncle Jules*], the name has acquired the recognized meaning of the uncle always expected to return from the United States unbelievably wealthy and thus the object of grandiose hopes.[139] In the original, the character is finally

Jiří Kolář, *Le Beau burg* **[The Beautiful Town].**

discovered in abject poverty by his family, who sneak away lest he see and recognize them. The family's hopes are dashed as their imagined future collapses. In Butor's version, the realism is converted into a fairytale: the rich uncle returns and they all live happily ever after. Thus revised, Uncle Jules has come home and is doing what rich uncles do, taking his nephews and nieces, visiting from out of town—probably from Lichtenstein—to see the sights. Each is one of those required of tourists, even the *Chateau noir* [*Black Castle*] (which could be any medieval fortress) because within it is a miniature of that quintessential tourist stop, the Eiffel Tower. Appropriating the innocent, childlike voice of De Maupassant's narrator, Butor's speaker reflects the enthusiasm of the turn of the century before the anticipated wonders of the future. But one by one those expectations are blended in the texts with mirage, fantasy, opera, trompe l'oeil. The parallel with De Maupassant's tale is inescapable: the future, which inevitably becomes the present, has not turned out as we had hoped.

The texts do not specifically state that this Uncle Jules has returned from the United States. Yet he seems Americanized: instead of the Louvre, he takes the nephews and nieces to the monument that to him is most representative of the wonders of modern industrialization. Butor's firsthand experience in the United States of today provides him an awareness of the problems industrialization can produce: air pollution, noise, and overcrowding, and they all appear in these texts.

By bringing De Maupassant's story into the present, Butor underscores the irony of "the industrial progress from which we expect so many advantages." Here is the family at the Pompidou Center, which of course was not there in De Maupassant's day, and even as Uncle Jules rhapsodizes on the wonders of the future, he speaks of being "free of the smoke of factories and locomotives." Today all that remains of any that might have been near the Beaubourg is the popular nickname for the Pompidou, drawn from its appearance, the "gasworks." The Halles of De Maupassant's day and recent memory, with the "often surly noise of the dusty and haggard crowd," its noise and frantic activity, is gone. In its place, the immense underground commercial Forum des Halles hardly suggests the mountains and forests of the engineers' "mirage"; au contraire.

Kolář's collage is vividly present in the text, in the contrast between the garish colors of the Pompidou and the earth tones of the castle, the geometrical rigidity of the building with the natural forms of the superimposed mountains. Although some might think of the Pompidou as primarily the glass, or transparent plastic of the escalator, Butor has called it "metallic," as it is the metal infrastructure that is most prominent in the photograph: Kolář trimmed the superimposed castle photo to allow more of the Pompidou pipes and red metal squares to show within the diamond. The little figures seen riding up the escalator certainly contrast with the castle's perch on a sheer cliff. The trees would have suggested the "balms of the forest" to Butor, and in this vision of jackdaws and lute-playing maidens, the armor for once functions primarily as atmosphere with appropriate sounds, not as a symbol of aggression.

Uncle Jules's niece or nephew is revealed as an accomplished poet in his choice of sounds in the text. The Germanic spelling of "burg" in the title, separated into two words, calls attention to the meaning of the familiar name of the neighborhood, Beaubourg, often today replacing the name of the Pompidou Center itself. The [y] of "burg," with that spelling, leads directly to the [y] sound of Uncle Jules, which reappears in critical words all through this text: *"altitude," "fumées," "usines," "rumeur," "armures," "luths,"* and *"s'amusent."* A similar reechoing of *i*'s recurs: *"édifices,"* the rhyming

"métalliques" and *"méchaniques,"* especially in the *"cris"* and *"cliquetis"* of the final *"mirage."* Soft sounds, the sibilants and frequent initial and internal *l*'s, mingled with *m*'s, occur throughout. The many front *a*'s have a changing effect, not always harsh, as in the parallel alliterative aspirate *"hargneuse"* and *"hagard,"* but becoming musical through the *r* in *"harpe,"* calm because of the soft *m* and [y] in *"armure,"* and then sharpened by the [ɲ] in *"hargneuse.* There the *a* is immediately softened by the [œ],which continues mellifluously in *"rumeur," "poussiéreuse"* and the final *"ingénieurs."* One of the most interesting occurrences of the front *a* is in its lengthened form in the last syllable of *"avantages,"* in *"dont nous attendons tant d'avantages,"* referring to the anticipated marvels of industrialization, two nasal *o*'s overlap with the initial front *a*'s, which are followed by two nasal [ã]'s before the lengthened *a*, a combination that strongly stresses the *"avantages."* At the end is an echo, with the same lengthened front *a*, in the rhyming *"mirages,"* whose meaning here exactly contradicts that of *"avantages."* Thus the sounds emphasize the contrast between the real advantages envisioned and the unreal mirage received.

The humor is gentle, ironic, stemming from the naive presentation by Uncle Jules's niece or nephew, who is so impressed by the Pompidou Center, especially the escalator. Because the human race survives through its ability to adapt, the Pompidou has been accepted, recognized as uniquely innovative in its library system (with open stacks) and it undeniably provides invaluable resources in contemporary art, music, and film, as well as a venue for the spontaneous street theater all around it. Nevertheless, some still feel the building is the visible symbol of the Big and Ugly. With all its technological marvels, those "advantages," we are still left longing for the imagined calm beauties of a natural "yesteryear," now only a "mirage."

Following the order of the texts as presented in *Avant-goût IV,* the next card is *Le Château noir [The Black Castle]*

Il est comme un bloc de houille au sommet de la butte, illuminé non point de braises, mais de phosphorescences froides. On l'appelle aussi le piège à Lune. Même en plein jour l'image de celle-ci est emprisonnée dans la tour, et cette captive suit fidèlement les phases de son modèle céleste. Il paraît que lorsqu'on réussit à découvrir le portail de cette forteresse aux moellons d'obsidienne si bien jointés, polis à miroir, on découvre à l'intérieur une ville entière en miniature avec l'agitation de ses véhicules chargées de lutins élégants, menues cannes à pommeau d'or, éventails de cailles ou de perruches, qui se déversent dans les bals ou les théâtres, ou encore s'écrasent sur les

Jiří Kolář, *Le Chateau noir* **[The Black Castle].**

ponts, afin d'admirer les feux d'artifice qui illuminent les voûtes vénérables où tournent lentement des étoiles peintes.[140]

The juxtaposition of the reality of Kolář's castle firmly situated in a real landscape plus the reality of the Paris night scene creates the startling unreality. We know very well the real Paris, with or without an abnormally large moon (which seems too big to have been part of the original city photograph), is not enclosed in a medieval castle. Little of the reality appears in the text: only the castle on its neatly terrassed "hillock," its vaults, and the moon. Of course, anyone would have difficulty in "succeeding in discovering the gateway of this fortress" since the face of the castle is obliterated by the photograph. The castle's lighting and polished stones are already part of the created unreality. Since there is now a Disneyland outside Paris, Butor would not necessarily be drawing on United States experiences in his painted stars, false interior night that reveals the "image" of the moon, and the activities of his

elegant goblins." However, it is easy to see the scene as a representation of some tiny automated Disney world, which is the ultimate in the carefully animated and technologically perfect artificiality.

The hard [k]'s and hiatus of the first phrase, *"comme un bloc de houille"* accord perfectly with that harsh black castle of the collage, but, after additional initial *b*'s, the fricatives and sibilants of "phosphorescences" lead to the soft sounds of the *"piège à Lune."* The hard sound [wa] of the *"froides"* is then regularly used in words suggestive of the cold and hard: the *"noir"* castle of the title, the *"moellons"* which are *"jointés"* and polished to a *"miroir"* surface, and in those other objects always conceived of as cold, the *"étoiles"* at the end. The *i*'s and [y]'s of the opening maintain as the primary vowel sounds, including the repetition of *"illuminé"* at the beginning and *"illuminent"* at end. The primary consonantal sound is *p,* usually initial but cunningly inserted also in the stones of *"obsidienne."* Thus the harsh sounds predominate in the outward appearance of the castle, the soft sounds in the imprisoned

moon and in Butor's vision of the imagined population of the miniature city. The harmony is fundamental to the beauty of this text.

Humor is limited to the lunatic idea, in the original sense of the word, of capturing the moon—a project accomplished by using an artificial one—and then to the familiar city reduced to a toy and populated by tiny goblins busily doing just what life-size Parisians in the real-life city do. One is reminded of Gulliver and his hilarious and often satirical adventures.

The next card *Opéra d'automne* [Autumn Opera] takes us to another familiar Parisian site.

> *La ville nous propose des spectacles à n'en plus finir. Au sortir des tunnels où la jeune et terrible fée électricité fait mouvoir mystérieusement des wagons de métal aux confortables canapés de bois et de cuir, un peu étourdi par tous ces crissements, grincements, tintamarres, notamment quand deux trains se croisent dans les virages à peine éclairés de loin en loin par un lumignon protégé dans quelque niche creusée dans la paroi suintante, il suffit de s'accouder à la balustrade du promenoir pour découvrir au-delà des chaînes protectrices un délicat décor de brumes derrière le clocher bulbeux d'un idyllique village où l'on sent que ne vont manquer ni sanglots argentins ni rires en cascade, avec le grondement des torrents et le cuivre des feuilles mortes qui tournoient doucement jusqu'aux tables de la taverne chargées de cruches et de fruits. (Avant-Goût IV 119)[141]*

Kolář's photograph of the metro staircase, with its "balustrade" and "protective chains," in the foreground of the artwork, has evoked its atmosphere for Butor, and his description in the text of the metro is very realistic. On the other hand, nothing is more unreal than opera, with its laughably implausible plots. Kolář's Garnier Opera, then, is the source of the "silvery sobs" and "cascades of laughter," which Butor transposes to the intercollage of the "fogs" behind the "bulbous steeple." The "torrents" and "dead leaves" would be those of the mountains seen there. The "idyllic village" is not visible to us, but could be derived from the indistinct shapes in the street in front of the Opera, below the intercollage, which have become for Butor the tables of a tavern appetizingly "laden with pitchers and fruits." Thus, as with the goblins of *Le Chateau noir*, Butor has added an

Jiří Kolář, *L'Opera d'automne* [The Autumn Opera].

element not seen in the artwork. However, the goblins and their artificial surroundings contributed to the unreality of that scene, whereas here the village tavern adds a charming feeling of reality.

The contrast is even sharper here than in the previous two texts, between the city, where "young and terrible" electricity reigns and the village, where leaves "revolve gently down." The noise of the metro is certainly unpleasant, even a little menacing: it moves "mysteriously," powered by that "terrible" electricity, through dimly lit tunnels. Its racket contrasts with the operatic "silvery sobs" and "laughter" heard in the village. The reference to Raoul Dufy's enormous 1937 painting, *Fée électricité* [*Electricity Fairy*], recalls the belief prevalent earlier, when the century as well as the use of electricity were "young," that there is something frightening, perhaps magical, about electricity. This feeling coincides with the awe of the speaker who was so impressed with the escalator at the Pompidou Center.

The main harmonic technique here is the alliteration. The soft *m* of the first lines, *"mouvoir," "mystérieusement," "métal,"* reappears toward the end in the *"mortes"* of the dead leaves. Between occur frequent alliterative *t*'s, repeated within the same word in *"électricité"* and *"tintamarres,"* but it is the initial hard [k] generated by the metro that predominates. The sounds of the metro are emphasized in the series *"crissements, grincements, tintamarres,"* in the overlapping sibilants, rhyming nasal *e*'s, and the *r*'s not only of *"tintamarres"* but also of the initial consonant groups in [kr] and *gr*. Many other consonant groups follow, with *r*'s and other consonants: the *"sanglots argentins"* of the opera, its *"grondement"* and *"cuivre."* Two soft [ʃ]'s appear, *"chaînes"* and *"clocher,"* and it is finally the alliteration of these hushing consonants in *"chargées de cruches"* that ends the text. Thus the sounds take us from the clatter of the metro to the tranquility of the *"village idyllique,"* where the *i*'s of the opening lines, threatening in *"terrible"* and *"électricité,"* reappear happily in *"rires,"* brightly in *"cuivre"* and juicily in *"fruits."*

The mild touch of humor is provided by the speaker's reaction to the thrills of the metro, so overwhelmed that he describes the wooden seats of the old metro as "comfortable."

C'est pour la visite officielle de la famille souveraine dans une fameuse et vénérable principauté entre Autriche et Suisse que notre ministre des cérémonies et décors a chargé un jeune artiste aussi sollicité que contesté, de transformer le lourd monument d'une de nos places les plus affairées en une sorte d'appel d'air. Bien sûr, il y a là quelque trompe-l'oeil, c'est en grande partie de la toile avec des images projetées par des centaines de lanternes disposées tout autour sur les toits des immeubles, reconsti-

tuant le paysage en changeant l'éclairage selon l'heure avec cet avantage qu'on peut y prolonger le soir par exemple quand tout le reste est dans la nuit. Et l'on y entre cette fois; on y trouve un sentier à s'y méprendre, de véritables branches, des cailloux, des rocs, une source, des solitudes. Certains des visiteurs n'en ressortent jamais. L'un d'entre eux aurait déclaré: "C'est ici qu'est notre dehors." On ne l'a plus revu depuis. (205)[142]

The intercollage *Triomphe de la vallée* [*Triumph of the Valley*] is very visible in the text and Kolář is obviously the "young artist" named as set designer for the visit of Lichtenstein royalty. Some of the traffic of this "one of our busiest squares" around the "heavy monument" can be seen, and some of the spotlights that normally illuminate the Arch of Triumph. In a still photograph we cannot observe any changing lighting, and for us the time of day inside and outside is the same. Nor, of course, can we see that the natural elements in the intercollage are not photographs, but "veritable," nor experience what that "certain visitor" did, feeling the photograph more real than reality. But we can see very well the contrast between the winding roads on the open mountain slopes and the rigidly straight lines of buildings, with their symmetrical little windows, along the avenues behind the Arch of Triumph.

The predominant sounds of this text, *i* and *l*, are introduced right away in the title. Other sounds in *"triomphe"* are put to significant use: first, the [f] is frequent in the first sentence and then disappears except for *"cette fois"*—and "this time" is indeed different from the previous scenes, for here it is possible to enter the scene of the intercollage. Second, the nasal *o* if *"triomphe"* recurs exactly in those words contrasting the artificial with the genuine: *"trompe-l'oeil"* and *"prolonger,"* as the lighting effects, previously suggested by the *Electricity Fairy,* are used deliberately to create unreality by extending a false tranquil evening in the middle of an actual crowded night. These effects are emphasized further by the assonance of nasal *e* in *"centaines"* and *"lanternes,"* and then by the two rhymes of *"reconstituant le paysage"* and *"changeant l'éclairage,"* forcefully repeated in *"avantage,"* the very advantage of the false prolonged evening. These sounds will recall the "advantages" of "industrial progress" in the first text, which proved to be after all "mirages." Hushing consonants and the soft [u] occur throughout, which give added force to the strong sounds of *"déclaré,"* and to that declaration itself, with its gasping internal hiatus, *"dehors."* The last line then soothes with the rhyming [y]'s of *"plus revu"* before the final *"depuis"* whose semivowel [ɥi] musically reminds us of the opening *i*'s. With its use of the same sound in related words, its repetitions, rhymes, and the resonating echoes of the previous texts, this text illus-

Jiří Kolář, *Triomphe de la vallée* [Triumph of the Valley].

trates particularly well Butor's artistry in the harmony of poetry.

Humor may be found in this text in the exaggerated qualification of Lichtenstein as "famous" and in the described complex decoration of its rulers' official visit—when in the real world flags on the lampposts of the Champs-Elysees are deemed sufficient to welcome rulers even of whichever world powers are currently deemed greatest. Another such touch lies in the evaluation of the "young artist" as "as much sought after as argued over." It would be a marvelous development if Parisians were to pay excited attention to Kolář's work, but that seems about as likely as an expensively decorated welcome for the Lichtenstein delegation. The litotes in limiting description of the Arch of Triumph to the simple word "heavy" is humorous by contrast. The adjective is accurate enough, but is that really all there is to say? The image of "visitors," who are unlikely to be Parisians, since no one visits the sites of his home town, but rather tourists—and we may picture them with camera, binoculars, Michelin guide, and dangling water bottle—announcing that the valley of the intercollage is the ultimate "outdoors" is comic in its ridiculous unre-

ality. We cannot be concerned about that one tourist who has not returned because within the fantasy it is clear he has deliberately chosen to stay, is living peacefully in one of the tiny houses dispersed along the rare roads of the Valley, and is contemplating the natural beauties. The speaker's calm and unquestioning acceptance of the story underlines its impossibility.

The four collaborations together form a coherent whole: there is progress from the first, where at the *Beau burg* we are specifically informed that it is "not yet possible" to visit the castle seen in the intercollage. In the second, we might succeed in finding a way in to that castle; in the third we can see the "idyllic village" right beyond the "protective chains," and finally "this time you go in." The speaker whose Uncle Jules is showing him around at first is very enthusiastic about the marvels of the Pompidou, and not especially attracted to the castle and its calm surroundings, but is rather intrigued by the captive moon and busy goblins. Then he is excited and somewhat frightened by the noise and dark of the metro, while finding the scene of the foggy "village" with its appealing café tables "deli-

cate." Finally he responds to that "call for fresh air" very favorably, conceding that "of course" there is "some" trompe-l'oeil, but he watches the lighting effects approvingly. He seems tempted to follow that visitor who never came back.

As for the harmonies of these collaborations, we have heard the sounds musically reflect and reinforce the meanings of the texts as they shift from one to the next. Some patterns recur: hard consonants and consonant groups are contrasted with *m*'s, *l*'s, and hushing consonants, while soft [u]'s and [y]'s alternate with harsh front *a*'s. In all there is a predominance of *i*'s: the *"édifices métalliques"* of the *Beau burg* reecho in the *"emprisonnée . . . captive"* in the *Chateau noir* and then in the *"crissements"* of the metro and the *"village idyllique"* of *L'Opéra d'automne,* at last encircling the *Triomphe de la vallée* in the *"visite officielle"* and final *"depuis."* Particularly effective in emphasizing the political statement is the rhyme *"avantages/ mirages,"* announced in the first text and echoed in the last.

One humorous aspect derives from the whole: the satire on Paris as the tourists' Mecca, emphasized by the conspicuous absence of the name. If there is any universally accepted truth in tourism, it is that Paris comes first, and Paris stars in all four of these collaborations. In three of the four artworks it is the subject of the primary photograph; in the other, it is the city of the intercollage. Yet the texts identify the city only by title or reference to the "city" or "capital" in three of the four; in the fourth, the sovereigns of the principality would be making their "official visit" to that "capital." Tour buses regularly make the circuit of these four "sights" of Paris: the Arch of Triumph, the Garnier Opera, the Eiffel Tower and the Pompidou Center. The humor derives from the insidious subtext. We thought we were going to read one more poem in praise of the beauties of Paris, and we end up convinced we would rather visit the natural world of Lichtenstein. Thus Butor turns the reader upside down. We should have expected it, since this Uncle Jules, unlike the original, has actually returned.

Throughout, the real and unreal are contrasted, initially through Kolář's two photographs in each, which individually show reality but that, when juxtaposed, create unreality. Butor treats each differently, but in all the question is posed of what is truly "real." At the Pompidou (real) the speaker specifically tells us that the castle is a mirage (unreal), even though we smell the forests and hear its sounds—the engineers are very accomplished in synesthesia! In the *Chateau noir* (real) it is the artificiality of the little Paris (unreal) that is emphasized, not its natural surroundings, which this time are the real. At the Opera the metro is very real, but it is in the invisible village (unreal) that we hear echoes of the vocal sounds of the (real) Opera, combined with instrumental sounds from the mountain scene (real) and learn of taverns that are invisible to us (unreal). In the last text the real is reduced to the "heavy monument," while the remarkable lighting effects that change night into day are directed at projected images (unreal) in trompe l'oeil (unreal). Entering the mountain scene (unreal) we are specifically warned that the path "may mislead us," apparently with its "veritable branches," etc. Thus in the Valley, become unreal in its present setting, it is the real that could confuse us. Like the tourist who never returned, we can no longer distinguish the real from the unreal. The mirage, the artificial stars, the stage set of the "idyllic village," and finally the trompe l'oeil, all make very clear that within the confines or frames of the depictions of Paris, the supposedly natural beauties are only man-made pretense, appealing, but fake.

Political statement pervades this text: industrial expansion is destroying (or has destroyed) the natural. In the first collaboration, Butor introduces Uncle Jules's and his young tourist relatives' interest in "progress." In the second, "they" are holding the moon captive, but it is artificial, only imitating the real thing. The occupants of the city, in this variant on Butor's "I hate Paris" theme,[143] are enclosed, removed from the natural setting as they revel in man-made delights. They choose to devote themselves to decadent frivolity and to ignore the true splendors of nature outside the city—or castle—world. In the third, there is the hint that electricity might be frightening, and in the last, the "call for fresh air." Even as Paris stars, the artworks suggest and the texts specifically name air pollution, noise, overcrowding, and the frantic quest for "distraction" of the city. The careless human lust for more of everything, luxury, entertainment, technology has gobbled up too many "springs" and "wildernesses." To experience the true peace and quiet of unspoiled mountain countrysides we must go to Lichtenstein, vigorously and favorably contrasted with the simulacra of the "city of light."

In Kolář's transformation, rough bare rock above the timber line touches the gilded symmetrical border of the roof of the Arch of Triumph, encapsulating the beauty of the natural versus the not so beautiful of the man-made. Butor does not propose solutions to the ecological problems of the planet, but in his title it is the *Vallée* that triumphs, and there is no doubt of his position. We must revisit the innocent enthusiasms of a century ago and recognize where they have led us. The so-called "advantages" of industrialization we now know are rife with problems and are themselves deceptive, dangerous "mirages." We must manage to differentiate between the real and the unreal, resist the artificial, and seek the truth.

4

Michel Butor and Pierre Alechinsky: The Double Gaze

INTRODUCTION

We turn now to Butor's collaborations with Pierre Alechinsky, whose works are very different from both Monory's and Kolář's. No longer do we find photographs of usually identifiable subjects, however altered by the artist to create new compositions. Where, for example, in Kolář's *Orgue de pieds et de bras,* it may be difficult to discern the subject matter, there is still representation. In Alechinsky's works, recognition of a subject often requires considerable imagination, and we will see that this is a challenge Butor accepts gleefully. Alechinsky's media are prints, Chinese ink drawings, and painting in acrylics. Further, Alechinsky often uses as support for his ink drawings *"papiers trouvés"* [found papers], the title given Chapter V of *Alechinsky dans le Texte* [*Alechinsky in the Text*].[1] In these pieces the completed artwork is composed of two different media, the printed or handwritten support and the superimposed drawing, which often obliterates parts of the original.

Studying Butor's collaborations with Monory required copies of the artworks and the two editions of the texts. Examining the ones with Kolář demanded those, and in addition a magnifying glass, strips of paper to cover one part of a *prollage* in order to see the other part more clearly, access to art libraries, and a functioning imagination to conjure up collages of which we have no reproductions. For treating the Alechinsky collaborations we need copies of the different editions of not only the texts, but also of the artworks, since the prints may be published in more than one stage, still a magnifying glass, probably not the strips of paper nor the art libraries, but definitely the imagination.[2]

Background information on Monory had to be found in art criticism beyond the collaborating pair, that for Kolář from similar external sources, but also from Butor's own statements about Kolář's work in *L'Oeil de Prague* and numerous other books. For the most part, we will not need externally produced information for Alechinsky, as Butor has written three books devoted exclusively to his work.[3] These three books, *Alechinsky dans le Texte, Alechinsky: Travaux d'impression* [*Alechinsky: Printed Works*] and *Frontières et bordures*

[*Frontiers and Borders*] (here abbreviated as *Texte, Travaux,* and *Bordures*) introduce another dimension. All three books carry two authors' names, Michel Butor and Michel Sicard. Further, the book *ABC de correspondance* [*ABC of Correspondence*][4] is also attributed to both Butor and Sicard. It contains, along with prose interpretations of Alechinsky's work in the part entitled *Grosses en stock* [*Gross in stock*], a poetic series of texts in the other part, *Dessins sur factures* [*Drawings on Bills*], which are collaborations between Butor and Sicard on the one hand and Alechinsky on the other. Sicard was Butor's student and Butor specifically states in *ABC* that their texts went back and forth between them. It is true that some of the *Dessins* texts seem to be unquestionably Butor's, and in their conversations recorded in the two other books comments are frequently attributed to Sicard that sound more like Butor himself. However, I generally treat the Butor/Sicard (here referred to as MB/MS) voices in all these texts as an entity and do not try to untangle this collaboration, since my focus in this study is limited to the collaborations between Butor and the visual artists.[5]

Alechinsky's works on "found papers" have elements in common, whether manuscript, letters, maps, or bills, and as an aid in understanding these collaborations, we have the exhaustive analysis by Butor/Sicard in *Travaux.*[6] In addition, in *Grosses en Stock* MB/MS thoroughly examine Alechinsky's series of artworks on old letters. The title is a pun on the name Stock, private secretary of the Duc d'Arenberg, to whom the Duke wrote the letters. MB/MS scrutinize the seals, carelessly blotted signatures, letterheads, patterns on the page, and spots. They catalogue the devices Alechinsky uses in drawing on the old letters: capture of lines, creation of figures, ornamentation, concealing, *"respiration des touches"* [breathing of the brushstrokes], an expression that refers to Alechinsky's frames in dotted lines, connecting or not with the handwritten lines of the support. They look to see his integration of the flourishes of the signatures and other handwriting into a figure, and of the lines of handwriting not only as part of a background or of a frame, but also as parts of the figure itself. The composition is studied carefully: the framing Alechinsky may or may not add, his use of blank spaces as

opposed to those of the support itself, his own signature and date.[7] As for the works on old maps, the entire chapter, *"Cartographies,"* in *Bordures* (73–104) is devoted to them.[8] Works on old bills are discussed in *Travaux* (96–102 and 123–28) and in *Texte* (122–28). These MB/MS interpretations help us to learn to look at Alechinsky's work, and I will refer to these commentaries as appropriate.

MB/MS's close reading of the support as well as of the drawing itself leads us to expect that Butor's text derived from his meticulous scrutiny of a given Alechinsky work on a "found paper" will reflect that support as well as whatever Alechinsky has added, drawing on, around, and in it. We have ample material for this consideration, as four of the works treated here are on "found papers": *Stances des mensualités* [*Stanzas of Monthly Payments*], *La Méduse des chocolats* [*The Medusa of the Chocolates*], *Comptine en blanc et noir* [*Counting Rhyme in white and black*], as well as *Dessins sur factures.*[9]

Before analyzing the collaborations, I need to supply pertinent biographical information about Alechinsky. Born in Brussels of parents both medical doctors, his childhood was affected by his being left-handed. Since at that time schools regularly tried to force children to use their right hand, he felt himself to be a dunce and took refuge in drawing. He has said he still feels part of a persecuted minority, seeking revenge on the world of the right-handed (*Texte* 78–84).[10]

After the war Alechinsky became, in 1949, the youngest member of the Cobra group. These artists, including Asger Jorn, Karel Appel, Walasse Ting, and Christian Dotremont produced works in all combinations of collaborations.[11] Explaining the name "Cobra" as derived from Copenhagen, Bruxelles, and Amsterdam, the original homes of the artists, Dotremont added that they may also have wanted to associate themselves with the bestiary.[12] The group's brief existence from 1948 to 1951 falls generally into the abstract expressionism movement, precursor to "action painting" (Schultze, *Extraits* 91).[13] Butor clarifies differences between the "automatism" of the surrealists and the spontaneity of Cobra, the latter similar in some ways to Jackson Pollock's (*Texte* 19, 23), but Butor specifies that Pollock never engaged in collaborations. Butor also distinguishes between the "Exquisite Corpse" (*cadavre exquis*) of the surrealists and the use of old papers by the Cobra artists:[14] in the latter the original drawing or writing is not concealed; rather, it becomes the soil from which *"quelque chose d'autre pourra pousser et fleurir"* [something else will be able to grow and flourish] (*Texte* 120).[15] Critics regularly refer to the Cobra experience as fundamental in the development of Alechinsky's art.

With the dissolution of Cobra in 1951 due to the ill health of both Dotremont and Jorn, Alechinsky moved to Paris, where with Hayter he studied engraving—appropriate for the left-handed, since a print is always reversed. In 1954 he met Butor. In the same year he learned from the Chinese-American artist Walasse Ting how to paint standing above canvas or paper spread out on the floor.[16] A visit to Japan the following year to film a documentary on calligraphy was a critical experience, especially because he was given the paint brush he would use for his work in inks for the next thirty years (*Bordures* 42). Reproductions of these early Alechinsky works, discussed by MB/MS, appear in *Travaux.*

It was Ting who introduced Alechinsky to acrylic paints in New York in 1965, and Alechinsky virtually abandoned oils. He compares himself to Swann, who for twenty years loved a woman who was not his "type"; oils were not Alechinsky's medium (*Paintings* 86–87). Critics agree that *Central Park,* his first work in acrylics on paper, is a landmark in his development.[17] It is in this painting that he adds for the first time what he calls *"remarques marginales"* [marginal remarks], black ink drawings that comment on the colorful center. For these big paintings, including the *"encres entourées"* [enclosed inks], which have black inks in the center and color in the frame, his techniques are unusual. He begins by creating an interesting surface by wrinkling the Formosa paper (which does not fade with age), before spreading it on the floor. Once the Chinese ink of the drawing has set, he determines, walking barefooted around the piece, where to put fresh ink lines or spots. He then uses a *lavis* [wash] in the form of a bucket of water splashed on the work. This process creates different nuances of gray or black that are more or less transparent. These are particularly effective when the support is a map, as in those used in *L'Atlas universel* [*The Universal Atlas*], for which Butor wrote his *Comptine en blanc et noir.* The paper is delicate, and in order to preserve it or to use acrylics (for frame or center, depending) he pastes it on fabric. He tells of looking everywhere for a long time before finding just the right kind of fabric, the same used by Pollock and Rothko for their monumental paintings. He finally located the source, which turned out to be next door, in Flanders (*Bordures,* 49). The smaller ink drawings on old papers often have been treated with a *lavis,* and in his etchings and lithographs on blank paper he utilizes similar techniques to produce variations in the ground.

Butor's interest in Cobra artists probably stemmed from their shared willingness to collaborate and to seek open-endedness. Butor specifies in *Texte* that the idea of collaboration was hardly new, citing the examples among others of Reubens and Breughel de Velours. From the recent past he describes the Cobra example of

Brauner and Matta, each painting a figure within the work of the other.[18] That the Cobra artists did not insist on personal recognition individually, but recognized that *"regarder les oeuvres d'autrui ne feraient que les enrichir"* [seeing the works of others could only enrich their own] (21), is a related position Butor certainly supports. A collaboration with Dotremont appeared in *Michel Butor et ses peintres* in 1973, and his collaborations with both Dotremont and Appel were included in the exposition, *En compagnie de Michel Butor* [*In the Company of Michel Butor*] in 1986.[19] The correspondence with Dotremont from 1966–79, the year of Dotremont's death, thoroughly documents Butor's interest in and sympathy with Cobra.

Highly experimental, Cobra took as a *parti pris* the same open-endedness Butor gives witness to. An example in Alechinsky's work is the cobra figure itself, who appears very frequently. Commonly seen as symbol either of wisdom or of evil, the serpent of Alechinsky is not so readily simplified. It is *"en vérité, un animal peu recommendable. . . . Pervers et protéiforme, il joue à cache-cache avec le pinceau d'Alechinsky"* [in truth, a scarcely respectable animal. . . . Perverse and proteiform, it plays hide-and-seek with Alechinsky's brush].[20] For Alechinsky, Butor says the cobra is *"celui qui transmet le message et maintient la tradition"* [the one who transmits the message and maintains the tradition], akin to Kipling's python-counselor, but adds, regarding the snakes in *"Partant du lac Ch'I Lin"* [*Starting Out from Lake Ch'I Lin*], that *"il peut exister de mauvais cobras, une trahison par rapport à l'enseignement du cobra ancien"* [bad cobras may exist, a treachery in respect to the teaching of the ancient cobra] (*Texte* 96–97). Whatever other function the snake may serve in a given Alechinsky work—and MB/MS and other critics interpret it in all gradations from the essence of evil to a beneficent totem—it always recalls Alechinsky's initial experience with the Cobra artists.

This possibility of multiple interpretations, undoubtedly attractive to Butor, could provoke impatience in the viewer. Where the uninitiate could see his work as an incomprehensible tangle of meaningless squiggles, Butor's texts show us how to look at it. Others, too, seem to know how: for example, Ionesco said of *Central Park*, *"Il est facile de mal dessiner. Il est plus difficile de bien dessiner. Il est plus difficile encore pour celui qui sait bien dessiner de mal dessiner. Dans le 'mal dessiner,' Alechinsky exprime son enfance, ses obsessions, ses épouvantes, son comique"* [It is easy to draw badly. It is more difficult to draw well. It is more difficult still for one who knows how to draw well to draw badly. In his 'drawing badly' Alechinsky expresses his childhood, his obsessions, his terrors, his comedy] (*Extraits* 145). Of particular importance to our

analysis of the collaborations is Butor's position on the effort to distinguish the figures, even as they change before our eyes—and they do: Sicard speaks of Alechinsky's having reached *"les limites de la figuration"* [the limits of figuration] in his inks on aeronautical maps, but Butor replies, *"Il est impossible de les interpréter comme un abandon de la figuration. Plus variée, plus poussée qu'avant, dans bien des cas, elle nous oblige à entrer davantage dans les détails"* [It is impossible to interpret them as an abandon of figuration. More varied, more elaborate than before, in many cases, it obliges us to enter farther into the details] (*Bordures* 102). But even MB/MS mention Alechinsky's *"fâcheuse tendance"* [annoying tendancy] not to encircle a given figure completely (*Texte* 101) and do not hesitate to use the titles for hints in recognition of figures (*Bordures* 41). Beyond the snake, MB/MS identify numerous recurrent figures: two semicircles that become closed eyes and then breasts (*Travaux* 42), eyeglasses (93–95) as on the cobra's hood or *"le double regard"* [the double gaze] (121–22), faces in profile (*Texte* 45), labyrinths, sphinx, the carnaval figure of Gilles with a plumed headdress, circles becoming disaster (47), volcanos, waterfalls, stuck-out tongues (*Texte* 56, *Travaux* 89), the "speaking" pictures that look at the viewer (*Texte* 58–60). Of these, perhaps the painting that looks back at us might be of most interest to Butor, in his quest for reader participation.

Many other aspects of Alechinsky's work would appeal to Butor: his revisions, the oriental influence, the incorporation of real-life impediments, his own writings and his sense of humor. The spontaneity controlled by the possibility of touching-up, of additions, as in Alechinsky's predellas or "marginal remarks" is very like Butor's own matrices or system of successive publications. With the matrices, setting the machine he has created in motion, he lets it run its course, subject always to his subsequent adjustments.[21] To mention only two examples, his *Envois* add an introductory paragraph to an original text, and the series of *Illustrations* is an intensely concentrated rearrangement of previously published works, with new additions. Sicard says to Butor, *"Il est des façons de rassembler de manière créatrice des oeuvres déjà existantes. Chose que vous connaissez, pour avoir souvent repris et 'réanimé' vos textes"* [There are ways of reassembling in a creative way works which already exist. Something which you know about, having often taken up again and 'reanimated' your texts] (*Travaux* 137). Alechinsky's "big inks," with their predellas and marginal remarks, produce a similar effect in a different medium. Both etchings and lithographs lend themselves well to the production of different "states," as we will see in the *Le Chien roi* [*The Dog King*] and the *Le Rêve de l'am-*

monite [*The Dream of the Ammonite*].[22] Butor says Alechinsky is a *"technicien hors ligne dans nombre de domaines de la gravure"* [superior technician in numerous domains of engraving] (*Texte* 71).

Alechinsky's "Chinese" style of painting large works with the canvas on the floor, as well as his Japanese calligraphic brushwork, could not fail to interest Butor. His fascination for the Far East can be seen among many other examples, in his collaborations with the South Korean artist Seund Ja Rhee and most recently in his inclusion of Chinese poetry in *Gyroscope*.[23]

The intrusion of real life on the artist's intention is shared between them. Explaining that in his house in Provence the size of his drawing table determined the size of the "marginal remarks" in the first large ink works, Alechinsky wrote, *"L'esthétique a ses raisons que la raison ne connaît pas"* [Aesthetics has its reasons which reason does not know].[24] Similarly, Butor wanted the lines from Ronsard included in his *Poème optique* collaboration with Dotremont to be printed in red. This incident occurred before *Boomerang,* and the publisher said it could not be done. Butor settled for a different typeface.[25] "Aesthetics has its reasons," and many times in his letters and interviews Butor mentions the way he would have wanted something to be printed, which finally could not be done.

That Alechinsky is a writer Butor has mentioned repeatedly, especially when Alechinsky says, *"Je peins parce que je n'ai pas la parole"* [I paint because it is not my turn to speak] (*Paintings* 26). Butor has often spoken of the importance of titles in literature, in the works of others as well as his own. That Alechinsky shares this opinion relative to artworks is demonstrated by his offering in 1967 to sixty-one writers the opportunity to entitle some of his works; only Ionesco and Butor passed the test (*Texte* 155).[26] This work, *Le Test du titre* [*The Test of the Title*] is subtitled *"6 planches et 61 titreurs d'élite"* [6 engravings and 61 crack titlers]. Two years later, in *Les Mots dans la peinture* [*Words in Painting*][27] Butor, while studying the function of a painting's title, calls Alechinsky a *"titreur d'élite."*

Alechinsky's sense of humor must be an important bond between the collaborators. It is irresistible to cite his postcard to Butor from Niagara Falls, after the publication of *6.810.000 litres d'eau par seconde* [*6,810,000 Liters of Water a Second*][28] as well as the collaboration, *Le Rêve de l'ammonite: "Toujours autant de litres: pas un de plus, pas un de moins. Parmi les cadeaux souvenirs, des tranches d'ammonite polies; c'est pas le rêve"* [Still as many liters: not one more, not one less. Among the souvenir gifts, slices of polished ammonite; it is not a dream] (*Texte* 52).

My order of examination is chronological. Of the seven collaborations, four are on supports of different kinds of old papers, as mentioned above, and three on a ground unadorned previously. The first is Butor's contribution to *Le Test du titre* (1967), black-and-white etchings. The second work is the second part of *Hoirie-Voirie* [*Inheritance–Garbage Dump*] (1970)*, Stances des mensualités,* in black inks on a support of old letters.[29] The third work is a drawing in black ink on an old bill: *La Méduse des chocolats,* exhibited in 1973 in *Michel Butor et ses peintres* and included in his *Guirlande liminaire,* the catalogue of that exhibit. The fourth work is *Le Rêve de l'Ammonite,* which began as the series of etchings in brilliant color that provoked Butor's text. The text then went back to Alechinsky, who added lithographed "marginal comments" and later a run of the etchings in different colors. An additional stage exists in only three copies; Butor's textual additions are reproduced here in Appendix F. The fifth work treated here is Butor's *Comptine en blanc et noir* included in *Bordures* (1984), corresponding to Alechinsky's ink drawings on old maps, some of which have color. The sixth is also a series of etchings, each in two stages, one with frames in stencilled watercolor, *Le Chien roi* (1984). The seventh is a collection of nineteen ink drawings on old bills, which served as basis for the joint collaborative text of MB/MS, *Dessins sur factures* in *ABC of Correspondence* (1986).

I will pursue the consideration of harmony and humor as they support a political message. Alechinsky's humor is already apparent in his artworks, and certainly his political position is evident in the works on "found papers": when the support is a legal document or old bill, Butor calls them *"papiers capitalistes"* [capitalist papers] (*Texte* 121). The past is revived in a new form and finally the papers are given genuine value through Alechinsky's art. These collaborations provide excellent examples of the many different ways Butor has derived inspiration from artworks for his texts.

LE TEST DU TITRE

In 1967 Alechinsky offered Butor and other artists and writers the opportunity to entitle a series of six of his engravings. The directions were: *"Offrir prénoms, citations, phrases descriptives, informations, rétentions, ironies, tirades, hommages, poèmes, giffles à la queue leu leu à des paquets d'images muettes"* [Please give first names, quotations, descriptive phrases, retentions, ironies, tirades, tributes, poems and slaps, one after the other, to sets of mute images]. The responses were published together with the engravings in *Le Test du titre: 61 titreurs d'élite* [*The Test of the Title: 61 Crack-shot Titlers*].[30]

Among the sixty-one are Cobra artists Karel Appel, Pol Bury, Asger Jorn, and other artists including Hundertwasser, Wilfredo Lam, Lichtenstein, Magritte, Matta, Saura, Walasse Ting, and the film director François Truffaut. In addition to Butor, the writers include Italo Calvino, Julio Cortazar, Carlos Fuentes, Julien Gracq, Eugène Ionesco, Joyce Mansour, André Pieyre de Mandiargues, Christiane Rochefort, Claude Roy, Philippe Sollers, and Yves Bonnefoy, the last labeling all six engravings, "Sans titre" [Untitled]. Each titler interpreted the instructions differently, but according to Alechinsky, only Ionesco and Butor passed the "test" (Texte 155).[31] However, Ionesco's lively and hilarious "titles" are separate descriptions, without the connections between them that Butor, and apparently Alechinsky, saw. Others among the titlers did read the engravings as a series. Lichtenstein entitled the last two, "SPLATT!!" and "Les désastres de la guerre" [The Disasters of War]. Walasse Ting named the same two, "Somebody push button" and "Where my nose? Where my foot?" Alechinsky's judgment on the results of the "test" reveals an opinion on examinations and examiners: success depends on one's ability to read the examiner's mind.

Reproduced here are Butor's responses, together with the engravings. Alechinsky created a challenging series for his "crack-shot titlers," and Bonnefoy's responses are understandable. We will match the elements in the text with those of the artworks—to the extent possible—before treating the work as a whole, its humor, harmonies, and political statement.

Text 1

Ça y est, je vous l'avais bien dit, la bouchère a présenté son bouquet de fleurs à l'épagneul qui l'a reçue de belle façon; tout l'immeuble en a fait des gorges chaudes. Quelle impudence! Ou quelle inconscience! Ou quelle . . . N'est-ce pas? Quelle . . . Qui l'aurait cru?[32]

Identifying in the first engraving, *Ça y est!* [*There you are!*], the elements that Butor selected to create his text, we find windows with three faces looking out and an empty space for a door, which create the "building" full of laughing neighbors; two others observe from outside.[33] The face in the central window, with its fingers on the sill, is a cartoon character, its bulbous nose making it the very image of a nosey neighbor. The bunch of flowers is clear, held by a woman wearing a hat and long, spotted, snakey scarf; it is she who has become the butcher's wife. The face on the viewer's right with droopy ears gives us the spaniel. Any of the group of neighbors, especially the chicken face just above the spaniel, with its beady eye, observing carefully and close up, could have provoked the gar-

rulous narrator, stuttering out unfinished sentences as a chicken clucks. Butor does not speak here of the face on the left, under the scarf, but as the narrative progresses we will remember it, already present but not mentioned.

Text 2

Hé hé hé, tout s'écroule, l'épagneul est en capilotade; les fleurs étaient astucieusement fourrées de serpents, et avec toutes ces peaux de bananes que les gosses ont glissées sous les escabeaux, j'en connais qui n'en mènent pas large; un peu plus de panique, s'il vous plaît![34]

This second engraving, *Hé hé hé!* [*Hey, Hey, Hey!*], is as full of movement as the first was calm and posed, which Butor reflects in the reiterated opening word and the request for still more panic. Snakes and banana peels can be seen here, as well as straight and right-angled forms that have become for Butor stepladders. The curvilinear mass on the floor is the smashed spaniel; the grumpy face in the upper left is probably our disapproving narrator. The other three faces—the one peeking out of the ladderlike object, the one flying through the air with long groping hands and the one stuffed through the frame in the bottom right—all have suggested breasts. They could have become the "kids," as two of them have hands for distributing those banana peels. The one in the frame with hair in symmetrical wild curls could be the butcher's wife, and the one in the ladder has an expression that might be surprise at the condition of the spaniel, or else panic. It has the simple form of the face under the scarf seen in the previous engraving.[35]

Text 3

Ça pousse, ou plutôt ça repousse; il n'y a qu'elle à avoir des idées pareilles, et tout fumier qu'il était l'épagneul ne se doutait vraiment pas qu'au petit matin il servirait à engraisser la collection ma foi coquette de talons de souliers en pots, au feuillage peau-debananoïde. Un peu de sang par là-dessus, de la colle d'os, et voilà le pelage de Monsieur qui devient le fond de gazon le plus approprié pour mettre en valeur les premières roses glauques.[36]

In this third engraving, *Ça pousse* [*It is growing*], the narrative diverges farther from the images. Recognizable only are the roses on the left and the banana-peel foliage. The banana peels are actually the potted arrangement in the center rather than the "charming" shoe heel collection, which is clearly the pile of irregular squares and triangles on the right. The splashes at the bottom have become blood and the lawn. Somehow, for Butor, the figures above those on the T-shaped stands became the spaniel in fertilizer form. Again, Butor does not mention the face breaking the frame on the left.[37]

Pierre Alechinsky, *Ça y est!* [There you are!].

Text 4

 Stupeur! Le voici tout ragaillardi, qui se trémousse rigolard sur sa butte, un des plus jolis détails de notre arrière-cour; elle a eu tout juste le temps de rafistoler deux ou trois serpents plus très frais sur sa toque en manière d'oiseau-lyre. Oh, elle peut toujours faire la fière, arborer son petit sourire modeste et sûr de soi, le marmot de service en blêmit pour elle. Ce n'est que le prélude au guignol; j'aperçois le mari jaloux qui s'imagine.[38]

This fourth engraving, *Stupeur!* [*What a surprise!*], continues the triple structure of the previous one, also maintaining a quiet mood. Butor has found in the figure on the right the revived spaniel—it does have a tail, and we can see the "not very fresh snakes" in the "lyre-bird"

hat of the butcher's wife in the middle. The third figure on the right must have provoked the serving boy who has turned pale. The airborne creature seems to be still the narrator, who finally acknowledges that face peeking over the hill and recognizes it as the jealous husband.[39]

Text 5

 "—Elle en pleure de rire; elle l'avait miné!—Miné?—Le mari! Un peu de poudre dans la soupe, et quand l'autre requinqué, snobinard, pétaradant, la rose glauque à la boutonnière, a voulu rallumer sa pipe."[40]

In this engraving, *Elle en pleure de rire* [*She laughs until she cries*], the violent action is reflected in Butor's interpretation of it as an explosion. The question and

Pierre Alechinsky, *Hé hé hé* [Hey, hey, hey].

answer sequence in the text recalls the interrupted phrases of the first text. (We assume the narrator ducked out of the way of the bomb, as she is not seen here.)[41] Only the rose near the center is clearly identifiable. In the upper right is a form resembling a skull, seemingly all that remains of the husband.[42]

Text 6

 Elle triomphe; toutes les médailles; et les gens qui défilent depuis le matin en se chuchotant ses histoires; il faut dire qu'elle a su très bien arranger ça: un goût, une aisance, et ce décolleté qu'elle s'est trouvé . . . ; ça s'est semé tout seul, c'est l'horticulture à la bombe; mais après quelle patience, que de soins, toutes les fumures, les arrosages, les épuçages, elle y passait ses nuits; alors la rose corset, la rose plume, la rose parapluie, la rose pomme à douche . . . Il faudrait tout citer.[43]

The strong dark strokes in *Elle triomphe* [*She is triumphant*] Butor does not see, as he did in *Elle en pleure de rire,* as an explosion, but rather as a celebration, while his butcher's wife is acclaimed for her success in bomb-gardening. Several of the people "parading" by may be seen on the left and one toward the center right; the haughty face on the far right would be the narrator, whose severe, reproving expression accords with "citing everything" in a legal sense. The butcher's wife is in the center with far too many breasts, the source of the "décolleté." The rose-corset is visible on the right, and the dark strokes have become rose-feathers and rose-umbrellas. The remarkable figure on the bottom left— which does not resemble a showerhead, even a rose-showerhead—Butor has chosen to omit.[44]

This collaboration illustrates very well Butor's imag-

Pierre Alechinsky, *Ça pousse* [It is growing].

ination. The series of drawings offers very few identifiable representations, and they are questionable. The only figures that reappear to support a chronological narration do so irregularly. Thus the woman in the scarf of Text #1 can be said to be definitely present after that only in Texts #4 and #6. The droopy-eared head of Text #1 might be the figure with a tail in Text #4. Roses or flowerlike forms are seen in all but Texts #2 and #4, snakes in all but Texts #3 and #5, if in #4 those are snakes as the tail and on the hat. The most recognizable repeated image is that of unattached heads, which appear in all, if we include the skull-like form in Text #5. Of these, the face peeking over the hill in Text #4 carries the most immediate force, in that it is certainly spying. The curious head-shaped object in the lower left of Text #6, is the most distinct form in that drawing; the female figure is facing it, and both stand out within the area left relatively clear of brushstrokes and splashes. But that figure remains a mystery.[45]

The movement of the text, a five-act play, follows that of the engravings, beginning with a kind of introduction to the situation, speaker, and initial action, which continues then in Text #2, followed by a period of apparent calm before violence explodes in Text #5 and then Text #6 leads us to a dénouement, as open-ended as the engravings. The narrative is thus an account of a murder: a woman blew up her husband and planted a garden on top of the remains. The narrator provides details: a butcher's wife[46] gave flowers to a spaniel, amusing and surprising several onlookers. That spaniel

Pierre Alechinsky, *Stupeur!* [What a surprise!].

is next "beaten to a jelly," "kids" are introduced, not to be mentioned again, some people are mortified, but more panic is needed. We learn of the wife's collection of shoe heels and of her successful use of the spaniel's remains to fertilize the lawn. Then the spaniel is inexplicably restored, and the narrator believes that the wife's behavior embarrasses her servant and feels that all this is leading up to a climax because of the jealous husband. The wife then cunningly booby-traps the husband and, though neighbors are whispering about her, the narrator recognizes her great success at bomb-gardening.

To present the story Butor has used a bare minimum of harmony. There are two instances of four repetitions: "what" (*quelle*) in the first text and "rose" in the last, but only one other, "mined" (*miné*) plus the exclamation

"*hey hey hey.*" There is only one true rhyme (*impudence, inconscience*), plus the one created with the neologism (*arrosages, épuçages*) and the identity (*pousse, repousse*). Alliterations occur in four words in two places (*p*'s in Text #2, *f*'s in Text #3) and in five words once (*p*'s in Text #5). Vowel repetition runs to five *i*'s in Text #5, and then to seven [u]'s and seven [y]'s in Text #6. Hard and hushing consonants are evenly balanced, but Text #6 contains two [ʒ]'s and also two [ʃ]'s in the same word, naturally "whispering" (*chuchotant*). Initial sibilants are frequent in Texts #2 and #3, in #4 in the series of five "*son petit sourire modeste et sûr de soi . . . service*" and very frequent in Text #6, ending with the last word, "*citer.*" Thus, while the harmony is muted throughout, the last text offers the onomatopoetic hissing of a gossip's speech.

Pierre Alechinsky, *Elle en pleure de rire* [She laughs until she cries].

The tale as a whole is confused as a direct consequence of the source. From her first words, the narrator's style renders her suspect. She speaks in incomplete sentences, twice (Texts #1 and #5) interrupted as if we we heard only one side of a telephone conversation. She uses familiar words (*rigolard, rafistoler, arborer*), neologisms (*snobinard, épuçages*), and slang (*requinqué*) as well as the surprising *"pétaradant,"* which means, when applied to a horse, "letting off a series of farts," a description Butor would be most unlikely to use, even for the folksy voice of the gossip, whereas in slang it means only "boiling mad." Then, her attitude toward the butcher's wife is inconsistent, beginning with the hypercritical, wavering to give her some dubious credit as "the only one to have such ideas" and to recognize her shoe heel collection as "charming," but then con-demning her outright for acting in ways that make the servant turn pale. In a final reversal, our gossipy narrator comes around to admire the wife's know-how in bomb-horticulture and the hard work required to produce the remarkable garden. Her last line could mean simply that every variety of rose in the garden deserves mention—or else that all this will have to come up in court, that the wife will not escape the consequences of her action. Butor has more than once remarked on the double meaning of "cite," "as in law" (*comme en justice*).

Thus our unreliable narrator in her colloquial voice tells a tale in which she herself is making assumptions based on suspicious data, to the extent that the reader can know nothing for certain. The wife could have caused an explosion and murdered her husband. She

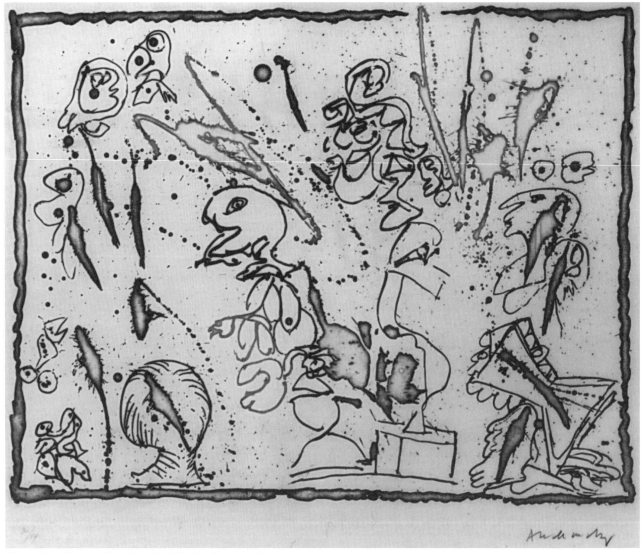

Pierre Alechinsky, *Elle triomphe* [She is triumphant].

could even have buried pieces of his body and planted a garden on top, since (at least in the United States) newspapers report such acts every day. But, while recognizing that the smashed spaniel, like the husband, could have been used as fertilizer, we really cannot believe that the same dog could have reappeared later in fine form.

If no other detail revealed the humor in this work, the spaniel incident would: here is clear contrast between the narrative and reality. But that the narrator is the object of Butor's satirical attack is apparent from the beginning. It is true that the narrator's reports on the wife's actions are themselves satirical as she describes and labels them. For instance, even though the wife's sticking not-very-fresh snakes in the shape of a lyrebird in her hat is humorous on the farcical level as elementary buffoonery, it is not the wife who is the

victim of Butor's satire but rather the narrator, and her telling such stories adds to her portrayal as foolish.

Butor portrays this foolishness with many of the traditional satirical techniques. Exaggeration is a fundamental part of her speech, as in her initial pronouncements, "There you are. I certainly told you so," and emphasized further by repetition in her "Hey hey hey" and the repetition insisting on the word "mined" as if the husband were a ship. Incongruities are inherently comic: the narrator twice speaks of banana peels—a traditional element of farce—and her qualification of them with a quasi-scientific term is similar to her calling the snakes "not very fresh" as if they were flowers. The use of the word "de-fleaing," reminding us of the spaniel, now used as the fertilizer that provides for a resplendent lawn and hybrid roses, is wildly incongruous: fleas are not among the pests gardeners deal

with. Then, we have all heard of peculiar collections, far beyond coins or postage stamps, but to date we have not heard of anyone's collecting shoe heels, certainly not displaying them like houseplants. The introduction of the stock commedia dell'arte character, the jealous husband, shows that the narrator is living in a comedic world. Contrasts between her account and what we presume to be reality appear in her qualification in Text #4 of the "hillock" as "pretty" since what all three protruberances most resemble is giant African termite hills, scarcely "pretty." Then the contrast occurs vividly in her request for more panic, given that panic is in a reasonable world found undesirable and not ordinarily generated deliberately. That contrast is emphasized by the polite "please," as if asking for more sugar for her tea. The "sea-green roses" the narrator mentions twice are also divorced if not from reality, at least from nature.

Our narrator often speaks ironically, whether intentionally or not we do not know, as when she speaks of the spaniel as "rubbish" (*fumier*), because *fumier* also means "manure," which is exactly what he is used for, fertilizer. Dramatic irony is latent in her telling of the servant's "turning pale": we might expect it to be caused by that amazing hat, but it is instead her behavior that distresses him. Similar dramatic irony occurs as the wife laughs "until she cries," a clue to our own anticipated reaction, which the dialogue cuts off short, creating suspense. Finally, the source of the woman's triumph and award is withheld. The people parade by whispering, which leads us to expect a funeral, and then comes the surprise: the bomb-horticulture is the object of their interest. The narrator exhibits a calm and thus comic (in this situation) dramatic reversal; she has been criticizing the wife on all counts, and now "has to admit" the wife has done a fine job, one requiring a great deal of hard work. Finally, what she intends by her use of "cite" is left open.

Through the satirical humor of the gossip's language and ambiguous account it is possible to hear Butor's political statement: don't believe everything you hear, for nothing is what it seems. This tale is, in legal terms, about an alleged murder. The butcher's wife is still innocent until proven guilty (at least in the United States). Even the gossipy narrator, whispering away, has come to admire her by the end. We may expect a trial from the "citing," and on the basis of the gossip's chatter everyone might condemn the wife, but we do not have proof. We cannot know, without solid factual evidence from credible witnesses, whether the wife is guilty or even whether the murder actually occurred. How many lives are smashed like the spaniel because of public opinion based on banana peels?

We know Butor does not condone violence and

would not think that blowing up one's husband, even a jealous one, was correct. But he would also be unlikely to sympathize with a jealous husband, even in jest. The speaker is the focal point of this text, and by his selection of that busybody's voice, Butor tells us that people and their lives are much too complicated to be superficially judged by an outsider.[47] His satire on the gossip is genial, hilarious, but definitely derisive.

Butor's ability to find or to create meaning in anything is well seen in this collaboration.

HOIRIE-VOIRIE: STANCES DES MENSUALITÉS

The *Stances des mensualités* [*Stanzas of Monthly Payments*] is the first of the four works studied here in which Alechinsky uses *"papiers trouvés"* [found papers].[48] The *Stances* compose one of the two distinct parts of *Hoirie-Voirie* [*Inheritance-Garbage Dump*]; the other is *Rescapés de la corbeille* [*Refugees from the Wastebasket*], a collection of Alechinsky's drawings on Butor's manuscript drafts.[49] The whole of *Hoirie-Voirie* is loose-leaf in the original, but the *Stances* naturally assume the order of the calendar months and are so reproduced here.

The support Alechinsky has "found" for the *Stances* are original documents from the seventeenth century (*Travaux* 192). Alechinsky had already collaborated with the support before Butor began to write his text, and thus Butor's inspiration was drawn from both together. These documents are almost entirely illegible;[50] the most understandable elements are the morass of signatures and the letterhead. (The bills and maps of the other three works treated in this study will reveal more of the content of the original.) Some of these signatures suggest that not all the signers were literate.[41] In *Janvier, Mars, Juin,* and *Juillet* Alechinsky put his own signature in among the originals; the others he signed outside the frame. Seven of the documents have a letterhead from Montpellier, the same one, with flags, plumes and a wreath, and Alechinsky has incorporated them all into the drawings. In three of the five that do not have the letterhead, Alechinsky has drawn a circle where it would have been; in *Octobre* he has left an irregularly shaped white space between the segments of ink obscuring the handwritten background. Only in *Juin* is there no letterhead, circle or space. The signatures and letterheads contribute to the legal appearance of the documents, which appear to be wills, an identification Butor clearly made. It is the "will" of the "Inheritance," and Butor bequeathes something to each month, with the legal term, "item" and refers to it as his *"testamenticule"* [testamenticle] in *Décembre*. He also

remarks in *Juillet* in a note that the sirens' song *"n'appartient pas au testateur"* [does not belong to the testator]. Alechinsky's selection of the support thus provoked for Butor the basic idea of a will.

Alechinsky created the twelve drawings in black and white, for a calendar for Olivetti.[52] This poem, reprinted in *Illustrations IV,* is composed of two stanzas plus two footnotes for each month.[53] Following each stanza reprinted here I will identify Butor's use of the corresponding Alechinsky work and finally look at the whole, the harmony, the humor, and the political force.

Throughout the series, in the text for each month Butor refers to the two matching zodiac signs, but sources in the drawings are probably coincidental. In *Février* the hatchmarks are not unlike fishbones, as in Pisces, the Fish; in *Juillet* forms appear that resemble *"les yeux sur pédoncule"* [eyes on a stalk], suggesting the Crab, and the letterhead has eyes and an open mouth, encircled by lines which could be the Lion's mane; in *Novembre* the primary form could be seen as a doubled Scorpion's tail. The identification is more sure in *Avril:* the *"rosaces"* [rose windows] look very much like the Ram's horns. However, I believe the use of the zodiac follows from the calendar rather than having been generated by the artworks.

JANVIER

> *Je lègue à Messire Janvier*
> *Outre la queue du capricorne*
> *Et la tête compatissante*
> *Du verseau penché sur son urne*
> *Mes deux mains sans le moindre sou*
> *Après les bringues des étrennes*
> *Tous les trous au fond de mes poches*
> *Et un sérieux enrouement (1)*
>
> *Ainsi je versificationne*
> *En comptant les pieds sur mes doigts*
> *Tapadipaditapada*
> *Avec innombrables licences*
> *Rimer serait trop difficile (2)*
> *Pour soupçon de modernité*
> *Du mirliton à références*
> *Du pas distingué distingué*

(1) Item une gueule de bois
(2) Rimer serait prétentieux[54]

Alechinsky's recognizable figure of a man apparently walking (although his legs trail off, unfinished) is clearly the source of Butor's Milord *Janvier.* The expression of the face Alechinsky found in the letterhead of the support and the gray ink of its collar and shirtfront suggest his being hungover, but it is the polydactyl hands that clearly captured Butor's imagination. They are reflected twice in the text, first as the figure becomes

Pierre Alechinsky, *Janvier* [January].

the speaker, because they are *my* hands (*mes mains*) and then as he counts the octosyllables on his fingers. The juxtaposition of the drawing to the text introduces a comic tone, since those hands have at least six fingers, and any counting done on them would be unusually inaccurate.

FÉVRIER

> *Item au frileux février*
> *Outre les cheveux du verseur*
> *Bourrasques ondées giboulées*
> *Et les silences des poissons*
> *Les plumes des Gilles à Binche (1)*
> *Des milliers de pépins d'oranges*
> *Roulant sur le goudron des rues*
> *Puis écrasés par les voitures*
>
> *Perfums enivrants des pelures*
> *Tortillées comme des lacets*
> *S'enroulant comme des rubans*
> *De sparadrap autour des fils*
> *Electriques dépenaillés (2)*

Au milieu des vapeurs d'essence
Et de la gadoue du dégel
Douces rancoeurs du carnaval

 (1) J'irai un jour les admirer
 (2) On sent percer le bricoleur[55]

The Gilles of Binche Butor mentions here is a tribute to Alechinsky's part in reestablishing the carnival at Binche after the war. There was a time, in recent memory, when there was no carnival there, but now it functions again, and one of the modern traditions is throwing oranges.[56] Thus the snakey lines and circles here provoked orange peels and oranges. Alechinsky's generous use of gray ink, the empty gray circle where the letterhead would have been and the grayish and dark grounds are reflected in "the tar of the streets" and "the mire of the thaw."

MARS

 Item à mars le dégradé
 Outre les nageoires dorsales
 Arêtes et quelques sillages
 Avec le museau du bêlier [sic]
 Une sorte de minaret (1)
 Entouré de palmes de zinc
 Monté sur un énorme socle
 En forme de cloche à fromage

 Décoré de bonnets phrygiens
 Une couronne de laurier
 Petits drapeaux quelques gravats
 Creusé d'égouts et de recoins
 A murs suintants à courants d'air
 Pour y installer les bureaux
 De la société protectrice (2)
 Des bactéries et des virus

 (1) Ici un souvenir d'Egypte
 (2) Une trace d'humanité[57]

Pierre Alechinsky, *Février* **[February].**

Pierre Alechinsky, *Mars* **[March].**

This drawing is clearly seen in Butor's text: a minaret mounted on a pedestal that resembles a cheese bell, the hatchmarks becoming both palms and the wakes of boats. Then Butor simply lists the elements easily recognizable in the letterhead, before their official nature leads him to his own Protective Society. The signatures, because they are sealed in by Alechinsky's black ink lines, have become bacteria and viruses. The two curious forms under the cheese plate have become bones (*os*), and the irregular wash of the ground the "dripping walls."

AVRIL

> *Item à ce farceur d'avril*
> *Outre la toison dédorée*
> *Avec les cornes mouchetées*
> *Du progéniteur des bovins*
> *Le tablier qu'à l'abattoir*
> *Met le boucher pour les occire (1)*
> *Les rosaces de ses tétons*
> *Les replis de son estomac*

Pierre Alechinsky, *Avril* [April].

> *Sa gueule ouverte pour un cri*
> *D'étonnement devant les pousses*
> *De pissenlit ou de persil*
> *Qui sortent entre les pavés (2)*
> *Raboteux et sanguinolents*
> *Du parking où il a rangé*
> *Sa camionnette pleine d'os*
> *Et les griffures de ses doigts*

(1) *Fumets des biftecks son de l'or*
(2) *Le sentiment de la nature*[58]

The figure in the drawing Butor sees as a butcher with his apron; his large mouth formed from the letterhead is his "open mug." The spirals on his chest have become "rose windows," but at the same time the "speckled horns" of the zodiac Ram. The signatures have become "sprouts of dandelions or parsley" and the wash of the ground "pavings . . . stained with blood." The butcher's clawlike hand is reflected in "the scratches of his fingers."

MAI

> *Item au joli mois de mai*
> *Outre une dernière envolée*
> *De la queue et le premier clin*
> *D'oeil du jumeau de droite à l'autre*
> *Sur une illustre morne plaine (1)*
> *Parcourue de vols de corbeaux*
> *Une pyramide à degrés*
> *Cherchant un peu son équilibre*
>
> *Touristes bicornes barettes*
> *Cadogans champignons galets*
> *Tulipes flaques et lunules*
> *Eclaboussures mouchetis (2)*
> *Crocs généraux et chuchotis*
> *Reporters lycéens évêques*
> *Plumes d'oie stylos crayons-feutre*
> *Se pressent en foule à son pied*

(1) *Wawawaterwawalhaloo*
(2) *Une technique impressionniste*[59]

The uneven pyramid with its steps is found in the first stanza; the curved lines above it have become crows. Any pyramid leads to Napoleon, and thus the dark wing-shaped forms and hatchmarks have become Hugo's "mournful plain." The forms in front of the pyramid have become a crowd of tourists, and their headgear is spelled out, based on the drawing. Butor would have selected the term "ponytail" for its eighteenth-century source in the name of the British general Catogan who sported that hairstyle. The other natural forms listed may be seen in the drawing, as well as the "unsmoothed plastering" of the ground with its

Pierre Alechinsky, *Mai* [May].

Pierre Alechinsky, *Juin* [June].

visible signatures. The short diagonal hatchmarks among the "tourists" have become the various writing instruments.

JUIN

> Item à juin le chaud compère
> Outre le clin d'oeil en réponse
> Du frère à son frère et les pinces
> Toutes frétillantes du crabe
> Une superbe tache d'encre (1)
> Un peu comme un poulet plumé
> Avec un grand tampon buvard
> Pour en limiter les dégâts
>
> Ah plaignez le dessinateur
> Les mains tachées les yeux bouffis
> Le nez écrasé sur ses feuilles
> Les pieds tordus le ventre aussi
> Plaignez le pauvre écrivasseur (2)
> Les doigts crampis le front barré
> Le dos cassé la gorge sèche
> Et sa tignasse indémêlable

(1) *Mémoire de Victor Hugo*
(2) *Lyrisme de l'individu*[60]

The "inkspot" resembling "a plucked chicken" is immediately recognizable, as is the "blotter." Butor does not mention the allusion to Hugo in the inkspot until the note,[61] but it is this connection that would have converted the face disappearing behind the frame into a "scribbler." His "forehead" is certainly "lined" and his hair unkempt, just as Butor says.

JUILLET

> Item au pétulant juillet
> Outre les yeux sur pédoncule
> Et le rugissement du lion
> Quelques Indes quelques idoles (1)
> A maints bras danseurs et palpeurs
> A chevelures à poitrines
> A lèvres invites réduits
> A cuisses boucles et senteurs
>
> Des lits des plages des prairies
> Des brises des vagues des flûtes

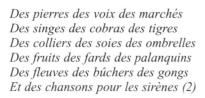

Pierre Alechinsky, *Juillet* [July].

Pierre Alechinsky, *Août* [August].

Des pierres des voix des marchés
Des singes des cobras des tigres
Des colliers des soies des ombrelles
Des fruits des fards des palanquins
Des fleuves des bûchers des gongs
Et des chansons pour les sirènes (2)

(1) Permanence de l'exotisme
(2) N'appartient pas au testateur[62]

While the ground of miniscule handwriting, with
bleeding from the other side, could have provoked the
"breezes," "waves," and from them the "beaches" of
summer, Butor's main use of this drawing is in his
image of the Indian idols, with their many arms. The
letterhead would be the idol's head and Alechinsky's
flowing lines the "heads of hair," the oval forms the
"breasts." It is this "exoticism" of the idols, emphasized
in the note, which generated the remainder of the text,
the jungle animals, the fringed boxlike rectangle which
has become in this context "palanquins" of elephants.

AOÛT

Item au moite à l'étouffant
Outre les traces dans le sable
Et les émotions de la vierge
Une boîte d'où sort un diable
Déguisé en feuilles d'acanthe (1)
Avec une tête en éclipse
Entièrement sculpté en liège
Pour flotter sur une fontaine

Au plus ombreux d'un parc désert
Osez mes jeunes demoiselles
Entraîner vos amis timides (2)
A délacer vos espadrilles
Et à dépeigner vos cheveux
Balancements orages gouttes
Eclaircie menthe rossignol
Et demain autres aventures

(1) Ou de rhubarbe à volonté
(2) La touche dix-huitième siècle[63]

Readily seen are the "box," the "devil," the "acanthus leaves," and the blank dark letterhead as "its head in eclipse." The acanthus leaves, however, are promptly transformed into a sculpture made of "cork to float on a fountain," and it is the fountain that has inspired the whole stanza. The dark hatchmarks of the ground might have provoked the "shadiest of a deserted park," and the ornate signatures the laces of the "espadrilles," but the synaesthetic summer vision of the second stanza is Butor's own expansion on the "eighteenth century touch," as he explains in the note, all generated by his fountain.

SEPTEMBRE

>*Item au sourcilleux septembre*
>*Outre les échos de la noce*
>*Et le plateau qui se relève*
>*Une terrasse et un détour*
>*Puis un autre détour un lac (1)*
>*Un débarcadère des marches*
>*Une grotte avec graffitis*
>*Des écorces à signatures*
>
>*Les bruits de la rentrée des classes*
>*Les pas des chasseurs sur les chaumes*
>*Les frémissements des roseaux (2)*
>*Les colloques des hirondelles*
>*La floraison des dahlias*
>*L'encre mêlée au jus des mûres*
>*Les feux de ronces et d'ordure*
>*La foule que vomit la gare*

(1) Tout cela au milieu des vignes
(2) Et encore une litanie[64]

Pierre Alechinsky, *Septembre* [September].

The clearest connections between this most puzzling drawing and Butor's text are through the support. Alechinsky has left wide spaces of this document visible: neat, straight lines with a pen stroke extending to the edge of the document, as the writer lifted his pen only rarely between words. This closely squeezed handwriting provoked Butor's note, "All that in the midst of the vines." Butor has seen Alechinsky's outline around the few legible words of the marginal note, in a different hand, as a fence, reading the whole as a map. Alechinsky's own primary form is the large inked-in gray circle extended in a neck, covering the signatures near the top of the page. His empty circle takes the place of the letterhead, and the additional ovoid forms are all empty. While Butor presents beautiful September images in the second stanza, I believe that gray head backed by black splatters, surrounded by empty circles, is the source of the mood of "the first day of term" at the beginning, and at the end, of the "trash" and "the crowd the train station vomits up."[65]

OCTOBRE

>*Item au plantureux octobre*
>*Outre l'autre plateau qui baisse*
>*Et les antennes du scorpion*
>*Un chou-fleur une montgolfière*
>*Un turban pour un grand muezzin*
>*Une turbine ou un zinnia (1)*
>*Une citrouille pour fantômes*
>*Un poing de pierre sur les i*
>
>*Cageots briques dalles carcasses*
>*Casiers dossiers journaux registres (2)*
>*Paraphes boucles gribouillis*
>*Ratures accents soulignés*
>*La ville dont rêve un notaire*
>*Les arbres à feuilles de rôles*
>*Les perspectives de classeurs*
>*Et les compromis en cascades*

(1) Un bubon une vésicule
(2) Fichiers tiroirs coffres reports[66]

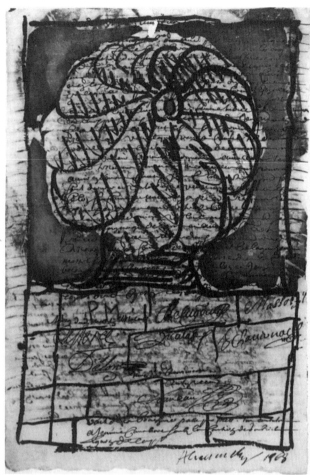

Pierre Alechinsky, *Octobre* **[October].**

Item au pluvieux novembre
Outre le dard qui se redresse
Et la flèche du cavalier
Les moisissures sur les tombes
Les allées de saules pleureurs (1)
Les manches ballantes des goules
Leurs sifflements au crépuscule
Les fanfares d'éternuements

Les trompes d'éléphants des zoos
Les oreilles des chimpanzés
Les nervures des feuilles mortes
Les tisanes des égrotants
Les épingles sur leurs pelotes
Les parquets à point de Hongrie
Les parquets à bâtons rompus
Les derniers zincs des vieux bistrots

(1) Tintinnabulements funèbres
(2) D'onglet mosaïque à l'anglaise[67]

Alechinsky's recognizable petaled flower and brick wall have each served as source for one stanza. The images conjured up by the shape of the flower are apt and pleasant if we understand the "ghosts" of the pumpkin as a reference to the seasonal holiday—and yet the zinnia is footnoted as "a bubo a blister." The "bubo" is a medical term infamous as an effect of bubonic plague, hardly a cheerful idea. The gray-inked ground barely allows the writing of the document to be seen; the signatures on the wall are obscured by bleeding from the document's other side; there is no letterhead or Alechinsky circle in its place, only an irregularly shaped blank. Darkness and absence brood over the whole drawing, and the flower becomes "a fist of stone on the *i*'s," leading to the "slabs, carcasses" of Alechinsky's "bricks" and the drabbest of the drab, official records, "pigeonholes" filled with the signatures dimly seen on the support. Thus Butor expands Alechinsky's darknesses to an image of a city only a lawyer could love whose "trees," "vistas," and "waterfalls" are all composed of menacing legal case histories.

Pierre Alechinsky, *Novembre* **[November].**

Here Butor sees first the grey rectangle as a tomb. The humanoid figure, with Alechinsky's use of the letterhead as head, is a "ghoul," with "dangling sleeves." The sleeves become then in the second stanza "ears of chimpanzees" and the whole figure an elephant, while the rectangle has become one of the "counters of the old bistrots." The hatchmarks are seen first as the "veins of dead leaves," then as "pins," and finally as two different arrangements of parquet flooring, with an additional parquet design added in the note.

DÉCEMBRE

Enfin au sommeilleux décembre
Outre les ruades du cheval
Et la barbiche du chevreau
Le serpent qui se mord la queue
Les replis de la concurrence
Les anneaux de l'année qui tourne (1)
Les méandres de l'intestin
Où se digère le passé

Pierre Alechinsky, *Décembre* [December].

Voeux cheminées souliers chaussettes
Bougies gui houx barbes vitrines
Rubans réveillons confettis (2)
De mon âge en l'année quarante
Et deux bien avant que j'aie bu
Toutes les hontes de mon lot
Que j'attends avec patience
Je clos ce testimenticule

(1) L'achat d'un agenda nouveau
(2) Orgues encens cloches blasphèmes
Achevé et relu à tête reposée
le 17 Mars 1969[68]

Alechinsky's serpent is readily recognized, with its head and forked tongue coming from beyond the frame, its body curling around to end at the letterhead. Butor sees it as biting its own tail, which leads him to "the folds of competition," or figuratively, "the innermost recesses." The coils lead to "the rings of the year," which become "the intestines." The second stanza leaps from this digestion to the "ribbons" of the holidays, still reflecting the serpent.

This work, with its twelve texts in identical format, is ideal for seeing the widely varied uses Butor makes of Alechinsky's drawings. In *Le Test du titre* each text utilized the drawing in a different way, and the texts themselves were not limited to a particular format and thus appeared in different lengths and with different structures, producing a single narrative. In this work one drawing and two stanzas (plus the notes) compose the collaboration for every month, and one might expect each of the twelve drawings to be reflected throughout the year in the same way, but this expectation will be disabused. There are, indeed, some whose treatment is the same: *Janvier* and *Février.* As so often in Butor's works, the beginning orients the reader: in these two months the whole of the drawing contributes to both stanzas. Once established, that approach does not reappear until *Avril;* the one other case in which the drawing is utilized in both stanzas comes six months later, in *Novembre,* where it is more complicated because both of the two elements of the drawing appear in both stanzas, but in opposite order, and the ground of hatchwork is added in the second stanza.

The drawings in three other months, *Mai, Juin,* and *Octobre,* contain two distinct figures, (considering the group of "tourists" in *Mai* as one figure), but the treatment is not at all the same as in *Novembre.* Each of the two figures in these three months may be seen clearly reflected in either the first or second stanzas of the text, but not both. More convoluted still is *Mars,* where Butor has seen the drawing as made up of three elements: the figure, which is described in the first stanza;

then in the second stanza, the letterhead, which pro-
voked a list of its components; and the ground, whose
signatures gave rise to that "Protective Society for Bac-
teria and Viruses."

The drawings for the remaining four months are
composed of a more or less unified single figure: *Juillet*
idol on a palanquin, *Août* devil-fountain, *Décembre*
serpent, and *Septembre's* dark emptiness. In *Juillet* and
Août the figure is reflected in the first stanza only, and it
is an element of that text, not of the drawing, plus a
reading of the ground, which leads on to the develop-
ment in the second stanza. *Décembre's* serpent appears
in the first stanza, but is barely echoed in the "ribbons"
of the second, where the text moves away from the
drawing altogether to end the poem and the year. Fi-
nally, in *Septembre* it is the ground that has conjured up
the first stanza, but the autumn images of the second
have no relation to the drawing beyond Alechinsky's
"ink" and "the beginning of term" as sensed in the
gloomy voids.

Thus this brief work demonstrates a number of Bu-
tor's uses of artworks for his texts. As he reads the
artwork, he may incorporate specific recognizable fig-
ures into the text, or label ambiguous ones, placing them
in the text in uniquely varied ways. A single element in
the drawing may provoke the whole of the text, or on the
other hand, the whole of the artwork, in this case both
drawing and support, may generate a mood that then
pervades the text. From even Alechinsky's wildest
swirls and blanks, Butor has found inspiration for his
panoply of poetic verbal imagery, his humor and his
political statement.

In this text Butor's use of poetic devices is restrained,
but nevertheless rhythm, repetition, rhyme, and har-
mony are all present and contribute to the effect of the
whole. The speaker explains that he "versificates" tak-
ing "innumerable liberties," preparing us here at the
very beginning. There are, however, very few "liber-
ties" in what follows, and they are easily "numerable."
The nonsense syllables in the second stanza of *Janvier*
call immediate attention to the octosyllabic rhythm that
is maintained throughout. The "tapadipaditapada," a
5+3 line, as the space introduced in *Illustrations IV*
makes clear, is no sooner counted out than it is rejected:
the last line of the stanza could indeed be counted 5+3
but is much more logically 2+3+3 or 2+6. The 5+3
rhythm is constantly varied, for example in February,
"adhesive tape around the wires" is distinctly 4+4.
There are only two exceptions to the octosyllable: the
last line of *Mars* has nine syllables, and the penultimate
line of *Décembre* requires reading *"patience"* as 3 syl-
lables to give the octosyllable. Two instances of hiatus
occur: *"de Hongrie"* in *Novembre, "des hontes"* in
Décembre, with the characteristic effect of interrupting

the flow: in *Novembre* the jolt serves to emphasize the
repetition of "floors," and in *Décembre* the point of the
whole poem is the speaker's "fate" full of "shames."

A particular technique affecting the rhythm is used in
four months: a series of unqualified nouns. These lists
in *Juillet, Octobre, Novembre,* and *Décembre* produce a
stacatto effect, especially in *Octobre* and *Décembre,*
where even the articles are omitted. The stacatto is
attenuated, however, by the large number of mute *e*'s in
three of these months: *Juillet* contains more than any
other month, for example, *"Quelques Indes quelques
idoles"* and *Octobre* and *Novembre* almost as many. On
the other hand, only *Avril* has fewer than *Décembre.* As
noted, the noun lists of *Octobre* and *Décembre* do not
include articles, but in *Octobre* those mute *e*'s smooth
the lines, whereas in *Décembre* the lists not only have
no articles to give melodious progression, but also in-
clude the monosyllabic "mistletoe" (*gui*) and "holly"
(*houx*).[69]

Other poetic techniques are also kept to a minimum
in this "doggerel with footnotes." Repetition appears
regularly in the two words "item" and "in addition to,"
which begin the first two lines except in *Janvier,* where
"item" is relegated to a note, and *Décembre,* where
"finally" replaces "item." Beyond that, there are only
six cases of repetition within a given stanza. Half are at
the halfway point, *Juin:* in the evocation of the Zodiac
sign, the Twins, "from the brother to his brother" and
then, creating the parallel between the artist and the
writer, "Ah pity the artist" and "Pity the poor scribbler,"
plus the "spot of ink" and "his hands spotted." In *Sep-
tembre* Alechinsky's swirls on the support are reflected
in "a meander/then another meander." *Novembre* and
Décembre both contain repetitions: "parquets" in
Novembre, and naturally in *Décembre* "year." Several
common words, such as "leaf" appear in more than one
stanza but without repetitive effect. Thus "in addition
to" (*outre*), which repeats at least a harmonious vowel
sound and soft consonant group, and "item," which is as
devoid of harmony as a lawyer's brief, are the only
repetitions serving as refrains.

The speaker warns us at the beginning that "rhyming
would be too difficult," expanding in the note to,
"rhyming would be pretentious," and yet that very sec-
ond stanza of *Janvier* ends with two interlocking end
rhymes: *licenses/références* and *modernité/distingué,*
and the note adds a third (*doigts/bois*). Every month
then contains at least one end rhyme, not regularly
ordered and sometimes between two stanzas or includ-
ing a note, but nevertheless rhymes.[70] Some of these
provide vivid contrast: of taste and smell in
"blackberries/garbage" (*mûres/ordures*) in *Septembre,*
and of habitats of animals and people in *"zoos/bistrots"*
in *Novembre* and of the future "fate/new" (*lot/nouveau*)

in *Décembre.* The repeated soft and harmonious rhyme in [œr] of *Juin* "artist/scribbler" (*dessinateur/ écrivasseur*) reappears in *Juillet* "dancing, palpating/ aromas" (*danseurs palpeurs/senteurs*) and again in the note "testator" (*testateur*), where the dry legal meaning of the term effaces the "exotic" effect Butor flags in his first note. The speaker uses rhyme with discretion and thus not "pretentiously," but he certainly demonstrates that it is not "too difficult" for him at all.

As for harmony, the [œr] of *Juin* and *Juillet* occurs in other stanzas, with no neighboring rhyming word. It appears first in *Février,* where it calls attention to the alteration of *Janvier*'s *Verseau,* who was "compassionate," seen as the conventional water bearer. In *Février* she has become just the "server" or waiter, "*verseur,*" the [œr] substituted for the previous long *o.* The two other [œr]s in *Février* produce an ironic effect: "*vapeurs*" of gasoline sound beautifully soothing but are in reality quite the opposite; in the "*douces rancoeurs du carnaval*" the irony is emphasized by both the sound and the meaning of "*douces,*" which contrasts with the two [k]'s. The soft [œr] reappears in *Octobre* in "*chou-fleur,*" musically combined with the cooing [u], but the meaning belies the sounds; "*classeurs*" remind us of the "*testateur*" of *Juillet,* which mocked the "exoticism" of that month. The "*saules pleureurs*" of *Novembre,* with two of the same soft vowel sounds, may remind us of the sarcastic "*sentiment de la nature*" of *Avril.* Only *Janvier, Mars* and *Décembre* contain no open [œr]; however, *Janvier* and *Décembre,* beginning and ending the poem, both contain three [φ]'s in the stanzas, and *Janvier* includes two more in the notes, one the unlovely and colloquial "*gueule*" in the expression "*gueule de bois.*" All the stanzas include at least one [φ], often an adjective termination, as in *Décembre,* "*sommeilleux,*" and the recurrence of "*queue*" in *Décembre* and elsewhere, a result of the references to the zodiac signs.

Thus the soft sound of [u] is the primary source of harmonious vowel sound. The repeated "*outre*" assures them throughout, and all the stanzas but *Juillet* and *Août*—and *Novembre,* which adds only "*goules*" to the "*outre*"—contain a large number. Other melodious vowels are relatively rare. There are six [y] in *Mai,* four in *Juin,* plus an outburst of four nasal *i*'s, then six [y] in *Juillet* with three [ɥi] as well, along with a bevy of nasalized vowels. *Septembre* and *Novembre* each offer four [y]'s. Long *o*'s appear noticeably in *Avril,* in the "*rosaces*" and the plural "*os*" [o] in the butcher's truck, but assume importance only at the end of the poem. Following the rhyming *o*'s of *Novembre*'s "zoo" and "bistrot," in *Décembre* the *o*'s build through "*chevreau*" and "*anneaux*" to the essential word, "*lot*" and the final "*clos.*"

As the use of vowels for harmony is limited, the consonants predominate. There are a number of alliterations in soft sounds, *l* (especially in *Août, Septembre,* and *Décembre*) and *f,* and sibilants occur throughout, and the hard [g] is seldom heard. There are some delightful alliterations, as for example, the *p*'s of "*les pousses/de pissenlit ou de persil/ . . . pavés*" in *Avril.* But there are very few hushing consonants, and the buzzing *z*'s which appear first in *Août,* often created by liaison (*déguisé, désert, osez, demoiselles* and *les émotions, plus ombreux, vos amis, vos espadrilles, autres aventures*) appear again in *Octobre* (*zinnia, muezzin,* and four with liaison) and increase still further in *Novembre* (*zoos, champanzés, zincs, mosaïque, l'anglaise,* and three from liaison). Of all the harsh consonants, it is the hard [k] that is used most generously in every stanza, often initial, producing alliteration as already in *Janvier,* for example, "*la queue du capricorne . . . compatissante,*" often final, for example, "*zinc*" in *Mars* and *Novembre,* and very often in consonant groups, as in *Octobre,* for example, "*octobre, scorpion, classeurs,*" where in the second stanza there are no fewer than five additional initial [k]'s. *Décembre* closes with a total of six [k]'s, including the "*cloches*" of the note. There the hushing [ʃ] attenuates the initial [k], but the effect of the whole accumulation remains effectively harsh. Certainly in "*je clos ce testamenticule*" Butor's created word accords not only with the meaning but also with that hard sound: this is a poem with a hard lesson, concealed throughout by the humor.

Two or three of Alechinsky's drawings are humorous without Butor's texts: the ridiculous *Janvier* figure, who sets the tone for the whole collaboration, the grotesque person of *Avril,* and depending on our reading of the central form—it could be an ax!—the head squashed at the bottom of *Juin.* The seal of the letterhead in the support conjures up a human head in many, but the drawings are not uniformly amusing. The text, however, especially the footnotes, is almost always humorous, mocking the speaker, the zodiac, other poets and utilizing incongruities liberally. As the figure of the *Janvier* drawing is revealed as the speaker, the humor becomes self-deprecatory. The speaker mocks himself for foolishness, for having spent and drunk excessively during the holidays, the latter clarified in the note by the colloquial expression and reiterated in the epigraph, when he has recovered and has "a clear head." Further, he derides through the choice of words, "doggerel," the neologism "versificate," and the octosyllabic nonsense word, his efforts at writing poetry. He then ironically explains it is for "a touch of modernity" that he will take poetic licenses and avoid rhyme. Even readers familiar with Butor only as a "new novelist" could not fail to find this irony hilarious: that he should seek out "moder-

nity"! That he, of all contemporary writers, will not use poetic techniques abandoned long ago and take liberties most contemporary poets consider the norm underlines the humor. The meaning is all the funnier because it is in this stanza only that two end rhymes occur: *licences/références, modernité/distingué.* Simple, not rich or superrich rhymes, which of course Butor writes when he pleases—just as the octosyllabic last line is created by the rhythmic repetition: he is twice "distinguished." His created persona develops in the two stanzas from anyone who has celebrated too much over the holiday to a writer of verse full of false modesty and dreams of glory. The mention of footnotes suggests that it might be not only pompous amateur poets who are targeted, but also, although one just might be reluctant to recognize it, scholars.

Self-deprecatory humor reappears in *Juin,* where the speaker is the "poor scribbler," exhausted, with cramped fingers and the tangled hair of the figure in the drawing. Throughout, the notes add to the identification: duct tape around electric wires in *Février* provokes "One senses the do-it-yourselfer breaking through"; although we may not have known this aspect of Butor's activities, the minaret in *Mars* calls up "a memory of Egypt," which we surely recognize as his memory. The five notes identifying literary commonplaces might cause us to remember classroom lectures we have heard or presented ourselves; readers of Butor's *Essais, Improvisations* or fortunate students in his classes know very well he would not use these traditional clichés and can well afford to scoff at them. The careful specification in *Juillet* that this "testator" does not own the sirens' song could be seen as self-deprecation, while posing also an unanswerable question: Who does own the sirens' song?

Beyond laughing at himself, Butor's treatment of the zodiac is almost uniformly disrespectful. No brooding, controlling mystic signs are these! It is true that the initial Aquarius is recalled as a sympathetic figure, but in *Février* it has become the "hair of the server," and if there is anything one does not want to notice in someone waiting on tables, it is hair. Similarly, the first appearance of the Pisces in *Février* is in the harmonious, remarkably realistic line, "The silence of the fish," but in the following month they are reduced to "flippers," "bones," and "wakes," the last two only the remains after the fish are dead or long gone. In the succeeding months, the various animal signs appear as parts of the body: two tails, horns, muzzle, antennae, beard, and as the kicks of Sagittarius's horse. Some are qualified unattractively: the Ram's fleece is not golden, but tarnished, the claws of the Crab are wriggly, its eyes seen as on a stalk, and Scorpio's stinger is already prepared to strike again. Some constitute mini-narratives: one Twin winks at the other in *Mai,* and the second winks

back in *Juin,* the pans of the Libra's scales move first up and then down, the Virgo is nervous in *Août,* and in *Septembre* only echoes of her wedding remain. Sagittarius may have his arrow, but his horse is bucking. Similarly, the Lion roars in *Juillet* but in *Août* has left only tracks in the sand. A devotee of the horoscope will find these images offensive; the sceptic will find them apt and amusing.

Laughing at himself and the zodiac, Butor also finds sources of humor in other poets. While saluting Hugo by qualifying the "mournful plain" and "spot of ink" as "illustrious" and "superb," respectively, he then stretches "Waterloo" to fit the meter, and the new words suggests not only the hunting cry "haloo" of the British, whose armies opposed Napoleon, but also Valhalla in the added syllable "wal" preceding that "haloo," which evokes the Prussian forces in the battle. The battle is not humorous, of course, and it occurred not in May but in June, but Butor's treatment of it is a reductio ad absurdum. Similarly, Poe is summoned up by the note "Funereal tintinnabulations" and the context of weeping willows seems appropriate, but that stanza ends not with Poe's bells but with the hilarious "fanfares of sneezes." (We find bells again in the very last note, with a totally different force.)

Those sneezes are incongruous, and the insertion of such inappropriate images is the primary source of humorous detail. Obvious examples are the patriotic figures in a cheese platter in *Mars,* the "rose windows" of the butcher's "nipples" in *Avril,* head gear coupled with mushrooms and high school students with bishops in *Mai,* the classic acanthus leaves of *Août* footnoted as "Or rhubarb if you will": rhubarb does actually resemble acanthus, but the image of that simple garden vegetable used to decorate the columns of a Greek temple creates an image of a cook as sculptor. The ordinary cauliflower begins the list of *Octobre,* and each element is unrelated to the others (except through the sounds of "turban" and "turbine," otherwise completely disjunct) until the pumpkin, another vegetable, resolves then into that "fist of stone" incongruously dotting the *"i'*s." As complex is the series of exotic images in *Juillet,* in which "pyres" are quietly included—an integral part of the Indian culture evoked, but surprising, if not funny. "The eighteenth-century touch" in *Août* is lightened by the anachronistic "espadrilles," and labeling the *Septembre* images a "litany" is surely incongruous. Between incongruity and exaggeration fall the butcher's "astonishment" over the weeds of *Avril* and the two different designs of parquet floors, amplified in the note of *Novembre.*

Some of the incongruities produce very different effects, as in the "vomit" of *Septembre* and finally in the "intestines" digesting away in *Décembre.* These darker details are rare, and the primarily humorous tone hides

the political almost entirely, but the message is there. The "trace of humanity" of *Mars,* protecting at least bacteria, might not be altogether a joke, since it seems that some bacteria are essential to life. In *Mai,* power figures, "generals," juxtaposed to "fangs," and "bishops" mill about together with contemporary paperazzi, secondary-school students, and the omnipresent tourists, all ridiculed by silly hats, in front of the pyramid, with its latent message of ancient civilizations now vanished. The most extended example of the political appears in *Octobre* in Butor's Orwellian vision of the city of the lawyer's dream, composed of all varieties of records, files and lists, in the stanza that pointedly opens with "slabs, carcasses." Finally, where the religious significance of the feast of *Février* is distorted in the Carnival, so in *Novembre* All Souls' Day is overwhelmed by elegant floor designs, animals confined in zoos, nostalgia for former times, and by the folk mythology of ghosts. Poe's "funereal tintinnabulations" are carried over into the evocation of Christmas, where the last note does allow for "organs incense bells," but ends with "blasphemies." The celebration of Christmas has become blasphemous, and we all understand that commercialization has taken over: *Janvier* began with empty hands.

Thus the texts of the *Stances des mensualités* clearly display their sources in the original seventeenth-century documents and in Alechinsky's drawings: they are truly collaborative. Despite the speaker's initial disclaimer, they are poetry, not verse, and are discreetly harmonious, mainly in the soft [u]s and harsh [k]s alternately predominating. They present a humorous series of images through satirical self-deprecation, mockery of the sacrosanct zodiac and incongruities of all kinds. Beneath the laughter lies the political message that things are not as they should be. The world is controlled by the powerful, the rich (who are not penniless in *Janvier*) and the lawyers, who govern the "cascades" of "jeopardies"—which could also be translated as "implications" in the sense of individuals who are "implicated" in some illicit affair. Writers and artists are at the bottom of the pile, and it is the businessmen of the "competition" who create the "shames" of "fate." Nevertheless, even recognizing that this is the way things are, the poem leaves us with "patience" and through that new year's appointment book, hope.

GUIRLANDE LIMINAIRE: *LA MÉDUSE DES CHOCOLATS*

In our earlier examination of Butor's *Vagues des villas éclosion* derived from Kolář's artwork in the exhibit, *Michel Butor et ses peintres* we reviewed the structure of the sixteen-part poem. Alechinsky's con-

tribution to that exhibit provoked this part, *La Méduse des chocolats* [The Medusa of the Chocolates]. The format of this poem is identical to the one for Kolář, and the matrix analyzed relative to the Kolář piece is carefully maintained here. The very facts, that the layout of the poems is the same—and is for all sixteen artists—and that many phrases arranged and rearranged are familiar, make it all the more remarkable that the poems are as varied in content and tone as are the artworks. Using basically the same building blocks, organized according to the predetermined scheme, Butor has achieved very different results.

We have examined Alechinsky's drawings on "found paper" in the *Stances des mensualités,* and his uses in the artworks of the original legal documents and their letterheads. Later, in his *Dessins sur factures* from the *ABC de Correspondance* we will see more examples of the imaginative ways he finds to recycle original phrases, lines, and images in otherwise boring old bills. He does not ordinarily write words himself, other than his signature, but we see here that he has added "Butor & Co." above the trademark. Butor's fondness for alphabetical order is well-known, but whether or not Alechinsky guessed that his own work would appear first in the poem, his addition of the poet's name provides a clear signal here at the very beginning of the collaborative nature of the whole *Guirlande,* that it is indeed the work of Butor "and company."

As before, the words and phrases used exclusively for Alechinsky are set here in boldface:

LA MÉDUSE DES CHOCOLATS

dans la province méditée *sous les pépins de l'aventure*
laissant des traces passagères épines lancées dans **l'oubli**
à la moindre des **impostures** *surimprimées en* **boucles**
 moîtes
pollen de la photographie insectes migrations
fissures développées
dans le miroir
 ALECHINSKY
 la méduse des chocolats
 devant son comptoir de dentelle
 alignant ses petits poissons
 dans l'aquarium des convoitises
 son regard soluble entouré
 du turban des odeurs exquises
 avec les bruits de **l'atelier**
 et les baisers sur les vitrines
 où se dédoublent les hantises
 dans la province méditée

 de l'encre
 et du fourmillement des ventouses
 des enquêteurs les cratères à explorer
 semences dans la **nuit** *des grues à l'écoute des stalactites*
 imprégnation de **sangliers** *étincelle des* **héritages**
 qu'entraîne une âme échevelée **la méduse des chocolats**[71]

Pierre Alechinsky, *La Méduse des chocolats* **[The Medusa of the Chocolates].**

himself, but a way for the painter to know the spectator, for the spectator to understand he is being examined by the painter] (62). The four eyes unquestionably produce in the spectator the sense that something is wrong.

Let us look first at Butor's three stanzas as a whole, as printed opposite that double gaze of Alechinsky's drawing. Unlike the Kolář part, this poem takes as subject not the artist, but the represented figure.

The harmonics are placed in such a way as to produce cohesion among the stanzas: sounds frequent in the upper triangle are found also in the dizain, and then others frequent in the dizain are heard again also in the lower triangle. Thus the prominent *p*'s of the first triangle are continued along with voiced plosive *b*'s and the dental *d*'s in the dizain, especially evident among the prepositions in *"devant son comptoir de dentelle"* and in the recurrence in *"dédoublent,"* while only two plosives are heard in the lower triangle, and they are internal. In the upper triangle, there is only one *z* in a liaison; in the dizain it occurs in the title, in *"baisers,"* twice in liaison and three times in the rich rhymes in *-ises;*[73] then it occurs in the lower triangle four times including two liaisons. Similarly, the two [wa]s of the upper triangle recur in the dizain frequently, four times, but are absent from the lower triangle. The soft sounds of [y] and [u] are evenly distributed throughout, while sibilants, frequent in both triangles, are almost entirely absent from the dizain, heard only in the *"poissons"* and *"soluble."* It is the hard [k] that is most noticeable in all three stanzas: twice already in the upper triangle and then five times again in the dizain and six times in the lower triangle. Thus the harmonies support a reading of the upper triangle as quietly unsettling, with only discreet suggestions of underlying problems, while the dizain links those hints to the unavoidable revelations of the lower triangle.

The four eyes are seen in the upper triangle as contemplating the "province," with the sense so often found of the "provinces" as opposed to Paris, backwoods, out-of-touch, out-of-date. The "pips" could also be translated slangily as "slip-ups" or "hitches." Within the uncertainty of "chance," there is a certainty that any tracks left behind, even thorny ones, will be "passing," tossed to "oblivion." "Deception" is introduced, and can be read as causing both the preceding hurling of the thorns and the following printing with curls. Printing something over something else, obscuring the original, is just what Alechinsky's ink drawing has done in blotting out parts of the original bill. It is also what photographic processes are capable of doing, as in "trick photography," which is purposely deceptive. The cracks are "developed," again a photographic term, and appear in a mirror: a cracked mirror could very well produce the four-eyed effect.

Butor's text makes obvious use of the bill's origin in a chocolate-shop; the address, Donzère, in Drôme, gives the location, "in the provinces," and the word underlined in the bill, *soluble,* appears in the text. *"Valeur"* [value] and the illegible word on the same line, and the column of prices probably generated the *"boucles"* [curls]. Alechinsky's line drawn around the face, with the trademark as a hairbow, forms the "turban" of the text. The face surrounds an item on the bill that has been deleted with an H-shaped set of slashes, encircled and connected to another circle; thus the ovoid forms appear in the drawing as pince-nez, below the double set of eyes that are the dominant feature of the drawing. Butor and Sicard refer to Alechinsky's theme of four eyes as the *"double regard"* [double gaze]: Alechinsky's painting looks at us even as we look at it (*Texte* 40–41).[72] Later Butor adds, *"La peinture, pour Alechinsky, est une façon de juger celui qui la regarde. Pas seulement une façon pour le spectateur de connaître, ou de se connaître lui-même: mais une façon pour le peintre de connaître le spectateur et, pour le spectateur, de comprendre qu'il est examiné par le peintre"* [Painting, for Alechinsky, is a way to judge the one who is looking at it. Not only a way for the spectator to know, or to know

In the dizain we learn the figure in the painting is the Medusa.[74] She may be "of chocolates," but the mythological character is traditionally fatally dangerous. The mirror in the upper triangle reminds us that there is only one safe way to look at her, as Perseus did in his polished shield. But here she is, calmly straightening out displays of little chocolate fish on their doilies in the glass case, which is naturally seen as an aquarium. Her "gaze" becomes a part of, dissolved in, the "delicious scents" and the "sounds of the workroom." The chocolate fish are objects of "longings," and certainly eager customers do long for the chocolate, but the tranquil scene has generated "redoubled hauntings" as the prim shopkeeper with her pince-nez ponders.

The ink of the lower triangle would here be Alechinsky's Chinese ink, but the idea of "swarming" takes us back to the "insects" of the upper triangle, and the chosen word, *"fourmillement"* is exactly derived from ants, *fourmis.* It is revolting to consider insects in conjunction with the chocolate. Pursuing this idea will lead us to envision the "investigators" as public health officials, using *"ventouses"* (which can be translated as "leeches") to suck something horrid from the "craters," which could be those gnawed out in the chocolate. This spector could well haunt our chocolate shopkeeper. But the combination of "craters" in conjunction with "to explore" and in close proximity to "stalactites," especially at "night," leads us rather into some other world, reflecting the "migrations" of the upper triangle. In the darkness we find huge machinery listening in—as if to broadcasting antennae—to "stalactites," which could be found in the "craters," and hearing sounds very different from the pleasant bubbling of the "workroom." In this other world are images of reproduction: "seeds," complementing the "pollen" of the upper triangle, together with the "impregnation" of "wild boars." The choice of animals, used only here in Alechinsky, is reminiscent of a distant, even possibly mythological setting. The "spark" or causative force of "inheritances"—and it is not only in literature that one finds the destructive effects of legacies—is "swept away" by this "disheveled soul." The "deception" of the shopkeeper is revealed: she is not at all as she appears in her pleasant shop, but seethes with resentment over her situation, longs to escape, and, even as we look at her, she looks at us with the gaze that turns others to stone.

The Kolář poem spoke on behalf of the oppressed as a group in need of "salvation," against a background of contradictions and crises. Although the subject of the Alechinsky poem might embody the type of a large group, provincial shopkeepers seething with resentment because rich Uncle Somebody left his fortune to Cousin Somebody Else, the thoughts reflected here are rather those of an individual.

We recognize two phrases seen in Kolář. In Kolář (II, 4) *"pollen de la photographie"* [pollen of photography] was in no way associated with deceptive practices, and seemed especially fit for Kolář, with his liberal use of photographs in his collages, whose "pollen" is scattered by the breezes of the juxtaposed images. As for "lining up her little fish" (Alechinsky II, 3), the "little fish" are similarly especially appropriate to Alechinsky's chocolate shop, where fish-shaped chocolates in silver paper are as much a part of seasonal displays as Easter eggs, whereas in Kolář (III, 3b), it was *une souche* [a stump] which *saigne* [is bleeding] (III, 2b) that was tidying fish, not chocolate ones, but living fish in their natural habitat, associated with the *"flux et reflux"* [ebb and flow] and "sel" [salt] (III, 1/2).

We must not leave the fish without seeking out their other appearance in the *Guirlande,* which will inevitably lure us on to other examples of the radical differences in tone and content produced by the matrix. The fish appear in the Matta poem in a series of lines taken accordingly to the matrix from the dizains of two other artists, all without change from the originals:

> *qu'admoneste un prophète rude alignant*
> *ses petits poissons recoins*
> *où mûrit la poussière*

> [which a rude prophet admonishes lining up
> his little fishes corners
> where dust ripens]
>
> (Matta I, 4–6)

The rude prophet (from Vieira da Silva II, 4) and the dusty corners (from Bryen II, 5) could hardly have a tone more different from that of our neat Medusa, whose hair is confined in a turban, from which only a curl escapes, in her certainly dust-free shop.

Another example of an unchanged Alechinsky line from the dizain combined with two others also unchanged illustrates perhaps even more clearly the differences in tone as well as content by the workings of the matrix:

> *que flaire*
> *un bovidé songeur devant son comptoir*
> *de dentelles remous des ruines fenaisons*

> [sniffed by
> a dreamy bovid before his counter
> of laces eddies of ruins haymakings]
>
> (Masson III, 1/3)

The source of the sniffing cow is Vieira da Silva (II, 6), easily associated with at least the haymaking derived

from Bryen (II, 3), but we would scarcely recognize the Medusa's lacey counter set down in the middle of a pasture.

Before tearing ourselves away from these fascinating combinations, we must cite three additional examples, each of which creates a completely different effect. In all three, the Alechinsky dizain line and the dizain line from one of the other artists is intact, while the third artist's line has been more or less altered. Each demands attention for a different reason:

> . . . *propagation de boules bises*
> *dans l'aquarium des convoitises remous*
> *de ruines fenaisons . . .*
>
> [. . . propagation of balls kisses
> in the aquarium of longings eddies
> of ruins haymaking . . .]
>
> (Parant I 3b–5)

The original of the "propagation" line was in Vieira da Silva (II, 5): *"propagation de cactées grises"* [propagation of grey cacti], which is varied here specifically for Parant, who is the artist noted for his use of balls, bubbles, and balloons, and these are not the same "kisses" as those on the "glass cases" of Alechinsky (II, 4), but rather the familiar term for the customary kiss on both cheeks, often used as a friendly salutation in a letter, *"grosses bises"* [fat kisses]. The charming balls and kisses spill over into the "eddies" we just saw with a cow in Bryen, which are now in the waters of the "aquarium of longings." Even among the "ruins," the whole is relaxed, contented, friendly.

Another intriguing example of these groups of three dizain lines, one altered, illustrates a certain gustatory delicacy:

> *palpitations incertitudes*
> *et les baisers sur les vitrines raisins de fatigue*
> *murmures*
>
> [palpitations uncertainties
> and the kisses on the glass cases grapes of fatigue
> murmurs]
>
> (Vasarely I, 1b–2b)

The first line, from Vieira da Silva (II, 9), and the first part of the second line, from Alechinsky (II, 8), are unchanged. But the second part of the second line was originally in Bryen (II, 7) *"crachats de fatigue murmures"* [spittle of fatigue murmurs], which was maintained intact in Dufour (III, 5b), but here, near the chocolates we remember very well are in the "glass cases," that "spittle" has mercifully been altered.

The last example of an intact Alechinsky line combined with lines from other dizains, one of which is slightly varied, is:

> *du turban des odeurs*
> *exquis échafaudage*
> *des angoisses dans les sifflements de l'envol*
> *halètement d'une poitrine . . .*
>
> [from the turban of scents
> delicious scaffold
> the anguish in the whistlings of flight
> panting of a chest. . . .]
>
> (Masurovski III, 1–4a)

"Scaffold . . . anguish" is unchanged from the original in Bryen (II, 2), but since *"exquis"* in its new placement (and differing adjective agreement) now modifies the "scaffold," it should better be translated here as "exquisite." The "whistlings of flight" are unchanged from Dotremont (II, 3); however, the *"halètement"* [panting] is altered to quite the opposite from the original in Dufour (II 4), which was *"l'apaisement d'une poitrine"* [quieting down of a chest]. Our shopkeeper's "turban of scents" is no longer "delicious" and is coupled with three painful images.

In the above examples from other artists' parts, the lines from the Alechinsky dizain are unchanged. Let us look now at the words Butor has altered specifically and exclusively for Alechinsky, most of which carry the weight of the ideas. The "thorns" are thrown into *"ennui"* [boredom] in the original dizain in Dufour (II, 7), repeated in Hérold (III, 5b), where the "thorns" are transformed into *"aiguilles"* [needles], but here they end in oblivion (I, 2b). In the original Francken (II, 6) we find *"à la moindre des tentatives"* [at the least attempt], repeated without change in Saby (III, 1/2) and Masson (III, 5a) but more "attempts" have significantly become "deceptions" here (II, 3a). The overprinting occurs on *"lèvres moîtes"* [damp lips] in the Herold dizain (II, 5), Matta (III, 4b), and Staritsky (I, 5/6), whereas here we find "damp curls," reflecting the Medusa's curls seen in the drawing (I, 3b), presumably "damp" from the heat of the kitchen, that "workroom" that occurs only here (II, 7).[74] Its noises are those Medusa hears, trapped in her daily drudgery! The noises are far more exciting in Dotremont (III, 5b): *"les bruits de la bourrasque"* [noises of the squall], and the "squall" becomes *"la débâcle"* [the debacle] in Staritsky (I, 5b). The *"semences dans l'épi des grues"* [seeds in the spike of cranes] of the original Peverelli (II, 4) are preserved without change in Hérold (I, 1/2) but with the Medusa we are in darkness, "in the night" (III, 3a). "Impregnation" appears in Staritsky (II, 6), but of harmless *"peupliers"* [poplars], which are retained

in Hérold (III, 1/2) and even in Matta (I, 3a) (where the "impregnation" becomes "calcination") but here there are "wild boars," in the shopkeeper's wild fantasy of escape (III, 4a). The *"étincelle qui se transmet"* [spark which is transmitted] of Vasarely (II, 7) becomes a transmitted "incantation" in Peverelli (I, 2b), but only here is the nature of the "spark" given: it is of "inheritances" (III, 4b). Together the words suggest the flames of endless familial fires ignited by one testament. One need only reread the Alechinsky as it might have been without the alterations to see the force of the changed words.

We might expect that the words so clearly referring to the four eyes, "cracks developed in the mirror" would appear only in Alechinsky, but that is not the case. "Cracks" appear also originally in Masson (II, 3) and again, rearranged, in Staritsky (III, 3b). "Developed" comes originally from Masurovsky (II, 5), where it is developed *"sur le miroir"* [on the mirror] and recurs in Saby (III, 4b) as it is in Alechinsky, *"dans le miroir"* [in the mirror], and is much altered in Dufour (I, 3b) to *"développés sur les lagunes"* [developed on the lagoons]. However, only in the Alechinsky poem do we find the arrangement of "developed" juxtaposed to "in the mirror." And only in the Alechinsky artwork do we see, as in a cracked mirror, the doubled eyes.

Literally innumerable other examples exist illustrating Butor's ability to create poetic imagery in any and all arrangements of the same words. It is the case that examples of Butor's use of humor do not leap to the eye in the *Guirlande liminaire,* but the "political," in his broad sense of the word, is present in this Alechinsky text. The four-eyed woman trapped in the conventional world of the "provinces," governed by "inheritances"—whether received or not received—is only pretending to be agreeable to her regular customers. Her surroundings are neat, and others find them wonderful, but she herself is haunted. Underneath her pose, the "deception," this Medusa desperately longs for escape to some other situation, and she is as dangerous as a "wild boar." She, with her "double gaze," is looking at us while we look at her, and we see what Butor saw when he said, *"On trouve une espèce de regard apocalyptique chez Alechinsky"* [One finds a kind of *apocalyptic gaze* in Alechinsky] (*Texte* 62–63).[75] She could turn us to stone.

LE RÊVE DE L'AMMONITE

With our next study, we return to the world of dreams, *Le Rêve de l'ammonite [The Dream of the Ammonite].*[76] It was published in 1975, the same year as its reprise in the second dream of the first *Matière de*

rêves [Stuff of Dreams],[77] because, as Butor explains at the end of *Ammonite,* he felt that the two were sufficiently different not to interfere with each other (35), which is indeed very much the case. In *Matière de rêves,* the original is interrupted by passages relating it to the previous dream, developing the new context, and the artworks are not included.[78] It is important to point out that an essential element of the artworks cannot be presented here either: the brilliance of Alechinsky's colors. The black-and-white reproductions of Alechinsky's etchings that we will examine present grotesque creatures, ambiguous forms, unintelligible chaotic scenes, disturbing in the extreme, and only the final figure, the ammonite, offers any sense of repose. If Butor had himself been looking at only the black and white, this text might have remained only an ordinary dream rather than a terrifying nightmare. And yet we will find humor, however "black," rich, resonant harmonies amidst the cacaphonies, and a political vision, surrounded indeed by grim forces of evil, but finally of peace and justice. It seems possible that the beauty of Alechinsky's colors is responsible for the light that shines through the text of *Ammonite.* Certainly true of this work are Jacques La Mothe's words about the collaborations in general: "The absent work thus hollowed out by the text leaves us with a melancholy, the profound desire of its presence."[79]

Analysis of this dream in its initial publication is a much simpler process than that of the *Rêve de Jiří Kolář* as it appears in *L'Oeil de Prague.* The two dreams differ in two ways basic to understanding the collaborative process: first, the text of the *Rêve de Jiří Kolář* has its own matricial structure and in *Ammonite* there is no matrix. Second, Butor determined the order of treatment of the Kolář collages, but in *Ammonite* followed in the text the order of presentation Alechinsky gave the etchings, which "Correspondances," a selection of letters among Butor, Alechinsky, and Bruno Roy, the publisher, included at the end of *Ammonite,* makes clear. Alechinsky there states that his numbering should not limit Butor, that the numbers will not appear on the etchings themselves, but Butor responds, *"J'ai respecté sans la moindre difficulté ta numérotation"* [I respected your numbering without the least difficulty] (46).

The letters of "Correspondances" explain the process of development of the work, which Butor later summarized as, *"Textes et images évoluent ensemble, par étapes et correspondance"* [Texts and images evolve together, through stages and correspondance].[80] The writer and artist pursued their collaboration through five stages: (1) Alechinsky's original series of twenty primary etchings, plus on a separate page, a *"souvenir"* [memory]; (2) Butor's text; (3) Alechinsky's *"remar-*

ques marginales" [marginal remarks], which are lithographs added after the text was completed: titles for each part and drawings provoked by an element in the text on that page; (4) composed exclusively of the etchings, reworked with a lighter bite, and the lithos, in color; only a few copies were printed; (5), of which three copies were made, additional comments by Butor in red and black inks.[81] The *Ammonite* serves as an excellent example of Butor's collaboration with an artist, extending as it does well beyond illustration or decoration, becoming a dialogue.[82] My study here will treat only stage 2, the text, as derived from stage 1, the etchings. Not included in the study here are Alechinsky's marginalia, stage 3, since they tell us which words, scenes or ideas set Alechinsky's brush in motion, rather than what in his work inspired Butor.[83] We will see Butor's texts move to and from the engraving, the writing only occurring once it is *"ancrée dans l'eau-forte"* [anchored in the engraving], as La Mothe says in *Echographies* (79).

Demonstrating the dialogue between the collaborators, one of Alechinsky's letters in "Correspondances" identifies four of his themes, which Butor maintained. The volcanos described by Alechinsky as *"devenant le 'cou coupé' d'une plantureuse, d'où jaillit le sang, donc la lave"* [becoming the cut neck of a buxom woman, from whom blood jets forth, thus lava](44) are found in Butor's text for subdivision #6 qualified by the same adjective: *"plantureuses pentes"* [buxom slopes]. Alechinsky's second theme is the *"machoire* [sic] *dégustant les deux yeux de sa propre tête"* [jaw tasting the two eyes of its own head] and we will find in the text the judge chewing and later swallowing his own eyes: *"ses yeux roulent dans ses mâchoires"* [his eyes roll in his jaws]. Although Alechinsky's representations of this theme do not have the ambiguity of the volcanos, and could even without his letter have generated Butor's text, especially as it is the subject of the second *Souvenir* (seen through the transparent page on which is printed a list of words with the same prefix, to be described later), the use of the same term, "jaws" indicates a direct borrowing. The third theme Alechinsky mentions is the most important: *"la langue tirée, déroulée en spirale rouge, lisible sur chaque planche, les unifiant, devenant ammonite à la cinquième"* [the tongue sticking out, unrolled in a red spiral, visible on every etching, unifying them, becoming ammonite in the fifth]. Butor certainly maintains that tongue, and builds from it the character of the writing woman, the "beauty" or "clerk"[84] who is eventually transformed into the ammonite. In the fourth theme, Alechinsky actually adds yet one more collaborative stage, a preliminary one from the time before he began the etchings: *"Outre les images précises ou vagues que je ne*

cherche pas (volontairement ou involontairement) à m'expliquer puisque tu seras formidablement là pour ça, il y a sans doute ta pluie de Séoul" [In addition to the precise or vague images which I do not try (voluntarily or involuntarily) to explain to myself since you will be there formidably to do that, there is undoubtedly your Rain on Seoul]. The work referred to is *La Boue à Séoul* [Mud in Seoul], found in the second *Génie du lieu: Où/ Ou [Spirit of the Place: Where/Or];*[85] in it the car transporting Butor to his scheduled lecture is repeatedly stuck in the mud. Alechinsky's reference has led Butor to transform the monsoon downpour, with its resulting adhesive, bottomless mud, into the *"déluge de poix"* [deluge of pitch] (32) found here.[86]

There are five parts to the *Ammonite: L'Arrestation* [Arrest], *L'Instruction* [Enquiry], *La Séquestration* [Confinement], *La Précipitation* [Haste],[87] and *La Respiration* [Breath], corresponding to the five Alechinsky etchings, each of which is printed on a double page. On one side is the primary etching, subdivided into smaller elements, a total of twenty subdivisions for the five etchings. The upper ones are always in blue, the lower ones changing through the rainbow for each etching : first red, second orange, third yellow, fourth green, and finally purple.[88] On the other side of the double page is a *Souvenir,* which picks up a detail of the corresponding etching opposite: these are all in reddish brown. Each of the double pages is protected by transparent leaves. On one side of the transparent folio are printed numerals that match up with the subdivisions of the primary etching underneath; each paragraph of Butor's text is numbered to correspond. On the other side of the transparent folio is a a *comptine* [counting rhyme,] a list of nouns ending in *-tion,* placed to fit under, over or beside the Alechinsky *Souvenir* it protects. For each chapter the words of the list all begin with the same prefix (*pré, con/com, inter, dé* and *trans*). La Mothe reads these as "playing the role of concealed commentaries on the title of each of the chapters," thus marking, in order, "anteriority; simultaneity, adding; reciprocal relationship, distribution; separation, distancing; passage, change, transformation."[89]

The pages of this work are unnumbered; I have assigned numbers for convenience, but have not counted in the transparent leaves, since by virtue of the transparency each is read together with the text of the page it covers. Reproduced in *Travaux* are two of the primary etchings, corresponding to *Arrestation* and *Instruction;* three *Souvenirs,* corresponding to those two etchings plus *Séquestration* and a few marginalia.[90] The other three primary etchings are reproduced here.

Butor describes this work as having the *"caractère sarcastique de rêve burlesque"* [sarcastic character of a burlesque dream] (*Texte* 190). We will find the hu-

morous here, but also amid the playful rhymes, repetitions and images, the seriously political, all rich in harmony. I will look very briefly here at passages from the first two chapters (whose etchings may be seen in *Travaux*), sketching the action and focusing on our areas of interest, and then examine parts of the last three in greater detail.

In *Arrestation*, a narrator, identified only as an *"bébé-vieillard islandais"* [Icelandic baby–old man] (*Ammonite* 8) finds himself sinking in a morass of filth, apparently in Iceland, among erupting volcanoes, which are identifiable in the etching. He hides in an igloo, observing both figures seen in the etching: the *"grand verdâtre"* [great greenish], of whom he says, *"Quelle morbidesse dans la tango! Dégingandé, gandin, ganache"* [What delicacy in his tango! Gawky, foppish old fogey], and "the beauty" (3), a woman with the tongue of a snake—Alechinsky's *Souvenir* shows her tongue as a giant spiral. La Mothe recognizes that "the igloo is not directly proposed by the artist," but finds its "curves" and "circular opening" by turning the etching upside down.[91] Then La Mothe has seen in the etching "at the back of the red character a long line of the same color divided in two segments and dragging almost to the ground. From that the idea of 'limp hands behind his back fiddling with a whip of string.'"[92] The woman licks the "Great Greenish" until he disappears:

> *De sa gueule de poisson frétillant pointe, darde une petite langue noire qui brunit au bout, rougit au bout, grandit, s'allonge, s'en va chatouiller la nuque du flandrin chlorotique, lequel en miaule, glousse et ronronne de contentement servile, s'enroule autour de son cou spongieux, lui lèche tout le visage, le déguste, s'effile en dard pour le picoter, s'étale en spatule pour le tapoter, en serpillière pour le lessiver, en tampon pour le vernir, puis se rétracte, se replie, et hop, le bec se referme avec un claquement. Après quelques reprises du manège, il devient manifeste que le bonhomme est en train de fondre comme un sorbet à la pistache dans le cornet d'un écolier* (5).[93]

Despite the vaguely threatening atmosphere, the humor is primary, through absurdity, amplification, and incongruity. With the remains of the narrator's destroyed igloo, which he calls *"ma demeure, (quelle hyperbole!)"* [my dwelling (what hyperbole!)] (7), the woman (hereafter referred to as the "clerk") has set up an office, where she reads the narrator's file: *"Se servant de sa langue comme plume, et de sa narine droite comme encrier, elle prend des airs inspirés pour corriger mes fautes d'orthographe en s'esclaffant"* [Using her tongue as a pen, and her right nostril for an inkwell, she takes on inspired airs to correct my spelling errors while guffawing]. She then accuses the narrator of crimes he cannot manage to understand, and the sequence of phrases he imagines she might be saying includes every one a parent or teacher ever used as a reprimand: *"qu'elle sera malgré sa peine bien obligée, que l'on sera bien obligé, que l'on va sans doute bientôt être obligé, très tôt"* [that she will in spite of her regret really be obliged, that one will really be obliged, that one will no doubt soon be obliged, very soon] (8). The section concludes with an understatement, *"Un seul point certain, c'est que ça va mal"* [One thing is sure, things are going badly].

In the first part of the second chapter, humor continues primary as the action moves to the site of the *Instruction,* in an image seemingly drawn from the animated cartoons of the contemporary world, incongruously garnished with a simile from the kitchen: *"A l'aide d'ingénieuses chenillettes montées subrepticement sous son installation, elle se propulse chez le juge en me balayant devant elle comme une rognure. Pas besoin de sonner, de frapper, de se faire annoncer, elle est attendue, toujours attendue"* [With the assistance of ingenious caterpillar tractor bands clandestinely mounted under her office setup, she propels herself to the judge sweeping me before her like a paring. No need to ring, to knock, to be announced. She is expected, always expected] (9). The narrator imagines an escape, in a barrage of hard [k]'s, the amplifications increasingly ridiculous: *"fausser compagnie ni vu ni connu, en catamini, en courant d'air, à tout ce joli monde de chicane"* [to give the slip on the q.t., on the sly, like a breath of air to all this pretty bunch of pettifoggers] (10). In a parody of ecclesiastical hierarchies, the narrator recognizes that any optimism he retains derives from his being a *"novice dans la section minimes de l'archiconfrérie des petits filleuls de saint Nicolas qui n'a encore jamais réussi à conquérir tes premiers badges de papelardise et d'onctuosité révérente"* [novice among the minims of the archbrotherhood of little godsons of St. Nicolas who has never yet succeeded in earning the first badges of sanctimoniousness and reverent unctuousness] (10). The humorous self-deprecation continues as he describes himself as in a state of *"demi-compétence de voleur de savoir"* [half-competence as a thief of knowledge] (13). It is at this point that we find the gruesomely humorous theme Alechinsky mentioned in the "Correspondances." As the judge examines the narrator's file, he becomes so excited his eyes pop out and he snaps them into his mouth—Alechinsky's *Souvenir* represents him as a crocodile, derived from the text: *"son visage de magistrat surexcité devient de plus en plus semblable à celui d'un serpent ou d'un crocodile"* [his face of an overexcited magistrate becomes more and more similar to that of a snake or crocodile] (15).

When the volcano becomes female[94] the humor is increasingly darkened by brief details, as in her ghastly incantation: *"Petit, petit, viens grimper ici, je te donnerai un shampooing de flammes, . . . petit, petit, viens fouiller ici, je te châtierai de fessées d'oursins"* [Little one, come little one, climb here, I will give you a flame shampoo . . . little one, little one, come dig here, I will punish you by spankings with sea urchins](15).[95] Another surreptitious detail is hidden away in the judge's repetitions in his response "song": *"Petit, petit, avoue petit, . . . petit, petit, trahis petit, je te gaverai de bonbons au purin; petit, petit, baisse les yeux, petit, je te châtierai de séances de l'Académie"* [Little one, little one, confess little one, . . . little one, little one, betray little one, I will stuff you with manure candies, little one, little one, lower your eyes, little one, I will punish you with sessions of the Academy]. Meanwhile, *"Progressivement métamorphosée en sauterelle, malgré les airs de sphinx qu'elle* [the clerk] *se donne, elle gratte, elle gratte, elle inscrit tout avec ses ongles qu'elle trempe dans l'encrier de son coeur labouré ourlé de mouches"* [Gradually metamorphosed into a grasshopper, in spite of the airs of a sphinx which she puts on, she scratches, she scratches, she inscribes everything with her fingernails which she dips in the inkwell of her rooted-up heart hemmed with flies] (16). The grisly image of the clerk and the flies may go beyond even black humor, but the narrator's finding on a *"cintre de rouille"* [rusty coathanger] *"un superbe déguisement d'amibe"* [a superb amoeba disguise] can only be read as comical.

In *Arrestation* are found frequent hard [g]'s and in *Instruction* hard [k]'s, and in both appear many alliterations, amplifications, repetitions of words, phrases and structures, as in the passages cited above. The "burlesque" should be evident, as in this last event: What would an amoeba disguise consist of? A sausage-shaped mass filled with Jello?[96] Further, the etching of the clerk does represent her as resembling a grasshopper (with her spiral tongue longer than ever), but without Butor's help we would not have realized she was putting on sphinxlike airs, an idea rife with incongruity.

The political is barely introduced in that worst of all punishments, "sessions of the Academy," but the "song" of the judge encourages betrayal and continues with, *"je te consolerai avec des adresses graveleuses où tu pourras entendre des allocutions cauteleuses au milieu du friselis des décorations filandreuses; petit, petit, bave petit, je t'ensevelirai sous des monceaux de paperasses parfumées à l'essence de recoins nouées de pansements marinés dans de la sueur de ministre"* [I will console you with obscene speeches in which you will be able to hear deceitful harangues in the midst of whispers of long-winded decorations; little one, little one, drool

Pierre Alechinsky, *Séquestrations* [Confinement].

little one, I will bury you under heaps of rubbishy papers perfumed with attar of crannies tied up with bandages marinated in minister sweat] (15). This eye-eating character is monstrous, bizarre, hilariously horrific, but he is supposed to be a judge. The concept of justice seems to be in question.

Séquestration begins with the judge's finally swallowing his eyes, as suggested by #4 of the preceding etching, and then being carried away by a bird, as in #8 in the present etching.

#8. Tant pis pour lui, son règne est passé. Hourrah! Il les a gobés ses deux yeux.Mais aucun avantage pour moi dans l'immédiat. Un de perdu, dix retrouvés, encore plus grognons, radins, mesquins, sanguinaires. Il ne lui reste plus qu'une bouche aveugle aux gencives purulentes au bout d'un cou de plus en plus flexible (ah! son intransigeance d'antan!). Quant à sa poitrine, où l'on croyait éternellement gravées les tables d'une immuable loi, il n'en reste plus qu'un vieux sac de chiffons qui ne se gonfle et ne se creuse plus qu'à peine. Les nageoires articulées qui savaient si bien feuilleter les annuaires et les codes sont réduites à des moignons de gelée. Manches d'au-

trefois, semblent-ils geindre, comme nous savions vous donner des envols pathétiques, avec quel grave sentiment de la destinée nous vous rabattions pour le verdict! Mouettes, pétrels, cormorans, albatros s'ébattent dans les nuages qui noircissent, et c'est une frégate, je crois, qui vient de saisir en son bec la laisse de la dépouille judiciaire (17–8).[97]

The previous incantations of the volcanos and of the judge contained words with odoriferous connotations; this passage shifts to unpleasant character traits and disgusting images: "purulent gums" and "stumps of jelly," the latter given a voice. The contrast between the present deteriorated condition of the judge and his former dignified status is presented incongruously by the sigh over his "intransigeance"—a behavioral trait rarely seen as admirable—and the interior monologue of those "stumps of jelly," as they nostalgically recall the flapping of the sleeves of his judicial robes. What would be a legitimate reason for sincere regret, the destruction of a fellow being, becomes at best ambiguous, given the nature of this judge as we have come to know him, and finally comic: a eulogy for sleeves is downright ridiculous. The harmony is heavy on hard *g*'s and [k]'s; the political is found in the "immutable law," "yearbooks and codes" of the judicial system now reduced to a scarcely breathing "old sack of rags."

The small beelike figure in #9, echoed in Alechinsky's *Souvenir,* is seen by Butor as an eclipse:

> #9. *Elle décolle comme un cerf-volant, signe furibarde des mandats d'amener sur le tableau noir du ciel craquelé où juge maintenant l'éclipse. Le soleil avait disparu depuis longtemps; c'était la lune qui le remplaçait au centre d'un halo sulfureux. Une énorme bulle de bave subitement gelée projette son ombre sur l'ancien astre des amoureux, celui des moissons est manifestement de l'autre côté de la terre pour longtemps. Plus moyen de compter sur le calendrier des ancêtres. Ses pages s'en sont allées au vau-l'air avec mes archives violées, entrailles remuées par les rapaces des limbes.* (18).[98]

The political aspect maintains, as an eclipse now serves as judge, while the kite, a raptor bird, is the "sign" of summonses. The narrator's private papers have been "violated." We do not know who "the rapacious" are, other than that they come from Limbo, eternal home of the unbaptized. Something has gone wrong with time; we will look later at the development of time in this chapter, as well as at the harmony. The only remotely humorous aspect here is in the narrator's tone, his matter-of-fact recounting of the unnatural events.

In the next three sections, #10, 11, and 12, Butor has related the corresponding texts to each other and to #13, at the bottom of the etching. Thus the flash of lightning

in the etching of #10 generated the beginning of that text: *"Décharge. Toute l'ouverture en est zébrée"* [Discharge. The whole opening is striped with it] (18), but it is not until the text of #11 that *"un éclair vient débusquer la scène"* [a flash of lightning comes to dislodge the scene] (18, 21). The lightning transects the frame top and bottom, and the openings in the frame give rise to the narrator's thoughts: *"Que n'ai-je trouvé l'issue, non point vers l'extérieur terrifiant"* [Why didn't I find the exit, not toward the terrifying exterieur], that is, toward the eclipse and the frigate bird above, *"mais vers les cavernes plus profonds"* [but toward the deeper caverns] (18) represented in #13 below. In #11 the familiar spiral has evoked *"Le croissant de l'ancienne lune tournoie autour de la nouvelle, s'effile, s'effiloche en balcons de vapeurs citronnées, chocolatées ou caramélisées"* [The crescent of the former moon turns around the new one, thins out, frays, in balconies of vapors, lemon-scented, chocolate-flavored, caramelized] (21). The spiral is also seen as an extension of the tongue of the face that appears in #12. However, the face's tongue is different here, and the text explains she is now writing with her fingernails rather than her tongue; the lighter, double line of this tongue could have generated the proboscis she uses in the next scene:

> #12. *Je l'aurais parié. Tout en continuant à gratter, gratter de ses dix doigts le dos, les ailes des oiseaux blancs ou noirs qu'elle capture au passage, les imprudents cherchant refuge en notre grotte contre les éruptions et l'orage, arrachant parfois les plumes pour graver en égratignures dans la peau palpitante les sentences d'un juge depuis longtemps disparu, utilisant sa langue comme une trompe de lépidoptère*[99] *elle suce les sorbets lunaires et les crèmes des nuées. La goulue, l'insatiable. Elle se régale en remerciant ses petits lares ventripotents de cette manne, mais sans en laisser une seule goutte, un seul grain rejaillir dans ma direction. Et l'horizon revient, bonne surprise. Depuis si longtemps on n'en avait plus entendu parler dans la nuit rosâtre. Il ne reste plus de l'ancienne lune qu'une ombre aussi rousse que les touffes de poils des volcanes-cheftaines, et la nouvelle enfle de plus en plus comme une outre qui va crever* (21).[100]

The clerk's casual cruelty to the birds is political only insofar as it demonstrates the evil nature of this character, who is one of those oppressing the narrator. Neither is it humorous, but the images of her household gods, which are "potbellied," and of her gobbling sweets from moon and clouds while jealously guarding every bite, does present her in a comical light, reinforced by the repetition of "single." Seeing the volcanos of the etching as Girl Scout troop leaders underlines the representation of the clerk's behavior as essentially childish. As

she is responsible for recording the sentences of the vanished judge, these activities exhibit "black" humor.

The horizon of the text could derive from the frames of etchings #10 and #12, and the circle around the number "13" seems to be the moon. Both horizon and moon serve an important function in stressing the passage of time, which recurs throughout this part. Already in #8 the narrator spoke of *"antan"* [yesteryear] (17) and *"autrefois"* [former times] in contrast to the immutable and eternal. Time is reemphasized in #9 by the eclipse, an event dependent on the passage of time among celestial bodies. The sun has been gone *"depuis longtemps"* [for a long time] (18) and will not reappear for *"longtemps"* [a long time]. The moon is of course the *"astre des amoureux"* [star of lovers], but now it is the *"ancien astre"* [former star]. Calendars are useless. The *"ossements"* [bones] of #10 are *"antiques"* [antique], and a future is suggested in the *"traces de chair séchée pendant les saisons arides permettraient quelque nourriture"* [traces of flesh dried during arid seasons would permit some nourishment] (18). In #11, the narrator recognizes he has lost track: *"Chaque minute (mais se sont peut-être des secondes très allongées; j'ai perdu ma montre dans la débâcle; ou des quarts d'heure précipités par mes angoisses)"* [Each minute (but they are perhaps greatly lengthened seconds; I've lost my watch in the debacle; or quarter-hours hurried by my anxiety)] (18). One of the many repeated phrases insists on this gradual passage of time. The texts of #10 and #11 contain the same words, as the narrator sinks deeper and deeper: *"mes pieds s'enfoncent doucement dans le charnier de plus en plus humide"* [my feet sink softly in the more and more damp carrion] (18) and *"je m'enfonce doucement, je suis déjà enterré dans mes frères antérieurs jusqu'à la ceinture"* [I sink softly, I am already buried in my earlier brothers up to the waist] (21). The phrase is partially repeated also at the beginning of #13: *"je suis enfoncé jusqu'au cou dans la charogne"* [I have sunk up to my neck in the carrion].

These reminders of the slow passage of time underline the feeling of the narrator's being in jail, for in this chapter the narrator himself is in "confinement." At the end of #10 this condition was made very specific: *"le déguisement d'amibe s'est carbonisé spontanément en dégageant une puanteur de tannerie et le cintre de rouille est venu m'enserrer les poignets de ses menottes"* [the amoeba disguise has spontaneously burned to a cinder giving off the stench of a tannery and the rusty coathanger is squeezing my wrists with its handcuffs] (18). He expresses pleasure at seeing the horizon again in #12, "fine surprise!" It is a spatial element; yet he thinks of it in terms of time: "For such a long time no one had heard it spoken of any more" (21). His delight seems at first ludicrous, as who would talk about the

horizon anyway? But our amusement is cut short by the realization that of course it is exactly prisoners who would talk about the horizon they have not seen "for a long time," since the horizon represents to them freedom.

In the tangled background of #13, Butor sees *"mes viscères s'enroulent autour des vieux os des autres"* [My viscera roll around the old bones of the others] (23), those "others" identified at the end of #11 as his *"frères antérieurs"* [earlier brothers] (21). The head in the etching is openmouthed, which generates the narrator's statement concluding this section:

> *Je bois pour eux tous; je leur choisis les plus lourds atomes dans ce qui tombe pour mieux les lester, l'oxygène le plus aigu, l'hélium le plus stable, l'hydrogène le plus volubile. Je les nourris et ils me soignent, je les éveille et ils me dorment, je tiens les yeux ouverts pour eux, et leurs dents recommencent à claquer. Je leur expédie des gouttes de pluie et dans leurs orbites germent des pupilles. J'écoute pour eux et ils me parlent; je goûte pour eux et ils me digèrent; je flaire pour eux et ils me dirigent; je suis tout un cimetière en gésine* (23).[101]

Here the political is undisguised. The selection of "heaviest atoms" cannot fail to evoke the "heavy water" fundamental to the preparation of nuclear bombs, especially in combination with the names of the chemical elements. It is very clear the narrator is dedicated to these "others," as the whole series of antitheses reiterates. The startling image of a cemetery giving birth provokes a range of thoughts, from macabre monsters to resurrection.

We would not expect soothing harmonies in this content and do not find them. Rhymes, such as *grognons* and *moignons* in the first paragraph, repetitions such as *gratter* in #12, reinforce the many occurrences of harsh sounds, [g], especially [gr], and [k], not only initial but internal, as in *verdict* and final, as in *bec.* The soft vowels of the repetition *"une seule goutte, un seul grain"* in #12 are undercut by those [g]'s and [gr]'s. Here are nasal vowels such as the rhyming *radins* and *mesquins* in #8, great patches of front *a*'s as, for example, looking only at some in #9, the choice of *furibarde* rather than *furieux,* the ominous *mandat,* onomatopoetic *craqueler,* the aspirate *halo* and threatening *rapaces.* These sounds are unremitting right on through #13, with its *accroc, alcool* and *claquer.* Only when the narrator's "I drink for them all" begins do the [u]'s heard already in the *goules* and *je m'en saoule* assume any prominence: *lourds, nourris, ouverts, gouttes, écoute, goûte.*

Despite the grimness of the situation, reflected in the sounds, touches of humor afford some relief. We have already mentioned the narrator's nostalgic regret, laced

with lyric language, over the judge's lost sleeves (#8). Among others, in #13, when *"La falaise s'est couchée comme le pli d'un drap sous le fer de la repasseuse"* [The cliff lay down like the fold in a sheet under the iron of the pressing-machine] (23), the domestic image could scarcely be more incongruous in the midst of the volcanos, mud, and rotting bodies. The image that follows is similarly humorous, especially through the precision of the qualifier: *"l'impressionnant portail a l'air maintenant d'un accroc, d'un vivier abandonné plutôt où je serais nénuphar hors saison"* [the impressive gateway now has the air of a rip, rather of an abandoned fishpond where I would be an out-of-season waterlily] (23). Any waterlily would be unimaginable in this situation, even out of season.

Thus, while the humor is quietly limited to the incongruous in this chapter, the political has become more apparent. The narrator—about whom we know otherwise only that he has not learned to be hypocritical and is modest about his own knowledge—felt sympathy toward the judge, as expressed in his song of the sleeves, that very judge determined to condemn him for crimes unknown to him or to us. The clerk is still recording the sentences of that absent judge, selfishly enjoying delicacies without sharing with the narrator, who said in #11, *"J'ai faim. Je voudrais dévorer ce ciel comestible, mais je m'enfonce doucement"* [I am hungry. I would like to devour this edible sky, but I am sinking softly](21). In direct contrast, the narrator has dedicated himself to the *"autres"* [others] (23), all those dead "earlier brothers" (21), as he "drinks for all of them." (23). The judge who condemned him has disappeared, the recording clerk is stuffing herself on sweets, and the narrator, hungry and imprisoned with no idea of his crime, is the one caring for others. There is no justice here.

The concentric circles in which the number of that part of the etching is enclosed, seen as the sun, provoked the exclamations of the beginning of this chapter:

> #14. *Le printemps, vous n'y pensez pas! Le jour, vous n'y croyez tout de même pas! Le soleil, vous n'allez pas imaginer! Oui, c'est bien le soleil; qui me parle? Qui veut me tromper encore? . . . Le jour? Je ferme les yeux. Le soleil? Je me bouche les yeux. Le ciel serait-il écorché? Oui, la bulle de tout à l'heure s'est entièrement vidée, je l'ai entièrement absorbée, et avec elle j'ai bu toute une couche de nuit. Je suis l'ogre du monde.* (25)[102]

Thus the self-sacrificing idea of "I drink for all of them" is continued as the narrator is found to have cleared away "the night." He is, however, unsure, wondering if he is caught up *"à me trahir, à me piéger"* [in betraying myself, trapping myself] (25), cautioning himself:

Pierre Alechinsky, *Précipitation* [Haste].

"Prudence, prudence . . . c'est vrai, ce doit être vrai" [Prudence, prudence . . . it is true; it must be true]. He is certain, however, in his political statement that *"c'est ma foule, personne ne pourra dire que je n'y suis pour rien. Je triomphe, grandeurs abolies, bouillie de tyrans, engrais de mes pousses!"* [it is my crowd, no one can say that I have nothing to do with it. I triumph, nobilities abolished, boiled pulp of tyrants, fertilizer of my sprouts!] (26). Although he can not be sure he has really accomplished anything—*"c'est moi, c'est peut-être moi"* [it is I, it is perhaps I] and then *"c'est moi ou ce n'est pas moi"* [it is I or it is not I]—he concludes, *"que vous importe, que m'importe?"* [what does it matter to you, what does it matter to me?].

And indeed it does not matter, because the figures of the etching appear to Butor as flowers, and following his questions, the narrator decides the transformation is not because he "triumphs," but rather because the flowers do, and he exhorts them.

> *Toute clavicule rhizome,*[103] *c'est leur triomphe; toute vertèbre bulbe, serre illimitée du temps foudre. Inespérées douceurs de nudités végétales, fleurs humaines montez,*

balancez vous coupes à la recherche de la rosée perdue, éparpillez vos larmes, vos soupirs, chantez, magnétophones à rêves, la polka des oursons et des moraines déchaînées, le quadrille des continents, l'aria de la nébuleuse du Crabe; barbouillez vos pistils de pollen, faites glisser la sève le long de vos nervures, perler le miel à la pointe de vos épines, claquez des sépales, sonnez des akènes, tintez des siliques, sifflez des vrilles. (26)[104]

The word "tendrils," has brought back the clerk we see in the next section of the etching, #15, and *"car vous figurez-vous par hasard que notre chère vieille connaissance la greffière soit le moins du monde troublée par ces transformations qui vous semblent si décisives? Nenni; elle s'est arrangée un petit chignon avec des peignes couleur roseau tendre, elle s'est appliquée sur ses temples chiffonnées une frange style arts-déco"* [do you imagine by chance that our dear old acquaintance, the clerk, is troubled the least in the world by these transformations which seem to you so decisive? Nothing of the kind: she has fixed herself up with a little chignon with combs the color of a tender reed, she has applied to her creased temples some art-deco style bangs] (26). Her new hairdo is suggested in the etching, but her amazing spiral tongue assumes primary importance: with it she is doing her accounts, how much each flower owes for various services: looking back at the previous segment, #14, Butor found in the forms suggestions of the flowers he lists: the *"fleur madrépore"* [madrepore flower],[105] *"fleur pomme"* [apple flower], the rectangle as the *"fleur oreiller"* [pillow flower], the *"fleur cornue"* [retort flower], the vessel found in chemistry laboratories, seen upside down (29). Seven forms with "stems" are seen in the etching, and an eighth one intersects with a "stem" and looks rather like a bud; Butor included it in his list of eight flowers against whom the clerk levies charges for services, all due by specified dates.

In this passage occur two instances of the mildly humorous that carry a political point. The one is not obvious in English, a literary allusion tucked away in the "triumph" of the plants: *"à la recherche de la rosée perdue"* [in search of lost dew] (26), which should elicit a smile, at least until one realizes these are the "human flowers" who are encouraged to seek "lost dew." One would think that was a futile endeavor, and yet the search for "lost time" resulted in a great work of art; these "human flowers" have the potential of finding art in the dew, and if there is anything we know, it is that art is the salvation of the world. Secondly, the "polka of the polar bear cubs and unchained moraines" evokes an image of bears dancing of their own free will, appropriately among moraines, since moraines are associated with glacial debris, just where polar bears live in the

wild. If not outright laughable, this is certainly a happy picture. Further, although "unchained" qualifies the "moraines," its proximity to the bear cubs allows for that association, and what could be a happier picture than unchained, free bears dancing because they want to? The contrast with the usual merciless exhibit of captured bears forced to dance is very vivid. The polka, a rollicking, relatively simple dance, is as appropriate for polar bears as the slithery, quickly reversing tango was for the Great Greenish.

Humor is more obviously present in the flower sequence, but gradually becomes subordinate to the political. The flowers are related to the services provided or to their debts in different ways. Thus the "madrepore flower," is required to bring in coral necklaces, and the *"fleur hirondelle"* [swallow flower] (27) is condemned to 150 hours of housework, deriving no doubt from the familiar term, the *"hirondelle d'hiver"* [winter swallow], meaning a chimney sweep. The "pillow flower" has received *"tapotements, câlineries, silences"* [pattings, wheedlings, silences] and owes *"cent cinquante berceuses en forme de fugue avec paroles adaptées en forme de ballades enrigistrables en nos studios de neuf heures du soir à six heures du matin chaque nuit"* [150 lullabyes in the form of a fugue with words adapted in the form of ballads to be recorded in our studios from nine in the evening until six in the morning every night], the apple flower must produce Calvados (apple brandy), for *"l'échauffement de nos assemblées consultatives dès leur prochaine session"* [the warming of our consultative assemblies at their next meeting].

Thus, some of the debts and penalties of the flowers are humorous, as the *"fleur sabot"* [wooden-shoe flower] (31) owes for *"déodorisation"* [deodorization], among other items, and the *"fleur perruque"* [wig flower] (29) owes for the accumulation of *"démêlage, saupoudrage, peignage, brossage, taillage et parfumage"* [untangling, sprinkling, combing, brushing, cutting, and perfuming], but its penalty is to produce ideas to improve the functioning of the penal colonies. Further, concerning these ideas, *"il vaut mieux qu'elles soient ingénieuses si elle ne veut pas les expérimenter par elle-même"* [had better be ingenious if she does not want to be testing them herself] (29). The ideas are due the day the next boatful of convicts leaves—but that date is a great secret, and the flower *"ne saura ni le jour ni l'heure"* [will know neither the day nor the hour] (31). The retort flower, with its connotations of the chemistry laboratory, brings us very close to the academically political, as this flower is required to provide refreshments for the next dinner of *"anciennes élèves dans la salle d'honneur de notre association dès nos prochaines élections de membres honoraires"* [former students in the ceremonial room of our association at

the time of the upcoming elections of honorary members]. The humorous is quite overwhelmed by the political when the *"fleur trompette"* [trumpet flower] (31) is ordered to produce music for capital punishments:

> *ouvertures pour accompagner les exécutions capitales dont nous déciderons dans l'instant qui suivra le renouvellement éventuel de certains murmures, de certains sourires, carnavals, mois de mai, de certains haussements d'épaules ou traînements de savates, de certains bâillements, de certaines moues ou bizarreries que nous n'avons déjà que trop tolérées. Quant au méprisable, au misérable, à l'abominable instigateur de toute cette floraison médiocre que nous n'épargnons que par grâce malgré l'indigence des services qu'il est capable de nous rendre, il va de soi qu'il est condamné à s'enfoncer davantage encore, à avoir ce qui lui reste de crâne finement broyé sans que mort s'ensuive, les oreilles tourmentées d'otites compliquées sans que surdité en arrive, à être enfermé à tout jamais sans que paralysie le délivre, dans les entrailles mêmes de celles qu'il a si follement blasphémées, les volcans, à y contempler pour sa constante honte son oeuvre indigne et avortée. Retards, retards, inadmissibles retards! Fautes d'impression, d'orthographe, de français même, endurcis, relaps! Ah la pitié ne sert à rien, canailles, que le déluge de poix commence! (32)[106]*

The initial list of crimes, with the smiles, carnivals, and yawns, that can merit the death penalty is so absurd as to be humorous, but the penalty the "instigator" is condemned to is surely one of the most grisly and terrifying collections ever imagined and we can only hope none of the world's current specialists in torture have seen it.[107] Even if we have not blasphemed any volcanos, any of us, all of us, are guilty of "delays," "errors in printing, in spelling, even in French," and we can read these accusations of the clerk with equanimity, recognizing their "black" humor in the contrast between the crimes and the punishments. However, the charge of "unworthy and failed work" alleged against this narrator, who we suspect is the writer, is unacceptable and scarcely humorous even as "black," a statement of the blatantly false. There has to be more, and the narrator has given us hints.

Early in this section, #14, he identified himself as part of the group: "It is my crowd, no one can say that I have nothing to do with it" (26) and spoke specifically of the abolition of *"grandeurs"* [nobilities] and the *"bouillie de tyrans"* [boiled pulp of tyrants]. Then, in the next section he said in another of his reversals, relative to using the word, "tendrils," *"Maladroit! Il ne fallait pas siffler ce mot-là; ou plutôt non, il était grand temps que quelqu'un osât déchirer le voile qui commençait à nous envelopper"* [Clumsy! That word should not have been hissed; or rather, no, it was high time for someone to

dare to rip the veil which was beginning to envelop us] (26). We see now that he has been that "someone" who indeed "dared." Then, hidden away among the actions that will recur and will provoke the reestablishment of capital punishment, there is the "month of May." Some remember a time when this reference would have implied pagan springtime dancing around a maypole, or religious ceremonies saluting the month of Mary, but no more, and certainly not in 1973 when this work was published: May 1968 has not been forgotten, and our narrator took part in it.[108] He continues to "dare" in the next section.

The lowest segment of the etching, #16, is described by Butor in *Travaux* as *"nuages avec de la pluie sur la mer, avec des oiseaux, liés au thème des chutes de Niagara"* [clouds with rain on the sea, with birds, linked to the theme of Niagara Falls] (82).[109] The "deluge of pitch" called for in *Séquestration* has begun. We can see the "flames," "lakes," "sky of tornados," "forest of waterspouts," and perhaps even the "birds" and "sulphurous pitch" that Butor sees:

> *#16. Je bois les flammes, je bois pour eux tous, je bois pour qu'ils puissent dire non; goutte à goutte j'amasse des étangs, des lacs de refus. De canaux en canaux l'acide se propage, se vaporise; les oiseaux déployés aux inscriptions sanglantes s'enflamment de toutes leur plumes, et ce feu neuf précipite en eau vive la poix sulfureuse qui nous menaçait. Merci, déluge! Creuse des fleuves dans nos tombes, charrie nos nervures et nos élucubrations jusqu'au chaudron des plages pour que de leur bouillonnement se distille dans le ciel des tornades l'elixir d'un texte juste. A travers la forêt des trombes, les rayons de la lune d'antan ne vont-ils pas se réveiller, nous caresser. Lune réinventée les pentes des volcanes fument d'émerveillement. (32)[110]*

The figure of the openmouthed head back in etching #13 seems to be still in Butor's mind, if not before his eyes, in the repetitions of "I drink," and the political statement is primary, as he "drinks" to enable denials and refusals. Then, the shadowy hollow lines on the left suggest vaguely human figures, leaning forward. Butor would have been looking at the same time at Alechinsky's *Souvenir* in which some of the forms are stick figures, dancing. They could have generated the idea of ghosts rising and hence of Butor's "tombs." Additionally, "acid" is vaporizing, "the boiling" of the "caldron of the beaches" is being "distilled" "in the sky" and those lines could have provoked Butor to blend into his text the idea of evaporation. There is no moon in the etching, but as each layer of the clouds, rain and sea is faintly reminiscent of writing, Butor must have seen there the distillation of "the elixir of a just text."

Rhythm predominates in this part, beginning with the repetitive structures of the short questions and responses in #14. The repetitions include not only the structures, but also single words, "Yes," "Prudence"; attenuative developments: "it's true, it must be true," "it is I, it is perhaps I," "it is I or it is not I,"; amplifications "what does it matter to you, what does it matter to me"; the contradiction, "I triumph," "it is their triumph"; and a long series of commands: "climb up, balance. . . ." The repetitions continue regularly through the clerk's accounting, introduced always by "the flower . . . owes" and the series of services rendered. Her sentence pronounced on the narrator begins with three parts, each including the phrase, *"sans"* [without] and ends with "Delays, delays, inadmissable delays" (31–32). The last section, #16, begins with the triple repetition of "I drink," and subsequently the repetitions taper off with single words.

With omnipresent and rhythmic repetitions, the harmonies are less prominent in this part. The most frequent sound is the front *a* in the repeated *"moi,"* offset by the many [y]'s. The harsh [k]'s and [g]'s have almost disappeared—except for *ogre*, whose meaning accords with the sounds—resurfacing only at the end of the segment in combination with the repeated [e]'s of the commands. The front *a*'s in the repeated "owes" (*Doit*) are contrasted here with the soft sounds of [œr] in "flower." The description of the clerk in her new hairdo is softened by three [ʃ]'s, *chère, chignon,* and *chiffonnées,* then in the familiar word *"chipés"* [snitched], and the endings of the many words for services given the flowers provide many more repetitions and rhymes, of *-ation, -ance, -ment,* and especially *-age,* with its soft [ʒ]. The clerk strongly reasserts the front *a*'s again in her last statement, three repetitions of *retards,* plus *relaps* (apostate) with its strikingly pronounced final consonants, and finally, *"canailles"* [scoundrels], a word virtually unequaled in its abrasiveness, as the front *a* of the first syllable becomes even harsher in combination with the back *a* and [j] of the second. In the final segment the repetitive *flammes, s'enflamment* lead to four more *f*'s; there are several *i*'s, many in combination with [j]'s. Both sounds continue, linking the two parts of the section, to the resolution of the almost exclusively soothing sounds of the last two sentences.

In *La Respiration* [*Breath*], the final chapter, in the "comic strip" form of Alechinsky's three sections, #17, 18, and 19, Butor has seen time passing as the creature becomes more and more visible, and he has conjured up various interpretations of the splashes in the background:

#17. Accalmie, le niveau de la mer a monté; je suis toujours enfoui jusqu'au cou dans les tombes, mais l'é-

Pierre Alechinsky, *Respiration* [Breath].

cume approche, un peu de sel commence à se déposer à l'intérieur de mes orbites vidées où de petits corbeaux font leurs nids et leurs fientes. Le ciel se vide aussi; quel vent! Quel espace! Des météores y passent acrobates, jongleurs, valseurs; l'eau monte. (33)[111]

While Alechinsky's figure appears to be rising, for the narrator in the text it is water that is rising, emphasized by repetitions, first to *"mi-gueule"* [mid-face] (34), then *"mi-orbite"* [mid-orbit] until finally in #18, *"Je saute. Je réussis à dégager la tête. Je me regarde à la surface de la mer. Si j'avais des yeux entre les mâchoires, ne ressemblerais-je pas à l'ancien juge? Mais je n'ai pas d'yeux, seulement un regard de vide, deux puits de nostalgie et d'errance"* [I jump. I succeed in releasing my head. I see myself on the surface of the sea. If I had eyes between my jaws, wouldn't I look like the former judge? But I don't have eyes, only a gaze of emptiness, two wells of nostalgia and wandering]. The gaze and teeth of the figure in #18 are reflected in this passage, and in #19, where Butor explains the shape of the figure and identifies the forms in the square eyes as tears: *"Je sursaute. J'ai été bien inspiré d'avaler la*

foudre (m'en a-t-il fallu des efforts! Electricité rancie qui me levait le coeur; cannibale des courants, ruminant d'étincelles). Je n'ai pas seulement des yeux, j'ai des larmes lestées de carbone en suspension" [I give a start. I was really inspired to swallow that lightning (and didn't it require efforts! rancid electricity which turned my stomach; cannibal of currents, ruminant of sparks). I have not only eyes, I have tears ballasted with carbon in suspension] (34, 37). Those tears will be echoed later.

In the narrator's gradual surfacing, the political is very present. The "salt" mentioned in #17 is essential, and *"En aspirant et soufflant j'établis une circulation d'eau pulvérisée pour ne retenir en mon crâne que le sel. Je l'amasse, je le propage, militant sournois. Travail de consolidation, travail de sape. Je n'en ai pas fini. Je cristallise pour nous tous, pour qu'on puisse dire, ne plus dire, lire, ne plus lire, fuir, ne plus fuir"* [Breathing and blowing I establish a circulation of pulverized water to keep in my skull only the salt. I collect it, I multiply it, sly militant. Work of consolidation, the work of sap. I have not finished. I crystallize for us all, so they can speak, no longer speak, read, no longer read, flee, no longer flee] (33–34). This immense effort is for the benefit of *"les nénuphars humains"* [human waterlilies] (34), to allow all of "us" the right to self-determination. As he describes them, the word *"vrilles"* [tendrils] brings him up short, as once before, but here it brings back memories that could not be more in contrast with the horrors he has lately experienced:

> *Cela me rappelle quelque chose d'effacé, d'enfoncé, d'englouti, de perdu, d'irremplaçable. Cela me rappelle la lune de mon enfance je crois, et des goûters dans des clairières; cela me rappelle des essaims d'insectes et l'enchantement des premières calligraphies, tous les espoirs que je mettais dans mes études, l'exquis labyrinthe des commentaires: bosquets de notules, allées des index, corbeilles de variantes, ruisseaux murmurants des incertitudes philologiques avec des débouchés soudains sur la campagne romaine, les geysers du Yellowstone ou l'air du large. (34)[112]*

Those of us who live with index cards and variants will find this evocation mildly amusing and very appealing, but certainly to all it is soothing. Here the scene serves as a goal: the struggles of the narrator must somehow lead to this kind of peace.

A *"maëlstrom"* [whirlpool] (34), which Butor may have seen in the background of #17, then reminds the narrator of the clerk, and his list of occupations is humorous in the incongruous juxtapositions: *"Cela me rappelle quelqu'un: la boulangère, la serrurière, l'institutrice, la jardinière, l'économe, la traductrice? Qu'est-elle devenue la greffière?"* [That reminds me of someone: the baker's wife,[113] the female locksmith, the

schoolmistress, the female gardener, the treasurer, the female translator? What has become of her, the female clerk?].[114] Although the clerk is not represented as such in this etching, Butor obviously has not forgotten Alechinsky's letter stating that her spiral tongue could be seen on each plate, unifying them and becoming finally the ammonite. From what we know of this character, we would expect the narrator to be glad she is not around. However, and this must seem humorously absurd, he misses her: *"Il manque quelque chose ou quelqu'un. Où est-elle? Il ou elle?"* [Something or someone is lacking. Where is she? He or she?] (37), even though he is uncertain of what exactly he misses. He thinks of *"réminiscences pourprées, musquées, aliacées [sic], linéaments d'un coquillage, légendes à propos de Vénus. Flottes d'argonautes, cornes d'Amon, aubes d'abondance, où sont-elles en cet océan superbe et frigide?"* [purplish reminiscences, scented with musk and garlic, lineaments of a shell, legends relating to Venus. Fleets of Argonauts, horns of Amon, dawns of abundance, where are they in this proud and frigid ocean?] (37).[115] The association of the spiral-tongued grasshopper woman, with Venus, the Argonauts, or Amon-Ra— even though she does "put on airs of the sphinx"—is wildly incongruous.

As these visions slip away, and with them the muted humor, the narrator recalls *"une vrille de la lune de mon enfance"* [a tendril of the moon of my childhood] (37). Again the word "tendril" brings back that beautifully peaceful scene, *"(vous ai-je vraiment vécues, nuits d'imminence, réverbérations généreuses de mes rancoeurs?) à des goûters dans des clairières (myrtilles et cidres, tabliers et lectures, herborisations et sérénades)"* [(did I ever really live you, nights of imminence, bounteous reflections of my rancors?) to picnics in the clearings (blueberries and ciders, pinafores and readings, botanizings and serenades)]. As the narrator regrets the lost past, we may recall those flowers "in search of lost dew" and the reminder that in art is found the salvation of the world. Indeed, all is not lost, for his tears remain distinct: *"mes larmes sombrent, mes larmes ne se mêlent pas à la mer"* [my tears sink down, my tears do not mingle with the sea]. The section ends with the lushest of harmonies; the politics of peace is offered in the softest of sounds.

In the last etching, #20, here finally is the ammonite of the title. Butor has explained elsewhere that *"c'est Alechinsky qui m'a trouvé cet ammonite avec ses dessins. Cette image convient parfaitement à ce texte qui se développe comme une spirale qui s'enfonce, un voyage dans le centre de la terre"* [it was Alechinsky who found me this ammonite with his drawings. The image perfectly suits the text which develops like a spiral sinking down, a voyage in the center of the

earth].[116] Here in the center of the earth only the spiral of the ammonite is shared with the clerk; the demure head and graceful "arms" at the end of the ammonite's tail could have provoked her final beautification in the text. Much changed from the grotesque images seen before, she might even seem lovable.

The narrator's recognition and subsequent reversal of his feelings for her give rise to a kind of humor, as he lists more incongruously juxtaposed occupations, among which only the "clerk" derives in any way whatsoever from the earlier moments of the dream: *"L'idée me vient que c'est le corps noyé de la bergère, de l'infirmière, de la pâtissière lavandière, de la prospectrice greffière, de la chère archéologue aventurière, linguiste coureuse, qui rajeunit enlacé, champagnisé, panefié, bonifié par les levures du grand verdâtre au retour de sa liquidation"* [The idea comes to me that it is the drowned body of the shepherdess, the nurse, the female pastry-cook washerwoman, the female prospector clerk, the dear archeologist adventuress, the libertine linguist, who is getting younger embraced, treated like champagne, made into bread, improved by the yeast of the Great Greenish on his return from his liquification] (37, 39). The return of the Great Greenish, last seen being licked into a puddle and now supplying "yeast" to help rejuvenate the clerk, is marvelously unexplained.

The amplification of the narrator's new and absurd attachment to the clerk continues even as he is becoming skeletal himself: *"Elle plonge encore. Quelles courbes, quelles circonvolutions, circonlocutions, quelle mémoire! Elle transperce l'asphalte des abysses. Au moment même où je fermente à plein registre, où des nappes de moisissures improvisant d'immense molécules thérapeutiques et exaltantes tombent en suaire de mes clavicules émergées, vais-je la perdre? J'en rêve. J'en rage."* [She plunges still. What curves, what circonvolutions, circomlocutions, what memory! She pierces through the asphalt of the abysses. At the very moment when I am fermenting at full throttle, when sheets of mildew improvising immense therapeutic and exalting molecules fall in a shroud from my emerged collar-bones, am I going to lose her? I dream of it. I rage over it] (40). A bizarre humor may be found in our narrator's reactions, as he is "fermenting," covered with "mildew" and shedding "molecules," for somehow she appears precious to him: *"Comment n'avais-je pas deviné ces trésors sous ses déguisements d'aigreurs. J'en tremble; un bourgeon de regard incisif entre ses deux folioles. Hélas je n'ai commencé à m'en instruire qu'aux approches de sa fossilisation. Elle n'a pu guérir cette fois qu'en devenant pierre"* [How did I not guess these treasures under her disguises of sourness? I tremble over it; a bud of a cutting glance between her two

leaflets.[117] Alas I have begun to learn about her only at the approach of her fossilisation. This time she has been able to heal only by becoming stone] (39–40).

Describing the ammonite's fall, the narrator again personifies the volcanos, *"qui l'accueillez par vos borborygmes et vos salves"* [who welcome it with your borborygmes and your salvos] (40). "Salvos" might be an objective enough term, but hearing stomach-rumbles in an erupting volcano diminishes the frightening aspect of the dream with this lightest touch of comedy relief. Finally, the narrator juxtaposes his last loving cry to the clerk/ammonite with a surprising epithet: *"Je t'aime d'un bout du ciel à l'autre, vieille dépouille de phénix, tourbillon qui s'évase dans l'histoire des émotions. Adieu, adieu, je sens que je m'éveille, essuie ma sueur avant que je ne recommence à taillader ma jungle"* [I love you from one end of the sky to the other, old phoenix remains, whirlwind which spreads outwards in the story of feelings. Farewell, farewell, I feel that I am waking up, wipe my sweat before I begin again to slash through my jungle] (40). "I love you from one end of the sky to the other" is a wonderful image of the spatial extent of love, but the address, "old phoenix remains" is joltingly contradictory. Phoenix or no phoenix, few lovers would appreciate being called "old remains," in the sense of "mortal remains," that is, a dead body. So far as we can tell, she is indeed dead—although in this dream one cannot be sure, and the reference to the phoenix hints that she, like the Great Greenish, could return, and when last seen she was "getting younger" (39)—but the narrator's choice of loving pet name seems at best inappropriate and in any case incongruous.

We may find "sourness" and "a cutting glance" inadequate attributes for this character, and would not expect either to give rise to any great love. We remember, if the narrator does not, that she had him arrested, judged (so to speak), condemned and imprisoned, for crimes such as spelling errors. One might think this was an example of a victim's learning to love his torturer, but the narrator attributes his feeling to her "treasures," which he did not recognize in time. We could see in this an ability somehow to find good in everyone, a political statement in favor of forgiveness. She is "healed," no longer subject to the demands of serving as prosecutor, free of the "disguises" that gave her the appearance of an aggressive monster. Becoming stone is seen as preferable to her former condition.

If the humor is questionable in this chapter, the harmony is quite overwhelming. In texts #17–19, the shifting meanings produce harmonies in which hard and soft sounds are vividly contrasted. The hard [k]'s so frequent thus far continue almost to the end, accompanied by a great many *i*'s and front *a*'s as established by the

first word, *accalmie;* gradually, however, softer vowels are entertwined and [g]'s take prominence over the [k]'s. The *i*'s in the first section are particularly evident in the repetitive *"Je cristallise . . . ne plus dire, lire, ne plus lire, fuir, ne plus fuir"* (34), and they reappear in #18 in the repeated important word, *"vrilles,"* heard again in #19. Meanwhile, open, closed and nasal *o*'s toll like bells in the repetitions, *"la mer a monté"* [the sea has risen] once and then *"l'eau monte"* [the water rises] three more times in #17, twice in #18, followed by *"sombre, sombre semblable . . . mes larmes sombrent"* [somber, somber, like . . . my tears sink] and in #20 *"elle sombre en pâmoison"* [she sinks in a faint]. The childhood memory of #18 illustrates the increased presence of soft vowels among the *i*'s and front *a*'s, a soft [ʃ] and two soft [ʒ]'s among the [k]'s. The alexandrine, *"tous les espoirs que je mettais dans mes études"* [all the hopes I put in my studies] contains only the one front *a,* and that softened by the *r.* The three times repeated *"cela me rappelle,"* with its front *a*'s, leads to the overwhelming *l*'s of #19, which continue in #20, the *"quelles"* series (*quelles courbes, quelles circonvolutions, circonlutions, quelle mémoire*), the repeated *"de lame en lame"* and *"déploie,"* followed by many others, including *papilles* and *pupilles* and very noticeable in *"oscillographes,"* since the *l*'s are sounded. Further repetitions reecho the *l*'s, such as *"volcans"* and especially *"larmes":* those "tears" that "sink down, do not mingle with the sea" become "insoluble" (37) and finally *"de résine"* [of resin] (40) and *"astringentes"* [astringent]. Toward the end of #20, soft sounds emphasized by repetitions and accompanied by *z*'s appear in *"de plus en plus prenante"* and *"de plus en plus reposante,"* and then in the contradictory amplification, *"grandiose bavarde, la silencieuse en furie"* [grandiose babbler, silent one in fury].[118] Only at the very end do the omnipresent *l*'s give way to [j]'s, as, following a generous number of initial [g]'s, the hard [k]'s continue but are accompanied by [ʒ]'s and *z*'s. These harmonies clearly reflect the changes taking place in the action: among the predominant hard sounds, soft ones gradually are heard more often, until at the very end the [g]'s and [j]'s come to the fore.

While in this last chapter humor is not so present, the "lull" of #17 brings with it a focus on politics not before made so clear. The narrator is devoting himself to others: "I crystallize for all . . . so they can speak" (34). He is the one who is collecting salt, as a "sly militant" and *"secrets d'état"* [secrets of state] are revealed to him in #20 (39). He manages to see a peaceful future: *"Quelle paix . . . quelles promesses"* [What peace . . . what promises] (37). The narrator actually finds benefit in having been jailed: *"De quelle acuité, perspicacité m'ont doté mon incarcération, mes épreuves . . . J'ai*

jusqu'à l'envie de faire partager à mes géôliers atténués exténués les pouvoirs dont ils m'ont rendu maître à leur insu" [With what sharpness, perspicacity, have my incarceration, my trials endowed me . . . I even have the desire to share with my attenuated exhausted jailers the powers of which without knowing it they have made me master] (39). Lest this saintly forgiveness seem excessive, he immediately adds, a more human if less virtuous thought, *"Délices des vengeances douces"* [Delights of sweet vengeances], but we will note that his revenge is "sweet" and does not involve physical torments. In laying blame on the evil volcanos he adds a specifically political touch. He accuses them, *"Volcanes! vous m'avez trahi, empuses! N'avais je point lieu de vous insulter, Complices, vous l'avez aidée à se trahir; vous l'avez empêchée de se livrer à moi, de me livrer à moi. Ils ont beau voguer là-haut dans leurs yachts avec leurs guitares et leurs médianoches sous les feux croisés de vos explosions attendries, ne l'ai-je point toute manquée?"* [Volcanos! You have betrayed me, mildew parasite of flies! Was I not right to insult you, Accomplices, you helped her betray herself; you kept her from giving herself to me, from giving myself to me. In vain do they sail up there in their yachts with their guitars and their midnight suppers under the crossed fire of your softened explosions, haven't I missed her altogether?] (40). The yachts and midnight suppers obviously implicate the powerful and the rich. Why the volcanos are held responsible, we do not know, but the narrator carefully distinguishes between the evil volcanos, who are those of *"des îles et des glaces"* [islands and ices] and the others, the *"terrifiantes du fond de la mer"* [terrifying ones at the bottom of the sea], whom he calls in spite of everything *"conciliabules"* [reconcilable] and from whom he hopes for a more magnanimous attitude. Thus our narrator, who has consistently struggled to help others throughout the nightmare, manages to include everyone except the evil volcanos in his final statement of concern and forgiveness—even managing to love that spiral-tongued clerk.

This work as a whole serves as a splendid example of Butor's collaboration with the artist. In the "Correspondances," Butor wrote to Alechinsky that once he had the etchings, *"Je les ornerai d'une immense légende. Un peu comme pour Le test du titre mais en beaucoup plus poussé"* [I will ornament them with an immense caption. A little like the *Test of the Title,* but much more extended] (43). We can see to what extent his "caption" is "extended" far beyond the artworks.

In "A perturbed text: *Matière de rêves* of Michel Butor," Léon S. Roudiez said, "Only those who have a deep knowledge of the productions of Butor know, for

instance, that there is a connection between the *Dream of the Ammonite* and the work of Pierre Alechinsky."[119] He goes on to say that while this knowledge gives "to the initiate a greater enjoyment of the text," it is not in itself important. However, Roudiez's own analysis of the *Rêve de Vénus* [*Dream of Venus*] as it derives from Delvaux's *Pygmalion* leads to a conclusion I believe is most important: "The painting, at this moment, plays the same role as what is called 'reality' in ordinary fiction. A certain number of elements are chosen, integrated into the story; the others are passed over in silence" (250). The identification of the elements Butor has chosen from the artworks certainly increases our delight in the text, but more than that, the resulting possibility of recognition of those elements that, in Roudiez's terms, "spring from an undefinable elsewhere, filtered, mediatized in the fancy of the writer," provide an otherwise unobtainable insight into Butor's boundless imagination.[120] Reading Butor's text of *Ammonite* along with Alechinsky's original etchings allows us to see just what Butor saw, to see what he selected for his text, what he omitted and what he added. Where the reader could imagine the "Great Greenish," the "clerk" with the spiral tongue, and the judge swallowing his eyes based on Butor's descriptions, with the etchings we can see exactly what the images are from which Butor derived his dream. On the other hand, we can also see those elements from Roudiez's "undefinable elsewhere," such as the narrator's description of himself as a "baby-old-man" at the beginning, and at the end as *"mon crâne barbu de vieillard larmoyant oscillant au-dessus de mon chapelet dépareillé de vertèbres"* [my bearded old man's skull weeping swinging above my stripped chaplet of vertebrae] (40). No such figure appears anywhere in the etchings. As with *Le Test du titre,* we can be confident another writer would have created a completely different account. This dream may have sources in Alechinsky's drawings, but the text is quintessentially Butor.

A fundamental aspect of this work is Butor's use of harmonies, emphasizing primarily the harsh, hard sounds, which are only temporarily softened during less painful episodes and only toward the end blended with soothing sounds. One of these tranquil moments occurs in the passage cited above, from #18 in *Respiration,* "picnics in the clearings." This beautiful extended metaphor of scholarship—from learning penmanship to philology—as a picnic in a tranquil countryside is virtually the only peaceful island in the sea of violence. When the repetition of "picnics in the clearings" reappears at the end of #19, with the added "blueberries," "botanizings," and so forth, the whole scene is reinvoked as the narrator weeps. This is one of the most effective repetitions. And the repetitions are very frequent, providing unity, as in the word *"vrilles"* [tendrils] in #14, 15, 18, and 19, and sometimes humor, as in the debts of the flowers in # 15, until they become painfully political. The comedy relief is desperately needed in what remains more a dreadful nightmare than any pleasant dream.

The events could all be amusing if they were not so horrible, but though that spiral-tongued clerk with her ridiculous lists of accusations is in a sense comic, she is also potentially dangerous. However, there is no anti-feminism here: women are not presented as an evil force. It is true that the volcanos are specifically female, as suggested by Alechinsky's etching, but there is no generalization. Though some are evil, those on the bottom of the sea—and they are also female—are deemed capable of hearing the exhortation to be "more magnanimous than your nieces of the islands and the ices." The clerk is dedicated to persecuting the narrator, but as we have seen, even she had hidden virtues he missed. The Great Greenish seems to be male, although the narrator questions his gender at the beginning (#2, 3) and he, too, pursues the narrator. The judge, a male, was on the side of evil, and he has simply disappeared. Gender is irrelevant in the allocation of labels for good and evil.

The dream has its burlesque aspect, as Butor said, but there is a deeper, more fundamental current running through it. Throughout, the narrator, as he experiences abuse, threats, torture, is constantly concerned for others. Even when he becomes a cemetery, he is not producing maggots, but giving birth (*en gésine*), as he works for the welfare of the others, breathing, circulating blood, sending them drops of rain. He regrets the judge's transformation into a sack of rags; the clerk is finally seen as beloved. Only the volcanos he was accused of blaspheming remain outside his embrace, but even there the narrator distinguishes one group as "reconcilable." Part of the concern for others, for all others, is the narrator's sense of unity with all things, living, dead, and nonliving. From the microscopic to the astronomical, the narrator is at one with the universe. Through the horror of the nightmare and the remembered serenity of childhood with "all the hopes I put in my studies," the narrator seeks "a just text."

Relative to this work, Butor replied when asked if he thought of himself as a utopian writer,

> *Je m'intéresse beaucoup aux utopies et dans la mesure où j'insiste toujours sur le fait que je veux changer quelque chose à la réalité, à la société dans laquelle je me trouve, oui, bien sûr, je me situe toujours en dehors du lieu actuel. Ça ne me suffit pas de trouver une place à l'intérieur de la société actuelle. Ce que je veux, c'est changer la société et donc je suis en dehors. Je veux représenter la*

*société parce que je ne peux pas la changer sans la repré-
senter. Pour la changer il faut que je la connaisse, il faut
que je la montre.*[121]

Improbably derived from Alechinsky's figures, light-
ened very judiciously by humor and couched in the
most musical of poetic harmonies, Butor has in this
work shown society through the eyes of the citizen
persecuted by bureaucratic madness and omnipresent
injustice. Waking up at the end of this dream to begin
again "to slash through my jungle," the narrator, that is,
Butor, has here already given us a "just text."

LE CHIEN ROI

Before the reader even opens the book, *Le Chien roi*
[*The Dog King*] (1983),[122] its content of protest and
resistance is suggested by Alechinsky's "marginal re-
marks" on the front cover. Since Alechinsky creates
these "remarks" after reading the texts, they do not fall
within the proper purview of my study, but his perspec-
tive on the whole is here atypically clear and demands
mention. On the cover we find a barking dog in front of
a graffiti-smeared wall that has a handprinted poster
plastered over it. The graffiti reads "LE—ROI," the
central word now obscured by the poster. That original
word could have been anything, depending on what the
graffitist supported, perhaps a cat king, or a lizard king,
or some other political favorite. With the poster pasted
over it, the message now reads, "LE CHIEN ROI," the
word *"chien"* in the place of the graffitist's candidate.
In the etching that was the source of the section of the
book with that name, the dog is lolling out his tongue,
but here on the front cover he is showing his teeth. He
wears a crown of Alechinsky's hatchmarks, and the
artist's and author's names are printed aslant from his
mouth as if he were barking them. The "remark" makes
a clear statement on the volatility of politics and fore-
warns us of the nature of the texts.

The work is composed of eight sections, each a prose
poem accompanied by two stages of an Alechinsky
etching. As we read *Le Chien roi* we find both stages of
the etchings: the first a complex one with black and
white center, framed by very colorful stenciled water
color forms, the second the same center but printed in
either one or two colors, framed only by Alechinsky's
scalloped edging.[123] Elsewhere Butor specifies that his
text derived from "(*la série de ses* [Alechinsky's] *huit
eaux-fortes entourées de pochoirs*" [the series of his
eight etchings surrounded by stencils],[124] that is, the
complex versions, and therefore my examination here
will focus on that series of etchings.

Butor has said he had thought of naming the work
Courant après [Running after], one of Alechinsky's

collection of possible titles for future works, *"qui con-
vient très bien à mon texte qui court après* le dessin où
l'impression de mouvement est extrêmement forte"
[which very nicely suits my text which *runs after* the
drawing where the impression of movement is ex-
tremely strong] (emphasis in original) (*Text* 172). He
has retained the feeling of "running after" in the poems:
from one stanza and its matching etchings to the next,
and the reader feels the text chasing Alechinsky's im-
ages. Although there is no apparent relationship in sub-
ject matter among the Alechinsky etchings, the form
remains constant throughout, and Butor has structured
his text accordingly. The subject matter of each prose
poem is quite disjunct from the others, but the form is
the same: they are approximately the same length, each
with at least two movements. Gradually an overall
design becomes clear. Each etching has suggested a
different way of speaking to the human condition, and
each prose poem adds to the meditation on the world
today. Once again Butor and Alechinsky have created a
whole greater than the sum of its parts.

I will look in detail at four of the sections and briefly
at the others, following the order of the book.

In the first text, *Les Oranges de Binche* [*The Oranges
of Binche*], external information about Binche is useful.
It was the site of a carnival until World War II, and
Alechinsky was involved in reestablishing the fes-
tivities, complete with a "Gilles" plumed figure and the
custom of throwing oranges.[125] The title thus might
lead us to expect some commentary on carnivals, on the
opportunities they give for disguise, a theme a number
of contemporary theorists have treated. Butor included
the carnivals of Nice and Rio in *Boomerang,* and has
spoken often of carnival displays in other works. How-
ever, with Butor we should know to expect the unex-
pected, and in this text just about all that remains of the
carnival is the oranges.

Les Oranges de Binche
 *Quand nous n'aurons plus de plumes d'autruche nous
en prendrons de cygne ou de condor, et quand il n'y aura
plus d'oiseaux nous prendrons des palmes ou des ramures,
et quand il n'y aura plus d'arbres nous prendrons des
fougères ou des champignons, et quand il n'y aura plus de
végétation nous découperons du papier, des feuilles d'alu-
minium ou des pneus, et nous les peindrons de mauve et de
rose pêche, de saumon, jaune d'or et vert Nil avec des
cernes d'azur intense que les grosses gouttes de la pluie
dilueront et mélangeront pour nous fabriquer des arcs-en-
ciel de fête sur nos pantalons blancs; mais si nous
n'avions plus d'oranges, si ces petits globes de soleil
liquide n'arrivaient plus des fabuleux pays du sud pour
nous revigorer, alors nous nous enfoncerions dans nos
mines, écoeurés de cette lueur laiteuse qu'est pour nous le
jour d'hiver, nous nous réchaufferions à quelques braises*

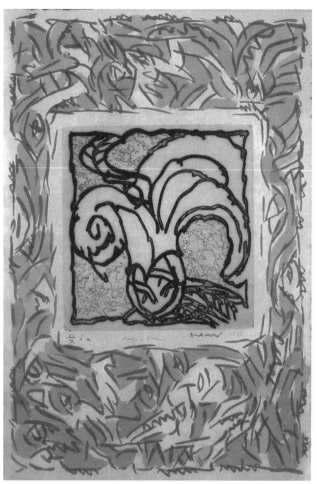

Pierre Alechinsky, *Les Oranges de Binche* [The Oranges of
Binche].

*l'ornementation de nos toques, et nous jonglerons avec
des boulets élastiques tandis que l'eau de nos fontaines
prendra un goût de curaçao.* (9–10).[126]

Alechinsky's figure with its headdress of three
different kinds of plumes, and the brilliant orangey
coloration clearly represents the "Gilles" of the carnival
of Binche. From it, and from the title, Butor has taken
his initial focus; the variety of plumes may have sug-
gested the solution of using the feathers of other birds.
The Binche carnival custom of throwing oranges has
led to the second movement. Historical events, the can-
cellation of the carnival during the war and its subse-
quent restoration, have supplied Butor's chronological
approach as he foresees the future. The colors of the
border are detailed in the text, and its designs could be
seen as suggestive of geographical maps; its rippling
colored streamers, some orange, might have provoked
the children's decorations of orange peels in school
windows.

The structure is very rhythmic, emphasized by the
play of the tenses: four phrases in the future tense,
"when" something is gone, each followed by its solu-
tion. The "but" separates that future from the two condi-
tional sequences, "if we had no more oranges . . . if
[they] no longer came," and the two results, "we would
delve," and "we would warm ourselves." "Happily"
then brings us to the present with the arrival of oranges,
"black Peter" (Alechinsky with his characteristic black
Chinese ink), children decorating with peels, and the
development of bigger fruit. The conditionals in "would
reproduce," "could be stamped," and "would need"
indicate a hypothetical situation, but the positive future
reappears optimistically in the uses Butor imagines for
the peels, in the juggling and the taste of the fountains.
Soft sounds predominate, a plethora of *p*'s throughout,
often with [y], as in the series of *plus* and the repetition
of *pelure.* Then the rains come with the harsh initial
[g]'s, *grosses gouttes,* echoed in the end of the nostalgic
memories of the "carnivals of yesteryear," *grelots . . .
guimbardes,* and again in the several toward the end,
globe, géographie, jongleront and *goût.* The last words,
goût de curaçao contrast the hard [g] and [k] with the *r*
and soft sibilant and move, sliding over the unstressed
front *a,* from one soft vowel sound to the next [u], [y], to
[o], ending thus most harmoniously and, one could say,
leaving a good taste in the mouth.

The giant oranges[127] stamped with a map of the
globe for the use of schoolchildren is, if not comic,
certainly delightful. Butor's specification that classes
studying the oranges would not in the future fall behind
reproduces the kind of exaggerated advertising that ac-
companies educational products, at least in the United
States. The inclusion of "in different languages" em-

*en songeant avec une ironique mélancolie à ces carnavals
d'antan qui replaçaient pour nous le voyage aux
Hespérides, lorsque nous faisions tinter nos grelots et
vibrer nos guimbardes. Heureusement il vient d'en arriver
des cageots superbes que nous allons pouvoir disposer sur
les cheminées lors de la Saint-Nicolas. Le noir Pierre lui-
même crache artistement ses pépins en sautant dans les
mares qui fleurent la vitamine C, tandis que les enfants des
écoles décorent les appuis des fenêtres avec les pelures
ingénieusement déroulées. Il paraît que dans ces mer-
veilleuses plantations sur les terrasses des palais an-
dalous, les ingénieurs agronomes mettent au point des
races nouvelles plus grosses nous a-t-on dit qu'un ballon
de basket ou selon certains de football-association, et dont
les rugosités reproduiraient celles du globe terrestre (les
noms des continents pourraient être tamponnés en
diverses langues pour les écoles élémentaires dans les-
quelles on n'aurait plus à déplorer le moindre retard pour
les classes de géographie); leurs pelures pourront former
de si longs rubans avec leur intérieur blanc de satin, le zist
et le zest, que ce sera la matière idéale, alchimique pour*

phasizes the satire: any teacher knows very well that the information printed on the oranges would not assure the children's learning either geography or foreign languages. Incongruity provides humor in the contrast between the dreamy scene evoked by "Andalousian palaces" and the potential quarrels between basketball and soccer fans as to the correct comparative size of the oranges. Carnival headgear decorated with orange peels presents an absurd image, but more attractive than the "aluminum or tires" suggested before Black Peter appeared.[128] The juggling and curaçao-flavored fountains are happy if not humorous ideas, in accord with carnival merry making. But then the oranges become cannonballs, and the incongruity introduced by the "elastic cannonballs" is "black" humor. Oranges are not elastic, and cannonballs that were elastic might or might not be effective missiles, depending on their composition. In any case, juggling cannonballs would seem a dangerous game.

The political force of this piece is very evident: the urgency to conserve nature. Butor's use of "when," rather than "if," regarding the disappearances emphasizes the fact that these losses will inevitably occur as current practices maintain. His selection of examples, the swan and the condor, combines the bird traditionally acknowledged as among the most beautiful with one already just barely preserved from extinction in government aviaries, on the dodo's road. Having destroyed not only the birds but also the vegetation, "we will cut up paper, sheets of aluminum or tires" and Butor again selects carefully for clever man's use items of which at least two are created from a base supplied exactly by the vegetation now lost: in the voice of a cheery prophet of a future that will be controlled by the ingenuity of man, Butor clearly demonstrates that it cannot happen that way. Even as the colors reflect the natural world: roses, peaches, salmon and the river, what results is an artificial rainbow. The shift to the speaker's realization that the loss of oranges would pose a very different problem is a shock, and quickly Butor paints a much grimmer picture of the future, as back in the caves again men recall the world of "yesteryear." His choice of that word "yesteryear" (*antan*) automatically summons up Villon's snows, with all the weight of the past as seen from the fifteenth century, twice removed, and all gone. Horticulturalists may help, but so long as we persist in destroying nature and in juggling cannonballs, the outcome is uncertain if not bleak. The second movement, begun so emphatically with "happily," leaves us feeling that only art, as personified in "black Peter," can still save the world.

The following three sections, *Gueule de proue* [*Mug on the Prow*], *Tunnel*, and *Rhizome* each offer a few political and humorous moments. Alechinsky's title for the first is remarkable in that the usual term for a ship's figurehead is *"figure"* or *"buste de proue"* (or *"de guibre"*). *"Gueule"* is unflattering if not slangy and also could summon up the common expression *"gueule de bois"* [hangover]. Figureheads are traditionally carved of wood, but the title leaves us wondering if this one is particularly unusual in form, material, or both. In the etching Butor sees a helmet, recognizes the cyclops and what is felt to be a sailing ship, and gives a classical reading: Ulysses's crew is trying to be quiet and resist the sirens, but the men are tempted to explore the depths of the sea. He then creates the sailors' belief, that their figurehead was once a man, who succumbed to temptation and drowned, becoming part of the sea, driftwood, then eventually was sculpted by them, and now watches over them. However, he also *"choisit certains d'entre nous pour lui succéder"* [chooses some of us to succeed him]. In this way we are warned against self-delusion, trusting something we created ourselves, which will in time lead us to disaster. We would do well to exercise prudence in trusting our fate to a force whose benevolence is questionable. Unless one can find "black" humor in the sailors' belief, in this section the humor is limited to the popular term *"marmaille"* [brats] for the children of the god of the winds in *"toute la marmaille d'Eole"* [all the brats of Eolus], incongruous in the classical context.

In *"Tunnel,"* Alechinsky and Butor treat the "Chunnel" well before its actual construction. Butor's *"train de fantômes"* [train of ghosts] rushes toward *"ce désastre planétaire"* [this planetary disaster]. The walls are painted with pictorial representations perportedly drawn from all the Temptations of St. Anthony. At first more or less orthodox leaders of religious movements appear, but at a turn in the tunnel an alarm sounds and the train stops. In the second part Butor sees the human figures in the wall-paintings as heretics. Finally, a series of creatures emerges from the corset of Diana of Ephesus (who is recognizable in the etching), including some familiar ones, real and legendary, but Butor adds to them *"astomi,"* ciliate mouthless protozoa,[129] *"nisnas,"* which are a subset of the *"guenons,"* long-tailed African monkeys, and *"blemmyes,"* a people contemporary with the heretics in the previous group, from the second century A.D. The *"sciapodes"* cannot fail to provoke laughter: we know only that they were a fabulous people of Libya with immense feet—used as sunshades. *"Cynocephales"* are baboons; *"sadhuzags"* can be found only without the *"zag,"* as Hindu mendicant ascetics, often abjuring clothing. The *"martichore"* is a variant of the *manticore,* which has the body of a lion, head of a man, quills of a porcupine, and the sting of a scorpion; it is also the name of an enormous South African insect with huge mandibles and no

wings. No description is available of the *"catoblépas,"* a fabulous beast whose glance is fatal. Distance in time, two thousand years, has confused the historical figures with the legendary, has proved a disaster for the memory of once living men and creatures. No one now can describe a *"catoblépas"* and no one living has seen the *"sciapodes"* or knows if they ever existed. The passage of time has similarly muddied the memory of all those heresies, over which thousands of people were slaughtered. The "Chunnel," the interference with nature, the man-made joining of two groups of people who have been happily separated by water throughout human history, constitutes the effacing of a distance in space, which may not bode well for the world. The phantom train slows its rush toward disaster only for today's real-life bureaucracy, as often for Butor symbolized by the customs officer, who sneers, perhaps at the dream of a finally united Europe (he will, as Butor has pointed out elsewhere, lose his job—except in Switzerland), but it is still of a disaster that we are reading, one affecting the whole planet.

As mentioned earlier in this study, the rhizome of "Rhizome" is a plant; iris, canna lilies, and some ferns, such as the "air plant," are of the family. In Butor's garden, *"patrouilles de fourmis d'Argentine"* [patrols of Argentinian ants] supply humor as they *"organisent leurs jeux industrieux"* [organize their industrious games], while *"les moucherons lèchent leurs articulations avant de continuer leur gymnastique en préparation du championnat prévu dans la cupule du silex sous les hampes des vulpins"* [the midges lick their joints before continuing their gymnastics in preparation for the scheduled championship in the flint cup under the stalks of foxtail grass]. The mayfly has finished laying and will provide *"une jolie portée de vers blancs"* [a pretty litter of white worms]. It is typical of Butor to describe white worms, which only the mayfly mother could love, as if they were kittens or puppies. The political appears clearly in the human hand of the gardener, who is mentioned only negatively: he keeps a rare species of iris separate from the other ordinary ones, he pulls up a fern, he cuts into roots with the hoe, he fails to keep up with the weeding. The vigorous, healthy, even sportive activity of the insects continues very well without man's help in the apparently static garden, creating rather than destroying. The plant and insect life, together with the microscopic cells, works with carrion, rot, and excrement to produce life and beauty. Human beings, personified in the gardener, do not know how to do that and only interfere.

The next section considered here, *Sphinx en chapeau* [Sphinx in a Hat], is almost entirely humorous, but the political weight hangs heavy at the very end.

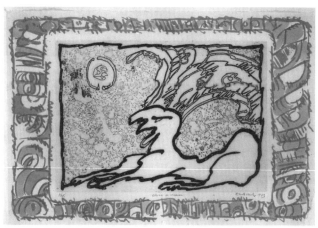

Pierre Alechinsky, *Sphinx en chapeau* [Sphinx in a Hat].

Sphinx en Chapeau

Sous le soleil de Béotie, c'est la sphynge de Binche, surnommée par les auvergnats la sphynche de Binje. Au milieu de sa coiffure en plumes d'autruche, ricane, yeux en bataille et pieds enflés, l'enfant Oedipe qui va la détroner, mais elle se vengera surabondamment en le forçant plus tard à s'arracher ces yeux mêmes qui la narguent, sur la place de l'Hôtel de Ville en présence de messieurs les échevins, au cours d'une déplorable exhibition de difficultés familiales, comme si ce genre de conflit ne gagnait pas à mijoter autour du poêle, derrière les rideaux de dentelle. Maintenant les yeux de toutes couleurs sont écarquillés, éparpillés, des verts aux mauves, et cela cligne et roule au milieu des racontars et commentaires. Je te colporte et je t'en rajoute et je t'insinue et je te suggère et je te remonte aux sources et je t'imagine les suites, ondes et ricochets, cela dévale toutes les ruelles de la vieille ville et se répand en mascaret sur les campagnes. Quelle affaire! On en reparlera dans deux mille ans; alors qu'en réalité, au début, vous savez au juste ce qu'il y a eu, trois fois rien, pas de quoi fouetter un chat, la banalité, la grisaille; mais c'est qu'elle veillait, la chienne parleuse; elle en avait gros sur le coeur. C'est une vengeance; naturellement c'était une vengeance d'amoureuse. Il l'aimait bien pourtant les premiers mois, c'est bien connu, tous les paysans des environs de Thèbes vous diront encore comme c'était amusant de le voir enfant se rouler entre ses pattes, mais quand elle a voulu passer aux choses sérieuses, quelque chose dans sa croupe de lionne, alors que tant d'autres non seulement s'en seraient contentés, mais en auraient été flattés, et puis sans doute quelque aguicheuse du coin dont il s'était légèrement coiffé . . . Surtout il y a eu cette histoire de plumes, car c'est lui qui l'avait ainsi décorée, sans penser à mal, et il est certain que ça lui donnait une allure extraordinaire en particulier au clair de lune; et il s'en servait comme d'un bosquet pour se cacher, les poils de la crinière tressés pour la fixer; et puis, vous savez comme les modes changent, c'est justement lors de la grande scène

*de la déclaration, celle qui a été reprise par Phèdre et tant
d'autres, qu'il s'est soudain esclaffé; et c'est cela surtout
qu'elle ne lui a point pardonné, bien plus que la fameuse
découverte du mot de l'énigme, car elle le lui avait soufflé,
c'est bien connu, elle ne s'en est jamais cachée. Elle veille
maintenant devant toutes les télévisions de Binche, guet-
tant les petits garçons qui veulent encore téter leur mère et
qui donnent des coups de pied à leur père quand ils se
glissent dans leur lit le soir; elle les fait approcher, ap-
procher pour leur couvrir la poitrine de décorations, les
chapeauter de képis à galons et leur donner pour jouets
des automitrailleuses et des téléphones rouges.* (25–
28).[130]

The sphinx of the etching is easily recognizable, and
one might expect Egypt, but the eyes Butor sees among
the plumes have elicited instead Oedipus and his
sphinx. The medallion, a bird or snake, would have
suggested the speaker, the cackling hen, or hissing gos-
sip of Thebes.[131] All the eyes that are watching, "from
green to mauve," can be seen in the colors of the border
and figures of eyes there. The division of the border into
segments suggests the various tellings of the story as it
goes from one person to the next, from city to
countryside. The two red spots in the border certainly
summon up Oedipus's bleeding eyes, and their color
probably also elicited the Sphinx's revenge today, her
gifts of red telephones to little boys.

At once, in the first lines, the text presents a playful
use of sounds, together with the repetition that con-
tinues throughout. Eyes and revenge, both critical in the
story, appear three times, while "so many others" and
"everyone knows that," imitating the gossip's style,
each appear twice. Then in the immediate repetition of
"come closer, closer" we hear the Sphinx coaxing the
little boys. Butor makes of his gossip a lively storyteller,
who creates the expression "eyes cocked," which is
ordinarily used (appropriately) for a "cocked hat" (*le
chapeau en bataille*). The speaker uses litotes in quali-
fying the Oedipus story as "deplorable," suggesting that
it is very ordinary with "this kind of conflict." The [y]'s
of *plumes d'autruche* are continued as varied nasals
(*surabondamment, forçant*) are skillfully combined to
lead up to the word harsh in both sound and meaning,
"narguent" [mock]. The quadruply rich rhyme,
écarquillés/éparpillés precedes a rhythmic liturgy of
six phrases of the gossip's activities, culminating in the
v's, *l*'s, and *r*'s of the tidal wave. The *v*'s recur at the end
as harsh sounds accumulate (*guettant, garçons, coups,
glissent, couvrir, décorations, képis, galons*) among the
soft [ʃ]'s and [ʒ]'s of *approcher, chapeauter, jouets,* and
rouge: the latter group are soft in sound but in contrast
the context gives them a cajoling, potentially threaten-
ing effect.

This soap opera version of the Oedipus story is comic
in its style, the familiar and repetitive speech of the
gossip, full of clichés and unsupported conclusions—
how could she possibly know that the sphinx whispered
to Oedipus the answer to her riddle? She is hilarious
from the very beginning, as Butor plays with the com-
bination of sounds, *"la sphynge de Binche"*: he is irre-
sistibly moved to translate into Auvergnat pronuncia-
tion, *"la sphynche de Binje,"* exactly as Balzac did for
his character Rémonencq in *Le Cousin Pons*.[132] The
gossip becomes a fleshed-out character as she chatters
on, mixing the vulgar word "bitch" with her delicate
treatment of "serious matters." Her juxtaposition of
Phaedra's speech with Oedipus's burst of laughter over
the feathers is so incongruous as to provoke the reader
to join in with Oedipus.

The political force is limited to the very end, but is
based on the accumulation of hubris, in very Greek
fashion. Oedipus's fate here does not result from the
curse on the house of Atreus, predestined by oracles,
which he unwittingly embraced through his hubris, but
rather from his laughing at a silly hat. It is this incident
that has produced the Sphinx's eternal quest for revenge
on his descendants, on all mankind, a reaction to ridi-
cule that amounts to hubris again, but the Sphinx's, not
Oedipus's. It is her hubris that drives her still today to
watch for little boys whose behavior resembles
Oedipus's, luring them closer, and she still today finds
revenge on Oedipus through her selection of gifts: mili-
tary costumes and medals to dress up in and feel impor-
tant and proud. Little boys grow physically into men,
filled with hubris, whose machine guns and red tele-
phones are no longer toys. Some might see Butor's
conclusion—that the female sphinx's revenge is the
ultimate source of war—implies that women are more
responsible for war than men. Such a conclusion, how-
ever, misses the point. The blame falls rather on that
hubris, which flourishes equally well in both men and
women. While we could learn from this new version of
Oedipus's story to be discreet about laughing at other
people's hats, we might also learn to keep a sharp eye
out for our own overweening pride.

Immediately after the Sphinx we are transported to
the jungle:

De toutes parts
 *Les regards avides et les mâchoires ouvertes dans la
jungle douce aquarellée d'orchidées. Certains yeux sont
acérés comme des crocs; ils clouent leurs proies optiques
sur le fond de liège ou de nuages; et à l'intérieur de
certaines gueules on observe des visages à l'affût, beau-
coup plus humains parfois que ceux dans lesquels ils sont
logés comme dans un masque; et il y a même des visages à
l'intérieur de certains yeux et des mâchoires supplémen-*

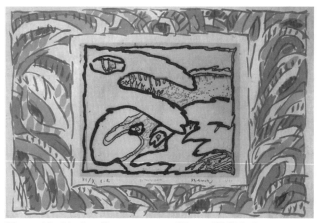

Pierre Alechinsky, *De toutes parts* [From All Sides].

taires dans certaines gueules. Pour rafraîchir les touristes qui vont gravir les pyramides mayas ou khmères, les marchands de glaces disposent leurs éventaires sur de larges feuilles de nénuphar qui flottent sur les mares profondes; la vanille et le cassis, la menthe et la cerise, entre deux flacons de boissons gazeuses avec pailles en mirlitons et deux caisses de bière amère et glacée que l'on agrémente d'une pincée de sel. Dans tous les fourrés borborygmes et reniflements; cela siffle et grogne et pétille et pépie, tandis que le papillon Jésus volette d'hibiscus en arum, le papillon raisin de datura en anthurium, et le grand aigle (la nature s'est amusée à lui dessiner des plumes avec ses écailles)[133] préfère les bromélias et les bananiers sauvages. De touffe en touffe les pythons déroulent leurs paraphs, signant, sifflant, crissant entre les ébullitions de l'oiseau-bouilloire, les sonneries de l'oiseau-timbre, les cliquètements de l'oiseau-castagnettes, tandis que l'oiseau-satin constructeur de boudoirs capitonne pour sa maîtresse dont le chant que nous sommes incapables de percevoir, si limitées sont nos oreilles, le remplit d'ivresse constructrice, des canapés, des ottomanes, des conversations et des bergères. N'oublions pas les crocodiles avec leur parfum d'ambre parmi les bulles sulfureuses, avec les aigrettes qui les nettoient de leur vermine, et du côté où cela commence à s'éclaircir en savane, les tapirs et les phacochères; torrents de baves, averses de larmes, deltas de sèves, réseaux de lymphes. L'administration des termites a lancé son défi au ministère des fourmis ailées. Dans le quartier des araignées on craint des manifestations massives qui empêtreraient la circulation. Une fois leurs toiles ont obligé l'un des autocars réguliers à rebrousser chemin; une jeep qui voulait forcer le passage a été bourrée de toiles, de fibres et de poils de chenilles jusque dans ses carburateurs, et il n'a pas fallu plus de huit jours pour que les fromagers, bougainvilliers et caoutchoucs l'aient entièrement recouverte; le conducteur a pu s'échapper de justesse, tranchant les vrilles préhensiles à coups de machete; et de temps en temps on est obligé de fermer le petit aéroport pour en nettoyer les pistes à grands flots de pétrole en flammes. Puis on réinstalle les bars et les vo-

lières, et le nouveau contingent de touristes débarque en caquetant, avec ses caméras-video. (29–32).[134]

Alechinsky's title, *De toutes parts* [*From All Sides*], would not necessarily have led Butor to the jungle, but the central figure is clearly a sort of crocodile. The figures below its jaw are similar to those of an earlier version of *De toutes parts*, which Butor saw as eyes: *"Nous avons là, 'de toutes parts' des regards"* [We have there, "on all sides" gazes] (*Bordures* 34). The faces containing other faces or eyes enclosing other eyes can be seen in the two eye-like figures under the crocodile's jaw, where a sort of face can be made from their outlines, or at least the right-hand eye can be seen as a face. In the lower right corner the parallel lines have a grassy appearance, and the border is composed of leaf-line forms. The colors of the border (green, yellow, and purple with dashes of orange and blue hatchmarks), stenciled in with watercolors, just as Butor says, could well have provoked the "orchids," the ice cream flavors, and the water-lily pads. That agitated and colorful border seethes with movement and probably generated the butterflies along with the flowers. The two figures on the right in the etching with snouts undoubtedly suggested the tapirs and warthogs.

The harmonies of this text increase as it proceeds. Initially it is the repetitions that stand out: *"mâchoires, gueules, yeux, visages, intérieur,"* while *"certains"* appears four times. Hard and soft consonants are contrasted in the repetitions: the [g] of *gueules* and the [ʃ] of *mâchoires,* the larger number of hard [k]'s and [g]'s balanced by the generous use of soft [ʒ]'s. No vowel prevails at the beginning, although there are many *i*'s. Then, beginning with *"pour rafraîchir les touristes"* the number of *i*'s increases more and more, until in *"de touffe en touffe"* they occur in each of the three rhyming participles: *"signant, sifflant, crissant"* At that point, the repetition of *"touffe"* plus *"déroulent"* offers soft [u]'s, and the [wa] and [o] of the four *"oiseau"* assume more importance through the repetitions, and in *"N'oublions pas les crocodiles"* the nasals of *"parfum d'ambre"* paired with the [yl]'s of *"bulles sulfureuses"* would overwhelm the *i*'s were it not for the importance of the words in *i*: *crocodiles, vermine, tapir,* and even *s'éclaircir.* The *"administration"* statement is full of *i*'s, and they continue prominent until the very end, appearing in essential words, such as the *"vrilles préhensiles."* Then the [u]'s, heard previously, sound again, especially noticeably in the tree sequence, *"bougainvillea"* and *"caoutchouc."* There against the constant background of *i*'s and the intermittent soft [u]'s, those two hard [k]'s plus the onomatopoetic *"caquetant"* contrast vividly, until finally a great upsurge of *r*'s is heard, initial, internal, and final. Throughout,

stylistic devices give cohesion to the whole: the parallel constructions such as, the series of the four qualified nouns in the *"N'oublions pas les crocodiles"* sequence, as well as the two series of three elements in the *"Une fois leurs toiles"* sequence. Rhymes and echos are heard constantly: *arum/anthurium,* the repeated *toiles* rhyming with *"poil,"* and the [ɲ] of *grogne* that is heard again at the end in *"castagnettes."* The opulence of the harmonies, repetitions, and parallels creates a music corresponding to the lushness of the jungle Butor sees in Alechinsky's etching.

The second sentence, "Some eyes . . . in some faces," while accurately reflecting the etching, is lightly humorous in its accumulations and repetitions. The image of eyes that pin the objects of their gaze to a cork base, as if to compose an insect display, is already surreal, but the alternative of "clouds," to which the objects might be pinned—and by our eyes—takes the reader one step beyond the surreal, to a state where no known scientific laws maintain, a super-surreal: the concept of nailing an object with physical properties to a cloud defies our imagination, but Butor presents it calmly as quite normal. The incongruity may not cause the reader to laugh out loud, but must at least provoke an amazed and admiring shake of the head. The image of ice creams set out on lily pads is similarly surreal, comical in its incongruity. More incongruities follow in the series of birds, each with a popular name (or one invented by Butor) taken literally, leading to that satinbird, busily upholstering furniture for the boudoir of some unidentified mistress, and they are increasingly humorous.

The termite administration and flying ant ministry are similarly incongruous, but in this last part bitter satire takes over the surreal. We could be reading a newspaper report of an oppressive government disturbed by protestors. Despite temporary successes of the oppressed, "they" still periodically clean out the airport: the burning gas recalls vividly far too many incidents in the real world. As the bars are reopened, the birds we saw earlier engaged in their free activities are now on display in cages. Those omnipresent tourists are not themselves represented as malevolent, merely sprinkling salt in their beer and carrying video cameras rather than guns or machetes. It is the system bringing the tourists in that is evil, motivated by greed and unconcerned by the destruction. Butor does not present the situation as one easy to resolve. On the one hand, the bus driver does use an ax, but on the other hand, Butor allows him to escape. Once again Butor speaks for the conservation of the beauties of the wilderness, but once again without recommending a solution that could harm bus drivers, ice cream sellers or native tourist guides.

It is particularly intriguing to read Butor's jungle scene since he brings to it life experience of not only the Egyptian pyramids in the midst of sand, but also those in the midst of jungles, both Mayan and Khmer. Further, the text is clearly influenced by Butor's literary experience with that jungle that many readers know best through Kipling. Béatrice Didier cites Butor on the *Jungle Books,* that the work *"fonctionnait comme une sorte de Bible ou de mythe premier chez les 'louveteaux,' c'est-à-dire le premier échelon du scoutisme de mon enfance"* [functioned like a sort of Bible or elemental myth with the "wolf cubs," that is to say, the first level of the Boy Scouts of my childhood].[135] Kipling is very present in this text in the "high squeak of Mang the Bat, which very many people cannot catch at all,"[136] the taking over of Butor's jeep by insects, and all those eyes: the same Kipling story includes a passage in which men in the jungle find that "shadows with glaring eyes watched them" (168). Even as Butor reads Jules Verne's works as far more than children's books, in *Le Chien roi* he shows an appreciation for Kipling that goes far beyond the contemporary view of his work as inhumanly colonialist. One might expect Butor's intertextualities to be limited to the *Jungle Books,* since it is in these tales that Kipling represents most animals as generally morally superior to man, Mowgli being the exception since he was reared by the wise wolves. However, in *The Return of the Boomerang* Butor states that he has just reread *Kim,* and *"Il y aurait beaucoup à dire sur Kipling, l'Empire britannique d'alors, la reine Victoria"* [There would be much to say about Kipling, the British Empire of the time, Queen Victoria].[137]

The title of the intervening *Papier de mur* [*Paper for Walls*] is drawn from Alechinsky's familiarity with Japanese culture, where walls in homes are often made of paper attached to a frame. (If Alechinsky had meant "wallpaper" he would have entitled the etching *Papier peint.*) This understanding accords with Butor's vision of movable walls in multiple arrangements. The central framed figure is kneeling on parallel lines, her hands behind her back; swirling forms in the colorful border suggest flora and fauna, and also eyes. Butor identifies the woman as Susanna, the parallel lines as *"l'eau ruisselant de la gravure"* [the rustling water of the etching] and fills the text with birds, flowers, and snakes, while the eyes are of course those of the elders. We will recall that Susanna was bathing in her garden when the wicked elders sneaked in to peek at and assault her. Butor arouses sympathy for the Susanna of the etching: she gropes behind her back for lightning bugs, which she would be unable to see and thus unable to catch, in holly, whose every sharp-pointed leaf would be tearing at her hands. The Susanna of the Apocrypha was not so helpless; she screamed and foiled the elders'

attack, precipitating the subsequent action. Thus Butor's presentation of Susanna already differs from the original.

In the second movement Butor develops four hypothetical perspectives on the scene: Susanna is seen in a room, then in a belvedere, as the spectator looks first in and then out, reflecting Alechinsky's title and the movable paper walls, which eventually become *"papier jardin"* [garden paper], and *"n'empêcherait nullement qu'il y ait un autre mur"* [nothing would prevent their being another wall] and still other views. The perspectives are expressed in the conditional tense, one introduced by *"il n'est pas impossible que"* [it is not impossible that], while *"l'histoire de Suzanne se détériore de la même façon"* [the story of Susanna deteriorates in the same way]. We will recall the series of conditionals in *Oranges,* which ended "happily" with the arrival of the crates of fruit and "black Peter." This series concludes differently: certainty returns with the past definite, the tense of tombstones: *"le crâne de cette vieille qui fut cette Suzanne dont on a tant parlé"* [the skull of the old woman who was that Susanna about whom people have talked so much]. Thus the paper walls have become the basis of an extended metaphor for art: how many representations have there been, by how many different artists and writers of the story of Susanna![138] I offer only one familiar example: Shylock's greeting Portia joyfully with, "A Daniel come to judgment!"—and then Portia traps Shylock just as Daniel trapped the elders. Nothing may remain of the original Susanna but a skull, but her story continues to inspire artists, and once again Butor demonstrates the infinite possibilities of salvation through art.

The final section gives the book its title:

Le Chien roi

 Pour composer la soupe du chien roi, on fait pêcher dans les rivières du nord les saumons et les truites, on sélectionne dans les élevages de l'ouest les jeunes boeufs les plus tendres pour en prélever les filets et les os à moelle; les pigeonniers de la cour fournissent leurs couples les plus dodus, les moissonneurs leurs cailles, les chasseurs perdreaux et faisans. Pour lier tout cela aubergines, potirons, épinards et les oignons de toutes teintes bien revenus dans le beurre ou le lard selon les jours de la semaine. Le tout servi dans une gamelle en bleu Ming. Le soir on dispose sur des coupelles de céladon coréen, des clémentines de Nice, pistaches décortiquées, lardons grillés, osselets et de ces petits biscuits salés dont les humains se servent pour leurs cérémonies apéritives. L'eau fraîche coule perpétuellement dans sa jatte en cristal de Bohême où l'on fait flotter des pétales de pommier ou de rose. Pour préparer la litière du chien roi, on choisit des toisons de moutons noirs et blancs, et l'on fabrique des mosaïques de velours et satin pour les édredons et coussins emplis de duvet. Pour construire la niche du

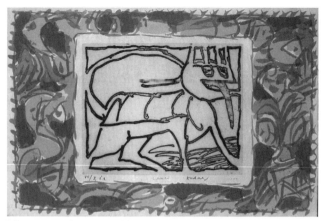

Pierre Alechinsky, *Le Chien roi* **[The Dog King].**

chien roi on abat les derniers cèdres du Liban, on surveille la formation des loupes d'ébène et de citronnier. De chaque côté du porche, des colonnes de marbre lisse et granit rugueux lui permettent de se frotter à sa guise, et derrière les salons de cérémonie, ses piscines d'albâtre, ses douches, ses hammams mènent aux niches de ses chiennes. Pour son manteau il préfère en général le vison ou l'ocelot; ce n'est que pour les grandes cérémonies du royaume qu'il adopte la peau des tigres dont il s'efforce alors d'imiter les rougissements. Pour certaines fêtes de famille il revêt une capeline en peau d'homme dont les tatouages représentent certains de ses ancêtres (que de ruses il aura fallu, que de menaces, que d'argent la plupart du temps, pour obtenir de ses tristes échantillons de l'ancienne espèce dominante qu'ils choisissent de tels modèles! Et il faut évidemment en choisir qui aient une vie suffisamment dangereuse, car la peau d'homme vieillit mal, mais point trop querelleurs pourtant, car une balafre et tout le travail est perdu; c'est un énorme souci pour ses costumiers), et il agrémente parfois sa crinière d'une chevelure de femme rousse qu'il entortille aux tourelles de sa couronne. Pour recruter le harem du chien roi, on lance dans les steppes, les villes et les chenils d'éducation, de jeunes lascars aux jappements irrésistibles, qui ramènent des beautés par troupes entières. De vieux chambellans fort expérimentés dans la matière font une première sélection avant de les proposer au choix du monarque. Les messagers se partagent en général le surplus. On assiste parfois à des scènes déchirantes, interminables hurlements à la Lune, violentes rixes où il n'est pas rare de voir l'un des combattants finir entièrement dévoré par ses rivaux, ses ossements minutieusement brisés et rongés. Tel est le pouvoir de la jalousie! Pour convoquer le conseil du chien roi on utilise de menus sifflets d'argent à quatre notes dont la succession désigne chacune des races ou tribus. Pour la promulgation de ses décrets les oculistes lui polissent des lunettes neuves (car toute cette dynastie est myope), tandis que les pédicures lui tranchent habilement une griffe que l'on apposera comme sceau à la touffe des poils sentences. Après les périodes d'agitation et de crise il faut parfois patienter plusieurs mois pour une

promulgation nouvelle en toute formalité. Et pour accompagner les réceptions qui suivent, on fait venir du fond des steppes les fameuses chorales à grelots et gongs que l'on revêt de livrées fauves. (39–41)[139]

The dog of Alechinsky's etching is panting and could be seen as smiling, but Butor has seen him as a monster. The birds and fish figures of the border would have suggested his elegant meals. The dog's crown is the sole element in the etching that suggests the human, since the "spectacles" could be just markings around the dog's eyes, and the coat could easily be just the sweater proud owners dress their poodle in. But, taking off from the crown, Butor uses both coat and spectacles in his satire of human tyrants. In *Texte* Butor speaks of the spectacles: *"Egalement, dans l'estampe 'Le chien roi' le chien a sur les yeux une paire de lunettes, ce qui a pour résultat de faire de l'animal un chien-cobra, celui qui transmet le message et maintient la tradition"* [In the same way, in the etching, "The Dog King," the dog has over his eyes a pair of glasses, which results in making the animal a dog-cobra, the one who transmits the message and maintains the tradition] (96). The cobra is ordinarily beneficent in Alechinsky, but as Butor points out, *"il peut exister de mauvais cobras"* [bad cobras can exist] (97).[140] Butor unquestionably sees Alechinsky's Dog King as one of the bad cobras.

In contrast with the other texts in this work, *Le Chien roi* is very restrained in its harmonies. The only repetitions are the five of "dog king" (plus, once, the feminine form of "dog," but without the corresponding "queen"), forms of "to choose" three times, "skin" three times, and "kennels" twice. The generous sibilants at the beginning decrease until the tattoo passage, where they increase again together with [z]'s, but they gradually return to normal occurrence. The numerous *p*'s of the opening decrease in frequency, except for the three repetitions of *"peau"* (skin), until the penultimate sentence, where five initial *p*'s occur: *périodes . . . parfois patienter plusieurs . . . promulgation,"* which are echoed in the three internal *p*'s of the last sentence. There are more hard consonants than soft, and as for vowels, soft [u]'s are heard throughout, soothing enough in *mouton, velours,* and *coussins,* but not at all in *tatouages,* just as the [y] of *dodu* is soft, whereas in *rugissements* the same sound is affected by the adjacent consonants and especially the meaning. The *i,* as in *chien,* is the most frequent vowel, but not preponderant to the extent heard elsewhere in these texts. Bad cobras generate hissings, puffings, harsh sounds, and deceptive cooings, but not music.

Similarly, the "message transmitted" by the bad cobra, the "tradition maintained," is not conducive to laughter. The whole, as a parody of human tyrants, is bitterly satirical, and it is only in a few words or phrases that Butor slips in ironic touches whose humor just barely survives the onslaught of horrors. For example, the dog king's onions are cooked "according to the days of the week"; in the dog-kingdom religious dietary laws are observed more scrupulously than they are in the contemporary human world, at least in the western part of it. Then a single word, "irresistible," is humorous in its incongruity as qualifier of "yapping." The mission the dogs carry out bringing back slave bitches for the king's harem is hardly meritorious,[141] and if Butor had written simply "barking," it would not be amusing, but "yapping" immediately connotes sounds universally producing annoyance, not one bit irresistible. The deliberate vagueness of the "old chamberlains very experienced in the matter" is humorous in its unstated suggestiveness, perhaps especially to readers who have just been revisiting Susanna and those elders: we know very well about "old chamberlains." Then, that "the whole dynasty is near-sighted" evokes certain European dynasties known for their big noses or a tendency to insanity: again it is the contrast that is humorous, as a defect is held up to be admired. However, the primary force of this text does not lie in the humor any more than in the harmony, but rather in the political statement.

It is a sad sight Butor presents, in which the dog tyrants of the future have nothing better to imitate than human tyrants, who thoughtlessly destroy nature (they are the *last* of the cedars of Lebanon!), pamper their own whims, and torture their slaves. Luxuries of all kinds are passed in review, each recalling vividly human despots, dictators, monarchs. The "young fellows" fighting over the "beauties" rejected by the king reflect human behavior, with the possible exception of eating one's defeated rivals—and yet, there have been human cultures and may still be where that practice maintains. Even the different order of notes played on the silver whistles evokes complicated rituals of human secret societies, a whole system of hierarchical divisions. Then, how many petty human dictators have sought to imitate the roaring of the tiger, whether conceived of as Julius Caesar, Genghis Khan, or Napoleon? Contemporary leaders are not spared, evoked by the new glasses the dog king requires to sign a new decree, which are painfully similar to the new fountain pens world leaders use and present to VIPs, as they sign treaties. The special musical groups brought in to entertain at receptions seem very modern, and for the months required to issue a new regulation we need look no farther than our own governments today. Still today human beings persist in wearing animal skins and furs to give themselves an air of importance. That the dog king's human models are not all taken from long ago and far away is especially emphasized by the tattoo sequence in its excruciating

detail. It is for the king's coat that the human skin is destined, and to be tattooed with figures of dogs the humans living inside those skins must be tricked, persuaded, or even paid—even in this desperate situation, humans keep their besetting lust for money. Of course, the skin should be young and unscarred, but before we shudder too virtuously at the behavior of the dogs, we must remember when humans used human skins, tattooed with concentration camp numbers, to make not coats, but lampshades, not very far away and not very long ago.

The crown on Alechinsky's dog has evoked this text, in which with limited harmony and very little humor Butor makes his statement regarding human beings. Dogs do not behave this way: humans do.

Butor may have selected as title *Le Chien roi* from among the other sections because its political statement is particularly strong, but "Running After," which he originally considered, would also have been appropriate. Certainly the feeling of movement is there in the texts as well as in the etchings: sudden changes of direction and point of view, of time and space, of levels of diction or styles. Taken as a whole, this series illustrates very well the endlessly varying ways Butor collaborates with the artist, "running after" him, beginning with the different ways he uses the artworks in his texts. The etching itself is mentioned by name only once, in *Papier de muir* in *"l'eau ruisselant de la gravure"* [the rustling water of the etching] where Butor also speaks specifically of *"un motif . . . en noir et blanc"* [a motif . . . in black and white], which is just the way the figure appears in the etching. But aspects of the etchings are very present in all the texts. For example, the colors of the borders are used in three different ways in *Oranges, Rhizome,* and *Sphinx* and the forms seen in the borders may be found in the text in the gourmet meals of the *Chien roi,* while the eyes in the borders of *Papier de mur* would have led to Butor's essential identification of Susanna's elders. Both border and framed image provoked the historical and legendary characters of *Tunnel,* the insects and vegetable life of *Rhizome,* and the jungle of the insects' revolt in *De toutes parts.* Each of the four etchings with a distinct figure in the frame is treated differently in its text: in *Oranges,* the carnival evoked by the center figure is mentioned, but it is the colors and swirls of the border that predominate in the text. In *Gueule de prou,* the image of a boat, the central figure, has generated the setting, but the text takes the form of an interior monologue by a sailor, who is simply not to be seen in the etching. Then, we see the Sphinx, but neither the gossipy speaker nor Oedipus appears in the etching. Only in *Le Chien roi* is the principal center figure the subject of the entire text, which could be another reason for his ending up in the title role.

The content is all-encompassing: plants, animals, and human beings historical and imagined, from all eras and locations, and Butor has treated each stanza with differing intensities of harmony, seen in the four texts whose poetic devices are examined here. In *Le Chien roi,* repetitions and the use of sibilants and plosives function noticeably only in the one segment of the tattooing, which thus is emphasized in contrast with the restrained sounds of the surrounding text: the kingdom of the dogs is scarcely a harmonious one, with its yapping and yowling. In *Sphinx* the repetitions and the rhythms of the narrator's speech are constant throughout; as she tells her story she evokes a professional storyteller surrounded by a circle of listening villagers. *Oranges* is very rhythmic, and we noted the deliberate placement of contrasting hard and soft sounds: we hear the rhythms of carnival dances together with the opposition of pleasing past and frightening future. The richest in parallel constructions and repetitions, along with the pronounced prominence of *i*'s, is *De toutes parts,* in which the harmonies increase as the repetitions decrease until finally the *r*'s predominate in the last sentence. This text is descriptive, ripe for poetic treatment, with the mini-narrative only at the end. In each case, Butor's use of poetic devices is tailored to the subject matter.

Drawn to different extents from the etchings, with more or less musical accompaniment, the sections of the series differ greatly in the dose of humor. Only one of the texts has none, *Papier de mur.* Two include only one amusing touch, *Gueule de proue* and *Tunnel,* where only the big feet of the "sciapodes," used as sunshades, are comical. Incongruities provide the humor in four, each time used differently. In *Le Chien roi* they appear simply in the choice of words. In *De toutes parts* they are surreal and lead to satire, while in *Rhizome* the incongruity of the "pretty litter of white worms" leads to the satirical presentation of the insects' gymnastics. Then in *Oranges* the incongruities and satire run throughout, humorous, even when the humor is "black." Finally, *Sphinx* presents all levels of humor, couched in the narrator's hilarious speaking style. Some say "black" humor is the result of the recognition that— since there is no longer any absolute standard of moral value—there is no place in the world now for tragedy. Butor's revision of Oedipus's story serves as the perfect illustration, as that classic tragedy accepted as the ultimate model ever since Aristotle is turned upside down into a comedy.

If some of these texts are lean as to harmony or humor, all have a political aspect, more or less fat.

Where there is a natural cycle of life, death and re-
generation, humans seem bent on interrupting it, per-
manently, with our red telephones. Three of the texts
are directed particularly toward the conservation of the
natural world, each in a different way. The first move-
ment of *Oranges* speaks clearly to environmental con-
cerns; *Rhizome* shows human interference with nature
as a negative force, a position refined in *De toutes parts*
to clarify that it is the rich and powerful who must be
restrained, but without damage to the humble. Butor's
political position of resistance to the destruction of na-
ture extends further to resistance to the violence com-
manded by human beings against one another. In *Tun-
nel,* the wars generated by opposing religious factions
are evoked, together with the implication that the rea-
sons given for all the slaughter have been lost in the
passage of years. *Gueule de proue* develops a theory of
death and transmutation and warns us against depend-
ing on godlike creatures we have only fabricated our-
selves. Both the *Sphinx* and *Le Chien roi* attack the pride
of the powerful, *Sphinx* showing us in addition that
truths we believed unassailable could be seen as com-
plete misconceptions. *Le Chien roi* demands recogni-
tion of the fact that human behavior is far more vile than
that of dogs.

But even in this vision of human civilization as a
shambles chaotically driven by greedy demagogues
Butor allows for a potential means of salvation. At the
beginning of the book, in the second movement of
Oranges, there is human artistic creativity busily work-
ing toward solutions to the problems. *Papier de mur,*
too, while accepting that in the course of nature Susanna
herself has disappeared, shows us that her story, how-
ever "deteriorated" or changed, survives and will con-
tinue through art. The work as a whole, the collabora-
tion between artist and writer, is a clear demonstration
of art's providing a way for mankind to endure, and not
at the expense of plants and animals. If at the end we are
left despairing by the dogs' destruction of the last cedars
of Lebanon, we need only go back to the beginning to
find "black Peter" dispensing the hope Butor never cuts
off altogether.

FRONTIÈRES ET BORDURES: COMPTINE EN BLANC ET NOIR

Unlike the *comptines* of the *Rêve de l'ammonite,*
which were composed of the five lists of words, each set
with the same prefix, this *Comptine* is a unified whole.
The four-stanza poem was published in 1984 at the end
of *Frontières et bordures,*[142] where the artworks it
derives from, pages from Alechinsky's *Atlas universel*
[Universal Atlas], drawn in Chinese inks on a support of

old maps, are also reproduced, one in color. The first
three stanzas were clearly written in collaboration with
the first three pages of Alechinsky's *Atlas,* but the gen-
eration of the fourth becomes more understandable if
seen as inspired by a combination of *Pages IV* (109), *V,*
and *VI* (89) of the *Atlas,* and I believe *Page VIII* (90) lies
behind the whole.[143] The poetic techniques are re-
strained, the humor sardonic, but the poem makes a
very strong political statement.

COMPTINE EN BLANC ET NOIR

1

Dans la potiche de l'Espagne
s'épanouit l'Estramadure
les tulipes du Portugal
plongent leurs pétales dans l'eau
que les navires de Vasco
sillonnèrent dans leur départ
vers le continent jaune et blanc
le dahlia des Asturies
conte fleurette aux myosotis
qui parsèment les deux Castilles
et envahissent le León
de leurs comptines délicates
les lys poivrés de la Galice
caressent de leurs éventails
l'asparagus guipuzcoan
et les giroflées de Navarre
les pivoines de l'Aragon
les jonquilles de Catalogne
dans la pavane des saisons
avec les ombres andalouses
s'enlacent autour des épines
des trois roses des Baléares
et les nuages du Languedoc
répandent leurs rosées de nacres
sur les caravelles aux ports
et les galions en haute mer
tandis que le nez dans ses livres
rue de Fleurus au trente-trois
les pieds dans une couverture[144]
algérienne Albert Pilon
maître éditeur songe aux mantilles
aux cigarières de Séville
aux fontaines d'Aranjuez
aux barils d'Amontillado
aux toreros et aux Califes

(107–8)[145]

Alechinsky's drawing and gray wash (in *Page I, Es-
pagne et Portugal*) make place-names on the map itself
difficult to discern, but Butor's vase full of flowers, the
roses of the Baleares, and the clouds over Languedoc
are easily seen. The place-names in Spain which Butor
uses are not visible, and although the names of some

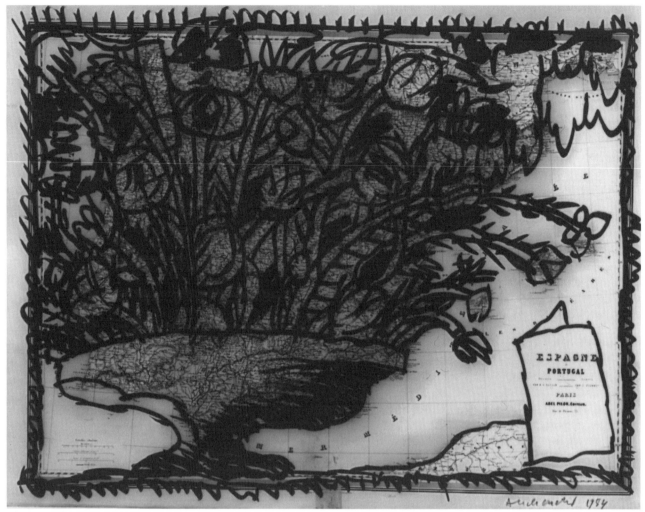

Pierre Alechinsky, *Page I, Espagne et Portugal* [Spain and Portugal].

French departments can be made out, they are not those Butor chose to include: Navarre and Languedoc. Other place-names, such as Estramadura, in Portugal, birthplace of Vasco da Gama, cannot be seen on the map, but the map legend makes clear that Portugal is there where we would expect it, and Alechinsky's wavy lines offshore in the Atlantic probably evoked da Gama's ships setting sail. Then, Butor has converted the framed map title, which looks like a partially open book, into an editor, "his nose in his books," with his feet in an Algerian coverlet since the bottom of the book is over Algeria. The address remains the same as in the map title, but Butor has changed the editor's name from Abel Pilor to Albert Pilon, perhaps to avoid the connotations of Abel; the change in the surname could be a quiet tribute to the stationer-bookseller Pilon in Montreal.[146]

The poem is octosyllabic with one or two nine-syllable lines in each stanza. Rhymes occur in this first stanza in *myosotis/Galice, mantilles/Séville, l'eau/*

Vasco, Aragon/saisons, the latter two echoing much later in *Amontillado* and *Pilon.* The predominant vowel sound *i* of those two rhymes appears as well just before the first pair occurs, in *Asturies,* and then again in *épines* and *livres* before *mantilles/Séville,* and then turns up in *Amontillado* and *Califs;* it sounds also often in other internal words, such as, *dahlia, giroflées, jonquilles.* Other vowels are heard in brief spates: the [y] of *Estramadura, tulipes, Portugal,* scarcely recurs until the end: *rue, Fleurus, couverture;* the [u] of *andalouse* and *autour* disappears until *couverture.* The consonants *p* and [k] are very frequent throughout, both initial and internal, the [k] emphasized by its final position in *Languedoc.* The initial *r*'s noticeable in *roses, répandent, rosées* fade to internal positions in *nacres, caravelles, ports,* and a final position in *mer* before becoming very present in the last lines, particularly in *toreros.* A pronounced final *s* hisses three times. The soft [ʃ] occurs only once, in *potiche, z* scarcely more,

even with the liaisons, soft [ʒ] only four times, and the hard [g] only six times. Thus neither the rhythm nor the rhyme is remarkable, and the harmony is muted. The predominant sounds are the vowel *i,* the consonants [k] and especially *p.*

We may find mild humor in the dahlia that "whispers sweet nothings" to the forget-me-nots, but in English the play on words in the literal meaning of "tells a little flower" is lost. The contrast between the luscious flowering vision of Spain and Portugal with their courageous explorers and the editor huddled under his afghan safely imagining literary—or operatic—scenes is amusing, but we may sense that any humor is likely to be "black."

In this romantic, exotic evocation of the Iberian peninsula as a land of flowers and brave seafarers, with a musical background supplied by the editor's dreams of Carmen and Aranjuez, Butor has slipped in premonitory touches. The reference to Amontillado recalls the terrifying Poe story, and Butor would not find bullfighters, no matter how grandly they might sing in opera, admirable. The forget-me-nots are "invading" with their "delicate counting-rhymes." Here the children's game takes on a threatening meaning, absent from those in the *Rêve de l'ammonite.* Whether "eeny meeny miney mo" or some other variant, the point of the children's recitation is to identify a winner, and of course, a loser or losers: someone is "it," and the others are not. Da Gama and his ships were headed for a different continent, initially voyages of discovery, but in no time at all they became bloody conquests. There are the editor's feet in Algeria; we know the map is from the nineteenth century, but not whether before or after the French conquest. Then the stanza ends with the Caliphs, conquerors of much of this continent who came from outside this continent: eeny meeny miney mo.

2

Amphitrite aux cheveux d'échelles[147]
et aux peignes de traits de plumes
vient baiser la forêt des Landes
l'Adour coule sur son menton
et la chaîne des Pyrénées
se tortillant comme un lombric
s'amuse à lui gratter la gorge
les collines lui font des seins
et juste à l'endroit de la Manche
où se batailla Don Quichotte
le plan des quartiers de Bordeaux
vient lui tresser des épaulettes
rampant au long des kilomètres
une serre aux griffes aiguës
met le grappin sur Saragosse
parmi les plumes de noirceur
et les noms des départements

répandent ses discours de sphinx
l'eau des fleuves devenant larmes
dont le sel s'amasse en ses rêves
de guerres entre paladins
sonnant du cor à Roncevaux
s'exterminant pour ses yeux doux
lorgnant les compagnons d'Ulysse
de l'autre côté des vignobles
harpie sirène messagère
d'un dangereux Eldorado
les continents rouges et jaunes
perchée sur les branches de l'arbre
où mûrissent les résultats
du mariage entre le ciel
des algues et de l'enfer des grappes
elle oblige l'Adam gascon
à quitter sa gentilhommière
se mettre en selle et s'en aller
pour en décorer son chignon
cueillir les pommes de Paris

(108–10)[148]

The indications of scale on the original map have influenced the hair of Alechinsky's woman. Butor has christened her "Amphitrite," who is not a well-known mythological figure. Homer used the name for the sea itself; Hesiod reports her as the wife of Neptune and mother of Triton, but the name reverted to the meaning of the sea in general again later. Alechinsky's placement of the face there in the Atlantic would be the source of Butor's choice. She is positioned where she might kiss the "forest of the Landes," and the river Adour does run into her chin, as the Pyrenees connect with her throat, which Butor sees as scratching it. The area she faces is the old province of Gascony. The inset can just be identified under the inking of her "epaulettes" as a city map of Bordeaux because the name of the Gironde is visible. Her hand with its "sharp claws" does reach to Saragossa. Names of some French departments are legible; the rivers can be seen; we know there are "vineyards" in the area, with their "clusters," and Roncevaux up in the mountains. La Mancha is a good way southeast of the inset and does not appear on the map; Butor deliberately added Don Quixote, who had his own way of preserving medieval traditions.

Two rhyming sounds from the first stanza reappear: nasal *o,* at the beginning, *menton,* and at the end, *gascon/chignon,* and then closed *o: Bordeaux, Roncevaux, El Dorado.* Only one repetition occurs: "feathers." The *i*'s of Amphitrite echo those of Stanza 1, but subsequently lose their importance, and no other vowel is substituted. There are more soft [u]'s (4) than in the previous stanza (2), but not a significant number, and whereas in the previous stanza the three [j]'s were all in Spanish words, here there are four in French. The consonants assume increased importance: more [g]'s and

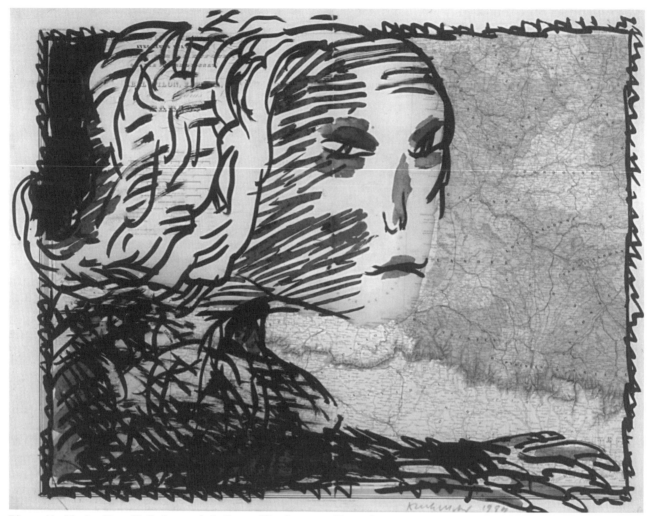

Pierre Alechinsky, *Page II, Sud-ouest de la France* [Southwestern France].

especially [gr], and the [k]'s remain numerous, including the pronounced final sound in *lombric*. Four [ɲ]'s occur, with their distinctive, vaguely unpleasant sound, but the number of soft consonants has increased, with balancing effect, five [ʒ]'s and eight [ʃ]'s, three of which appear in the very first lines. Again, particular sounds are placed together, as for example, *l*'s and *r*'s in *"l'eau des fleuves devenant larmes/dont le sel s'amasse en ses rêves/de guerres entre paladins/sonnant du cor à Roncevaux."* The harmony has modulated, with less vowel emphasis and more of both harshest and softest sounds.

The humor will produce smiles rather than uproarious laughter. The "worm" scratching the woman's throat is incongruous, as is Amphitrite's leering at Ulysses's men while at the same time dreaming of knights who fight for her favors. Her metamorphosis into Eve, who sends an Adam after apples, is unexpected. Further, this Adam is a Gascon, traditionally a braggart,

able to talk his way out of difficulties, and he lives in a manor house. Yet Amphitrite is still able to "oblige" him to run her errand. There is comic reversal in her not wanting this Adam to eat the apple, but just bring some back to her to ornament her hair.

As for the political, Amphitrite's claw hooked in Saragossa, home fortress of Charlemagne's Saracen enemy, is an immediate sign in the drawing of a threat, and the text develops her as the creator of conflicts. Delivering the "sphinx's speeches," those riddles known to lead to tragedy—and indeed the river water turns to tears—Amphitrite dreams that Roland's knights were killing each other for her favors. This is hardly the case according to the literature, since they were rather fighting those same Moors generally referred to as "Caliphs" in Stanza 1.[149] She cares not a whit for the death of Roland but "looks out of the corner of her eye" (alternative translation of *lorgner*) at Ulysses's companions, leaping space to the sea where Ulysses's ships would be, even as

she spans time in the centuries between. The terms, "harpy, siren" certainly meant problems for Ulysses, and the quest for El Dorado has brought catastrophes all over the globe; Butor pointedly qualifies it here by "dangerous." The depiction of Amphitrite as initiator of evil culminates with her "perched" in a tree, and although we do not know it to be a forbidden one, "the results of the marriage between the sky . . . and hell" "are ripening" there. She is not coaxing Adam to eat the apples, but she is sending him off to a site symbolic of temptation, held back until the last emphatic word, Paris.

Pierre Alechinsky, *Page III, Nord-ouest de la France* [Northwestern France].

3

Les uns disent c'est un taureau
mais nous n'en voyons pas les cornes
les autres que c'est un tapir
mais il lui manquerait la trompe
c'est une bête de Bretagne
que chevauche quelque grenouille
énorme ou peut-être un castor
harnaché par le Cotentin
et les îles anglo-normandes
havresac baudrier plumets
que chevauche à son tour un aigle
ou une mouette ou un corbeau
rasant de son vol les falaises
blanches de Douvres et les grèves
ou les rochers de Cornouailles
que chevauche le roi des nuages
portant les brouillards londoniens
comme une hache à sa ceinture
une longue lance à l'aisselle
pour occire l'affreux serpent
qui se love dans les faubourgs
en obligeant les jeunes mères
à lui livrer leurs nourrissons
pour les mettre dans ses saloirs
sur le continent rouge et noir
intrigués par tous ces éclats
sur les rives de Picardie
des Flandres et de la Hollande
les foules en gros godillots
se détournent des championnats
de football ou de rock and roll
pour revivre les péripéties
de ce combat moyenâgeux
et applaudissent à tout rompre
en absorbant leurs casse-croûte
aux coups de tonnerre que donne
le défenseur des demoiselles
à l'ophidien trafiquant d'armes
dont les canons ou les avions
les fusils les échafaudages
les cuirassiers les sous-marins
commençaient à proliférer
sur les sargasses des gulf-streams

(110–11)[150]

Butor's question on the nature of the principal animal is easily derived from the engraving. However, he has freely rearranged the riders. The humanoid figure is wearing a helmet with a face guard, and it is possible to see something slightly froglike to his left, but the beaver and birds have been generated in Butor's imagination from the lines, plumes, or fur, drawn over the head of the knight and possible frog. The placements given in the text, the Cotentin peninsula, Dover, and Cornwall, are not helpful in distinguishing details, and the knight's weapons are not to be seen. The coiled serpent, however, is recognizable in Alechinsky's lower frame, and the crowds in Picardy who turn from their soccer matches could be suggested by a line with hatch marks in that area of the map, which looks much like the stitching on an American football.[151] It is true a soccer ball does not have the same stitching, but Butor could easily meld the two, not being himself noted for an interest in sports. The crowds who attend both sporting events do have the reputation of being rowdy. Then a combination of elements in the drawing would have provoked Butor's arms race: the insectlike figure over the map legend, whose antennae, directed toward France, are like listening devices, and opposite the insect, the arch Alechinsky has left open suggests a secret lair under France. Certainly Alechinsky's encircled letters of "O C E" floating in the open sea, and the fringed lance or arrowhead evoke mines and weapons.

Here we find four sets of rhyming words, one of three words in nasal *i*, and one in the closed *o* we have seen before: *taureau, corbeau, godillots,* the same sound as in the three times repeated *chevauche*. There are only two occurrences of [ʃ] in addition, but the persistent

repetition of "which is ridden by" establishes that soft sound. There are four [ʒ]'s, and seven soft [u]'s. Other vowels are not remarkable, and the prevalence of *p*'s continues. There are brief patches of alliteration of a particular sound, such as the *t*'s of the *taureau, tapir, trompe* at the beginning, or the *b*'s of the *bête de Bretagne,* or *d*'s of *donne le défenseur des demoiselles,* but throughout, in contrast with those soft [ʃ]'s, six hard [g]'s are heard, together with a large number of [k]'s again. Even the foreign words included, English instead of Spanish in this stanza, contain hard sounds, the [k] of *rock and roll* and [g] of *gulf-streams.* The last lines reverberate with them: *casse-croûte, trafiquant, canons, cuirassiers, commençaient, sargasses, gulf-streams.*

Humorous touches are limited to the bull versus tapir discussion between "some" and "others," which is couched in simplistic terms, with the effect of the reader's feeling he is overhearing the argument of two children. The resolution is absurdly childlike as well—what could a Britanny beast actually be? Then, the portrayal of the clumping crowds, accustomed to soccer matches or rock concerts, who are perfectly happy to munch on their junk food and applaud frenetically over the battle between the king of the clouds and the snake, is amusing in its accurate detail, but only until we recognize what it is they are watching.

The political is foregrounded in this stanza. The military costumes of the stack of riders on the bull/tapir builds from the "knapsack shoulder-belt plumes" of the frog/beaver to the "battle-ax" and "long lance" of the "king of the clouds," which he will use to "slay" the serpent. Mothers are forced to give up their children, and the area where Alechinsky's hatch-marked sausage is placed Butor has chosen to name Picardy, Flanders, and Holland. All three were devastated in the last two world wars: Picardy is remembered as where roses bloom in the World War I song, and Flanders will always be where the poppies of the poem grow. When the crowds applaud the "medieval combat," all wars are the subject, condensed here to the "defender of damsels" as a medieval knight, versus the contemporary arms dealer, "snakelike," motivated by good old greed. Our "king of the clouds" was armed with battle-ax and lance to fight against planes and submarines, clearly futile. We should note among the arms, "scaffolds," not ordinarily classed as military weapons. Once they might have been, when a medieval force scaled the walls of a fortress, but today a scaffold stands rather as the means of executing traitors or criminals, at least in uncivilized countries. We should note, too that the child-abducting "frightful serpent" lurks in the "suburbs": the battle may be fought elsewhere, but the soldiers are conscripted right here at home.

4

Madame Turquie en perruque
tricote un châle pour son Caire
elle a Chypre dans sa prunelle
et la Syrie sur son oreille
son mari le vieux Roumanie
noue sa cravate balkanique
sur son faux col adriatique
devant le miroir de Crimée
où grimace comme un faux frère[152]
son sosie à bec de corbeau
quant à la chatte tyrrhénienne
avec son museau tunisiem
elle miaule sur ses épaules
devant les casiers de la France
remplis de coteaux modérés
de plumes des Folies-Bergère
de chômeurs et de diplômés
posés sur le buffet d'Espagne
avec ses aficionados
paellas infantes duègnes
et la fenêtre sur le golfe
où le cygne d'Albion caresse
le naufrage de l'Armada
de l'autre côté du salon
une odalisque barbaresque
au teint de rose et de lilas
roucoule en mâchant ses loukoums
et caressant son léopard
affalée dans la véranda
qui donne sur la mer fermée
où se cambrent les hippocampes
et d'autre part sur les déserts
où les goules et les chacals
vont se disputant les charognes
parmi les silex et les dunes
de ce continent jaune et noir
c'est la famille bien unie
qui veille sur les traditions
de notre civilisation
remontant à l'antiquité
comme le dit la faculté
de ce continent rouge et blanc
tandis que le dîner mijote
et qu'on allume la télé
pour regarder les variétés
avant de jouer à la belote

(111–12)[153]

Three "Pages of the Universal Atlas" contributed to this fourth and final stanza.

I follow here the order of the text, identifying elements seen in each of the three "Pages." Where the first three maps were of Western Europe, *Page IV* takes us away from such territory, comfortably familiar to Westerners, labeled not only "Turkey," but "of Asia." The first three stanzas have established that the rumblings of conflict are not so distant in time as the old maps might

Pierre Alechinsky, *Page IV, Turquie d'Asie* [Turkey of Asia].

Pierre Alechinsky, *Page V, Mer Mediterranée* [The Mediterranean].

suggest, but are still very present today. Now, lest we think the current threats come only from the direction of Asia, Butor uses the next two pages of the "Atlas," going back to the Mediterranean in *V* and then *VI,* whose legend is "Europe Today." Alechinsky's selection of the map with that title has influenced Butor's vision of the whole, which focuses finally on the here and now.

The focal figure of *Page IV* is the face with two eyes and mouth over Russia, and body with crosshatched legs, and its clearest relationship to the text is the knitting, drawn from the cross-hatching. The woman with the breasts above Egypt (and it is not Cairo, but Alexandria) became Mme Turquie: she has a fringed halo for wig, Cypress is off her shoulder, not in her eye, and Syria is near her ear. The old Roumanian husband must be the face in the Black Sea, because the woman with

the breasts does look rather like him, not quite a "double," but with a "crow's beak." The lines resembling hair have become the husband's appropriately Balkan tie. The mouth of the face over Russia has turned into the Etruscan cat's muzzle, over Libya, not Tunisia, ears laid back, and the face's arms have become the cat's legs. The text next speaks of French hills: France is included in the map of *Page V,* but it is in *Page VI* that lines may be seen suggesting hills, and a humanoid figure over England, which looks more like a puppy than a swan, is very near a sort of boat, which would be the shipwrecks of the Armada. The phrase "on the other side of the salon" in the text leads us away from England to North Africa on the map of *Page V.* The color reproduction in *Bordures* shows that in the couple with faces touching the man is blue-faced and the woman pink-faced: Butor has combined them in the "barbarian odalisque" with her "pink and lilac complexion." The leopard she is petting would be drawn from the catlike face outlined in spots in the Mediterranean (whose eyes utilize the blue of Corsica and Sardinia). The "closed sea" of the text derives from *Page VI,* where Alechinsky has firmly blocked off the Straits of Gibralter. On *Page V,* the horse's head seen near the leopard could have suggested to Butor the seahorses of the text, and the face with long green hair the "ghouls," but the jackals are not visible in any of the three *Pages.* In *V,* Alechinsky's beautiful little head with green hair, over Turkey, has darkly shaded eyes, which give him a melancholy air. He has been watching too many of "the shows" Butor mentions, which emit from the bottomless evidently empty (pink) box over France, the TV. In *Page V,* the furious (yellow) face over Austria and the (gray) face opposite, plus, in Page VI all the animal faces with open jaws, brandishing claws and teeth, confronting one another—even both snakes curling along the sides of Italy hissing at each other—have surely provoked the sarcastic "very united family."

The last two lines of this stanza have nine-syllables, and the rhymes are noticeable throughout: *balkanique/ adriatique, armada/veranda,* but at the end are emphasized by proximity or occurrence in series: *traditions/ civilisations, mijote/belote,* and where there have already been four rhymes in [e], right at the end are four more in pairs of two. The relatively soft sounds of *mijote/belote,* both signifying neutral, inoffensive actions, contrast with the strong vowel sound [e] of of *antiquité* and *faculté,* with their heavily weighted meanings, which in turn, emphasized by the use of the same sound, contrast with the meanings of the basically idiotic *télé* and *variétés.* As before, the soft [ʃ] and [ʒ] and [u], the last, especially in the cases of its appearance in both syllables, *roucoule* and *loukoums,* somewhat balance the [k]'s. However, the harsh sound predominates,

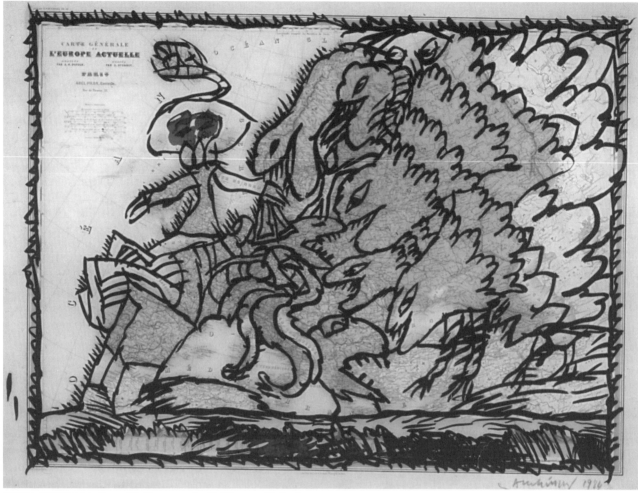

Pierre Alechinsky, *Page VI, Europe actuelle* **[Europe Today].**

in the rhymes, the final sound in *bec* and penultimate in *silex,* and the only repeated word, *caresser*—which, through its meaning and other soft sounds might be soothing elsewhere, but here among the plethora of [k]'s is assimilated as harsh. The foreign words are Spanish again; the only [ɲ]'s which are not Spanish are in *cygne* [swan] and *charogne* [carrion]: what a contrast!

Any humor here is clearly "black." The parallel between *faux-col* [false collar] and *faux frère* [traitor] recalls nineteenth-century celluloid collars, emblem of an economy-minded respectable bourgeoisie, while "traitors" are found in all social classes, including the bourgeoisie. The contrast between the odalisque's cooing and eating Turkish candies and the ghosts' and jackals' eating carrion is scarcely amusing. The whole is bitterly ironic: the faculty teach that the traditions are carefully maintained, but the traditions evoked must be seen as noxious. The reactions of the ironic "very united family" to endless wars is totally incongruous, and its being an accurate portrayal could seem humorous only to the confirmed cynic.

Every place-name Butor selects evokes present or recent conflict. That Tyrrhenian cat meows in front of the pigeon-holes of France, which are filled not only with tourists' gentle hills and the flamboyant, expensive entertainment of the Folies-Bergère, but here also with the "unemployed," whom Butor couples with the "certified," hinting that it is not only the nonskilled who cannot find work. Alechinsky's puppy-faced creature in *Page VI* appears blind, and the point that Butor's "swan of Albion" is still today concentrating on a successful naval battle of three hundred years ago seems wilful blindness. The exotic Spanish words, the "dueñas" and "infantas," recall a lost culture, that of the pretty pictures of the first stanza. The inclusion of "paellas" in that group implies that they, too, may be lost today. For half of this century, Spanish streets were filled with

armed soldiers under an oppressive regime, and although conditions are vastly improved now, at the time this poem was written still only the privileged few enjoyed elegant meals. Then, back at home in France, there is a dinner to "simmer," and the family engages either in passive watching of TV, frequently violent and almost invariably mindless, or else in that least productive of all pastimes, a card game. It seems that the "traditions" the "faculty" "watch over" include both waging war and behaving as if there were no war.

The whole of the poem is carefully built up to the climax. The stanzas gradually increase slightly in length, 35, 37, 43, and then 46 lines. In a similarly subtle way, the harmony also becomes with each stanza more audible. Until the pair of nine-syllable lines at the end, the rhythm is almost constant throughout. The harmonies shift only gradually. The consonants fluctuate: as the many p's of the first stanza diminish in the third and become rare in the last, [g]'s and especially [gr]'s are very present only in II and III, soft [ʃ]'s are noticeable after the first stanza, [ɲ]'s occur only in II and IV. The hard [k]'s are less frequent in II, though heard very often in all the others. The predominant i sounds of the beginning combine next with closed o's given importance at the ends of the lines, and then numerous [u]'s appear, but only in the last stanza does the closed [e] at the rhyme recur repeatedly. The number of rhymes per stanza varies only from three (I, II) to two sets of three rhyming words in a total of four rhymes (III) until the end where there are four rhymes, one recurring in two other end words and in the final four lines. Thus, there is variation among the stanzas, with the last clearly the most musical.

As noted stanza by stanza, this "counting-rhyme" could seem humorous only to an uninvolved alien from outer space, observing from a safe distance. There are light touches, plays on words, and incongruities, but the portrayals of individuals ranging from the pathetic—the editor—to the ridiculous—Adam,—from the heinous serpent of the suburbs and arms dealer to the uncaring soccer-match crowds and oblivious family could provoke laughter only in those who find aggression and bloodshed amusing.

Evidently the force of the poem is political. Two points concerning the whole require mention. First, that animals appear in three of the four stanzas: in I, the bulls who will be tormented by bullfighters; in II, the bull/tapir, mysterious Brittany beast, frog, and eagle, gull or crow; in IV, the cat, leopard, and jackal. While humans are slaughtering each other, none of these animals is hurting any other creature; the predators are not shown seeking their food, and the jackals are only performing their function as sanitary officers. Second, each stanza

contains a line stating the colors of the continent(s) until the fourth, which has two such lines. Thus, Da Gama was headed for the "yellow and white continent"; El Dorado was situated in the "red and yellow continents"; the "salting-tubs" where "nurselings" are sent are on the "red and black continent" and finally the "ghouls and jackals" are on the "yellow and black continent"; and the "traditions" so carefully guarded are those of "this red and white continent." The simplest explanation would be as a reflection of the colors of the artwork, those of the original maps. However, in the color reproduction of Page V, the original map is in black and white except for spaces filled in by Alechinsky in accord with his drawings, which only coincidentally match the forms of the map. Alternatively, the colors could represent human skin colors predominating in the geographical areas alluded to. However, the "red," generally identified with the native American Indian, regularly refutes this solution. Rather, I believe Butor selected the colors deliberately so they would exactly *not* fit those common generalizations, showing thus how inadequate, superficial, and incorrect such categorizations are.

The Alechinsky Pages reproduced above contributed together to Butor's ironic "very united family." We have seen particular sources in them for the historical sweep from antiquity through the Moorish invasions to World War I and the present. For the whole of the "traditions of our civilization going back to antiquity," we need to consider briefly the four remaining Pages reproduced in *Bordures*. *Page VII* is on an almost entirely obscured map of Egypt in four segments, the environs of the Red Sea, covered by a dark wild-eyed creature, a serpent, a large-beaked bird, and a beast with heads at both ends; the only legible legend is "Israel." *Page IX,* on a map of the "World Known to the Ancients," shows an angry faced, horselike head, a human face with shoulders, dressed in palm leaves, and a frame with the "Ethiopia" of the map showing through. *Page X* shows a plumed Gilles holding a book, drawn on a map of Europe; Lake Geneva—ah! The League of Nations!—is just visible. The book covers two inset city maps; the one of Marseilles, earliest Greek settlement in France, is identifiable. Although no individual elements are recognizable in Butor's text, the general force of these artworks unquestionably contributed to Butor's "traditions," so carefully taught by the "faculty." Indeed, I believe *Page VIII* could have generated the idea of the whole.

Whatever the plumed figure, Alexander, is doing to that limp human form, it is not beneficent. The face with the enormous spreading headdress that incorporates the map legend appears as the definition of this historical

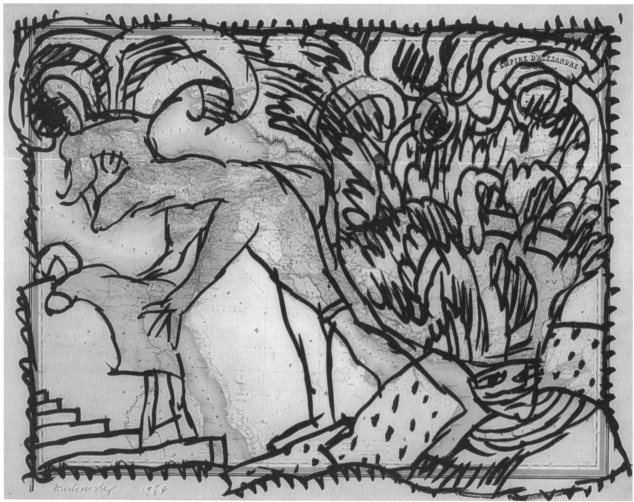

Pierre Alechinsky, *Page VIII, Empire d'Alexandre* **[The Empire of Alexander].**

figure as he has been passed on by the generations, taught as the epitome of the successful leader and warrior, who supposedly "wept because he had no more worlds to conquer." This is the image the "faculty" would be teaching, the tradition the "very united family" is watching over. This is a tradition of conquest, with accompanying massacres, rapes, pillage, looting, for no reason beyond self-aggrandizement. The various conflicts Butor mentions have often been supported by excuses of self-defense, *lebensraum,* and, throughout history, ethnic preferences. Alexander's slaughter could not even claim these pitiful excuses, nor would he have thought them necessary, even when his own troops were decimated by disease and famine. As emblem of the "traditions" so carefully upheld, he is an appalling example. Vividly portrayed by Alechinsky, Alexander served, I believe, as the fundamental overall source of Butor's poem.

Thus, the poetic techniques and the humor are minimal, but the political force is crystal clear. In the game of man's inhumanity to man, who will be "it" next?

ABC DE CORRESPONDANCE: DESSINS SUR FACTURES

Readers of Butor know to expect the unexpected and will not be surprised that this work, *ABC de Correspondance [ABC of Correspondence]*[154] is not a how-to book on the basics of letter-writing. The *ABC* contains two parts, the first, *Dessins sur factures [Drawings on Bills]*, composed of Alechinsky's nineteen drawings on turn-of-the-century bills, set every few pages among 104 brief disparate texts by Butor and Sicard, presented in the alphabetical order suggested by the title of the whole. The second part, *Grosses en Stock [Grosses in*

Stock], consists of Alechinsky's drawings on old letters, but they served not as inspiration for the text but rather as the object for analysis, for in it MB/MS meticulously examine Alechinsky's uses of elements of the support in expository dialogue.[155] Thus it is the first part, *Dessins sur factures,* that is the focus of my study here. Through these texts our society is exposed as dedicated to getting and spending and as cruelly divided between the have's and the have-not's. The work stands as demonstration of the solution: in the hands of Butor, Sicard, and Alechinsky the very essence of our commercial society—the bill—becomes art, which resists the acquisitive pressures surrounding us all.[156]

The creation of *Dessins* began when Alechinsky found some late nineteenth- and early twentieth-century bills and painted images on them. We know from the *Stances des mensualités* [*Stanzas of Monthly Payments*], *"La Méduse des chocolats"* [*The Medusa of the Chocolates*], and *Comptine en blanc et noir* [*Counting Rhyme in White and Black*] that Alechinsky is given to this sort of support. The process of composition of the text of *"Dessins"* is described in a prefatory note:

> *Michel S. reçoit un ensemble de factures ornées de peinture. Il écrit à Michel B. ses impressions de lecture. Il lui remet le tout à sa première visite. Avec une liste de cinquante-deux mots—deux fois autant qu'il y a de lettres à notre alphabet—qui l'ont marqué: termes trouvés ou seulement suscités. A charge pour Michel B. de commenter, de s'essayer, de poursuivre. Il commence à noter ses digressions sur un petit carnet, tout spécialement conçu pour recueillir les bribes de pensée lors des attentes d'avions, etc. Il s'amuse à son tour à proposer une liste égale à Michel S., en lui rendant l'ensemble concerné. Michel S. se met au travail aussitôt. A la fin de l'été, Michel B. et Michel S. échangent et comparent leurs divagations respectives. Ils décident de tout remettre indifféremment dans l'ordre alphabétique. (7)[157]*

In this work, then, in addition to the writers' collaboration with Alechinsky, there is an additional layer of collaboration between MS and MB. Further, as each writer is writing on the "support" of the other, the text mirrors in a way Alechinsky's use of the support of bills. There is no difficulty in distinguishing Alechinsky's drawings from the support, and in these texts, through close textual analysis, it would be possible to determine with some degree of certainty the author of each item. A few texts contain autobiographical references identifying them as Butor's. Many texts are composed of two fairly distinct developments and are probably the work of both authors. However, since Sicard was Butor's student and Butor would have made the final decision on material to be included, we here treat the whole as Butor's, only noting where pertinent any that are obviously Sicard's.[158]

Most of the works we have examined in this study demonstrate a one-to-one relationship between a given artwork and a particular text; only in the *Comptines* did we find a clear derivation of a text from three distinct artworks. The *Dessins* pose a challenge to organizing the analysis in that the 104 texts are not only unrelated to one another, but may take their inspiration from one, two, or any number of the artworks. Certainly the support, the collection of old bills, supplied the impetus for the work, and the writers have responded to it, but they have also clearly reacted to individual elements of both support and drawings. Thus we must outline the basic arrangements of both artworks and texts before pursuing our goal of seeing the connections and just how the resulting collaborations exhibit either harmony or humor or both within an overall political cast.

The placement of the nineteen artworks among the texts is random, other than the choice for the front cover of one of the six drawings representing the artist and probably also the selection of *Charronage* [*Cartwright*] (#18) for the end of *Dessins* (since the second Bon Marché bill, #19, is bound in with *Grosses*). The old bills of the support feature an elegant letterhead from a turn-of-the-century business, often with a detailed line drawing of the factory or store.[159] The two bills from the Bon Marché are widely separated; one drawing appears between the two from the Victor Magnant Construction and Cement Company, and the letterheads of each pair vary slightly. There are two for *Voitures de luxe* [*Deluxe Automobiles*], but from different companies, and separated by five other drawings. The other bills are all from different businesses; one is unidentifiable, completely painted over except for a *"quittance"* [receipt] stamp.[160]

From the bills we learn a great deal about one particular family, since almost all of the bills are directed to M. or Mme de La Bastide, some including *"à la Cour* [on the courtyard] via Allogny, Cher," and the *Caves girondines* [Girondine Cellars] in Bordeaux address them at the *"Ch^au de la Cour"* [Manor of the Courtyard]. The collection supplies details about the comfortable life of the couple: M. de La Bastide had an additional address in Chartres, and his piano tuner was also located there. He bought his stove in Limoges, his firearms in St. Etienne, his construction materials in Angoulême, and his light fixtures in Bourges; someone named Julien—probably a servant—ordered draperies made in Lyon. But the couple patronized the local grocery-tobacconist, the local branch of the Bon Marché,[161] bought their tools from the Degrenne Brothers' local branch of Moulin de Rochefort (whose home office was in the department Orne, in a town beginning Tinchebr—but its ending has been painted out by Al-

echinsky), and had their automobiles and carriages repaired locally. Thus for everyday needs, the de La Bastide family did business with the locals, but for special requirements they were free to go farther afield. We meet them often in the texts.

On this assortment of bills selected by Alechinsky as support, six of his drawings represent an artist at work; the others are unrelated to one another. Four reflect the nature of the business named in the letterhead and seven incorporate some element from the support.[162] Two are simply painted on the support: the ladder (#6) (reproduced here), with its "receipt" stamp, and *Chaudronnerie* [Boilerworks] (#10) in which the letterhead is barely visible behind the black swirls of the painted figure. The six which depict an artist at work are #1 and 4 (both reproduced here), plus #11, 12, 14, and 17. In each case, Alechinsky has framed the image of the letterhead and incorporated it in the artist's easel. We know Alechinsky is left-handed and prefers to paint standing up, and the figure in the drawing is standing in all but one, the *Cuisinières* [*Stoves*] (#4), where he is seated on a chest printed in the letterhead, and in four of the six he is painting with his left hand, holding his ink pot in the right.[163] These quasi–self-portraits underline the presence of this particular artist even as, throughout, Alechinsky's choice of support demonstrates the transformation of these otherwise useless out-of-date products of the commercial society into art, with genuine, permanent value.

The texts, the "ramblings" referred to in the prefatory note, are indeed ordered "indiscriminately" for the most part. However, the four A's, *"Adresse"* [Address], *"Affaires"* [Business], *"Articles"* and *"Artisanat"* [Manual Trade] provide an orientation of sorts to what follows (9–10). The first text seems to support the title, as it actually describes the process of addressing a letter, and there are other mentions of letters throughout, but they are few and far between. "Address" then also reveals the setting in time through the clothing of the character. The second text spells out the basic conflict between art and society, and we will examine it later. The fourth, "Manual Trade," shows in a humble workshop, among the ordinary tools, an engraving plate and artist's brushes: art is omnipresent regardless of the social status of the character. The third text, "Articles," serves very well as an introduction to the whole:

> *La langue nous apprend qu'ils sont définis ou indéfinis. Mais il existe bien d'autres articles: de cuisine, de foire, de ménage, de pêche. . . . Tous en rapport avec le commerce! Les dessins sont-ils un commerce particulier? Qu'est-ce qui s'échange? Peut-être le bord et le centre, le dessus et le dessous, la figure de droite contre celle de gauche, la matière contre le support et le motif contre la signature. La peinture a maintenant plus besoin d'articles que de*

> *thèmes ou même de mythes. Car l'article semble la légèreté même, l'asssentiment à tous nos artifices. Peindre, ou dessiner, en laissant se rejoindre une devanture, une machine à écrire, une grand-rue, une trompette, un valet sur une échelle, une réserve et un trou de nez. . . . La liste brute serait la notion clef du dessin et non plus seulement la forme. Bref, ces articles nous retiendront tous, et peut-être jusqu'à l'énigmatique dernier: l'article de la mort. (10).*[164]

Here are previews of the businesses whose bills we will see and mentions of elements visible in the artworks, all within the primary issue of the place of art in the commercial society. A clear indication of the structure of the work is given in the "raw *list,*" that the list will be the "key notion" here of the drawing, and as we look at the whole work we see that the list is fundamental to the individual texts as well, "and no longer only the *form.*" At least a short list appears in the majority of the 104 texts, and the alphabetical list of course underlies the whole.

"Articles" evidently presents the main political force of this work, and in addition illustrates Butor's use of humor, in the incongruities inherent in the list of items that can be juxtaposed—many of which are seen in Alechinsky's artworks—and, on the other hand, harmony, with the parallel constructions and the repetitions of "article." A suggested additional repetition of the word "article" occurs, hidden in the last words, "at the point of death," which is often expressed by the Latin phrase *in articulo mortis*. The last Z text, *"Zone"* [Shantytown],[165] echoes that phrase, and we may be sure this text was not "indiscriminately" placed any more than the four A's. It begins, *"A la fin, que ne serais-je las d'un tel monde ancien! Nous en avons assez de vivre dans l'antiquité romaine, franque et moderne. La question post."* [Finally, how weary I am of such an ancient world! We have had enough of living in Roman, Frankish or modern antiquity. The question of post] (50). The text continues with recalls of a number of the preceding alphabetical texts, lush with elegant material goods quite unattainable by those living in the Zone. As in the celebrated undefinable or at least inadequately defined term, "postmodernism," "the question of 'post,'" is repeated three times. The world of the bills is turn of the century, "modern," and the *Dessins sur factures* are therefore chronologically post-modern. Inevitably, other expressions with "post" come to mind: postmortem and posthumous, which provoke a recall of the "Articles" at the beginning, of that "article of death," and we have come full circle.

Beyond the alphabetical order of a word selected as title, the arrangement of the texts assures variety of at least three aspects: form (description, narration, monologue, dialogue, mini-essay, a combination of these),

sources of the text (one or more of Alechinsky's art-works), and tone (humorous, political, both or neither). Twice brief sequences of the same form occur, first of five descriptions and then of six narratives,[166] and there are other sequences of three or two texts in the same basic form, but always varying so much from one another in source and tone as to appear quite different. The structure of the whole is thus that of a "raw list," as we were told in "Articles," the 104 alphabetical texts arranged just as Butor said, "indiscriminately," exception made for the initial and final items, with the only constant the variation from one to the next.

My focus in this study on the political, reinforced by harmony and humor, would seem to be easily shown, as many texts exhibit either harmony or humor or both within the overall political cast. But my overarching goal is to understand just what Butor found in an artwork that inspired his texts, and it would be to miss a great deal simply to say that the support of old bills evoked them. Certainly the support supplied the impetus for the whole, and the writers have responded to it, but they have also clearly reacted to individual elements of both support and drawings.

The average number of texts recognizably provoked by each artwork is six. The *Typewriter* (# 9) contributed to only three, but the local grocery store and tobacconist, *Millet-Armand* (#15), at least nine. Its letterhead mentions everything from ready-made clothing to gasoline, while the bill legibly lists household items from cheese to stove polish; the *"huile"* [oil] and *"vinaigre"* [vinegar] included in the list have each provoked a text with that title, and in addition turn up in several other different texts. Similarly, the concept of a department store in the two Bon Marché bills has generated many texts. For example, "Louvre" is made up of displays directed toward various animals, as if lions were prospective consumers, too. The relationship of text to artwork is not at all one-to-one—a point most easily seen in the numerous texts listing the businesses that produced the various bills—and the writers have utilized elements from any artwork wherever they pleased.

I will look at eight of the artworks, selected as examples of their particularly clear use as source for texts that illustrate our focus on the political supported by harmony or humor. Artworks not studied here are either reproduced elsewhere or else did not provoke so many texts answering our interests. The reader is enthusiastically encouraged to read the whole work to discover a myriad of resonances and associations that cannot be intimated here.[167]

My analysis consists of two parts, the first concerning layers of society, treated in a great many of the texts. Six texts set up contrasts between the rich and the poor,

seven more treat class distinctions, one a fable warning us to stay far away from *"les grands"* [the great]. Seventeen address the conditions of workers. In his *Improvisations on Balzac,* Butor has studied the class structure that Balzac portrayed in his carefully distinguished layers of society as it was half a century or so prior to our bills, a study that reveals the complexities of Balzac's view, with its depiction of individuals moving up, or trying to move up, or trying not to move down on the social ladder and his "geniuses" who fit nowhere.[168] The society of *Dessins* cannot be so clearly delineated from the 104 texts populated almost entirely by anonymous characters. Nevertheless, three discrete categories are identifiable: (1) the workers, (2) a middle group of salesmen, salaried employees, middle managers, provincial proprietors of small businesses, and (3) the rich, owners of big businesses and bankers. In this first part I will examine two artworks that provoked texts on workers (#6, *The Ladder* and #4, *Stoves*), continue with one (#19, *Bon Marché II*) that inspired texts on salesmen, salaried employees, and middle managers, plus one (#7, *Pianos*) that engendered additional texts on the middle group but also some on the wealthy, and then two (#15, *Millet-Armand* and #8, *Girondine Cellars*) that generated other texts on the wealthy and the pseudo-aristocracy.

The second part of this analysis is an approach to the whole through two contrasting artworks: (#18, *Cartwright* and #1, *Lighting. Cartwright* led to despairing texts on the miserable aspects of our society, not necessarily related to class structure, and *Lighting* is one of the six artworks representing the artist, who, like Balzac's "geniuses," cannot be fixed in any class. There are far fewer texts on the general problems of the world than on the artist, for exactly half of the texts, fifty-two, mention artists' materials, tools, techniques, an artist, or art itself. However, the *Cartwright* texts are important examples of Butor's political concerns and must be recognized in an overview of the whole. The *Lighting* texts are full of joy and hope, but we need not think, given the problems, that the solution will be easy.

Part I: Social Classes

Workers

The first artwork, #6 (The Ladder), retains of the support only the "receipt" stamp. We have already seen a reflection of this drawing in "Articles," the "manservant on a ladder." Here the unrelieved black background generated for MB/MS the work of chimney sweeps, carried out in total darkness, teetering on a ladder. Comparable to the proverbial salt mine in the danger of falling, the polluted air, and the hideously

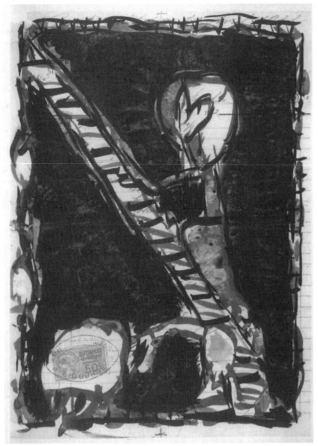

Pierre Alechinsky, The Ladder.

chacune de leurs traces émettait au bout de quelques heures de longues phrases sinueuses racontant les rêves du responsable, et elle a décidé d'en faire un livre, le plus grand du monde, qu'elle et Roméo offriront à leurs parents le jour de leur mariage où tous les petits ramoneurs tiendront des torches et lanceront des poignées d'escarbilles. (15)[171]

The three very long sentences, the repetitions and the alliterations endow the text with harmony. The reversal of the tragic characters, become an ordinary engaged couple who are on good terms with their parents and kind to unfortunate little children, is mildly humorous in its contrast with the familiar tale. But the suggested conditions of the workers are not at all humorous. Three times referred to as "little," these chimney sweeps are definitely children, and there are a large number of them, since there is one on every step of the ladder. Of course their hands are covered with soot and thus can easily leave handprints on Juliet's sheet. Their hands, too, are "often moist," implying that the inside of the chimneys is perhaps humid, clearly unhealthy. Their way of celebrating the wedding is to "carry torches," not necessarily disagreeable, and appropriate to their work, but they toss not flowers, but cinders, since that is all they have to offer. Their relief from this dreadful life can only be in their dreams, so many that the book Juliet will make of them is "the biggest in the world." The contrast with Romeo and Juliet is especially vivid in that Juliet was a child, too, only fourteen, and Romeo probably not much older. Yet they pursued their dreams in their lives, unconstrained by any need to perform manual labor. (That they made a colossal mess of it is not pertinent in this revised version.) The chimney sweeps still have to scramble up the chimney to receive Romeo's benevolently offered snacks—and rather than "little salt crackers," would not bread have been more appropriate? Ah, the uninformed charity of the nobility! With the creation of the "biggest book" Juliet serves as patron for the young dreaming artists, but no matter how thoughtful these aristocratic children may be, those other children, the chimney sweeps, will still have to clamber in the chimneys to earn their skimpy living.

Child labor in the chimneys is the worst of the workers' conditions depicted in the texts, but many others appear. For example, we learn in "Xylocope" (which is the carpenter bee) that not only are the workers miserable, but the next layer of management is, too. Concerned that the bees have infested the shop and are destroying the tools and the work in wood before the workers can finish, in a monologue a worker tells us: *"Un de ces jours cela s'écroulera, mais le contremaître ne veut rien savoir. Peut-être qu'il l'attend, qu'il l'espère, par haine du patron ou de nous tous, comment*

cramped working conditions, chimney sweeping was the labor of children. In *"Timbre"* [Stamp] we learn that the one-centime postage stamp depicts the *"ramoneur avec son échelle et son hérisson"* [chimney sweep with his ladder and his flue-brush] (40), the miniscule value of the stamp reflecting the value society accords these children and their terrifying work—even the artist is accorded a one-franc stamp![169] In *"Warrant"* [Warehouse] are stored twenty-three chimney sweeps' ladders, without a hint of what happened to their owners (45).[170]

Echelle

Sur chaque barreau un petit ramoneur jusqu'au balcon de Juliette qui leur ouvre sa fenêtre et les conduit jusqu'à son lit sur lequel elle a étendu un grand drap blanc où chacun doit laisser les marques de ses deux mains avant de grimper par la cheminée jusqu'au toit où Roméo les attend pour leur offrir un chocolat chaud ou un jus d'orange bien frais au choix avec petits gâteaux salés. Quand un drap est rempli, Juliette le met à sécher en l'accrochant aux clous du mur, car les mains des petits ramoneurs sont souvent humides, et le remplace par un propre où les suivants impriment les leurs. Elle avait observé que

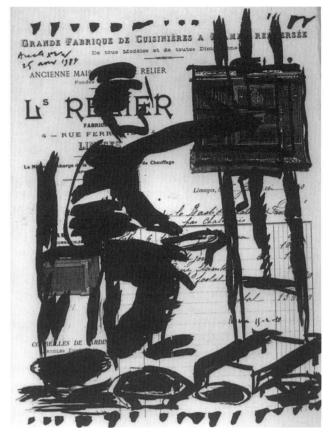

Pierre Alechinsky, *Grande fabrique de cuisinières* **[Big Stove Factory].**

savoir?" [One of these days it will collapse, but the foreman does not want to know anything about it. Maybe he is waiting for that, hoping for it, through hatred of the boss or all of us, how do we know?] (46). As the floor has given way under one of the workers and production is affected, we can be sure the boss will not be pleased.

The next artwork provoked part of a text on the daily life of the factory worker. In this text, the reference to "stoves with inverted flame" indicates the source of the text in this artwork, but the "deluxe automobiles," also made in factories, would derive from *Deluxe Automobiles I* (Artwork #11) and *II* (Artwork #17).

Manufacture

Serrés sur notre banc sous la verrière, il est bien rare que nous puissions lever les yeux vers les nuages entre deux interventions sur les objets que le tapis roulant fait défiler si rapidement devant nous, toujours les mêmes du matin au soir, toujours nouveaux d'un jour sur l'autre. Hier c'était un coup de marteau qu'il fallait donner sur les portes des cuisinières à flamme renversée, avant-hier un tour de vis pour les accoudoirs des voitures de luxe. En pointant le matin nous trouvons les outils nécessaires, mais nous ne devinons leur usage précis que lorsque notre

contremaître a fait le premier geste sur le premier exemplaire avant de monter au mirador avec ses jumelles et son revolver. Ce que nous redoutons le plus, ce sont les pinceaux et les couleurs; certes, il arrive qu'il nous faille peindre des boîtes à gants ou à chapeaux, des chaises, même des affiches, mais c'est lorsque commencent à défiler les toiles que la sueur se met à ruisseler sur notre échine.(28)[172]

This text builds its details to a conclusion that makes us shudder with its black humor. The workers are physically squeezed, temporally rushed, trapped in monotony or constant change, dealing with objects meant for the affluent, kept in ignorance until the power figure divulges a scrap of information and promptly becomes an armed guard posted in that symbol of the prison. The reader coasts along in the Chaplinlike atmosphere, and then the foreman draws his revolver. The workmen are willing—and surely painting posters would not be easy at all—but their fear of painting canvases, a task they are either not prepared to perform or do not have time to think through, as an artist must, is perfectly reasonable. The workers' situation is desperate; it seems that if they do not paint the canvases, the foreman will shoot them. The image of inhuman treatment of the innocent oppressed transcends the humor. Many other types of workers appear in the texts, some of whom we will see derived from other artworks.

Salaried Employees, Salesmen, Bosses, and Middle Managers

The contrast is not so simple as between poor workers and rich bankers, for just as the texts mention different species of have-not's, they treat different layers of the have's. Some of these actually work for a living: the salesman, the accountant, the managers, the proprietors of provincial businesses, all hot in the pursuit of wealth by whatever means, ethical or not, and somehow driven by dreams of material gain.

Bills from the Bon Marché, the huge "Mother House" in Paris (Artwork #5, *Bon Marché I* and Artwork #19, *Bon Marché II*) have provoked treatment of the store's employees, better off than the manual laborers or domestic servants, but still subject to the dictates of bosses and very aware of what they are incapable of acquiring. Seven of the 104 texts mention keeping accounts of what is bought and sold; for example, we see the accountant in *"Zébrure"* [Stripe] relieving the cramps in his fingers by drawing zeros, which become money as he writes up *"factures de rêve"* [dream bills] (49) to himself for silk, Persian carpets, increasingly large containers of wine, curtains, and, for his cars, accessories made *"de nacre et d'écaille"* [of mother-of-pearl and tortoise shell]. He stamps his hand-

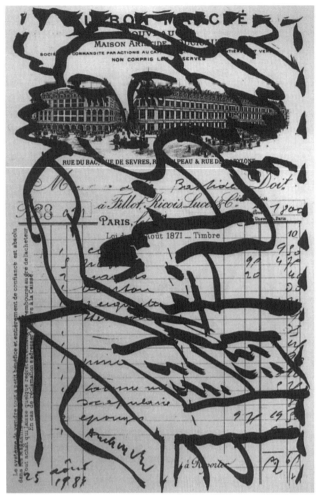

Pierre Alechinsky, *Bon Marché II.*

ther, both clearly show the *"Maison Aristide . . . au capital,"* which *Bon Marché I* (#5) almost reveals through Alechinsky's inky additions as a capital of *"vingt millions"* [twenty million], and both Bon Marché bills state, *"Non compris les réserves"* [Not including the reserves].[173] The drawings are of course different, but both are of women.

This text derived from the Bon Marché artworks combines humor and politics in an indivisible form.

Suite

 Ce que nous apprécions, c'est le client fidèle. Il faut qu'il revienne en nos magasins. C'est pourquoi nous n'hésitons pas, dans les cas prometteurs, à faire un trou au beau milieu d'une pièce d'étoffe longue et mûrement choisie, pour être sûr que l'acheteuse reviendra se la faire changer. Et ne croyez pas la pièce perdue pour autant. L'emplacement du défaut a été soigneusement choisi par le vendeur-troueur expert juste au moment de l'emballage, de telle sorte que nous puissions la découper pour le prêt-à-porter. En général cela procure une seconde vente, nettement plus importante. Nous attachons une grande valeur au physique, à la tenue, à l'entregent, au bagout de nos employés dans certains rayons stratégiques, la ganterie, par exemple. Et il y a certains domaines qu'un esprit superficiel jugerait exclusivement masculins, où une vendeuse fait merveille parmi ses confrères. Il en est ainsi des armes à feu. Il lui faut un aspect de Diane chasseresse. Son domaine est décoré de croissants de lune, d'arcs et de carquois, de ramures de cerfs. Elles doivent toujours être capables de donner des leçons particulières dans nos stands ou à domicile (croyez bien qu'elles savent se défendre), aussi bien à la campagne qu'en ville. Elles ne nous restent en général pas très longtemps et la maison leur offre un trousseau complet pour leurs noces; en effet, leurs maris reviennent souvent rôder parmi nos comptoirs pour leur comparer celles qui les remplacent. (38)[174]

The figures in both *Bon Marché* drawings, *I* (#5) and *II* (#19), could have contributed to "Sequence" in that both women appear naive and would be unlikely to notice the "expert hole-maker" at work and certainly not suspect the Bon Marché of cheating them. The bill from the gun factory (Artwork #12) would have inspired that detail in this text, but the descriptions of the lust for profit do not have a source there, and this two-part fantasy is developed rather from the general concept of a department store as the quintessence of greed.[175]

The humor is immediately apparent in the contrast between the "faithful customer" and the deliberately deceptive practices of the store management. "We do not hesitate," the manager says, as if about to proclaim some act of great bravery, and the careful details, the time spent making a selection, the cunning placement of the hole by an "expert," the planning for a "definitely bigger sale" all strengthen the contrast between the

iwork *"Payable dès la réception"* [Payable upon receipt], a variant of the stamped phrase seen in *Bon Marché I* (#5), and then tears it up and goes back to work.

In addition, the Bon Marché artworks have generated texts portraying managers and bosses engaging in rampantly unethical practices. The department store, exemplar of the distinction between rich and poor, has thus served as fertile ground for Butor's imagination, and as an inexhaustible source of humor.

The letterhead of *Bon Marché I* (#5) (reproduced in *Travaux)* differs slightly from this one: the pictures of the store, easily recognizable today, show minute changes in the people dispersed in the streets, just visible through Alechinsky's drawings. More important for my purposes, the instructions printed down the side regarding return of merchandise are directed to separate groups: the first to the provincial ladies, and the second to the Parisians; the Bon Marché exhibited a concern for its dual market worthy of marketing experts today. Fur-

"faithful customer" and the shocking operational principles of the House, openly, even proudly, admitted. The incongruity of a store's deliberately spoiling its own merchandise in order to produce more and larger sales is already laughable, but the management's unashamed use of women as bait becomes harsher satire: these policies could and do exist in the real world. We might never have thought anything unfavorable about the placement of a saleswoman in the glove department, where any salesperson would naturally and usefully be stroking the fingers of glove-buyers, but in this context of duplicity we have to reconsider. The rhetorical device compelling our agreement, that only a "superficial mind" could think men are the ones who must sell firearms, is so obvious as to provoke a smile; the technique is a commonplace for salesmen: "Smart people buy . . . ," "Good cooks use. . . ." *Caveat emptor.* There is further incongruity in the classic Diana the huntress, goddess of the moon, here seen firing graceless guns. The salesgirls' job description as outlined here includes not only skill in handling firearms but also in teaching at any location, always at the employee's risk. The fringe benefit of a trousseau is ironic, a pathetically inadequate compensation. Finally, the parallel between the ordinary shopper who gets home to find a hole in the fabric she just bought and the wife-hunter in the gun department results in a painful truth: the salesgirls are nothing but merchandise to the store managers. The ordinary shopper is expected to spend even more when she returns to exchange her purchase; the new husband returns to make his comparisons, and the implication is that he, too, might decide to exchange his wife, no doubt along with a "definitely bigger sale." Thus the humorous presentation, in the voice of the store's personnel manager, reveals toward customer and employee alike grossly inhumane policies.

The instructions printed on the letterhead have also provoked several texts. *Ombre* [Shadow] cites directly: *"La Maison ne répond ni des avaries, ni des manquants en cours de route'"* [The House is responsible neither for damage nor items lost en route], and the text adds *"comme ombre annonciatrice de la perte"* [like a foreboding shadow of loss] (31). Given the routinely dishonest practices of this House, anyone might think twice before ordering anything delivered—the House could simply claim it had disappeared, and the customer still would have to pay for it. The following text uses those instructions to make its political point, as the manager broadcasts the fine qualities of the business and reveals his attitude toward the customers.

Kyrielle
 Les magasins les plus vastes du monde, c'est vite dit; essayez donc de compter les fenêtres de ceux-ci. Et puis,

vous savez, le système de vendre à petit bénéfice et entièrement de confiance y est absolu. Tout achat qui laisse quelque regret y est remboursé au gré de l'acheteur. En cas de réclamation, il faut toujours, et cela suffit, s'adresser à la caisse. Ah, si vous êtes en province, vous êtes instamment prié de toujours les aviser des retours de marchandises que vous pourriez avoir à leur faire, et ils vous recommandent de bien vouloir leur indiquer très exactement votre nom et votre adresse sur l'enveloppe des paquets réexpédiés soit par poste soit par chemin de fer. Il y en a tant! Il y a tant de clients avec tant de lubies! Vous devriez voir leur fichier, leurs tapis roulants de redistribution, ces armées de camions à remorque repartant dans toutes les directions acclamés par les ménagères des villages qu'ils traversent, et la porte de leurs caves blindées où. dit-on, des locomotives électriques tirent des wagons de monnaies que la Banque de France leur envie. (26)[176]

We see the windows in the letterhead: there are indeed a great many. In addition, the two direct citations from the letterheads clearly show their immediate influence: "the system of selling at small profit . . . speak to the cashier" from this *Bon Marché II* (#19), and the other, "you are urgently requested . . . or by railroad," which is taken from *Bon Marché I* (#5). The speaker is explaining the system to an outsider, perhaps a manager from another department store. His attitude toward the customers becomes increasingly clear. The force of the text is found in the part with no visible source in the artwork. From the chatty, "you know," through the clarification that these instructions are for the provincials (not so easily able to run into Paris to make their exchanges), the contemptuous reference to the "whims" of the customers, there is a gradual acceleration. Finally, the last sentence, with its "armies" of delivery trucks and "cheering housewives"—a vivid evocation of real armies driving through liberated towns—leads us to those railroad cars filled with cash, image of the frightening power of the Bon Marché.[177]

These texts present the managers of the central "House" of the Bon Marché enunciating their disgusting policies. The great "Houses" require salesmen, and seven of the texts treat what we today call deceptive advertising. Salesmen for several products are heard, putting this sort of policy into practice and often providing humor. The following text derives primarily from *Stoves* (#4, reproduced above), with reflections of the two *Deluxe Automobile* artworks (#11 and #17), but the speaker would fit right in at the Bon Marché:

Pratique
 Notre nouvelle cuisinière à flamme renversée devrait vous donner toute satisfaction. Vos patrons vous féliciteront, vos amies vous envieront. Non seulement c'est la propreté, la souplesse de réglage, l'économie, mais c'est aussi une sorte de gaieté qui irradie dans tout le ménage.

Les relations sont facilitées: autres conversations, autres perspectives. Si vous êtes automobiliste, et c'est un sport qui se développe dans toutes les classes de la société, gagnant de plus en plus le sexe aimable, vous apprécierez nos carrosseries transparentes, avec nos gammes de trompe-l'œil qui permettent lors des croisements ou doublages les méprises les plus amusantes et constituent de véritables pièges à voleurs, lesquels, après quelques déconvenues mémorables qui les couvrent de ridicule auprès de leurs collègues qui en ont vent (et l'on sait comme les nouvelles se propagent vite dans ce milieu), laissent généralement tranquilles toutes les voitures du quartier. (34)[178]

This satire on advertising, in which the product is touted as providing all possible benefits, that is, "gaity for the whole household" initially depends on hyperbole. When the transparent car bodies are introduced, since the salesman is ready to push any product, the humor shifts to litotes: "the most amusing misunderstandings," and the thieves "covered by ridicule among their colleagues." The background of an earlier time when driving was considered a sport and women as "the lovable sex" evokes images of women in motoring costumes, their broad-brimmed hats secured by veils tied under the chin. The contrasts of these genteel and sedate figures with an automobile body that has become transparent, and of the surreal automobiles with the matter-of-fact statement of supposedly common knowledge combine to make multifaceted humor.

I cite one additional text to demonstrate the lengths to which a salesman will go to earn his commission. This text derives not from the letterhead, but from the drawing; the woman is apparently a satisfied customer, with her hand over her heart as she pens her letter of gratitude.

Xiphoïde[179]

Au rayon des bustiers vous apprécierez nos articles finement matelassés avec le dessin spécial que nous avons mis au point pour les baleines. Comment en effet allier le confort à la minceur de la taille de plus en plus de rigueur en ce passage au nouveau siècle? Il fallait absolument dégager la région du coeur, tout en maintenant fermement les côtes. Désormais vous palpiterez à l'aise. Votre main pourra le sentir ou naturellement toute autre autorisée. Certaines de mos clientes, sujettes autrefois à des vapeurs fréquentes, nous ont écrit leur reconnaissance. Leurs lettres sont à la disposition de quiconque à nos bureaux. Nos ateliers travaillent à l'élaboration d'un tube acoustique incorporé qui permettra d'amplifier à volonté les vibrations. Il est des circonstances où les mots font défaut. (45)[180]

It may be that to appreciate completely this parody of a sales pitch one would have at least to have tried on a long-line strapless bra, which would normally exclude some readers. For their benefit, permit me to say that a "comfortable long-line strapless brassiere" is as much an oxymoron as "military intelligence," that is, it cannot exist, even "finely padded" and patterned on the needs of whales—a touch perhaps inspired by the former use of whalebone for corsets. The allusions to the turn of the century and to those suffering from the "vapors" summon up Godey's *Ladies Book,* together with the opinion of today's medical world on the damage done by the foundation garments intended to create those wasp waists. The underlying force of the quest for fashion over good health, however, is in this text undercut by the humor. Those other hands that are "authorized" to check on the palpitations and the "acoustic tube" to amplify any irregular thumpings are farcical. As for the "available" letters from grateful clients, they clinch the satire: truth is not to be found in the words of a salesman. This is also one of the few letters mentioned in *Dessins sur factures* since the envelope was prepared in "Address"; the title of the work itself could be seen as an example of deceptive advertising. We will hear from more salesmen as we proceed, as they are excellent sources of humor along with their political function of providing social critique of consumerism.

The next artwork contains the word "correspondants" in the letterhead of a piano store. That word, indicating that Genet Brothers are part of a larger and infinitely more important establishment, has provoked texts referring to the "Mother House" and its grand superiority over provincial branches. (We will consider texts derived from the piano under the third category, the wealthy.)

Correspondants

On trouve des correspondants littéraires, non pas ceux qui vous répondent, qui ont l'obligeance de vous renvoyer la balle, mais ceux qui sont dépositaires des périodiques à la mode, et qu'on suit fidèlement. Puis viennent les correspondants des divines "Maisons," autrement plus sérieux, mais qui sont un peu les avatars des premiers —car ce qui importe, c'est la Marque, le Nom—et vous toisent avec de grands yeux profonds. Ils s'en font les témoins, les disciples: c'est le nec plus ultra de ce qui se fait en France, en Europe, au Monde. Ce phénomène de correspondant, s'interroge le philosophe, ne serait-il pas un retour du césarisme? La capitale impériale propagée jusqu'aux limes des agglomérations contadines. . . . Le correspondant est le délégué direct, le substitut, le suppôt de l'objet fétichisé qu'il représente, dans tous ses prestiges, sa prestance unique. Quand un correspondant vient à mourir, on l'enterre sans grande pompe, comme pris en défaut d'agir. Qui sait exactement où est la Maison-Mère? Qui la connaît? Si seulement on avait encore un signe. . . . Ce qui est sûr, c'est qu'elle existe, que jadis, une fois, on a eu cet

Pierre Alechinsky, *Piano*

objet si précieux! Même si nos articles ne portent plus ces marques légendaires—on ne pourrait pas, ce serait trop coûteux, ils ne parviendraient pas jusqu'à nous—on s'en approche tellement, on les a construits si sensiblement de la même manière, que c'est cela—presque. (12)[181]

The speaker is a provincial who has to deal with representatives from the central office. He recognizes that, despite their disdain for the locals, these individuals have no importance in themselves; even their death is scarcely acknowledged, as if it were due to their negligence. However, the speaker retains an awe for that main office that is almost religious, as he speaks of "witnesses, disciples" and sighs, "If only we still had a sign!" The conviction of preeminence held by some to be exclusively and inarguably theirs is often confronted in *Dessins sur factures.* This satirical text echoes Butor's ongoing struggle for decentralization, for recognition of the value of activities that occur outside Paris; his regular publications with small provincial presses demonstrate his commitment. The speaker is resigned to inadequate approximation and to the chasm separating the humble from the great; that is the way it is.

The concept of the Mother House, the House "with a capital letter," reappears in this text, which is rich in harmonies.

Maison

La maison résonne de pain grillé, de glouglous d'évier, de tentures qu'on tire, de draps qu'on repousse, de lèvres et de paupières qu'on retrousse, d'yeux qu'on ouvre un peu plus ou qu'on trouve dans les tasses du matin, de rêves qui se tissent, de cheveux qu'on tresse, de bobos qu'on panse, de projets qu'on pense, de parfums qui revigorent, de soucis qu'on ballotte, d'espoirs qu'on nourrit et transporte vers ces autres Maisons, à majuscules et rallonges, de ciment, de chaux, de ferronnerie, d'orfèvrerie, de tabac et de serrurerie, plus dures que le granit et l'acier de leurs machines, qui crissent, mugissent, rugissent, gémissent, posent, imposent, explosent, exposent une fois l'an, qui nous font craindre mille morts—sur quoi les Maisons ne font pas de crédit! (27–28)[182]

This homey house, comfortable, with children whose hair has to be braided and various bandaids adjusted, is typical of an ordinary, middle-class family, full of love, hope, and dreams. The contrast between it and the House that is a department store is here supported by the dual structure, the rhythms, the rhymes, and the harmony. In the first part the unremitting parallels are filled with soothing [u]'s, alliterations in *t, p, m,* many internal *s*'s and the *b*'s of *bobo,* a nursery word, and *ballotte,* the rhyme *repousse/retrousse* and the identity rhyme of the homonyms *pense/panse.* In the second part, the House "with a capital letter," the relatives and complements disappear, leaving the barest of items for the lists: first the six which are "harder than granite," contain three rhymes in *-erie* among the references to businesses we now know very well. The hard [gr] of *granit* makes its first appearance since *grillé* in the opening. In the opening were also the onomatopoetic *glouglous,* but in between the only hard [g] occurred internally in *revigorent.* Hard [k] of course appears throughout, without emphasis, in the *qui* or *que,* but then only in *tabac* and *crissent* before coming to the fore in *craindre* and *crédit.* The rhyming verbs, two series of four, in *-iss* and [oz] offer a complex interweaving of sounds. In the first occurs the repeated [y] previously heard only in *tentures* at the beginning, before its meaningful redoubling in *majuscules* and then the pointed *dures.* The superrich rhymes of the two verbs in [yʒis] echo the *dures* even as they hiss. The three [ʒ]'s will toughen up to [z]'s in the second rhyming sequence, in which the prefixes and the one *l* make all the difference. Then, with three tolling nasal *o*'s and the alliterative *m*'s the final irony is emphasized.[183] The contrast between the happy atmosphere of the home, with its living beings, and the threatening, unfeeling concrete and metals of the House is thus strongly supported by the harmonies.

The Wealthy

From the pitiful resignation of the provincial in "Correspondants" and the musical setting of the contrast between a home and a House of business in "House," I turn now to texts portraying those with plenty of money. Here are the owners of big Parisian businesses and banks, already wealthy but still engaged in the quest for accumulating more and more. Then there are the established have's who apparently have no need to acquire money, but who actively spend it. I have cited texts on the middle class, derived from the word "correspondants" on the support of *Genet frères Piano* (#7). Now I examine a text derived from the piano shown in that support, where the subject is the piano's owners, who would possess at least a modicum of wealth. The drawing depicts a well-off student with her private instructor—who will be paid, although probably not adequately recompensed for the damage done to his musical soul.

A piano keyboard is mentioned briefly in a number of texts,[184] for example, in *"Entrepôt"* [Storage] (a bored workman has mounted *"un clavier de piano sur le capot d'une berline"* [a piano keyboard on the hood of a sedan] (15), but the piano itself is the main subject in this text:

Piano

De son front haut comme une façade, le jeune maître de musique scande la retombée des doigts de Madame de La Bastide qui a vraiment peu de dons pour cet instrument. Quelques disques Pathé pourraient aisément suppléer, airs de valse ou d'opéra, à cette sonate de massacre. Dans la vitrine des Frères Genet, trônent encore les carcasses vides d'un Pleyel et d'un Gaveau, gigantesques comme des orgues, ornés comme des reposoirs, devant lesquels les promeneurs furtivement s'inclinent. Dans l'attirail des objets usuels, au XIXe siècle, le piano occupait une place de choix, comme pour nous l'avion à réaction, la planche à voile ou l'ordinateur. Il symbolise tout l'espace, mais sécable, décomposable, chaque touche élément d'une chaîne laborieuse, le morceau devenant accumulation de notes comme d'un capital. Au début du siècle, le piano rechigne, claudique un peu, on ne le veut plus vraiment aussi sensible (finis les Clair de lune!), il se fait mécanique, automate qui se parodie pour les fêtes et foires. On entend venir de l'office quelques duos de saxophone et de trompette avant que ne résonne sur le gramophone du bistrot "Some of These Days." (34)[185]

Mme de La Bastide is treated satirically: a recording would be preferable to her playing. Idle passersby are called "furtive" in their genuflections before the semblance of an Altar of Repose; "furtive" lest someone see their devotion to what the "empty carcasses" represent,

that is, "enthroned" wealth. The simile recalls a much earlier world when people from all layers of society would salute the resting place of the Blessed Sacrament during its absence from the altar between Good Friday and Easter; now the symbols of wealth have taken its place. The contrast between the honor given the piano in the nineteenth century and the items we honor today emphasizes the perceived need for more and more wealth: the computer is probably as commonly present in homes today as the piano used to be, but not everyone even moderately well-off owns a sailboard and certainly not a jet plane. The summary of the piano as "an accumulation of notes as of capital" is telling. It is seen as a whole symbolizing everything but still "each key an element in a laborious chain": many different workers have toiled individually to make the instruments that produce the music. The history of the popularity of the piano is not at all satirical, then, but accurate: out with Debussy, in with honky-tonk. The implication is clear that "saxophone and trumpet duets" would not appeal to Mme de la Bastide. The song is just the one which so moved Roquentin in *La Nausée,* in his struggle with the meaninglessness of existence.

The next artwork, *Millet-Armand Bureau de tabac* [*Tobacconist*], has provoked a number of texts treating the rich, some derived from the letterhead,[186] and many from the legible list of purchases on the bill. All but one of the texts drawn from this artwork see the figure as the wealthy Mme de la Bastide, in her fur-collared coat. One text, "Impression," describes the figure in the drawing as *"la tenancière, très digne, en chapeau et voilette, derrière son comptoir épicier"* [the manager, very proper, in hat and little veil, behind her grocery counter] (22). We can see the "little veil" in the letterhead lines, but most of the texts do not utilize this figure as a shopkeeper, a working woman or even proprietress whom we do not otherwise know. The alternate reading of the figure contributes to the dichotomy presented in the whole between the have's and the have-not's.

The multiplicity of items produced for sale is included in thirteen of the 104 texts. The items in the list on the bill provide the basis of this text, but in the text three other purchases are added that do not appear in the artwork: chestnut cream, sirloin, and crystals, each contributing to the political message.

Kilo

Un kilo de gruyère, autant de champignons blancs, pour une recette nouvelle; un demi-kilo de sel de mer; deux kilos de tapioca, pour les potages ordinaires; deux de crème de marrons, pour agrémenter les desserts; cinq kilos de coeur d'aloyau, pour nos travaux de force, déplacement des toiles sur châssis démesurés, plongée

Pierre Alechinsky, *Millet-Armand Bureau de tabac* [Tobacconist].

aux archives très anciennes; dix kilos de cristaux, pour augmenter la transparence. . . . Ajoutés à la facture liquide, plus quelques kilowattheures, quelques kilovapeurs et quelques kilomètres parcourus, vous aurez une impression quantitative assez précise de ce qui bout dans la marmite domestique hebdomadaire de la famille de La Bastide, nuages compressés des dissensions, mais parures des accommodations, robes et vestons qui fument avant des grandes soirées amidonnées, office qui mijote, souffle et grille toutes ses prétentions, machine qui s'emballe comme une locomotive, engouffre comme un haut fourneau et siffle comme le coucou mécanique des considérations. (26)[187]

The speaker who knows these intimate details of the de La Bastides's daily life is one of the servants, as he refers to "our forced labor," and he explains it to an outsider, "you," the reader. Two of the three new items stand out as luxury goods: chestnut cream may not be prohibitively expensive but is certainly not economical, and the beef, especially ten pounds of it, is beyond most families' budget. Then, transparency-producing crystals are listed among the references to the artist that fall under "forced labor": those "outsized canvases" sound

very like Alechinsky's "big inks," and the "very old archives" rather like these very bills he is drawing upon. It would seem that the "transparency," with its suggestive suspension points, is a product of the "forced labor," and thus of the art. The de La Bastides' "domestic kettle" is filled thanks to that "liquid invoice," which is a "tab" or accumulating balance similar to a credit card, but the normal expenses of electricity and travel are affected by "kilo vapors." How is a vapor weighed? We must recognize something irregular about the de La Bastides' accounting. The family table is always, "weekly," supplied, and family life is represented as normal, the usual combination of quarrels and compromises. However, against the background of elegance and comfort, the speaker, who is in a position to know, tells us the "pantry," where the servants stay, is destroying the pretentions. The servants are in charge of this "machine," likened to a locomotive and a blast furnace: esteem for status is reduced to something automatic and meaningless. The "labor" that enabled the transparency of the artworks was "ours," says the speaker, and it is through these transparent artworks that we are able to see the situation: the servants who eat "ordinary soups" will not be subservient forever, and the artist will have had a part in the change.

From the de La Bastide's bill at the local grocery store, we turn to a bill from a business that is itself a "Mother-House" in Bordeaux; this letterhead has generated a number of texts, often presenting the wealthy.

The two figures in the drawing *Caves girondines* [Girondine Cellars] have served as sources hardly at all. The one on the left appears in two texts, but the person on horseback on the right, despite the surprised expression and the zebra-striped mount, can be only tentatively recognized in one text, *"Cuve"* [Vat], where there are "shouts," possibly derived from the "O" of the mouth.[188] As a whole "Vat" is clearly inspired by this artwork: its *"colonnes de chiffres"* [columns of figures] (12) acquire mildly political overtones in the *"la cote"* [stock market quotations]. *"Le nez de la patronne, empourprée d'une végétation agreste"* [The nose, flushed with an uncouth growth, of the proprietress] is drawn from both support and drawing, but we cannot tell if this proprietress is herself one of the rich who invest in the stock market. The customers, however, are indubitably wealthy. Certainly drinking wine is not the exclusive prerogative of the prosperous, but large orders of cases of fine wines, as mentioned often in the texts, cannot claim a place in the working-class budget. This artwork has lent itself to many texts, and among the several that include lists in different forms of the businesses issuing these bills the *"Cellars"* are almost always present.[189]

In addition, eight texts refer to wine or winemaking,[190] among them *"Timbre"* [Stamp] tells of the

Pierre Alechinsky, *Caves girondines* [Girondine Cellars].

cally named. The buyer's wealth, which enables him to order the delivery of cases of wine, does not provide him the ability to resist a salesman nor prevent his overdoing the tasting as he wanders, as the title indicates, from one wineshop to the next, and finally *"tombe endormi sur les marches de sa villa"* [falls asleep on the steps of his house] (49). The humor here is farcical, the thoughtful interior monologue contrasting with the subtle portrayal of the uneven perhaps even staggering path.

It is the affluent in general in all their pomposity who are under attack in the next text. Elements of the artwork include from the letterhead the cherubs with their wineglasses and bare bottoms in the "celestial jungle," and from the drawing that "beautiful woman with her pretentious emanations," but we might note that *rombière* can have implications of "middle-aged" and "ridiculous," and that the "beautiful" could well be sarcastic. Her nose may have been transferred to the Jurors', which are "like unicorn chins," and indeed her hairdo could be seen as their two-cornered hat.[191]

Jury

 Dans le Grand Jury réuni par les Caves Girondines, les tastevins en bicorne et nez en menton de licorne hument les nectars de l'année 1905, venus des meilleures contrées: portos rouges et blancs, malagas, muscats et grenaches, tandis que la belle, avec ses effluves de rombière, claudique et disparaît. Sur le Jury de l'Exposition Internationale de Bourges, les phares de la création industrielle sont braqués: les jurés en grand complet, habit à basques et queue de morue, palpent amoureusement les carcasses, coffres, capots, portières, pneumatiques, grelots, dans une étreinte prothétique. Pour le Jury de l'Exposition Vaticane, les pênes retiennent leurs sanglots. Leur enfer sera doux! Mais dans l'ombre, l'Autre Jury, sur lequel tout le monde cancane mais dont personne n'a réussi à connaître l'exacte raison, décerne une médaille d'or de rêverie, un grand prix de vertige, une mention de pirouette, un accessit de vague à l'âme, des félicitations de tape-à-l'oeil et grand tapage, une tournée générale d'allégresse, sous la férule d'angelots piaillant dans une jungle céleste de ceps et pampres, de coupes et croupes émoustillés. (23)[192]

The political, delightfully enhanced by satirical humor, throbs in this text. Here are the important pillars of communities wearing the dress symbolic of their rank, presiding over the established, recognized, and venerated expositions of wine and automobiles. There are all the best (and undoubtedly most costly) wines, and "industrial creation" is displayed in the deluxe cars. But, amid the pomp and luxury, that woman limps and the jurors have only artificial limbs with which to embrace the elegant cars. It is possible that the ceremonial costumes of the text led to the creation of a Vatican Exposition with its suggestion that pretentions there go

double Franc stamp commemorating the *"vigneron avec sa hotte et son pressoir"* [winegrower with his basket and his winepress] (40), which we cannot fail to notice is twice the value of the stamp depicting the artist, and two hundred times the value of the stamp devoted to the chimney sweep! *"Pressoir"* [Winepress] focuses on winemaking in a lyrical hymn that suggests the artist: *"Même sur la grille des facturations, le moût dépose dans ce philtre de ses transports la figuration nouvelle"* [Even on the grid of the invoicing, the must deposits in the transmission filter the new representation] (35). This "new representation" could be that of Alechinsky, refusing to conform to established norms.

Many of these texts are humorous, such as, *"Naseau"* [Nostril], in which the satirical treatment of governmentally organized schooling in espionage includes research in the new science of smells. Trainees were required to give up smoking, but their internships with winemakers were soon discontinued: *"comme il fallait s'abstenir de boire, on devenait vite suspect"* [as they were required to refrain from drinking, they quickly became suspect] (29). Humor is also present in the depiction of an obviously well-off buyer in "Zigzag," in which the Girondine Cellars are specifi-

so far as to include anticipation of a higher-class after-life. The contrast with the Other Jury is vivid. Their awards are for activities that cost nothing, and their prize-giving for "joy" is accompanied by what seems to be a fine, if rowdy, party. Any of us, even if we are not rich, can enter these competitions; even an academic administrator could sign up in the "changing policy" category and perhaps win a medal to add to the diplomas on his office wall.

Part II: Problems and Solutions

Problems

From that happy party we turn now to an artwork with a different tone, *Charronage* [*Cartwright*], the last one bound in with *Dessins.* Its placement at the end seems deliberate, not "random." The texts derived from this artwork are almost entirely without humor.

This artwork is not the only one to suggest a threat. We have seen the dark background of the *Ladder* (#6), and a similar blackness obscures the letterhead of the *Boilerworks* (# 10), allowing only for a Gilles de Binche figure with an indecipherable expression. In Victor Magnant *Cement II* (#16), a Kilroy face encircled by an Alechinsky serpent broods over the whole. But in this drawing there is more than a grim foreboding of un-specified nature. Why is that head set on what seems to be an anvil? Two texts refer to it quite neutrally: *"En-trepôt"* [Storage], where the same bored workmen we saw earlier fixing a piano keyboard to a car also *"montent une perruque sur une enclume"* [mount a wig on an anvil] (15) and in "Impression" the eyes made from wheels are described as *"les yeux-essieux jetés sur l'en-clume de la chevelure"* [the eye-axles thrown on the anvil of the head of hair] (22). In the artwork, the head seems at best a plastic form used in store displays, with a wig. Or at worst it really is a severed head—the object with the hatchmarks in the lower right could be seen as a guillotine basket. The figure on the left is definitely reaching for the head with both hands while the other figure appears to be supervising; neither figure seems well-intentioned. This artwork is ominous, and most texts provoked by it maintain the mood.[193]

For example, an anvil is mentioned in *"Médailles"* [Medals], a text provoked both by *Cartwright* and by Victor Magnant I, *Construction,* whose letterhead depicts medals and a smoking factory chimney. In that text a medal depicts *"le jeune apprenti somnolent dans sa forge reçoit la visite de l'inspiration charronnière"* [the young apprentice dozing by his forge [who] re-ceives a visit from the cartwrightian inspiration] (28), who kisses his *"son front pur, humide de transpiration saine"* [pure forehead, damp with healthy perspiration]

Pierre Alechinsky, *Charronage* [Cartwright].

and gives him a *"marteau magique"* [magic hammer], while the presidents of the Third Republic are shown dancing in a circle on the back of the medal. We are told that the various medals show an anvil and *"des fumées montant des hauts fournaux"* [smoke rising from the tall furnaces] and finally the motto, *"Ne point relâcher son effort pour parvenir à la maîtrise"* [Never give up the effort to achieve mastery]. Thus the worker is cyn-ically offered the glorious goal of someday enabling the company owners to win a medal if he perseveres in his virtuous, mind-numbing, and perspiration-producing manual labor.

It is the drawing rather than the support of *Cartwright* that is reflected in both content and harmony of the next text:

Ferronnerie
 Front en ventre de marmite, menton en poignée de serrure, nez en lame de couteau, yeux en moyeux et rais de roues de dog-cart ou de calèche, sourcils en brancards de tilbury. Et encre en poupe, ou croupe, entrecoupée, en-trelacée, en rampe, barreaux, balustres, volutes, bracelets et corset du Maître à l'Elégante qui se sangle avec sa dignité, pour n'être pas de bois, dans les lacis de ses dentelles vipérines: ferronnerie dard! (18)[194]

The figure on the right is the Master with Elegance, the boss, complete with an effort to appear sensitive. The bare-chested costume of the other figure shows him to be some kind of worker, possibly a blacksmith, since they work, often without shirts, around a hot fire. Blacksmiths put horseshoes or other metal objects on anvils in order to pound them into shape; is the worker going to pound that head into some other shape? Despite the careful description of both characters, there is not one word about that head, which is nevertheless the focus of the drawing.

In this disturbing text, the harmony is appropriately unsettling. The rhythm is pronounced, but refuses to become regular. It begins with a series of more or less octosyllabic lines before taking off in the long line of the identity rhyme, *yeux en moyeux.* The second sentence with its rhymes then could be read in staccato leading up to the series beginning *en rampe* before the return to the quasi-regular octosyllables and the sudden five-syllable conclusion. The very first words establish the tone, with the interlocking assonances of *front, ventre, menton,* nasals that are reechoed then in *encre* and in the succeeding interlocking assonances (*poupe, croupes, entrecoupée, entrelacée*). In the latter sequence the soft [u]'s heard in *roues* and *sourcils* sound again, but they will not reappear. As those soft [u]'s are overwhelmed, harsh front [a]'s take over; murmuring alliterations in *m* are outnumbered by plosive alliterations in *b.* The harsh [k] is equally ambiguous: it is scarcely heard, and when it is, it is twice softened by the [u] or [ʃ] (*calèche*), or distracted by a rhyme (*bracelet/ corset*). Only in the foreign word "dog-cart," rhyming with *brancards,* does the [k] retain its force, aided by the front *a,* and that *a* strongly emphasizes the harsh meaning of *dard* at the end. The Master of Elegance may wrap himself in assonance (*Elegante/sangle*) and liquid *l*'s, but hidden beneath the costume are the harsh front *a*'s of *dard* and rhyming *brancards*—which as well as "shafts" means "stretchers."

The text of "Ironmongery," if read together with the drawing, would suggest that a boss has ordered his worker to commit some mysterious but clearly evil act. This is only one example of the effect *Cartwright* had on MB/MS. The next text derives specifically from the handwritten bill, parts of which are legible around the drawing: M. de La Bastide had many items repaired.

Réparation
 Les dossiers cassés, les sièges troués, roues voilées, manches brisés, outils rouillés, vitres fêlées, tonnes éventrées, pneus crevés, cheminées bouchées, phares en panne, robes déchirées, chapeaux défoncés, rails gauchis, serrures bloquées, cordes éraillées, touches muettes, échafaudages tordus, livres moisis, lettres brûlées,

affiches lacérées, toiles manquées, comptes truqués, phrases bancales, doigts arrachés, pieds broyés, yeux crevés, têtes à l'envers, vies de chien, mondes immondes. (36)[195]

The harmony is insistent: the remorseless final [e] heard in virtually every word demands notice as it batters on until the last nasal *o*'s. "Repair" illustrates very well what Butor means by "political," that is, pointing out anything he feels is not right in our society. The series of items passes in review many of the bills and artworks we have seen: wheels, casks, chimneys, pianos, and others not mentioned in this study. It is true that some might not consider poor sentences or even silent piano keys to be serious issues, but the list form of the text does not distinguish degrees of gravity. The problems needing an automobile repairman or (alas!) a chimney sweep expand to include wrecked clothing and railways and then an item which cannot be repaired, the "burned letters." The "ripped posters" evoke May 1968 (or any city walls today); the "canvases" and "accounts" recall the artist and the ongoing attacks on the commercial world—both omnipresent in this work—and with the sloppily constructed sentences one might believe the sad accumulation was winding down. But, nothing of the kind: here are atrocities found regularly in daily newspapers, as irreparable as the burned letters. The blinded eyes always recall Oedipus, if not Samson, with tragic connotations. The "brains in a whirl" has the literal meaning of "heads upside down," a nightmare Idi Amin could have arranged.[196] "A dog's life" is a popular expression, and once more one might think the horror had passed, but the "filthy worlds" are literally "unworldly worlds." And yet, this is the world where we live.

Solution

We have seen examples of texts that present the drab misery and dangerous conditions of workers abominably treated by their dishonest bosses, the glib patter of salesmen preying on the naïve, and the pretentious, vacuousness of employees concerned only to increase the number of their material possessions, glimpses of the uncaring, exploitative wealthy, and then, above, a dark, despairing view of our whole society. The artwork, *Cartwright,* with its ambiguous scene of some dreadful situation, seems a fitting end to *Dessins.* But we have not yet examined specifically the appearances of the artist, who remains resolutely outside any societal classification, and he is the primary force in the whole.

The introductory text, "Articles," posed the question whether artists were involved in commerce, and throughout the work we have found references to the

ABC DE CORRESPONDANCE

Michel Butor & Michel Sicard

Pierre Alechinsky, *Articles d'éclairage* [Lighting].

artist's function in society, which to Butor is very much a political issue. Any of the drawings representing the artist could illustrate these points, but the one selected for the cover is especially apt. In the dark text, "Repair," we saw posters and canvases, all spoiled, and there were also "burned-out lights." Now let us look back at the cover of the *ABC,* where the artist is drawn on the support of a bill from a light fixtures business—light! Here in *Articles d'éclairage* [*Lighting*] is Alechinsky painting away with his left hand, and the letterhead in the frame reminds us of "Articles," but also includes, along with the hardware and locksmithing, *"éclairage"* [lighting]. And that is what art brings us. Listen to the artist replying to the critics as he refuses to conform:

> *Unité*
> *—Ces dessins n'ont aucune unité, voyons!—C'est que je n'y vois pas de règle de temps, de lieu, d'action, d'occupation et de corps de métiers.—Peignez classique!—D'unité en unités, je m'y perds. De directions, je découpe. De sens, j'erre. De lenteur, je serpente. De fuite, je me retrouve ailleurs.—Unité au fond, au front, de tout cela, qui se délite, mais d'élite. C'est ma médaille au carré, mon*

timbre sans quitus, ma folie, ma passade. J'aime, je persiste—je ne renonce pas. (41)[197]

The critic looks for adherence to the classical dramatic unities—rarely respected today—and adds a new rule, the unity of "occupation or body of workers." If this is a new unity required in art today, it would seem similarly adhered to only rarely, perhaps in Diego Rivera murals, since the rule today is rather to reject all rules. The artist will have none of this, even if it is "top-notch." He has no symbols of official approval, his invoices are not stamped "paid," as they are on this and other bills,[198] and he does not care. *Dessins sur factures* is as a whole a clear example of the work of the artist who does not "give up."

As one half of the texts include the artist, his techniques, paraphernalia, and place in society, we have more than enough texts from which to choose illustrations of the political supported by harmony and humor.[199] The artist himself dances exuberantly through the texts, *"décalquant les formes de la vie même"* [transferring the forms of life itself] (*"Balai"* [Broom]) (10). He turns the trunk of a car into *"un grand panier des îles"* [a big island basket], its chrome into *"un éclair du Fuji-Yama"* [a flash of lightning from Fuji-Yama], and its *"pneus, avec jante et rayons"* [tires with rim and spokes] into *"quatre chapeaux chinois"* [four Chinese hats] ("Garage") (18). He has his tender moments, for among other albums, that of the painter contains breathtaking beauty and *"vous pourrez déchiffrer votre premier baiser comme votre dernier soupir"* [you can make out your first kiss as well as your last sigh] ("Keepsake") (24). He even has tidy spells: the artist's biannual housecleaning gives rise to the dream of an *"serpillière adhésive"* [adhesive floorcloth] that would automatically collect all the discarded drawings and produce them in a *"gigantesque patchwork"* [gigantic patchwork] that *"comme un voile de Véronique"* [like a veil of Veronica] would record everything and *"rendre nos enfers habitables"* [render our hells livable] (*"Ménage"* [Housekeeping]) (28–29).[200] Among many other texts, he stands still long enough to be photographed in *"Ypréau"* [White Poplar] (48) and even entertains, in his fashion: figures from the artworks congregate in his studio, where stands *"la guillotine du chevalet, prélude à la mort industrielle"* [the guillotine of the easel, prélude to industrial death] (*"Ornement"* [Ornament]) (32).[201] And there we have the function of the artist in society: to produce the art that will eventually bring down the tyranny of industry.

The text, *"Vinaigre"* [Vinegar] uses that item from the letterhead list of Millet-Armand (#15) as an excuse for juxtaposing the ingredients in salad dressing to the

subjects of art, such as *"un zest du couchant"* [a zest of sunset], to create *"la salade du peintre"* [the painter's salad] (43). The following text treats the other primary ingredient of salad dressing, with a pinch of humor:

> *Huile*
>
> *Monsieur l'Epicier, je vous serais reconnaissant de me faire parvenir dans les meilleurs délais—un litre d'huile d'olive, pour ma salade quotidienne;—deux litres d'huile de lin, pour restaurer mes anciens tableaux;—trois litres d'huile de moteur, si vous avez, pour vidanger le carter de ma figuration;—quatre litres d'huile de pépins de raisin, pour redorer quelques vieux rêves;—cinq litres d'huile de foie de morue, pour fortifier mon auditoire;—six litres d'huile de baleine, pour jeter sur le feu des enseignes, des en-têtes, des entrechats et des entre-deux-vins. Vous y ajouterez aussi quelques mesures d'huile de coude, pour donner de la vaillance à mes biographes futurs.* (21)[202]

The request is proper and polite: only gradually is it revealed that the order comes from an artist, as the uses to which he will put the oils move farther and farther from the kitchen. The repetition of "oil" emphasizes that each oil is a different kind. The concision of each additional item increases the surprise factor of the intended use: the terminology accompanying the "motor oil" leads us to expect an oil change for a car, but totally removed from anything so practical, the artist wants to freshen up his drawing. As we think, with the regilding of "old dreams" that we are back in the artist's world of restoring his "old paintings," suddenly the artist has an audience and ignites a Savanarola-model fire, but with a difference. He is certainly not burning the "vanities," art, but rather the "signs" of the businesses and the "letterheads" of their bills, those adjuncts of consumerism, which deserve destruction. (We may be very sure these are unimproved bills, not those Alechinsky has used as support, which have become art.) To keep us on our toes, so to speak, the entrechats of a ballet dancer and the elegant dinner are not amplifications but in contrast: the one from the world of art and the other from the world of good taste. The juxtaposition is mildly humorous, but both terms contribute to the alliteration in [ã] found in the repetitions of *entre,* lost in translation, as is the last repetition of "oil" in "elbow grease." If the reader does not find the incongruities amusing, the self-deprecatory humor regarding biographers must still be appreciated.[203]

Different kinds of humor are found in the following text treating artists' materials: satire, incongruities, and surreal contrasts.

> *Outillage*[204]
>
> *Nous tenons à votre disposition toute une gamme de produits qui permettent au commençant de rivaliser avec les spécialistes chevronnés. Ainsi le tachoir, le*

dégoulinoir, le pointilloir et le déchiroir. En ce qui concerne la figuration, nous avons mis au point une série de pochoirs déformables, permettant les anamorphoses des visages les plus connus comme dans un palais de miroirs. Vous pouvez ainsi mincir à votre guise toutes les grandes barbes fin de l'autre siècle: Hugo, Brahms, Jules Verne ou Garibaldi, les élargir à l'horizontale ou l'oblique, leur imposer les transformations cycloïdes ou spirales les plus réjouissantes. Après l'essai vous ne pourrez plus vous passer de votre caricaturoir. (32)[205]

The salesman we have seen before spouting deceptive promises does not hesitate to use his patter even on artists' tools. In the process he raises the question whether cunning devices will supplant the genius of the flesh and blood artist. In *Dessins sur factures,* three texts show that advertising operates in opposition to art,[206] ten suggest that society is opposed to or afraid of art; thus we may suspect the salesman of intentionally erasing any demand for real art, driving the artist, one might say, out of business. We recognize in his examples Butor's own interests: the "beginner" would use a "dripper" to imitate Jackson Pollock, whom Butor has often discussed. He has also treated anamorphosis in painting more than once, as in his allusions to Arcimboldo in the *Confessions of Winter* in *L'Oeil de Prague.* Hugo and Verne would naturally appear among his preferred writers as "great beards," and Garibaldi represents the epitome of the hero of struggles for freedom (and even fought for France in the Franco-Prussian War); he is usually portrayed with an excellent full beard. Brahms may very well be included just for his beard, to assure the presence of a composer. But does competence in operating a computer graphics program enable one "to rival rapidly with the experienced specialists," that is, the artists? As enthusiastically as Butor supports technological advances, he would not encourage such a claim, as this text makes clear. An artist could create art with the "caricaturer," but in the hands of the ordinary person, the proposed manipulations would be simply ridiculous.

With or without humor or harmony, the artist and art are fundamental to the whole of *Dessins sur factures.* The next text, *"Affaires"* [Business], mentioned at the beginning of this chapter, is primary to the work and makes very clear the function of art in society. Butor is careful never to pretend to solve the problems of the world, but in this one, with its "algebraic invariable," he does suggest a "miraculous solution."

> *Affaires*
>
> *Il y a deux mondes d'affaires bien distincts. Le premier, que nous appellerons le Marché A, change denrées contre devises, cote en bourse chaque jour, s'effondre quelquefois dans d'énormes craquements que les ouvriers de la sonorisation ont la charge d'atténuer. Le second, que*

*nous appellerons le Marché B, dont personne ne sait ex-
actement où sont les centres réels de décision et apprécia-
tion, troque images contre fables, valorise les ouvrages
disparus, ou seulement imaginés, fait surgir des espaces
secrets d'habitation, sentir l'herbe des prés rares, ou ces
amours turbulentes qui sont les grandes affaires de la vie.
Il arrive qu'un coupon du Marché B émerge sur celui du
Marché A, ou vice versa, ce qui ne manque pas de provo-
quer des remous. Par exemple, lorsqu'un rectangle de
toile fameux apparaît dans l'antre d'un conseil d'admin-
istration. Des experts du Marché A ont entrepris de mes-
urer l'exact rayon d'action et d'infraction sur nos actes de
ces objets suspects. Ils envisageraient même de disposer
discrètement en regard des appareils assez sophistiqués,
pour compenser cette influence déviante. Mais aux der-
nières nouvelles, une association prétendument phi-
lanthropique, proche du Marché B, se pencherait sur la
formule inverse, voudrait imposer des objets du Marché B
sur chaque place du Marché A, comme solution miracle à
nos problèmes, et cela en toute indépendance, cette quan-
tité diffuse mais partout égale pouvant jouer le rôle d'un
invariant algébrique dans toutes nos opérations vitales.*
(9)[207]

It may or may not be reassuring to us to know that the
next time the stock market crashes, a plan is in place to
minimize its effects: it is the workers, of course, who
have been assigned to take care of it. The detail that it is
the "sound effects" workers provides the humor of in-
congruity, humor that may or may not be "black," de-
pending on one's memory of the great Depression. In
the identification of Market B, the inclusion of its func-
tioning to exchange "images for plots" (as in this col-
laboration), confirms our suspicion that this market
"about which no one knows exactly where the real
centers of decision and valuation are," is the art market,
with its wonderful effects. Meadows and their grasses
may have become scarce, but art allows them to per-
fume the air again.[208] Art brings them back, even as it
accomplishes the impossible tasks of appraising lost
works and those not yet created. Certainly art deals in
secret hiding places and "turbulent loves," but it is
surprising and intriguing to learn that the latter are the
"big business of life." We are familiar with the "distur-
bance" a "rectangle of famous canvas" can produce
when one is offered at auction, and perhaps we should
have known that the "administrative council" of Market
A inhabited a "lair" and was installing devices to fore-
stall the "deviant" effects of art. From the satirical pre-
sentation of the "real" business world, savage and reso-
lutely determined to suppress art, Butor takes us to his
"miraculous solution," which lies in the equal distribu-
tion of art, in whatever form, among all peoples. We
hope with Butor that the "supposedly philanthropic as-
sociation" exists somewhere and will prevail.

Thus the texts on art and the artist vigorously contrast
with and counteract those on the multiple generalized
ills of society, including the evils of the class system.
The artist cannot be relegated to any particular level of
the social class system; he is present in all, from the
tradesman's shop in "Manual Trade" to the "canvases
on outsized frames" moved around by servants in the de
la Bastide's house in "Kilo," to the awards of the Other
Jury in "Jury." Where the despairing texts present
"filthy worlds," as in "Repair," and misery that cannot
and should not be ignored, those on the art and artist are
a constant source of hope and indeed joy.

Conclusion

The unique nature of the structure of this work might
tempt one to label it humorous (which it is), have a good
laugh and then set it aside as just another of Butor's
iconoclastic productions. Or one might read *"Maison"*
[House] aloud in French and just listen to the harmony.
However, in this frolic among Alechinsky's drawings
on some old bills, there is a very powerful statement
about society and the place of the artist in that society,
the "political" according to Butor's wide definition.

We have seen that the artworks served as sources of
these texts in at least three ways. First, the six drawings
of the artist, with easel, paint pots, and brushes, cer-
tainly permeate the whole, and some of the other figures
are recognizable as well, the man on the ladder, Mme.
de la Bastide at her piano lesson, the ladies shopping at
the general store and Bon Marché and even the severed
head. Second, a few texts were inspired by or include
details from Alechinsky's incorporation in his drawing
of an element found on the letterhead: the illustration,
columns of numbers, medals, etc. Third, however, it is
the support, the bills themselves, the illustrated let-
terheads, printed information, and lists of items pur-
chased, all visible evidence of commerce and industry,
which has provoked the greatest number of texts. Al-
echinsky's selection of these bills to serve as support is
as critical to this collaborative product as his drawings.
Both together stimulated the imagination of the writers,
and the wealth of that imagination appears
inexhaustible.[209]

The setting provided by the bills displays the world of
a century ago. Elements of today's consumer society are
very present in these letterheads, similar to the adver-
tisements, so often deceptive, which shriek at us today
from every direction. The thriving commerce and in-
dustry the support gives witness to become the primary
focus of the texts as a whole. The bills provide, through-
out the work, inescapable reminders of human greed.

We have looked in our study at Butor's harmonies,
seen his use of rhythm, both regular and very irregular,

of octosyllables versus very long sentences. We have noted his widely varied repetitions: in structures, parallel constructions, sometimes multiplied to seven or more in sequence. We have seen and heard the rhymes, including identity rhymes but also rich and superrich, and assonances, the parallels with the same vowel sound, the alliterations. We have noted the careful distribution of vowel sounds, *i*'s and [j]'s, nasals, sharp [e]'s and the soothing [u]'s, and the controlled use of harsh [k]'s. Regularly the sounds accord with and emphasize the meaning. The wide majority of the texts are harmonious, musical poetry in prose.

The humor has kept us laughing: the puns, the farcical touches, the parodies and rhetorical devices. The techniques of hyperbole and litotes add to the comical incongruities, which, together with the contrasts, are the primary sources of the humor. Throughout, the satire, occasionally gentle, but often mocking and sometimes bitter and "black," shows us this world we live in more clearly, perhaps, than we would want to see it.

The political statements, of course, are the raison d'être for the harmony and humor of the whole, and the work offers a wide assortment of issues Butor includes in his understanding of the "political." He speaks in favor of decentralization, against pretentiousness and pomposity. The commercialized world gets its comeuppance, with emphasis on the accepted cheating that goes on everywhere. The deceptive patter of salesmen is parodied. Certainly mistreatment and oppression of workers or servants is condemned, especially child labor, and in general, man's consistant refusal to behave decently toward his neighbor. Throughout, art is omnipresent, in the support chosen by the artist, in his drawings representing an artist, and in the texts, where the artist predominates and offers the solution to the problems of the world.

The precise form that solution might take is never explicitly spelled out, but there are hints. For example, an autobiographical touch in the text, *Bon Marché* states, *"Le grand magasin de mon enfance, rue de Sèvres, avec le square où l'on voit l'épouse du fondateur avec une amie, en toque, manchon et pelisse qui descend les degrés d'un perron pour accueillir un méritant adolescent pauvre auquel je m'identifias"* [The department store of my childhood, in the rue de Sèvres, with the square where the wife of the founder is seen with a friend, in bonnet, muff and cloak, coming down a flight of steps to welcome a poor deserving adolescent with whom I identified] (11). That "poor deserving adolescent" has grown up to utilize artworks drawn on Bon Marché bills to attack the evils of consumerism, acquisitiveness, the profit-making motive. This attack is surely part of the solution, and it is typical of Butor to include miniscule suggestions that even the Bon

Marché is not exclusively evil. That "wife of the founder" has a "friend," and she is putting herself out to "welcome" one of the "poor." More significant in the struggle between commerce and art is the point, *"Aujourd'hui l'on s'efforce de retrouver ce qui reste de l'architecture originelle"* [Today they are endeavoring to rediscover what remains of the original architecture]. There could be a hidden acknowledgment here on the part of the Bon Marché that whatever art might be present in that architecture has value, one that is actually not commercial. Many texts, still without delineating precisely the form the "solution" will take, encourage belief in its existence. In "Gruyère,"[210] one of the texts derived from the *Ladder* (#6) and its "receipt" stamp, we find *"l'animal philosophe, juché sur une échelle au-dessus d'un abîme"* [the philosophical animal, perched on a ladder above an abyss] (15), as if seeking his destiny inside the cheese, where *"dans l'ombre, les trous des tampons sur timbres de quittance—étiquettes vers quelle destination?— ouvrent des horizons d'espoir"* [in the dark the holes of the stamps on the receipt marks—labels for what destination?—open horizons of hope]. In the blackness of the artist's drawing the writer, "philosophical animal" that he is, finds in the receipt stamp (of all things) reason for hope. Then, we have no idea just how the *"guillotine du chevalet"* [guillotine of the easel] (32) will contribute to the solution by serving as *"prélude à la mort industrielle"* [prelude to industrial death], but the image with its powerful connotations is unforgettable.

The *ABC of Correspondance* is certainly not a manual for epistolary style, but the *Dessins sur factures* still hides a didactic purpose, an "ABC" for living in the world. Even as the texts teach us of miserable aspects of society we might not have known, reading them encourages resistance, resistance to despair. So long as art and artists exist, there is hope.

The *Dessins* are an excellent illustration of Françoise van Rossum-Guyon's succinct summary of Butor's works: "Indeed, there is not a single genre on which Butor has not exerted himself to subvert as much the form as the function."[211] *Dessins* supports her conclusion, "To destroy fixed forms, abolish frontiers, invent new ways to read, that is to say, to see, to hear, to perceive, to imagine, to understand, that all works together" (50).[212] We have seen that this work exemplifies the absence of established forms of poetry, the collapse of distinctions between political discourse and flights of fantasy, and certainly another new way to read.

If this artistic collaboration, were to be secretly slipped into the "Market A" as suggested in "Business," it would contribute to the "miracle solution to our problems." This collection of 104 disparate texts, randomly

associated with nineteen confusing drawings on old bills, is a treasure trove. The picture of the last century, as it was actually lived, is presented here memorably, in endlessly varied harmonies and in humor varying from the mild to the hilarious. The writers and artist paint the folly of consumerism, the frantic desire for more and more inanimate things, in devastatingly accurate detail. They reveal the suicidal bent of our contemporary society, dependent on merciless exploitation of others, in brilliantly clear light. They show salvation through art as the only possibility, and *Dessins sur factures* is itself a prime example.

5

Conclusions

My study has treated only a minuscule segment of Butor's works, those written with only three of the hundreds of artists with whom he has collaborated. However, my findings should shed light on his other collaborative works. In particular, we have seen that the effect of the source may appear limited in the end result, but the source is still essential to the composition of the whole. When we do not know of the source, when we have not seen it, we lack a link in the chain from Butor's mind through that source to his text. Reading the novels, we are familiar with Paris-Rome trains, apartment buildings in Paris, foggy British industrial towns, the routine and program of French lycées, and reading other works, if we have not ourselves traveled to Australia, British Columbia, Egypt, Korea, Japan, China, Mexico, and New Mexico, to mention only a few of Butor's destinations, we have seen photographs. But we have not seen an apple with a zipper or a judge swallowing his eyes. We could guess that Butor found these images in dreams, but that response is unsatisfactory, as the ideas remain without visible form to us, hidden in the dreamer's mind. Many writers of fantasy, oneiric visions, are content to leave the reader wondering, or chasing down an image in other literary sources, but with Butor we can see the dressed apple in a Kolář collage, the eye-swallowing judge in an Alechinsky engraving. In our study we have found the effects of such sources to vary widely in nature and in extent among the artists and among works of the same artist. This shining light is selective as it passes through the prisms, and each resulting rainbow is different from all the others.

THE ARTWORKS AND THE TEXTS

In this study of Butor's collaborations, we have found Butor sometimes deriving from the artworks the organization and mood of his texts as well as details taken from the figuration. The horizontal division of many of Monory's artworks provoked a dual structure in the texts. Kolář's varied collage techniques certainly underlie the organization of the *Dialogue avec Charles Baudelaire*. Alechinsky's calendar divisions are seen naturally in the texts of the *Stances,* and his numbered sectioning of the Ammonite etchings are paralleled in Butor's numbered paragraphs. In *Le Chien roi,* however, the frame and central figure of each artwork are blended rather than distinguished in the texts. Thus we may conclude that a distinct organization of the artwork often, but not always, provides a corresponding one in the text.

As for mood, Monory's blue has touched with melancholy all the *Bicentenaire kit* poems. Kolář's influence on the mood of the texts is more complicated. His works can elicit for the spectator a range of reactions, from sadness to merriment. The *Cathédrale ivre froissage* is a pathetic image, reflected in the text, while the road sign and little horseman planted on the moon, the apples, clothed and covered with smiling lips, have all generated cheerful, even happy texts. Alechinsky's *Le Test du titre* demonstrates how uncertain the reading of an artwork's mood is, how dependent on that of the spectator. Nonetheless, in *Septembre* of the *Stances* the predominant grays and blacks of the artwork would seem to have influenced the depressed mood of that text, and the calm smiling figure of the Ammonite in the last etching of that series must have contributed to the peacefulness of the end of that text. Of the numerous examples of the artwork's affecting the mood of the text in *Dessins,* perhaps the most evident are the blackness of *The Ladder* (#6), whose mood is reflected in the story of the chimney sweeps, and the mysterious threat of *Charronage* (#18), with its list of items needing repair, virtually all-inclusive. The six drawings of the artist have unquestionably contributed their joyous mood to the many texts on art and the artist. For the most part, the mood of the artwork is reflected in the texts.

From the figuration, the recognizable representations in the visual art, Butor has taken scenes, natural forms, and characters, human and animal. With Monory the identification is readily seen, with Kolář often more difficult, requiring, for example, deconstruction of the *prollages.* With Alechinsky, identification becomes even more challenging, but Butor's texts reveal to us what he saw in the artwork, occasionally more than one

vision and not always unarguably clear. Each of the texts studied here illustrates Butor's use of some figure from the artwork.

Inspired by the works of all these artists, Butor freely alters, selects, adds, and omits in his texts. With all three, the figures, clearly depicted or not in the artworks, become characters in Butor's texts: their personalities, their monologues or dialogues, and their actions all come from the "undefinable elsewhere" Roudiez spoke of.[1] For example, no hint that the woman just drove from Las Vegas can be found in Monory's serigraph; the Pageboy's former belief that "Madame" is really his mother is not to be seen in Kolář's collage; the Dreamer himself never appears in that series of Kolář collages, and whereas his adventures may be suggested by the artworks, they do not depict an attack on Mme de Pompadour. On the other hand, Nixon is clearly recognizable in the collage *La Reina du cinéma,* yet in the text Butor refrains from identifying him other than as any celebrity seen in tabloid photographs. Then, the gossiping narrator of Alechinsky's *Test du titre,* the development of the self-deprecating Mr. January and all the other characters and actions of the *Stances* are Butor's inventions; the signatures on the support of *Mars* are illegible scribbles, but Butor knows they are "bacteria and virusus." The entire action of the *Rêve de l'ammonite,* the whole sequence of persecution, imprisonment and final resolution is Butor's. In the *Comptines en blanc et noir,* Butor has added Don Quixote, jackals and the knight's weapons, all from that "undefinable elsewhere." The *Chien roi* series is fraught with these additions: no future dearth of oranges is shown in *Les Oranges de Binche;* the tales of the *Sphinx en chapeau* and *De toutes parts* are all Butor's; the dog wears a crown in Alechinsky's etching of the *Chien roi,* but the specifics of the dogs' behavior as they imitate humans are Butor's. Examples from the *Dessins* are readily recalled: Mme de la Bastide and the other figure do not have happy expressions in the drawing, but it is Butor who has seen that he is her music teacher and that she just "massacred" a sonata. Butor insists that the artworks are essential to the creation of these texts, and our examination confirms their fundamental function, but recognition of the part played by the "undefinable elsewhere" discloses that in many if not most cases the artwork has provided the stage set before which in the texts Butor's characters act out Butor's dramas. It is the light passing through the prism that creates the rainbows.

HARMONY, HUMOR, AND POLITICS

My study has found Butor's use of harmony to correspond usually with the meanings of his texts. As we know, particular elements of the artwork affect the meanings of his texts very differently, and one cannot simply state that a given artwork produced a given harmony. Nevertheless, with our single set of collaborations with Monory, we can see that the rhythms and repetitions of the texts correspond with those of the artworks. Further, I would posit the theory that the uniform nature of those artworks, their cold blue combinations of images, has persisted through the meanings of the texts to the restraint in the harmony, the general absence of harmonious sounds.

With the Kolář works we have seen that the harmonies vary in kind and intensity with the meanings of the texts rather than with the individual collages. As the meanings vary widely, so do the harmonies, and in all cases the harmony is a vital element of the text. Even in *Vagues des villes éclosion,* with its matrix, the hard and soft sounds are balanced. In *La Reine des neiges* those sounds appear in contrast, while in *Résistance* among the many repetitions the hard sounds predominate, in accord with the meaning of the text. Where the meaning is not serious, the harmony is limited, as in the *Anatomie illustrée* composed almost exclusively of simple alliterations. The richest harmonies are found in the *Ballade des froissements du monde,* with *i*'s, [u]'s, sibilants, and alliterations, appropriate to the message of art as the salvation of the world and to the salute to Kolář. Throughout the series of collages of the dream appear contrasting hard and soft sounds, alliterations, especially *v*'s, which are prominent in three of the segments, widely separated. The text of the zippered apple stands out with its short sentences and simple repetitions, and then the harmony increases through the musical "*le long d'un Nil de notes,*" until the Mars scene, which has no harmony, only repetitions and not one, but two instances of hiatus, a clear example of the sound's reflecting the meaning, as is the ending with its soft sounds of peace. In the Lichtenstein postcards the harmonies follow the meaning, with appropriately contrasting hard and soft sounds, often in alliteration, and the last one relates through sounds to the previous three. We may safely say that Kolář's collages have inspired Butor to create extremely harmonious texts.

The collection of Alechinsky's works has generated far fewer harmonies than Kolář's. It appears that his artworks have led Butor to write texts whose meanings are only rarely composed of the kind of contrasts that suggest a parallel use of hard and soft sounds. The *Stances* contain rhymes (giving the lie to the speaker's announcement that "rhyming would be too difficult") and alliterations, many soft *v*'s and hard *k*'s, the latter found also in *La Méduse des chocolats.* Similarly, in the *Comptines en blanc et noir,* the harmony is muted, with *i*'s, *u*'s, [k]'s, and final *s*'s, modulated first to more

contrast and then to more steadily harsh sounds; there are rhymes throughout, but only the last stanza is very musical. *Le Chien roi,* too, contains rhymes, rhythms, and repetitions often in parallel constructions, with some increase in harmony in *De toutes parts,* but almost none in the final text. The *Ammonite* presents repetitions, alliterations, often in *g*'s and *k*'s, with front *a*'s, but only in the flower scene and the picnics in the clearing do we find rich harmonies built on soft sounds. Then, *Dessins* contains some texts that are extremely harmonious, along with repetitions, parallels, and rhymes. In the example, *Maison,* cited above, the text may be seen as derived from the support of Alechinsky's artworks *Piano* (#7), but the appropriateness of the lush harmony depends on the text alone.

Our examination of humor has shown that Butor's texts only sporadically follow that of the artworks. We found no humor in the Monory collaborations, in neither serigraphs nor text. In Kolář's works appear particular moments of humor, based on the incongruity natural to collage, notably the zippered apple and Mme de Pompadour's head of Daudet. Butor's texts follow the humorous lead: the apple is "half-undressed" (31) and the Dreamer "cannot resist" (32) opening the zipper, letting "a cloud of typed letters" pour out, later slipping inside himself (37). Butor describes Mme de Pompadour's "enormous limp head" (78) her moustache and beard before she "takes on the smile of Alphonse Daudet." On the other hand, the collages of the Lichtenstein postcards are not in themselves humorous, but the reactions of Butor's naive speaker produce a different humor, ironic and satirical.

Alechinsky's artworks are very often themselves humorous, but Butor's texts only infrequently reflect the humor in a lighthearted tone. Even without Butor's texts the *Test du titre* pictures seem comical, as the large majority of the responding writers and artists would agree. From them Butor drew satire, irony, again based on incongruities. In the *Stances* only the artwork of Mr. January is itself amusing, and the narrator Butor created from that drawing supplies most of the the humor in these texts with their ridiculous footnotes. The drawing of the *Méduse* might seem comical with her four eyes, but the text is not. The engravings of the *Ammonite* are puzzling, but the Great Greenish and the metamorphosis of the spiral-tongued clerk have generated humor, often "black," in the text. The just recognizable and not comic flowers are certainly the source of the debts and penalties listed by the clerk, which are humorous in their incongruities and absurdities, but finally become grim and terrifying. The images of the *Comptines en blanc et noir* with their distorted forms and faces plastered confusedly on the maps could seem amusing (with the exception of Alexander), but the

humor of the texts is sarcastic, sardonic and "black." The *Chien roi* engravings are themselves neutral, but there are elements of satirical humor in most of the texts, particularly in the speech of the narrator of the *Sphinx en chapeau* as she recounts her absurd revision of the tragedy. The artworks of the *Dessins,* then, are all amusing in the use Alechinsky makes of the support, as even *Charronage,* with its severed head, utilizes wheels for eyes in the figures. The derived texts offer, among the very serious ones, all varieties of humor, puns, farce, parody, in exaggerated hyperbole and litotes, the startling incongruities, and much "black" humor.

Thus, based on the one collaboration with Monory, we could conclude that Butor's use of humor (or not, as in his case) corresponds to that of the artworks. However, in collaborations with both Kolář and Alechinsky, the humor of the texts varies widely. Nothing in Kolář's artwork provoked the narrator's finding the metro "comfortable" in *l'Opéra d' automne,* and in Alechinsky's artworks nothing in the *Ammonite* would have generated the "amoeba costume" nor in the *Chien roi* the onions that are cooked according to the day of the week. We can see that most often the presence of humor in Butor's collaborative texts is determined by its appropriateness in the text rather than by the artwork.

As to Butor's "political" statements, again with only the single collaboration to consider, Monory's presentations of the United States have definitely enabled Butor's poems reflecting our racism, violence, consumerism, and alienation. The political topics that appear in the Kolář collaborations reappear in Alechinsky collaborations, together with additional topics not in Kolář. In the collaborations with both artists, Butor sets forth his resistance to oppression, by the rich of the poor, and by men of women. His enthusiastic support for the conservation of nature, especially the protection of animals, is a frequent topic in the collaborations with both artists. The works of both have generated statements against war, although the collaboration with Kolář, *La Reine des neiges* allows for the possibility that war might be a necessary evil to bring an end to lies. With both artists we find texts speaking against lies and deception, including with Alechinsky the texts representing the evil of gossip, so often founded on lies. The distortion of religious practices is mentioned in one Kolář collaboration, more often in Alechinsky. Protests against institutionalized wrongs appear primarily in the Alechinsky collaborations, in the treatment of the Academy, lawyers and the judicial system, and the "traditions" supported by the universities. The variety of topics in the Alechinsky collaboration of *Dessins* allows for extensive coverage of our whole society, seen to be unjust, cruel, and motivated by self-interest. Suggested in the Kolář collaboration, *Vagues des villes*

éclosion the precept to help others is forcefully expressed in the Alechinsky collaboration, the *Ammonite.*

Identifying political force in these texts may be more subjective than a scholar likes to admit. Many critics have spoken of Butor's wanting to make the world a better place, the whole world, for everyone, everything in it, and there may be readers and scholars who do not agree with Butor's political statements, who are not concerned with the plight of the exploited or with the destruction of nature, native populations, innocents of all species, including insects. Those readers and scholars may not find Butor's *De toutes parts* political at all, as who cares about caged birds? But I read those birds as among the unjustly imprisoned of the world. One of Butor's tenets I expect readers and scholars would all accept is his indomitable hope. In the Monory collaborations we can see that even in the United States, otherwise a broken dream, a nurse cares for a child, and someone is concerned for the disabled. In the *Ballade des froissements du monde* Butor saw the "newborn savior" (36) in Kolář's collages, which we recognize as art, bringing hope, and in the midst of the strife there is finally a kiss of peace. Again and again in the Alechinsky collaborations we found art as the salvation of the world, and even in the threatening nightmares Alechinsky's work has evoked, Butor persistently gives us hope, for a new year's datebook, for those who dare to and will say "no," for the end of industrial greed. The means to the hoped-for end are most patent in *Dessins,* but underlie Butor's whole oeuvre: art must be and is the answer. Resisting the destructive forces all around us, his own art is the outward and visible sign of that hope.

FURTHER STUDY

This study has confirmed a need that Butor scholars already know very well: the need for a compendium of his complete works. It is of course very possible to study the texts standing alone without the artworks, as the enormous quantity of critical literature demonstrates, and those texts are available, some more readily than others. However, examining the collaborations as a whole, artwork and text together, can pose frustrating problems, since the intact works are not always readily accessible. Still, the experience of reading and seeing the complete collaboration is invaluable. If we have seen Monory's serigraphs, we still see them in our mind as we read *Boomerang;* if we know the Kolář and Alechinsky artworks, we still see them as we read *Matière de rêves I* and *II,* and we probably ourselves dream differently, or as Butor would hope, better. For the scholar determined to follow the process of Butor's

composition, the desired compendium would have to include reproductions of the artworks, preferably in color, with recordings and scores of the music, a computerized database for construction of concordances, and some wonderful futuristic collection of the "book-objects," "artists' books," and sculptures, all constantly updated as he continues to publish.[2] A bibliography of the critical literature published in all the many languages would be a useful appendix. At this time, the William J. Jones Rimbaud-Butor collection, with its indispensable catalogue by F. C. St. Aubyn, at the Southwest Missouri State University Library is the most complete in the United States. The Internet connection to our own Library of Congress is already in place, and it should not be too far in the future that scholars in the United States will be able to access the Bibliothèque nationale including the new Mitterand library, the Bibliothèque municipale de Nice, as well as the Centre de documentation of the Pompidou, and the library of the Université de Québec at Montréal. Until the complete works and the Internet access become available, travel is inevitable. Butor would approve.

Second, since writing about these texts written with visual artists is not easy for the literary scholar, trained in a different discipline, one must hope that critics of the visual arts will not only be kind enough to point out any incorrect statements made here, but also will be interested in participating in this endeavor. The explanations by Butor, Butor/Sicard, and sometimes the artists themselves about techniques and media enable the reader to appreciate the different effects, but the expert in visual art willing to provide a kind of apprenticeship, teaching how to paint photographs, cut up reproductions of paintings into tiny squares, select old maps and splash water on them—just for these three artists—would do literary scholars a great service. Then, art experts could address the visual artists' use of self-citations. Monory recycles his own previous works in different arrangements; Kolář uses the same frames, such as Piero della Francesca's *Federico II de Montefeltro,* in intercollages with different interiors; Alechinsky's serpent makes an eternal return, as does his mysterious spoked wheel. Do these recurrences, from the point of view of an art expert, achieve the same effects as Butor's, of demanding recognition of the existence of an infinity of possible combinations, each with a different meaning? Then, the study of collaborations in which the text preceded the artwork reveals more about the visual artist's work than about Butor's. Surely art experts must want to take up the torch. A number of texts exist to which more than one artist has responded: these would seem irresistible to those expert in the works of one or more of the artists. Collaborative studies by a pair of scholars would seem most appropriate to the back-and-forth collaborations,

which speak equally to both art and literature experts. Even without art experts to hand, the Butor scholar cannot afford to set aside text-first collaborations, lest he miss something marvelous that the visual artist found in the text.

Finally, this study has uncovered many areas demanding further study unrelated to the artworks: details, comparisons, and questions promising to require extensive responses. One of Butor's use of Kipling would be a relatively possible endeavor. We need a comparative study of the effect of the variants between the *Bicentenaire kit* and *Boomerang,* including the punctuation, which has been omitted here unless it evidently affects the meaning, but which Butor has regularly altered along with capitalization—he is not wont to make changes without reason. The effect of the original *Stances* versus the republication in *Illustrations IV* needs to be examined. I would like to know the source of the Archevêque de Melun-sur-Yèvre in *Dessins,* and whether there was originally a twentieth artwork. Butor's "*méchantes*" [naughty] translations of the American Founding Fathers should be examined, preferably by a historian, and perhaps also those of the Mormons and Hilton, much cited in the *Bicentenaire kit.* The matrix of the text of *Musique de la chambre noire* needs to be deciphered and its relation to the photographs of Villers explained. The opera libretto of the *Procès du jeune chien* needs consideration relative to the use of the *cent phrases* in *Matière de rêves* as well as in the *Dialogue avec Charles Baudelaire* of *L'Oeil de Prague,* and should be treated by a music expert as well. *Le Test du titre* needs to be studied by a combination of experts in all the authors and visual artists together.

It may seem that further work on Butor's collaborations cannot be properly carried forward without a throng of eager art experts in attendance, to whom must be added psychologists and philosophers of perception, since we have ever with us the recognition that assigning meaning to lines, colors and forms is a subjective affair. Given Butor's interest in modern science and his firm foundation in mathematics, we need to be prudently prepared for his possible invention of a new kind of collaborative genre with mathematicians and physicists and thus should invite specialists in those fields as well. Once all varieties of experts were assembled, we could hold a faculty meeting, which would result in the usual squabbles. Butor, with his long experience in academe, could have a wonderful time creating text with fragments of the ensuing speeches. Alternatively, suppose we could coax our artists into the meeting. Monory could take a group photograph, tint it blue and add blindfolds, arrows and endless numbers. Kolář might make his collage from Daumier and George Grosz with interspersed Escher, perhaps *Convex and Concave.* Alechinsky would use as support an antique diploma with Latin calligraphy and paint on it mushroom-like figures and, of course, his serpent. If Butor were to be moved by these artworks to create a text, to shine his light through these prisms, what rainbows would dance over the assembled faculty! Their beauty would bring peace to the gathering.

If any reader discovers these collaborative texts to be not only readable but utterly captivating and comes to see in them what Butor does—the future of literature through the breakdown of boundaries among the arts, the salvation of the world through effecting change in the way people think, and thence to changing our governments—then this study will have been worthwhile. It is futile to put out a call for Butor scholars of the world to unite, for the number of approaches to these works would be as different as the scholars themselves, which Butor would approve. United or not, we have nothing to lose but our complacence. I long to read what other scholars may say about the collaborative works.

Appendix A. Monory: Variants, *Bicentenaire kit* to *Boomerang*

The "tranches" listed in *Retour* reproduce the "Catalogue" of the *Kit*, in order and clearly identifiable, to enable the reader to follow without a *Kit*. Variants fall in several categories:

Format. In *Boomerang*, items are not referred to by number, as in the *Kit*, but labeled by title, beginning and ending with the ($) signal. Typography, font, and punctuation are altered as necessary.

Throughout, the unnumbered parts of the *Kit* are signalled as if they followed one another directly: "people ($)BICENTENAIRE KIT($) things" (101) and "things ($)BICENTENAIRE KIT($) interlude" (110).

The Franklin citations or cross-stitch aphorisms are separated by the ($)BICENTENAIRE KIT($) signal from the texts with which they originally appeared.

Factual Corrections. Minor, probably printer's, errors are corrected, such as the date of Madison's death (1836 rather than 1936), the number of states in the Union under Cleveland (thirty-eight rather than forty-four) and Harrison (thirty-nine rather than thirty-eight).

Style. Changes are made to avoid repetition, to omit unnecessary words, to substitute a more precise word.

Two such variants in the offprint from *Critique* are particularly interesting: Butor's translation into French of Duchamp's *In Advance of the Broken Arm* was originally "*avant le bras cassé*." In *Boomerang* it has become "*Avant la fracture du bras*" (#37, 271 in the offprint; 176). Then with the change of audience, "*s'appellent en français*" in the *Kit* has become in *Boomerang* "*chez nous*" (#37, 291 in the offprint; 273).

Omissions. Throughout, translations from French to English are deleted.

The sections drawn from *Mobile* in #11, "*Nappe des présidents*," are considerably abridged (46–48, 97–101).

In "*L'écorce du coke, même, écrasé*" (#22, 111) a reference to #27 "*l'Appel urgent, blues*" is omitted, as also in "*Timbre-poste, même*" (#35, 172) a reference to "*New York en globe, même, fragile*" (#23, 111) has disappeared.

From a letter from Butor to Lebaud of 8 May 1974, this statement has been deleted: "*le problème pour moi étant de trouver des choses suffisamment nouvelles par rapport à MOBILE*" (#38B, 354).

In the acknowledgments, mention of objects in the box that do not, obviously, accompany the book, are omitted (349).

Additions. To accommodate the changed format, the name of a cited author, the "signature," is inserted within the citation to correspond with the other sections of *Boomerang*.

A description of the box, unnecessary for the reader who had the *Kit* in front of him, has been added (#2 "*Boîte, fabrication*" 33).

A reference is added in #17 "*Stickers antagonistes, mêmes*" to the dollar bill contained in the box (109).

After the original "*Déclaration d'Indépendance*," listed in the *Kit* in #32F, "*Authentic facsimile memorabilia, même*," is added the translation, "*nous tenons pour évidentes ces vérités: que tous les hommes ont été créés égaux*" (171). Butor seems to have wanted to assure the irony was understood by an audience not necessarily familiar with the text.

To #37, the offprint, is added regarding the stamp, "*reproduction interdite*," that "*Finalement le tampon n'a pas été imprimé*," since the offprint would have appeared after the completion of the *Kit* and before *Boomerang* (175).

A whole new descriptive phrase is added in *Boomerang* in #41B "*Jeu de cartes*," where Chateaubriand appears in the signature: "*un gentilhomme breton les cheveux en bataille*" (364).

The simple reference in #41E "*Jeu de cartes*" in the *Kit* is elaborated in *Boomerang* to a description of the toy map made in Hong Kong: "*Permettant de défaire et refaire, par le glissement de ses carrés, la carte actuelle des Etats-Unis*" (423).

In #44, "*Six masques de carton léger, fabrication*," (the description of the Shalako dances), names of colors are moved and repeated to compensate for the uninterrupted typography of *Boomerang* (427–30). To the end, "*chemise noires et des rubans jaunes, turquoise, rouges et blancs*" is added in *Boomerang*, "*ainsi pourrez-vous vous sentir*," and the text moves on to the next "blues" poem (430).

In #49, simply "*Ceci*" in the *Kit*, there is added in *Boomerang*, "*Voici ce qu'il y avait sur sa dernière page:*" preceding the usual acknowledgments.

The three *Mobilis in Mobile* of *Boomerang,* identified in *Retour,* differ greatly from the *Kit.* As mentioned above, the #11 "*Nappe des présidents*" (46) is much abridged in *Boomerang. Mobilis in Mobile 2* and *3* do not appear in the *Kit* and are not signalled by the usual italics, capitals and ($). *Mobilis in Mobile 2* (366–68, 417–18) begins at the end of #41C and ends at the beginning of #41D (418). *Mobilis in Mobile 3* (418–23) begins at the end of #41D and ends at the beginning of #41E.

The six "*rêves bleus*" of *Boomerang,* numbered "0" in *Retour,* which relate to black or red sections of *Boomerang,* do not appear in the *Kit.*

Appendix B. Monory: Serigraphs

The numbers are those of the corresponding poem in the "Catalogue" of the *Kit,* followed by its page number. Serigraphs included here are indicated by *; reproductions of some may be found, as detailed, in these sources:

Bailly, J. C. "*Monory ou le goût du catastrophe.*" *Cimaise* 133–34 (November 77–January 78): 54–63.

Clair, J. "First Issues of the World Catalogue of Incurable Images" (review of Monory expo.). *Chroniques de l'art vivant* 52 (October 1974): 29–31.

Jouffroy, A. "*Une certaine exigence traverse la douleur et le rire.*" *Derrière le miroir* 227 (January 1978): 2–28.

Lascault, Gilbert. "*Les Images incurables de Jacques Monory.*" *XXe siècle* 36.43 (December 1974): 182–83.

"Monory: Made in U.S.A." Paris: *Galerie-jardin des arts; revues et publications* 154 (January 1976): 32ff.

Stephano, E. "Masked Reality." *Art and Artists* 9.3 (June 1972): 28–33. See also La Mothe, J. "*American Holiday: Jeux de sociétés.*" In M. Calle-Gruber, *Butor et l'Amérique.* Paris and Montreal: l'Harmattan, 1998. Notes 4, 5, 6.

* 1. *Tombée de la nuit, blues,* 12

 3. *La famille du meurtrier, blues,* 14
 Clair, *Image incurable #25* (upper segment)
 Jouffroy, *Technicolor #7* (array of guns similar but not identical to lower segment of *La famille*)

* 6. *Les figurantes de Washington, blues,* 21

 9. *Hopper's land, blues,* 28
 Jouffroy, "Technicolor #11" (background house similar but not identical)

 12. *Les détails de Miss Liberty, blues,* 41 (described by Monory in Stephano 31)

*15. *Sous le couvert, blues,* 47

 18. *Les éventails de l'autoroute, blues,* 50
 Galerie-jardin des arts, Made in USA (entire)
 Stephano, *USA 31 1974* (upper segment, super-highway)

 21. *Dans l'antre de la panthère noire, blues,* 53

 24. *La rue mur, blues,* 59

*27. *Appel urgent, blues,* 63

 30. *Souvenirs de l'Ouest, blues,* 68

 33. *L'instruction publique, blues,* 73
 Clair, *Image incurable #6* (scene on screen and audience altered)

*36. *Balistique, blues,* 76

 39. *La foule en ruines, blues,* 80
 Clair, *Image incurable #5*

 42. *Les aveugles, blues,* 85
 Bailly, *Image incurable #10* (uncropped)
 Clair, *Image incurable* (uncropped)
 Lascaut, here entitled *#11, Institut de Technologie, Massachusetts*" (uncropped)
 Stephano 32 (uncropped)

 45. *Les jeux du hasard, blues,* 90
 Bailly, *Déposition #2* (lower segment only)

 48. *Fauves d'intérieur, blues,* 94
 Bailly, *Image incurable #30* (uncropped, screens in prison)
 Clair, *Image incurable #15* (woman with cat and trophies) and *Image incurable #24* (possible source of monkey)
 Lascault, here called *#23, Conscription 1917, USA,* same border of monkeys as above

*50. *Le diamant du large, blues,* 96

Appendix C. Kolář: Variants

Variants are listed alphabetically by the earlier work used in this study. In all cases there are minor editorial changes in punctuation, mentioned only if they affect the meaning.

Ballade des froissements du monde. Exprès: Envois 2 to
 L'Oeil de Prague

The *Ballade* appeared originally in *Exprès (Envois 2)* with an introductory paragraph (11–13), which is divided in *L'Oeil de Prague* between the Explicator and Organizer (71–72). In this introduction there are two variants: *"se soulever comme une foule"* in *Exprès* becomes in *L'Oeil de Prague* *"se soulever comme une houle, comme une foule."* The *"foule"* of the original may well have been a misprint that Butor decided to keep. The other variant is from *"pourra reconnaître"* in the original to the more positive *"reconnaîtra."*

In the poem itself there are only two variants: *"le tabac"* in *Exprès* becomes *"les tabacs"* in *L'Oeil de Prague,* and *"le cuir"* in *Exprès* is converted to a very different aroma in *L'Oeil de Prague:* *"le lard cuit."*

Cartes postales pour un ami de Liechtenstein to *Avant-goût*
 IV

The four Lichtenstein postcards written in collaboration with Kolář are set in *Avant-goût IV* throughout the book, in an order intermingled with four written with Gregory Masurovsky:

JK: *Le Beau burg* (9),
GM: *Château de Vaduz* (31)
JK: *Château noir* (63)
GM: *Eglise à Bendern* (89)
GM: *Vallée de Samina* (123)
JK: *L'Opéra d'automne* (149)
GM: *Vaduz* (177)
JK: *Triomphe de la vallée* (205)

There are a few variants:

Cartes Postales		Avant-goût IV
Le Beau burg		
on atteint une certaine altitude	9	on atteint certaine altitude
altitude, délivré		altitude, alors délivré
locomotives, de la rumeur		locomotives comme de la rumeur
ce qu'on entend alors c'est le cri		ce qu'on entend, c'est le cri

Château noir		
dans les bals ou les théâtres	63	dans les bals et les théâtres
feux d'artifice qui illuminent		qui éclaboussent
L'Opéra d'automne		
virages à peine éclairés	149	éclaircis
un lumignon protégé		un lumignon abrité
protégé dans quelque niche creusée dans la paroi		abrité dans quelque anfractuosité de la paroi

Triomphe de la Vallée		
changeant l'éclairage	205	changeant d'éclairage
avantage qu'on peut		avaantage que l'on peut

Chantier (1985) to *L'Oeil de Prague* (1986)

Included in the first section of *Chantier, Inscriptions pour Jiří Kolář,* are all the poems read by the Singer in *L'Oeil de Prague* except the *Ballade des froissements du monde.* There are very few variants, although of course in *L'Oeil de Prague* the poems are interrupted frequently by the other speakers. In *Chantier,* in *Le Page, "jus d'orange"* (13) becomes in *L'Oeil de Prague, "jus d'oranges"* (13–14). In *Chantier* the third stanza of *Toilette nocturne* ends with *"la clef des âmes"* (14), which in *L'Oeil de Prague* maintains the same expression used throughout that poem, *"la clef des dames"* (20). In *Chantier, "Qui commencent à poser leurs teintes"* (21) has a printer's error in *L'Oeil de Prague: "Qui commence"* (53–54).

The *Anatomie illustrée* is set differently in *Chantier* (18–20). The subtitles are set above the various sections, whereas in *L'Oeil de Prague* they are included in the Organizer's speeches. In *Chantier,* the sections run #1–18, #19–31, #32–38, #39–44, #45–48, #49–54, #55–58. In *L'Oeil de Prague* #32–38 are moved to fall between #18 and #19, and the subset title, *Le contenu du gant,* is moved to correspond (44). In *Chantier* the last three subtitles are set before their sections: *La bouche de la Méduse* precedes #45–48; *Respiration en montagne* precedes #49–54; *L'intérieur de la vue* precedes #55–58; in *L'Oeil de Prague* the three are combined before #45 (46).

In *La Reine des neiges* in *Chantier* (26), the lines that did not appear in the artwork in *Métaphores* are all present: stanza 2, line 4: *"Duvet de supplices bracelet de plaies,"* stanza 3, line 3: *"Les remparts deviennent marées les empires torrents,"* stanza 3, line 4: *"Dans le gouffre entre ses jambes s'effondrent les mensonges,"* and these lines are maintained in *L'Oeil de Prague.* The reading of the original, *"Reposer un*

instant la tête dans le creux qu'elle cache," is maintained in *Chantier,* but clarified in *L'Oeil de Prague: "sa tête"* (66).

The *Cent phrases pour les éventails d'Arnold Schoenberg* appear in *Chantier* (53–59), included in the second section, *Inscriptions pour Gregory Masurovsky,* but set separately. In their original publication in the libretto of the opera written with Henri Pousseur, *Petrus Hebraicus ou Le Procès du jeune chien,* the *Phrases* are collected at the end in the same order (61–64). However, the libretto specifies that the actor may replace given sentences by others at will (38), and some of them occur in the text of the libretto itself (for example, 57).

There are three variants, one clearly a misprint, as #38 *"Ne déclineront point l'hoirie d'antan"* remains the same in *Chantier* before becoming: *"Ne délineront point"* in *L'Oeil de Prague.* Second, #73 *"Plus du moins"* becomes *"Plus ou moins"* in *Chantier* before returning to *"Plus du moins"* again in *L'Oeil de Prague.* Third, #82 *"leurs syntaxes"* becomes *"leur syntaxe"* in *Chantier* and finally *"la syntaxe"* in *L'Oeil de Prague.*

"Opusculum Baudelairianum" in *"Hommage à Baudelaire"* exposition catalogue to *Répertoire IV* (1974) to *L'Oeil de Prague* (1986)

There are three deletions and one printer's error between the exposition catalogue and *Répertoire IV:*

Catalogue	Répertoire IV
II. L'Homme et la mer	
reprenant à peu près exactement le premier	reprenant à peu près le premier (238)
IV. Le Voyage	
en un cercle parfait	en un cercle (240)
V. Réversibilité	
flux grammatical, j'ai du	j'ai dû (241)
modifie considérablement leur musique	modifie leur musique (241)

The original is followed by a German translation of the whole.

Variants in the layout occur from the Catalogue to *Répertoire IV* as there are no type size changes in the former. In *Répertoire IV* the *"Mon cher ami"* letter (read by the Letter-Writer in *L'Oeil de Prague*) is set in the same size type as the Baudelaire quatrain variations. In the Catalogue the *"Mon cher J.K."* letter (read by the Combiner in *L'Oeil*) is set in larger sized italics throughout. There is one printing error: the Baudelaire quatrain *"O boucles"* is printed in italics along with the preceding segment of the *"Mon cher J.K."* letter (240, L'Oeil 39).

In *L'Oeil de Prague* some additional illustrations are provided by the Combiner to clarify the process of creating the variations. Butor cites the original Baudelaire stanzas from *Le Balcon,* and *Moesta et errabunda* (21–22), *Harmonie du soir* (36–37), and *La Chevelure* and *Flacon* (39), adjusting the introductory lines from the *"Opusculum"* appropriately. A second variation is added utilizing *La Chevelure* and *Flacon: "Du passé . . . vertige"* (39). The Baudelaire lines re-

ferred to as inverted when repeated (29–30) are cited unchanged. Then an additional set of three quatrains entitled appropriately *Revenant,* appear at the end (77–79). The first new quatrain contains two lines from the third variation at the beginning of the work (16), using Mason's abbreviations: BHFB. The second is the same as the first variation (14) except the first line, which is from *Harmonie du soir* instead of *Moesta et errabunda:* HMBM. The third and last is identical to the second variation: BMBM (15). The final verbatim repetition on page 79 of the *"Mon cher J.K."* letter (15–16) does not appear in the *"Opusculum."*

There are two other variants from *Répertoire IV* to *L'Oeil de Prague,* to accommodate the new context: The *"à l'aide du quatrain supplémentaire"* in *Répertoire IV* (241) becomes *"à l'aide des quatrains supplémentaires pour 'Harmonie du Soir'"* (50), and *"une intervention au lecteur"* in *Répertoire IV* (241) becomes *"une intervention à l'ordonnateur"* (50).

Le Rêve de Jiří Kolář in *Coloquio/Artes* to *Matière de rêves II (Second Sous-sol)* to *L'Oeil de Prague*

In the original version in *Coloquio/Artes,* the Baudelaire citations are not transformed and are limited to one to three lines long. Each is from a different poem: *La Masque* (5), *Bénédiction* (6), *Moesta et Errabunda* (8), *Hymne à la Beauté* (10), *Métamorphoses du vampire* (11), *Parfum exotique* (12), *Spleen et Idéal* XXVII, incipit *Avec ses vêtements ondoyants et nacrés* (12), *L'Irréparable* (13), *Les bijoux* (14). These are not identical to those in *"l'Opusculum Baudelairianum."*

The text of *Le Rêve de Jiří Kolář* is dispersed throughout *Matière de rêves II,* with delightful variations: for example, the white horseman becomes a blue horseman (MR 24), and shortly thereafter, the violin also turns blue (MR 25). However, integral citations begin in Chapter II, *Le Rêve des pommes,* and are most useful for verification of Butor's true variants as opposed to printer's errors. Regularly in *Le Rêve des pommes,* the text used is the same as in *Le Rêve de Jiří Kolář,* and the Baudelaire citations are the same. Throughout, obvious printer's errors in *Le Rêve de Jiří Kolář* are corrected, together with grammatical clarifications and other very minor changes. The only substantive variant is: *"la manche courte"* of the cutting-board becomes a *"manche de corne."* Kolář's chopping-board does indeed resemble an old-fashioned "hornbook," with its connotations of one-room schoolhouses, a much more vivid description than simply "short."

Le Rêve de Jiří Kolář		Matière de rêves II	
5, col. 1	je n'arrive pas encore à saisir les puits d'écriture Telle un courant d'air	57	je n'arrive pas à saisir un puits d'écriture tel un courant d'air
col. 2	confortablement affalé la voix de la dame calmement	58	confortablement installé la voix de la dame profère calmement

	se soient débouchées	59	fussent débouchées
6, col. 1	une hotte de vignerons		une hotte de vigneron
	le collier un galon doré de col d'homme ancien	60	le collier le galon doré d'un col
	énorme mugissement d'eaux	61	énorme mugissement d'eau
6, col. 2	nouvelles criques et de nouveaux nuages		nouvelles criques ou de nouveaux nuages
	leurs artichauts, leurs salades ou leurs pommes	62	leurs artichauts, salades ou pommes
7, col. 1	quatre planchettes du fond	62–3	quatre planches du fond
7, col. 2	Telle un courant d'air	64	Tel un courant d'air
9	Tout autour les pics	65	Tout autour, des pics
10, col.1	plumages, gréments	69	plumages, gréements
col. 2	La cantatrice n'en croit ses yeux	70	La cantatrice n'en croit pas ses yeux
12, col. 1	Telle un courant d'air	73	Tel un courant d'air
	elle est tout entière faites d'une peau de neige		Elle est tout entière faite d'une peau de neige
col. 2	lamelles de verre mobile	83	lamelles de verre mobiles
	réaliser des travestis		réaliser leurs travestis
13, col. 1	un miroir rectangulaire à manche court	89	rectangulaire à manche de corne
14, col. 2	Les garde-françaises me saississent	98	me saisissent
	que je leur abandone		que je leur abandonne

62–63	quatre planches du fond		quatre planchettes du fond
63	d'une matrone calmement étendue dans sa mort, d'un géant enlevant une sabine géante, leçon d'anatomie du professeur Tromp		étendue dans sa mort, de la Leçon d'anatomie du Professeur Tulp
	courtaud, appuyé sur sa cane	25	courtaud, appuyé sur une cane
	Le sol est comme articulé		Le sol est articulé
	je glisse de côté ou d'autre		je glisse de côté et d'autre
64	échancrures-poches sous les bras	30	échancrures-poches sour [sic] les bras
69	sapins bleus, verts et pourpre dans la neige de cuivre. Un lâcher d'oiseaux-barres au dessus des terrasses d'émail	42	pourpres au-dessus des terrasses d'émail
70	de la tour de l'horloge à demi englouti sort une élégante	47	de la tour de l'horloge sort une élégante
	célèbre en un aria	49	célèbre dans un aria
73	Je joue dans une felouque, je glisse le long d'un Nil de notes. Passe une longue barque à multiples rameurs. Tout est aminci. Une touffe de papyrus comme dans les tombes de l'Ancien Empire.	52	Je joue dans une felouque, je glisse au Je joue dans une felouque, je glisse au papyrus comme dans dans les tombes de l'Ancien Empire.
	commentent de leurs froissements	55	commentent de leurs froissement
78	la ruelle Kotec	56	la ruelle V. Kotcich
	place Wenceslas	57	place Venceslas
	il monte de cette pomme		il s'élève de cette pomme
	il monte de ces ruelles		il s'élève de ces ruelles
	la cathédrale de Saint-Vit		la cathédrale Saint-Guy
	les serrures s'ouvrant	58	les serrures s'ouvrent
82	la vitre de la boîte se délite en menues lamelles	63	en minces lamelles
	avec un léger ronflement		avec un léger sifflement
83	lamelles de verre mobiles	64	lamelles de verres mobiles

The variants from *Matière de rêves II* to *L'Oeil de Prague* are almost exclusively new printer's errors. The most grievous is certainly the various omissions. Then, probably a deliberate change, the *"je connaîtrais"* of the last lines becomes *"je connaîtrai."* Through this change, the Dreamer moves from a conditional state to a determined certainty.

	Matière de rêves II		*L'Oeil de Prague*
57	je respire les bribes	12	je respire les brides
61	une colonne de brumes	18	une colonne de brume
62	sont taillés eux aussi dans la matière	24	sont taillés dans la matière

90 à un poteau, plongé
 jusqu'aux genoux
 dans l'eau des sous-
 bois, c'est encore
 moi que je rencontre

70 poteau, c'est encore
 moi

98 que je caresse ces
 chiens

99 en te mâchant, je
 connaîtrais

78 que je caresses ses
 chiens

80 je connaîtrai

Appendix D. Kolář: *Le Rêve de Jiří Kolář* Matrix

Schema of contents of phases of *Rêve de Jiří Kolář*

The names given to collages as suggested by the text are here set in boldface. Those not available in *Coloquio/Artes* are indicated by brackets. Three collages that are not reproduced here for other reasons are indicated by braces.

"A" repetitions are set flush left, on first appearance page numbers of subsequent repetitions are given; on later appearance each is identified only as A1, A2, etc.

The "B" matrix items are numbered.

My notes on particular items are given in braces.

A printer's error on p. 52 of *L'Oeil de Prague* that duplicated one line (*Je joue dans une felouque, je glisse*), and added an *au,* omitted two of the repetition lines. Both are found in *Coloquio/Artes* and also in *Matière de rêves II* (71, 73). Thus the passage should read, *"un Caire en paix, serait-il possible? Je joue dans une felouque, je glisse <u>le long d'un Nil de notes. Passe une longue barque à multiples rameurs. Tout est aminci. Une touffe de</u> papyrus comme dans les tombes de l'ancien Empire."* The omitted portion is here underlined.

Opening (9–12)
Pluie de presse [Rain of Printed Matter]
(A1) *Je suis sous une pluie de presse* [I am under a rain of printed matter] 9, 18
(A2) *Dans mon miroir-lit de supplices, je capte l'approche d'un désert, oasis de calme et soulagement* [In my mirror-bed of tortures, I intercept the approach of a desert, an oasis of calm and relief] 10, 71
　　—*le feu couve* [fire smoulders]—

Phase 1 (14–19)
Dame d'antan [Lady of Yesteryear]
(A3) *Tel un courant d'air passe une dame d'antan: je l'ai déjà vue quelque part.* [Like a breath of fresh air passes a lady of yesteryear: I have already seen her somewhere.] 14, 29, 55
(A4) *Puis on transforme encore le dispositif en détaillant chacune des lamelles de verre en petits carreaux.* [Then they transform the devices again by cutting up each of the glass slides into little squares.] 14, 68
(A5) *Ce n'est qu'une ombre de profil, mais je reconnais son chignon, son collier, son nez;* [It is only a shadow in profile, but I recognize her chignon, her necklace, her nose;] 14, 55
　　{Only here do three "A" repetitions appear in sequence.}

"B" matrix:
1. *au moment où je pénètre en ce profil* [at the moment that I penetrate in this profile]
　　{After this phase *"au moment où"* becomes *"tandis que."* In these phrases the Dreamer always interacts with the Lady.}
2. *la voix de la dame profère calmement* [the voice of the lady utters calmly]
　　{This phrase always introduces a Baudelaire quatrain; other quatrains appear in many other locations.}
3. *tous les musées du monde s'écroulent par plaques* [all the museums of the world collapse by slabs] *variable: musées* [museums]
4. *tandis que mes semelles de papier frottent sur le granit humide* [while my soles of paper rustle on the damp granite] {To Phase 4}
5. *les coups de canon lui répondent* [the cannon booms reply to her] {repeated verbatim throughout}
6. *tandis que mes doigts diaprés chiffonnennent les tulles* [while my mottled fingers rumple the tulles] {To Phase 7}
7. gift: test-tube rack
Menu meuble [Little Test-tube Rack]
(A6) *Au tournant de la rue un énorme mugissement d'eaux, des vapeurs.* [At the turn of the street, an enormous roaring of water, vapors.] 18, 25
(A1) {In all succeeding cases, the second "A" of this second pair in a phase repeats the first "A" of the second pair of the preceding phase.}
Mugissement d'eaux [Roaring of Waters]
　　—*la nuit couve* [night smoulders]—

Phase 2 (21–27)
Dame de ce temps-ci [Lady of Today]
(A7) *Longeant tranquillement la chaudière fraîche, une dame de ce temps-ci s'approche.* [Tranquilly walking along the cool boiler, a lady of today approaches.] 21, 36
(A8) *Au détour des moraines d'affiches j'entre dans un salon rococo délavé.* [Winding around the moraines of posters, I enter a faded rococo drawing-room.] 21, 77
1. *tandis que j'entre dans sa robe* [while I enter her dress]
2. *Dame de ce temps-ci* [Lady of today]
3. variable: *bibliothèques* [libraries]
4. *tandis que mes semelles de papier écrasent les fleurs de l'herbe et les pétales tombés* [sic] *dans le grondement*

des cascades [while my paper soles crush the flowers of the grass and the petals fallen in the roaring of the cascades] {To Phase 5}

5. cannon
6. *tandis que mes doigts de papier liquida la décoiffent* [while my liquid paper fingers undo her hair] {To Phase 8}
7. gift: *cageot . . . à artichauts* [artichoke hamper]

 23 **[Cageot à artichauts [Artichoke Hamper]]**

(A9) *Degrés, rochers.* [Stairs, rocks.] 25, 32

(A6)

 25 **Venise [Venice]**

 —*le bruit couve* [noise smoulders]—

Phase 3 (29–34)

 30 **[Elégante au bijou de macramé [Elegant lady with Macrame jewel]]**

(A10) *De la porche de la tour de l'Horloge à demi-englouti sort une élégante* [From the porch of the half-engulfed Clock Tower comes forth an elegant lady.] 29, 47

(A3)

1. *tandis que je pénètre sous ses arcades* [While I penetrate under her arches]
2. Elegant lady with macramé jewel {adds "*la même voix*" [the same voice] continued throughout with one exception}
3. variable: *donjons* [dungeons]
4. *tandis que mes manches de papier frôlent les marbres* [while my paper sleeves graze the marbles] {To Phase 6}
5. cannon
6. *tandis que, filant au vent lunaire qui s'est engouffré, dispersant les lambris, j'arrache les membres de tous les obséquieux* [while, spinning with the lunar wind which has swept down, dispersing the panelling, I tear the members off of all the obsequious ones] {To Closing}
7. gift: clothed apple

 31 **Pomme vêtue [Dressed Apple]**

(A11) *Je la palpe, je la respire.* [I touch it, I breathe it.] 31, 56 {without second *je*}, 80 {In each of its three appearances, A11 has no partner.}

(A12) *Le ciel est tellement noir qu'il paraît blanc.* [The sky is so black it appears white.] 32, 41

(A9)

 32 **{Surface de la lune [Surface of the Moon]}**

 —*le gel couve* [frost smoulders]—

Phase 4 (36–42)

 36 **Reine du cinéma [Movie Queen]**

(A13) *Dans une salle aux murs recouverts d'alvéoles lumineux trône la reine du cinéma* [In a room with walls covered with luminous cells, the movie queen sits in state. 36, 54

(A7)

1. *tandis que je pénètre entre ses lèvres* [while I penetrate between her lips]
2. Movie queen

3. variable: *législation*s [legislations]
4. *Tandis que mon masque de papier essuie l'intérieur de ses lèvres* [While my paper mask wipes the interior of her lips] {To Phase 7}
5. cannon
6. *tandis que mes semelles de papier frottent sur le granit humide* [while my paper soles rustle on the damp granite]{From Phase 1}
7. gift: pipe

 40 **Pipe**
 41 **[Paysage à buée d'ambre [Landscape with Amber Steam]]**

(A14) *Tout est aminci.* [Everything is thinned.] 40, <u>52</u>

(A12)

 —*le glissement couve* [slipping smoulders]—

Phase 5 (47–52)

 48 **Plein opéra [Complete Opera]**

(A15) *Et voici que les triangles deviennent frondaisons.* [And here the triangles become foliage.] 47, 61

(A10)

1. *tandis que je me glisse dans les drapés* [while I slip into the drapes]
2. Opera soprano {"*la voix de la cantatrice, la même voix*" [the voice of the singer, the same voice]}
3. variable: *paysages* [landscapes] {becomes from this point on "*du monde entier*" [of the whole world]}
4. *Tandis que mes doigts dégrafent son corsage* [While my fingers unfasten her blouse] {To Phase 8}
5. cannon
6. *tandis que mes semelles de papier écrasent les fleurs . . .* [while my paper soles crush the flowers . . .] {From Phase 2}
7. gift: violin

 50 **Violon [Violin]**

(A16) *Passe une longue barque à multiples rameurs.* [A long boat with many oarsmen passes.] <u>52</u>, 57

(A14)

 52 **[Le long du Nil [Along the Nile]]**

 —*le tremblement couve* [trembling smoulders]—

Phase 6 (54–58)

 54 **Ville moyenne [Average City]**

(A17) *C'est une ville moyenne: des garages, quelques voitures* [It is an average city: garages, some cars] 54, 68

(A13)

(A3 and A5) {Lady of Yesteryear + chignon line with *peau de neige*}

1. *tandis que je caresse sa nuque avec mon pantalon de papier* [while I caress her nape with my paper pants]
2. Bust with huge eye
3. variable: *murs* [walls]
4. *tandis que je pénètre à l'intérieur de ses paupières* [while I penetrate inside her eyelids] {To Closing}
5. cannon
6. *tandis que mes manches de papier frolent les marbres* [while my paper sleeves graze the marbles]{From Phase 3}

7. gift: apple of Prague

 56 {**Pomme du vieux Prague** [**Apple of Old Prague**]}

(A11)

(A18) *Le temps a passé plus lentement qu'en bien des points du monde, mais beaucoup plus vite qu'en Egypte* [Time has passed more slowly than in many points of the world, but much more swiftly than in Egypt] 57, 63

(A16)

 57 **Cathédrale ivre** [**Drunken Cathedral**]

 —*le fissurement couve* [splitting smoulders]—

Phase 7 (61–65)

 62 **Orgue de pieds et de bras** [**Organ of Feet and Arms**]

(A19) *A l'intérieur les premières communiantes virevoltent, leurs robes teintes dans les fibres des vitraux* [Inside the first communicants turn around swiftly, their dresses dyed in the fibers of the stained-glass windows] 61,77

(A15)

1. *tandis que je me recouvre de battements pastel* [While I cover myself with pastel battements]
2. Face dimly seen in organ
3. variable: *frontières* [frontiers]
4. *tandis que mes doigts diaprés chiffonnent les tulles qui gonflent dans la nef* [while my mottled fingers rumple the tulles which swell in the nave] {From Phase 1}
5. cannon
6. *tandis que mon masque de papier essuie l'intérieur de ses lèvres* [while my paper mask wipes the inside of her lips] {From Phase 4}
7. gift: box of Japanese butterflies

 62 [**Boîte de papillons japonais** [**Box of Japanese Butterflies**]]

(A20) *La vitre de la boîte se délite en minces lamelles qui vibrent, tournent sur elles-mêmes avec un léger . . .* [The glass of the box splits into thin slices which vibrate, turn on themselves with a light . . .] 63: *sifflement* [whistling], 71: *ronflement* [rumbling]

(A18)

 63 [**Papillons acteurs-danseurs** [**Butterfly Actors-Dancers**]]

 —*la transparence couve* [transparency smoulders]—

Phase 8 (68–72)

 69 [**Springmaid femme-battement** [**Springmaid Fluttering Woman**]]

(A4)

(A17)

1. *tandis que je nage dans ses humeurs* [While I swim in her humors]
2. Springmaid girl + battement-woman
3. variable: *surfaces*
4. *tandis que mes doigts de papier liquide la décoiffent* [while my liquid paper fingers undo her hair] {From Phase 2}
5. cannon
6. *tandis que mes doigts de papier dégrafent son corsage* [while my paper fingers undo her blouse] {From Phase 5}
7. gift: chopping-board

 70 **Planchette à découper** [**Chopping Board**]

 {A "while" phrase occurs on p. 71 that is not a part of the matrix: "*tandis que je pensais me refraîchir dans la piscine*" [while I thought I would refresh myself in the swimming pool]}

(A2)

(A20)

 72 **Stratification**

 —*le baiser couve* [the kiss smoulders]—

Closing 77–80

 77 **Mme de Pompadour**

1. *tandis qu'elle m'essuie dans les flots de son énorme tignasse* [while she wipes me off in the floods of her enormous shock of hair]
2. Mme de Pompadour
3. variable: *impossibilités* [impossibilities]
4. *tandis que, filant au vent lunaire ...obséquieux* [while, spinning with the lunar wind . . . obsequious] {From Phase 3}
5. cannon
6. *tandis que je pénètre à l'intérieur de ses paupières* [while I penetrate inside her eyelids] {From Phase 6}
7. gift: apple of youth

(A11)

 80 {**Pomme de jouvence** [**Apple of Youth**]}

{The elements of this closing could be buckled into those of the Opening to form another symmetrical phase.}

Appendix E. Alechinsky: Variants

Le Rêve de l'ammonite to *Matière de rêves*

The variants in the first appearance are editorial, primarily punctuation with the addition of a number of exclamation points. Fragments of this *Rêve* appear throughout the remaining four volumes of *Matière de rêves,* and any further variants are not covered here.

original: "son cou s'allonge en fumée d'usine"
MR, 46, first appearance (before . . .): no change
in repetition (after . . .): "s'allonge en cheminée d'usine"
Note: in *Travaux,* MS cites it as "cheminée d'usine" (80).

original: "des grosses larmes sirupeuses"
MR, 49, in repetition (after . . .): "de grosses larmes"

original: "toute vertèbre bulbe"
MR, 63: "toute vertèbre bulle"

original: "théorie musicale, de"
MR, 65: no comma

original: "blasphémées, les volcanes"
MR, 65–66: no comma

original: "de sable en fable"
MR, 72: "de sable en sable"

The *Rêve* is not paginated. I have supplied page numbers for readers' convenience, including the *souvenir* pages but not the five primary engravings. The *souvenir* pages fall as follows:

p. 5 the "gaillarde" or "greffière" *pré-* words
p. 11 the crocodile with eyes in his mouth; *con-/com-* words
p. 17 the eclipse; *inter-* words
p. 23 clouds, rain and sea; *dé-* words
p. 29 contented or sleeping ammonite; *trans-* words.

For readers without access to the original, herewith the page numbers and division into paragraphs of *Rêve* and *Matière de rêves:*

Rêve	*Matière de rêves*
L'Arrestation	
p. 2 ¶1 Est-ce l'Islande? . . . de ma pelisse.	39

p. 3 ¶2 C'est alors que le grand verdâtre . . . champignons en symbiose.	39
(pourquoi dit-on "le" grand verdâtre? . . . aussi molles.	40
pp. 3–7 ¶3 Paraît la belle . . . déjà plus grand-chose.	40–41
La tête est absorbée . . . Je transpire dans le froid.	41–42
Elle discourt . . . c'est que ça va mal.	42–43
L'Instruction	
p. 8–9 ¶4 A l'aide d'ingénieuses . . . turbulences du dégel.	45
Si cela se produisait . . . en fumée d'usine.	45–46
son visage s'enfle . . . en forme de yatagans.	46–47
pp. 9–10 ¶5 On dirait de petits volcans . . . n'a rien de rassurant.	7
pp. 10–12 ¶6 Le cou du volcan s'élargit . . . giclant de jus.	47–48
Irrésistibles fumets . . . ses yeux chassieux.	48–49
p. 13 ¶7 Quant à la gaillarde . . . ses dents de putois.	49–50
La Séquestration	
pp. 14–15 ¶8 Tant pis pour lui . . . la dépouille judiciaire.	54
p. 15 ¶9 Elle décolle comme un cerf-volant . . . disparu depuis longtemps.	54–55
c'était la lune qui le remplaçait . . . les rapaces des limbes.	55
¶10 Décharge . . . de plus en plus humide.	55
pp. 15–16 ¶11 Chaque minute . . . jusqu'à la ceinture.	55–56
p. 16 ¶12 Je l'aurais parié . . . La goulue, l'insatiable!	56
elle se régale en remerciant . . . une outre qui va crever.	56–47
pp. 16–18 ¶13 Vomissements . . . un cimetière en gésine.	57
La Précipitation	
(*Note: MR* 61 repetition of "je suis tout un cimetière en gésine," from ¶13 and two lines later, "je gobe les yeux," from ¶8.)	
pp. 20–21 ¶14 Le printemps, vous n'y pensez pas! . . . sifflez des vrilles.	62–63
pp. 21–25 ¶15 Vrilles? Maladroit! . . . que le déluge de poix commence!	63–66

p. 25 ¶16 Je bois les flammes . . . fument 66
 d'émerveillement.
 La Respiration
pp. 26–27 ¶17 Accalmie, le niveau de la mer 68
 . . . fuir, ne plus fuir; l'eau monte
 J'en ai jusqu'à mi-orbite . . . à n'y plus 69
 bien voir.
p. 27 ¶18 Je saute . . . Belles armes par- 69
 lantes.
pp. 27–28 ¶19 Je sursaute . . . ne se mêlent 69–70
 pas à la mer.
pp. 28–31 ¶20 Mes regards télescopiques 70–72
 . . . taillader ma jongle

Le Chien roi to *Matière de rêves V*

In *Matière de rêves V: Mille et un plis* (Paris: Gallimard, 1985), the texts of *Le Chien roi* are preceded by, "*Buffon rêve. Je découvre alors . . .*" followed by the title of the engraving, and the title of the engraving again signals the end of the passage. *Oranges de Binche* is in Part I, 27–29; *Tunnel* and *Papier de mur* are in Part II, 49–50 (where the ending is altered to *Papier sur le mur*) and 53–54. *Rhizome* and *Gueule de proue* are in Part III, 72–74 and 77–79. *Sphinx en chapeau* and *De toutes parts* are in Part IV, 97–99 and 102–104. Finally, the *Chien roi* appears in Part V, 126–29.

There are some variants, primarily editorial, correcting spelling, regularizing capitalization, altering singular and plural, and one clarification ("*mais aussi*") two producing what appear to be errors:

Chien-roi	*Matière de rêves V*
16 Nabuchodonosor en bête	53 Nabuchodonosor en tête
36 murs intérieurs	49 murs extérieurs (lapsus from "extérieurs" in next line)

and two omissions:

27 de le voir enfant se rouler	97 "enfant" omitted.

(I do not believe Butor would deliberately have cut this from his image of the baby Oedipus playing between the Sphinx's paws.)

17 blemmis, pygmées, sciapodes	53 "pygmées" omitted.

(Possibly Butor, defender of indigenous populations, would have removed the pygmies from exotic and legendary company.)

Appendix F: Alechinsky: Text of Special Three-Copy Edition of *Le Rêve de l'ammonite*

Presented here schematically are Butor's handwritten additions to *Le Rêve de l'ammonite,* taken from the copy in the Bibliothèque nationale. Fürstenberger reproduces in her dissertation pages 2 and 38 from the same version, which give an idea of the whole. One can see there, on page 2, which contains paragraphs 2 and 3 of the text, that it is near the end of the tail of Alechinsky's figure in the margin that Butor has written, "*Remarque du maître: confus.*" On page 38, the *souvenir* page in the last part, one sees the Ammonite with eyes closed contentedly, the list of words in *trans-* under its tail to the right, under the list Butor's hand printed capitals of the title, and finally the handwritten *Complainte de l'évadé.* La Mothe's citation of the *Complainte de l'évadé* in *Architexture* (155) is not identical and must come from Butor's or Alechinsky's copy, providing an example of Butor's varying the text to avoid tedium when writing several copies by hand.

Page breaks are indicated by a line of hyphens. The text given was handwritten by Butor in both black and red ink, the red here indicated by italics. His strikeovers are in black, except the last one, which is in red.

Set in brackets are titles, etc., from the original printed text, for identification of the location. The numbers of the paragraphs of text (#—) run down the left-hand side. I have noted elsewhere the reproduction in *Travaux* of two of the primary etchings (the first appears also in La Mothe's *Architexture* (156). Three of the *souvenir* pages are reproduced in *Travaux* also, with their lists of words in *pré, con/com,* and *inter.* I reproduce all five here, with the titles acquired in this edition, to facilitate recognition of their relationship to the new texts, *Comptine* and the four *Complaintes.* (The *dé* list, not reproduced to date elsewhere in its original form, would be difficult if not impossible to recapture from *Matière de rêves.*)

Set in braces is information I have added: the original pages are unnumbered, and I have added numbers as used in my study, in the lower righthand corner. (I have not assigned numbers to the transparent pages, as the numbers of the engravings on the one hand and the lists of words with the same prefix on the other are read in conjunction with the texts on the pages they cover.) My explanatory comments are similarly set in braces.

In the original, the arrangement of the *souvenir* and the lists of words with the same prefix is different in each section. In this special edition, Butor's additions, written on the pages with the *souvenirs,* are also placed to form each time a different pattern as the list on the transparent leaf is superimposed. For example, in *Précipitation,* Butor's new text, *Complainte du condamné* is set above the *souvenir* drawing of rain and sea, and the list of words in *dé-* is set as close to the drawing as it can be.

 Rara Ammonita
 Et l'éditeur? {viii}

 L'encre en est jetée: {ix}

 rajeunie
 Salut coquille ~~d'antan!~~ {x}

 le rideau se lève {xi}

[#1] [L'Arrestation]
 /~~crachat~~/ /---/glaires
 (correction d'auteur) {1}

[#2]
[#3--] Remarque du maître: confus! {2}

 {Engravings #1 - #3} {3}

 AJOUT
 J'aperçois la Esmerelda. Dehors il pleut. J'aperçois Quasimodo qui me fait signe. Champignons en symbiose.
{*Matière de rêves* 39–40} {4}

[--#3--] *Enoncé de devoir: qu'auriez-vous fait à la place du* {5}
 personnage?

 COMPLAINTE DU POURCHASSE
 ébauhi par la convocation des interdictions moustique
 éberlué par l'interjection des décollations crapaud
 ébahi par la défoliation des déflagrations punaise
 éborgnée par la transition des transcriptions hibou
 ébloui par la translation des transpositions je halète
 COMPTINE
 [La prétention
 La prévention
 La prévarication
 La précaution
 La présentation
 La préservation
 La prédication
 La présomption
 La préoccupation
 La prédestination]
 {6}

[--#3--] *Murmure du comité: Malsain!* {7}
 PALIER
[--#3] Le héros s'efforce de comprendre ce qu'on veut de lui. {8}

 [L'Instruction]
[#4--] /~~juge~~/ /----/ magistrat
 (Suggestion d'éditeur) {9}

[--#4] *Annotation du professeur: méfiez-vous de votre* {10}
 imagination!

 {Engravings #4-#7} {11}

GREFFON

Secousse. L'homme auquel il avait appartenu était donc venu là, et il y était mort. Ecartèlements. La Esmerelda accouche. Dehors il vente. J'entraîne Djali à l'écart, la caresse. Reflets. S'effondre, filer dans les turbulences du dégel. {*Matière de rêves* 45} {12}

[--#5] *Proposition de dissertation: analysez cette scène:*
[#6--] *tout cela est-il vraisemblable?* {13}

REFRAIN
 [La convocation
 La comparution
 La confiscation
 La confrontation
 La contradiction
 La consultation
 La complication
 La conspiration
 La congrégation
 La condamnation]

COMPLAINTE DE L'INCULPTE

épaté par l'interception des démolitions pétrel
épuisé par la détonation des transpirations mouche
épinglée par la transsudation des transplantations crabe
éploré par la prétension des préventions putois
éprouvé par la prévarication des précautions j'abandonne {14}

[--#6] *Grondement du jury: dangéreux!* {15}

COULOIR
[#7] Le héros est sur le point de prendre une décision. {16}

[#8] [La Séquestration]
 /~~sa poitrine~~/ /---/son poitrail
 (intervention d'illustrateur) {17}

[#9] *Commentaire de l'inspecteur: vous êtes sur*
[#10] *une mauvaise pente!* {18}
[#11--]

 {Engravings #8–13} {19}

TRANSPLANT

Delphine de Nucingen me fait signe. Pourrissements. Dehors les grondements. J'entraîne la vicomtesse de Beauséant à l'écart, la caresse. Laves. A la frontière du sommeil mes souvenirs de Paris. Le soleil avait disparu depuis longtemps. {*Matière de rêves* 55} {20}

[--#11] *Thème d'interrogation: énumérez dans*
[#12] *ce passage les éléments classiques et*
[#13--] *les éléments romantiques. A votre*
 avis, lesquels prédominent? {21}

COMPLAINTE DU PRISONNIER

étonné par la déploration des transformations ignare
étiqueté par la transmutation des présentations périple
étranglé par la préservation des prédications mouton
étiré par la comparution des confiscations crasseux
étuvé par la confrontation des contradictions je rampe

RENGAINE
 [L'interdiction
 L'interjection
 L'interception
 L'interpellation
 L'interrogation
 L'intervention
 L'interruption
 L'interpolation
 L'interposition
 L'interprétation] {22}

[--#13] *Exclamation du tribunal: scandaleux!* {23}

 PASSERELLE
 Une lueur d'espoir {24}

 [La Précipitation]
[#14--] Prudence, /~~prudence~~/ /---/patience
 (bévue de plagiaire) {25}

[--#14] *Rapport de l'examinateur: Ce n'est pas avec*
[#15--] *des développements de ce genre que*
 vous franchirez les barrages! {26}

 {Engravings #14–16} {27}

 SYMBIOTE
 Sonnerie. Le téléphone reprend: "le second Bernard a maintenant mon costume de serveur. Je t'aime. Le teint
de sa peau a foncé. Textes déchiquetés. Avec un coquillage il verse du whiskey sur le nombril offert, Agnès. Une
douce toison de cheveux blonds y prolifère, s'organise en corolle au-dessus de laquelle grandit une brillante étoile
bleue . . ." Je raccroche. Les pentes des volcans fument d'émerveillement. {*Matière de rêves* 67} {28}

[--#15--] *Question de concours: récrivez tout ce*
 passage conformément à l'esthétique
 de l'Académie de votre choix. {29}

 COMPLAINTE DU CONDAMNE
 écrasé par la transmigration des présomptions puce
 éclatée par la préoccupation des consultations ilote
 écaillé par la complication des conspirations périscope
 écoeuré par l'interpellation des interrogations moutard
 écrabouillé par l'intervention des interruptions je claque des dents
 RITOURNELLE
 [La décollation
 La défoliation
 La déflagration
 La démolition
 La détonation
 La déploration
 La déréliction
 La déprécation
 La dénégation
 La détermination] {30}

 Cris de l'assemblée: intolérable! {31}

[--#15] ECHANGEUR {32}
[#16] quoi?

[La Respiration]
[#17--] /~~espace~~/ /—-/trou
 (indice de faussaire) {33}

[--#17] *Décision du censeur: c'en est trop!* {34}
[#18]
[#19--]

 {Engravings 17–20} {35}

INCUBE

Je fais l'amour avec Delphine. Etouffements. Cette pension, connue sous le nom de la maison Vauquer, admet également des hommes et des femmes, des jeunes gens et des vieillards, sans que jamais la médisance ait attaqué les moeurs de ce respectable établissement. Interruption. Dehors la banquise. Tourmentes. La vicomtesse accouche; je tiens dans mes bras sa fille. A la frontière du sommeil, mes souvenirs de Buffalo. L'eau monte. {*Matière de rêves* 68} {36}
[--#19] *Sujet d'anxiété: qu'écrira l'auteur après*
[#20--] *tout cela?* {37}

RETOUR
 [La transition
 La transcription
 La translation
 La transpostion
 La transsudation
 La transplantation
 La transformation
 La transmutation
 La transmigration]

COMPLAINTE DE L'EVADE
éliminé par la prédestination des congrégations cradingues
éloigné par la condamnation des interpolations purin
élaboré par l'interposition des interprétations ibis
élargi par la déréliction des dépréciations pédoncule
élucidé par la dénégation des déterminations je vogue
[Butor explained "*cradingues*" as slang from the 1950s, from "*crasse.*" Another slang word, "*cradeaux,*" had a similar meaning, but he specified that "*cradingues*" here means even more "*crasseux*" than "*cradeaux.*" Marie-Jo concurred. (Conversation, Montreal, 30 October 1992.)] {38}

[--#20--] *Hurlement de la foule: à mort!* {39}

 AIGUILLAGE
 Dérivent vers d'autres signatures
[--#20] {PA and MB signed here} {40}

 APPENDICE
 ~~vermiculé~~ {strikeover is in red} {41}

{Following the printed list of collaborators:}
 Et le temps qu'il faisait à St. Laurent du Var, à Monpellier, à Nice, à Bougival, à Albuquerque, à Paris et aux Launes. {42}

 [Correspondances] {43–5}

{Under "*moins triste,*" with arrow pointing to "*triste*":} Pas de quoi

Bon anniversaire! {46}

Lettre de M.B. à P.A. et B.R.

Les Launes, 1er avril 1975

Je suis dans la grande neige. Est-ce l'Islande? Heureux que B.R. soit venu jeudi dernier. Il aurait eu du mal ces jours-ci à me montrer son exemplaire. Je termine mes marginalia. Vous aurez tout le 24 avril lors de la présentation à la Hune.

Mille poissons pour vos nasses. {47}

EXPLICIT
OPUS
INCERTUM {48}

Exemplaire spécialement préparé pour la Bibliothèque Nationale

MB

Nice, le 28 mars 1977 {49}

Notes

1. Introduction

1. *Portrait de l'artiste en jeune singe* (Paris: Gallimard, 1967) is a prime example. In addition, in his essay, *"L'Alchimie et son langage,"* originally published in 1953 and reprinted in *Répertoire I* (Paris: Minuit, 1960), Butor provides a history of the development of alchemy and its need for secrecy, resulting in oral transmission or coded written manuals. He specifically states, *"A l'extrême limite, n'importe quoi pourrait désigner n'importe quoi"* (17). Critics have found this connection irresistible, as thoroughly studied by Barbara Mason in *"La Critique et l'alchimie,"* (*Oeuvres et critiques* 10.2 [1985]: 129–44). She states, tellingly, *"Tous les critiques s'accordent à reconnaître que la patience avec laquelle le lecteur de Butor doit se mettre à déchiffrer les textes est analogue à la patience avec laquelle l'alchimiste se met à son travail"* (130). I agree.

2. In the first volume of his studies on Balzac, Butor treats Balzac's alchemists as seeking not gold or diamonds, but the ultimate truths (Michel Butor, *Improvisations sur Balzac I, Le Marchand et le génie* [Paris: La Différence, 1998]).

3. Madeleine Santschi, *Voyage avec Michel Butor* (Lausanne: L'âge d'homme, 1982), 133, 78.

4. Butor's own bibliography lists this first collaboration as the catalogue for a Zañartu exposition (Paris: Galerie du Dragon, 1958). The poem was subsequently republished as *"Rencontre,"* in *Les Lettres nouvelles* 29 (October 1962): 31–35; separately as *Rencontre* (Paris: Editions du Dragon, 1962), n.p.; and then, without the artworks, included in *Illustrations* (Paris: Gallimard, 1964), 31–53 (MB, unpublished bibliography, 1945–83, 47).

5. Michel Butor, *"Thèmes, variations, suites et non,"* in Mireille Calle-Gruber, *Les Metamorphoses-Butor* (Quebec: Griffon d'argile 1991), 23.

6. Bernard Telon-Nouailles, in *Passage de Butor II* (Montpellier: Galerie Wittmer and Musée de Bordarieux, 1991), n.p.

7. Jesus Camarero-Arribas, *Bibliographica Butoriana* (Vitoria, Spain: Arteragin, 1996).

8. Some may remember a cartoon about Lawrence Durrell's *Alexandria Quartet:* a man with four page-turning machines, whose friend remarks that he has just about managed to read the books. With Butor's work the machines would have to be in the hundreds and respond not to pages but to words, or at least phrases, since his whole work is integral.

9. Michel Butor, *Improvisations sur Butor: Transformation de l'écriture* (Paris: La Différence, 1993), 224.

10. *"Histoire de Suzanne," "Miroir de Suzanne,"* and *"Trois femmes enlacées"* appear in *Gyroscope* in *Porte chiffres: Miroir de Suzanne* 166–200, Channel 1. *Picasso-labyrinthe* is in *Gyroscope* in *Porte chiffres: Picasso-labyrinthe* 8–171, Channels B, 3 and D.

11. We have now donated our *Kit* to the Butor collection at the Southwest Missouri State University library.

12. Georges Raillard, director, *Butor: Centre Culturel international de Cerisey-la-salle* (Paris: Union général d'éditions, 1974).

13. Further, as it happens, these texts subsequently illustrated by our artists clearly show Butor's achievement of his frequently reiterated goal of sending the reader to other texts. The collaborations with Kolář include *Victor Hugo Ecartélé,* which caused this reader to reread *Travailleurs de la mer, 1793,* and for the first time to read *Le Rhin,* for *La Légende du beau Pécopin et de la belle Bauldour,* this last only after Butor had kindly identified it for me. The issue of the *Arc* created by Butor and a number of collaborators in addition to Kolář required reading Balzac's *Gambara* for the first time. *Fenêtres sur le passage intérieur* absolutely necessitated rereading Poe's *The Raven,* and meeting for the first time, of all things, Boas's collection of American Indian tales. Along the same lines, Alechinsky's *Rescapés de la corbeille* sent this reader back to Butor's own *Portrait de l'artiste en jeune singe,* since it was mainly discarded manuscript pages from that work that Alechinsky used as support for his drawings. Study of these works requires unusual equipment: scissors, magnifying glass, and colored pencils, and for the *Rescapés* one needs also a mirror.

14. Michel Butor, *Utilité poétique* (Saulxures: Circé, 1995), 106.

15. Michel Butor, *L'Oeil de Prague* (Paris: La Différence, 1986), 34. 29

16. Michel Butor, *Curriculum vitae* (Paris: Plon, 1996), 187.

17. Pierre Alechinsky, *Le Test du titre* (Paris: Eric Losfeld, 1967).

18. James Boswell, *The Life of Samuel Johnson* (New York: Modern Library, 1932), 633; qtd. in Ronald Strom, "Impossibile Belli," *Il Cannocchiale, rivista di studi filosofici* 1/2 (January–August 1994): 263.

19. Barbara Fürstenberger, *Michel Butors literarische Träume: Untersuchungen zu Matière de rêves I bis V* (Heidelberg: Carl Winter Universitätsverlag, 1989), 360.

20. J.-F. Lyotard, *Discours, figure* (Paris: Klincksieck, 1978), 360–75. In *Métamorphoses* Lyotard discusses the genesis of his study (Mireille Calle-Gruber, *Les Métamorphoses-Butor* [Quebec, Canada: Griffon d'argile and Presses universitaires Grenoble, 1991], 62–63). Butor lent Lyotard his own copy of the issue of *Réalités.*

In her review of Butor's reception in France, Seda Chavdarian gives credit where it is due to Lyotard's reading of Butor (Seda Chavdarian, *"Michel Butor devant la critique française: 1955–70," Oeuvres et critiques: Michel Butor—Regards critiques sur son oeuvre* 10.2 (1985): 25–36). Her own reading is not only sensitive but lyrical. In his article in the same collection (Michel Launay, *"La Machine critique de l'oeuvre de Butor en France," Oeuvres et critiques:* 13–24), Michel Launay says, *"Il me paraît inconcevable de parler de Butor à des professeurs et à des 30 étudiants sans leur faire voir des reproductions d'oeuvres peintes ou photographiques"* (22). This issue contains other very valuable articles by noted Butor scholars.

21. I would recommend particularly Wendy Steiner's *The Colors of Rhetoric*, which includes a brilliant analysis of William Carlos Williams and Breughel among others. (Wendy Steiner, *The Colors of Rhetoric: Problems in the Relation between Modern Literature and Painting* [Chicago: University of Chicago Press, 1982]. Jean Hagstrum's *The Sister Arts* is an especially readable and thorough study (Jean Hagstrum, *The Sister Arts: The Tradition of Literary Pictorialism and English Poetry from Dryden to Gray* [Chicago: University of Chicago Press, 1958, repr. 1987], as is W. J. T. Mitchell's more recent work (W. J. T. Mitchell, *Iconology: Image, Text, Ideology* [Chicago: University of Chicago Press, 1986). In his essay on the teaching of comparative arts, however, Mitchell finds many excellent reasons for not comparing arts, and feels no metatheory has yet been proposed to suit everyone (W. J. T. Mitchell, "Against Comparison: Teaching Literature and the Visual Arts)," in Jean-Pierre Barricelli, Joseph Gibaldi, and Estella Lauter, eds. *Teaching Literature and Other Arts* [New York: MLA, 1990], 30–37). Norman Bryson's collection of current essays is most useful, including two Barthes pieces (Norman Bryson, *Calligram: Essays in New Art History from France* [New York: Cambridge University Press, 1988], and in her book Renée Riese-Hubert treats many of the issues that arise in our present study. For example, her introduction provides, along with thorough background information on their historical development, a careful consideration of "artist's books" as opposed to "ordinary illustrated books" (Renée Riese-Hubert, *Surrealism and the Book* [Berkeley: University of Cal Press, 1988], 19).

22. Thomas J. Hines, *Collaborative Form: Studies in the Relations of the Arts* (Kent, Ohio: Kent State University Press, 1991), 169.

23. Raphaël Monticelli, "Approche du continent Butor," *Echanges: Carnets 1986* (Nice: Z'Editions, 1991), 10. In the text Monticelli identifies "Litanie d'eau," a collaboration with Masurovsky in 1964, as Butor's first collaboration with a visual artist, which he corrects in a note to *Rencontre* with Zañartu in 1958. Monticelli treats also the musical structure Butor incorporated in his text, *Chanson pour Don Albert* (21–24). The collection *Echanges* contains numerous Butor collaborative pieces, without the artworks, as well as other Butor texts that will reappear elsewhere.

24. Michel Butor, *L'Embarquement de la reine de Saba* (Paris: La Différence, 1989).The differences between, on the one hand, *L'Embarquement* and the collaborations with contemporary artists and, on the other, between both of these and the Butorian art criticism in *Répertoires* are well worth further study.

25. Mireille Calle-Gruber, *La Création selon Michel Butor* (Paris: Nizet, 1991). Included in this collection are two philosophical articles that mention the collaborations: Oppenheim aims to demonstrate Butor's "contextualist" (or relational, as opposed to analogic or contrastive) vision in *L'Embarquement,* a thesis supported by allusions to *La Modification.* In passing, she refers to *"la collaboration entre artistes (autrement dit un mode implicitement dialogique et interlocutoire)"* (Lois Oppenheim, "L'Anesthétique de Michel Butor," 249). Dällenbach's essay also treats the element of the dialogical in Butor's collaborations; he relates Balzac and Butor: *"ce que Butor admire par-dessus tout chez Balzac, c'est sa dimension dialogique méconnue, qui fait de lui précisément un Moderne."* Dällenbach mentions particularly that Butor is *"un écrivain qui pratique les textes en dialogue, et de plus en plus les oeuvres en collaboration"* (Lucien Dällenbach, "Une écriture dialogique?" 209).

26. Léon Roudiez, *"Le Réel et la peinture: comment décrire ce qui se dit?"* in *La Création,* 169. Roudiez finds Butor's text more effective than Lorrain's painting in demonstrating that our concept of reality is *"précaire, incertaine, illusoire et, souvent même oppressive,"* particularly in that Butor shows that it may be possible to escape from the grip of that reality (*Création* 174). In the same essay Roudiez treats *"Litanie d'eau,"* from which at least one of the Masurovsky engravings Butor worked with is relatively accessible. In addition, Roudiez had the opportunity to study the original Zañartu engravings used in *Rencontre* and the artworks of Batuz for which Butor wrote *Méditation sur la frontière* in 1983.

Although Roudiez declines to discuss Butor's collaborations with musicians, *"car mon incompétence là est encore plus grande qu'ailleurs,"* his essay reveals no incompetence in discussing visual art!

27. *Anthropos: Michel Butor: Escrituras, una pasiòn par la invenciòn estética* 178/179 (May–August 1998) (Barcelona). Several of the essays included here appeared elsewhere in French.

28. Jacques La Mothe, *L'Architexture du rêve: La littérature et les arts dans Matière de rêves de Michel Butor* (Amsterdam: Rodopi, 1999).

29. Jacques La Mothe, *"Prélude pour déchiffrer Matière de rêves,"* Texte, *Revue de critique et de théorie littéraire* (Trinity College, Toronto, Canada) 11 (1991): 173–211.

2. Michel Butor and Jacques Monory: Bicentennial Blues

1. Michel Butor, *Bicentenaire kit* (Paris: Philippe Lebaud, au Club du livre, 1975), *Catalogue* 33.

2. The titles of the unnumbered sections, in French and English, as cited, are: *"Bicentenaire* Prélude" (preceding #1), *"Bicentenaire* People" (preceding #4), *"Bicentenaire* Things" (preceding #13), *"Bicentenaire* Interlude" (preceding #22), *"Bicentenaire* Story" (preceding #30), *"Bicentenaire* Party" (preceding #39), and *"Bicentenaire* Postlude" (preceding #48).

3. Michel Butor, *Le Retour du boomerang* (Paris: Presses universitaires de France, 1988), 103–5. This work is written as a dialogue between Butor and Béatrice Didier, professor and editor, but the dialogue is immediately revealed as spurious: the whole is Butor's work. It provides guidelines for reading *Boomerang,* for locating the sections from the different sources. Butor's many stays in the United States are mentioned throughout, but the dialogue discussion of the *Kit* itself in *Retour* is quite brief (159–62).

Here are added, marked with a zero, six texts that do not appear as such in the original *Kit: "rêves bleus"* and three "Mobilis in Mobile" in parentheses; the first of these "Mobilis in Mobile" does appear in the *Kit,* but in a considerably longer version. (See Appendix A on variants.) Butor also identifies in *Retour* as *"rêves du bicentenaire"* four of the "blues" poems that are used elsewhere in *Boomerang* (*Retour* 107).

Two printing errors occur in the page references given in *Retour: "Sous le couvert"* appears on pp. 107–8 of *Boomerang* and the *"rêve rouge"* on p. 21.

4. See also Jacques La Mothe," *American holiday: jeux de sociétés,"* in Mireille Calle-Gruber, *Butor et l'Amérique* (Paris: l'Harmattan, 1998), notes 4, 5, and 6.

5. Readers may have seen his *"Velvet Jungle #13"* (1971) on exhibit at the Paris Musée d'art moderne in 1988.

6. E. Stephano, "Masked Reality" *Art and Artists* 9.3 (June 1972): 29.

7. Michel Butor, *Exprès: Envois 2* (Paris: Gallimard, 1983), 110–11.

8. Conversation with author, Montreal, 30 October 1992.

9. J. C. Bailly, *"Monory ou le goût du catastrophe,"* Cimaise 133–34 (November 1977–January 1978): 62.

10. Gilbert Lascault, *"Les Images incurables de Jacques Monory,"* *XXe siècle* 36.43 (December 1974): 83.

11. P. Gaudibert, *"Monory, une fausse sortie, suite,"* *Opus international* 70–71 (winter 1979): 89.

12. World premier of the musical collaboration at the International Meeting of Contemporary Music, 14 November 1991, in Metz. Michel Butor, *Gyroscope* (Paris: Gallimard, 1996) includes *"Hallucinations simples"* Porte chiffres: Canal 1, Le Voyant 1, 10–40; Canal 2, Le Voyant 3, 96–112; Entrée lettres: Canal B, Le Voyant 2, 40–62.

13. J. F. Lyotard, *Figurations 1960–73* (Paris: Union générale d'éditions, 1973), 168–69.

14. Labels appear in serigraphs #1, 30, 35, in the text handprinted on 12, and numbers are found in #15, 42, and 45.

15. Gilbert Lascault, *"Opéras glacés: Monory,"* *Derrière le miroir* 217 (January 1976): 1–30.

16. A. Jouffroy, *"Les 'Opéras glacés' de Jacques Monory,"* *XXe siècle* 46.38 (September 1976): 46.

17. A. Jouffroy, *"Une certaine exigence traverse la douleur et le rire,"* *Derrière le miroir* 227 (January 1978): 8.

18. Other relationships may be only coincidental, natural given the subject: the Jefferson memorial, which appears in serigraph #6 *Les figurantes de Washington, blues* (C: 21, B: 37) is referred to in the flyer from the wax museum, #4 *Prospectus, même* (C: 16, B: 37) and the collapse of Wall Street in #24 *La rue Mur, blues* (C: 59, B: 112), and #39 *La foule en ruines, blues* (C: 80, B: 363) is mentioned relative to Coca-cola, #22 *"L'écorce du coke, même écrasé"* (C: 56, B: 111).

19. Léon S. Roudiez, *"Le Réel et la peinture: comment décrire ce qui se dit?"* in Mireille Calle-Gruber, *La Création selon Michel Butor: Réseaux—frontières—écart* (Paris: Nizet, 1991), 173.

20. Jacques La Mothe, *"American Holiday: Jeux de sociétés,"* in Mireille Calle-Gruber, *Butor et l'Amérique* (Paris: l'Harmattan, 1998), 119.

21.

AT NIGHTFALL, BLUES (#1)

At nightfall in the streets of Flagstaff Arizona
The Indian come in from the Navajo or Hualapaï reservations
Leaning on a brick wall among trashcans and newspapers
In the light of signs and traffic signals
Dreams of Floridian girls with fair hair lazy in their lagoons
Blue because "to see blue devils" means to have black ideas

(C: 12, B: 33)

22. Of course, by omitting the "B" Monory not only tells us where we are but also emphasizes the U.S. that in addition here is "US." Butor identifies the same play on words in #17 *Stickers antagonistes, mêmes: "et surtout le jeu US (nous): US (Etats-Unis)"* (C: 49, B: 108).

23. Lascault has interpreted this line in Monory's *Opéras Glacés* as meaning *"le monde est barré"*: we are excluded, *"témoins impuissants,"* an interpretation that applies well to this serigraph also. Lascault, *"Opéras glacés,"* 22.

24. Throughout the poem we are reminded how readily Butor identifies with animals, as in *Portrait de l'artiste en jeune singe*, and many others. Monory often portrays animals, and here the man on horseback is staring into space, but his horse is looking at us.

25.

Above the aerosol cans of hairspray for the secretaries' coiffures,
Above the aerosol cans of varnish to put a patina on old junk
.

Above the hollows of the rocks in the midst of the towers of rock the Navajo
.

(C: 68, B: 166)

26. Again, Butor regularly speaks of *"noirs,"* rather than using the politically correct terms that are currently the order of the day in the United States. His empathy goes beyond words.

27.

Outside clouds of smoke which launch an assault on the moldings
Springing from the dark furnace among the metallic columns

(C: 53, B: 110)

28. Seeing the child as "a little prince" while he plays with an airplane cannot fail to recall Saint-Exupéry's presumed fatal crash.

29. This use of "I" is one of only two in these poems and the use of the artist's name the only one.

30.

BALISTICS, BLUES (#36)

The Winchester company technicians using high-speed photography
Discovered that guns with a barrel 25 inches long
Recoil less than those 30 inches long of the same weight
With the same bullet such studies will permit facilitation of the task
Of our valiant warriors inside and outside our frontiers
Blue because the uniform of the Federals was blue

(C: 76, B: 172)

31. Michel Butor, *Les mots dans la peinture* (Geneva: Skira, 1969).

32.

THE WALK-ONS OF WASHINGTON, BLUES (#6)

In front of the Jefferson Memorial in the midst of the
flowering cherry trees young girls in dresses from the roaring twenties
Crowned with plastic grapes check through the latest notices of sales in the daily papers
Waiting for the filming of their dancing jingle for a fruit juice commercial
Babbling about soldiers while scribbling to their old parents a hello
Stamped with the Iwo Jima monument blue
Because "to tell blue stories" means to tell smutty stories

(C: 21, B: 37)

33. Butor may also suggest here the generally accepted unimportance of truth, both in commercial advertising such as that in the poem, and also in a wider sense. The Japanese cherry trees were renamed "Korean" during the second World War, only to become Japanese again afterward. Butor will have known of this temporary change of name intended to support that war effort, as he refers in *Mobile* to the *"don d'une nation d'outre-Pacifique"* (134), not specifying which nation.

34. In a lecture on *Mobile* at the University of Geneva in 1991 Butor said some of his translations of the Founding Fathers, and there are many from Jefferson, were *"méchantes":* excellent material for study by a scholar.

35. One statement includes a curious misspelling or misprint, "thiekness."

36. Note another example of Butor's imaginative translation, using Rimbaud's title, *"La Cloche fêlée"* [The Cracked Bell] rather than "Liberty."

37. Butor's visiting professorships in the United States have included the University of Oklahoma; it may be that Monory has seen that desolate state first-hand also.

38.

UNDER COVER, BLUES (#15)

Separated from the naked horizon by the shelter of some trees
Near a town in Oklahoma under the roof covered with slats
Behind the wall covered with boards and the window with little panes
 which are opened
Cautiously when a handle is turned because of the dust storm
In the shadow of the half-lowered shade in the folds of a curtain from
 Sears
The child watches the empty road blue because "to feel blue" means to
 have the blues

 (C: 47, B: 107)

39. This is the text chosen as a sample in *Le Retour du Boomer-
ang,* where Butor altered *"l'enfant surveille"* to *"Je surveille."*
Obviously, the serigraph no longer accompanied the poem.

40. For example, the phrase appears in *Blues des projets,* in
Travaux d'approche (Paris: Gallimard, 1972), 163, and in *Auto-
portrait des années 70, Frontières* (Marseille: Le temps parallèle,
1985), 76.

41.

In the decor of a glorified Texas blue because "to be between the devil and
 the deep blue sea"
Means to be between Scylla and Charybdis between hammer and anvil
 between tornado and torpor between vestige and vertigo between cen-
 ter and absence

 (B: 28, C: 45)

42. One of the variants in *Boomerang* occurs in this poem: a line
has been omitted from *Les Aveugles, blues* (C: 185, B: 426): *"Dans
toutes les circonstances de leur vie fabuleuse et sous la surveillance
d'un assesseur immobile."* Since, for its inclusion in the *Kit,*
Monory clipped the original image and removed the figure of the
assistant, it is possible that Butor decided to omit the line. However,
because all the poems are sizains, and because he could easily have
revised the lines, his usual practice, I believe this omission is a
printing error.

43.

In the trembling hope of an improvement in their fate the man and the nun
 with their faces masked with opaque masks to eliminate the little vision
 remaining to them
Seek with the aid of a little portable radar their way between the trash cans
 suitcases shutters and stools

 (C: 85, B: 426)

44.

EMERGENCY CALL, BLUES (#27)

Beneath the ceiling of a bank the phones remain silent in the night
Beneath the floor of this bank the subway-riders
Wait for the last train of the night and beneath all this network of wires and
 of business
Of tracks and of overtime in the depths of a specialized hospital
A child weary of waiting for the last visit of the night has collapsed in the
 arms of his nurse
Blue because "to go blue" means to flush crimson

 (C: 63, B: 163)

45.

THE DIAMOND OF THE OPEN SEA, BLUES (#50)

In the midst of its uproar the subway of New York City warns us that
 pride fear and confusion
Prevent five million handicapped from receiving the help they need

And the silent cry which it instills in our bones what's stopping you is
 echoed back by all the gulls on all the beaches of all the coasts
And it can be heard also in the milling of the enormous crowd in the
 Houston Astrodome which boos and hisses at the baseball idols
On the field called "diamond" that is to say both a rhombus or rather a
 square on its point and a diamond
Blue because "blue Peter" means to sailors the flag of departure

 (C: 96, B: 432)

46. La Mothe, *"American holiday,"* 118.

47. Big Bill Broonzy, "Feelin' Lowdown." Courtesy Robert M.
Miller.

48. Other parts of the *Kit* itself and the rest of the "Catalogue" are
full of Butor's humor, irony, and satire. For example, his selections
of five aphorisms from Franklin's *Little Blue Book* and seven
"Thoughts" recommended for cross-stitch embroidery are all witty
in themselves. Other examples appear in the material for the Bicen-
tennial Party, all satirical: the masks represent all the races of the
United States, including "rainbow" (before the use made by Jesse
Jackson); thus we can pretend we are other than we are. We are
encouraged to make new maps and flags according to new imagina-
tive delineations of states, just as if they were not already locked in
federal versus states' rights conflicts as well as conflicts between
states.

49. Class lecture, University of Geneva, May 1991. Also, in
Vanité, the discussion runs to the artists' desire to improve society, a
desire always disappointed, with the comment *"heureusement"* be-
cause *"s'il réussit vraiment dans cette transformation de l'alentour,
ne va-t-il pas justement supprimer sa différence, donc son existence
comme individu?"* (Michel Butor, *Vanité* [Paris: Balland, 1980], 66–
67). Interestingly, this *"heureusement déçu"* is altered in the revised
version to *"désir qui inclut sa propre déception"* (Michel Butor,
Répertoire V [Paris: Minuit, 1982], 293). Thus in the final version,
Butor's artist would voluntarily give up his difference as an individ-
ual in the interest of improving the world—his certain knowledge
that he will be disappointed in his effort cannot detract from the
nobility of his willingness to try.

3. MICHEL BUTOR AND JIŘÍ KOLÁŘ: PRINCES OF JUXTAPOSITION

1. The final *ř* has more the sound of English *ch,* as in "ouch," but
the similarity is striking. (My thanks to Dr. Roy Rosenstein of the
American University in Paris for this verification.) See also Arturo
Schwartz, Jiří Kolář, Vladimir Burda, Jindrich Chalupecky, *Jiří
Kolář: L'Arte come Forma della libertà* (Milan: Galleria Schwarz,
1972), 15.

2. André Candela, *Kolář: Poème Préface* (Cannes: Impro.
Bosco, n.d. [1980]), 11. Photographs by Andé Villers.

3. Michel Butor, *Les mots dans la peinture* (Geneva: Skira,
1969), 158.

4. Chalupecky cites Kolář's belief that "one day it will be possi-
ble to make poetry out of anything" (Schwartz, Jiří Kolář, 45), which
Mahlov also cites, adding "from Auschwitz to butterflies, from
Picasso to the computer" (Miroslav Lamač and Dietrich Mahlow,
Jiří Kolář, (Kolář expo.) (Cologne: M. Dumont Schauberg/Institut
für moderne Kunst, Nuremberg, 1968), 51.

5. Frédéric Appy, *Nixe: Mise en question et exaltation du livre*
(Paris: La Différence, 1985), 29.

6. Chalupecky in Schwartz, *Jiří Kolář,* 26.

7. Kolář in ibid., 16.

8. Chalupecky in ibid., 32.

9. Kolář in ibid., 42.

10. Michel Butor, *L'Oeil de Prague* (Paris: La Différence, 1986).

11. Louis Aragon, *"Un art de l'actualité: Jiří Kolář,"* *Les Lettres françaises* 1282 (7 May 1969). Rept. in *Ecrits sur l'art moderne* (Paris: Flammarion, 1981): 253–58.

12. Janus, *Jiří Kolář* (Milan: Gruppo editoriale fabbri, 1981), n.p. [6].

13. This stage of *passage* is a frequent subject of Butor's. See, e.g., *Frontières (*Marseille: Le temps parallèle, 1985), 71–72.

14. Kolář in Schwartz, *Jiří Kolář,* 50.

15. Cited by Thomas Messer, *Jiří Kolář* (Kolář expo.) (New York: Guggenheim Museum, 1975), 10–11.

16. Lamač 28, 30–31. See also Jacques La Mothe, *Architextures* (181–86) for Kolář's work as it differs from that of Arp, Ernst, and Masson and *"s'inscrit dans le prolongement de celle de Schwitters dont il reconnaît ouvertement l'influence"* (182). His work, like Butor's, is *"foncièrement réaliste"* (185). La Mothe's reflexions on Kolář's various techniques are very useful (184–85).

17. Messer, *Jiří Kolář,* 15.

18. Gérald Gassiot-Talabot, Preface, *Jiří Kolář* (Kolář expo.) (Paris: Galerie Maeght-Lelong, 1983), n.p. [last page].

19. Kolář in Schwartz, *Jiří Kolář,* 49.

20. Burda in ibid., 100.

21. Janus, *Jiří Kolář,* 17.

22. Kolář in Schwartz, *Jiří Kolář,* 49.

23. Charlotta Kotik, *Transformations* (Kolář expo.) (Buffalo, N.Y.: Albright-Knox Art Gallery, 1978), 20.

24. François Aubral, *Michel Butor* (Paris: Seghers, 1973), 70–71.

25. Michel Butor, *Illustrations II* (Paris: Gallimard, 1969).

26. Michel Butor, *Illustrations* (Paris: Gallimard, 1964).

27. Messer, *Jiří Kolář,* 11.

28. Ibid., 12. Cited and translated by Messer from Wieland Schmied, *Der Weg des Jiří Kolář* (Kolář expo.) (Hannover: Kestner-Gesellschaft 1969).

29. In response to Lamač's questions on the frequent appearance of an apple in his works, Kolář replied that it was not only the mythological role that interested him, but also a personal one: "My parents planted an apple tree when I was born" (Lamač 46).

30. Michel Butor and F.-Y. Jeannet, *De la distance* (Rennes: Ubacs, 1980), 120.

31. *Frontières* 125.

32. Other collaborations with Kolář (not examined here because the texts preceded the artworks) exemplify even more clearly Butor's reusing his own earlier texts, with or without citations from other authors: for instance, *Fenêtres sur le passage intérieur* (Boisle-Champ: Aencrages et Cie., 1982) offers not only combinations of Butor's own texts with Baudelaire's and Mallarmé's translations of Poe, but also his own versions of Molière and some native American folktales.

33. Janus, *Jiří Kolář,* [12].

34. Kolář in Schwartz, *Jiří Kolář,* 54.

35. Butor himself explains precisely the procedure used to create the textual matrix in his collaboration with the artist, Albert Ayme, and the musician Jean-Yves Bosseur in *Seize et une variations* (Albert Ayme, Michel Butor, and J.-Y. Bosseur, *Seize et une variations* [Paris: Edition traversière, 1983]. A number of critics have treated his use of musical structures. For example, see my note, "Michel Butor's *Quadruple fond* as Serial Music," among many others.

36. In another collaboration with Kolář in which the text preceded the artwork, Butor's matrix is a fundamental technique, and Kolář does not use one: *Victor Hugo écartelé* (Xonrupt-longemer: Aencrages et Cie., 1988). In a third text-first collaboration, *L'Arc* (Aix en Provence) No. 39 (1969)), Butor includes several minimatrices; Kolář's contribution is the cover, with no matrix. Kolář's

use of the same contours, as in the apples of *L'Oeil de Prague,* is unrelated to a matrix. Similarly, his use of the same kind of image, as in the birds throughout *Zone Franche* (Montpelier: Fata Morgana, 1989) the remaining text-first collaboration, derives from the title. In any case, that text is not built on a matrix.

37. Bernard Magné, *"Don Juan dans l'ordinateur,"* *Texte en main 2* (été 1984): 45–50. The initial series, *Matériel pour un Don Juan* (Michel Butor, affiches de Pierre Alechinsky, cassette enregistrée de Jean-Yves Bosseur [Losne: La Louve d'Hiver, 1977]) is analyzed by F. C. St. Aubyn in "Michel Butor and the Legend of Don Juan; the example of 'Don Juan dans la Manche,'" *Studi Francesi* 33, 3 (1989): 439–52. See also St. Aubyn, "Butor with Don Juan up his Sleeve," *Kentucky Romance Quarterly* 1 (1985): 33–38. One version provoked a collaboration with Alechinsky, not examined here because the text preceded the artwork.

38. Michel Butor, *Michel Butor et ses peintres: Guirlande liminaire* (Le Havre: Musée des beaux-arts, 1973) [n.p.] Rpt. Elinor S. Miller, "'*Michel Butor et ses peintres*': catalogue and Michel Butor's '*Guirlande liminaire*': Introductory study," *Yearbook of Comparative and General Literature* 38 (1989): 36–78.

The artists included are as follows, in alphabetical order:

Alechinsky	Francken	Masurovsky	Saby
Bryen	Hérold	Matta	Staritsky
Dotremont	Kolář	Parant	Vasarely
Dufour	Masson	Peverelli	Vieira de Silva

The artists whose works were included in the exposition but who did not send the artworks to Butor in time to be a part of the poem are Cremonini, Petlin, and Zañartu.

39. In the republication in the *Yearbook of Comparative and General Literature,* the Kolář piece is printed upside-down, and the text of the poem and the analysis of the matrix appearing there contain several printer's errors. The diagram included here is corrected and revised for clarity and simplicity.

The text was republished, somewhat rearranged and without reproductions of the artworks in *La Forme courte* (Marseille: le Temps parallèle, 1990). In that edition lines 6 and 7 of the Staritsky dizain, *"imprégnation des peupliers/imprécations des hirondelles"* are combined in an error, *"imprégnations des hirondelles,"* which gives only nine lines in the dizain and upsets the regular pattern.

40.

Interpreter of between the lines caresses gongs turnings inside-out
tundra of afternoons cudgels of **employers**
eyes of **wading birds** teeth of **cog-wheels** the charmer with **an air of parasols**
in the company of aged men wise roots
seeking prophecies electrodes
and plectrums

KOLAR
Waves of cities blossoming
of companions of interference
humus of our libraries
pollen of photography
ornithology of echoes
message-center of tremblings
atlas of multiplications
gardener of resistances
salvation through inadvertence
interpreter of between the lines

from ebb to flow
salt tinkles on which a stump
bleeds lining up its little fish
seeds stirred **festivals** descending while balancing
to overturn the **heaviness** with weapons of **foundlings**
and the organ of sweet storms **waves of cities blossoming**

41. In this diagram of the sources of the texts of the triangles, the number of the artist (in parentheses: see note 38 for order) to which the original dizain text (II) moves is counted without the original artist. To find in an artist's triangle the original dizain line which is its source, locate on the diagram the triangle line in question, count forward the number of artists, and the source should be the dizain line given of the new artist. To track the reappearances of a dizain line, reverse the process. Thus with line 3 of the Kolář dizain, count forward six artists, to Saby III, 3b. The other notation for dizain line 3 indicates that it reappears again nine artists later, in Vieia da Silva I, 4/5. However, dizains from Masson do not regularly follow the pattern. See note 42.

I Upper triangle:	1 a:	labeling line, 10	b:	(+15) dixain line 9
	2 a:	(+14) 8	b:	(+13) 7
	3 a:	(+12) 6	b:	(+11) 5
	4 a:	(+10) 4		
	4/5	(+9) 3		
	5/6	(+8) 5		
III Lower triangle:	1/2	(+8) 6		
	2/3	(+7) 2		
	3 b:	(+6) 3		
	4 a:	(+5) 4	b:	(+4) 5
	5 a:	(+3) 6	b:	(+2) 7
	6 a:	(+1) 8	b:	labeling line 1

42. In Masson, the eighth artist, halfway through the poem, the ninth line of the dizain, *"murailles crêtes avalanches"* is never repeated at all. As one would expect, the omission disturbs the matrix, but only very slightly, and the omitted repetition of Masson 9 is replaced by an extra use of one of the other phrases The space in the triangle where Masson II, 9, would have been repeated contains instead Masson II, 8, producing a domino effect which affects the upper triangles only. Where Masson II, 8, would have been repeated according to the matrix, we find Masson II, 7; where Masson II, 7, would normally have been we find Masson II, 6; where Masson II, 6, would have been, there is Masson II, 5. Finally, where Masson II, 5, would have been, there is Masson II, 4, and at that point order is restored, as Masson II, 4, appears as well in all its prescribed places, compensating for the omission of Masson II, 9. Needless to say, Butor has made alterations in the basic Masson II, 4, as it keeps turning up in succeeding artists. The original read, *"éclaboussures frôlements."* This phrase appears in the regular line 4 places in its original form in Bryen (I, 4a), then as *"accélérations frôlements"* in Saby (III, 4a), and the last additional time, (where it replaces the expected Masson II, 5) as *"éclaboussures imprudences"* in Dotremont (I, 3b).

43. The collage is reproduced in Schwartz, as 26, entitled *"Une Tentative"* from the *"Hebdomadaire 1967,"* n. 16, 1967 (Arturo Schwartz, Jiří Kolář, Vladimir Burda, Jindrich Chalupecky. *Jiří Kolář: L'Arte come Forma della libertà* [Milan: Galleria Schwartz, 1972], 33).

44. In *La Forme courte* the lines are reassembled into three stanzas of three primarily sixteen-syllable lines; three lines here have seventeen syllables (1, 3, 4) due to mute *es* now in the interior of the line, and line 7 here has eighteen due to the addition of *dans les* before *fêtes,* which changes the reading. In the original, the *semences* are not necessarily *remuées dans les fêtes* but simply precede them.

45. We will see that in the Alechinsky stanza the little fish have a very different taste.

46. For example, the poem by that name examined in *L'Oeil de Prague,* and Butor's collaborative work with Launay, *Résistances* (Michel Butor and Michel Launay, *Résistances* [Paris: Presses universitaires de France, 1983]).

47. *"Sages"* can qualify both the *"anciens"* and the *"racines."*
48. In Francken, the *"armes"* [weapons] could also be thought of as "arms," as in "coat of arms."
49. The contiguous lines in each case are altered from the originals: the *"incendies"* of Francken were *"tremblements"* in Hérold II, 9, and Francken's *"brasiers"* were *"tonnerres"* in Masson, II, 6. *"Dans le pelage des silences"* in Masurovsky II, 7, becomes *"dans les fourrures des silences"* in Hérold (I, 2b). It is all too easy to succumb to the lure of following one phrase to another artist, and then another phrase to yet another, seeing the images and meanings shift with each one.
50. I recommend for work with the entire *Guirlande liminaire* a generous supply of colored pencils, and I am not the only scholar to have found this pedestrian method efficacious.
51. Michel Butor, *L'Oeil de Prague: Dialogue avec Charles Baudelaire autour des travaux de Jiří Kolář* (Paris: La Différence, 1986).
52. Barbara Mason reads these *froissages* included in *L'Oeil de Prague* as "charged with a highly critical, questioning political spirit, warning of the dangers of a lost and fallen Prague" and presents the theory that Kolář's protest suits Butor's use of Baudelaire's poetry: both are "concerned with undermining, knocking down, subverting structures of domination," and thus Butor selected these Kolář works to include in *L'Oeil de Prague* rather than those from the Baudelaire exposition (Barbara Mason, "'Opusculum Baudelairianum': Collage and Contestation," *Australian Journal of French Studies* 25:2 [1988] 207–20) (213). Mason cites from Kolář's *"Réponses"* in her discussion (213–14).
53. Jiří Kolář, *Hommage à Baudelaire* (expo.) (Nurnberg: R. Johanna Ricard, 1973).
54. Michel Butor, *"Le Rêve de Jiří Kolář,"* *Coloquio/Artes* (Lisbon) (June 1975): 5–14. A citation from the text is identified as *"Le Rêve des pommes"* in Michel Butor, *Passage de Butor II* (Montpelier: Galérie Witmer and Musée Bédarieux, 1991), and the section of *Matière de rêves II* that includes the text is entitled *"Rêve des pommes"* (*Matière de rêves II: Second sous-sol.* [Paris: Gallimard, 1976], 57–100).
55. Curiously, Skimao et Bernard Teulon-Nouailles describe *L'Oeil de Prague* as *"un dialogue entre trois personnages "l'ordonnateur/le rêveur/le compositeur,"* seeing a relationship between this work and the structure of *Vanité,* a conversation between the Painter, the Writer, and the Traveller (*Vanité* [Paris: Balland, 1980]. Rpt. in *Répertoire V* [Paris: Minuit, 1982], 275–98). Further, they see in *L'Oeil de Prague* a correspondance between the *"trois protagonistes"* of *Vanité* and the *"construction en trois volets,"* referring to Butor's text, Kolář's *"pliages-collages-découpages"* and Kolář's own *"Réponses"* (Skimao and Bernard-Toulon Nouailles, *Michel Butor: Qui êtes-vous?* [Lyon: La manufacture, 1988], 277–78). As noted, only the Butor text is studied here.
56. *The Organizer:* Were it not for our attributes: the couch for the Dreamer, the professorial stick of chalk for the Explicator, the sheet music for the Singer, the music stand for the Composer, the book for the Reader, the calculator for the Combiner, and for myself the inevitable tape recorder, we would have the air, all eight of us, of reflections of each other in a complex mirror (9).
57. Michel Butor, *Opusculum Baudelarianum, Répertoire IV* (Paris: Minuit, 1974), 237–44.
58. In Michel Butor and Henri Pousseur, *Procès du jeune chien (Petrus Hebraicus)* (Milan: Edizioni Suvini Zerboni, 1980).
59. We will see later Alechinsky's use of "old papers," very different from Kolář's, and Butor's very different textual responses.
60. The original text of the *Opusculum* was published in the catalogue for Kolář's exposition, *Hommage à Baudelaire,* where it included a translation into German. There are very few variants in

the republication in *Repertoire IV* . In its reappearance here in the *Dialogue avec CB,* the text is altered primarily to allow for the various speakers, but there are some additional illustrations provided by the Combiner to clarify the process of creating the variations: Butor cites the original Baudelaire stanzas from *Le Balcon* and *Moesta et errabunda* (*L'Oeil* 21–22), *Harmonie du soir* (*L'Oeil* 36–37) and *La Chevelure* and *Le Flacon* (39), adjusting the introductory lines from the *Opusculum* appropriately, and another variation is added utilizing *La Chevelure* and *Le Flacon, Du passé . . . vertige* (39). Finally a new set of three quatrains entitled appropriately *Revenant* is added at the end (77–79) and the verbatim repetition on page 79 of the *"Mon cher J.K."* letter (15–16) does not appear in the *Opusculum.*

61. The whole of *L'Oeil de Prague* could be seen as a collaboration between at least four artists: Butor, Kolář, Baudelaire, and Kafka. As noted, Mason discusses the included *froissages,* and the indomitable Jacques La Mothe has pursued his investigation of the Kolář/Baudelaire collaboration to the point of first identifying specific artworks Kolář used in the collages of the *"Hommage à Baudelaire"* exposition and then demonstrating their relationship to specific Baudelaire lines. (Jacques La Mothe, *L'Architexture du rêve: la littérature et les arts dans Matière de rêves* de Michel Butor [Amsterdam: Rodopi, 1999], 198–200.)

62. Mason's essay displays a thorough understanding not only of Butor but also of Kolář and Baudelaire. She rejects Susan Sontag's definition of interpretation as impoverishment even as applied to the *Opusculum* and examines with scrupulous care the implications of textual collage as violence. Her precise analysis of the structure of the rearrangements confirms our reading of Butor's and Kolář's work as political. She concludes with: "a new edifice [Butor's] is constructed upon the stripped scaffolding [Baudelaire's], less wondrous, absorbing or rich perhaps, but instead provocative and challenging" (Mason 219). I applaud her "perhaps."

63. LaMothe's conclusions take into account the whole field of interart creation: *"le dualisme de la perception et de la représentation, la distinction entre la vision et l'écriture permet à cette dernière de filer une substance infiniment plus précieuse et de s'affranchir de la représentation"* (*Architexture* 207).

64.

> Mother of memories, mistress of mistresses,
> Tell me, does your heart sometimes fly away, Agatha,
> Oh you, all my pleasures, oh you, all my duties,
> Far from the black ocean of the unclean city?
>
> (14)

65. Four such collages in the exposition are named in the text: *Baudelaire, Le Rêve du douanier, Le Cygne,* and *Plainte d'un Icare* (26).

66. The Organizer mentions also a collage in which *"nous voyons ici apparaître les mots EAU et AIR"* (26), which are contained in the name of Baudelaire. This particular collage is not reproduced in the catalogue, although a number of collages using the letters of the name are seen there, such as the layer in the Swan, which contains all the letters but jumbled, overlapping, not spelling words.

67.

> And the green paradise of childish loves
> From the luminous past collect every vestige
> With the art of evoking happy minutes,
> Oh curls, oh perfume weighted with languor
>
> (62)

68. V. La Mothe's reading (*L'Architexture* 205–206).

If one reads the Dreamer's speeches intercalated between the serpent and paradise, a kaleidoscope of images glitters: the "spring-maid" girl reflected in the water is reminiscent of the ships in Baudelaire's "Serpent," while the *femme-battement* who smiles as the Dreamer *"nage dans ses humeur*s" (69) recalls *"l'eau de ta bouche"* of Baudelaire. All the while the Dreamer's fractured Cathedral looms in the background, and we think of the included Kolář *froissage* of the Cathedral of St.-Guy (105).

69. Lecture, University of Geneva, 4 June 1991. See also Michel Butor, *Improvisations sur Butor: L'écritureen transformation* (Paris: La Différence, 1993), 155–58.

70. See note 60.

71. La Mothe speaks often of the spiral in this work.

72. In the opera itself, the force of the *Phrases* is amplified by their resonance with the opera, with its intense integration of Schoenberg's musical innovations, with his unfinished opera, *Moses and Aaron,* and with Butor's views. A complete study of this work would require another essay; La Mothe has of course examined it as used in *Matière de rêves.*

73. While he does not reveal that these *Phrases* appear in *Dialogue avec CB* as the Composer's speeches, the Explicator does mention their use also in *Matière de rêves IV: Quadruple fond* (Paris: Gallimard, 1981), where they appear at the end of sections, introduced by the word, *Phrase* (20).

74. The identifying numbers assigned (here designated by #) refer to the *Phrases* in their order in the opera and in *Dialogue avec CB.* In the original republication in *Chantier* (Gourdon: Dominique Bedou, 1985) (53–59) the order is reversed by sections, each followed by a set of three words framed in asterisks.

75. *"Ne fuiront plus l'omniprésence de l'oeil"* (#26) (30), recalling Hugo's *Cain* or *La Conscience,* here acquires an additional recall of the title of the whole, *L'Oeil de Prague,* and offers an excellent example of Butor's creation of multiple possible readings as he moves his autocitations from one text to another.

76. Sixteen of the Singer's eighteen poems were first published in *Chantier* as *Inscriptions pour Jiří Kolář. Ballade des froissements du monde,* was previously published in *Envois 2: Exprès* (Paris: Gallimard, 1983); the other poem, *Astre des nuits,* is mentioned briefly here regarding Butor's position toward women. See Appendix C for variants.

Two of these Kolář works from set 2 each inspired a group of poems, one of three, one of five.

77. Butor has two of these collages, one of those made with strings attached, and the one based on Piero della Francesca's *Diptych of Federico II de Montefeltro et Battista Sforza,* used in the poem, *Dialogue.* Kolář has the others (Conversation, Montreal, 30 October 1992).

78. Of the Singer's eighteen poems, we do not treat here *"Vagues des villes éclosion,"* as it has been previously considered in this study. Three other short poems are not examined here, as not political, *Horlogerie fine, L'Heure exacte,* and *Monocle,* although *Monocle* is mentioned briefly in the Conclusion. Further, space has not allowed detailed presentation of the three additional poems treating women, *Astre des nuits, Le calendrier des réjouissantes, Confessions d'hiver* or the three closely interrelated poems on societal problems in general: *Trois frères jumeaux, La Femme sauvage,* and *La Chevalière de l'industrie.* However, the political force and poetic value of all these poems and their resonance with the rest of the text should not be overlooked.

79. *Organizer.* Let us stop for a moment before this "Woman at her Toilette" of Giovanni Bellini in the Vienna museum, on which are balanced, suspended by strings, a card representing a watch on the face of which the hours are replaced by the following occupations:

Singer. 1. The buffoon,
 2. The pageboy,
 3. The painter,
 4. The gondolier,
 5. The clockmaker,
 6. The merchant,
Composer. No more illness necessary
Singer. 7. The doctor,
 8. The judge,
 9. The condottiere,
 10. The banker,
 11. The patriarch,
 12. The doge,
Organizer. And an old American comic postcard representing two enormous oranges on a railroad car, with a little boy in overalls, oilcan in his hand to give the scale, on the back of which cards one may read this song called "The Pageboy":
Singer. It is I who bring to Madame
 Her morning orange juice
 It is I who clean for Madame
 The carriages for her visits

 It is I who notify Madame
 Of the rendez-vous with her lovers
 And point out to her between times
 The appetites of her children

 It is I who find Madame again
 After her conversations of the day
 We come from the same gypsy caravan
 I thought I was her son

 But I no longer know what to think of it
 When she squeezes me in her arms
 And gives me a last kiss
 Before going to adorn herself.

 (12–14)

80. In the Montpellier catalogue, *Passage de Butor II,* this collage is printed opposite a citation given as *Le rêve des pommes* rather than the professions and poem, *Le Page,* and the effect of the combination is quite different, as one would expect. The citation is from the Dreamer's speech, 9–10: *"Je suis [sous] une pluie de presse . . . je le poursuis, il se retourne"* (The "sous" is probably omitted through printer's error.) A variant occurs in the omission of: *"j'y reconnais des caractères allemands. Elle me caresse le visage, m'aveugle."*

81. The inscriptions on the banderolles around the Bellini are in sequence, #39–43, with part of #34 visible on the back of the banderolle. Around the postcard the series is interrupted: #67–68 are on the right-hand sides of the diamond; #69–70 are omitted; #71–72 take up again on the left-hand sides. (*Chantier* 59–60). Let it not be thought that Butor selected them at random: *"Evalueront leur ignorance"* (#69) and *"Choirs du coeur"* (#70) do not fit this poem so well, while their actual placement in *Dialogue avec CB* adds depth to the poems surrounding them there (60).

82. To take only one example, *Lessive pour Marie-Jo,* which one might expect would present that housewives' task as just as menial as that of cooking, the items in the wash each address Marie-Jo directly, revealing different aspects of that whole person together with a vision of the varied, active, and loving life of the couple. The overalls which Marie-Jo makes for Butor provide him the opportunity to make fun of himself:

LA SALOPETTE

uniforme de ses tournois
risible chevalier des mots

fruit de l'adresse de tes mains
je proclame son allégeance

 (*Forme Courte* 110)

[THE OVERALL

uniform of his tournaments
laughable knight of words
fruit of the skill of your hands
I proclaim his fealty]

Thus Marie-Jo as seamstress ascends to a medieval pedestal. Her apron becomes a thing of beauty:

LE TABLIER

rubans noués sur ta ceinture
t'enlaçant pour te protéger
la poche pleine des trésors
que tu cueilles dans tes journées

 (105)

[THE APRON

ribbons knotted at your waist
encircling you to protect you
pocket full of treasures
which you gather during your days]

In Marie-Jo's hands even a dishrag is lovely, as in *Le Torchon* (101).

My source here for these poems is the republication in *La Forme courte.* The U.S. Library of Congress holds two different editions of the original work, one published in Las Palmas de Gran Canaria by Asphodel in 1986, the other described on the LOC card as "a paper strip folded accordion style; issued loose in a box with a clothespin and twine," illustrated by Michel Camoz and Pierre Leloup, published in Chambéry and Lucinges without publisher's name in 1989.

83. As the Reader's only speeches are the Baudelaire variations, we may be sure that the assignment of the Chateaubriand text to the Reader instead of the Singer is a printer's error (67).

84. Examples of Kolář's use of this diptych in intercollages are reproduced in Schwartz, #75, *Arbre dormant* 1971, #76, *Soldats* 1971, where they are reversed with a background massacre of the innocents, #78, *Course perpétuelle* 1971 and #77 *Dante & C.* 1971. (Arturo Schwartz, Schwartz, Arturo, Jiří Kolář, Vladimir Burda, Jindrich Chalupecky, *Jiří Kolář: L'Arte come Forma della libertà* [Milan: Galleria Schwarz, 1972]). Federico alone is reproduced in Janus, #134, *Chi sai?* [*Who Knows?*] (Janus, *Jiří Kolář* [Milan: Gruppo editoriale fabbri, 1981]).

85.

 Dialogue

I see your eyes I see your eyes
Your horizon Your hair
Your sleep Your earrings
Your cares Your sighs
Your smile Your horizon
Your river Your ramparts
Your breathing Your breasts
I see your heart I see your heart
Where I see myself Where I see myself

 (65)

86. It is fascinating to speculate on which of these texts Butor would have selected—perhaps something from the part of the dream that takes place on the moon.

87. Again, we can amuse ourselves imagining which he selected.

88. Michel Butor and André Villers, *Musique de chambre noire* (Mougins: 1980). Text alone, rpt. Michel Butor, *Ballade des valeurs arc-en-ciel* in *Envois 2: Exprès* (Paris: Gallimard 1983), 11–13.

89.

To explore the plastic possibilities of the new printing photocopiers, André Villers arranged on photographed grounds, old cracked walls for example, whose intended treatment was to transform the materials profoundly, familiar objects producing perfectly identifiable empty figures: toothbrush, ball of yarn, carpenter's rule, tube of glue, spoon, pliers, pair of scissors, gardener's glove, etc., sometimes with transparent places, recesses for text in which I made my sentences meander like ants in their tunnels, striving to extract treasures of color from these amphoras of white buried in the darkness). (*Envois 2: Exprès* 37)

90. The *"niches"* for text include, for example, the tape on a roll of Scotch tape, where Butor has set the text, *"Ile pénétrant les nuages des territoires et des vents"* (n.p.), and the text curls around the roll. Keys are mentioned three times in the *Musique* text, but only one silhouette of a key can be distinguished in the images; other than that, the domestic objects used are not the basis of the text.

91. Examples of the little squares appear in André Candela, *Kolář: Poème Préface* (Cannes: Impro. Bosco, s.d. [1980]). To my knowledge the only copy of this work in the United States is at the Southwest Missouri State University Library, in the Butor/Rimbaud collection.

92.

NOCTURNAL TOILETTE

The ladies undress
In the mirror of the Moon
And go to seek the key of the clouds
At the store of the toys of winter

The moon undresses
In the store of the clouds
Goes to seek the key of the mirrors
Among the toys of the ladies of the winter

The clouds undress
In the mirror of the toys of winter
And go to seek the key of the ladies
In the stores of the Moon

The mirrors undress
In the clouds of the toys of the ladies
Go to seek the key of the Moon
In the stores of the winter

(20)

93.

THE QUEEN OF SNOWS

On a bed of destructions
The Olympian woman relaxes
At her neck a pearl of lightning
At her feet mules of lava
Her glance is drowned in the fires
All this anguish will become mother-of-pearl for her fingernails

On a cloud of the end of the world
The delicious woman takes her ease
Born of the foam of History
Coverlet of tortures bracelet of wounds
For her smile how many cities

We would distill in catastrophe
To rest an instant one's head in the hollow which she hides

On the fury of the ancients
The brand-new stretches her ivory
The ramparts become tides the empires torrents
In the gulf between her legs lies are collapsed
Alambic of the apocalypse the Earth is changing

(66)

The handwritten variant in *Métaphores,* found also in *Chantier, "la tête"* [one's head] is obviously correct, as opposed to *"sa tête"* [his or her head] in *Dialogue avec CB.* There are several variants, additions and a change, from the original in *Métaphores* to *Dialogue avec CB.* See Appendix C.

94. Michel Butor, *La Reine des neiges, Métaphores* 2 (Nice) (1980): n.p.

95.

Stanza 1	Stanza 2
The time of insects	The time of sounds
Sounds in the fields	Freezes in the winter
Sounds of insect-wings	Waltz of the elite
Round buzzings	Growling of brakes
The metamorphoses	The metamorphoses
At the will of the seasons	Drifting through salons
Generations	Revolutions
From morning til night	From night til morning
Polished metals	Rusted metals
Of the harnesses	Of the uprootings
Which break	Which take fire
In the dust	In misery

(58–59)

96. Poets do not often include insects in their worldview, but Butor does. For example, *Les éphémères,* #24 in *Zone franche* (Montpelier: Fata Morgana, 1989), and especially *L'Ecole d'Orphée* (Michel Butor and Henri Pousseur, *"L'Ecole d'Orphée: Constellation Michel Butor."* Performed Geneva, 7 October 1989, text included in *Program,* week of 25 November–3 December 1989. [Geneva: Département de langue et littérature françaises modernes, Faculté des lettres, U of Geneva, 1989]). *"Fourmis argentines"* appear frequently, often unexpectedly, crawling or marching, for example, through *Matière de rêves III: Troisième dessous* (Paris: Gallimard, 1977).

97.

RESISTANCE

A champagne they will not serve us
But all of whose bubbles we will know
An intoxication which we will not endure
But all of whose vapors we will study

A coat which we will not slip into
But all of whose velvets we will stroke
A gauze which we will not lift
But all of whose folds we will kiss

A banknote which they will not exchange for us
But all of whose creepers we will make out
A country where they will not invite us
But all of whose tombs we shall visit

A soldier who will not get up again
But all of whose groans we will record
A massacre which we will not prevent
But all of whose corpses we will bury

A sky where we will not go
But all of whose spheres we will imagine
An age to which we will not return
But all of whose perfumes we will distill

A title which we will not explain
But all of whose meanings you will unfold

(35–36)

98. This Cranach Venus is not the same one the Organizer related to *La Femme sauvage* (27), who was probably the *Venus in a Landscape* of the Louvre, as in the latter painting she has a notable almost invisible veil, ineffectual as covering, but that she delicately fingers as in the poem: *"Palpez ce que l'étoffe couvre."* The Venus of the Borghese gallery is a less likely candidate, I think, as her veil is scarcely there at all, and it is her hat that is remarkable. One *Quellnymphe* by the Elder is in Berlin (or was in 1937), one by the Younger was in Kassel at that time; either fits the contour of the *Résistance* figure, but the background of the collage, which could confirm the identification, cannot be made out in our reproduction. (Cranach, Lucas the Elder and Cranach, Lucas the Younger, *Ausstellung* [Berlin: Staatlich Museum Berlin, 1937]).

99. This speech of the Composer is set in *Dialogue avec CB* immediately after the Dreamer's description of Nixon as he appears in a collage.

100. Letter to author Lucinges, 16 May 1999.

101. *Artistes avec Michel Butor/ Michel Butor mit Künstlern* (Zurich: Collegium Helveticum 1999), 15.

102. Letter to author Lucinges, 26 July 99.

103. The line on the Dutch genre painting reads, *"J'entends le glas de mon enfance trahie"* and that on the Wild West poster, *"J'entends la cloche du train fantôme à l'approche du pueblo dévasté par les fièvres."* We can watch for these two beautiful and totally unrelated lines in future Butor poems. However, I wonder if he has already used them since the publication of the *Ballade* in 1983, because of his use (in his same note to me) of the pluperfect: *"les autres n'avaient pas été reprises."*

104.

BALLAD OF THE CRUMPLINGS OF THE WORLD

I hear the cooing of the sea in the ear of the bare rocks
I hear the flight of locks of hair in time which passes
I hear the guitar of Parisian bistrots at the turn of the century
And the gallop of a runaway horse in the autumn avenue.

I smell absinths and teas sawdust and Oriental tobacco
In the wake of the lady in a little veil and feathered shawl
In the furrows of old papers rising

I hear the shakings of huge funds which will engulf us in their whirlwinds
I hear the roarings of wild beasts who have decided to invade our classical arbors
I hear Venice in London urchins' cries and calculations in banks
The scraping of anchors along the quays and bells of street-sellers

I smell displays of fish-mongers collections of perfumes and spices
Tar smoke bacon leather and glue
In the grooves of old papers fermenting

I hear the snappings of locks beneath the fists of voracious rebels
I hear the steps of the arsonist who wants to extract gold from our shams
I hear the snake of imperial follies
Which vocalizes its monotonous songs on the watered silk of deserts in the morning

I smell the acidity of the lichens the chalky soot of petrified battering-rams

The exaltation of powder and the call of sage
In the creases of old papers reeling

I hear the kisses in cascades the explosion of laughter
The distant thunders rumbling and wine-growers' dances
I hear the whinnying of horses and rubbing of silks
The clanking of arms and tinkling of jewels

I smell the honey of caves and the juniper of lawns
The musk of recesses the salt of tears and sweat of the forge
In the drapes of old papers germinating

I hear the groans of stamens the cries of pleasure of pistils
The snarls of opening petals and chirpings of the Moon
I hear the crunchings of bones and ripening of pustules
The writhing of worms and the wind on the peaks

I smell the breath of boars dung of eagles mold of frames
The soured sweat in folds of the monk's frock and the incense of dawn
In the valleys of old papers swarming

I hear the moaning of larvae which our incantations snatch away
From the foolishness they have delighted in for millennia
I hear the croaking of flames the sneering of proverbs and muttering of ruins
The splattering of soldiers and death-rattles of the kitchen

I smell the stings bites cuts and rips
The fractures chokings and fevers
In the convolutions of old papers trembling

Prince of juxtapositions enlargements reductions and contractions
Intersections splices mutations deductions and multiplications
You uncover the first babblings of a newborn savior
In the lips of old papers bleeding

(72–76)

105. The differing translations occur first in the stanza 2 quatrain, "urchins' cries *(appels des marmots)* and the stanza 3 tercet "call of the sage" *(appel des sauges)*; second in the stanza 3 quatrain "snappings of locks" *(craquements des serrures)* and the stanza 5 quatrain, "crunchings of bones *(craquements des ossements)* and third in the stanza 5 quatrain "writhing of worms" *(grouillement des vers)* and its tercet "old papers swarming" *(vieux papiers qui grouillent).*

106. The other repetition, of "horse" *(cheval)* in the stanza 1 quatrain and "horses" *(chevaux)* in the stanza 4 quatrain, functions differently. Still apparent in English, in French the sounds relate to the harmony. In the first cases, the "al" is immediately repeated in *"cheval emballé"* while in the second case, the closed *o* of the plural recalls the closed *o* of "explosion," and the quatrain mingles other "o" sounds, [wa], open *o* and nasal *o*, all lost in translation.

107. For example, *"le roucoulement de la mer,"* recalling a Canaletto Venice scene, appears in stanza 1 (Mucha), and *"le genièvre des pelages,"* which evokes a Canaletto English estate landscape, in stanza 5 (Grünewald). Ernst's Napoleon is reflected in *"le cliquetis des armes"* of stanza 4 (Veronese) and *"le clapotement des soldats"* in stanza 6 (Breughel). The *"rochers nus"* of stanza 1 are more Breughel than Mucha, the *"ébranlements," "tourbillons"* and *"rugissements"* of stanza 2 are more Breughel than Canaletto. Then, the resonance of "Mad Meg" is heard throughout: that *"cliquetis des armes"* associated loosely with Ernst's Napoleon in stanza 4 (Veronese) is more audible—or visible—in "Mad Meg" than in any of the other artworks. In stanza 5 (Grünewald) the monsters blend, generally, but the *"les craquements des ossements"* suggested in the Grünewald, seem more visible in "Meg" in the leg not yet swallowed by the giant fish in the foreground.

108. Alexander Wied, *Breughel* (Milan: Mondadori, 1979. Rpt. (Danbury, Conn.: Masterworks Press, 1984), 111.

109. In this same section Butor offers one of the many puns: "42) The ankle or the strangling" (*La cheville ou l'étranglement*) moves from the immediate understanding of "ankle" to another meaning of *cheville,* a "plug" for filling holes, and thence to *étranglement* as a constriction or bottleneck in a road. There are far too many to cite here.

110. In phase 6 there is a third pair of "A" repetitions, which are unique in that they do not introduce a new scene.

111. In his analysis of *Le Rêve des pommes* in *Matière de rêves II,* La Mothe sets the introduction and concluding sections off as slightly irregular and finds in them not a circle but a spiral (192).

112. A misprint in the *Dialogue avec CB,* corrected here, reads *"brides"* instead of *"bribes,"* as in the *Coloquio/Artes* and *Matière de rêves* texts.

113.

I am under a rain of printed matter (9). / In my mirror-bed of tortures, I intercept the approach of a desert, an oasis of calm and relief. / Newspapers, posters, pages of books fall in a flurry. / I struggle, unable to read for the moment. One sheet soars more slowly, comes closer; I recognize on it German characters. / It strokes my face, blinds me, rolls around my chest, slides over my legs, spreads out on the ground which is entirely covered over by those which preceded. / On this sheet are groupings of British characters, but I cannot manage to grasp one word as a whole. I almost caught that one, which draws me into the maze of the downpour of labels; I pursue it; it turns around: I almost trapped an entire sentence (10). / And then here are inverted circumflex accents on certain letters, which warn me that I have passed into a Czech language region. / Manuscripts mix in, more and more ancient; descent into a well of writing. / Trickles of Morse and Braille, scraps of geographical maps, dust of student textbooks: all my clothes are soaked through; I am myself drenched. / My hands are molded into gloves of missel, my legs wrapped in trousers of dictionary, and I am wearing a mask of ironworks catalogue(11). / I breathe scraps and downstrokes, the interior of my nostrils is lined with samples. I chew words. I am suffocating . . . / Fire smoulders. (12)

114. Only here at the very beginning do three of these sentences appear in sequence (*"Tel un courant d'air frais . . . son nez"*); subsequently each phase begins with two.

115.

Like a breath of fresh air passes a lady of yesteryear:/ I have already seen her somewhere. Then they transform the devices again by cutting up each of the glass slides into little squares. / It is only a shadow in profile, but I recognize her chignon, her necklace, her nose; all around her the weather is calming in a classic landscape. Behind big rocks a natural storm is moving away carrying along in its last eddies hawks and gulls. / Beneath the branches of great oaks, I make out a bay with a port, even a ship. A workman urges on his cattle; conversations of shepherds. In the bushes spying satyrs are hiding (14). / The spirit of these lands, crowned with laurel, comfortably installed on a couch of stones and moss, listens to the song of a flute. I know it is played by the monster musician with only one eye, the clayey Polyphemus, just set free from his mountain, but at the place where he should be seen a modern street is hollowed out in the interior of the passing lady, a street which some fifty years ago would have seemed modern in the extreme, but paved with granite shining from the last shower. / In her nostrils slender boughs represent the nervous excitement produced by Sicilian smells: thyme, lavender and cheeses. At her back, the sides of two blueish automobiles. The rearview mirror of the first invites me to venture into this gentle urban solitude; and at the moment that I enter this profile the voice of the lady utters calmly, as if she had already been talking for a long time, but as if my ears had been unstopped only at the instant of my passage: . . . (15)/. All the museums of the world collapse by slabs, and while my paper soles shuffle on the damp granite, cannon booms reply to her . . . / . . . and while my mottled fingers rumple the tulles which are swelling in the nave, the hollow lady turns and makes me a gift of one of those little racks which chemists set out on their shelves in order to observe conveniently the development of their preparations in their test-tubes. (16)

116. Three of the collages in this set (3) are *rollages.* See Candela for an example of the little squares. André Candela, *Kolář: Poème Préface* (Cannes: Impr. Bosco, n.d.).

117. The series of texts, *Le menu meuble Le mugissement d' eaux,* and *La Dame de ce temps-ci* is cited and commented upon by La Mothe (188–90). He examines the variables in the *"Tous les—du monde"* phrases (our third element of Matrix B) as they reverberate with the repetitions in that "B" matrix (192–94) , and reads the "smouldering" phrases as the *"forces latentes qui préparent en secret"* the *"écroulement par plaques"* of the elements serving as variables (195). He notes that the "gifts" derive from Kolář artworks, and that the "lady" is metamorphosed along with the descriptions (196–97).

For the full dissection of the matrix, see Appendix D. Minor variants in La Mothe's citations and those found here are attributable to his working with the *Matière de rêves II* text, while mine is that of the *Dialogue avec CB,* which contains not only the *Opusculum Baudelairianum* and the *Rêve* texts, but also those from the set 2 collages, here read by the Singer, which have not appeared elsewhere in conjunction with descriptions of the collages.

118. A larger reproduction of what may be the same artwork clearly shows at least the eyes. See Candela, *Kolář.*

119. The second repetition "A" phrase, *"Tel un courant d'air passe une dame d'antan, je l'ai déjà vue quelque part"* suggests that this collage (which we do not have) contains the same contour of a woman seen in *La Dame d'antan.* She reappears in phase 6 in *La Ville moyenne.*

120.

It is an apple dressed in a shirt, not only a shirt, it is a half-undressed apple: there remain a square of red velvet, a gore of black satin, several layers of pink and grey striped cotton, with blue stripes, pink polkadots, little squares. / It is an apple with a zippered fly. I cannot resist. I open it gently: a cloud of typed letters comes forth from the slit. I close it again. I am no longer in Venice . . . / (32)

121. For example, as soloist in the opera, *Elseneur* (Yverdon: Henri Cronaz, 1979), reprinted in *Avant-Goût III: l'appel du large* (Rennes: Ubacs, 1989), and also much rearranged in *Transit B.* (*Transit :Le Génie du lieu IV* [Paris: Gallimard, 1992]).

122. *Cavalier* could also be translated as "knight," and when this figure first appeared on the Moon he was a *"cavalier blanc"* [white knight]. The connotations would be appropriate only sarcastically when he is transformed into Nixon; hence the translation "horseman."

123.

It must be Elizabeth Taylor. Black hair swept up in a large chignon with a gold band, gauze veil embroidered with gold, diamond necklaces, brocades. But her face is masked by a rectangle of invisibility. The horseman dismounts from his horse. In the light of this room, he takes on the complexion of magazine illustrations, hair brushed back, incipient baldness in two points, dark tie and white collar. / It is the apple in my hands, which I have not stopped touching, which evidently interests him. I get out of the car which goes away. It is this apple which he thinks will interest the queen. He siezes then a magnifying glass for clarification, which, while permitting her to scrutinize the enticing fruit, permits me to ogle her gluttonous lips. / I profit by a moment of the horseman's inattention to slip inside the fly. The queen takes the apple in her hand, and while I penetrate between her lips, her voice, the same voice, utters calmly: . . . / All the legislations in the world collapse by slabs, and while my paper mask wipes the inside of her lips, the cannon booms reply to her . . . / (37–38)

124. In the *Bicentenaire kit,* after spotting Nixon's portrait on the presidential placemat with axle-grease, Butor says of him that he *"achève de mourir"* (40).

125. In *Dialogue avec CB,* this phrase, *"Tout est aminci"* ends the Dreamer's speech on p. 40, following *"l'ascenseur fait sur-*

face." In *Coloquio/Artes* the phrase is set beginning the Dreamer's next speech on the next page, preceding *"Le ciel est tellement noir"* (41).

Here a printer's error robs us of vibrant images, given here underlined: *"Quelques sapins bleus, verts et pourpres dans la neige de cuivre. Un lâcher des oiseaux-barres au dessus des terrasses d'émail"* (42, *Coloquio/Artes 10, MR II* 69).

126. See La Mothe's treatment of this autobiographical theme (23–25).

127. Some of the Kolář *froissages* included in *Dialogue avec CB* correspond to monuments mentioned as being on the apple collage: the Hôtel de la vieille ville (100), the Château de Prague (102 and 124), the Cathédrale Saint-Guy (105), and the Tour Poudrière (120). In them, the figures are in modern dress, not *"crinolines et chapeaux hauts de forme"* (57), as in this text.

128. As the second sentence is one of those omitted by printer's error on its first appearance (52), we may not recognize it as an "A" statement.

129.

A sort of rectangular mirror with horn handle. . . . It is a question in reality of one of those little boards which housewives use to cut cheeses, vegetables, sausages into rounds, to mince parsley or chives, carved from the material of museums. I look at myself in it and indeed see my reflection: it thus really is a mirror, too; but I recognize myself in the features of the god I hate the most, the handsome god Mars, the seductive sword, whereas am the son of Vulcan, actually his distant nephew, through migrations and turns of the wheel of Fortune, Mars sliced into sections, who is swaying with his mini-skirt barely showing below his armor. (70)

130.

Many books and music scores, a basket of candied fruit, the teapot and the sugar bowl. Head down between her shoulders in her heap of satins, flounces, furbelows, garlands, bracelets, knots, laces, gauze roses, she supports her enormous limp head on cushions. / Her vague glance tries through her shaky monocle to distinguish her favorites among the crowd; her long moustache dips into her cup, and her pepper-and-salt beard flows down across her upright chest. / (78)

131. I touch it, I breathe it; it is a fruit which has reddened on the tree of the orchard of elsewhere, of the orchard of then, of the orchard of awakening, of the one illuminations and tapestries speak about confusedly, and I can relive its drama by licking, biting its skin. / Pulp of lips and smiles, in chewing you I shall be acquainted with the knowledge of good and evil, I shall resemble the most beautiful words of all languages, when they are murmured or sung by the most sensitive of all women. / I shall become haunted, joined by all the gods my fathers, pip of reconciliation, kiss of peace, the gold of the open sea. (80)

132.

Composer. They will no longer bear grudges against one another.
Organizer. "Monocle," conversing in the clockfaces with a Munch
Singer. The time of a perfume
 The breast of sufferings
 The clockworks of heads of hair
 Night
Dreamer Inside the first communicants turn around swiftly, their
 dresses dyed in the fibers of the stained-glass windows. And here
 the triangles become foliage.
Organizer: Now it is our turn to read to us your version of "Exotic
 Perfume."
Letter-Writer. In the hope that some of these broken pieces will be
 lively enough to please you.
Reader. For what good is it to seek your langorous beauties
 (The violins vibrating behind the hills)
 Elsewhere than in your dear body and in your heart so sweet
 With the jugs of wine at evening in the groves
 (61)

133. One could read the cathedral scene as a complex metaphor: cider of the apples evokes the wine, the butterflies' performance the drama of the Mass, the butterflies themselves as symbols of the metamorphosis of the soul. However, Kolář does not seem given to religious imagery, and Butor ordinarily is not, though it filters in occasionally, as in the "kiss of peace" of the Closing.

134. Bernard Weinberg, *The Limits of Symbolism* (Chicago: University of Chicago Press, 1966), 246.

135. There is not only the beauty of the concept, the quality of the engineer, there is also the moment of exquisite adjustment. People who bring automobiles into running order are artists in their field. In correctly regulating the carburetor they make the machine sing. A good mechanic must have an ear. There is a moment when that sounds right, which he must know how to sieze. If we combine two images or two cuttings of the same image, we must make them slide gently in relation to each other, and watch for the moment when they begin to vibrate. That is the ear of the eye. (58)

136. Butor's correspondence on his own handmade collage postcards is celebrated and much appreciated by those happy enough to receive them. Skimao, among others, has written a heartfelt tribute to them, in which he asks, *"Qui donc n'a pas songé à recevoir par la Poste des oeuvres d'art?"* (Michel Butor, *Passage de Butor II* [Montpellier: Galerie Wimmer et Musée Bédarieux, 1991], n.p.)

137. Michel Butor, "Cartes postales pour un ami de Liechtenstein" *Liechtensteiner Almanach.* (Vaduz: Brunidor-Serien, 1989. Rpt. *Avant-Goût IV: en mémoire,* Rennes: Ubacs, 1992), 9, 31, 63, 89, 123, 149, 177, 205.

138.

The Beautiful Town
 Uncle Jules showed us one of the most impressive metallic buildings of the capital. Ah, it is when you are swept away on its mechanical suspended staircase that you feel rolling in some way under your feet the industrial progress from which we expect so many advantages! And imagine that when you reach a certain height, free of the smoke of factories and locomotives, of the often surly noise of the dusty and haggard crowd, you perceive a castle among the mountains, you smell the balms of the forests, and what you hear then is the cry of jackdaws, the clinking of armor and the melodies of maidens with harps and lutes. But it is not yet possible really to go there. It is only a mirage with which our engineers entertain themselves. (*Avant-Goût IV* 9)

139. The corresponding figure in the United States today would be Willy Loman's brother Ben returning from Africa with his pockets full of diamonds.

The Uncle Jules who turns up in *Matière de rêves III: Troisième dessous,* talking with Uncle Tchouang (*Matière de rêves III: Troisième dessous* [Paris: Gallimard, 1977] 83, 91, et passim) is revealed as a totally different Jules: he *"ne venait nous voir que tous les 80 jours (le reste du temps il faisait son tour du monde)"* (131, 232).

140.

It is like a block of coal at the top of the hillock, illuminated not by embers, but by cold phosphorescences. It is also called the moon trap. Even in full daylight its image is imprisoned in the tower, and this captive faithfully follows the phases of its celestial model. It appears that when you succeed in discovering the gateway of this fortress with its well-jointed stones of obsidian, polished to a mirror finish, you discover inside an entire city in miniature with the agitation of its vehicles loaded with elegant goblins, with little canes with gold pommels, fans of quail or parakeet feathers, who pour out into the dancehalls or theaters or else squash themselves on the bridges, in order to admire the fireworks which illuminate the venerable vaults where the painted stars revolve slowly. (63)

141.

The city proposes no end of sights to us. Coming out of tunnels, where the young and terrible electricity fairy makes metal cars with comfortable seats of wood and leather move mysteriously, a little dizzy from all the grindings, gratings, uproar, especially when two trains pass in the turns, barely lit every now and then by a very pale light protected in some niche dug in the dripping wall, you need only lean on your elbows on the balustrade of the walkway to discover beyond the protective chains a delicate scene of fogs behind the bulbous steeple of an idyllic village where you feel there will be no lack either of silvery sobs or cascades of laughter, with the booming of the torrents and the brass of dead leaves which revolve gently down to the tavern tables laden with pitchers and fruits. (149)

142.

It is for the official visit of the sovereign family of a famous and venerable principality between Austria and Switzerland that our minister of ceremonies and decorations has instructed a young artist, as much sought after as argued about, to transform the heavy monument of one of our busiest squares into a sort of call for fresh air. Of course, there is some trompe-l'oeil in it; it is for the most part canvas with images cast on it by hundreds of projectors distributed all around on the roofs of the buildings, reconstituting the landscape by changing the lighting according to the time of day, with the advantage that they can prolong the evening, for example, when all the rest is in the night. And this time you go in; there you find a path that could mislead you, veritable branches, pebbles, rocks, a spring, wildernesses. Certain visitors never again come out. One of them is supposed to have declared, "Here is where our outdoors is." He has not been seen since. (205)

143. See Butor's *Le Génie du lieu II: Où/Ou* 103–44.

4. MICHEL BUTOR AND PIERRE ALECHINSKY: THE DOUBLE GAZE

1. Michel Butor and Michel Sicard, *Alechinsky dans le texte* (Paris: Editions Galilée, 1984), 117–42.

2. When the papers Alechinsky is using are Butor's manuscript drafts, as in *Rescapés de la corbeille,* (in Michel Butor, *Hoirie-Voirie* [Torino: Pozzo Grosmonti, 1970]) the texts of the support obviously preceded the artworks.

An additional challenging element in the study of the Alechinsky drawings on "found papers" is Alechinsky's left-handededness: he has been known to write backward, especially his signature. Writing that has bled through from the reverse side of a page is as legible to him as that on the front. To determine whether a word, rather than the pattern of print, has provoked an Alechinsky image, one must try to decipher and identify the words (or fragments remaining after Alechinsky has drawn on the page) on both the recto and those bled from the verso. Hence another piece of equipment is essential: a mirror. Studying these text-first collaborations has produced, at the least, great admiration for scholars reading Leonardo.

3. Michel Butor and Michel Sicard, *Alechinsky: Frontières et bordures* (Paris: Editions Galilée, 1984). Michel Butor and Michel Sicard, *Alechinsky: Travaux d'impression* (Paris: Editions Galilée, 1992). References to Alechinsky are frequent in Butor's many published interviews. See also Christian Dotremont and Michel Butor, *Cartes et lettres: Correspondence 1966–79,* Michel Sicard, ed. Preface by Pierre Alechinsky [Paris: Galilée, 1986]. and *Cobra 1948–51* (expo) (Paris: Jean-Michel Place, 1983).

4. Pierre Alechinsky, Michel Butor, and Michel Sicard, *ABC de correspondance* (Paris: Daniel Lelong, 1986).

5. Of interest to a scholar bent on untangling would be the collaboration between MB and MS, *En Marge,* an artist's book published in 550 copies, in which Butor wrote the primary poems and Sicard added Chinese ink drawings and five of his own poems (Michel Butor and Michel Sicard, *En Marge* (Paris: Orte, 1992).

6. MB/MS discuss Alechinsky's use in *Hoirie-Voirie* of old manuscript pages in *Travaux* (36–37), and many other examples are reproduced and discussed there.

7. These drawings are discussed more briefly in *Texte* (136–42), where only two of the drawings are treated: 23 December 1840, *"Encore moi mon cher Stock,"* and the undated two-part drawing, one side on the address and the other on *"Je suis bien charmé."* In *Grosses en Stock* in *ABC* this passage is revised from the prose of *Texte* to the speeches of MB/MS, with an amplified consideration of the other drawings in the series.

8. Discussion and examples of Alechinsky's works on maps may also be found in *Travaux* (58–59, 155, 176–77, 184–85, 107, 209, 211–19).

9. *Stances des mensualités* is in *Hoirie-Voirie; Méduse des chocolats* in *Michel Butor et ses peintres: Guirlande liminaire* (Le Havre: Musée des beaux-arts, 1973); *Comptine en blanc et noir* in *Bordures;* and *"Dessins sur factures"* is the first part of *ABC.*

10. See also Pierre Alechinsky, *Peintures et écrits,* ed. Yves Rivière (Paris: A.M.G., 1977). *Paintings and Writings.* (English trans.) (New York: Abrams, 1977), passim, and passage cited by Fremon in Michel Sicard, ed., *Pierre Alechinsky: Extraits pour traits* (Paris: Galilée, 1989), 181.

11. An example appears in *Extraits.* Dotremont's *Notice* includes a reproduction of a joint drawing by Appel and Alechinsky taken from Hugo Claus, *Poèmes pour Appel et Alechinsky* in *Encres à deux pinceaux* (*Extraits* 151–54). Several collaborative works by Alechinsky and other artists are reproduced in *Travaux,* and *Cobra* includes collaborations in a number of different combinations. Almost all the texts in this collection of the *Cobra* and *The Little Cobra* journal reflect the collaborative force.

12. Cited by Esteban in *Extraits* 184.

13. However, Dotremont vigorously distinguished Cobra from any other "movement," including surrealism and expressionism; as for Pollock, Dotremont firmly stated that Cobra *"en 1948–50 ignorait absolument l'existence de 'l'action-painting'"* (*Cartes* 171). He identified the essence of Cobra as the *"peintures-mots"* he and Jorn created, adding decentralization and internationalism. See his long letter # 117 in *Cartes* 165–73.

14. Butor describes the *"cadavre exquis": "Il s'agit d'un dessin en collaboration, avec cette particularité que l'un des collaborateurs ignore le travail des autres, ne connaissant que quelques points d'ancrage et le lieu de sa participation par rapport à la figure générale. Cela représente dans la plupart des cas un personnage: le premier fait la tête, le second le haut du corps, le troisième les jambes, etc.; mais le dessinateur n'a pas sous les yeux—c'est caché—le reste du dessin"* (*Texte* 13).

15. In what must be recognized as a biblical reference, Butor continues, *"ces lettres précieuses sont des papiers d'affaires mortes—et c'est de ces cadavres que quelque chose va renaître"* (*Texte* 120).

16. Photographs in *Bordures* and in *Travaux* show him in the process.

17. See, for example, *Extraits* (De Vree 134 and passim).

18. *"dans deux séries de tableaux, un personnage de Matta regardait un Brauner, pendant que dans l'autre série un personnage de Brauner regardait un Matta. Et c'était Matta qui avait peint les Matta et Brauner les Brauner"* (*Texte* 13). Later, Butor adds, *"chacun des artistes ayant laissé à l'autre un rectangle à l'intérieur de sa toile"* (*Texte* 202).

19. Michel Butor, *En Compagnie de Michel Butor* (expo) (Valence: Musée de Valence, 1986).

20. Cited by Esteban in *Extraits* 185.

21. A pertinent example is the *"Guirlande liminaire"* with its matrix carefully changed to suit the particular artist.

22. Michel Butor, *Le Chien roi* (Paris: Daniel Lelong, 1983); Michel Butor, *Le Rêve de l'Ammonite* (Paris: Fata Morgana, 1975).

23. For example, Michel Butor and S. J. Rhee, *Replis des sources* (Paris. Seuil, 1977) and Michel Butor and S. J. Rhee, *Bouquet d'impressions* (Nice: J. Matarasso, 1986); and also Michel Butor, *Génie du lieu V: Gyroscope* (Paris: Gallimard, 1996) "Cathay."

As regards Alechinsky, Butor finds the Japanese influence stronger than the Chinese: *"Le caractère chinois, dans son aspect pétrifié, solide, ne semble pas avoir beaucoup retenu Alechinsky; en revanche, l'a beaucoup inspiré l'écriture japonaise la plus cursive, ces inscriptions coulées de haut en bas sur une page, notamment sur fonds pailletés. Il y revient constamment"* (*Texte*, 68–69). Sicard mentions Alechinsky's liking *"l'estampage chinois,"* however, relative to Alechinsky's medallions which resemble Chinese signature-stamps (*Travaux* 73, 84 ff).

24. Cited by de Vree from *Paintings* in *Extraits* 135.

25. The publication of the *Poème optique* (*Strates* 7 (October 1966), is the subject of many of the Butor-Dotremont letters. (*Cartes* 27–91, passim).

26. Published as *Le test du titre, 61 titreurs d'élite* [*The Test of the Title, 61 Crack-Shot Titlers*] (Paris: Eric Losfeld, 1967), this work is difficult to locate in the United States, but in addition to the Library of Congress, it is held at the University of Wisconsin at Milwaukee.

27. Michel Butor, *Les mots dans la peinture* (Geneva: Skira, 1969). Butor here includes a photograph of Alechinsky signing a painting, with his Japanese brush (15–29). See also in *Travaux* a series of seven photographs showing Alechinsky about to begin to paint, and then how the work develops under his brush (191–203).

28. Michel Butor, *6,810,000 litres d'eau par seconde* (Paris: Gallimard, 1965) Translated as *Niagara* (Chicago: Regnery, 1969).

29. The first part is *Rescapés de la corbeille*. See note 2 above.

30. Note the pun in the *Titreurs d'élite,* from the military term for the best marksman: *tireur d'élite.*

This brief work offers fascinating material not only for those studying Butor, Ionesco and interart relations, but also the individual artists.

The original is not paginated. The English translation of *Peintures et écrits* gives this citation on p. 90, and reproduces all six engravings on one page, with Engravings 5 and 6 reversed (Pierre Alechinsky, *Peintures et écrits,* ed. Yves Rivière [Paris: A.M.G., 1977], trans. *Paintings and Writings* [New York: Abrams, 1977]).

31. Ionesco's responses are cited in *Paintings and Writings* 14–15.

32.

Text 1

There you are, I certainly told you so, the butcher's wife has presented her bouquet of flowers to the spaniel who received it very nicely; the whole building had a good laugh over it. What impudence! Or what insensibility! Or what . . . isn't it the truth? What . . . Who would have believed it?

33. Several of the "titlers" saw this as a theater scene, and Ernest Pirotte called it, *"De sa fenêtre elle me demande de monter la voir."*
34.

Text 2

Hey, hey, hey! Everything is collapsing; the spaniel is beaten to a jelly; the flowers were cunningly stuffed with snakes, and with all those banana peels the kids sneaked under the stepladders, I know some who felt small; a little more panic, please!

35. Enrico Baj saw this engraving as *"Au-dessus volaient des êtres étranges de probable origine extra-terrestre."*

36.

Text 3

It is growing, or rather it is growing again; she is the only one to have such ideas, and even though he was rubbish the spaniel did not really suspect that early in the morning he would be used to fertilize the—my goodness charming collection of potted shoe heels, with the banana-peelish foliage. A little blood on top, some bone paste, and there is Monsieur's fur becoming the most appropriate base of lawn to show off the sea-green roses.

37. Some of the other *"titreurs"* saw these three T's as orchestral music stands, some as a reference to the crucifixion, and a few counted the fourth figure that breaks through the frame.
38.

Text 4

What a surprise! Here he is all invigorated, frisking about full of fun on his hillock, one of the prettiest details in our back yard; she just had the time to patch up two or three no longer very fresh snakes, for a lyre-bird on her hat. Oh, she can always act proud, sport her little modest, self-assured smile, the serving boy turns pale for her over it. It is only the prelude to the puppet show; I make out the jealous husband who is imagining.

39. Gudmundur Ferro entitled this one *"La chute de l'embryon."*
40.

Text 5

"She laughs until she cries; she had mined him." "Mined?" "The husband! A little powder in the soup, and when the other, all spruced up, a bit of a snob, boiling mad, with his sea-green rose in his buttonhole, started to relight his pipe."

41. Since this text treats of stereotypes, I use the feminine form for the narrator, although we all know men who gossip.

42. Some of the *"titreurs"* saw this engraving as a view through a microscope and several others, like Butor, as some kind of explosion.
43.

Text 6

She is triumphant; all the awards; and people have been parading past ever since morning whispering stories about her to each other; we have to admit she really knew how to arrange it all: with taste, with ease, and that décolleté she found for herself. . . . ; it all planted itself, it is bomb horticulture; but after how much patience, care, all the manuring, the de-fleaing, she spent her nights at it, then the corset-rose, the feather-rose, the umbrella-rose, the showerhead-rose. . . . Everything would have to be cited.

44. This is the engraving that Hundertwasser entitled *"Fourmis de tous les pays, unissez-vous!"* having worked ants into his previous titles as well.

45. Ionesco saw this figure as *"le heaume d'une cuirasse, fendu, comme un visage fendu,"* and Pierre Faucheux entitled this engraving, *"Le masque de fer au jardin des statues. Il y a encore du sang partout."*

46. To see any allusion to Pagnol's unfaithful baker's wife (*La femme du boulanger*) would be a mistake. What we know of the butcher here is not sympathetic, at least according to the narrator, and the baker's wife of Pagnol returned to her grieving, loving husband after her fugue.

47. We may hear this speaker as similar to the gossip of Thebes in *Le Chien roi* and recognize that there is more to this story than we know, just as in Thebes we have to suspect that perhaps Sophocles's version of the events was more accurate than that of the gossip.

48. As mentioned before, this is a term used as title for Chapter V of *Texte* (Michel Butor and Michel Sicard, *Alechinsky dans le texte* [Paris: Editions Galilée, 1984], 117–42).

49. Michel Butor, *Hoirie-Voirie* (Torino: Pozzo Grosmonti, 1970). In *Rescapés* the artist is responding to the writer and thus the work is not included in the present study. The drawings are reproduced in the published work on heavy translucent paper, almost like a very thin plastic. The drawings of the *Stances,* however, are printed on opaque paper, as is the text.

50. The words that can be made out are *"année"* in *Avril* and again in *Juillet* (which appears in Butor's text in *Décembre*), as well as *"pour donner."* Then *"soussigne"* (which appears in the text in *Octobre*) is legible, as is *"cancelle en ce que"* in *Septembre*.

51. In *Août* the original document shows "cros" printed, rather clumsily, under the signature "croze." Then, in printed capitals, "BP" appears over a space blank except for words bleeding from the other side. On the same document, an additional set of initials, "JP" is obscured by an Alechinsky line. Another such set of initials appears in *Octobre,* "PM."

52. Letter to author, 19 May 1993.

53. In *Illustrations IV,* each stanza is printed in boldface in the middle of a page, framed by lines of poetry, which create "contamination." The term is Butor's, precisely described in Santschi (146).

The text reproduced here is the original, with corrections made of the typographical errors. The variants in *Stances* in *Illustrations IV* are minimal: the notes are numbered consecutively from 1 through 24; the typographical errors are corrected with the exception of *"bélier,"* and a new error is introduced: *Avril*'s *toison dédorée* has become a *corne dédorée,* probably a printer's error from the *cornes* in the following line. These variants are as follows:

	Original	*Illustrations*
Jan.	tapadipaditapada	tapadipadi tapada
Apr.	camionette	camionnette
	toison dédorée	corne dédorée
Aug.	moîte	moite
	boite	boîte
Oct.	perspectives de classeurs	des classeurs
Nov.	tintinabulements	tintinnabulements
Dec.	Bougies gui houx barbes	Bougies houx gui barbes
	aage	âge

In *Illustrations IV Stances* is used as a "solid" text; that is, the surrounding lines pick up words from *Stances,* while *Stances* itself remains intact. At first the "contamination" is very slight, with only two words, *"mains"* on the first page and *"doigts"* on the second picked up in the upper and lower lines of poetry. Gradually the number increases, until in *Juin* only two words in the text, *"déceptions"* and *"centre"* are *not* used in the upper and lower lines. The number gradually decreases again until in *Décembre,* in which the first page has only two words, *"anneau(x)"* and *"repli"* used in both framing lines, and on the second and last, only one, *"houx."* Inglis believes the "solid" texts of *Illustrations IV* are "never contaminated" by the "liquid" texts, but rather that the "solid" text "acts as a catalyst in the intertextual movements" (Angus A. Inglis, "The Application and Development of Michel Butor's Collage Principle in *Illustrations IV,*" *Review of Contemporary Fiction* 5:3 (fall 1985): 104). Since "contamination" means substitution of one text within another, this does indeed not occur here. However, the choice of words printed above and below the stanzas does affect the reading, through the "intellectual chord." (See Weinberg, cited above.) One effect visible in *Illustrations IV* is that the original *Stances,* now

surrounded by reiterated words with serious connotations, lose their humor.

54.

JANUARY

I bequeathe to Milord January
In addition to the tail of Capricorn
And the compassionate head
Of Aquarius bent over her urn
My two hands without a single penny
After the sprees of gift-giving
All the holes in the bottom of my pockets
And a serious hoarseness(1)

Thus I versificate
Counting the feet on my fingers
Tapadipaditapada
With innumerable liberties
Rhyming would be too difficult(2)
For a touch of modernity
Some doggerel with footnotes
At a dignified dignified pace

(1) Item a hangover
(2) Rhyming would be pretentious

55.

FEBRUARY

Item to chilly February
In addition to the hair of the server
Squalls showers hailstorms
And the silence of the Fish
The feathers of Gilles in Binche (1)
Thousands of orange seeds
Rolling on the tar of the streets
Then squashed by the cars

Intoxicating perfumes of the peels
Twisted like shoestrings
Rolling up like ribbons
Adhesive tape around the wires
Electric tattered (2)
In the midst of the gasoline fumes
And the mire of the thaw
Sweet animosities of the carnival

(1) I will go some day to admire them
(2) One senses the do-it-yourselfer breaking through

56. See also *Les Oranges de Binche* in *Le Chien roi,* (Pierre Alechinsky and Michel Butor, *Le Chien roi* [Paris: Daniel Lelong, 1984]).

57.

MARCH

Item to March the dilapidated
In addition to the dorsal flippers
Bones and some boat wakes
With the muzzle of the Ram
A sort of minaret (1)
Surrounded by zinc palms
Mounted on an enormous pedestal
In the form of a covered cheese-plate

Decorated with Phrygien bonnets
A crown of laurel

Little flags some rubble
Hollowed out with sewers and crannies
With dripping walls with drafts
To install there the offices
Of the protective society (2)
For bacteria and viruses

(1) Here a memory of Egypt
(2) A trace of humanity

58.

APRIL

Item to this joker of April
In addition to the tarnished fleece
With the speckled horns
Of the progenitor of bovines
The apron which at the slaughterhouse
The butcher puts on to slay them (1)
The rose windows of his nipples
The folds of his stomach

His mug open in a cry
Of astonishment before the sprouts
Of dandelion or of parsley
Which come out between the pavings
Uneven and stained with blood (2)
Of the parking lot where he has put
His truck full of bones
And the scratches of his fingers

(1) Pleasant smells of beefsteaks sound of gold
(2) The feeling for nature

59.

MAY

Item to the lovely month of May
In addition to a last flight
Of the tail and the first wink
Of an eye from the Twin on the right to the other
On an illustrious mournful plain (1)
Swept by flights of crows
A pyramid with stairs
Seeking its balance a little

Tourists bicornered hats, birettas
Ponytails mushrooms pebbles
Tulips puddles and half-moons
Splashes unsmoothed rough-renderings (2)
Fangs generals and whisperings
Reporters high-school students bishops
Goosefeathers fountain pens felt-tip pencils
Squeeze in a crowd at its foot

(1) Wawawaterwawalhaloo
(2) An impressionist technique

60.

JUNE

Item to June the warm comrade
In addition to the wink in response
From the brother to his brother and the claws
All wriggly of the Crab
The superb spot of ink (1)

A little like a plucked chicken
With a big blotter stopper
To limit its damage

Ah pity the artist
His hands spotted his eyes swollen
His nose crushed on his pages
His feet twisted his stomach too
Pity the poor scribbler (2)
His fingers cramped his forehead lined
His back broken his throat dry
And his shock of hair impossible to untangle

(1) In memory of Victor Hugo
(2) Lyricism of the individual

61. Inkspots as emblematic of Hugo figure prominently in Butor's poem illustrated by Jiří Kolář, *Victor Hugo écartélé* (Xonrupt-longemer: Aencrages et Cie., 1988).

62.

JULY

Item to petulant July
In addition to the eyes on a stalk
And the roaring of the Lion
Some Indies some idols (1)
With many dancing and feeling arms
With heads of hair with breasts
With lips advances retreats
With thighs loops and aromas

Beds beaches prairies
Breezes waves flutes
Stones voices markets
Monkeys cobras tigers
Necklaces silks parasols
Fruits cosmetics palanquins
Rivers pyres gongs
And songs for the sirens (2)

(1) Permanence of exoticism
(2) Does not belong to the testator

63.

AUGUST

Item to the damp the stifling
In addition to the tracks in the sand
And the emotions of the Virgin
A box from which comes forth a devil
Disguised in acanthus leaves (1)
With a head in eclipse
Entirely sculpted from cork
To float on a fountain

In the shadiest of a deserted park
Dare my young ladies
To draw your timid friends (2)
To unlace your espadrilles
And to ruffle your hair
Swingings storms drops
Lull mint nightingale
And tomorrow other adventures

(1) Or rhubarb if you will
(2) The eighteenth-century touch

64.

SEPTEMBER

Item to haughty September
In addition to echos of the wedding
And the balance-pan which rises
A terrace and a meander
Then another meander a lake (1)
A wharf stairs
A grotto with graffiti
Bark with signatures

The noises of the first day of term
The feet of hunters on the stubble
The shivering of the reeds (2)
The conversations of swallows
The blooming of dahlias
The ink mixed with blackberry juice
The fires of brambles and trash
The crowd the train station vomits up

(1) All that in the midst of the vines
(2) And yet another litany

65. Although he has often spoken of the vital importance of his teaching to his writing, it is the case that only in summer is the teacher free, and in September the beginning again weighs heavy. Butor said in a letter to F.-Y. Jeannet in 1978, *"J'ai moi aussi, tous les ans, l'angoisse de la rentrée"* (Butor, Michel, and F.-Y. Jeannet, *De la distance* [Rennes: Ubacs, 1980], 108).

66.

OCTOBER

Item to abundant October
In addition to the other balance-pan that descends
And the antennae of the Scorpio
A cauliflower a hot-air ballooon
A turban for a great muezzin
A turbine or a zinnia (1)
A pumpkin for ghosts
A fist of stone on the *i*'s

Crates bricks slabs carcasses
Pigeonholes records newspapers ledgers (2)
Flourishes loops scribbles
Strike-outs accents underlinings
The city the notary dreams of
Treees with leaves of lists
Vistas of files
And jeopardies in cascades

(1) A bubo a blister
(2) Card-indexes drawers strongboxes balance sheets

67.

NOVEMBER

Item to rainy November
In addition to the sting that stands up again
And the arrow of the Knight
The molds on the tombs
The walkways of weeping willows (1)
The dangling sleeves of the ghouls
Their whistling in the twilight
The fanfares of sneezes

The elephant trunks of the zoos

The chimpanzee ears
The veins of dead leaves
The decoctions of invalids
The pins on their pincushions
The herringbone floors
The tongue in groove floors (2)
The last counters of the old bistrots

(1) Funereal tintinnabulations
(2) English-type mitred mosaic

68.

DECEMBER

Finally to sleepy December
In addition to the kicks of the horse
And the little beard of the goat
The snake who bites his tail
The folds of competition
The rings of the year which turns (1)
The windings of the intestines
Where the past is digested

Wishes fireplaces shoes stockings
Candles mistletoe holly beards shopwindows
Ribbons midnight suppers confetti (2)
From my age in the year forty-
Two well before I have drunk
All the shames of my fate
Which I await patiently
I close this testamenticle

(1) Purchase of a new datebook
(2) Organs incense bells blasphemies

Finished and reread with a clear head
17 March 1969

69. In the republication in *Illustrations IV,* these two words are reversed and the line reads: *"Bougies houx gui . . ."* I believe this variant was deliberate, to produce an echo of the two sounds of *bougies,* [u] and *i,* in the same order.

70. End rhymes (rhyming words in notes in parentheses, rhyming words between stanzas in brackets):

Jan.: *licenses/références*
 modernité/distingué
 doigts (bois)
Feb.: *voitures/[pelures]*
 février/[admirer]
Mar.: *sillages/fromage*
 dégradé/bélier/(humanité)
Apr.: *dédorée/mouchetées/pavés/[rangé]*
May: *mouchetis/chuchotis*
June: *plumé/[barré]*
 dessinateur/écrivasseur
July: *danseurs,palpeurs/senteurs/(testateur)*
Aug.: *sable/diable*
Sept.: *mûres/ordure/[signatures]*
 graffitis/(litanie)
Oct.: *i/gribouillis*
Nov.: *zoos/bistrots*
Dec.: *concurrence/[potence]*
 lot/(nouveau)

Other occurrences of the end rhyme in [œ] in addition to those of June and July: Feb.: *verseur,* Oct.: *classeurs,* Nov.: *pleureurs.*

71.

THE MEDUSA OF THE CHOCOLATES

In the pondered province under the pips of chance
leaving passing traces thorns hurled into oblivion
at the least **deception** printed over with damp **curls**
pollen of photography insects migrations
cracks developed
in the mirror

 ALECHINSKY
 the medusa of the chocolates
 in front of her counter of lace
 lining up her little fish
 in the aquarium of longings
 her soluble gaze surrounded
 with the turban of delicious scents
 with sounds of the **workroom**
 and kisses on the glass cases
 where hauntings redouble
 in the pondered province
 ink
 and swarming of nozzles
 of the investigators craters to explore
 seeds in the **night** of cranes listening in to stalactites
 impregnation of **wild boars** spark of **inheritances**
 which a disheveled soul sweeps away **the medusa of the chocolates**

72. Michel Butor and Michel Sicard, *Alechinsky dans le texte* (Paris: Editions Galilée, 1984). The term reappears relative to the four-eyed figure in Alechinsky's collaboration with Dotremont, "Linolog II," reproduced in Michel Butor and Michel Sicard, *Alechinsky: Travaux d'impression* (Paris: Editions Galilée, 1992), 121.

73. One additional weak rhyme in [e] appears three times in the dizain with occasional echos in the triangles; its force is rather in the cohesiveness of the rhyme than as repetition of the sound.

74. Thus line II, 7, of Alechinsky is altered in both its appearances elsewhere. Two lines of II reappear twice with no changes (3, 8) and three others are adjusted grammatically in subsequent appearances (2, 5, 9) Seven others are changed in only one of two or three appearances, and only three times is an altered meaning introduced. Thus *"l' aquarium des convoitises"* (II, 4) becomes in Hérold (III, 4a) *"dans l'hermitage aux convoitises."* The *"turban des odeurs exquises"* (II, 6), cited above in Masurovsky, becomes in Saby (I, 3a) *"aux confins des odeurs exquises,"* and in Dufour *"du turban des fureurs exquises."*

75. See also *Travaux* 121.

76. Michel Butor, *Le Rêve de l'ammonite* (Paris: Fata Morgana, 1975).

77. Michel Butor, *Matière de rêves* (Paris: Gallimard, 1975). In 1984 Butor stated that he had been working on the *Ammonite* for three years [Michel Butor and Michel Sicard, *Alechinsky: Frontières et bordures* (Paris: Editions Galilée, 1984], 120. Hereinafter abbreviated as *Bordures.*) In *Texte* he mentions it as having been begun in May 1968 at the same time as *Hoirie-Voirie* (Michel Butor and Michel Sicard, *Alechinsky dans le texte* [Paris: Editions Galilée, 1984], 205).

78. In *Matière de rêves,* the end of each interruption is regularly signalled by the repetition of a word, phrase or the last sentence or so of the dream at the point of interruption. The series of words with the same prefix, the *Comptines,* appear in the new text arranged in different ways, still within the original part—beginning, middle, or end—but sometimes the group is divided, and, to make the connection, the last word is repeated when it next appears. The titles of the five parts move through each section of the *Matière de rêves* version, sometimes appearing several times.

See Appendix E for variants and page numbers of corresponding texts in *Ammonite* and *Matière de rêves.* With *Travaux* (Michel Butor et Michel Sicard, *Alechinsky: Travaux d'impression* [Paris: Editions Galilée, 1992]) for the etchings and *Matière de rêves* to hand, plus the reproductions included here and the information in Appendices E and F, the reader can reconstitute almost all of the complete original *Ammonite* and is vigorously entreated to do so. Excerpts can never provide the experience of the whole.

79. Jacques La Mothe, *L'Architexture du rêve: la littérature et les arts dans Matière de rêves* de Michel Butor (Amsterdam: Rodopi, 1999), 145.

La Mothe studies the structure of all the dreams in the five volumes and includes several of the schemas he deciphered. Unfortunately, his publisher made the unwise decision to omit from the book La Mothe's appendices in which are collected the linking phrases of each dream, material of enormous value to scholars. His presentation of Butor's *Rêves* as collaborations with visual artists begins with a very valuable concise survey of the development of writing about painting, of *ekphrasis.* (*Architexture* 137–45)

80. *Bordures,* 120. La Mothe carefully tracks the collaboration among all three in *"Echographies: Alechinsky et Butor," Dalhousie French Studies* 31 (summer 1995): 65–80. See also *Architexture* 146–57.

81. *Texte* 191–92. One is in the BN; the other two are held by Butor and Alechinsky. For the text of the fifth stage, the edition in three copies, dated 1977, Butor's primary source is the words of his list of words with the same prefix, rather than Alechinsky's marginalia. (See La Mothe, *"Echographies,"* 72.) His self-critiques, purportedly noted by a supervising professor (mired in the dullest of conventional pedantry) pertain to the text, especially to the clerk's attacks on his writing, rather than to the etchings or lithos. See Appendix F for the text of Butor's comments added for this special edition.

82. Focusing on Alechinsky's participation, Butor says, *"Cette collaboration très intime, très poussée, nous permet de bien voir comment il prend le texte qu'il illustre à certains moments, qu'il décore de remarques à d'autres moments. Ces remarques animent le texte plastiquement, transforment un mot en idéogramme. Une circulation s'introduit à l'intérieur de la page, la faisant trembler, ainsi que tout le texte"* (*Texte* 192). The function of the Butor text in the collaboration is clarified as he continues, *"Ceci n'est évidemment sensible que dans la mesure où on lit le sens des mots: un étranger ne comprenant pas le français ne saurait profiter de ces phénomènes et perdrait beaucoup"* (192).

83. When a reader examines a page of the original *Ammonite,* he sees etchings (including the *souvenirs*), and then the text and marginal comments. He probably looks back at the etchings as he reads. Thus the end product combines the two stages of the collaboration. Indeed, as the reader moves from etching to text to lithograph (stage 3), and back again, his experience is more than threefold. Aware of this, in speaking of the "sarcastic character of a burlesque dream" in *Texte,* Butor said that Alechinsky's marginalia increased that character and *"perturbe considérablement l'équilibre du texte"* (190). Examples are given in *Travaux: "Dans le chapitre précédent, en litho, un cercle qui est la lune et deux traits que j'interprète comme une montre: 'j'ai perdu ma montre dans la débâcle,' parce que, tout à côté, il y a une image de lune avec une image d'horloge"* (82). In that previous chapter the broken circle Butor speaks of does appear next to the passage in #9 about the moon *"qui le remplaçait au centre d'un halo sulfureux"* (*Ammonite* 18). And the two angled lines imitating clock hands are next to the passage in #11 that

includes *"J'ai perdu ma montre."* On the following page, the Al-echinsky drawing Butor refers to here (reproduced in *Travaux*) combines the two next to the passage, *"Le croissant de l'ancienne lune tournoie autour de la nouvelle"* (21). We can see the "perturba-tion" of which Butor speaks.

84. Called *"la belle"* upon her introduction (3), she is later known as "the clerk," as in a "clerk of court," but in a feminine form (*la greffière*), which in slang has a vulgar meaning. She acquires many other epithets in the text, but for clarity I have referred to her here simply as "the clerk."

85. Michel Butor, *Le Génie du lieu II: Où/Ou* (Paris: Gallimard, 1971), 21–38.

86. Alechinsky also mentions in his letter the suggestions of Joyce Mansour, *"gésier, geyser"* [gizzard, geyser], which Butor chose not to use. The *"geysers"* of *Respiration* are unrelated to Alechinsky's volcanos and would come rather from Butor's experience.

87. The secondary meaning of *précipitation* is "rain," and one more time the English translation cannot carry the full meaning of the French.

88. Elsewhere Butor explains that the final colors of the five primary etchings are not the same as in the original etchings he worked with to create the text; thus the *"Grand verdâtre"* [Great Greenish] of the original has become finally red (*Travaux* 82).

89. *Architextures* 152.

90. Reproduced in *Travaux* are:

	Rêve	*Travaux*
Etching #1	3	79
Etching #2	11	81
Souvenir (pré)	6	80, upper
Souvenir (con/com)	14	80, lower
Souvenir (inter)	22	85
Title with marginalia	1	84
Marginalia	10	77
	16	83, lower
	17	78
	21	82
	23	83, upper
	31	76
Cover		100
Poster		152

The *Ammonite* is not paginated. I have supplied page numbers for all pages except the transparent leaves with their lists of words with the same prefix, the *Comptines*.

91. *Architexture* 158.

92. Ibid., 161. I am very grateful to La Mothe for this detail, which I had not seen, nor did it occur to me to turn the image upside-down to find the igloo. He reads the *"tango"* as a part of the author's *"rêverie,"* rather than derived from the image, but adds that it is also *"un terme qui désigne précisément la couleur utilisée par Al-echinsky pour cette partie de la gravure"* (*Echographies* 76; *Archi-texture* 160). *"Tango"* is a yellowish-orange color, and La Mothe cites MB/MS's discussion of Alechinsky's various stages, including one in which the lower segment was in orange; La Mothe seems to have seen this stage.

I regret very much that La Mothe limited his close analysis to the first part, *L'Arrestation.* However, in *Echographies* La Mothe pur-sues through three parts his most perspicacious examination of Butor's movement from engraving to text and back to the engraving. Both studies investigate broader issues as well.

93.

From her mug of a wriggling fish thrusts, darts a little black tongue which turns brown at the end, turns red at the end, grows, lengthens, goes off to tickle the nape of the chlorotic lout, who mews over it, chuckles and purrs with servile contentment, and then rolls around his spongy neck, licks his whole face, tastes it, thins out into a sting to prick it, spreads out in a spatula to smack it, into a dishcloth to scrub it, into a buffer to polish it, then retracts, folds up and hop, the beak closes with a clack. After several repetitions of this trick it becomes apparent that the fellow is in the process of melting like pistaccio ice cream in the cone of a schoolchild. (*Ammonite* 5)

94. Butor refers to the volcanos as female in *Travaux* (76).

95. Butor cites from Michaux, *Ecuador,* a passage beginning in these same words, *"Ah petit, petit"* (Michel Butor, *Le Sismographe aventureux, Improvisations sur Michaux* [Paris: La Différence, 1999], 32). The expression is hardly unusual enough to indicate unconscious recall, and yet, it is possible. In his prefatory poem Butor explains that it was twenty years before, that is, 1979, that he was teaching his courses on Michaux, which would be after the publication of *Ammonite.* Further, the published study of Michaux is dedicated to Bruno Roy.

96. One of the humorous moments is lost in translation. The clerk *"elle n'a nullement perdu le nord (plus difficile qu'on ne pense, car il s'agit bien de l'Islande, en réalité c'est la Terre du Feu)"* [has in no way lost her head (more difficult than one would think, because it is a question of Iceland, in reality it is Tierra del Fuego)] (16). The literal translation of *"a . . . perdu le nord"* would be "lost the north," which would make not make much sense in English.

97.

So much the worse for him, his reign is over. Hurray! He has gulped them down, his two eyes. But no immediate advantage for me. One lost, ten found, even more grumbling, cheap, petty, bloodthirsty. He no longer has anything but a blind mouth with purulent gums at the end of a more and more flexible neck (ah! its intransigence of yesteryear!). As for his chest, where, it was believed, the tablets of an immutable law were eternally engraved, nothing is left but an old sack of rags which now just barely swells and sinks. The articulated flippers which knew so well how to leaf through yearbooks and codes are reduced to stumps of jelly. Sleeves of former times, they seem to groan, how well we knew how to give you pathetic flights, with what grave feeling of destiny we slammed you down for the verdict! Gulls, petrels, cormorants, albatrosses, gambol in the darkening clouds and it is a frigate-bird, I think, which has just siezed in its beak the leash of the judicial remains. (17–18)

98.

It takes off like a kite, furious sign of warrants to appear on the blackboard of the cracked sky, where now the eclipse judges. The sun had disap-peared a long time ago; it was the moon which replaced it in the center of a sulphurous halo. An enormous bubble of suddenly frozen drool projects its shadow on the former star of lovers, the one of harvests will evidently be on the other side of the earth for a long time. No way any more to count on the calendar of the ancestors. Its pages have gone away in the air current with my violated archives, entrails stirred up by the rapacious of limbo. (18)

99. Lepidopters are the order of insects that includes butterflies.

100.

I would have bet on it. While continuing with her ten fingers to scratch, scratch the back, the wings of the black or white birds which she captures in passing, imprudent ones seeking refuge in our grotto from the eruptions and the storm, sometimes tearing out feathers to carve in scratches on the palpating skin the sentences of a judge who disappeared a long time ago, using her tongue like the proboscis of a lepidopter, she sucks in the lunar

sherbets and the cloud creams. The gluttonous, the insatiable! She treats herself thanking her little potbellied lares for this manna, but without letting a single drop, a single speck rebound in my direction. And the horizon returns, fine surprise. For such a long time no one had heard it spoken of any more in the rosy night. Nothing remains of the former moon but a shadow as reddish-brown as the volcano-scoutmistresses' tufts of hair, and the new one swells more and more like a leather bottle about to burst. (21)

101.

I drink for all of them, I choose the heaviest atoms in what falls to ballast them better, the most penetrating oxygen, the most stable helium, the most volubile hydrogen. I nourish them and they care for me, I wake them and they put me to sleep, I keep my eyes open for them, and their teeth begin to chatter again. I send off to them drops of rain and in their orbits pupils germinate. I listen for them and they speak to me; I taste for them and they digest me; I smell for them and they direct me; I am a whole cemetery in child-bed. (23)

102.

Springtime, you don't think that! Daylight, you don't really believe it! Sunshine, you're not going to imagine that! Yes, it really is the sun; who is talking to me? Who wants to deceive me again? Daylight? I close my eyes. The sun? I cover my eyes. Could the sky be flayed? Yes, the bubble of awhile ago has been entirely emptied, I have entirely absorbed it, and with it I have drunk a whole layer of night. I am the ogre of the world. (25–26)

103. Butor's knowledge of botany may leave some of us behind. A *rhizome* is a stalk that develops underground, as the iris or ginger. At the end of this paragraph, *sepals* are the inner extremities of the flower's petals; *achene* are any fruits, such as the acorn or hazelnut, which do not open; *siliqua* are lengthened dry fruit which open in four slits, such as the flower, "stock."

104.

Every collar-bone a rhizome, it is their triumph; every vertebra a bulb, limitless greenhouse of lightning time. Unhoped-for sweetness of vegetable nudities, climb up human flowers, balance your cups in search of lost dew, scatter your tears, your sighs, sing, tape recorders for dreams, the polka of the polar bear cubs and unchained moraines, the quadrille of the continents, the aria of the Crab nebula, daub your pistils with pollen, make your sap slide along your nervures, make honey pearl on the point of your thorns, clap your sepals, sound the achene, jingle the siliqua, whistle the tendrils. (26)

105. As with botany, Butor assumes we all know zoology as well as he does: the *madrepore* is a form of coral.

106.

overtures to accompany the capital executions which we will decide on in the instant which follows the eventual renewing of certain murmurs, certain smiles, carnavals, months of May, certain shruggings of shoulders or dragging of shoes, certain yawns, certain grimaces or eccentricities which we have already only too much tolerated. As for the contemptible, the miserable, the abominable instigator of all this mediocre flowering whom we spare only by grace in spite of the poverty of the services which he is capable of rendering us, it goes without saying that he is condemned to sink still farther down, to have what remains of his skull finely ground without death ensuing, his ears tormented with complicated tympanitis without deafness ensuing, to be locked up for ever and ever without paralysis delivering him, in the very entrails of those whom he has so foolishly blasphemed, the female volcanos, to contemplate there for his constant shame his unworthy and failed work. Delays, delays, inadmissible delays! Errors in printing, in spelling, even in French, the callous one, the apostate! Oh pity serves no end, scoundrels, let the deluge of pitch begin! (31–32)

107. In stage 5, Butor's handwritten comments through this section portray increasing disapproval from the audience until finally at this point there is a chorus, *"Intolérable!"* See Appendix F.

108. Not only the narrator, but the writer took part. For Butor's involvement, see his poem *Tourmente* [Michel Butor with Alechinsky, Dufour and Herold, *Tourmente* (Montpellier: Fata Morgana, 1968]), and *Curriculum Vitae* [Paris: Plon, 1996]), as well as a number of references in the many published interviews.

109. See earlier reference (p. 95) to Alechinsky's visit to Niagara Falls, where Butor clarifies: *"Connaissant mon livre* 6.810.000 litres d'eau par seconde, *il me disait qu'il avait bien vu et compté les litres, que c'était bien ça* (Texte 52).

110.

I drink the flames, I drink for all of them, I drink so they can say no; drop by drop I collect the ponds, the lakes of refusals. From canals to canals the acid is propagated, is vaporized; the birds deployed with bloody inscriptions ignite with all their feathers, and this new fire hurls down in living water the sulphurous pitch which menaced us. Thank you, deluge! Hollow out rivers in our tombs, carry along our nervures and our concoctions to the caldron of the beaches so that their boiling may distill in the sky of tornados the elixir of a just text. Across the forest of waterspouts, the rays of the moon of yesteryear will they not awaken, caress us. Reinvented moon, the slopes of the female volcanos smoke with wonder. (32)

111.

#17. Lull. The level of the sea has risen; I am still buried up to my neck in the tombs, but foam is approaching, a little salt begins to be deposited inside my emptied orbits, where little crows make their nests and their droppings. The sky is emptied also; what a wind! What space! Meteors pass there, acrobats, jugglers, waltzers; the water rises. (33)

112.

That reminds me of something erased, sunk down, engulfed, lost, irreplacable. That reminds me of the moon of my childhood I think, and picnics in clearings; it reminds me of swarms of insects and the enchantment of first penmanship, all the hopes I put in my studies, the exquisite labyrinth of commentaries, copses of little notes, alleys of indexes, baskets of variants, murmuring streams of commentaries of philological uncertainties with sudden openings-out on the Roman Campagna, the geysers of Yellowstone or the air of the open sea. (34)

113. Note this is not the butcher's wife as in *Le Test du titre,* but this baker's wife seems as unrelated to Pagnol's character as was that butcher's wife.

114. The narrator regularly uses feminine forms where they exist. English is not so malleable: a "gardeneress" would not do.

115. The misspelling of *alliacées* is maintained in *Matière de rêves* (70).

116. Barbara Fürstenberger, *Michel Butors literarische Träume: Untersuchungen zu Matière de rêves I bis V* (Heidelberg: Carl Winter Universitätsverlag, 1989), 370.

117. One of Alechinsky's "marginal remarks" clearly represents a single eye like a bud between two leaves (34).

118. The sentence containing the "grandiose babbler" begins with a rhyme, *"De sable en fable, de plus en plus"* [From sand to story, more and more] (40), which is altered in *Matière de rêves* to *"De sable en sable"* [From sand to sand], producing yet one more repetition (72).

119. Léon S. Roudiez, "Un Texte perturbé: *Matière de rêves* de Michel Butor," *The Romanic Review* 85 (1984): 246.

120. Roudiez goes on to treat Butor's use of musical forms, mentioning the *Le Rêve des pommes* and Jiří Kolář in passing.

121.

I am very much interested in utopias and to the extent that I always insist on the fact that I want to change something in reality, in the society in which I find myself, yes, of course, I always situate myself outside the actual place. It is not enough for me to find a place in the interior of the society of today. What I wish is to change society and therefore I am outside it. I want to represent society because I cannot change it without representing it. To change it I have to know it, I have to show it. (Fürstenberger, *Träume*, 366).

122. Pierre, Alechinsky, and Michel Butor, *Le Chien roi* (Paris: Repères, Ed. Maeght Lelong, 1984).

123. Butor and Sicard discuss earlier versions of the etchings in 1982 in *Bordures* (Michel Butor and Michel Sicard, *Alechinsky: Frontières et bordures* [Paris: Editions Galilée, 1984], where three etchings with the same names as in our book are reproduced: *Le Chien roi* (11), *De toutes parts* (20–21), and *Oranges de Binche* (40). The *Oranges de Binche* is very similar to the one in our book, but the figure is set horizontally, rather than vertically; *Le Chien roi* faces left against a very dark ground, and other details are also altered; *De toutes parts* differs the most, having eyes among its larval forms, and it lacks the crocodile face.

The catalogue of the exposition, *En Compagnie de Michel Butor* (Valence: Musée de Valence, 1986), includes a reproduction of the etching *Le Chien roi* in black and white, the simple stage as it is printed on page 38 of the book. The wide margins are filled with Butor's handwriting of the text through *"Tel est le pouvoir de la jalousie"* (41). Curiously, the introductory citation in the catalogue is from *Les Oranges de Binche* and not from *Le Chien roi.*

In the later publication, *Travaux,* some of the etchings from our book are reproduced, five in color (Michel Butor et Michel Sicard, *Alechinsky: Travaux d'impression* [Paris: Editions Galilée, 1992]):

Tunnel in color (65), the complex version on page 19 in the book, *Le Chien roi;*
Le Chien roi in color (116), the complex version from the frontispiece;
Papier de mur in color (117), the complex version from page 35 in the book;
De toutes parts in black and white, the complex version (136) from page 30, and the simple one (137) from page 33;
Rhizome both stages, in color (139) from pages 20 and 23 in the book.

Fürstenberg reproduces in black and white the simple stage of *Sphinx en chapeau* from page 26 of the book, *Le Chien roi* (Barbara Fürstenberger, *Michel Butors literarische Träume: Untersuchungen zu Matière de rêves I bis V* [Heidelberg: Carl Winter Universitätsverlag, 1989], 372.20).

124. Michel Butor and Michel Sicard, *Alechinsky dans le texte* (Paris: Editions Galilée, 1984), 172.

125. The Alechinsky "Chronology" in *Bordures* specifically states, "1946. *Assiste à la reprise du carnaval de Binche, le premier après la guerre"* (115).

126.

The Oranges of Binche
When we no longer have any ostrich feathers we will take those of the swan or condor, and when there are no longer any birds we will take palms or branches, and when there are no longer any trees we will take ferns or mushrooms, and when there is no longer any vegetation we will cut up paper, sheets of aluminum or tires, and we will paint them mauve and rosey peach, salmon, yellow gold and Nile green with borders of deep blue which the big drops of rain will dilute and mix to create for us festival rainbows on our white pants; but if we had no more oranges, if these little globes of liquid sun no longer came from the fabulous countries of the south to reinvigorate us, then we would delve deep into our mines, sickened by that milky light that is for us a winter day, we would warm ourselves at some embers dreaming with ironic melancholy of those carnivals of yesteryear which for us replaced the voyage to the Hesperides, when we made our bells tinkle and our wretched guitars vibrate. Happily some superb crates of them have just arrived which we will be able to place on our mantlepieces on St. Nicholas' Day. Black Peter himself artistically spits his pits while jumping in the pools smelling of vitamin C, while schoolchildren decorate the windowsills with ingeniously unrolled peels. It seems that in those marvelous plantations on the terraces of Andalousian palaces, the agricultural engineers are perfecting new kinds bigger they have told us than a basketball or according to some a soccer ball, and whose roughnesses would reproduce those of the terrestrial globe (the names of the continents could be stamped in different languages for the elementary schools where no one would need to deplore any longer the least lag in geography classes); their peels will be able to form such long ribbons with their white satin interior, the zist and the zest, that it will be ideal alchemical material for the ornamentation of our caps, and we will juggle with elastic cannonballs while the water of our fountains takes on the taste of curaçao (9–10)

127. Could Butor have recalled the giant orange in the postcard Kolar used for his collage with the Bellini nude, the one that generated the poem, *"Le Page"*?

128. We note that the orange peels could be transformed by alchemy, but Butor does not tell us what new material would be produced.

129. Corrected in the variant to *astomis,* but Larousse gives only the masculine plural form: *astomes.*

130.

Sphinx in a Hat
Under the sun of Beotia, there is the female sphinx of Binche, nicknamed by the people of Auvergne the sphinche of Binx. In the middle of her hairdo with its ostrich feathers sneers, his eyes cocked and his feet swollen, the baby Oedipus who will dethrone her, but she will revenge herself superabundantly by forcing him later to tear out those very eyes which are mocking her, on the square of City Hall in the presence of milords the aldermen, in the course of a deplorable exhibition of family problems, as if that kind of conflict did not deserve to simmer by the stove, behind lace curtains. Now eyes of all colors are wide open, scattered, from green to mauve, and all that blinks and rolls in the midst of the gossip and remarks. I spread the news to you and I add more for you and I insinuate for you and I suggest for you and I go back to the sources for you and I imagine for you the results, waves and rebounds, it rushes down all the alleys of the old city and spreads out in a tidal wave over the fields. What a story! They will talk about it again in two thousand years, while in reality at the beginning, you know exactly what there was, less than nothing, nothing to write home about, triteness, dullness; but the thing is that she kept watch, the blabbermouth bitch; it rankled with her. It was revenge; naturally it was a lover's revenge. He liked her well enough, however, the first months, everyone knows that, all the peasants around Thebes will still tell you how amusing it was to see him as a child rolling between her paws, but when she wanted to move on to serious things, something in her lionness' hindquarters, whereas many others would have been not only pleased, but flattered, and then probably some temptress on the corner whom he took a little fancy to. . . . Especially there was that story of the feathers, because he was the one who had decorated her that way, without meaning any harm, and it is certain that it gave her an extraordinary allure particularly by moonlight; and he used it as a thicket to hide in, the hair of her mane braided to fasten it, and then, you know how fashions change, it was just at the great scene of the declaration, the one which was taken up again by Phaedre and so many others, when he suddenly burst out laughing; and it was that especially which she could never pardon him for, much more than the famous discovery of the key to the puzzle, because she prompted him, everyone knows that, she never hid it. She keeps watch now in front of all the televisions of Binche, lying in wait for little boys who still want to suckle their mother and who kick their father when they slip into their bed at night; she has them come

closer, closer to cover their chest with medals, to put military hats with stripes on their heads and to give them as toys automatic machine guns and red telephones. (25–28)

131. Both stages of the etching of *Sphinx en chapeau* include a bird/snake medallion; it appears for the third time in the simple *Tunnel,* but in the complex *Tunnel* it is replaced by a figure resembling one of Alechinsky's wheels, as shown on the back cover of *Travaux,* but with only five spokes. It is in black, standing out against the uniform reddish brown of the etching. One could see it as a dancer, with costume flourishes on one leg and arm, and a head. *Gueule de proue* has no medallion in the complex etching, but the simple one includes the ammonite or snail medallion, as does the complex *Rhizome;* the simple *Rhizome* shows for the only time in *Le Chien roi* the medallion of a face with encircling tongue. See *Travaux,* 64.

132. Butor does not treat the pronunciation in his study (*"Les parents pauvres," Répertoire II* [Paris: Minuit, 1964], 193–98). Like Balzac, he abandons the transcription *"pour la clarté du récit"* (Honoré de Balzac, *Oeuvres complètes: La Comédie humaine. Scènes de la vie parisienne, VI. Les Parents pauvres: II. Le Cousin Pons* [Paris: Louis Conard, 1914], 140.

133. Butterflies do have "scales" (arctia) on their wings, which are microscopic and are the source of the colors. As usual, Butor knows more about nature than most readers.

134.

On All Sides

 Avid glares and open jaws in the soft jungle watercolored with orchids. Some eyes are sharp-edged like fangs; they nail their optic prey on the bottom of cork or clouds; and in the interior of some maws one observes faces on the look-out, much more human sometimes than those in which they are lodged as in a mask; and there are even faces in the interior of certain eyes and supplementary jaws in some faces. To refresh the tourists who will clamber up the Maya or Khmer pyramids, the ice-crean vendors spread out their trays on wide water-lily leaves which float on the deep pools: vanilla and cassis, mint and cherry, between two flasks of carbonated water with straws of toy flutes and two cases of bitter iced beer which they embellish with a pinch of salt. In the thickets borborygmes and snufflings; it all sniffles and groans and crackles and chirps, while the Jesus butterfly flutters from hibiscus to arum, the grape butterfly from datura to anthurium, and the great eagle (nature amused itself in designing feathers for him with his scales) prefers the bromeliads and the wild bananas. From tuft to tuft the pythons unroll their flourishes, signing, whistling, rustling between the seethings of the boiler-bird, the ringing of the timbre-bird, the clicking of the castanet-bird, while the satin-bird builder of boudoirs upholsters for its mistress whose song we are incapable of perceiving, so limited are our ears, fills him with an elation for constructing sofas, ottomans, loveseats and easychairs. Let us not forget the crocodiles with their amber perfume among the sulfurous bubbles, with the egrets who clean them of their parasites, and on the side where a savannah begins to open up, the tapirs and warthogs: torrents of slobbers, downpours of tears, deltas of saps, networks of lymphs. The termite administration has thrown out its challenge to the ministry of winged ants. In the spiders' quarter massive demonstrations are feared which would snarl traffic. Once their webs forced one of the regular buses to turn around; a jeep which tried to force its passage was stuffed with webs, fibers and caterpillar hairs right into its carburetors, and it took no more than a week for the kapoks, bougainvillias and rubber trees to cover it up completely; the driver was just barely able to escape, hacking the prehensile tendrils with blows of his machete; and from time to time they are obliged to close the little airport to clean its runways with great waves of flaming gas. Then they reinstall the bars and the bird cages and the new contingent of tourists disembarks cackling, with its camcorders. (29–32)

135. Michel Butor, *Le Retour du boomerang* (Paris: Presses Universitaires de France, 1988), 49–50.

136. Rudyard Kipling, "Letting in the Jungle," *The Jungle Book, The Second Jungle Book* (New York: Exeter Books, 1986), 154.

137. Michel Butor, *Le Retour du boomerang* (Paris: Presses universitaires de France, 1988), 51. A study of Butor and Kipling should be fascinating.

138. It is curious that Jean-Claude Prêtre's *Suzanne* (Paris: Bibliothèque des arts, 1991), which includes three Butor texts and reproductions of 186 visual representations of Susanna and her elders, does not contain this Alechinsky piece. Butor may have thought of Prêtre along with Alechinsky, as Prêtre has created 121 variations on Tintoretto's *Susanna.* The same book contains other "perspectives" on Susanna's story by other writers; not all uphold her innocence. See Butor texts also in *Recent Paintings* (expo. catalogue) (London: Brompton Gallery, 1985), and *Prêtre, d'après Suzanne* (expo. catalogue) (Geneva: Galerie Andata/Ritorno, 1993).

139.

The Dog King

 To compose the soup of the dog king, they fish from the rivers of the north salmon and trout, they select in the stock farms of the west the tenderest young beef to take from it the filets and the bones with marrow; the pigeon huts of the court furnish their plumpest couples, the harvesters their quail, the hunters their partridges and pheasants. To bind all that, eggplant, pumpkins, spinach and onions of all colors, well browned in butter or bacon according to the days of the week. The whole is served in a blue Ming platter. In the evening they place on little cups of Korean pale green some clementines from Nice, hulled pistachios, grilled bacon bits, knucklebones, and those little salted crackers which humans use for their aperitif ceremonies. Fresh water flows perpetually in his basin of Bohemian crystal where appletree or rose petals float. To prepare the bedding of the dog king, they choose black and white sheep fleeces and create mosaics of velvet and satin for the counterpanes and cushions filled with eiderdown. To construct the kennel of the dog king they cut down the last cedars of Lebanon, they watch over the growth of boles of ebony and lemon tree. On each side of the porch, columns of smooth marble and rough granite permit him to rub himself at his pleasure, and behind the ceremonial salons, his swimming pools of alabaster, his showers, his Turkish baths, lead to the kennels of his bitches. For his coat he generally prefers mink or ocelot; it is only for the great ceremonies of the kingdom that he assumes the skin of the tiger, whose roaring he strains every nerve then to imitate. For certain family parties he puts on a little cape of human skin whose tattoos represent certain of his ancestors (what ruses it takes, how many threats, how much money most of the time, to persuade these sad samples of the former dominant race to select such patterns! And it is essential to choose those among them who have a sufficiently dangerous life, because the skin of man ages badly, but, however, not too quarrelsome, because one scar and the whole work is lost; it is an enormous worry for his dressmakers) and he decorates his mane sometimes with the hair of a redheaded woman which he twists around the towers of his crown. To recruit the harem of the dog king, they send forth into the steppes, the cities and the training kennels young fellows with irresistible yappings, who bring back beauties by entire troops. Old chamberlains very experienced in the matter make a first selection before proposing them to the choice of the monarch. The messengers generally share the surplus. Sometimes earsplitting scenes take place, interminable howlings at the Moon, violent brawls where it is not rare to see one of the combatants end up entirely devoured by his rivals, his bones minutely broken and chewed up. Such is the power of jealousy! To convoke the council of the dog king tiny silver whistles are used, with four notes whose succession designates each of the races or tribes. For the issuing of his decrees the oculists polish up for him new spectacles (because this whole dynasty is nearsighted) while the pedicurists skillfully cut off a claw which will be placed as a seal on the tuft of the judgment hairs. After periods of agitation and crisis it is sometimes necessary to wait several months for a new promulgation in all its formality. And to accompany the receptions which follow, they bring in from the most distant steppes the famous chorales with bells and gongs, dressed in savage livery. (39–41)

140. See p. 94. In the same passage in *Texte* Butor refers to Kipling's python, Kaa, the wise counselor-snake. Readers will also

recall Kipling's wild dogs, the "dhole," more dangerous than the tiger Shere Khan. Butor's spectacled *Chien roi* is clearly closer kin to the "dhole" or to the "bad cobra" than to any benevolent figure; the message he transmits and the tradition he maintains are those of the human tyrant.

141. Alechinsky's back cover shows the dog king trotting along, his tail held high and his crown worn jauntily, with a fifth leg, perhaps inspired by the text concerning the dog-king's harem.

142. Michel Butor and Michel Sicard, *Alechinsky: Frontières et bordures* (Paris: Editions Galilée, 1984), 106–12.

143. Three additional pages of Alechinsky's *Atlas universel* not reproduced here appear in *Bordures: VII* on page 90, *IX* and *X* on page 99.

144. That "Algerian" qualifies the "coverlet" and not Albert Pilon is clear in French, but would not be in English without displacement of the word from the beginning of the line, thus losing the additional emphasis it there receives in French. Also lost is its correspondance with other word orders later in the poem, for example, in stanza 2, the "frog/enormous" and the "cliffs/white."

145.

1

> In the vase of Spain
> Estramadura blooms forth
> the tulips of Portugal
> plunge their petals in the water
> which the ships of Vasco
> furrowed on their departure
> toward the yellow and white continent
> the dahlia of the Asturias
> whispers sweet nothings to the forget-me-nots
> which besprinkle the two Castilles
> and invade Leon
> with their delicate counting-rhymes
> the peppered lilies of Galicia
> caress with their fans
> the Guipuzcoan asparagus
> and the gillyflowers of Navarre
> the peonies of Aragon
> the jonquils of Catalonia
> in the pavane of the seasons
> with the Andalousian shadows
> intertwined around the thorns
> of the three roses of the Baleares
> and the clouds of Languedoc
> spread their dews of mother-of-pearl
> on the caravelles in the ports
> and the galleons on the high sea
> while with his nose in his book
> at thirty-three Fleurus Street
> with his feet in an Algerian
> coverlet Albert Pilon
> editor-in-chief dreams of mantillas
> of cigarette girls in Seville
> of the fountains of Aranjuez
> of the casks of Amontillado
> of bullfighters and of Caliphs
>
> (107–8)

146. The address of the publisher printed on the map, 33 rue de Fleurus, is adjacent to the apartment where Gertrude Stein lived for many years, 27 rue de Fleurus.

147. Literally, "hair of scales," referring to the indications of scale measurements on the original map, which can be seen under her hair.

148.

2

> Amphitrite with hair to scale
> and with combs of lines of feathers
> comes to kiss the forest of the Landes
> the Adour runs on her chin
> and the chain of the Pyrenees
> wriggling like a worm
> whiles away the time scratching her throat
> hills make breasts for her
> and right at the place in La Mancha
> where Don Quixote gave battle
> the map of the neighborhoods of Bordeaux
> comes to braid epaulettes for her
> crawling along kilometers
> a talon with sharp claws
> puts a hook on Saragossa
> among the feathers of blackness
> and the names of the departments
> scatter her sphinx's speeches
> the water of the rivers becoming tears
> whose salt collects in her dreams
> of wars among the knights errant
> sounding the horn at Roncevaux
> destroying each other for her soft eyes
> ogling Ulysses's companions
> on the other side of the vineyards
> harpy siren messenger
> of a dangerous El Dorado
> the red and yellow continents
> perched in the branches of the tree
> where the results are ripening
> of the marriage between the sky
> of algae and the hell of the clusters
> she makes the Gascon Adam
> leave his manor-house
> get in the saddle and go
> to decorate her chignon with them
> to pick the apples of Paris
>
> (108–10)

149. *The Song of Roland* begins with the incorrect claim that Charlemagne had conquered all Spain, but is accurate in excepting exactly Saragossa, and even Einhard does not pretend that Charlemagne ever captured that fortress.

150.

3

> Some say it is a bull
> but we do not see its horns
> others that it is a tapir
> but it would be lacking a trunk
> it is a beast of Brittany
> which is ridden by some frog
> enormous or perhaps a beaver
> harnassed by the Cotentin
> and the Anglo-Norman islands
> knapsack shoulder-belt plumes
> which is ridden in turn by an eagle
> or a gull or a crow
> skimming in its flight the cliffs
> white of Dover and the shores
> or the rocks of Cornwall
> which is ridden by the king of the clouds
> carrying the London fogs
> like a battle-ax in his belt
> a long lance under his arm

to slay the frightful serpent
who is coiled in the suburbs
forcing young mothers
to give up to him their nurselings
to put them in the salting-tubs
on the red and black continent
intrigued by all these scandals
on the shores of Picardy
Flanders and Holland
crowds in big hobnailed boots
turn away from the championships
of soccer or rock and roll
to live again the vissicitudes
of this medieval combat
and bring down the house with applause
while absorbing their snacks
at the thunderous blows which deals
the defender of damsels
to the snakelike arms trafficker
whose cannons or airplanes
guns scaffolds
breast-plates submarines
were beginning to proliferate
in the sargasso of the gulf streams

(110–11)

151. In *Bordures* Butor and Sicard discuss Alechinsky's use of sewing in his *Sucre et sel* (103).

152. The French expression *"faux frère,"* literally, "false brother," means "traitor," but the parallel with "false collar" is lost in the translation.

153.

4

Madam Turkey in a wig
knits a shawl for her Cairo
she has Cypress in her eye
and Syria on her ear
her husband the old Roumanian
knots his Balkan tie
on his Adriatic false collar
before the mirror of Crimea
where grimaces like a traitor
his double with a crow's beak
as for the Tyrrhenian cat
with her Tunisian muzzle
she mews on his shoulders
before the pigeon-holes of France
filled with temperate slopes
of feathers of the Folies-Bergère
of the unemployed of the certified
laid down on the sideboard of Spain
with its aficionados
paellas infantas dueñas
and the window on the gulf
where the swan of Albion caresses
the shipwreck of the Armada
on the other side of the salon
a barbarian odalisque
with pink and lilac complexion
coos while chewing her Turkish sweets
and caressing her leopard
flopped on the veranda
which looks out on the closed sea
where seahorses throw their chests out
and on the other hand on deserts
where ghouls and jackals
keep on fighting over the carrion
among the flint and the dunes
of this yellow and black continent

this is the very united family
which watches over the traditions
of our civilization
going back to antiquity
as the faculty says
of this red and white continent
while dinner simmers
and they turn on the TV
to watch the shows
before playing cards

(111–12)

"Belote" is here translated simply "cards," as "belote," a card game, might not be meaningful to many readers.

154. Pierre Alechinsky, Michel Butor, and Michel Sicard, *ABC de correspondance* (Paris: Daniel Lelong, 1986).

155. This second part, *Grosses en Stock,* provides much very useful information on the MB/MS approach. There are seventeen Alechinsky drawings (or eighteen if a double page is counted as two) on the support of old letters. Dating from the early nineteenth century, almost all the letters are from the Duke of Arenberg to his private secretary, Stock. MB/MS conclude, *"Bel exemple d'un corps étranger détourné, intégré à une imagerie qui transforme complètement l'objet primitif!"* (56). We will see examples in which some of the elements on the old bills of *Dessins* are similarly transformed, but others actually illustrate the affairs of the business that issued the bill.

156. Artists have historically been dependent on wealthy patrons and many still today put bread on the table through various commercial activities, but Butor does not treat these undeniable facts.

157.

Michel S. receives a collection of bills decorated with painting. He writes to Michel B. his impressions on reading. He gives the whole to him on his first visit. With a list of fifty-two words—twice as many as there are letters in our alphabet—which have struck him: terms found or only evoked. It is up to Michel B. to comment, to try his hand, to follow up. He begins to note his digressions in a little notebook, especially designed to receive bits of thought during waits for planes, etc. He diverts himself in turn by proposing an equal list to Michel S., returning to him the collection in question. Michel S. immediately begins work. At the end of the summer, Michel B. and Michel S. exchange and compare their various ramblings. They decide to put the whole together indiscriminately in alphabetical order. (7)

158. At the end of *Naseau* is a phrase that could not be Butor's as it refers to *"les plus grands des nouveaux romanciers"* (29). The modest Butor would not refer to himself in this way, and, further, has distanced himself from the group.

Sicard speaks of the process of composition as having included a phase of tape-recorded reactions, and summarizes that he and Butor were involved *"un travail de danse par rapport à la peinture."* (Mireille Calle-Gruber, *Les Métamorphoses-Butor* [Quebec, Canada: Griffon d'argile and Presses universitaires Grenoble, 1991], 141–42).

159. In addition to the drawings included here, indicated by an asterisk, three are also reproduced in *Travaux,* #5, #9, #ll (*Alechinsky: Travaux d'impression* [Paris: Editions Galilée, 1992]). The complete list is as follows. (Where Alechinsky's date is legible it is included.) The numbers 1–19 here and throughout the text are mine, for the reader's convenience.

 *1 (cover) *Articles d'éclairage,* Gaucher Fils, Bourges
 2 (frontispiece) Albrand *tapisseur,* 20 November 1984
 3 (precedes title page) *Exploitation forestière,* Charente, 24 August 1984
 *4 (follows title page) *Grande fabrique de cuisinières,* Limoges, 25 August 1984

5 (13) Bon Marché I, 1986 (*Travaux* 101)

*6 (17) figure on ladder with *"quittance"* stamp

*7 (20) *Pianos, Genet brothers,* Chartres, 27 April 1984

*8 (25) *Caves girondines,* Bordeaux, 4 November 1984

9 (30) *Machines à écrire,* Chartres, 26 August 1984 (*Travaux* 98)

10 (33) *Chaudonnerie/ Installation d'Eau et pompes),* Gaudichou, St. Emilion

11 (39) *Voitures de luxe* I, Guillemain brothers, Limoges, 25 August 1984 (*Travaux* 99)

12 (43) *Armes,* St. Etienne, 27 August 1984

13 (47) *Outillage,* Dagrenne-Guitten, Tinchebr—, Orne

14 (51) Victor Magnant I, *Construction,* Angoulême, 28 August 1984

*15 (52) *Bureau de Tabac,* Millet-Armand, Allogny, 5 November 1984

16 (54) Victor Magnant II, *Ciment,* 29 August 1984

17 (59) *Voitures de luxe* II, Tours, 6 August 1984

*18 (66) *Charronage,* Allogny, Cher, 5 November 1984

*19 (84) Bon Marché II (bound in with *Grosses en Stock* text) 25 August 1984

160. Since there are an uneven number of artworks (and the even number of eight is bound in with *Grosses en Stock*), and since an even number of pages with illustrations would be the norm, it is conceivable that there was originally a twentieth artwork. Its letterhead would show the name and location, *"Larchevèque* [sic] *de Mehun sur Yèvre,"* which appears in *"Serrurerie,"* and a locksmith is listed among the other companies in *"République."* All other proper names and towns can be found somewhere in the letterheads. Such an artwork might have included a checkered figure, as there are allusions to checkerboards, and the text *"Quadrille,"* a rhapsody on squared and checkered items, including quartets of musicians, has no visible source otherwise.

161. The words are partially painted over in *Bon Marché I* (#5), but *Bon Marché II* (#19) legibly states that payment is due to Fillot, Rocors, Lucet et Cie., presumably in Allogny, while the letterhead pictures are of the Paris Bon Marché, and the bills are dated from Paris.

162. *Bon Marché I* (#5), *Machines à écrire* (#9), *Bon Marché II* (#19), and *Bureau de tabac, Millet-Armand* (#15) all reflect the nature of the business.

Those incorporating main elements on the bill are: *Albrand Tapissier* (#2), *Pianos* (#7), *Victor Magnant II, Ciment* (#16), and *Charronage* (#18); in three drawings it is the column of numbers that is integrated: *Exploitation forestière* (#3), *Caves girondines* (#8), and *Outillage* (#13). Other uses are remarked in the analysis of the particular artwork.

163. The two in which he paints with his right hand are *Voitures de luxe* I (#11) and *Victor Magnant I, Construction* (#14).

164.

Articles

Language teaches us that they are *definite* or *indefinite.* But there exist many other articles: kitchen, fair, household, fishing. . . . All in relationship to commerce! Are drawings a particular commerce? What is exchanged? Perhaps the edge and the center, the top and the bottom, the figure on the right with that on the left, the subject matter with the support and the motif with the signature. Painting now has more need of articles than of themes, or even of myths. Because the article seems delicacy itself, the consent to all our contrivances. To paint, or to draw, allowing a shopwindow, a typewriter, a main street, a trumpet, a manservant on a ladder, a warehouse and a nostril to be joined. . . . The raw *list* would be the key notion of drawing—and no longer only the *form.* In short, these articles will preserve us all, and perhaps all the way to the enigmatic last one: the point of death. (10)

165. *"Zone"* means "zone" in the sense of an area, as in the "demilitarized zone," but historically *"La Zone"* was the largely undeveloped area outside the Paris fortifications, which today has taken on the meaning of a shantytown, the dwelling of the wretchedly poor. Butor uses *"zone"* in this sense as he explicates Balzac's vision of Paris as the hell of Dante's concentric circles. Beyond the fortifications lies the *"'zone,' ceinture des plaisirs de la misère"* Butor brings the landscape up to date, speaking of Napoleon III's last ring of fortifications: *"nos boulevards péréphériques les enserrant aujourd'hui de leurs fosses hurlantes"* (Michel Butor, *Improvisations sur Balzac II: Paris à vol d'archange* [Paris: La Différence, 1998], 23).

166. Early in the alphabet, from *"Correspondents"* to *"Dessin animé"* five descriptions appear in sequence. First, the entry, *"Correspondents"* includes a monologue, and the word is found in the support of the two Bon Marché bills (#5 and #19); the text is political satire. Second, the entry, *"Cuve,"* full of metaphor, is taken from the *Caves girondines* (#8) and it suggests the political, but humorously. Third, *"Dactylographie,"* a series of metaphors, was generated by the bill from *Machines à écrire pratiques (#9)* and transforms the typewriter into a snake. Fourth, the word *"Décalcomanie"* describes the artist's techniques and could be drawn from any or all of the drawings; it focuses on the creativity of the artist. The last of the five, *"Dessin animé"* identifies itself as the *fourneau emblématique* clearly visible in the letterhead of *Grande fabrique de cuisinières* (#4), but the description of smoke from factory chimneys derives from the letterheads depicting them, *Voitures de luxe I* (#11) and *Victor Magnant I, Construction* (#14). Then, the only angels in the artworks to have evoked the *anges dactylographes* are those of the *Caves girondines,* who are neither typing nor stamping celestial documents as described in *"Dessin animé,"* but lolling about among bunches of grapes. The tone is humorous, but with a political subtext in the contrast between workers and those owning the deluxe cars.

The sequence of six narratives occurs later, from *"Garage"* to *"Hasard,"* with similarly wide differences among them. They are filled with description, lists, and *"Gruyère"* is so surreal as to be scarcely narrative. They derive from even more drawings than do the descriptions outlined above, and where the artist predominates in *"Garage"* and *"Gaucher,"* there is scarcely any political hint in the six, other than the list of tasks performed by the workmen—on a Sunday morning—in *"Garage."* Their humor varies from the incongruities in most to the farcical *"menu pilote"* of the roulette ball in *"Hasard."*

167. Even if the whole work were translated, much would be lost, such as the puns on homonyms in the orderly progression through the alphabet in the sequence, *"Enluminure"* (A–I) and *"Lettrine"* (J–Z).

168. Michel Butor, *Improvisations sur Balzac I: Le Marchand et le génie. II: Paris à vol d'archange III: Scènes de la vie féminine* (Paris: La Différence, 1998). Interestingly, Balzac's lawyers, part of his grouping of the most wealthy and powerful, do not appear in the picture of society given in *ABC* at all.

169. Alechinsky was commissioned to make a five-franc stamp, which is reproduced in *Travaux* (102). He decided on his *Roue de l'écriture* and asked Butor to set a text behind it. Butor states in *Travaux* that he selected a part of *Le Rêve de l'ammonite.* Subsequently, Alechinsky enlarged the engraving of the stamp and added color and a predella. Butor states *"J'ai écrit la suite du texte, ce qui permet d'avoir à chaque fois des estampes différentes, puisque le texte est différent pour chaque estampe"* (101). The legible words in the reproduction in *Travaux* are clearly from the *Sphinx en chapeau* from *Le Chien roi: "bataille et pieds," "l'hôtel," "présence," "déplorable," "familiales," "poêle"* (poêle in the reproduction of the stamp), *"dévale," "vieille ville," "veillait, la chienne parleuse,"*

"naturellement," "pourtant." The reproduction shows the actual stamp with the first-day seal, as printed by the post office.

170. The ladder reappears in *"Noir, "où grimpe l'intendant peu scrupuleux à l'échelle du soir, dans la serpente aux vivres et provisions"* (29–30). In *"Inscription" "Il* [the artist] *laisse alors tomber quelques gouttes-pensées sur le clavier des passions, l'échelle de revers, l'ange des tentures et des textures"* (22).

171.

Ladder

On each bar a little chimney sweep all the way up to the balcony of Juliet who opens her window for them and leads them to her bed on which she has stretched out a big white sheet where each one is to leave the marks of both his hands before climbing up the chimney to the roof where Romeo is waiting to offer them a choice of hot chocolate or cold orange juice with little salt crackers. When a sheet is filled, Juliet hangs it to dry attaching it with nails to the wall, because the hands of the little chimney sweeps are often moist, and replaces it with a clean one where the next ones print theirs. She had observed that each of their handprints emitted at the end of a few hours long sinuous sentences recounting the dreams of the one responsible and she decided to make a book of them, the biggest in the world, which she and Romeo will offer to their parents on their wedding day when all the little chimney sweeps will carry torches and throw handfuls of cinders. (15)

172.

Factory

Squeezed on our bench under the skylight, it is very rare that we can raise our eyes toward the clouds between two operations on the items which the conveyor belt parades so rapidly before us, always the same from morning to night, always new from one day to the next. Yesterday it was a hammer blow that had to be given to the doors of the stoves with inverted flame, day before yesterday a turn of the screw for the armrests of the deluxe automobiles. When we check in of a morning we find the necessary tools, but we cannot guess their precise use until the foreman makes the first gesture on the first model before climbing up to the watchtower with his binoculars and his revolver. What we fear most are the brushes and paints; certainly, sometimes we have to paint glove or hat boxes, chairs, even posters, but it is when the canvases start to parade by that sweat begins to rustle down our spines. (28)

173. *Bon Marché I* (#5) does not show *"Loi du . . . août 1871"* seen here in #19, which is loosely related to a text, *"Loi."*

174.

Sequence

What we appreciate is the faithful customer. He must return to our store. That is why we do not hesitate, in promising cases, to make a hole right in the middle of a long and carefully chosen piece of fabric, to be sure the woman buyer will come back to have it exchanged. And do not think the piece is lost as a result. The placing of the defect has been carefully chosen by the expert salesman–hole-maker just at the moment of wrapping it, in such a way that we can cut it up for the ready-to-wear. In general this brings about a second sale, clearly bigger. We attach a great value to the physical appearance, the bearing, tact and glibness of our employees in certain strategic departments, gloves for example. And there are certain fields which a superficial mind would judge as exclusively masculine, where a salesgirl does wonders among her male coworkers. This is the case for firearms. She has to have the look of Diana the huntress. Her domain is decorated with crescent moons, bows and quivers, stag antlers. They must always be capable of giving private lessons in our shooting-galleries or in the home (you may be sure they know how to protect themselves), in the country as well as in town. They do not generally stay with us very long and the House presents them a complete trousseau for their wedding; indeed, their husbands often come back to prowl around among our counters to compare them to those who have replaced them. (38).

175. Note that now, years later, listed among the ten wealthiest individuals in the United States are four heirs of a fortune accrued by the owner of a department-store chain.

176.

Litany

The most spacious stores in the world, that is easy to say; then try to count the windows of these. And then, you know, the system of selling at small profit and entirely in confidence is absolute. Every purchase which leaves something to be desired is reimbursed at the pleasure of the buyer. In the case of a claim, one need always speak to the cashier and that is sufficient. Ah, if you are in the provinces, you are urgently requested always to inform them of merchandise returns you might need to make to them, and they recommend that you be sure to indicate very exactly your name and address on the envelope of packages returned either by mail or by railroad. There are so many! There are so many clients with so many whims! You should see their index card box, their assembly lines for redistribution, those armies of trailer-trucks taking off again in all directions cheered by housewives in the villages they pass through, and the door of their armed cellars where, they say, electric locomotives pull railroad cars full of money which the Bank of France envies them. (26)

177. The file box of this text is treated more extensively in *"Numérotation."* The code for translating letters to numbers is clearly explained and then: *"Dans la gestion des plus vastes magasins du monde, chaque client aura son numéro, avec toutes sortes de renseignements inclus. Surtout, il est possible de faire passer à l'aide d'une simple facture les renseignements les plus confidentiels"* (31). Once again Butor has foreseen this Orwellian future that we live in today. How many mail-order catalogues have deluged us because once, years ago, we ordered a vegetarian cookbook?

178.

Practical

Our new stove with inverted flame ought to give you complete satisfaction. Your employers will congratulate you, your friends will envy you. Not only is there cleanliness, flexibility of adjustment, economy, but there is also a sort of gaiety which radiates through the whole household. Relations are facilitated: other conversations, other perspectives. If you are a motorist, and this is a sport which is spreading out to all classes of society, winning over more and more the lovable sex, you will appreciate our transparent bodies, with our ranges of illusions which permit at intersections or overtakings the most amusing misunderstandings and which constitute real traps for thieves who, after some memorable unexpected failures which cover them with ridicule among their colleagues who hear of them (and we know how rapidly news spreads in that circle) generally leave all the cars of the neighborhood alone. (34)

179. The title is clearly a way to fill in an "X." The term is usually applied to the appendix. However, it may very well be, although I do not know, that appendices are also harmed by these undergarments.

180.

Sword-shaped

In the long-line strapless brassiere department you will appreciate our finely padded articles with the special design we have perfected for whales. How indeed to unite comfort to the slenderness of the waist which is more and more obligatory at this passage to a new century? It was absolutely necessary to free up the region of the heart while still holding the ribs firmly. From now on you can palpitate as you please. Your hand, or naturally any other authorized, will be able to feel it. Some of our clients, formerly subject to frequent vapors, have written to us of their gratitude. Their letters are available in our offices to anyone. Our workshops are developing an incorporated acoustic tube which will permit amplification of the vibrations at your discretion. There are circumstances where words are not enough. (45–46)

181.

Correspondents

One finds literary correspondents, not those who reply to you, who are obliged to return your ball, but those who are agents for the fashionable

periodicals, who are faithfully followed. Then come the correspondents of the divine "Houses," more serious in another way, but somewhat avatars of the first—because what matters, is the Brand, the Name—and they look you up and down with their big deep eyes. They make themselves witnesses, disciples : it is the *nec plus ultra* of what is done in France, in Europe, in the World. The philosopher asks himself whether this phenomenon of the correspondent could not be a return to Caesarism? The imperial capital propagates itself all the way to the boundaries [*limes*] of the rustic centers. The correspondent is the direct delegate, the substitute, the servitor of the fetishized object which he represents, in all its prestige, its unique demeanor. When a correspondent happens to die, they bury him without great pomp, as if caught in a failure to act. Who knows exactly where the Mother House is? Who is acquainted with it? If only we still had a sign. . . . What is sure is that it exists, that formerly, once, we had this precious object! Even if our goods no longer carry these legendary brandnames—we couldn't, it would be too costly—they couldn't get all the way to us—we are so close, we have so evidently made them in the same way, that they are the same—or almost. (12)

182.

House

The house resonates with toast, gurgles from the sink, curtains being drawn, sheets pushed back, lips and eyelids being curled up, eyes opened a little more or that are found in the morning cups, dreams that are woven, hair that is braided, little hurties that are treated, projects that are thought up, perfumes that reinvigorate, cares that are shaken about, hopes that are nourished and transported toward those other Houses, with a capital letter and extra lengths of cement, lime, ironwork, goldwork, tobacco and metalwork, harder than the granite and steel of their machines, which creak, moan, roar, groan, set down, impose, explode, expose once a year, which cause us to fear a thousand deaths—on which the Houses do not give credit! (27–28)

183. The coupling of *"exposent une fois l'an"* with the fear of ruinous debt could suggest that Butor does not approve of the commercialization of Christmas. We will recall "M. Janvier" in the *"Stances des mensualités." "Vitrines pour Noël"* appear here also in the text, "Bon Marché," but without comment (11).

184. The piano itself appears often: *"Décalcomanie"* includes *"vieilles transcriptions pour piano à quatre mains"* (14) and *"Nom"* lists *"le monstre velocité du pianoforte"* (41). In *"Réserve"* the department store keeps in a secure environment *"pianos historiques certains dédicacés; nous avons en particulier toute une série adressée par George Sand à Frédéric Chopin pendant leur séjour à Majorque"* (36).

185.

Piano

With a forehead high as a façade, the young music master marks the fall of the fingers of Mme de La Bastide who is scarcely gifted with this instrument. Some Pathé records, waltz or opera airs, could easily take the place of this massacred sonata. In the shopwindow of the Genet brothers the empty carcasses of a Pleyel and a Gaveau are still enthroned, gigantic as organs, decorated like the Altar of Repose, before which strollers furtively bow. In the outfit of ordinary objects, in the nineteenth century, the piano occupied a choice place, as does for us the jet plane, the sailboard or the computer. It symbolizes all space, but divisible, decomposable, each key an element in a laborious chain, the piece of music becoming an accumulation of notes as of capital. At the beginning of the century, the piano balks, limps a little, they really no longer want it so tender (all over with those "Clair de lune"!) it becomes mechanical, an automaton parodying itself for festivals and fairs. Heard coming from the back room are some saxophone and trumpet duets before the bar phonograph reverberates with "Some of these Days." (34)

186. The letterhead also advertises *pétrole* and *essence*, *"Vêtements confectionnés et sur mesure"* and shows that the all-purpose store also serves as the *Café de la Mairie*. Each of these points has

influenced at least two texts: for example, *"Balai"* contains the address of *Deluxe Automobiles I* (#11), which is located in Limoges, but specifies the Café de la Mairie in Allogny as the source of the broom the artist needs to clean up his studio. The location of the café is stipulated in *"Kaleidoscope,"* anachronistically as *"sur la place derrière le monument des morts."*

187.

Kilo

A kilo of gruyère, the same of white mushrooms, for a new recipe; half a kilo of sea salt; two kilos of tapioca, for ordinary soups; two of chestnut cream to decorate desserts; five kilos of beef tenderloin, for our forced labor, moving canvases on outsized frames, plunging into very old archives; ten kilos of crystals, to increase transparency. . . . Added to the liquid invoice, plus some kilowat hours, some kilo vapors and some kilometers traversed, you will have a fairly precise quantitative impression of what is boiling in the weekly domestic kettle of the de La Bastide family, compressed clouds of dissensions, but trimmings of adaptations, dresses and coats which smoke before the grand starched evening parties, the pantry which simmers, puffs and roasts all its pretentions, a machine which races like a locomotive, gobbles like a blast furnace and whistles like the mechanical cuckoo of esteem. (26)

188. *"Cuve"* also provides unrelenting rhythms and very interesting harmony: alliterations in *f* and, in three three-syllable infinitives, in *m* and rhymes in [e]; hard [k]'s, *i*'s, and nasal [ã]'s and *o*'s are prominent from one end to the other.

189. The word "cellar" without the sense of a wine cellar appears in *"Stock,"* which begins with a salesman's pitch, *"On ne sait jamais,une guerre est si vite arrivée, ou une épidémie, un séisme, un déluge, l'invasion des extra-terrestres. Vous avez une cave, j'imagine"* (37–38). The salesman recommends his specialists for the best and most luxurious of bomb shelters, which does not happen to supply a wine cellar, but will include *"tous les outils pour vous ouvrir une issue parmi les décombres."* The salesman does not address the problem of what the buyer is to do then.

190. *"Jeu"* speaks of the *"cellariste et raisins"* (23), *"18 fûts de porto rouge"* are held in *"Warrant"* (45), "Bordeaux" wines are mentioned in *"Salutations"* (37), *"cuves et pressoirs"* in *"Exploitation"* (16), and the very cellars of the letterhead, *"les caves girondines avec dégustation"* appear in *"Kaleidoscope"* (24).

191. The influence of other artworks is visible in this text. An Exposition at Bourges is mentioned in the letterhead of *Deluxe Automobiles II* (#17) where that company won prizes, and various prizes were awarded to *Deluxe Automobiles I* (#11) at an Exposition at Limoges and to the *Arms Company* (#12) in Lyon and Paris. Medals are shown in their letterheads and also in both Victor Magnants (#14 and #16), but in the latter the details of the exposition have been painted out. The influence of the Automobile letterheads is clear in "Jury," but no Vatican Exposition can be found among the bills.

192.

Jury

In the Grand Jury called together by the Girondine Cellars, the wine tasters in two-cornered hats and noses like unicorn chins sniff the nectars of the year 1905, come from the best regions: red and white ports, malagas, muscatels and grenaches, while the beautiful woman, with her pretentious emanations, limps and disappears. The spotlights of industrial creation are trained on the Jury of the International Exposition of Bourges, the jurors fully decked out in full dress with swallowtail coats, amorously palpate the frameworks, trunks, hoods, doors, tires, bells in a prosthetic embrace. For the Jury of the Vatican Exposition, the latches hold back their sobs. Their hell will be sweet! But in the shadows, the Other Jury, which everybody gossips about but of which no one has succeeded in learning the exact purpose awards a gold medal for dreaming, a grand prize for being giddy, an honorable mention for changing

policy, a certificate of merit for yearning, congratulations for making a loud flashy uproar, a general round of drinks for joy, completely ruled by the cherubs squealing in a celestial jungle of wine stock and wine branches, of excited cups and rumps. (23)

193. *Cartwright* is reflected in numerous texts; the name in the letterhead appears in the several texts listing the various businesses. At least one text derives from the handwritten items on the bill, and more than one allude to the use Alechinsky has made of the carts as parts of faces. *"Voiture"* specifically mentions the carts of the letterhead's illustration, presenting succinctly the history of the entire world in terms of the wheel, with vehicles powered by humans as well as animals and machines. In this one text, there is a touch of humor, for included in the parade is Cinderella's pumpkin coach (43–44).
194.

Ironmongery
Forehead like the belly of a pot, chin like the handle of a lock, nose like the blade of a knife, eyes like hubs and spokes of wheels of a dogcart or calèche, eyebrows like shafts of a gig. And ink astern, or behind, intersected, interlaced, on a slope, bars, bannisters, twists, bracelets and corset of the Master with Elegance who is tightly laced in his dignity, in order to be more sensitive than he looks, in the network of his venemous laces: ironmongery barb! (18)

195.

Repair
Shattered seatbacks, hole-filled seats, warped wheels, snapped-off handles, rusted tools, cracked windowpanes, smashed casks, punctured tires, stopped-up chimneys, broken-down lights, torn dresses, battered hats, crooked rails, jammed locks, frayed cords, silent piano keys, twisted scaffoldings, mildewed books, burned letters, ripped posters, botched canvases, faked accounts, wobbly sentences, fingers torn off, crushed feet, eyes gouged out, brains in a whirl, dogs' lives, filthy worlds. (36)

196. Butor points out that the young Balzac published a collection anonymously with two friends, entitled *Contes bruns écrits par une tête à l'envers* (*Improvisations sur Balzac* I, 46).
197.

Unity
These drawings have no unity, just look!—The thing is I don't see in them any rule of time, place, action, occupation or body of workers.—Paint classically!—From unity to unities, I lose my way. With directions, I clip them out. With sense, I wander. With slowness, I meander. With flight, I find myself elsewhere.—Unity of background, of foreground, all that, which cracks, but is top-notch. It is my plain badge, my stamp with no receipt, my madness, my passing fancy. I love, I persist—I do not give up. (41)

198. The other bills stamped *"payé"* or *"quittances"* are #6, 17, and #18.
199. An extraordinarily harmonious text, *"Iridescence,"* drawn directly from the list on the de la Bastides' bill from Millet-Armand, *Bureau de tabac* (#15) includes materials an artist needs: turpentine and linseed oil. However, both items are listed on the original support, and the rest of the purchases are quite everyday. Thus we cannot justify citing this text, but recommend it strongly for its synesthetic presentation of a grocery list, filled not only with harmony but also with color and perfume.
200. This is one of the texts that is definitely Butor's and not Sicard's, as the phrase is virtually the same as that he cited in an article, about the chess king in check, who *"peut avoir l'air de se désintéresser de la chose,"* strolling about the board, trying to find a way to *"rendre la mort habitable"* (Michel Butor, *"Reproduction interdite,"* *Critique* 334 [March 1975]: 282).

201. The text entitled *"Chevalet"* (11) has a different message, delivered through "black" humor: the easel becomes an instrument of torture on which the model's body is hanged, examined, and dissected. Humor through contrast lies in a touch appended to the grisly: we are blandly informed that most artists are interested primarily in flesh tones.
202.

Oil
Mr. Grocer, I would be grateful if you would send me at your earliest convenience —a liter of olive oil, for my daily salad;—two liters of linseed oil, to restore my old paintings;—three liters of motor oil, if you have it, to drain the crankcase of my figuration;—four liters of oil of grape seeds, to regild some old dreams;—five liters of cod-liver oil, to give strength to my audience;—six liters of whale oil, to throw on the fire of signs, letterheads, entrechats, and intervals between wines. You will add also a few measures of elbow grease, to give courage to my future biographers. (21)

203. An additional text, *"Façon"* would presumably not be of enormous use to the biographers, no matter how courageous. It follows the order of this bill's list up to a point. Humorous throughout, it mentions salad recipes of *"mon père,"* *"ma mère,"* and *"ma grand-mère,"* as well as a technique for polishing the stove according to *"mon autre grand-mère,"* derived obviously from *Stoves* (#4).The recipe for preparing mushrooms requires salt sprinkled on the straws from a new broom—*"neuf ou du moins réservé exclusivement à cet usage"*—and *"mon grand-père"* was an expert at turning the salad with the broom handle, in a *"gigantesque saladier bleu."* (16)
204. The title of this text would have been provoked by the support of the artwork *Outillage* (#13), which carries the word in the letterhead. The drawing, however, does not seem to have generated any texts.
205.

Tools
We have at your disposal a whole range of products which permit the beginner to rival rapidly with the experienced specialists. Thus the spotter, the dripper, the stippler, and the shredder. As concerns figuration, we have perfected a series of distorting stencils, permitting the anamorphoses of the best-known faces as in a hall of mirrors. You can thus thin out as you please all the great beards of the end of the century: Hugo, Brahms, Jules Verne or Garibaldi, enlarge them horizontally or at an angle, impose the most delightful cycloid or spiral transformations upon them. Once you have tried it you will no longer be able to do without your caricaturer. (32)

206. One pseudo-advertisement is not opposed to art but rather offers a splendid invention: *"Notre exclusivité: la peinture sur gaz, les surfaces qui se développent dans l'espace sans aucun support apparent. Un art d'avenir."* (*Peinture*) (34).
207.

Business
There are two very distinct business worlds. The first, which we will call Market A, exchanges commodities for currencies, lists on the stock market every day, collapses sometimes with enormous cracking which sound effects workers are charged with decreasing. The second, which we will call Market B, about which no one knows exactly where the real centers of decision and valuation are, trades images for plots, appraises works which have disappeared or only been imagined, causes secret dwelling spaces to rise up, causes us to smell grass of the rare meadows or to feel those turbulent loves which are the big business of life. Sometimes a dividend from Market B turns up on Market A, or vice versa, which does not fail to cause a disturbance. For example, when a rectangle of famous canvas appears in the lair of an administrative council. Market A experts have undertaken to measure the exact range of action or infraction of these suspect items on our transactions. They are even considering installing opposite some rather sophisticated devices to counterbalance this

deviant influence. But at last report a supposedly philanthropic association, close to Market B, is interested in the reverse formula, and would impose objects from Market B on each spot in Market A, as the miraculous solution to our problems and, completely independantly, this diffuse but everywhere equal quantity would be able to play the role of an algebraic invariable in all our fundamental operations. (9)

208. We will recall Butor's nostalgic vision of the outside world in the *Cartes postales poun un ami de Liechtenstein,* where the artistic rendering of hills and mountains through photographs in collage was compared unfavorably with the "real" landscape, located according to that work in Lichtenstein.

209. The *"Banque de France,"* as in *Kyrielle,* would have no interest in this kind of wealth at all.

210. Butor is of course familiar with Rimbaud's use of *gruyère,* spotlighted by André Breton in his *Anthology of Black Humor,* but black as Rimbaud's humor may be, according to Breton, this particular use of "bathroom" humor is not typical of Butor. See Alan R. Pratt, ed., *Black Humor: Critical Essays* (New York: Garland 1993), 18.

211. Françoise van Rossum-Guyon, *Le Coeur critique* (Amsterdam: Rodopi, 1979), 48.

212. Van Rossum-Guyon cites in this work from Butor's *"L'appel des Rocheuses,"* derived from the photographs of Ansel Adams and Edward Weston (*Réalités* 197 [June 1962]: 76–83. Rpt. as *"Les montagnes rocheuses,"* in *Illustrations* [Paris: Gallimard, 1964]), as well as from *Cycle,* derived from the gouaches of Calder (Michel Butor and Alexandre Calder [Paris: La Hune, 1962]), and also from *Litanie d'eau,* derived from the engravings of Masurovsky (Michel Butor and Gregory Masurovsky [Paris: La Hune, 1964]). The study reveals a profound understanding and appreciation of Butor's work with "his painter friends" (*Coeur* 44).

5. CONCLUSION

1. Léon S. Roudiez, *"Un Texte perturbé: Matière de rêves de Michel Butor,"* *The Romanic Review* 85 (1984): 246.

2. Butor's website, *"Poésie au jour le jour,"* was opened in July 2000, at that time 138 pages of primarily, if not exclusively, previously unpublished poems. All appear to be collaborative works, as each is dedicated to an artist. Two were written in collaboration with Jiří Kolář. One of the artworks, with the text handwritten on it, *Portrait d'un autoportrait,* may be seen in *22 Artistes avec Michel Butor* (Le Mans: Médiathèque Louis Aragon, 1998), 31. I have not yet located the Kolář source of the other, *L'Enseigne de Vénus.*

Further, in May 2001; the website *Dictionnaire Butor* (http://perso.wanadoo.fr/henri.desoubeaux) was initiated by Henri Desoubeaux, who welcomes contributions of bibliographical listings, not limited to collaborations.

Works Cited

The references are divided into four categories: works by Butor (including those in conjunction with other writers or artists), studies about Butor's works, works by the three artists and studies of their artworks, and other sources cited.

WORKS BY MICHEL BUTOR

Alechinsky, Pierre, Michel Butor, and Michel Sicard. *ABC de correspondance*. Paris: Daniel Lelong, 1986.

——— and Michel Butor. *Le Chien roi*. Paris: Repères, Ed. Maeght Lelong, 1984.

———, Michel Butor, and Michel Sicard. "Dessins sur factures." *ABC de correspondance*. Paris: Daniel Lelong, 1986.

———, Michel Butor, and Michel Sicard. "Grosses en Stock." *ABC de correspondance*. Paris: Daniel Lelong, 1986.

Ayme, Albert, Michel Butor, and J.-Y. Bosseur. *Seize et une variations*. Paris: Edition traversière, 1983.

Butor, Michel. "L'Alchimie et son langage" (1953). Rpt. in *Répertoire*. Paris: Minuit, 1960.

———. *L'Arc* (Aix en Provence) No. 39 (1969).

———. *Artistes avec Michel Butor/Künstlern mit Michel Butor*. Zurich: Collegium Helveticum 1999.

———. *Avant-Goût II*. Rennes: Ubacs, 1987

———. *Avant-Goût IV: en mémoire*. Rennes: Ubacs, 1992.

———. "Ballade des froissements du monde." In *Envois 2: Exprès*, 11–13. Paris: Gallimard, 1983.

———. "Ballade du tremblement du ciel." In *Envois 2: Exprès*, 110–11. Paris: Gallimard, 1983.

———. "Ballade des valeurs arc-en-ciel." In *Envois 2: Exprès*, 37–38. Paris: Gallimard, 1983.

———. *Bicentenaire kit*. Paris: Philippe Lebaud, au Club du livre, 1975.

———. *Boomerang*. Paris: Gallimard, 1978.

———. "Cartes postales pour un ami de Liechtenstein." *Liechtensteiner Almanach*. Vaduz: Brunidor-Serien, 1989.

———. "Cent phrases pour l'éventail d'Arnold Schoenberg." Michel Butor and Henri Pousseur. *Procès du jeune chien (Petrus Hebraicus)*. Milan: Edizioni Suvini Zerboni, 1980.

———. "Chanson pour Don Albert." *Echanges: Carnets 1986*. Nice: Z'Editions, 1991.

———. *Chantier*. Gourdon: Dominique Bedou, 1985.

———. *Colloque de Cerisey*. Paris: Union générale d'éditions, 1974.

———. *Curriculum vitae*. Paris: Plon, 1996.

———. "Dialogue avec Charles Baudelaire autour des Travaux de Jiří Kolář." *L'Oeil de Prague*. Paris: La Différence, 1986.

———. *Echanges: Carnets 1986*. Nice: Z'Editions, 1991.

———. "Ecorché vif." *Butor: Colloque de Cerisey*. Edited by Georges Raillard. Paris: Union générale d'éditions, 1974.

———. *Elseneur*. Yverdon: Henri Cronaz, 1979.

———. *L'Embarquement de la Reine de Saba*. Paris: La Différence, 1989.

———. "En Compagnie de Michel Butor." (Expo.) Valence: Musée de Valence, 1986.

———. *Envois 2: Exprès*. Paris: Gallimard, 1983.

———. *Fenêtres sur le passage intérieur*. Bois-le-Champ: Aencrages et Cie., 1982.

———. *Forme courte*. Marseille: le Temps parallèle, 1990.

———. *Frontières*. Marseille: Le temps parallèle, 1985.

———. *Frontiers*. Translated by Elinor S. Miller. Birmingham, Ala.: Summa Publishers, 1989.

———. *Le Génie du lieu II: Où/Ou*. Paris: Gallimard, 1971.

———. *Le Génie du lieu III: Boomerang*. Paris: Gallimard, 1978.

———. *Le Génie du lieu IV: Transit*. Paris: Gallimard, 1992.

———. *Le Génie du lieu V: Gyroscope*. Paris: Gallimard, 1996.

———. "Guirlande liminaire." *Michel Butor et ses peintres*. Le Havre: Musée des Beaux Arts, 1973. Rpt. in *Yearbook of Comparative and General Literature* 38 (1989): 36–78.

———. "Hallucinations simples." *Avant-Goût II*. Rennes: Ubacs, 1987. Rpt. *Gyroscope*. Paris: Gallimard, 1996.

———. "Histoire de Suzanne." Jean-Claude Prêtre. *Suzanne*. Paris: Bibliothèque des arts, 1990.

———. *Hoirie-Voirie*. Torino: Pozzo Grosmonti, 1970.

———. *Illustrations*. Paris: Gallimard, 1964.

———. *Illustrations II*. Paris: Gallimard, 1969.

———. *Illustrations IV*. Paris: Gallimard, 1976.

———. *Improvisations sur Balzac I: Le Marchand et le génie. II: Paris à vol d'archange III: Scènes de la vie féminine*. Paris: La Différence, 1998.

———. *Improvisations sur Butor: L'écriture en transformation*. Paris: La Différence, 1993.

———. *Improvisations on Butor: Transformation of Writing*. Translated by Elinor S. Miller. Edited by Lois Oppenheim. Gainesville: University of Florida Press, 1996.

———. *Improvisations sur Michaux*. Paris: La Différence, 1998.

———. *Improvisations sur Rimbaud*. Paris: La Différence, 1989.

———. *Lessive pour Marie-Jo*. Las Palmas (Canary Islands): Asphodel, 1986. With illustrations by Michel Camoz and Pierre Leloup, *Lessive pour Marie Jo*. Chambéry and Lucinges: n.p., 1989. Rpt. in *La Forme courte*, 95–124. Marseille: le Temps parallèle, 1990.

————. *Matériel pour un Don Juan.* Affiches de Pierre Alechinsky, cassette enregistrée de Jean-Yves Bosseur. Losne: La Louve d'Hiver, 1977.

————. *Matière de rêves.* Paris: Gallimard, 1975.

————. *Matière de rêves II: Second sous-sol.* Paris: Gallimard, 1976.

————. *Matière de rêves III: Troisième dessous.* Paris: Gallimard, 1977.

————. *Matière de rêves IV: Quadruple fond.* Paris: Gallimard, 1981.

————. *Matière de rêves V: Mille et un plis.* Paris: Gallimard, 1985.

————. *Méditation sur la frontière.* (Batuz expo.) Schaumberg: Fondation Gulbenkien, 1983.

————. "La Méduse des chocolats." "Guirlande Liminaire." *Michel Butor et ses peintres.* Le Havre: Musée des Beaux Arts, 1973. Rpt. in *Yearbook of Comparative and General Literature* 38 (1989): 36–78.

————. "Miroir de Suzanne." Jean-Claude Prêtre. In *Suzanne* 181–92. Paris: Bibliothèque des Arts, 1990.

————. *Mobile.* Paris: Gallimard, 1962.

————. "Les montagnes rocheuses." *Illustrations.* Paris: Gallimard, 1964. Rpt. of Michel Butor, Ansel Adams, and Edward Weston. "L'Appel des Rocheuses." *Réalités* 197 (June 1962): 76–83.

————. *Les mots dans la peinture.* Geneva: Skira, 1969.

————. *L'Oeil de Prague.* Paris: La Différence, 1986.

————. "Opusculum Baudelarianum." In *Répertoire IV,* 237–44, Paris: Minuit, 1974.

————. "Les Parents pauvres." *Répertoire II.* Paris: Minuit, 1964.

————. *Passage de Butor II.* Montpellier: Galerie Wimmer and Musée de Bédarieux, February 1991.

————. "Poème optique." *Strates* 7 (Oct. 1966).

————. *Portrait de l'artiste en jeune singe.* Paris: Gallimard, 1967.

————. "La Reine des neiges." *Métaphores* (Nice) 2 (1980): n.p.

————. *Rencontre.* Paris: Galerie du dragon, 1962. Rpt. in *Illustrations,* 31–53. Paris: Gallimard, 1964.

————. *Répertoire II.* Paris: Minuit, 1964.

————. *Répertoire IV.* Paris: Minuit, 1974.

————. *Répertoire V.* Paris: Minuit, 1982.

————. "Reproduction interdite." *Critique* 334 (March 1975): 269–83.

————. "Rescapés de la corbeille." *Hoirie-voirie.* Torino: Pozzo Grosmonti, 1970.

————. "Résistance." *Métaphores* (Nice) 2 1980: n.p.

————. *Le Rêve de l'ammonite.* Montpellier: Fata Morgana, 1975.

————. "Le Rêve de Jiří Kolář." *Coloquio/Artes* (Lisbon) (June 1975): 5–14.

————. *6.810.000 litres d'eau par seconde.* Paris: Gallimard, 1965. Translated as *Niagara* by Elinor S. Miller. Chicago: Regnery, 1969.

————. "Stances des mensualités." *Hoirie-Voirie.* Torino: Pozzo Grosmonti, 1970.

————. "Thèmes, variation, suites et non: Entretiens avec Michel Butor." *Les Métamorphoses-Butor.* Quebec, Canada: Griffon d'argile; Grenoble: Presses universitaires, 1991.

————. *Travaux d'approche.* Paris: Gallimard, 1972.

————. "Trois femmes enlacées." In Jean-Claude Prêtre. *Suzanne,* 161–63. Paris: Bibliothèque des Arts, 1990.

————. *Utilité poétique.* Saulxures: Circé, 1995.

————. "Vagues des villes éclosion." "Guirlande liminaire." *Michel Butor et ses peintres.* Le Havre: Musée des Beaux Arts, 1973. Rpt. in *Yearbook of Comparative and General Literature* 38 (1989): 36–78.

————. *Vanité.* Paris: Balland, 1980. Rpt. in *Répertoire V,* 275–98, Paris: Minuit, 1982.

————. *Victor Hugo écartélé.* Xonrupt-longemer: Aencrages et Cie., 1988.

————. *Zañartu.* Paris: Galerie du dragon, 1958.

————. *Zone franche.* Montpellier: Fata Morgana, 1989.

————, Ansel Adams, and Edward Weston. "L'appel des Rocheuses." *Réalités* 197 (June 1962): 76–83. Rpt. as "Les montagnes rocheuses." *Illustrations.* Paris: Gallimard 1964.

———— with Pierre Alechinsky, Bernard Dufour, and Jacques Herold. *Tourmente.* Montpellier: Fata Morgana, 1968.

———— and Alexander Calder. *Cycle.* Paris: La Hune, 1962.

————, and Béatrice Didier. *Le Retour du boomerang.* Paris: Presses universitaires de France, 1988.

———— and F.-Y. Jeannet. *De la distance.* Rennes: Ubacs, 1980.

————, and Michel Launay. *Résistances.* Paris: Presses universitaires de France, 1983.

———— and Gregory Masurovsky. *Litanie d'eau.* Paris: La Hune, 1964.

———— and Henri Pousseur. "L'Ecole d'Orphée." "Constellation Michel Butor." (Performed Geneva, 7 October 1989) *Program,* week of 25 November–3 December 1989. Geneva: Département de langue et littérature françaises modernes, Faculté des lettres, U of Geneva, 1989.

———— and Henri Pousseur. *Procès du jeune chien (Petrus Hebraicus).* Milan: Edizioni Suvini Zerboni, 1980.

———— and S. J. Rhee. *Bouquet d'impressions.* Nice: J. Matarosso, 1986.

———— and S. J. Rhee. *Replis des sources.* Paris: Seuil, 1977.

————. and Michel Sicard *Alechinsky dans le texte.* Paris: Editions Galilée, 1984.

————and Michel Sicard. "Comptine en blanc et noir." *Alechinsky: Frontières et bordures.* Paris: Editions Galilée, 1984.

————. *Alechinsky: Frontières et bordures.* Paris: Editions Galilée, 1984.

————. *Alechinsky: Travaux d'impression.* Paris: Editions Galilée, 1992.

———— and Michel Sicard. *En Marge.* Paris: Orte, 1992.

———— and André Villers. *Musique de chambre noire.* Nice: Mougins, 1980.

———— and André Villers. *Picasso-labyrinthe: livret pour un film.* Tübingen: Rive gauche, 1986. Rpt. Butor, Michel. *Au jour le jour: Carnets 1985.* Paris: Plon, 1989.

Charbonnier, Georges. *Entretiens avec Michel Butor.* Paris: Gallimard, 1967.

Dotremont, Christian, and Michel Butor. *Cartes et lettres: Correspondance 1966–79.* Edited by Michel Sicard. Preface by Pierre Alechinsky. Paris: Galilée, 1986.

STUDIES ABOUT BUTOR'S WORKS

Appy, Frédéric. *Nixe: Mise en question et exaltation du livre.* Paris: La Différence, 1985.

Calle-Gruber, Mireille, ed. *Butor et l'Amérique.* Paris and Montréal: l'Harmattan, 1998.

———. *La Création selon Michel Butor: Réseaux—frontières—écart*. Colloque de Queen's University. Paris: Librairie A. G. Nizet, 1991.

———. *Les Métamorphoses-Butor*. Quebec, Canada: Griffon d'argile; Grenoble: Presses universitaires, 1991.

Camarero-Arribas, Jesus, ed. "Michel Butor: Escrituras, una pasion par la invención estética." *Anthropos* (Barcelona) 178/79 (May-August 1989).

———. *Bibliografica Butoriana*. Vitoria (Spain): Arteragin, 1996.

Chavdarian, Seda. "Michel Butor devant la critique française: 1955–70." *Oeuvres et critiques: Michel Butor—Regards critiques sur son oeuvre* 10.2 (1985): 25–36.

Dällenbach, Lucien. "Une écriture dialogique." In *La Création selon Michel Butor*, edited by Mireille Calle-Gruber, 209–14. Colloque de Queen's University. Paris: Librairie A. G. Nizet, 1991.

Fürstenberger, Barbara. *Michel Butors literarische Träume: Untersuchungen zu Matière de rêves I bis V*. Heidelberg: Carl Winter Universitätsverlag, 1989.

Inglis, Angus A. "The Application and Development of Michel Butor's Collage Principle in *Illustrations IV*." *Review of Contemporary Fiction* 5.3 (Fall/1985): 103–107.

La Mothe, Jacques. "American Holiday: Jeux de sociétés." In *Butor et l'Amérique*, edited by Mireille Calle-Gruber. 115–26, Paris and Montreal: l'Harmattan, 1998.

———. *L'Architexture du rêve: la littérature et les arts dans Matière de rêves de Michel Butor*. Amsterdam: Rodopi, 1999.

———. "Echographies: Alechinsky et Butor." *Dalhousie French Studies* 31 (summer 1995): 65–80.

———. "Prélude pour déchiffrer *Matière de rêves*." *Revue de critique et de théorie littéraire* (Toronto) 11 (1991): 173–211.

———. "Traces préliminaires pour une exploration de l'Ile de Vénus." In *La Création selon Michel Butor*, edited by Mireille Calle-Gruber, 85–100. Colloque de Queen's University. Paris: Librairie A. G. Nizet, 1991.

Launay, Michel. "Michel Butor 1980: Exploration of the Resistances to a Harmonious New World." *World Literature Today* 56.2 (spring 1982): 291–96.

———. "La Machine critique de l'oeuvre de Butor en France." *Oeuvres et critiques* 10.2 (1985): 13–24.

Lyotard, J. F. *Discours, figure*. Paris: Klincksieck, 1978.

Magné, Bernard. "Don Juan dans l'ordinateur." *Texte en main* 2 (été 1984): 45–50.

Mason, Barbara. "La Critique et l'alchimie." *Oeuvres et critiques* 10.2 (1985): 129–44.

———. "'Opusculum Baudelairianum': Collage and Contestation." *Australian Journal of French Studies* 25.2 (1988): 207–20.

Miller, Elinor S. "Michel Butor's *Quadruple fond* as Serial Music." *Romance Notes* 24.2 (1983): 196–204.

———. "'Michel Butor et ses peintres': catalogue and Michel Butor's 'Guirlande liminaire': Introductory study." *Yearbook of Comparative and General Literature* 38 (1989): 36–78.

Monticelli, Raphaël. "Approche du continent Butor." *Echanges: Carnet 1986*. Nice: Z'Editions, 1991.

Oppenheim, Lois. "L'Anesthétique de Michel Butor." In *La Création selon Michel Butor*, edited by Mireille Calle-Gruber, 247–57. Paris: Librairie A.G. Nizet, 1991.

———. "Animation of the Work of Art: Michel Butor's *L'Embarquement de la Reine de Saba*." *Modern Language Notes* (September 1994): 741–52.

Raillard, Georges, ed. *Butor: Colloque de Cerisey*. Paris: Union générale d'éditions, 1974.

Roudiez, Léon S. "Le Réel et la peinture: comment décrire ce qui se dit?" In *La Création selon Michel Butor*, edited by Mireille Calle-Gruber, 164–76. Paris: Librairie A.G. Nizet, 1991.

———. "Un Texte perturbé: *Matière de rêves* de Michel Butor." *The Romanic Review* 85 (1984): 242–55.

Santschi, Madeleine. *Voyage avec Michel Butor*. Lausanne: L'age d'homme, 1982.

Sicard, Michel. "Don Juan dans le texte." *Texte en main* 2 (été 1984): 39–44.

Skimao and Bernard-Toulon Nouailles. *Michel Butor, Qui êtes-vous?* Lyon: La manufacture, 1988.

van Rossum-Guyon, Françoise. *Le Coeur Critique*. Amsterdam: Rodopi, 1979.

St. Aubyn, F. C. "Butor with Don Juan up his Sleeve." *Kentucky Romance Quarterly* 1 (1985): 33–38.

———. "Michel Butor and the Legend of Don Juan; The Example of 'Don Juan dans la Manche.'" *Studi Francesi* 33.3 (1989): 439–52.

———. "Michel Butor's Rare and limited editions: 1956–1983." *The Review of Contemporary Fiction* 3 (1985): 176–83.

Teulon-Nouailles, Bernard. *Passage de Butor II* (Expo.) Montpellier: Galerie Wimmer and Musée de Bédarieux, 1991.

Waelti-Walters, Jennifer. *Michel Butor*. Victoria, British Columbia, Canada: Sono Nis Press, 1977.

———. *Michel Butor*. Amsterdam and Atlanta: Eds. Rodopi, 1992.

WORKS BY AND ABOUT ARTISTS

Alechinsky, Pierre. *Encres à deux pinceaux*. Edited by Yves Rivière. Paris: Arts et Mètiers graphiques,1978.

———. "Impression en cours." *Le Monde* 6 février. 1991, Sélection hebdomadaire: 13.

———. *Peintures et écrits*. Edited by Yves Rivière Paris: A.M.G., 1977. Translated into English as *Paintings and Writings*. New York: Abrams, 1977.

———. *Le Test du titre*. Paris: Eric Losfeld, 1967.

Aragon, Louis. "Un art de l'actualité: Jiří Kolář." *Les Lettres françaises* #1282. Paris 7 May 1969. Reprinted in *Ecrits sur l'art moderne*. Paris: Flammarion, 1981. 253–58.

Ayme, Albert, Michel Butor, and J.-Y. Bosseur. *Seize et une variations*. Paris: Edition traversière, 1983.

Bailly, J. C. "Monory ou le goût du catastrophe" *Cimaise* 133–4 (November 1977–January 1978): 54–63.

Candela, André. *Kolář: Poème Préface*. Photographies André Villers. Cannes: Impro. Bosco, n.d. [1980].

Clair, J. "First Issues of the World Catalogue of Incurable Images." (Monory expo.) *Chroniques de l'art vivant* 52 (October 1974): 29–31.

Cobra, 1948–51. (Expo. Musé d'art moderne de la Ville de Paris; Maison de la Culture de Namur; Centre d'art contemporain, Bruxelles, 1983) Paris: Jean-Michel Place, 1983.

Gassiot-Talabot, Gérald, Preface. *Jiří Kolář*. (Kolář expo.) Paris: Galerie Maeght-Lelong, 1983.

Gaudibert, P. "Monory, suite." *Opus International* 70–71 (winter 1979): 88–91.

Janus. *Jiří Kolář*. Milan: Gruppo editoriale fabbri, 1981.

Jouffroy, A. "Les 'Opéras glacés' de Jacques Monory." *XXe siècle* 46.38 (September 1976): 44–51.

———. "Une certaine exigence traverse la douleur et le rire." *Derrière le miroir* 227 (January 1978): 2–28.

Kolář, Jiří. *Ausstellung, 7 Feb.–15 March '69.* Preface by Wieland Schmied and Dietrich Mahlow. (Kolář expo.) Hannover: Kestner Gesellschaft, 1969.

———. *Dictionnaire des méthodes.* Alçortville: Eds. Revue K, 1991.

———. *Hommage à Baudelaire.* (Kolář Expo. Museum Hans Lange, Knafeld, 8 April–17 June 1973.) Nuremberg: R. Johanna Ricard, 1973.

Kotik, Charlotta. *Transformations.* (Kolář expo.) Buffalo, N.Y.: Albright-Knox Art Gallery, 1978.

Lamač, Miroslav, and Mahlow, Dietrich. *Jiří Kolář.* (Kolář expo.) Cologne: M. Dumont Schauberg/Institut für moderne Kunst, Nuremberg, 1968.

Lascault, Gilbert. "Les Images incurables de Jacques Monory." *XXe siècle* 36.43 (December 1974): 182–3.

———. "Opéras glacés: Monory." *Derrière le miroir* 217 (January 1976): 1–30.

Lyotard, J. F. *Figurations 1960–73.* "Contribution des tableaux de Jacques Monory," 154–238. Paris: Union général d'éditions, 1973.

Messer, Thomas. *Jiří Kolář.* (Kolář expo.) New York: Guggenheim Museum, 1975.

"Monory: Made in U.S.A." Paris: Galerie-jardin des arts; revues et publications 154 (January 1976): 32ff.

Schmied, Wieland. *Der Weg des Jiří Kolář.* (Kolář expo.) Hannover: Kestner-Gesellschaft, 1969.

Schwartz, Arturo. *Jiří Kolář: L' Arte come Forma della libertà.* (Includes essays by Chalupecky, Kolář, Burda.) Milan: Galleria Schwarz, 1972.

Sicard, Michel, ed. *Pierre Alechinsky: Extraits pour traits.* Paris: Galilée, 1989.

Stephano, E. "Masked Reality" *Art and Artists* 9.3 (June 1972): 28–33.

OTHER WORKS CITED

Balzac, Honoré de. *Oeuvres complètes: La Comédie humaine. Scènes de la vie parisienne, VI. Les Parents pauvres: II. Le Cousin Pons.* Paris: Louis Conard, 1914.

———. *Gambara.* Paris: Flammarion, 1981.

Baudelaire, Charles. *Les Fleurs du Mal.* Paris: Flammarion, 1991.

Boas, Franz. *Bella Bella Tales.* New York: American Folk-Lore Society, 1932.

Boswell, James. *The Life of Samuel Johnson.* New York: Modern Library, 1932.

Bryson, Norman. *Calligram: Essays in New Art History from France.* New York: Cambridge University Press, 1988.

Cranach, Lucas the Elder, and Cranach, Lucas the Younger. *Ausstellung.* Berlin: Staatliche Museen Berlin, 1937. (Expo April–June.)

Hagstrum, Jean H. *The Sister Arts: The Tradition of Literary Pictorialism and English Poetry from Dryden to Gray.* Chicago: University of Chicago Press, 1958, rpt. 1987.

Hines, Thomas J. *Collaborative Form: Studies in the Relations of the Arts.* Kent, Ohio: Kent State University Press, 1991.

Hugo, Victor. "Cain" or "La Conscience." In *French Literature of the Nineteenth Century,* edited by Robert Foster Bradley and Robert Bell Mitchell, 104–6. New York: Crofts, 1946.

———. *Le Rhin.* Lettre XXI. Strasbourg: Buob and Eoumaux, 1980.

———. *Travailleurs de la mer.* Romans de Victor Hugo. Tome III. Paris: Seuil, 1976.

Kipling, Rudyard. *The Jungle Book and The Second Jungle Book.* New York: Exeter Books, 1986.

Larousse du XXe siècle. Paris: Larousse 1928.

Mitchell, W. J. T. "Against Comparison: Teaching Literature and the Visual Arts." In *Teaching Literature and Other Arts,* edited by Jean-Pierre Barricelli, Joseph Gibaldi and Estella Lauter, 30–7. New York: MLA, 1990.

———. *Iconology: Image, Text, Ideology.* Chicago: U of Chicago P, 1986.

Moir, Alfred. *Caravaggio.* New York: Abrams, 1989.

Poe, Edgar Allan. "The Raven." George Perkins and Barbara Perkins, eds. *The American Tradition in Literature,* vol. I, 1492–94. New York: McGraw Hill, 1994.

Pratt, Alan R., ed. *Black Humor: Critical Essays.* New York: Garland, 1993.

Prêtre, Jean-Claude. *Prêtre, d'après Suzanne* (expo catalogue). Geneva: Galerie Andata/Ritorno, 1993.

———. *Recent Paintings,* (expo catalogue). London: Brompton Gallery, 1985.

———. *Suzanne: le procès du modèle.* Paris: Bibliothèque des arts, 1991.

Riese-Hubert, Renée. *Surrealism and the Book.* Berkeley: University of California Pres, 1988.

Steiner, Wendy. *The Colors of Rhetoric: Problems in the Relation between Modern Literature and Painting.* Chicago: University of Chicago Press, 1982.

Strom, Ronald. "Impossibile Belli." *Il Cannocchiale, rivista di studi filosofici.* Edizioni Scientifiche Italiane (1/2 January–August 1994): 263–69.

Weinberg, Bernard. *The Limits of Symbolism.* Chicago: University of Chicago Press, 1966.

Wied, Alexander. *Breughel.* Milan: Mondadori, 1979. Rpt. Danbury, Conn.: Masterworks Press, 1984.

Index

Note: Page numbers in italics refer to illustrations.

ABC de Correspondance [*ABC of Correspondence*] (Alechinsky, Butor, and Sicard)
 authorship and collaborations of, 92
 and didactic purpose of *Dessins sur factures,* 170
 structure of, 92, 152–53
 See also *Dessins sur factures* [*Drawings on Bills*] (Alechinsky, Butor, and Sicard); *Grosses en stock* [*Gross in Stock*] (Alechinsky, Butor, and Sicard)
abstract expressionism, 93, 207 n. 13
alchemy, 15, 195 nn. 1 and 2
Alechinsky, Pierre, 92–171
 and art as salvation, 135, 143, 163, 169, 170–71, 175
 Asian influences on, 95, 139, 208 n. 23
 "big paintings" of, 93, 94, 95
 Butor's appreciation of, 94–95
 Butor's books on, 92
 Butor's interpretations of, 18, 92, 94, 112, 172–73
 and Cobra group, 93–94
 "found papers" of. *See* "found papers" (*"papiers trouvés"*) of Alechinsky
 humor of, 95
 left-handedness of, 93, 154, 207 n. 2
 "marginal remarks" of (*"remarques marginales",*) 93, 94, 95, 119–20, 133, 212 n. 83, 214 n. 117
 multiple interpretations possible in work of, 94
 personal background of, 93–94
 political messages of, 18, 95, 174–75
 and reader participation, 94
 supports of, 92, 93, 94–95, 209 n. 49. *See also* "found papers" (*"papiers trouvés"*) of Alechinsky
 symbols of, 94, 116, 141, 212 n. 72, 216 n. 140
 techniques of, 93, 94–95
 and titles, 95
 understanding art of, 92, 207 n. 2
 as writer, 95
 See also Butor, Michel, collaborations with Alechinsky; *Chien roi, Le* [*The Dog King*] (Butor and Alechinsky); *Comptine en blanc et noir* [*Counting Rhyme in White and Black*] (Butor) and *Atlas universel, L'* (Alechinsky); *Dessins sur factures* [*Drawings on Bills*] (Alechinsky, Butor, and Sicard); *Guirlande liminaire* [*Prefatory Garland*] (Butor et al.); *Rêve de l'ammonite, Le* [*The Dream of the Ammonite*] (Butor and Alechinsky); *Stances des mensualités* [*Stanzas of Monthly Payments*] (Butor and Alechinsky); *Test du titre: 61 titreurs d'élite, Le* [*The Test of the Title: 61 Crack-shot Titlers*] (Alechinsky et al.)
Alechinsky: Travaux d'impression [*Alechinsky: Printed Works*] (Butor and Sicard), 92
 on Alechinsky's "found papers," 92, 93
 Butor on Alechinsky's marginal comments, 212 n. 83

 Cobra group collaborations in, 207 n. 11
 photographs of Alechinsky in, 208 n. 27
 reproductions from *Le Chien roi,* 215 n. 123, 219 n. 169
 reproductions from *Dessins sur factures,* 158, 218 n. 159, 219 n. 169
 reproductions from *Le Rêve de l'ammonite,* 93, 127, 213 n. 90
Alechinsky dans le texte [*Alechinsky in the Text*] (Butor and Sicard), 92
 and Alechinsky's "found papers," 93
 Butor on collaboration in, 93–94
 and Butor on *Le Rêve de l'ammonite,* 212 n. 77
 and Butor on dog king in *Le Chien roi,* 141, 216 n. 140
alienation/isolation, and *Bicentenaire kit,* 23, 30–35
ammonite. *See Rêve de l'ammonite, Le* [*The Dream of the Ammonite*] (Butor and Alechinsky)
anamorphosis in painting, 168
Anatomie illustrée [*Illustrated Anatomy*] (Butor and Kolář), 62–64, 81, 82, 83, 84, 173, 205 n. 109
animals
 in *Bicentenaire kit,* 33, 34, *34,* 35, 197 n. 24
 Butor and, 174, 197 n. 24
 in *Le Chien roi,* 133, 135, 136, 139, 141–43
 and *Comptine en blanc et noir,* 148, 149, 151
 in *Dessins sur factures,* 155
 in *La Méduse des chocolats,* 117
 in *L'Oeil de Prague,* 74, 76, 203 n. 96
 in *Le Rêve de l'ammonite,* 123, 126, 203 n. 96
 in *Stances des mensualités,* 110, 111, 114
 in *Le Test du titre,* 96–97, 99–100, 102
Anthropos (journal), 20
Apollinaire, Guillaume, 40
Appel, Karel, 93, 96, 207 n. 11
"Approche du continent Butor" [*Approach to the Butor Continent*] (Monticelli), 19–20, 196 n. 23
Aragon, Louis, 39
Arc, L' (Butor), 195 n. 13, 199 n. 36
Architexture (La Mothe), 20, 199 n. 16, 201 nn. 61, 63, 68, 212 n. 79
Arrestation, L' [*Arrest*] (Butor and Alechinsky), 120, 121, 122, 213 nn. 92 and 93
Articulations (Kolář), 57, 83, 84, 203 nn. 95 and 96
Astre des nuits (Kolář), 54, 201 nn. 76 and 78
Atlas universel, L' [*The Universal Atlas*] (Alechinsky). *See Comptine en blanc et noir* [*Counting Rhyme in White and Black*] (Butor) and *L'Atlas universel* (Alechinsky)
Aubral, François, 40
Avant-goût IV [*Foretaste IV*] (Butor), 84, 86. *See also Cartes postales pour un ami de Liechtenstein* [*Postcards for a friend from Lichtenstein*] (Butor and Kolář)
Ayme, Albert, 199 n. 35

Bailly, J. C., 22
Baj, Enrico, 208 n. 35

228

Ballade des froissements du monde [*Ballad of the Crumplings of the World*] (Kolář), 51, *59,* 59–63, 64, 201 n. 76, 204 nn. 103–7
 and art as salvation, 84
 and Breughel's *Mad Meg,* 60, 62, 204 n. 107
 Composer's interruptions and, 62
 as epitome of "correspondences," 61
 and Ernst's *Napoleon in the Desert,* 60, 61–62, 204 n. 107
 Explicator's introduction and, 59–60, 61
 froissages in, 59–60, 61–62, 204 n. 107
 harmonies in, 61–62, 83–84, 173
 and "I hear" focus, 61
 movement of poem, 62
 Organizer describing, 59–60
 political message in, 62, 84, 175
 repetitions in, 61, 83, 204 nn. 105 and 106
 translation issues and, 61, 204 nn. 105 and 106
Ballade du tremblement du ciel [*Ballad of the Skyquake*] (Butor), 22
Balzac, Honoré de
 and alchemy, 195 n. 2
 and Butor, 195 nn. 2 and 13, 196 n. 25
 Contes bruns, 222 n. 196
 and *Dessins sur factures,* 219 nn. 165 and 168, 222 n. 196
 Le Cousin Pons, 137
Bastian, René, 22
Bathsheba (Rembrandt), 63
Baudelaire, Charles
 Butor's and Monory's shared interest in, 22
 Butor's collaborations with texts of, 199 n. 32
 Kolář's collaborations with texts of, 47–48, 201 nn. 61 and 62
 Le Balcon, 48, 200 n. 60
 La Chevelure [*The Head of Hair*], 48, 200 n. 60
 Correspondances, 61
 Harmonie du soir, 48, 200 n. 60
 Moesta et errabunda [*Sad and Vagabonding*], 48, 49, 200 n. 60
 See also *Dialogue avec Charles Baudelaire autour des travaux de Jiří Kolář* [*Dialogue with Charles Baudelaire Around Works of Jiří Kolář*] (Butor)
Baudelaire (Kolář), 48, *49*
Beau burg, Le [*The Beautiful Town*] (Butor and Kolář), *85,* 85–86, 90, 91, 206 n. 138
Beethoven, Ludwig van, 83
Bicentenaire kit [*Bicentennial Kit*] (Butor and Monory), 21–37
 alienation and isolation in, 23, 30–35
 allusions in, 32, 36
 animal images in, 33, 34, *34,* 35, 197 n. 24
 "blues" of, 23–24, 25, 27, 29, 30, 31, 32, 35
 and *Boomerang* variants, 35, 176, 198 n. 42
 box description, 21
 Butor's additions to, 23, 24, 25–26, 28, 29, 31, 32, 34, 36
 and Butor's re-use of earlier works, 40
 and capitalism, 22
 "Catalogue" and, 21, 35, 198 n. 48
 children, images of, 26, 30–31, *31, 33,* 33–34
 coldness of, 23–24, 27–28
 collaboration and, 17, 21–23, 172, 173
 compassion, images of, *33,* 33–34, *34,* 35
 and consumerism, 23, 28–30
 contrasts in, 23, 24–25, 26, 27, 28, 29, 30, 35, 36
 figurative language in, 29–30, 33
 first-person narrator in, 26, 35, 197 n. 29
 form and structure of poems, 23, 24, 35, 36, 172
 harmony in, 36, 173
 humor and absence of humor in, 35, 174, 198 n. 48

 objects of, 21, 22–23
 poetic devices in, 23, 25, 27–28, 29–30, 34–36
 political message of, 23, 24–26, 27, 35–36, 37, 174, 175, 198 n. 49
 and politically correct terms, 24, 197 n. 26
 Postlude of, 37
 Prélude, 24, 36, 196 n. 2
 racism and, 23, 24–26, 27
 references to other *Kit* documents, 30
 relationships of serigraphs to poems and between poems, 23, 172, 197 n. 18
 and *Le Retour du boomerang,* 21, 196 n. 3, 198 n. 39
 sadness and melancholy in, 35
 and sameness of American cities, 73
 themes of, 23
 unnumbered texts of, 21, 196 n. 2
 violence in, 23, 26–28
 vocabulary of, 23, 28, 36
 ways of seeing in, 33
 See also *Bicentenaire kit* [*Bicentennial Kit*], serigraphs and poems; *Boomerang* (Butor)
Bicentenaire kit [*Bicentennial Kit*], serigraphs and poems:
 Appel urgent, blues [*Emergency Call, Blues*] (#27), *33,* 33–34, 35, 36, 198 n. 44
 Les Aveugles, blues [*The Blind, Blues*] (#42), 32, 36, 198 nn. 42 and 43
 Balistique, blues [*Ballistics, Blues*] (#36), 23, *27,* 27–28, 36, 197 n. 30
 Dans l'antre de la panthère noire, blues [*In the Black Panther's Lair, Blues*] (#21), 26, 35, 36, 197 nn. 27–29
 Les Détails de Miss Liberty, blues [*Details of Miss Liberty, Blues*] (#12), 30, 36, 197 n. 35
 Le Diamant du large, blues [*The Diamond of the Open Sea, Blues*] (#50), 30, *34,* 34–35, 36, 198 n. 45
 Les Éventails de l'autoroute, blues [*Fans of the Highway, Blues*] (#18), 31, 36
 La Famille du meurtrier, blues [*The Family of the Murderer, Blues*] (#3), 28, 36
 Fauves d'intérieur, blues [*Wild Beasts of the Home, Blues*] (#48), 32–33, 34
 Les Figurantes de Washington, blues [*The Walkons of Washington, Blues*] (#6), 28–29, *29,* 36, 197 nn. 18, 32–34
 La Foule en ruines, blues [*The Crowd in Ruins, Blues*] (#39), 29–30, 36, 197 n. 18
 Hopper's land, blues (#9), 22, 23, 31–32, 198 n. 41
 L'Instruction publique, blues [*Public Education, Blues*] (#33), 25–26, 36
 Les Jeux du hasard, blues [*Games of Chance, Blues*] (#45), 28, 36
 La Rue mur, blues [*Wall Street, Blues*] (#24), 29, 33–34, 36, 197 n. 18
 Sous le couvert, blues [*Under Cover, Blues*] (#15), 30–31, *31,* 36, 197 n. 37, 198 nn. 38 and 39
 Souvenirs de l'ouest, blues [*Memories of the West, Blues*] (#30), 24, 25, 34, 36, 197 nn. 23–25
 Tombée de la nuit, blues [*At Nightfall, Blues*] (#1), *24,* 24–25, 36, 197 nn. 21 and 22
Bird in Space (Brancusi), 40
Boas, Franz, 195 n. 13
Bonnefoy, Yves, 96
Boomerang (Butor)
 carnivals in, 133
 and "Catalogue," 21
 and *Le Retour du Boomerang,* 21, 196 n. 3
 variants of *Bicentenaire kit,* 21, 35, 176, 198 n. 42

See also *Bicentenaire kit* [*Bicentennial Kit*] (Butor and Monory); *Retour du boomerang, Le* [*The Return of the Boomerang*] (Butor and Didier)

Bordures. See *Frontières et bordures* [*Frontiers and Borders*] (Butor and Sicard)

Bosseur, Jean-Yves, 199 n. 35

"Boue à Séoul, La" [*Mud in Seoul*] (Butor), 120

Brahe, Tycho, 71, 205 n. 121

Brancusi, Constantin, 40

Brauner, Victor, 94

Breton, André, 223 n. 210

Breughel, Pieter, 60, 62, 204 n. 107

Breughel de Velours, Jan, 93

Bryen, Camille, 42, 44, 45, 117, 118

Bryson, Norman, 196 n. 21

Bury, Pol, 96

Butor, Michel, collaborations of
analogies for, 15, 195 nn. 1 and 2
approaches to and challenges of studying, 16, 17, 18–19, 175, 195 n. 8
and art as salvation, 45, 84, 135, 143, 169, 170–71, 175, 206 n. 135
and bibliography of works, 16, 175
Butor's thoughts on collaborations, 15–16, 18
compendium/inventory of collaborations, 16, 175
databases of collaborations, 16, 175, 223 n. 2
deriving texts from artworks, 172–73
four modes of collaboration, 15–16, 17, 195 n. 13
further study on, 175–76
harmony and, 18, 173–74
humor and, 18, 174
with musicians, 20, 40, 199 n. 35
the original artwork and, 172–73
political statements and aims to improve the world, 17–18, 35, 37, 40, 91, 103, 174–75, 198 n. 49, 215 n. 121
and politics in poetry, poet's responsibility, 17–18
scholars of Butor's collaborations, 19–20, 175–76, 195 n. 20, 196 nn. 23–26. See also La Mothe, Jacques; Roudiez, Léon S.
and scholars of interart works and visual arts, 19, 175–76, 196 n. 21
separately published collections and conversations, 16, 19
and Sicard, 20, 92–93, 94, 116, 147, 153, 207 nn. 5 and 7, 218 nn. 151 and 155
studies of variants and reproductions, 176
and translations, 19
"undefinable elsewhere" and, 173
See also Butor, Michel, collaborations with Alechinsky; Butor, Michel, collaborations with Kolář; Butor, Michel, collaborations with Monory

Butor, Michel, collaborations with Alechinsky, 92–171
and alphabetical order, 115
and art as salvation, 135, 143, 169, 170–71, 175
and artist's intentions, 95
and Asian influence, 95, 208 n. 23
Butor's appreciation of Alechinsky, 94–95
Butor's books on Alechinsky, 92
and Cobra group, 93–94, 207 n. 14
and cobra symbol, 94, 141, 216 n. 140
and harmonies, 173–74
and humor, 95
as illustrating Butor's imagination, 98–99, 103, 132
and importance of titles, 92, 95
and the political, 174
and reader participation, 94

structures of artworks reflected in texts, 172
techniques and, 94–95
See also Alechinsky, Pierre; *names of individual works*

Butor, Michel, collaborations with Kolář, 38–91
aims to change the world, 40, 84, 91, 198 n. 49
Butor's re-use of earlier texts in, 40, 199 n. 32
characteristics shared with Kolář, 39–41
and demands on reader, 40
and intertextuality, 40
Kolář as inspiration for, 40, 173
and Kolář's art as political, 18, 38, 39, 45, 84
and matrices, 40–41, 199 nn. 35, 36
and openendedness/resistance to closure, 40
re-use of own texts, 40, 199 n. 32
and unclassifiability, 39, 41
See also Kolář, Jiří; *names of individual works*

Butor, Michel, collaborations with Monory, 172, 173, 174
La Mothe on, 23–24, 35
selection of *Kit* objects and correspondence, 17, 22–23
shared interests, 21–23
See also *Bicentenaire kit* [*Bicentennial Kit*] (Butor and Monory); Monory, Jacques

Calder, Alexander, 16

Calendrier des réjouissantes, Le [*The Calendar of the Rejoicing Women*] (Kolář), 55, 201 n. 78

Calle-Gruber, Mireille, 20, 196 n. 25

Calvino, Italo, 96

Camarero-Arribas, Jesus, 16, 17

Canaletto, Antonio, 60, 61, 62, 204 n. 107

capitalism
and *Bicentenaire kit,* 22
and *"papiers capitalistes"* [capitalist papers], 95
See also consumerism

Caravaggio, 63

Cartes postales pour un ami de Liechtenstein [*Postcards for a friend from Lichtenstein*] (Butor and Kolář), 84–91
harmonies of, 84, 88, 89, 90, 91, 173
humor in, 84, 86, 88, 89, 91, 174
and industrial progress, 86, 91
as *intercollage,* 41, 85, *85,* 86, *87,* 88, *88,* 89, *90*
Kolář collaborations, 84–91
Masurovsky collaborations, 84–85
and Maupassant, 85–86
nature and the city in, 85, 89, 91, 223 n. 208
political message of, 84, 90, 91
real and unreal contrasted, 85–86, *87,* 89, 91
situation and speaker of, 85–86, 90–91
sounds in, 86, 87–88, 89–90, 91
and tourism, 85–86, 90, 91
unclassifiability in, 41
and Uncle Jules, 85–86, 206 n. 139
Le Beau burg [*The Beautiful Town*], *85,* 85–86, 90, 91, 206 n. 138
Le Château noir [*The Black Castle*], 85, 86–88, *87,* 90, 91, 206 n. 140
L' Opéra d'automne [*Autumn Opera*], *88,* 88–89, 90, 91, 174, 207 n. 141
Triomphe de la vallée [*Triumph of the Valley*], 89–90, *90,* 91, 207 n. 142

Cathédrale ivre, La [*Drunken Cathedral*] (Butor and Kolář), *75,* 75–76, 81, 82, 172

Cent phrases pour l'éventail d'Arnold Schoenberg [*One Hundred Sentences for the Music Stand of Arnold Schoenberg*] (Butor and Pousseur), 50–51, 52–53, 59, 82, 201 nn. 72–75, 202 n. 81

Central Park (Alechinsky), 93, 94

Chalupecky, Jindrich, 198 n. 4

Chanson pour Don Albert (Butor), 196 n. 23

Chantier (Butor), 201 nn. 74 and 76

Château noir, Le [*The Black Castle*] (Butor and Kolář), 85, 86–88, *87,* 90, 91, 206 n. 140

Chavdarian, Seda, 195 n. 20

chiasmage, 39, *42,* 42–43, 65, *65*

Chien roi, Le [*The Dog King*] (Butor and Alechinsky), 133–43
 and art as salvation, 135, 143
 bird/snake medallion in, 137, 216 n. 131
 borders and, 134, 138, 142
 and Butor's additions, 173
 Butor's titling of, and "running after," 133, 142
 collaboration, 94–95, 133, 142, 172, 173
 and gossip of Thebes, 137, 208 n. 47
 harmonies in, 137, 138–39, 141, 142, 174
 humor in, 135, 136, 139, 141, 142, 172
 and Kipling influence, 139, 216 n. 140
 marginal remarks in, 133
 nature in, 135, 136, 139, 142, 143
 poetic devices in, 133, 142
 political message of, 135, 136, 137, 139, 141–43, 175, 216 n. 140, 217 n. 141
 reproductions in other texts, 215 n. 123, 219 n. 169
 structure of work, eight sections, 133
 two stages of etchings, 133
 Les Oranges de Binche [*The Oranges of Binche*], 133–35, *134,* 142, 173, 215 nn. 123 and 126–28
 Gueule de proue [*Mug on the Prow*], 135, 142, 143, 216 n. 131
 Tunnel, 135–36, 142, 143, 215 n. 123, 216 n. 131
 Rhizome, 135, 136, 142, 215 n. 123, 216 n. 131
 Sphinx en chapeau [*Sphinx in a Hat*], *136,* 136–37, 142, 143, 173, 215 nn. 123 and 30, 216 n. 131, 219 n. 169
 De toutes parts [*From All Sides*], 137–39, *138,* 142, 173, 174, 175, 215 n. 123, 216 n. 134
 Papier de mur [*Paper for Walls*], 139–40, 142, 143, 215 n. 123, 216 n. 138
 Le Chien roi [*The Dog King*] (etching), *140,* 140–42, 215 n. 123, 216 nn. 139 and 140, 217 n. 141

Chien roi, Le [*The Dog King*] (Butor and Alechinsky), etching and text, *140,* 140–42, 215 n. 123, 216 nn. 139 and 140, 217 n. 141

"Ciel est si noir qu'il paraît blanc, Le" [*The sky is so black it appears white*] (Butor and Kolář), 71

Cobra group, 93–94, 207 nn. 11 and 13

collage, Kolář's
 chiasmage, 39, *42,* 42–43, 65, *65*
 collage sculptures, *68,* 68–69
 collage techniques, 39–40
 froissage, 39, 46, *59,* 59–60, 61–62, 75, 200 n. 52, 204 n. 107, 206 n. 127
 humor in, 39
 intercollage, 39, 41, 52, 72, 77, 85, *85,* 86, *87,* 88, *88,* 89, *90*
 openendedness of, 40
 as poetry, 38, 40, 198 n. 4
 as political artwork, 39, 201 n. 62
 prollage, 39, 72–73, *73*
 recurring images in, 40, 77, 199 nn. 29 and 36
 rollage, 39, 40, 46, 48, 55, 66, *67, 77,* 77–78, 203 n. 91, 205 n. 116
 rollage multiplié, 40, 46, 50
 stratifié, 39–40, 58, 63, 78, *78*
 techniques of, 38
 unclassifiability of, 39

ventillage, 40, 55, 58, 63

Coloquio/Artes (Butor), 46, 47, 64, 205 nn. 112 and 125

Comptine en blanc et noir [*Counting Rhyme in White and Black*] (Butor) and *L'Atlas universel* (Alechinsky), 93, 95, 143–52
 and *L'Atlas universel* as support, 93, 143
 Butor's additions, 173
 climax of poem, 151
 colors and, 151
 and *Empire d'Alexandre,* 151–52
 "found papers" of, 93, 95, 143–52
 harmony in, 144–46, 151, 173–74
 humor of, 145, 146, 148, 150, 151, 174
 poetic techniques, rhymes and sounds, 144–46, 147–48, 149–50
 poetic techniques of whole, 151
 political themes of, 146–47, 148, 150–52

Comptine en blanc et noir [*Counting Rhyme in White and Black*] (Butor) and *L'Atlas universel* (Alechinsky), works of:
 Page I, Espagne et Portugal [*Spain and Portugal*], 143–45, *144,* 217 nn. 144–46
 Page II, Sud-ouest de la France [*Southwestern France*], 145–47, *146,* 217 nn. 147–49
 Page III, Nord-ouest de la France [*Northwestern France*], *147,* 147–48, 217 n. 150
 Page IV, Turquie d'Asie [*Turkey of Asia*], 148–49, *149,* 218 n. 153
 Page V, Mer Mediterranée [*The Mediterranean*], 149, *149*
 Page VI, Europe actuelle [*Europe Today*], 149–51, *150*
 Page VII, 151
 Page VIII, Empire d'Alexandre [*The Empire of Alexander*], 151–52, *152*
 Page IX, 151
 Page X, 151

comptines [counting rhymes] of *Le Rêve de l'ammonite,* 120, 143, 213 n. 90

Confessions d'hiver [*Confessions of Winter*] (Kolář), 56, 168, 201 n. 78

consumerism
 and *Dessins sur factures,* 157–61, 169, 170, 220 n. 175
 and *Bicentenaire kit,* 23, 28–30
 See also capitalism

"Conversation: sur des tableaux d'Alessandro Magnasco, La" [*Conversation on Some Paintings of Alessandro Magnasco*] (Butor), 20, 196 n. 26

Cortazar, Julio, 96

counting rhymes. See *Comptine en blanc et noir* [*Counting Rhyme in White and Black*] (Butor) and *L'Atlas universel* (Alechinsky); c*omptines* [counting rhymes] of *Le Rêve de l'ammonite*

Coup de dès . . . , Un (Mallarmé), 40, 83

Cousin Pons, Le (Balzac), 137

Création selon Michel Butor, La [*Creation According to Michel Butor*] (Calle-Gruber), 20, 196 n. 25

Cygne, Le [*The Swan*] (Kolář), 48, *49*

Dällenbach, Lucien, 196 n. 25

Dame d'antan [*Lady of Yesteryear*] (Butor and Kolář), 66, *67,* 74, 205 nn. 115–17 and 119

Dame de ce temps-ci [*Lady of Today*] (Butor and Kolář), 69, *69,* 79, 80, 82, 205 n. 117

Dante Alighieri, 39

Declaration of Independence, 21, 30

Dessins sur factures [*Drawings on Bills*] (Alechinsky, Butor, and Sicard), 95, 152–71
 and advertising, 159–60, 168, 220 n. 178, 222 n. 206

and art as solution and salvation, 163, 169, 170–71, 175
and artist at work, 154, 166–69, 172, 219 n. 166, 222 nn. 199, 201–3, and 205
and artist's function in society, 166–69, 218 n. 156, 222 nn. 197, 200, and 201
and artist's left-handed painting, 154, 167
and artist's materials, 168, 222 nn. 199 and 205
character categories of, 155–65
collaborations of, 92, 153, 169, 170–71, 173, 218 n. 158
critique of consumerism in, 157–61, 169, 170, 220 n. 175
drawings, list of, 218 n. 159
and family of Mme de la Bastide, 153–54, 162–63
"found papers" of, 92, 93, 95, 152–169
harmonies in, 154, 156, 161, 166, 167–70, 174, 221 n. 188, 222 nn. 201 and 203
humor in, 154, 157, 158–59, 160, 161, 164, 167–70, 174, 219 n. 166, 222 nn. 201 and 203
luxury items and consumer goods in, 162–65, 221 n. 189
metaphors of, 219 n. 166
moods in, 165, 172
Mother House concept, 161, 163
and nature of business, 154, 219 n. 162
pianos in, 162, 221 n. 184
political messages of, 167–69, 170, 220 n. 175, 222 nn. 201 and 203
and possible twentieth artwork, 176, 219 n. 160
as postmodern, 154
problems of, 165–66
and process of Alechinsky's creation, 153, 169, 218 n. 157
reproductions in *Travaux*, 218 n. 159
salaried employees, salesman, bosses, and middle managers, 155, 157–61
satire in, 154, 157, 159, 160, 161, 164, 169, 170, 174, 219 n. 166, 222 n. 201
Sicard and, 153, 218 n. 158
society's ills in, 155–65, 169
solutions in, 166–69
structure of, 153–55, 169, 219 n. 166
and the wealthy, 155, 162–65
and winemaking and cellars, 163–64, 221 nn. 189 and 190
and workers, 155–57
Dessins sur factures [*Drawings on Bills*], artworks of:
#1 *Articles d'éclairage* [*Lighting*], 155, 167, *167*
#2 *Albrand Tapissier*, 219 n. 162
#3 *Exploitation forestière*, 219 n. 162
#4 *Grande fabrique de cuisinères* [*Big Stove Factory*], 154, *157*, 159, 219 n. 166, 222 n. 203
#5 *Bon Marché I*, 153, 155, 157–59, 219 nn. 161, 162, 166, 220 n. 173
#6 *The Ladder*, 153, 154, 155–57, *156*, 165, 170, 172, 222 n. 198
#7 *Genet frères Piano*, 161, 162, 174, 219 n. 162
#8 *Caves girondines* [*Girondine Cellars*], 163, *164*, 219 nn. 162 and 166
#9 *Machines à écrire* [*Typewriters*], 155, 219 nn. 162 and 166
#10 *Chaudronerrie* [*Boilerworks*], 154, 165
#11 *Voitures de luxe I* [*Deluxe Automobiles I*], 153, 154, 157, 159, 219 nn. 163 and 166, 221 nn. 186 and 191
#12 *Armes* [*Arms Company*], 158, 221 n. 191
#13 *Outillage* [*Tools*], 219 n. 162, 222 n. 204
#14 *Victor Magnant I, Construction*, 154, 165, 219 n. 166, 221 n. 191
#15 *Millet-Armand Bureau de tabac* [*Tobacconist, Millet-Armand*], 155, 162, *163*, 167–68, 219 n. 162, 221 n. 187, 222 n. 199

#16 *Victor Magnant II, Ciment* [*Victor Magnant II, Cement*], 165, 219 nn. 162, 163, 221 n. 191
#17 *Voitures de luxe II* [*Deluxe Automobiles II*], 153, 157, 159, 221 n. 191, 222 n. 198
#18 *Charronage* [*Cartwright*], 153, 155, *165*, 165–66, 172, 174, 219 n. 162, 222 nn. 193 and 198
#19 *Bon Marché II*, 153, 155, 157–59, *158*, 219 nn. 161, 162, and 166
Dessins sur factures [*Drawings on Bills*], texts of:
"Adresse," 154, 160
"Affaires," 154, 168–69, 222 n. 207
"Articles d'éclairage," 154, 155, 166–67, 219 n. 164
"Artisanat," 154, 169
"Balai," 167, 221 n. 186
"Bon Marché," 170
"Chevalet," 222 n. 201
"Correspondants," 160–61, 219 n. 166, 220 n. 181
"Cuve," 163, 219 n. 166, 221 n. 188
"Dactylographie," 219 n. 166
"Décalcomanie," 219 n. 166, 221 n. 184
"Dessin animé," 219 n. 166
"Entrepôt," 162, 165
"Exploitation," 221 n. 190
"Façon," 222 n. 203
"Ferronnerie," 165–66, 222 n. 194
"Garage," 167, 219 n. 166
"Gaucher," 219 n. 166
"Gruyère," 170, 219 n. 166, 223 n. 210
"Hasard," 219 n. 166
"Huile," 168, 222 n. 202
"Impression," 162, 165
"Inscription," 220 n. 170
"Iridescence," 222 n. 199
"Jeu," 221 n. 190
"Jury," 164–65, 169, 221 nn. 191 and 192
"Kaleidoscope," 221 nn. 186 and 190
"Keepsake," 167
"Kilo," 162–63, 169, 221 n. 187
"Kyrielle," 159, 220 nn. 176 and 177, 223 n. 209
"Ladder," 156–57, 220 n. 171
"Louvre," 155
"Maison," 161, 169, 174, 221 nn. 182 and 183
"Manufacture," 157, 220 n. 172
"Médailles," 165
"Ménage," 167, 222 n. 200
"Naseau," 164, 218 n. 158
"Noir," 220 n. 170
"Nom," 221 n. 184
"Numérotation," 220 n. 177
"Ombre," 159
"Ornement," 167
"Outillage," 168, 222 nn. 204 and 205
"Piano," 162, 221 n. 185
"Pratique," 159–60, 220 n. 178
"Pressoir," 164
"Réparation," 166, 167, 169, 222 n. 195
"Réserve," 221 n. 184
"Salutations," 221 n. 190
"Stock," 221 n. 189
"Suite," 158, 220 n. 174
"Timbre," 156, 163–64, 219 n. 169
"Unité," 167, 222 n. 197
"Vinaigre," 167–68
"Voiture," 220 n. 193
"Warrant," 156, 221 n. 190

"Xiphoïde," 160, 220 nn. 179 and 180

"Xylocope," 156–57

"Ypréau," 167

"Zébrure," 157–58

"Zigzag," 164

"Zone," 154, 219 n. 165

De toutes parts [*From All Sides*] (Butor and Alechinsky), 137–39, *138,* 142, 173, 174, 175, 215 n. 123, 216 n. 134

Dialogue avec Charles Baudelaire autour des travaux de Jiří Kolář [*Dialogue with Charles Baudelaire Around Works of Jiří Kolář*] (Butor), 46–84

"A" repetitions in, 64–65, 66, 67, 69, 70, 71, 73, 74, 75, 76–77, 78, 79, 81, 205 n. 119

apple in, 70–71, *71,* 72, 75–76, 80, *80,* 82, 206 nn. 127 and 131

"B" repetitions in, 80, 81

Baudelaire/Kolář collaboration and, 47–48, 201 nn. 61 and 62

Baudelaire variations and, 47–50, 82, 83, 200 n. 60

butterflies in, 76–77, *77,* 78, 81–82

and *Cent phrases,* 50–51, 52–53, 55, 59, 82, 201 nn. 72–75, 202 n. 81

The Combiner in, 46, 47–50, 200 n. 56

The Composer in, 46, 50–51, 52–53, 59, 62, 65, 82, 84, 200 n. 56, 201 n. 73, 204 n. 99

and "correspondences," 61

and diptych of Piero della Francesca, 54, 175, 202 nn. 84 and 85

The Dreamer in, 47, 50, 55, 64–67, 73–74, 80, 81, 84, 201 n. 68, 204 n. 99

The Dreamer and Writer in, 73–74, 81

eight characters of, 46–47, 82, 83, 200 n. 56, 206 n. 132

The Explicator in, 46, 47, 50, 54, 55, 57, 63, 84, 200 n. 56, 201 n. 73

froissages, 46, *59,* 59–60, 61–62, 204 n. 107, 206 n. 127

harmonies in, 52, 55, 56, 61, 64, 68, 69–70, 72, 75, 76–77, 80, 81–82, 83–84, 173

and *Hommage à Baudelaire,* 46, 47, 48, 200 n. 60, 201 n. 61

horseman in, 71, 72, 81, 205 nn. 122 and 123

humor in, 63–64, 68, 69, 70–71, 72, 73, 80, 82–83, 84, 174

and the "intellectual chord," 83

intercollages, 52, 72

and language barriers, 65, 82

The Letter-Writer in, 47–50

matrices of, 64, 66–67, 71, 81, 205 n. 117

and the mirror, 78, 79–80

and Mme de Pompadour, *79,* 79–80, 81, 82, 84, 174, 206 n. 130

musical references in, 50–51, 83, 201 nn. 72 and 73

and Nixon, 72, 173, 204 n. 99, 205 nn. 122 and 124

and *L'Oeil de Prague,* 46

and *Opusculum baudelairianum,* 47, 48–49, 50, 200 n. 60

The Organizer in, 46, 47, 48, 49, 50, 51–52, 54, 55, 56, 57–59, 200 n. 56, 201 nn. 66 and 79

paper theme and, 65, 66–67, 68, 71, 81

poems in, 47–50, 51–64, 82, 83, 200 n. 60, 201 nn. 76 and 78. See also *Dialogue avec Charles Baudelaire,* collages and poems in

political in, 51, 57–63, 65, 69, 70, 71, 74, 78, 80, 81, 82, 83, 84, 201 n. 78

and printer's omission, 74

prollages, 72–73, *73*

The Reader in, 46, 47–50, 200 n. 56, 202 n. 83

religion and religious imagery in, 76, 83, 206 n. 133

repetitions in, 52, 55, 56, 58, 61, 83–84, 204 nn. 105 and 106

and repetitions paralleling Kolář's collages, 80–81

rollages, 55, 66, *67, 77,* 77–78, 205 n. 116

rollages multipliés, 46, 50

and salvation through art, 84, 206 n. 135

and sameness of American cities, 73–74

set 2 collages of, 51–64, 201 n. 77

set 3 collages of, 64–82, 205 n. 116

The Singer in, 46, 51–64, 200 n. 56, 201 n. 76

society in, 57–63, 84

speeches of, 50–51, 52–53, 59, 82, 84, 201 n. 73, 204 n. 99

structure of text, 46, 64, 66

translation issues and, 61, 204 nn. 105 and 106

Tycho Brahe in, 71, 84

ventillage, 55, 63

violence in, 79–80, 81

"while" statements of, 66–67, 73

women in, 47, 52–57, 84, 202 n. 82

See also *Dialogue avec Charles Baudelaire,* collages and poems in; *Dialogue avec Charles Baudelaire,* the Dream

Dialogue avec Charles Baudelaire, the Dream

and dream threads woven together, 79–80

Dreamer and, 47, 50, 55, 64–67, 73–74, 80, 81, 84, 201 n. 68, 204 n. 99

and matrix of dream, 64, 66–67, 71, 81

and movement from one phase to next, 66, 68, 69, 205 n. 114

and organization of Dream, 64, 66, 71, 81–82

Opening Phase of Dream, 64–66, *65,* 81, 205 nn. 112 and 113

Phase 1 of Dream, 66–69, 74, 205 nn. 115–18

Phase 2 of Dream, 69–70

Phase 3 of Dream, 70–71

Phase 4 of Dream, 71–72, 81

Phase 5 of Dream, 72–74

Phase 6 of Dream, 74–76

Phase 7 of Dream, 76–77

Phase 8 of Dream, 77–79, 206 n. 129

Closing Phase of Dream, 79–80, 81

Dialogue avec Charles Baudelaire, collages and poems in:

Anatomie illustrée [*Illustrated Anatomy*], 62–64, 81, 82, 83, 84, 173, 205 n. 109

Articulations, 57, 83, 84, 203 nn. 95 and 96

Astre des nuits, 54, 201 nn. 76 and 78

Ballade des froissements du monde [*Ballad of the Crumplings of the World*], 51, *59,* 59–63, 64, 81, 83–84, 201 n. 76, 204 nn. 103–7

Calendrier des réjouissantes [*Calendar of the Rejoicing Women*], 55, 201 n. 78

Cathédrale ivre [*Drunken Cathedral*], 75, 75–76, 81, 82, 172

"Le Ciel est si noir qu'il paraît blanc" [*The sky is so black it appears white*], 71

Confessions d'hiver [*Confessions of Winter*], 56, 168, 201 n. 78

Dame d'antan [*Lady of Yesteryear*], 66, *67,* 74, 205 nn. 115–17, 119

Dame de ce temps-ci [*Lady of Today*], 69, *69,* 79, 80, 82, 205 n. 117

Hommage à Bela Kolářova [*Homage to Bela Kolářova*], 54

Menu meuble [*Test-Tube Rack*], *68,* 68–69, 205 nn. 117 and 118

Mugissement d'eaux [*Roaring of Waters*], *68,* 68–69, 205 n. 117

Orgue de pieds et de bras [*Organ of Feet and Arms*], 76, *76*

Page [*Pageboy*], 51–54, *53,* 59, 83, 201 n. 79, 202 nn. 80 and 81, 215 n. 127

Pipe, 72, *72*

Planchette à découper [*Chopping Board*], *77,* 77–78, 81, 206 n. 129

Plein opéra [*Complete Opera*], 72–73, *73,* 81

Pomme de jouvence [*Apple of Youth*], 80, *80,* 81, 206 n. 131
Pomme vêtue [*Dressed Apple*], 70–71, *71,* 81, 82, 205 n. 120
Pompadour, 79, 79–80
Reine des neiges [*Queen of Snows*], 56–57, 83, 84, 173, 203 n. 93
Reine du cinéma [*Movie Queen*], 71–72, *72,* 82, 84, 205 nn. 123 and 124
Résistance, 51, 57–59, 63, 64, 83, 84, 173, 203 n. 97, 204 nn. 98 and 99
Sous une pluie de presse [*Under a Rain of Printed Matter*], 64–65, *65*
Stratification, 78, 78
Toilette nocturne [*Nocturnal Toilette*], 55–56, 57, 83, 84, 202 n. 86, 203 nn. 87 and 89–92
Venise [*Venice*], 69–70, *70,* 81
Ville moyenne [*Average City*], 74–75, *75,* 81, 205 n. 119
Violon [*Violin*], 73–74, *74*
Didier, Béatrice, 139, 196 n. 3
Dog King. *See Le Chien roi* [*The Dog King*] (Butor and Alechinsky)
Dotremont, Christian
 and Cobra group, 93, 94, 207 nn. 11 and 13
 and collaborations with Butor, 94, 95
 and dizains in *Guirlande liminaire,* 42, 44, 118
Drawings on Bills. See Dessins sur factures [*Drawings on Bills*] (Alechinsky, Butor, and Sicard)
Dream of the Ammonite. See Le Rêve de l'ammonite [*The Dream of the Ammonite*] (Butor and Alechinsky)
Dufour, Bernard, 44, 118, 119, 212 n. 74
Dufy, Raoul, 89

Echanges (Butor), 196 n. 23
Echographies (La Mothe), 20, 120, 213 n. 92
Ecole d'Orphée: Constellation Michel Butor, L' (Butor and Pousseur), 203 n. 96
Embarquement de la Reine de Saba, L' [*The Embarcation of the Queen of Sheba*] (Butor and Lorrain), 20, 23, 196 nn. 24 and 25
Empire d'Alexandre [*The Empire of Alexander*] *Page VIII* (Alechinsky), 151–52, *152*
En Compagnie de Michel Butor [*In the Company of Michel Butor*] (exposition), 215 n. 123
En Marge (Butor and Sicard), 207 n. 5
Envois 2: Exprès (Butor), 22, 55, 59, 62, 94, 201 n. 76, 203 n. 89
Ernst, Max, 60, 61, 204 n. 107
Espagne et Portugal [*Spain and Portugal*] *Page I* (Alechinsky), 143–45, *144,* 217 nn. 144–46
Europe actuelle [*Europe Today*] *Page VI* (Alechinsky), 149–51
Eye of Prague, The. See L'Oeil de Prague [*The Eye of Prague*] (Butor and Kolář)

False Start, Continued, A (Monory), 22
Faucheux, Pierre, 208 n. 45
Fée électricité [*Electricity Fairy*] (Dufy), 89
Fenêtres sur le passage intérieur [*Windows on the Inner Passage*] (Butor), 17, 41, 195 n. 13, 199 n. 32
Ferro, Gudmundur, 208 n. 39
Forme courte, La (Butor), 199 n. 39, 202 n. 82
"found papers" (*"papiers trouvés"*) of Alechinsky, 92, 207 n. 2
 Butor/Sicard on Alechinsky's use of, 92–93
 and *Comptine en blanc et noir,* 93, 95, 143–52
 and *Dessins sur factures,* 92, 93, 95, 152–69
 and *La Méduse des chocolats,* 93, 95, 115–19, 153
 old bills, 65, 93, 152–69
 old documents, 93, 103–12, 200 n. 59

old letters, 92–93, 95, 153
old maps, 93, 95, 143–52
 as *"papiers capitalistes"* [capitalist papers], 95
 political positions evident in, 95
 and *Stances des mensualités,* 93, 103–12, 153, 209 nn. 49–51
Francken, Ruth, 44, 45, 118, 200 nn. 41, 42, 48, and 49
froissage, 39, 46, *59,* 59–60, 61–62, 75, 200 n. 52, 204 n. 107, 206 n. 127
Frontières et bordures [*Frontiers and Borders*] (Butor and Sicard), 92
 and Alechinsky's "found papers," 93
 discussion of Alechinsky's etchings in, 215 n. 123
 reproductions from *Le Chien roi* etchings in, 215 nn. 123 and 125
 See also *Comptine en blanc et noir* [*Counting Rhyme in White and Black*] (Butor) and *L'Atlas universel* (Alechinsky)
Fuentes, Carlos, 96

Gaudibert, P., 22
Génie du lieu, Le [*Spirit of the Place*] (Butor), 16
Génie du lieu II: Où/Ou, Le [*Spirit of the Place: Where/Or*] (Butor), 120
Génie du lieu V: Gyroscope, Le [*Spirit of the Place: Gyroscope*] (Butor), 16, 22, 95
Gracq, Julien, 96
Grosses en stock [*Gross in Stock*] (Alechinsky, Butor, and Sicard), 152–53
 artworks in, 153, 219 n. 160
 and Butor/Sicard on Alechinsky, 92–93, 153, 207 n. 7, 218 n. 155
 title of, 92
Grünewald, Matthias, 60, 61–62, 204 n. 107
Gueule de proue [*Mug on the Prow*] (Butor and Alechinsky), 135, 142, 143, 216 n. 131
Guirlande liminaire [*Prefatory Garland*] (Butor et al.)
 and Butor's changes for each artist, 42, 44–45, 115, 200 n. 49
 collaborations of, 41, 42, 199 n. 38
 dizains of, 41–42, 43, 44–45, 116–19, 200 nn. 41, 42, 200 nn. 45, 48, and 49
 humor of, 119
 matrices of, 41, 42, 44–45, 115–19
 and *La Méduse des chocolats,* 95, 115–19
 methods of studying, 45, 200 n. 50
 political in, 119
 shared words and images in, 43, 44
 text organization of, 41–42
 triangles of, 41, 42, 43, 200 nn. 41, 42
 See also *La Méduse des chocolats* [*The Medusa of the Chocolates*] (*Guirlande liminaire*) (Butor and Alechinsky); *Vagues des villes éclosion* [*Waves of Cities Blossoming*] (*Guirlande liminaire*) (Butor and Kolář)
Gyroscope [*Le Génie du lieu V*] (Butor), 16, 22, 95

Hagstrum, Jean, 196 n. 21
Hallucinations simples [*Simple Hallucinations*] (Butor, Pousseur and Bastain), 22
harmony
 in *Bicentenaire kit,* 36, 173
 in *Cartes postales,* 84, 88, 89, 90, 91, 173
 in *Le Chien roi,* 137, 138–39, 141, 142, 174
 in *Comptine en blanc et noir,* 144–46, 151, 173–74
 in *Dessins sur factures,* 154, 156, 161, 166, 167–70, 174, 221 n. 188, 222 nn. 201 and 203
 in *Dialogue avec Charles Baudelaire,* 52, 55, 56, 61, 64, 68, 69–70, 72, 75, 76–77, 80, 81–82, 83–84, 173

in *La Méduse des chocolats,* 116, 173, 212 n. 73
in *Le Rêve de l'ammonite,* 123, 124, 128, 129, 130–34, 174, 214 n. 118
in *Stances des mensualités,* 112, 113, 115, 173
in *Le Test du titre,* 100
in *Vagues des villes éclosion* 43, 173
Hayter, William, 93
Hérold, Jacques, 45, 118, 200 n. 49, 212 n. 74
Hines, Thomas, 19
Hoirie-Voirie [*Inheritance-Garbage Dump*] (Butor and Alechinsky). See *Rescapés de la corbeille* [*Refugees from the Wastebasket*] (Butor and Alechinsky); *Stances des mensualités* [*Stanzas of Monthly Payments*] (Butor and Alechinsky)
"Homage to Kasimir Malewitch" (Kolář series), 39
"Hommage à Baudelaire" [*Homage to Baudelaire*] (Kolář exposition), 46, 47, 48, 200 n. 60, 201 n. 61
Hommage à Bela Kolářova [*Homage to Bela Kolářova*] (Kolář), 54
Hopper, Edward, 22, 23, 31–32, 198 n. 41
House by the Railroad (Hopper), 22, 31
Hugo, Victor, 17, 106, 107, 114, 168, 210 n. 61
humor
 in *Bicentenaire kit,* 35, 174, 198 n. 48
 in *Cartes postales,* 84, 86, 88, 89, 91, 174
 in *Le Chien roi,* 135, 136, 139, 141, 142, 172
 in *Comptine en blanc et noir,* 145, 146, 148, 150, 151, 174
 in *Dessins sur factures,* 154, 157, 158–59, 160, 161, 164, 167–70, 174, 219 n. 166, 222 nn. 201 and 203
 in *Dialogue avec Charles Baudelaire,* 63–64, 68, 69, 70–71, 72, 73, 80, 82–83, 84, 174
 in *Guirlande liminaire,* 119
 in *Le Rêve de l'ammonite,* 95, 119, 120–22, 123, 124–25, 126–27, 130, 132, 174, 213 n. 96
 in *Stances des mensualités,* 104, 113–14, 115, 174
 in *Le Test du titre,* 102–3, 174
Hundertwasser, Friedensreich, 96, 208 n. 44

Illustrations series (Butor), 16, 19, 94
 Illustrations, 20, 40, 195 n. 4
 Illustrations II, 40
 Illustrations IV, 104, 112, 176, 209 n. 53, 211 n. 69
Improvisations sur Balzac (Butor), 155, 195 n. 2, 219 nn. 165 and 168, 222 n. 196
Improvisation sur Butor (Butor), 16, 195 n. 9
Improvisations sur Rimbaud (Butor), 22
Incurable Image (Monory), 25
Indians, American, 24–25, 27, 195 n. 13, 199 n. 32
Instruction. L' [*Enquiry*] (Butor and Alechinsky), 120, 121–22
"intellectual chord," 83, 209 n. 53
intercollage, 39, 41, 52, 72, 77, 85, *85,* 86, *87,* 88, *88,* 89, *90*
Ionesco, Eugène, 39, 94, 95, 96, 208 n. 45

Janus, 39
Jefferson, Thomas, 29, 197 n. 34
Johnson, Samuel, 83
Jorn, Asger, 93, 96, 207 n. 13
Jouffroy, A., 22
Jungle Book (Kipling), 139

Kafka, Franz, 46, 201 n. 62
Kim (Kipling), 139
Kipling, Rudyard, 94, 139, 176, 216 n. 140
Kolář, Jiří, 38–91
 Baudelaire collaboration, 47–48, 201 nn. 61 and 62
 Butor on, 18, 38, 39, 40, 45, 84. *see also* Butor, Michel, collaborations with Kolář

characteristics shared with Butor, 39–41
collaboration with artists of past, 39
effect on Butor's art, 40
humor in art of, 39
influence of poets on, 40
intertextuality of, 40
matrices of, 40–41, 199 n. 36
name of, 38, 198 n. 1
openendedness/resistance to closure of, 40
personal background of, 38
political art of, 18, 38, 39, 45, 47, 57, 84, 174–75, 201 n. 62
unclassifiability of, 39, 41, 199 n. 16
on written word, 38–39, 40, 65
 See also *Cartes postales pour un ami de Liechtenstein* [*Postcards for a friend from Lichtenstein*] (Butor and Kolář); collage, Kolář's; *Dialogue avec Charles Baudelaire autour des travaux de Jiří Kolář* [*Dialogue with Charles Baudelaire Around Works of Jiří Kolář*] (Butor); *Guirlande liminaire* [*Prefatory Garland*] (Butor et al.); *Oeil de Prague, L'* [*The Eye of Prague*] (Butor and Kolář); *Vagues des villes éclosion* [*Waves of Cities Blossoming*] (*Guirlande liminaire*) (Butor and Kolář)
Kolář: Poème Préface (Candela), 203 n. 91

La Mothe, Jacques
 Architexture, 20, 199 n. 16, 201 nn. 61, 63, 68, 212 n. 79
 on Butor/Alechinsky collaboration in *Le Rêve de l'ammonite,* 119, 120, 121, 212 n. 79, 213 n. 92
 on Butor collaborations, 20, 48, 201 n. 63
 and *Dialogue avec Charles Baudelaire,* 205 n. 117
 Echographies, 20, 120, 213 n. 92
 on Kolář, 199 n. 16, 201 n. 61, 205 n. 117
 on Kolář/Baudelaire collaboration, 201 n. 61
 on Monory and *Bicentenaire kit,* 23–24, 35
 study of *Matière des rêves,* 48, 201 n. 72, 205 nn. 111 and 117
Lam, Wilfredo, 96
Lamač, Miroslav, 39, 199 n. 29
Lascault, Gilbert, 22, 197 n. 23
Launay, Michel, 195 n. 13
Lessive pour Marie-Jo (Butor), 202 n. 82
Lévi-Strauss, Claude, 38
Lichtenstein, Roy, 96
Liechtenstein postcards. See *Cartes postales pour un ami de Liechtenstein* (Butor and Kolář)
"Litanie d'eau" (Butor and Masurovsky), 196 nn. 23 and 26
Little Prince, The (Saint-Exupéry), 26, 197 n. 28
Lorrain, Claude, 20, 23, 196 n. 26
Lyotard, Jean-François, 19, 22, 195 n. 20

Mad Meg (Breughel), 60, 62, 204 n. 107
Magritte, René, 72, 96
Mahlow, Dietrich, 198 n. 4
Mallarmé, Stéphane, 22, 40, 83, 199 n. 32
Manet, Edouard, 56–57
Mansour, Joyce, 96, 213 n. 86
maps. See *Comptine en blanc et noir* [*Counting Rhyme in White and Black*] (Butor) and *Atlas universel, L'* (Alechinsky)
"marginal remarks" (*"remarques marginales"*) of Alechinsky
 in "big ink" paintings, 93, 94, 95
 Butor on, 212 n. 83
 and Butor's matrices, 94
 in cover of *Le Chien Roi,* 133
 first use of, 93
 in *Le Rêve de l'ammonite,* 95, 119–20, 212 n. 83, 214 n. 117
Mason, Barbara, 48, 195 n. 1, 200 n. 52, 201 nn. 61 and 62

Masson, André, 16, 45, 118, 119, 200 nn. 41, 42, and 49
Masurovsky, Gregory
 collaborations with Butor, 84–85, 196 nn. 23 and 26
 dizains in *Guirlande liminaire*, 44, 119, 200 n. 49
Matière de rêves [*Stuff of Dreams*] (Butor), 16, 19, 22
 La Mothe's study of, 48, 201 n. 72, 205 nn. 111 and 117
 Matière de rêves, 119, 212 nn. 77–79, 214 n. 115
 Matière de rêves II, 20, 48, 50, 201 n. 72, 205 nn. 111 and 117
 Matière de rêves III: Troisième dessous, 203 n. 96, 206 n. 139
 Matière de rêves IV: Quadruple fond, 201 n. 73
matrices
 and Alechinsky's predellas and marginal remarks, 94
 Butor's use of, 40–41, 199 nn. 35 and 36
 in *Guirlande liminaire: La Méduse des chocolats*, 45, 115–19
 in *Guirlande liminaire: Vagues des villes éclosion*, 41, 42, 44–45, 117
 Kolář's non-use of, 40–41, 199 n. 36
 and *L'Oeil de Prague: Dialogue avec Charles Baudelaire*, 64, 66–67, 71, 81, 205 n. 117
Matta, Roberto, 42, 44, 94, 96, 117, 118, 119
Maupassant, Guy de, 85–86
Medusa (Caravaggio), 63
Méduse des chocolats, La [*The Medusa of the Chocolates*] (*Guirlande liminaire*) (Butor and Alechinsky), 95, 115–19
 artwork of, *116*
 Butor's text of, 115–16, 119, 212 n. 71, 174
 dizains in, 42, 44, 45, 116–19, 200 n. 45
 and *double regard* [double gaze], 116–17, 119
 "found papers" of, 93, 95, 115–19, 153
 harmonies in sounds, 116, 173, 212 n. 73
 lines altered for Alechinsky, 118–19, 212 n. 74
 and lines in other poems, 117–19
 "little fish" in 117
 matrices of, 45, 115–19
 Medusa figure in, 117
 phrases found in Kolář poem, 117
 political in, 119
 See also *Guirlande liminaire* [*Prefatory Garland*] (Butor et al.)
Menu meuble, Le [*The Test-Tube Rack*] (Butor and Kolář), *68*, 68–69, 205 nn. 117 and 118
Mer Méditerranée [*The Mediterranean*] *Page V* (Alechinsky), 149, *149*
Métaphores 2 (Butor), 56, 58, 200 n. 46
Michaux, Henri, 213 n. 95
Michel Butor et ses peintres [*Michel Butor and His Painters*] (Butor), 41, 94. See also *Méduse des chocolats, La* [*The Medusa of the Chocolates*] (*Guirlande liminaire*) (Butor and Alechinsky); *Vagues des villes éclosion* [*Waves of Cities Blossoming*] (*Guirlande liminaire*) (Butor and Kolář)
Mitchell, W. J. T., 196 n. 21
Mobile (Butor), 22, 31, 36, 40, 197 nn. 33 and 34
Molière, 199 n. 32
Mon Oncle Jules [*My Uncle Jules*] (Maupassant), 85–86
Monory, Jacques, 21–37
 coldness of, 22, 23–24
 collaboration with Butor, 17, 21–23, 172, 173, 174
 collage techniques of, 38
 interests shared with Butor, 21–23
 La Mothe on, 23–24, 35
 Lyotard on, 22
 portrayals of animals, 33, 34, *34*, 35, 197 n. 24
 realism of, 21, 22
 techniques of, 21–22
 use of monochrome blue, 22, 23–24

 See also *Bicentenaire kit* [*Bicentennial Kit*] (Butor and Monory)
Montagnes rocheuses, Les [*The Rocky Mountains*] (Butor, Adams, and Weston), 19
Monticelli, Raphaël, 19–20, 196 n. 23
Moses and Aaron (Schoenberg), 201 n. 72
Mots dans la peinture, Les [*Words in Painting*] (Butor), 38, 40, 95, 208 n. 27
Moulin, Raoul-Jean, 39
Mucha, Alphonse, 60, 61, 62, 204 n. 107
Mugissement d'eaux [*Roaring of Waters*] (Butor and Kolář), *68*, 68–69, 205 n. 117
music
 and blues music of *Bicentenaire kit*, 23–24
 and Butor's collaborations with musicians, 20, 22, 40, 197 n. 12, 199 n. 35
 musical references in *Dialogue avec Charles Baudelaire*, 50–51, 83, 201 nn. 72 and 73
 musical structure of *Chanson pour Don Albert*, 196 n. 23
 and *Vagues des villes éclosion*, 43
Musique de chambre noire [*Music of the Dark Room*] (Butor and Villers), 55, 176, 203 n. 88

Napoleon in the Desert (Ernst), 60, 61, 204 n. 107
Nixon, Richard, 72, 173, 204 n. 99, 205 nn. 122 and 124
Nord-ouest de la France [*Northwestern France*] *Page III* (Alechinsky), *147*, 147–48, 217 n. 150

Oeil de Prague, L' [*The Eye of Prague*] (Butor and Kolář), 45–84
 ambiance of, 46
 and Baudelaire's poetry, 200 n. 52
 Butor's re-use of earlier texts in, 40
 collaborations of, 16, 45–46, 200 n. 52, 201 nn. 61 and 62
 and *Confessions of Winter*, 56, 168, 201 n. 78
 and *Dialogue avec Charles Baudelaire*, 45–84
 froissages, 46, 75, 200 n. 52
 and Kolář stanza from *Guirlande liminaire*, 41
 Kolář's influence on, 40
 and Kolář's "*La Prague de Kafka, 1977-78*," 46, 75, 200 n. 52
 and Kolář's "*Réponses*," 38–39, 46
 Kolář's use of apples in, *71, 80*, 199 n. 36
 matrices in, 41, 64, 66–67, 71, 81, 199 n. 36, 205 n. 117
 and political in Butor's poetry, 18, 45–46, 201 n. 62
 rollage multiplié, 46
 structure of, 46
 and *Vanité*, 200 n. 55
 See also *Dialogue avec Charles Baudelaire autour des travaux de Jiří Kolář* [*Dialogue with Charles Baudelaire Around Works of Jiří Kolář*] (Butor)
Olympia (Manet), 56–57
Opéra d'automne, L' [*Autumn Opera*] (Butor and Kolář), *88*, 88–89, 90, 91, 174, 207 n. 141
Oppenheim, Lois, 196 n. 25
Opusculum baudelairianum, Répertoire IV (Butor), 47, 48–49, 50, 200 n. 60, 201 n. 62
Oranges de Binche, Les [*The Oranges of Binche*] (Butor and Alechinsky), 133–35, *134*, 142, 173, 215 nn. 123, 126–28
Orgue de pieds et de bras [*Organ of Feet and Arms*] (Butor and Kolář), 76, *76*, 92

Page, Le [*The Pageboy*] (Butor and Kolář), 51–54, *53*, 59, 83, 201 n. 79, 202 nn. 80 and 81, 215 n. 127
Papier de mur [*Paper for Walls*] (Butor and Alechinsky), 139–40, 142, 143, 215 n. 123, 216 n. 138

papiers trouvés. See "found papers" (*"papiers trouvés"*) of Alechinsky

Parant, Jean-Luc, 42, 44, 45, 118

"Partant du lac Ch'I Lin" [*Starting Out from Lake Ch'I Lin*] (Alechinsky), 94

Passage de Butor II [*Butor's Passing*] (Butor), 46, 48, 52, 202 n. 80

"A Perturbed Text: *Matière de rêves* of Michel Butor" (Roudiez), 131–32

Peverelli, Cesare, 42, 44, 119

Picasso, Pablo, 16

Piero della Francesca, 54, 175, 202 nn. 84 and 85

Pierre Butor and Michel Alechinsky (Roudaut), 20

Pieyre de Mandiargues, André, 96

Pipe (Butor and Kolář), 72, *72*

Pirotte, Ernest, 208 n. 33

Planchette à découper [*Chopping Board*] (Butor and Kolář), *77,* 77–78, 81, 206 n. 129

Plein opéra [*Complete Opera*] (Butor and Kolář), 72–73, *73,* 81

Poe, Edgar Allan, 22, 114, 115, 195 n. 13, 199 n. 32

Poème optique (Butor), 95, 208 n. 25

political themes
 in *Bicentenaire kit,* 23, 24–26, 27, 35–36, 37, 174, 175, 198 n. 49
 in *Cartes postales,* 84, 90, 91
 in *Le Chien roi,* 135, 136, 137, 139, 141–43, 175, 216 n. 140, 217 n. 141
 in *Comptine en blanc et noir,* 146–47, 148, 150–52
 in *Dessins sur factures,* 167–69, 170, 220 n. 175, 222 nn. 201 and 203
 in *Dialogue avec Charles Baudelaire,* 51, 57–63, 65, 69, 70, 71, 74, 78, 80, 81, 82, 83, 84, 201 n. 78
 in *La Méduse des chocolats,* 119
 in *L'Oeil de Prague,* 18, 45–46, 201 n. 62
 in *Le Rêve de l'ammonite,* 119, 122, 123, 124, 125, 126–27, 129, 130, 131, 132–33, 175
 in *Stances des mensualités,* 114–15
 in *Le Test du titre,* 103
 in *Vagues des villes éclosion,* 41, 44, 45, 117, 174–75

Pollock, Jackson, 93, 168, 207 n. 13

Pomme de jouvence [*Apple of Youth*] (Butor and Kolář), 80, *80,* 81, 206 n. 131

Pomme vêtue [*Dressed Apple*] (Butor and Kolář), 70–71, *71,* 81, 82, 205 n. 120

Pompadour (Butor and Kolář), *79,* 79–80

Portrait de l'artiste en jeune singe (Butor), 195 nn. 1 and 13

postcards. *See Cartes postales pour un ami de Liechtenstein* [*Postcards for a friend from Lichtenstein*] (Butor and Kolář)

Pousseur, Henri, 22, 50

"Prague de Kafka, 1977–78, La" [*The Prague of Kafka*] (Kolář), 46, 75, 200 n. 52

Précipitation, La [*Haste*] (Butor and Alechinsky), 120, *125,* 125–28, 212 n. 87, 214 nn. 102–10

"Prélude pour déchiffrer Matière de rêves" [Prelude for Decoding *Stuff of Dreams*] (La Mothe), 20

Prêtre, Jean-Claude, 16, 216 n. 138

Procès du jeune chien (Petrus Hebraicus) [*Trial of the Young Dog*] (Butor and Pousseur), 50, 176, 201 n. 72

prollage, 39, 72–73, *73*

Proust, Marcel, 29, 36

Rabelais, François, 18

racism, and *Bicentenaire kit,* 23, 24–26, 27

"Raven, The" (Poe), 22, 195 n. 13

Réalités, 19, 195 n. 20

Reine des neiges, La [*The Queen of Snows*] (Butor), 56–57, 83, 84, 173, 174, 203 n. 93

Reine du cinéma, La [*The Movie Queen*] (Butor and Kolář), 71–72, *72,* 82, 84, 173, 205 nn. 123 and 124

Rembrandt, 63

"Rencontre" (Butor), 195 n. 4, 196 nn. 23 and 26

"Réponses" [*Responses*] (Kolář), 38–39, 46

Rescapés de la corbeille [*Refugees from the Wastebasket*] (Butor and Alechinsky), 103, 195 n. 13, 207 n. 2, 209 n. 49

Résistance (Butor and Kolář), 57–59, 63, 64, 84, 173, 200 n. 46, 203 n. 97, 204 nn. 98 and 99

Respiration, La [*Breath*] (Butor and Alechinsky), 120, *128,* 128–31, 132, 212 n. 86, 214 nn. 111–15, 118

Retour du boomerang, Le [*The Return of the Boomerang*] (Butor and Didier), 21, 139, 196 n. 3, 198 n. 39. *See also Boomerang* (Butor)

Reubens, Peter Paul, 93

Rêve de Jiří Kolář, Le [*The Dream of Jiří Kolář*] (Butor and Kolář), 46, 47, 119

Rêve de l'ammonite, Le [*The Dream of the Ammonite*] (Butor and Alechinsky), 119–33
 and the ammonite, 129–30
 and capital punishment, 127, 214 nn. 106 and 107
 and the clerk, 123, 125, 126, 129, 130, 131, 132
 collaboration of, 17, 94–95, 119–20, 131–32, 173, 212 nn. 81–83
 colors of, 119, 120, 213 n. 88
 comptines [counting rhymes] in, 120, 143, 213 n. 90
 "Correspondances" of, 119–20, 121, 131
 etchings of, 94–95, 119–20, *122, 125, 128,* 212 n. 83
 eyes and gaze in, 128–29
 flowers in, 125–27, 214 nn. 102–5
 forgiveness in, 130, 131
 good and evil in, 131, 132
 and Great Greenish, 121, 126, 130, 132
 harmonies in, 123, 124, 128, 129, 130–34, 174, 214 n. 118
 humor in, 95, 119, 120–22, 123, 124–25, 126–27, 130, 132, 174, 213 n. 96
 marginal comments in, 95, 119–20, 212 n. 83, 214 n. 117
 in *Matière de rêves,* 119, 212 nn. 77–79
 and narrator's concern for others, 125, 129, 130, 131, 132
 political vision of, 119, 122, 123, 124, 125, 126–27, 129, 130, 131, 132–33, 175
 process and development of collaboration, 119–20, 212 nn. 81–83
 rain on Seoul and "deluge of pitch" in 120, 127
 and reproductions in *Travaux,* 120, 213 n. 90
 and *Le Rêve de Jiří Kolář,* 119
 Souvenirs in 120, 121, 123, 127
 structure of, 120
 and *Le Test du titre,* 131, 214 n. 113
 themes of, 120
 time in, 123, 124, 126, 212 n. 83
 tongues in, 120, 121, 123, 126, 129, 132, 213 n. 100
 volcanos in, 120, 122, 130, 131, 132
 L'Arrestation [*Arrest*], 120, 121, 122, 213 nn. 92 and 93
 L'Instruction [*Enquiry*], 120, 121–22
 La Séquestration [*Confinement*], 120, *122,* 122–25, 213 nn. 97–100, 214 n. 101
 La Précipitation [*Haste*], 120, *125,* 125–28, 212 n. 87, 214 nn. 102–10
 La Respiration [*Breath*], 120, *128,* 128–31, 132, 212 n. 86, 214 nn. 111–15 and 118

Rêve de Paul Delvaux, Le [*The Dream of Paul Delvaux*] (Butor), 20

Rêve de Vénus, Le [*The Dream of Venus*] (Butor), 132
Rêve des pommes, Le [*The Dream of the Apples*] (*Passage de Butor II*) (Butor), 46, 48, 202 n. 80, 205 n. 111
Rhee, Seund Ja, 95
Rhizome (Butor and Alechinsky), 135, 136, 142, 143, 215 n. 123, 216 n. 131
Riese-Hubert, Renée, 196 n. 21
Rimbaud, Arthur, 22, 197 n. 36, 223 n. 210
Rochefort, Christiane, 96
rollage multiplié, 40, 46, 50
Roudaut, Jean, 20
Rothko, Mark, 93
Roudiez, Léon S., 20, 23, 131–32, 173, 196 n. 26, 214 n. 120
Roy, Bruno, 119, 213 n. 95
Roy, Claude, 96

Saby, Bernard, 42, 45, 118, 119, 200 n. 41, 212 n. 74
Santschi, Madeleine, 16
Saura, Antonio, 96
Seize et une variations (Ayme, Butor, and Bosseur), 199 n. 35
Séquestration, La [*Confinement*] (Butor and Alechinsky), 120, *122,* 122–25, 213 nn. 97–100, 214 n. 101
Shakespeare, William, 39, 56, 156
Sicard, Michel, 20, 92–93, 94, 116, 147, 153, 207 nn. 5 and 7, 218 nn. 151 and 155. See also *ABC de Correspondance* [*ABC of Correspondence*] (Alechinsky, Butor, and Sicard); *Alechinsky: Travaux d'impression* [*Alechinsky: Printed Works*] (Butor and Sicard); *Alechinsky dans le texte* [*Alechinsky in the Text*] (Butor and Sicard); *Dessins sur factures* [*Drawings on Bills*] (Alechinsky, Butor, and Sicard); *Frontières et bordures* [*Frontiers and Borders*] (Butor and Sicard)
6.810.000 litres d'eau par seconde [*6,810,000 Liters of Water a Second*] (Butor), 95, 214 n. 109
Skimao, 200 n. 55, 206 n. 136
Sollers, Philippe, 96
Song of Roland, 217 n. 149
Sontag, Susan, 201 n. 62
Sous une pluie de presse [*Under a Rain of Printed Matter*] (Butor and Kolář), 64–65, *65*
Southwest Missouri State University Library, William J. Jones Rimbaud-Butor collection, 175, 195 n. 11
Sphinx en chapeau [*Sphinx in a Hat*] (Butor and Alechinsky), *136,* 136–37, 142, 143, 173, 174, 215 nn. 123, 30, 216 n. 131, 219 n. 169
Spleen (Baudelaire), 47
St. Aubyn, F. C., 175
Stances des mensualités [*Stanzas of Monthly Payments*] (Butor and Alechinsky), 95, 103–15
 and Butor's additions, 103–4
 end rhymes of, 112–13, 114, 211 n. 70
 "found papers" of, 93, 103–12, 153, 209 nn. 49–51
 harmony in, 112, 113, 115, 173
 humor in, 104, 113–14, 115, 174
 incongruities in, 114–15
 irony in, 113–14
 mood of text in, 172
 poetic devices and techniques in, 112–14, 173, 211 n. 70
 political message of, 114–15
 and re-use in *Illustrations IV,* 104, 112, 176, 209 n. 53, 211 n. 69
 signatures in, 103, 209 n. 51
 structure of, 104, 111–12, 209 n. 53
 and wills, 103–4
 zodiac signs in, 104, 114

Stances des mensualités [*Stanzas of Monthly Payments*] (Butor and Alechinsky), texts and artworks:
 Janvier [*January*], 103, 104, *104,* 111, 112, 113–14, 209 n. 54, 211 n. 70
 Février [*February*], 104–5, *105,* 111, 113, 114, 115, 209 n. 55, 211 n. 70
 Mars [*March*], 103, *105,* 105–6, 111–12, 113, 114, 115, 209 n. 57, 211 n. 70
 Avril [*April*], 104, 106, *106,* 111, 112, 113, 114, 209 n. 50, 210 n. 58, 211 n. 70
 Mai [*May*], 106–7, *107,* 111, 113, 114, 115, 210 n. 59, 211 n. 70
 Juin [*June*], 103, 107, *107,* 111, 113, 114, 210 nn. 60 and 61, 211 n. 70
 Juillet [*July*], 103, 104, 107–8, *108,* 112, 113, 114, 209 n. 50, 210 n. 62, 211 n. 70
 Août [*August*], *108,* 108–9, 112, 113, 114, 209 n. 51, 210 n. 63, 211 n. 70
 Septembre [*September*], 109, *109,* 112, 113, 114–15, 172, 209 n. 50, 211 nn. 64, 65, and 70
 Octobre [*October*], 103, 109–10, *110,* 111, 112, 113, 114, 115, 209 nn. 50 and 51, 211 nn. 66 and 70
 Novembre [*November*], 104, *110,* 110–11, 112, 113, 114, 115, 211 nn. 67 and 70
 Décembre [*December*], 103, 111, *111,* 112, 113, 114, 209 n. 50, 211 nn. 68 and 70
Stanzas of Monthly Payments. See Stances des mensualités [*Stanzas of Monthly Payments*] (Butor and Alechinsky)
Staritsky, Ania, 42, 44–45, 118
Steiner, Wendy, 196 n. 21
Stratification (Butor and Kolář), 78, *78*
stratifié, 39–40, 58, 63, 78, *78*
Stravinsky, Igor, 28, 36
Strom, Ronald, 19
Stuff of Dreams. See Matière de rêves [*Stuff of Dreams*] (Butor)
Sucre et sel (Alechinsky), 218 n. 151
Sud-ouest de la France [*Southwestern France*] *Page II* (Alechinsky), 145–47, *146,* 217 nn. 147–49
surrealists, 93, 207 nn. 13 and 14
Suzanne (Prêtre), 16, 216 n. 138

Taylor, Elizabeth, 71–72
Temptation, The of St. Anthony, (Grünewald), 60, 61–62, 204 n. 107
Test du titre: 61 titreurs d'élite, Le [*The Test of the Title: 61 Crack-shot Titlers*] (Alechinsky et al.), texts and artworks:
 Text 1, *Ça y est!* [*There you are!*], 96, *96,* 99, 101, 208 nn. 32 and 33
 Text 2, *Hé hé hé!* [*Hey, Hey, Hey!*], 96, *98,* 99, 208 nn. 34 and 35
 Text 3, *Ça pousse* [*It is growing*], 96, 99, *99,* 208 nn. 36 and 37
 Text 4, *Stupeur!* [*What a surprise!*], 97, 99, *100,* 103, 208 nn. 38 and 39
 Text 5, *Elle en pleure de rire* [*She laughs until she cries*], 97–98, 99, 101, *101,* 208 nn. 40–42
 Text 6, *Elle triomphe* [*She is triumphant*], 98, 99, *102,* 208 nn. 43 and 44
Test du titre: 61 titreurs d'élite, Le [*The Test of the Title: 61 Crack-shot Titlers*] (Alechinsky et al.), 18, 95–103, 111, 208 n. 30
 artists and writers involved in, 96
 collaboration illustrating Butor's imagination, 98–99, 103, 132
 confusion and the unreliable narrator in, 101–2
 harmony muted in, 100

humor in, 102–3, 174
images and symbols in, 96–99, 208 n. 37
movement of text in, 99–100
as murder account, 99–100, 103, 208 n. 46
political statement of, 103
and *Rêve de l'ammonite,* 131, 214 n. 113
satire of gossip in, 102–3, 208 n. 47
Teulon-Nouailles, Bernard, 16, 200 n. 55
Texte. See *Alechinsky dans le Texte* [*Alechinsky in the Text*] (Butor and Sicard)
Ting, Walasse, 93, 96
titles
 and Butor's collaborations with Alechinsky, 92, 95
 "running after" and Butor's titling of *Le Chien roi,* 133, 142
 See also *Test du titre: 61 titreurs d'élite, Le* [*The Test of the Title: 61 Crack-shot Titlers*] (Alechinsky et al.)
Toilette nocturne [*Nocturnal Toilette*] (Kolář), 55–56, 57, 83, 84, 202 n. 86, 203 nn. 87 and 89–92
Tourmente [*Torment*] (Butor), 17, 214 n. 108
"*Traces préliminaires pour une exploration de l'île de Vénus*" [*Preliminary Tracks for an Exploration of the Island of Venus*] (La Mothe), 20
Travaux. See *Alechinsky: Travaux d'impression* [*Alechinsky: Printed Works*] (Butor and Sicard)
Triomphe de la vallée [*Triumph of the Valley*] (Butor and Kolář), 89–90, *90,* 91, 207 n. 142
Triumphal Diptych of Federico II de Montelfeltro and Battista Sforza (Piero della Francesca), 54, 175, 202 nn. 84 and 85
Truffaut, François, 96
Tunnel (Butor and Alechinsky), 135–36, 142, 143, 215 n. 123, 216 n. 131
Turquie d'Asie [*Turkey of Asia*] Page IV (Alechinsky), 148–49, *149,* 218 n. 153

Vagues des villes éclosion [*Waves of Cities Blossoming*] (*Guirlande liminaire*) (Butor and Kolář), 41–45, 115, 174–75, 199 n. 40, 201 n. 78
 as *chiasmage, 42, 42*–43
 dizains of, 41, 42, 43, 44–45, 200 nn. 41 and 42, 200 nn. 45, 48, and 49
 doom and hope contrasts in, 43–44, 45
 effects of other dizains on, 45

"foundlings" in 43, 44, 45
harmony of, 43, 173
and Kolář as interpreter, 43
little fish in, 43, 117, 200 n. 45
matrices of, 41, 42, 44–45, 117
music and senses in, 43
political in, 41, 44, 45, 117, 174–75
in relation to whole *Guirlande,* 44–45
repetitions of, 42, 44–45
republication of, 199 n. 39
and resistance through art, 42, 43, 44, 45
See also *Guirlande liminaire* [*Prefatory Garland*] (Butor et al.)
Van Rossum-Guyon, Françoise, 170, 223 n. 212
Vanité (Butor), 198 n. 49, 200 n. 55
Vasarely, Victor, 42, 44, 45, 119
Venise [*Venice*] (Butor and Kolář), 69–70, *70,* 81
ventillage, 40, 55, 58, 63
Venus and Mars (Veronese), 60, 61, 204 n. 107
Verne, Jules, 139, 168, 206 n. 139
Veronese, Paolo, 60, 61, 204 n. 107
Victor Hugo écartelé (Butor), 195 n. 13, 199 n. 36, 210 n. 61
Vieira de Silva, Maria Helena, 42, 44, 45, 117, 118, 200 n. 41
Ville moyenne, La [*The Average City*] (Butor and Kolář), 74–75, *75,* 81, 205 n. 119
violence
 and *Comptine en blanc et noir,* 151, 152
 in *Dialogue avec Charles Baudelaire,* 79–80, 81
 as subject of *Bicentenaire kit,* 23, 26–28
Violon [*Violin*] (Butor and Kolář), 73–74, *74*

Waves of Cities Blossoming. See *Vagues des villes éclosion* [*Waves of Cities Blossoming*] (*Guirlande liminaire*) (Butor and Kolář)
Weinberg, Bernard, 83
women
 and *Dialogue avec Charles Baudelaire,* 47, 52–57, 84, 202 n. 82
 and *Le Rêve de l'ammonite,* 129–130, 132

Zañartu, 16, 195 n. 4, 196 nn. 23, 26
Zone Franche (Butor), 199 n. 36, 203 n. 96